THE MALCOVE COLLECTION

The magnificent art collection of Dr Lillian Malcove consists of 513 pieces: paintings, drawings, furniture, icons, manuscripts, and textiles, as well as works in terracotta, glass, bronze, stone, enamel, ivory, silver, and gold. They represent a vast range of art history, from prehistory to the twentieth century, including Greek, Roman, Byzantine, and western mediaeval works, and even a few pieces from the Far East.

Dr Malcove, a psychoanalyst in New York, bequeathed the collection to the University of Toronto so that it might be used for teaching. It is housed in the University of Toronto Art Centre.

This catalogue was initially produced in conjunction with the first exhibit of the collection, presented at the University of Toronto in two parts, late in 1985 and early in 1986. Each piece is illustrated in the catalogue, and this new paperback edition features eight pages of colour photographs. Extensive descriptions, identifying and evaluating the objects, have been provided by scholars who represent diverse areas of expertise in art and archaeology. Also included are five brief memoirs by friends of Dr Malcove.

The catalogue stands as a permanent record of an extraordinary collection and a unique perspective on art from a variety of cultures throughout history.

SHEILA D. CAMPBELL, the curator of the Malcove Collection, is a professor at the Pontifical Institute of Mediaeval Studies, Toronto.

EDITED BY SHEILA D. CAMPBELL

The
Malcove
Collection

A CATALOGUE OF THE OBJECTS IN
THE LILLIAN MALCOVE COLLECTION
OF THE UNIVERSITY OF TORONTO

UNIVERSITY OF TORONTO PRESS
Toronto Buffalo London

©University of Toronto Press 1985
Toronto Buffalo London
Printed in Canada

Reprinted in paperback in 1997

ISBN 0-8020-8169-X (paper)

Printed on acid-free paper

Canadian Cataloguing in Publication Data

University of Toronto
 The Malcove Collection : a catalogue of the objects in the Lillian
Malcove Collection of the University of Toronto

ISBN 0-8020-8169-X

1. Art, Byzantine − Catalogs. 2. Art, Medieval − Catalogs.
3. Art objects − Catalogs. 4. Art − Private collections −
Ontario − Toronto − Catalogs. 5. University of Toronto −
Catalogs. 6. Malcove, Lillian − Art collections − Catalogs.
I. Campbell, Sheila D., 1938− . II. Title.

N5964.C3T67 1997 709'.02'0740113541 C97-931689-8

Front cover: *Adam and Eve*, Lucas Cranach the Elder (catalogue 468)
Back cover: *Draped Seated Woman*, Henry Moore (catalogue 497)

Contents

Foreword

Few universities in Canada have been fortunate enough to enjoy a gift as generous, prestigious, and useful as the bequest of the late Dr Lillian Malcove Ormos. The University of Toronto has received through Dr Malcove not only a collection of art objects of excellent quality and great beauty, but also a valuable instructional tool to assist our students in their knowledge and appreciation of the past. Students in mediaeval studies, history, art history, archaeology, theology, liturgy, and many other disciplines have benefited from their access to the Malcove Collection. Seldom do advanced students in North American universities have the opportunity to examine and study directly objects of such quality.

Dr Malcove intended that her collection be used as teaching materials. She desired that her own passion for art and learning, especially of the Byzantine and mediaeval periods, be extended to serious students through access to her collection. In this way her interest in art and history is sustained and grows, spreading from this university throughout the world with our students, who in turn teach others.

Therefore, Dr Malcove's gracious gift of her celebrated collection and the funds that support it has made a contribution to studies everywhere, not just in this university. However, the University of Toronto is especially advantaged by her bequest and proud that it was the reputation of

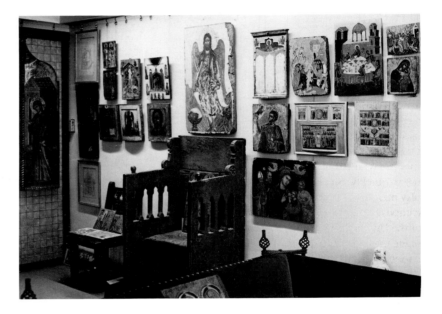

The apartment

our academic programs in mediaeval studies in particular and the fame of our sister institution, the Royal Ontario Museum, that finally convinced Dr Malcove to will her collection, acquired over her long life by informed and careful purchase, to the University of Toronto.

In co-operation with the Royal Ontario Museum, the university will continue to work to fulfil the intentions of Lillian Malcove's generous gift and sustain thereby the study and knowledge of those moments in history represented in her collection. Dr Malcove's great contributions to the university and the city of Toronto have been received proudly and with

great appreciation. She has immeasurably enriched our university and we honour her for it.

KENNETH R. BARTLETT
Acting Vice-President
Institutional Relations
February 1985

Introduction

When Dr Lillian Malcove decided to leave her large art collection to the University of Toronto it was with the clear intention that the collection should be used for teaching. On Friday, 26 February 1982, the shipment arrived in Toronto. As early as Monday morning, two of the pieces were used in a class. We feel sure that Dr Malcove would have been pleased that her wonderful gift was put to use so quickly. Since then, many faculty members, on both the St George campus and the Scarborough campus of the University of Toronto, have made use of the collection in a great variety of courses, both for demonstration and for teaching research skills. In addition, there have already been a number of small exhibitions and loans to travelling exhibitions. Now we are able to make a larger and more public acknowledgment of this bequest in the form of a catalogue and exhibition of the entire collection, to take place in two stages.

A list of the people who have helped with the many aspects of this collection would be far too long to reproduce. Initially, I must acknowledge the roles of Dr John Evans and Dr Hsio Yen Shih, whose early support helped ensure that the collection might come to the University of Toronto, and of Michael Dollard, Dr Malcove's friend and executor, who worked closely with me and my colleagues at the University before and after the collection was transferred to Toronto. Thanks must also

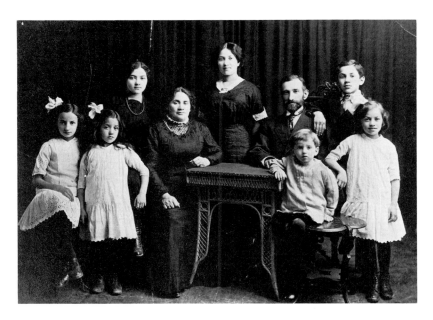

Malcove family portrait

go to the Pontifical Institute of Mediaeval Studies, in particular Fr Ambrose Raftis (president) and Fr Donald Finlay (librarian) who, at very short notice, made the space available for temporary housing of the collection. Fr Michael Sheehan and Sr Wilma Fitzgerald worked tirelessly in helping to unpack the forty-seven crates, while the administrative details were ably handled by Dr Kenneth Bartlett. The assistance and co-operation of the Royal Ontario Museum should also be noted.

The preparation of the catalogue has required the co-operation and assistance of many colleagues who willingly fitted my requests for catalogue entries into their already busy schedules. Their help has been much appreciated. In addition, the Department of Publications at the Pontifical Institute of Mediaeval Studies provided excellent advice. The staff at the University of Toronto Press have been extremely helpful, especially Joan Bulger, Will Rueter and Rosemary Shipton. I also thank the Social Sciences and Humanities Research Council of Canada for two research grants to support the preparation of this manuscript.

SHEILA D. CAMPBELL
June 1985

Lillian Malcove

MICHAEL DOLLARD

Always, when studying works of art displayed in public museums, I offer homage to the collectors whose insight and generosity have made such works available to everyone. Their efforts have added much to the expansion of our knowledge and appreciation of all cultures. Yet the background and motivations which cause a benefactor to collect and then make a bequest of the works of art often remain obscure or unknown. The biographical sketches of Lillian Malcove which follow are an attempt to give those who study the Malcove Collection in all its diversity some sense of the personality of the collector.

At my first meeting with Lillian in 1968 we discussed a Russian icon she was considering acquiring. She then led me through the various departments of her tiny 'museum,' selecting a particular masterpiece or a quite utilitarian artefact with equal enthusiasm, modestly expressed erudition, and genuine curiosity to hear my opinion. Often touching the work in question with the care of a conservator, as with a gentle loving concern she blew some excess dust from the surfaces, she said: 'Dust damages far less than dusting, so my cleaning lady is allowed only to vacuum the carpet in here.' To visit a museum or attend an exhibition with Lillian was both exhilarating and humbling. She studied every object intensely, sharing animated insights and explanations without the slightest tinge of condescension – even at times with a de-

lightful irreverent wit. Six hours of unremitting attention would not tire her.

One evening, about seven years before she died, Lillian asked me in the most matter-of-fact manner to help her find a suitable institution for the bequest of her collection, where it could be used as a teaching tool for scholars and for the general public. I sadly agreed, whereupon she produced a carefully prepared, highly detailed inventory listing every work with its original provenance, cost, and conservation report. Such was Lillian's dedication that she continued to collect until the very end of her life.

I know little of her professional practice as a psychoanalyst as she never discussed her work. But I do remember clearly that, in the last year of her life, when it became obvious that her energies were waning rapidly, both I and another dear friend of hers, Malcolm Wiener, suggested that she consider retiring. She quietly reproved us, saying that all her files were in complete order; that each one of her clients was referred to an analyst, and that it was her duty and her debt to mankind to work until she could no longer do so. She kept her resolve, only ceasing to practise shortly before she entered the hospital for the last time.

TRUDY (MALCOVE) SCHWAB

Lillian Malcove was born on 8 June 1902 in a small village in Mogilev, outside of Kiev, on the Dnieper River. She was the fourth youngest

child of a family of nine children. Two died in infancy; the remaining seven later went into the professions and business. We left Russia in early May 1905 to escape persecutions and pogroms and emigrated to Winnipeg, Manitoba.

For Lillian, the school years in Winnipeg were exciting. She lived a good part of the time in her own world of books and learning, and had little time to waste on frivolities. She was studious, curious, observant, and with a good 'dry' sense of humour. Through most of her life it seemed that people who came in contact with her were somehow uplifted. She seemed always to leave them on a happy note.

Lillian put herself through medical school by working part time as a night cashier at a hotel. During the night hours there was time to read and study. She graduated from medical school at the University of Manitoba and continued with her internship at the Winnipeg General Hospital in Manitoba. She was overworked and contracted tuberculosis. After her recovery she moved to New York and went on to specialize in psychiatry. In 1933 she began her own practice of psychoanalysis, which lasted almost fifty years. From 1939 she taught at the New York Psychoanalytic Institute.

The museums and many galleries in New York opened up a new world and she began buying art with the income from her early years in practice. She loaned works from her collection for exhibition to the New York Metropolitan Museum of Art, the Museum of Fine Arts in Boston,

Lillian Malcove

and the Fogg Art Museum in Cambridge, Mass. She gave works to Yale University, the Israel Museum, and the Fogg Museum.

Lillian married Laszlo Ormos, a Hungarian director of documentary films, who died of a heart attack at the age of forty-five. She became ill with encephalitis and, after a year of consultations with no improvement, she decided to do her own research and treatment and the following year resumed her practice. Her will and discipline were unmatched. She loved classical music, especially the Baroque period, and enjoyed attending concerts, opera, ballet, as well as theatre. Although she was a serious person, she had a delightful sense of play.

After she acquired her country estate, she became a fine bird-watcher and botanist. Through her funding, the Rockland Audubon Society began the tradition of encouraging Rocklanders to experience nature at the Audubon summer camps. After her death the Rockland Audubon Society established a camp scholarship in Lillian's memory.

MARGARET (MIGGY) MEISS

Lillian had many facets. She sparkled like a diamond, was sharply defined, and was to me a very precious per-

son. My husband, an art historian, and I met her in the latter half of the 1940s, some years after her husband had died. We became a close threesome, spending many weekends together. The friendship continued after my husband's death, so we two had thirty-five years of good companionship.

Lillian's collecting, as she grew older, absorbed some of the time and enormous energy that she had earlier devoted to her rural retreat from New York City. This property, like her collection, was special. It lay on both sides of a wonderfully active brook which, on a small scale, had created a miniature Grand Canyon. Again like her collection, there was diversity: wet areas, dry upland meadows, a field of berries for the birds, an area devoted to food for the ducks, a pond formed by diverting the brook, quiet water in contrast to the tumultuous flow, a serene spot for swimming, places in sun or shade in which to sit and contemplate and dream.

Everything that Lillian did was done intensely and in depth because that was the way she enjoyed doing it. It was fun. Her life list of birds was large; sometimes she followed them south for a vacation near their winter homes. She knew the botanical names of mosses, grasses, flowers, and trees. For many years she had the local Audubon group at her place on Saturday or went elsewhere with them. Weekends were precious, outdoors in spring and fall, in winter at museums, dealers, and concerts in New York, New Haven, Boston, and Philadelphia. The week itself was devoted to her profession. From early morning until early, sometimes late, evening she saw patients, and in addition taught at night at the New York Psychoanalytic Institute. She particularly liked teaching a course on dreams or myths. Best of all she liked the continuous case seminar which she taught until a year before her death.

When we first met Lillian she lived in a small, distinctive penthouse with a fair-sized terrace covered with planters. Later she moved to a more usual apartment with good security.

A short sketch of this new home, in which she lived until she died, demonstrates her ever increasing commitment to the collection you will now see. In the beginning this apartment, which faced west and south, was flooded with light. The windows housed flowering plants and vines. There were a few icons and larger pictures on the two long walls. Opposite the main bank of windows, sliding doors, translucent but not transparent, separated and completely concealed the living room from the waiting room. Her office to the right of the living room was furnished in dark brown, complete with bookcases, a couch and chairs, her lovely desk, and a few objects and drawings. The living room was sparsely furnished, but a few chairs and a table made a central focus for tea or drinks and space to look at catalogues and new objects. Slowly the icons kept coming and coming. In the end they completely covered the walls, turning them into scintillating gold. Then the outdoor light disappeared. Some windows were covered with stained glass, others became display space for small objects. The dining alcove off the living room was sheathed in linenfold panelling, recreating a monk's cell. Special heating and humidification were installed to protect the collection. The hidden secret room became a small private museum.

This catalogue will surely document the breadth and depth of Lillian's taste and interests. It will also demonstrate her knowledge which led her to purchase unique and sometimes atypical examples. Some may note that this small lady had a special affinity for small artefacts – objects that could evoke a personal relationship, objects that could be held tenderly in small, competent hands.

LAWRENCE J. MAJEWSKI

I first met Lillian Malcove through a fellow conservator, the late Alan Thielker, when we were both working at the Conservation Department of the Metropolitan Museum of Art

in 1954-5. Alan, who knew her through family connections, took me to her apartment where I was overwhelmed by her collection of paintings and objects.

While I was deputy field director of the Byzantine Institute in Istanbul, Turkey, in 1956-60, Lillian came to see me. The work being done at Haghia Sophia and the Kariye Djami greatly increased her love for paintings and objects of the Byzantine era. She began collecting fine-quality icons, metal works, ivories, frescoes, and wooden artefacts, and continued to do so throughout her life.

We had marvellous times together – browsing in bazaars, boating up the Bosphorus and around the islands of the Sea of Marmara, dining in some of the exotic restaurants of Istanbul, Athens, and elsewhere. Lillian had a magnificent eye for quality and only collected objects that she first learned to love. She loved each object of her collection like a dear friend or child and gave it the best of care. All her objects were examined by experts who recommended the type of care or treatment they should receive. Her icons were put into first-rate condition by conservators of highest repute. Her bronzes were constantly inspected for bronze disease or other problems and treated accordingly. And perhaps most important, she provided an environment of proper humidity and temperature to preserve each object in its pristine condition.

I last saw Lillian Malcove shortly before I left for an archaeological excavation in Turkey in 1981. When I returned to New York in September I learned of her death and felt a great personal loss. I still see her fondly caressing a fine bronze lamp or a small reliquary and will always remember her as a dear friend and a connoisseur of connoisseurs.

HSIO YEN SHIH

Lillian Malcove came to Toronto one autumn weekend in 1974 especially to see the first great exhibition of Chinese archaeological finds to be shown in North America. Her profes-

Lillian Malcove

sional duties gave her only Saturday and Sunday for the visit and so, as we had met in New York previously, it was arranged that she would be admitted to the exhibition in the Royal Ontario Museum at 8:30 in the morning in order to make the best use of her time. She could have over an hour of viewing in relative tranquility, disturbed only by my inspection round with the curators from the People's Republic of China, before the gates opened to crowds at 10:00. Having my own curatorial duties and assuming that she, like I, would prefer to look without commentary, I did not seek out Lillian until several hours later. She was so engaged with the exhibition that she disclaimed any need for nourishment or other comforts. Except for a tea break, she remained in the special exhibition halls until closing time late in the evening. The next morning, having asked me a series of questions, back she went to review the objects with a different perspective. This was only the first of many times when Lillian taught me how to see.

More usual were subsequent visits to her apartment in New York, when she would concentrate on a single object, or a distinct group of objects, to look at, think about, and discuss. Her collecting interests were as

much intellectual as aesthetic; her approaches included connoisseurship, but extended to archaeological, art, and cultural historical concerns. For these reasons, Lillian's collection does not include only those artefacts classified as 'fine arts,' but also objects apparently less imposing yet revealing of techniques, ideas, and other aspects of human endeavour that can help to define the complexities of a civilization. We would consider the significance of a Byzantine balance-scale weight as intensely as we would a Gothic ivory altarpiece.

I did not know that Lillian was considering the gift of her collection to Toronto until she asked to meet some of my younger colleagues who were mediaeval specialists. Having satisfied herself as to the physical conditions available for the collection, she was particularly concerned about its potential uses in scholarship. A small group of friends gathered to meet Lillian; they included a textile historian, a literary historian, an economic historian, and a social historian, as well as archaeologists and art historians studying the mediaeval world from the Near East to Western Europe. It was a friendly and informal evening, but Lillian managed to speak to each person present and to form very distinct impressions. I would like to think that it was the presence of these young scholars at the University of Toronto that convinced Lillian of the suitable placement for her collection.

THE MALCOVE COLLECTION

NOTE: Dates are AD unless specified. Measurements are given in the order height, width, depth, or height, diameter, thickness. Full bibliographical information is given the first time a reference is cited; subsequent listings are restricted to title or surname only, followed by the abbreviation [cat.] and the entry number of the first citation.

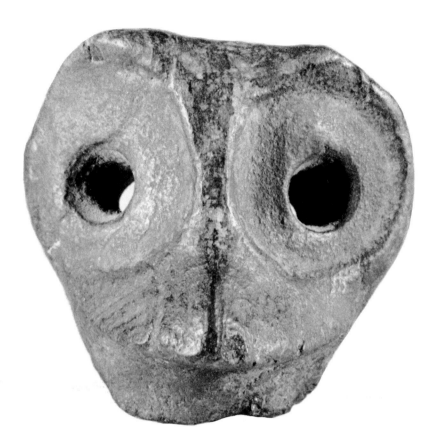

1 Animal / Bird mask (?)

Dark greenish-black stone.
4.4 × 4.5 × 2.6 cm
Easternmost part of Anatolia,
probably 4th–3rd millennium BC
 M82.268

Essentially triangular in shape, the
object has a deeply cut concave back
surface and a flattened top. Two
large drilled holes serve as eyes, each
accented by an encircling indented
ring. A third hole was drilled verti-
cally from the top near the back
to provide a means of attachment.
The hooked 'beak' is pointed, with a
deep undercutting below for the
neck. The piece is intact, with occa-
sional chipped surfaces and edges.
The bridge of the top hole is broken.
It probably served as an amulet of
some kind, to be worn about the
neck.
 Both this object and catalogue 2
are said to come from the eastern-
most part of Anatolia, although ac-
quired separately by the dealer, and
are strikingly similar in detail. Pre-
sumably they represent the same
figure, possibly a deity of some kind.
Hardly anything is known about
the prehistory of this area of Anatolia
for very little scientific excavation
has taken place here. The complete
lack of context and of parallels else-
where render interpretation virtually
impossible at this time. The objects
probably date to about the fourth
or third millennium BC.
 With thanks to James Mellaart,
FBA, University of London, Institute
of Archaeology, for his help and
advice concerning this object and
catalogue 2 and 3.

Purchased from Peter Mol,
Amsterdam JSP

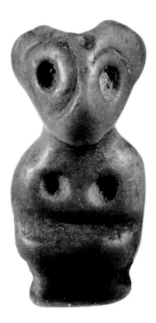

3 Zoomorphic figurine

Bronze. 5.8 x 2.1 cm
Eastern Anatolia / northwestern Iran
area, Bronze Age (?), 3rd millennium
BC or later M82.270

The object is a small solid-cast bronze figurine, representing a standing male zoomorphic being, possibly a deity. It has a long thin body with a flat stomach, rounded back, and short bent legs leaning slightly to the right. A single tapering length of bronze, curled at either end and attached to the head, seems to represent down-curved horns. The head is triangular, with pointed nose and chin and two indentations for the mouth and bottom of the nose. Both arms are bent in front of the body, each having three 'toes.' Their position and a short raised point seen behind the left 'paw' suggest that it may have originally been supporting or holding something now missing. The legs bend into the feet. Genitals and a tail are indicated by a raised vertical line front and back, accentuated by tooling on either side. It was probably made using the lost wax method.

The complete lack of context, documentation, and parallels elsewhere render interpretation virtually impossible. Small bronze figurines are found throughout the Bronze Age Near East, although there do not seem to be close parallels to this one. The provenance suggested is based on a minor tradition in this area of a standing moufflon-headed daemon figure having bent legs and arms, who appears on 4th millennium seal stamps. A relationship is, however, very tenuous at best. For the daemon seal stamps see Edith Porada, 'Early Seals of Western Iran (c. 4th millennium BC),' in Glenn Markoe, ed., *Ancient Bronzes, Ceramics and Seals: The Nasli M. Heeramaneck Collection of Ancient Near Eastern, Central Asiatic and European Art* (Los Angeles, Los Angeles County Museum of Art, 1981), 190, 199, no. 1010.

Purchased from Peter Mol,
Amsterdam, 1969 JSP

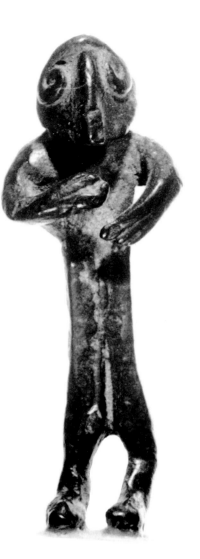

2 Small anthropomorphic figurine

Light greenish stone.
2.4 x 1.0 x 0.9 cm
Easternmost part of Anatolia,
probably 4th–3rd millennium BC
 M82.269

This figurine has a triangular head and a flat back. Eyes and breasts are indicated by drilling, the eyes accentuated by incompletely incised rings. At the top and back of the head, holes were drilled to meet at right angles inside to provide a means of attachment. The head is very similar to catalogue 1 and may be related to it, although this figurine has a more rounded chin. It is intact except that the bridge of the hole is broken at the back. Possibly it was intended as an amulet to be worn about the neck or wrist.

The piece was reported to have been found in the same area as catalogue 1, but was acquired separately by the dealer.

Purchased from Peter Mol,
Amsterdam, 1969 JSP

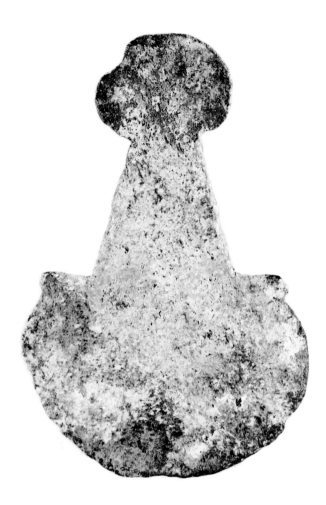

At some point it was broken at the top of the neck just below the head and repaired.

The use of these figurines is not certain, but they are usually identified as idols. This example, found around Burdur in southwestern Turkey, is schematic in style, a feature which remained characteristically Anatolian although the related and far more famous Cycladic figurines became increasingly more naturalistic in presentation. Some Kusura-type figurines were found, evidently deliberately broken, in graves of children. Others were found in habitation contexts, while many of the Beycesultan-type figurines were discovered within a shrine. All are dated to the Early Bronze Age II period. For comparative examples see Jürgen Thimme, *Art and Culture of the Cyclades* (Chicago 1977), nos. 511, 518; Kojiro Ishiguru, *Mr. and Mrs. Ishiguru Collection*, vol. I (Tokyo 1976), no. 63(A).

Purchased from Peter Mol,
Amsterdam, 1969 JSP

4 Schematic stone figurine

Poor quality grey / white marble.
10.6 × 6.7 × 0.3 / 0.4 cm
Area around Burdur, Turkey, Early
Bronze Age II, circa 2700 BC or slightly
later M82.341

This object is a thin, flat abstract-schematic figurine of the Kusura-Beycesultan variety, with a slightly flattened, disc-shaped body and head, joined by a tall neck which widens considerably towards the shoulders. Rounded stumps of arms project on either side of the body. The indentation on the left side of the head may be an early development of the 'horn' characteristic of this variety, for this side is broader than the other. The arm stumps are less pronounced than other examples. Both are indications that this particular figure may be an early form of the variety. It is intact, but encrusted and weathered, with slightly chipped edges.

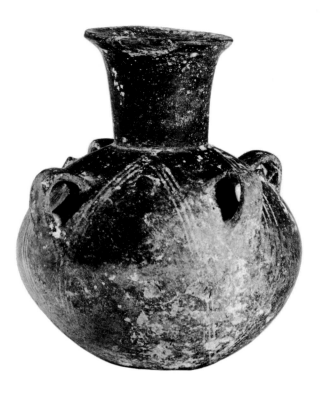
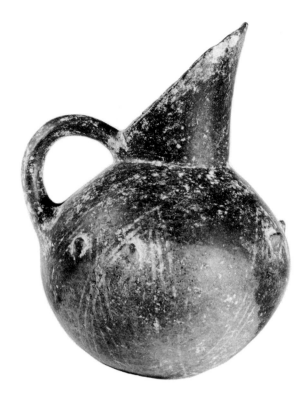

5, 6 Clay vessels

Fired clay.
5: 21.5 × 14.7 cm
6: 18.0 × 15.2 cm
Yortan, west-central Turkey, late
Early Bronze Age I–IIIa,
circa 2800–2500 BC M82.344,345

Number 5 is a jug with a short cut-away neck, a single handle from neck to lower shoulder, and a small flattened base. The jug was deliberately unevenly fired, red at the bottom and black at the top to the lower shoulder and further below the handle and at the front. The exterior surface is polished and decorated with three pairs of raised 'nipples' at the front and sides. Each nipple is separately accentuated by a series of triple white-painted lines in an inverted 'v' pattern. The vessel is intact, but chipped at the neck edge with a pitted and occasionally worn surface.

Number 6 is a hand-formed collar-necked jug with a flaring rim, four vertical strap handles, and a small flattened base. As with no. 5 it is polished and unevenly fired to achieve a two-toned surface, black at the neck and shoulder and red below. Decoration consists of four raised 'nipples' high on the shoulder, alternating with the handles and accentuated by a series of triple white-painted lines in an inverted 'v' pattern. The lines meet at the top of the shoulder and below the handles. This decoration, although similar to that of catalogue 5, is finer and more carefully executed. It is intact, but with occasional pitting and surface wear, and chipped at the rim. One large chip has been repaired. Similar vessels are found supported on three legs, with a lid, without handles, in various combinations.

These vessels are typical of the Yortan culture which appears to have flourished during the late Early Bronze Age I–IIIa period in west-central Turkey. The type-site of Yortan itself consists of a series of cemeteries, the majority of which have been illegally plundered for their contents. The pottery is especially prized for its technical and artistic superiority and examples are found in most private and public collections. Consequently, little is known of the ceramic and cultural development, so vessels are dated by associated finds at Troy, Beycesultan, or elsewhere. The vessels were placed in large jar or cist burials, either as grave goods or as containers for food or drink for the dead. Such concern for the welfare of the deceased was common in Bronze Age Anatolia and elsewhere, and speaks of a culture which believed in a physical afterlife dependent on the support of the living. For comparative works see Winfried Orthmann, 'Keramik der Yortankültür in den Berliner Museen,' *Istanbuler Mitteilungen, XVI,* 1966, p. 5, pl. 2:12 (no. 5), p. 11, pl. 5, especially 5.39, p. 13, pl. 6, especially 6.40.41 (no. 6); Turkan Kamil, *Yortan Cemetery in the Early Bronze Age of Western Anatolia* (London, British Archaeological Reports, International Series, vol. 145, 1982), figs. 40-2, especially 41.150 (no. 5) and 30–1 (no. 6).

Purchased from Peter Mol,
Amsterdam, June 1968 JSP

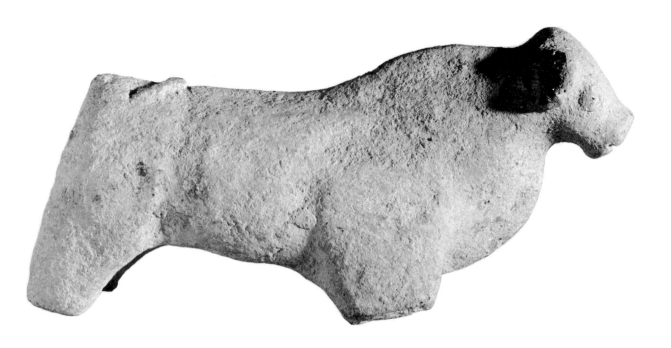

7 Water buffalo or bull figurine

Fired clay. 10.4 × 17.6 × 6.0 cm
Alaca Hüyük, north-central Turkey,
probably Hittite period, circa 2000–
1200 BC M82.342

The clay figurine has a hollow interior, base, and rear. The pellet eyes and ears, horns and tail are added, with the mouth and nostrils indicated by incised lines. Proportionally, the head is small. It has a pronounced hump, backbone, and dewlap on a barrel body supported on very short strap legs. The horns are broken off just above the ears. The tail curls over the backbone, a missing portion originally over the left haunch. The front legs are broken, but the rear legs have a flat base. It is otherwise intact, with a heavily encrusted outer and inner surface which is much chipped and worn, revealing a groggy, light pinkish-orange clay. It was probably made by pouring the clay into a mould, as it is not hand formed.

The pronounced hump and dewlap may indicate that this figure is a water buffalo (an animal uncommonly represented but known to exist in Anatolia from the beginning of the Bronze Age, if not earlier) rather than a bull. It is said to come from the Alaca Hüyük excavations, a site which was occupied in the Early Bronze Age, during the Hittite era, and by the Phrygians. It does not fit comfortably into any of these periods in comparison to published figures, being too stocky for the Early Bronze Age and not as stylized as the Phrygian. It is best compared to some of the heads found in the Hittite layers, although no body pieces are similar. For comparative examples see Hâmit Zubeyr Kosay, *Alaca Hüyük Kasısı 1940–48* (Ankara 1966), pls. 25, 28:A1.i.256, pl. 29:A1.g.230, and p. 167.

Purchased from Peter Mol,
Amsterdam, 1969 JSP

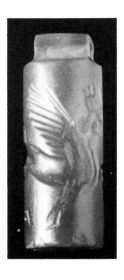

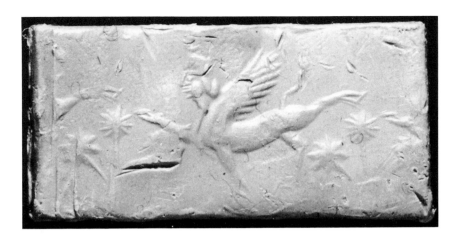

8 Cylinder seal

Carnelian. 5.2 × 0.8 cm
Northern Iraq (?), Middle Assyrian,
circa 1300–1200 BC M82.232

The seal is a tall cylindrical shape, having a drilled hole through a long carved ring at the top. Around the circumference of the body, a design consisting of a winged, human-headed sphinx galloping past a stylized bush is carved in low negative relief. The sphinx is beardless and wears a crown, with its left front and right rear legs strongly extended and tail flying. The other legs stand on a ground indicated only by the presence of the bush which divides itself into three branches.

The design and details of the seal are typical of the thirteenth-century BC Middle Assyrian type, which developed a naturalistic style following Assyrian ascendancy over Mittanian overlords circa 1350 BC. Traces of Mittanian influence are still evident in the patterned treatment of the head (especially the face and hair) and the rather stiff bush. It is intact with a few slight chips at the base.

Cylinder seals are typical of the Mesopotamian world, where they are found as early as the fourth millenium BC. The image was carved around the circumference of the cylinder so that when it is impressed onto soft clay the design could be endlessly repeated to produce a continuous frieze. Each design is unique, the resulting impression (sealing) often used to proclaim ownership of the contents, such as goods or letters, which had thus been sealed. The drilled hole at the top was used to string the seal so that it could be worn about the neck or wrist of the owner.

According to Dr Malcove's notes, she showed this seal to Professor Edith Porada, Columbia University, who attributed the date shown above with the comment that it was an especially fine specimen. For comparisons see Edith Porada, *Corpus*

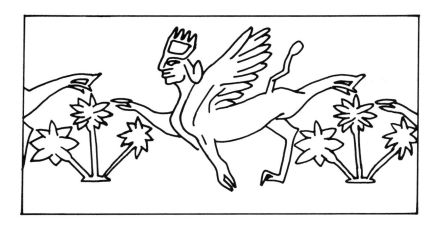

of *Ancient Near Eastern Seals in
North American Collections,* I: *The
Collection of the Pierpont Morgan
Library* (New York 1948), pl.
LXXXIV:601E; D.J. Wiseman, *Cylinder
Seals of Western Asia* (London nd),
pp. 61–2; *Catalogue of Ancient Near
Eastern Seals in the Ashmolean
Museum,* I: *Cylinder Seals* (Oxford
1966), pl. 38:569 and 570.

Purchased from Covered Bazaar,
Istanbul, 1964 JSP

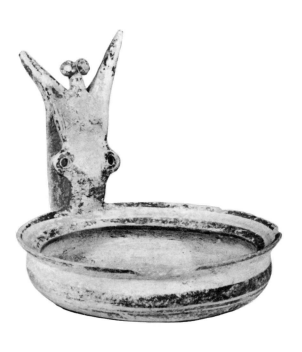

9 Shallow painted bowl

Fired clay. 14.1 × 14.6 cm
Probably southeastern Italy
(northern Apulia or surrounding
area?), Subgeometric Daunian II,
circa 550–400 BC M82.346

This hand-formed, shallow, 'cornuto'
ceramic bowl with a high looped
handle has a flaring rim and concave
base. The inner loop of the handle
has a slightly convex surface, taper-
ing towards and attached to the rim,
with a hole pierced through a semi-
circular projection on either side.
At the top the handle divides into
two upraised 'horns,' flanking a
smaller third onto which two flat
circular discs have been attached.
The black-painted decoration is
much flaked and worn, but possibly
restorable to a panel consisting of
thin cross-hatched triple lines bor-
dered on either side by three thin
vertical lines and on a ground of two
thick horizontal lines. The
remainder is almost solidly painted.

The outer loop, also slightly convex,
appears to have a series of horizontal
stripes, but this is uncertain as the
paint is almost completely lost. It is
attached to the lower body of the
bowl.

The bowl itself is painted over a
light beige slip, chiefly with a series
of horizontal stripes near and at
the rim. The central stripe on the
interior rim is painted red, the re-
mainder of the decoration being in
black. The lower exterior body has a
series of double-striped triangles,
with a single pendant stroke at the
apex. Alternating with the triangles
are a series of multiple pendant
strokes attached to the lowermost
horizontal stripe, in two groups of six
strokes between each apex, and four
on either end. On either side of
the handle is a very wide rounded
hook as a termination of the design.
On the exterior base is a triple-lined
cross, bordered by a thick line which
determines the base. At the centre
of the interior base is a highly stylized
design consisting of a triangle aligned

to the handle, from whose base
emerges two mirrored triple-lined L-
forms, and at either end a single
v-shaped line. The design is very
worn, and other parts may be miss-
ing.

It is intact except for the tip of the
left 'horn,' and is chipped several
times at the rim and once on the
body. The paint is flaked and com-
pletely worn away in numerous
areas, most notably the outer surface
of the handle, the body and base
near the handle, and the interior
base. There is also heavy incrustation
in places.

Both the form and decoration are
characteristic of the Daunian civili-
zation of southeastern Italy, which
was centred in Apulia north of the
Ofanto River. Highly decorated and
often with fantastic handles, these
vessels are also found in central Italy
and the Northern Adriatic coast of
Yugoslavia. They were probably used
as funerary ritual pottery, as they
are found only in tombs and their
shape precludes any practical func-

tion. The civilization that developed in this area owes much to the influence of Greek colonists who began to play a significant role in the cultural development of southern Italian civilizations beginning in the sixth century BC. The decoration of Daunian vessels evolved in part out of the Geometric Style in Greece even before this time, although it was increasingly removed from it by internal stylistic development. This particular bowl fits comfortably into the mainstream of this development in both form and decoration. As no provenance is given for this piece, it may have come from any area in which Daunian wares are found, but it is most likely to have come from northern Apulia or its immediately surrounding area, the centre of the culture itself. For comparative examples see Ettore M. de Juliis, *La Ceramica Geometrica della Daunia*, Studi e Materiali di Etruscologia e Antichita Italiche, vol. XIV (Florence 1977), pl. XX:3:i, 3:l.

PUBLICATION
Parke-Bernet Galleries, *Art of Antiquity* (New York, Sale no. 2278, 29–30 April 1964), no. 278

Purchased from Parke-Bernet, New York, 30 April 1964, together with catalogue 10 JSP

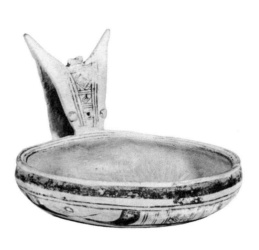

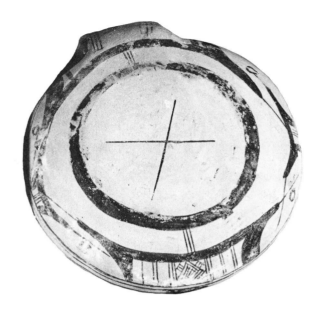

10 Shallow painted bowl

Fired clay. 9.4 × 12.4 cm
Provenance and date see catalogue 9
M82.347

This hand-formed, shallow, 'cornuto' ceramic bowl has a high looped handle and a slightly concave base, decorated with brown painted design over a light beige slip. The inner loop of the handle has a slightly convex surface, tapering strongly towards and attached to the exterior rim. Near the bottom is a central pierced hole, flanked by two attached flat circular discs. At the top, the handle divides into two upraised 'horns,' flanking an attachment in the form of miniature 'horns' (?). All three attachments were solidly painted. The decoration on both handle surfaces consists of three panels, divided by thin horizontal lines (double on the outer handle, triple on the inner) and three vertical lines which are terminated by a single horizontal line near the bottom.

On the inner handle surface, the lowest panel encloses the pierced hole, which is emphasized by paint. The central panel has two lozenges, one enclosed within the other, and the upper panel is an elaboration of this design with the inner lozenge filled with diagonal lines and the outer surrounded by the same. On the outer handle, the upper and lower panels are empty, the central panel having a thick painted circle surrounding another large pierced hole.

The bowl itself is undecorated on the interior, except for three thin horizontal stripes along the interior rim. On the exterior is a wide decorated zone, defined by three horizontal stripes above and another at the base. On the bottom is a thinly painted cross. The decorated zone is divided into two large and two small panels, each with a strongly incurving vertical outer border which terminates in a long thin line that passes that of its neighbour; in one case, they cross. Above this and be-

tween the panels is a small painted circle. Within the two small panels are three or four thin vertical stripes. The large panel at the base of the handle consists mainly of the handle itself, but a thick vertical stroke separates it from the outer border. The other large panel consists of a series of unevenly divided groups of thin vertical lines, flanking two lozenges in a pattern identical to that of the uppermost panel of the inner handle. Below this, and below the handle, are three thin vertical lines to the base.

It is intact, with slight chips at the rim. The paint is well preserved except for the top of the outer handle surface. There is some encrustation and there are four horizontal gouges attempting to hide a painting error near the base, below the second large panel.

Several features of this bowl – the rim profile, the handle decoration, the lack of a motif on the interior base, and the minimally painted cross of the exterior base – are un-

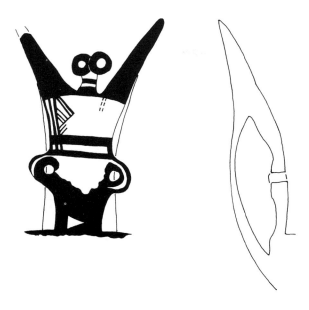

usual, and do not allow the bowl to
fit comfortably into Daunian ceramic
development. A close connection
is, however, apparent. The nearest
parallel (in shape, the decoration is
unclear) comes from the area around
Melfi, which was under strong
Daunian influence and is dated by
the excavator to the beginning of the
Daunian II period, mid-sixth century
BC. The decoration of our bowl,
although unusual, may also be of
this transitional date. It is possibly a
provincial adaptation or perception
of the Daunian style, but as it does
not have a known provenance, a
specific understanding of its place is
difficult to ascertain. For general cul-
tural context see comments to cata-
logue 9. See also Giuliana Tocco,
'Scavi nel Territorio de Melfi (Basilicata),'
*Atti del Colloquio Internazionale
di Preistoria e Protostoria della
Daunia*, Foggia 24–29 Aprile 1973
(Florence 1975), pl. 96:3 lower left,
for shape, and de Juliis [see cat. 9], pl.
LXIII:D,E, for decorative similarities.

PUBLICATION
Parke-Bernet Galleries, *Art of Antiq-
uity* (New York, Sale no. 2278, 29–
30 April 1964), no. 278

Purchased from Parke-Bernet, New
York, 30 April 1964, together with
catalogue 9 JSP

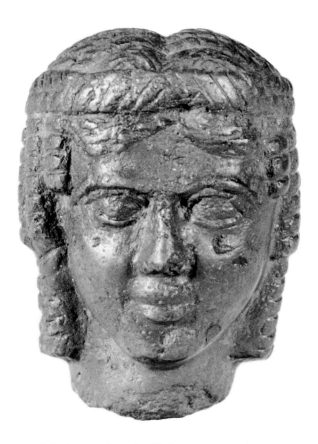

11 Miniature head of Isis or a priestess of Isis

Hematite.
6.5 cm (chin to crown 5 cm) × 3.8 cm at eye level
Egyptian (?), 1st century BC

M82.310

Apart from minor chips, mainly on the face, this piece is well preserved. It is broken off at the middle of the neck.

The hair style of the woman is that of Isis or an Isiac priestess. She wears a wreath or headband with diagonal incisions, covering towards the centre in front, and which shows stylized leaves at the back. She has large eyes and pronounced eyebrows. The corners of her thick-lipped mouth are upturned. The small head looks like a portrait head rather than a divinity, and I am inclined to see an Isis priestess here. A fairly close parallel is provided by a marble head from the island of Cos (L. Laurenzi, 'Monumenti di Scultura del Museo Archeologico di Rodi – IV E

Dell'Antiquarium di Coo II,' *Clara Rhodos*, 1938, p. 52, fig. 32; F. Dunand, 'Le culte d'Isis dans le bassin oriental de la mediterranée, III: Le culte d'Isis en Asie Mineur,' *Etudes préliminaires des religions orientales* [EPRO], XXVI, 1973, 30ff, with note 5, pl. VI). The Cos head has a different headgear, which is badly damaged and thus unidentifiable, and the eyes are hollowed out for inlays. However, the shape of the face and some details are comparable to our miniature head. The Cos head has been dated to the Hellenistic period. The Malcove head was given a date in the third/fourth century (see Publications), which appears much too late to me. The shape and treatment of the eyes are comparable to a portrait of possibly Marc Anthony, which has also been identified with one of the late Ptolemies (G. Grimm et al., *Kunst der Ptolemäer – und Römerzeit im ägyptischen Museum in Kairo*, Mainz 1975, no. 15, pls. 20, 21; A. Krug, 'Die Bildnisse Ptolemais IX, X und XI,' *Das ptolemaische Ägypten*,

ed. H. Maehler and V.M. Strocka, Mainz 1978, p. 15ff, figs. 25–8, Ptolemaios IX, Soter II). We may also compare a head from Paraitonion, identified by Antje Krug, with Ptolemy XI Alexandros II (Krug, pls. 29–33). Some female portraits that probably show late Ptolemaic queens before Cleopatra VII may also be compared, for instance a head in Berlin where the treatment of the Isis locks is very similar (H. Kyrieleis, *Bildnisse der Ptolemäer*, Archealogische Forschungen 2, Berlin 1975, M13, pl. 105).

The provenance of this head is not assured, but it is likely to be Egypt. I propose a date in the first century BC.

PUBLICATIONS
Pagan and Christian Egypt (Brooklyn Museum 1941), no. 28
Early Christian and Byzantine Art (Baltimore 1947), no. 19
Brummer Sale Catalogue (Zurich 1979), p. 18, no. 3

Purchased from O. Brummer EAR

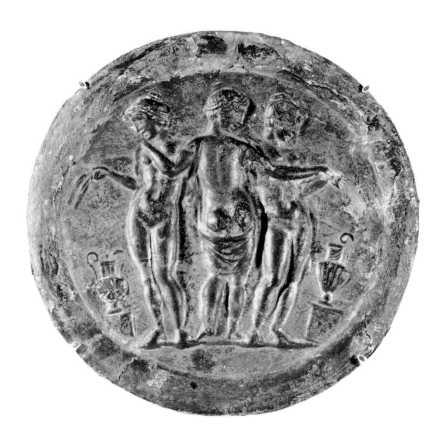

12 Mirror

Gilt bronze and silver. 100 cm
Roman, 1st / 2nd century M82.357

This mirror is based on Hellenistic
models, but was produced in the first
two centuries AD. The relief surface
of the back shows the Three Graces
flanked by a two-handled vase on
a stand on the left side and a one-
handled fluted jug on a stand on the
right. Only the central figure has
any drapery and that covers only her
thighs, without reappearing any-
where else. The other two are com-
pletely nude. On the front, much
of the original reflective silver surface
has been preserved. See M. Comstock
and C. Vermeule, *Greek, Etruscan
and Roman Bronzes in the Museum
of Fine Art* (Boston 1971); *Romans
and Barbarians* (Boston 1977), no. 65.

Purchased from Zakos, Istanbul,
Turkey SDC

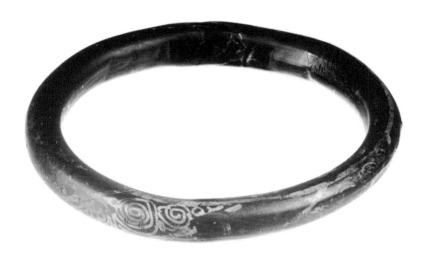

13 Painted glass bracelet

Painted glass. 9.3 × 0.5 cm
Roman, provenance and date
unknown M82.205

The bracelet is made of dark green
glass with a painted decoration in
white and silver of diagonal lines and
dense scroll motifs. It is quite large
and was probably intended to be
worn on the upper arm. If it is placed
on an upper arm, with the join on
the glass to the inside, then the best
preserved area of the decoration is
on the outside, as might be expected.

 SDC

14 Relief of goddess flanked by Dioskuroi

Marble. 29 × 41.5 × 3 cm
Asia Minor, Antonine / Severan
period, 2nd / 3rd century M82.319

The fragment has been cut out of a
larger piece, and there was probably
an inscription below the relief. In
the centre is a female figure draped
in a chiton and a himation that may
have been pulled over the back of
her head (unless the piece of cloth on
the head is a separate veil). Only
the tips of her feet emerge from under
the garment. Her right arm rests in
the folds of her mantle as in a sling,
and she holds an object in her right
hand that looks like a scroll or a
phial. With her left hand she holds
up her mantle. She is flanked by the
two Dioskuroi, characterized by their
pilei, each holding a spear. Their
short mantles flutter behind them.
Although their horses are rendered in
strict profile, their heads are almost
frontal. They have curly hair, as does
the female figure. The shapes of all
three are remarkably similar, with
button-like eyes and almost identical
mouths.

In the low pediment we see a
crudely carved crescent and star
above the goddess and small button-
like stars above the heads of the
Dioskuroi.

The theme of the Dioskuroi in the
service of a goddess has been treated
by Chapouthier (F. Chapouthier,
Les dioscures au service d'une déèse,
Paris 1935), who included in his
catalogue reliefs from Pisidia, a fresco
from Theadelphia in the Fayum,
coins minted in Phrygia, Pamphylia,
and Egypt, and other objects. Of
the reliefs discussed by him, none is
stylistically comparable to our relief,
although the iconography is doubt-
lessly the same (ibid., no. 2, p. 23, pl.
I, from Telmessos, now in Vienna;
no. 16, p. 38, pl. VII, from Isinda,
Pisidia, now in the museum in
Konya; no. 18, p. 40, from Pisidia.
See also *Monumenta Asiae Minoris
Antiquae* [MAMA], VI, 402, pl. 72,
in the museum in Afyon). Practically
all the representations originate in
the eastern Mediterranean region.

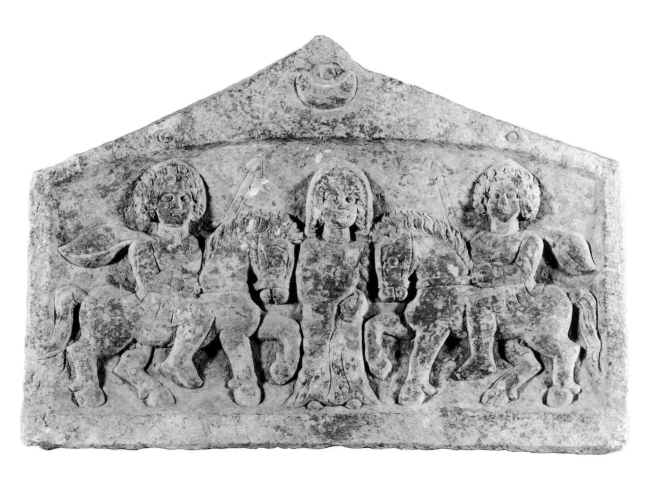

The goddess in the centre can be Cybele, or Artemis, but above all Helena, the sister of the Dioskuroi, not so much in her role as the beautiful temptress, but rather as a divinity that had a cult related to that of the moon goddess and also some of the other female divinities with whom the Dioskuroi are associated (on Helena, legend and cult, see Chapouthier, pp. 127–51; as moon goddess, p. 237ff; on Cybele, pp. 153–84).

Our relief was acquired in Amsterdam, from Peter Mol, who gave as provenance 'Anya' near Antalya in Turkey. I know of no place name in this region that corresponds to this alleged provenance; perhaps it is a mistake for Alanya, which is east of Antalya. The real find spot is almost certainly not Alanya, but there is some provincial art in the hinterland of Alanya. However, nothing that I know from this region shows the same style. We probably have to be content with a general Asia Minor origin for the relief.

The datable reliefs with this theme listed by Chapouthier are mainly from the Antonine and Severan periods (ibid., p. 97ff), and such a date appears to me possible for our relief also.

Purchased from Peter Mol,
Amsterdam, 1971 EAR

15 Grave stele of Atilia

White marble. 64 × 45 × 17 cm
Zeugma (Belkis, Turkey), 150–75
M82.152

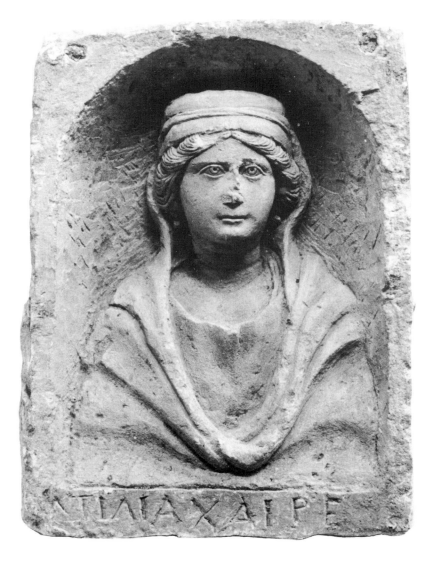

The gravestone is a rectangular slab with an arched recess containing the portrait bust of a woman, clad in a chiton and a cloak which covers the back of her head. She wears a turban (on this kind of turban see K. Parlasca, *Trierer Winckelmanns-programme* 3, 1981, 10) and her hair is parted in the middle, arranged in overlapping loops along her face. Her ears are covered, but small earrings hang from them. The pupils and irises of the eyes are indicated.

The arrangement of the hair along the face, covering the ears, seems to be inspired by the first 'Bildnistyp' of the portraits of Faustina Minor, AD 147–9 (K. Fittschen and P. Zanker, *Katalog der römischen Porträts in den Capitolinischen Museen und den anderen kommunalen Sammlungen der Stadt Rom*, III: *Kaiserinnen-und Prinzessinenbildnisse, Frauenporträts*, Mainz 1983, p. 20, no. 19, pls. 24–6; p. 21, no. 64, pl. 26; p. 69, no. 91, pl. 112, with bibliography), although some of the oldest portraits of Lucilla still show a related hairstyle (ibid., p. 24, no. 24, pl. 33).

Parlasca, who has published this monument, has suggested that the provenance of the relief almost certainly is Seleukeia-on-the-Euphrates / Zeugma (Belkis) in southeastern Turkey, where several slabs of the same type occur (on this group of slabs see J. Wagner, *Seleukeia am Euphrat / Zeugma*, Wiesbaden 1976, pp. 223–51, pls. 43–51, 54; Parlasca, pp. 9–14, pl. 6, 1–2; pl. 7, 1–2, 4; pls. 8–10; pl. 12, 1–2, 4; pl. 14, 1; pl. 15, 1; pl. 16). They seem to have served as loculus slabs (Wagner, pp. 149–50, fig. 16; Parlasca, p. 9).

PUBLICATION
Parlasca, K., *Trierer Winckelmanns-programme* 3, 1981, 10, pls. 11, 1; 13, 2

Purchased from Dr Hans Berger / Norbert Schimmel MW

INSCRIPTION
Letters 4 cm, probably 2nd century AD

Text: Ἀτιλία, χαῖρε (Atilia, farewell)

The form is the most basic one of ancient funerary inscriptions. Atilius (– a) is a common Roman name, and Atilia was probably a Roman citizen. If so, her family's citizenship might be due to T. Atilius Rufus, who governed Syria from about 82–4

(*Prosopographia Imperii Romani*, 2nd ed., A 1304). M. Atilii are found in Heliopolis (Baalbek) and Antioch on the Orontes (Heliopolis: *Corpus inscriptionum latinarum*, 8.18084, line 92, Antioch: *Bulletin de correspondance hellénique* [BCH], LXXXIII, 1959, p. 493, no. 22). CPJ

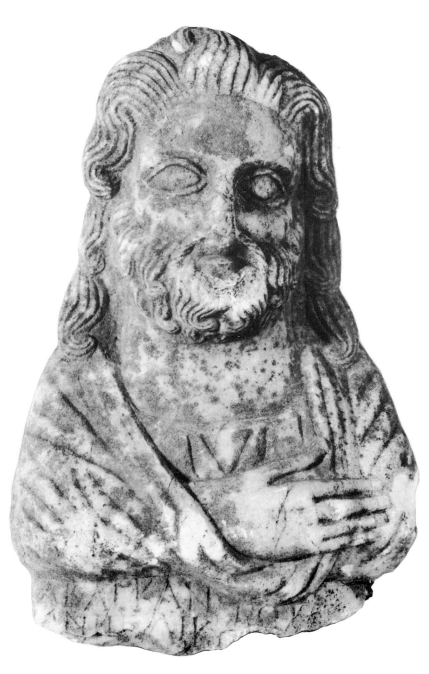

16 Bust of Zeus Ampelikos

White marble. 29.5 × 17 × 5 cm
Anatolia, circa 210–25 M82.308

The fragment is a rather flat bust of
Zeus Ampelikos on a small inscribed
socle. His hair consists of long in-
ward curling locks and his beard is
rendered in the same way. He has
large almond-shaped eyes without
indication of the pupils or irises. He
is clad in a chiton and a himation;
his right hand rests in the folds of the
cloak draped around his chest. This
hand, which occurs on all votive
stelae discussed by L. Robert (BCH
[cat. 15], CVII, 1983, p. 535, fig. 13,
and p. 539, fig. 14), is a kind of trade-
mark of the sculpture of the Upper
Tembris Valley, where it can also be
found on hundreds of funerary stelae
representing busts or full-sized figures
of the deceased. The nose is damaged.

The bust belongs to a series of
votive busts of Zeus from the Upper
Tembris Valley (Altıntaşovası
between Kütahya and Afyon in
Northwest Phrygia, Turkey). The
inscriptions identify four of the busts
as Zeus Thallos, one as Zeus Ampe-
leites, of whom our bust is only
another version, whereas an unpub-
lished bust is dedicated to Zeus
Bronton.

These votive monuments were
made by a group of itinerant stone-
cutters connected with the major
workshop of the area, whose activity
can be traced from the middle of
the second century to the first quarter
of the fourth century (an extensive
study of this workshop by Waelkens
is in preparation; for a preliminary
report see M. Waelkens, *Die kleina-
siatischen Türsteine*, Mainz 1985, 89–
93: type C Altıntaş 1). Most of them
produced without distinction all
the types of votive monument listed
above, besides sepulchral stelae or
altars. The Zeus bust in Toronto can
be ascribed to one of the artists in
particular: the almond-shaped eyes,
the shape of the hand, and especially
the way in which the individual
locks of hair and the central locks of
the beard curl inward, not outward,
are almost identical to the corre-
sponding elements of the bust on

a votive stele for Zeus Andreas signed by Epitynchanos 'latypos' (T. Drew-Bear, *Greek, Roman and Byzantine Studies*, XVII, 1976, p. 252, no. 9, pl. 7, fig. 4; Robert, BCH [cat. 15], CVII, 1938, p. 543, no. 1, fig. 1). The same applies to the lettering of both monuments. This sculptor is also known from a second signature (Drew-Bear, p. 254, no. 11, pl. 8, fig. 3), this time on a votive stele for Zeus Bennios, executed jointly with another sculptor from the same workshop, Zelas, who was the son of the 'latypos' Teimeas, and whose activity can be dated to the middle and late Severan period. One of the Zeus Thallos inscriptions is almost certainly another work of the same Epitynchanos and his hand can further be detected on four funerary stelae from the Upper Tembris Valley, dating his activity in the area circa 210–25. This must also be the date of the Toronto bust. MW

INSCRIPTION

Letters 1.5 cm; the forms fit the date of 210–25 proposed by Waelkens.

Text: Ἀβάσκαντος [Διὶ]
Ἀνπελικῷ εὐ[χήν]
(Abascantos [paid] a vow to Zeus Ampelicos).

As Waelkens has observed, the bust belongs in a series of dedications to Zeus Ampeleites recently assembled by Louis Robert. The inscription takes the usual form of a dedication, with the main verb omitted. The name 'Abascantos,' meaning 'not subject to βασκανία (the Evil Eye),' is common in the Roman period. The dative of Zeus might have taken one of several forms, for example ΔΕΙ. The substitution of nu for mu in the group Ἀνπ- is normal, and occurs in all except one of the examples collected by Robert. By contrast, this is the first in this series in which the root Ἀνπελ- (vine) has the termination –ικος instead of –ειτης. Robert argued that 'Ampeleites' did not mean 'guardian of vines' but rather that the shrine of this Zeus was at a place called 'the Vine' or 'the Vines.' That is supported by the new inscription, for the difference between the two terminations is that –ειτης expresses derivation from a place (ἐθνικόν), and –ικος ascription to a place (κτητικόν). W. Dittenberger, *Hermes*, XLIX, 1906, 78–102, 161–219

Robert argued against the supposition that 'Ampeleites' signified 'protector of vines' from the fact that most of the known dedications to this Zeus show livestock, especially cows or mares suckling their young, as the objects entrusted to him, and never vines. The new bust tends to corroborate that view, but it is worth citing a literary text which illuminates the connection between viticulture and animal husbandry precisely in Phrygia (M. Waelkens, *Ancient Society*, VIII, 1977, 278–83, viticulture, 283–8, animal husbandry). Recent years have shown the importance of the fifth-century poet Nonnos for the myths of the eastern empire, including Phrygia (for Phrygia, see L. Robert, *Journal des Savants*, 1975, 169–81). Nonnos relates how the young Dionysos fell in love with a Phrygian youth, Ampelos; Hera, hostile to Zeus's son by Semele, caused Ampelos to ride a bull which threw and gored him fatally; the corpse of the slain youth was then turned miraculously into a vine (Nonn. D. 10.175–12.291: I owe this reference to G.W. Bowersock. On Ampelos see also Stoll in W.H. Roscher, *Ausführliches Lexicon der griechischen und römischen Mythologie*, I, 1884–6, 292; M.A. Zagdoun, *Lexicon Iconographicum Mythologiae Classicae*, I, 1981, 689–91). The myth is clearly aetiological, and not connected only with the fact that vines were extensively cultivated in Phrygia. Nonnos explains that the water sprayed by the bull on Ampelos as it drank was a portent of the time when 'bulls toiling in an endless circle in the earthy furrows around a post irrigate the vine-planted earth with water' (Nonn. D. 11.165–6. Since Nonnos refers to motion around a point, he seems not to mean a water-wheel, as might be expected, but perhaps the device called the 'cochlea': Daremberg-Saglio s.v. IV). The poet locates the myth of Dionysos and Ampelos both in Lydia and in Phrygia, though he connects the youth's death with the Sangarios (Nonn. D. 12.128–30). The shrine of Zeus Ampeleites was near Appia in the valley of the Upper Tembris, and so in southeastern Phrygia, close to the border of Lydia. While Nonnos's myth is not likely to have a direct connection with the shrine, it seems to preserve a local legend of Phrygia which reflected two of the principal activities of the region, viticulture and animal husbandry, just as 'Zeus of the Vine' was a protector of livestock. CPJ

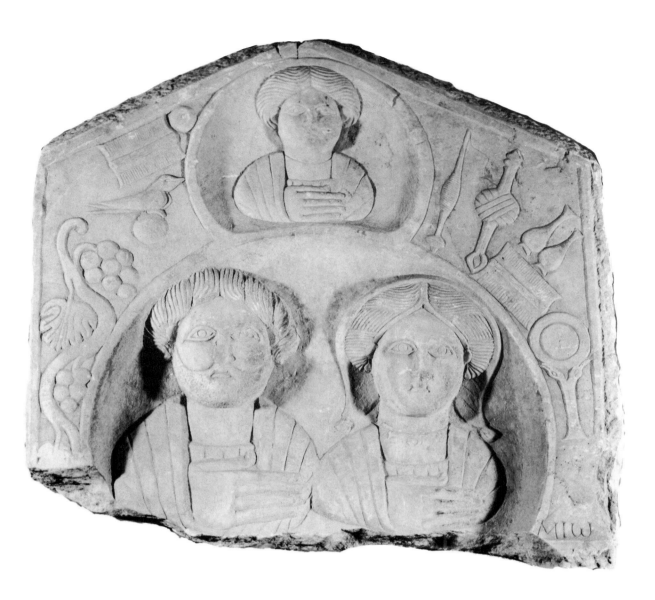

17 Gable of a funerary stele

White marble. 42 × 47 × 7 cm
Asia Minor, 230–40 AD M82.323

The fragment is a pentagonal pedi-
ment with an external ledge and
roughly carved sides, treated with a
pointed chisel (for similar treatments
of the sides of Phrygian stelae see
Waelkens, *Türsteiner* [cat. 16], p. 7).
It is broken in the lower part of a
slightly more than semicircular cen-
tral arch. A similar if smaller arch

sits on top of the first one, both arches
being framed by a ledge-shaped archi-
volt. The bigger arch contains a male
and a female bust, either the
deceased or the commissioners of the
stele. A smaller female bust (daugh-
ter or mother?) occupies the upper
arch. The noses of all the figures are
broken. Each person is clad in a
chiton or tunica and a himation,
with a large right hand resting in the
folds of the cloak around his or her
chest (see catalogue 16 for a discus-
sion of these large hands.) The hair of

the man is combed forwards in bangs.
He has a beard in low relief, the
hairs of which are rendered by very
densely set fine dots. The woman
to his right wears a necklace, in re-
lief, from which hangs a circular
ornament between two outer pen-
dants in the shape of an ivy leaf. Her
hair, whose intertwined linear treat-
ment may suggest the presence of
waves, is held up by a kind of net or
ribbon along the front, which is
taken backwards over the centre of
her skull. Earrings hang from her ears

and she wears a short veil which ends in a tassel on either side. The woman in the upper arch also has a necklace, which this time has simply been incised. Her hair is parted in the middle and combed in very light waves down the sides, leaving the ears completely uncovered. All the figures have almond-shaped eyes, in which the pupil and iris have been indicated. The slightly lower section of the pediment to the left of the arches contains a vine or vine tendrils. The corresponding section on the right has a mirror below a spindle and distaff, connected by an incised thread, two perfume flasks, and a comb.

The gable belongs to a series of stelae, executed by the stonecutters connected with the major workshop of the Upper Tembris Valley (catalogue 16). This workshop produced 'doorstones' as well as stelae with a niche containing full-sized standing figures of the deceased ('Bogenfeldstelen') (Waelkens, pp. 89–90. A more complete study by the same author is in preparation). While the production of the doorstones at first overshadowed that of the 'Bogenfeldstelen,' the former type gradually disappeared in the late Severan period, when the latter obtained a monopoly until the end of the century. The pilasters of the 'Bogenfeldstelen' and the frames of the doorstones at first were decorated with ivy tendrils, their leaves some-times alternating with flowers or poppies, and were maintained on the doorstones of the workshop until the end of their production (ibid., pp. 99–100, nos. 233–5, pl. 35). However, the 'Bogenfeldstelen' gradually came to be decorated with vine tendrils, introduced during the later first decade of the third century. (An unpublished stele in the museum of Kütahya which can be dated exactly between 208 / 209 and 212 / 213 is the first example.) These vine tendrils became the standard decoration from the third decade of the third century onwards (see, for instance, E. Berger, *Antike Kunst* 22, 1979, 46, pl. 17.2; E. Gibson, *Zeischrift für Papyrologie und Epigraphie*, XXVIII, 1978, 11 no. 1, pl. 2a) to the first quarter of the fourth decade, when they adorned the frame of the panel-shaped stelae of the same workshop, which towards the end of the third century gradually ousted the production of the 'Bogenfeldstelen.' Several details, such as the shape of the palmette acroteria, the moulding and decoration of the capitals and bases, the composition of the tendrils, the way in which the folds of the himatia of the figures are rendered, and the portraits themselves, allow a precise classification of these stelae and their attribution to individual sculptors.

Our gable is clearly a work of the sculptor who had executed a doorstone which turned up in 1979, as a private gift, in the North Carolina Museum of Art, Raleigh, and which will shortly be published by the author (*Bulletin of the North Carolina Museum of Art*. I thank Mrs M.E. Soles, curator of ancient art at the museum, who most kindly sent me photographs of this stele). In the Raleigh example there are, as well, an arch of the same type as ours, containing two busts which are almost identical with ours (eyes, hair, beard, folding of the clothes, veil) and other decorative elements, such as vine and mirror, which are clearly carved by the same artist as ours and which fill a pentagonal pediment. The lower part of the stele represents a door set within the characteristic doorframe of the big workshop mentioned above (Waelkens, pp. 89–90). Most probably a similar door originally occupied the missing part of our stele.

The two superposed arches can be found on several other stelae from the same workshop (the oldest example thus far seems to be the gable published by W.H. Buckler, W.M. Calder, and L.W.M. Cox, *Journal of Roman Studies*, XVIII, 1928, p. 32, no. 247, pl. III, which may have been an early work of Teimeas from Mourmate, see below, carved circa 180 / 190–200; for a later example see, for instance, Waelkens, p. 115, no. 273, pl. 35). This statement can also be extended to both types of necklaces on the female busts as well as to the hairdo, with net or ribbon, of the women in the main arches at Raleigh and Toronto. This hairdo, which most probably was a local one, occurs for the first time on a stele signed by Teimeas from Mourmate in the final decade of the second century (E. Pfuhl and H. Möbius, *Die ostgriechischen Grabreliefs*, II, Mainz 1977, p. 502, no. 2089, pl. 300; Waelkens, p. 92), and on another work, possibly made by the same artist around the turn of the century

(Waelkens, p. 92, note 184, pl. 32, Izmir stele). The hairdo of the woman in the upper arch looks like a smoother version of it, without net or ribbons, but can even better be compared with the way the hair is rendered on another stele from the same area, this time carved by a different artist, named Andromachos, somewhere during the third decade of the third century (Waelkens, p. 101, no. 240, pl. 38). The treatment of the beards, both at Toronto and Raleigh, is also similar to that on the stele signed by Andromachos, yet it may be more recent, since it has become even less plastic and seems to announce already the corresponding treatment on the gable in catalogue 18.

There is, however, a fair chance to establish precisely the identity of our sculptor. Even if some details might suggest a slightly younger date, there cannot be any doubt that the door of the stele in the museum at Raleigh, as well as the tendril decoration on both its lintel and its doorposts, have been carved by the sculptor who had executed these elements on a doorstone from Kütahya, now in the Museum at Ankara (Waelkens, pp. 92, 97, no. 228, pl. 33). The latter was made during the middle to late Severan period, most probably in the third decade of the third century, and is signed by two 'latypoi' (Waelkens, p. 90, note 167), Zelas, son of Teimeas, and Alexandros. The former could be identified as the son of Teimeas from Mourmate and has left us, among several other monuments which now can be attributed to him,

another stele bearing his signature alone. The four portrait busts on this stele, which thus had been carved by Zelas himself, were clearly executed by a different, far more skilled hand than those on our gable and on that in Raleigh. The latter stele's lower section, however, has beyond any doubt been completed by the man who was responsible for the carving of the corresponding section on the doorstone in Ankara, signed by both Zelas and Alexandros. Therefore it looks as if this man can only have been Alexandros himself, who may have been less skilled as a portrait sculptor than Zelas. If the stele in Raleigh, as most of the others from the same workshop, was the work of a single artist, Alexandros can also be identified as the sculptor of our gable. If different people finished the door and the gable from Raleigh, our gable was certainly completed by someone who was active within the same group of artists as Zelas and Alexandros, and who was clearly influenced by the works of Teimeas, who may have trained them all. The relationship of the Toronto gable to the doorstone in Ankara, and to others from the same workshop, thus suggests a date in the later third or early fourth decade of the third century AD. MW

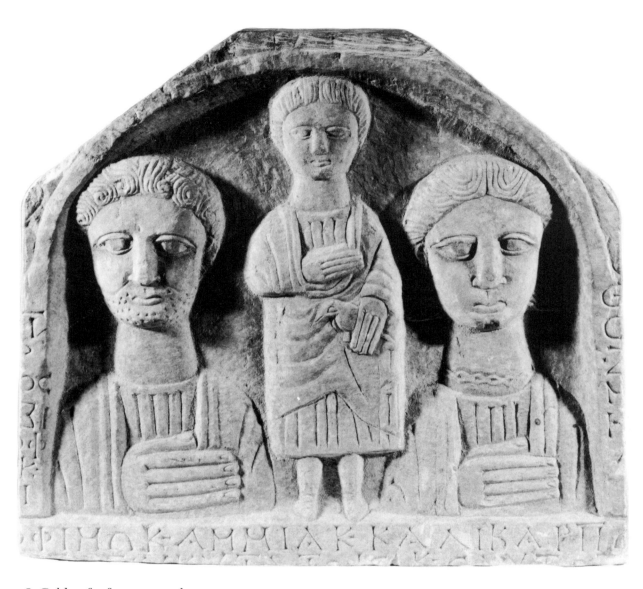

18 Gable of a funerary stele

White marble. 63.5 × 60 × 6.5 cm
Anatolia, 280-5 M82.328

The pediment, whose edges are con-
siderably trimmed away, is cut off
below a horseshoe-shaped arch con-
taining a male (left) and a female
(right) bust on both sides of the full-
sized figure of a boy. The two adults
must be the husband and his
deceased wife, the youth one of their
children mentioned in the inscrip-
tion. All figures are clad in a chiton
or tunica and a himation, with their
right hands resting in the folds of
the cloak around the chest. The boy
holds a bird, a favourite pet in antiq-

uity in his left hand (see J. Pollard,
Birds in Greek Life and Myths, 1977,
pp. 135–40; Pfuhl and Möbius [cat.
17], p. 528). His hair is combed for-
wards in bangs. The man has a beard
in low relief, the hair indicated by
dots. His slightly waved hair is
combed forwards, where the locks
end in curls. The woman wears a
necklace. Her hair is parted in the
middle and combed in slight waves
down the sides, leaving the ears com-
pletely uncovered. Her coiffure wid-
ens considerably towards the neck,
an effect normally caused by a plait
of the 'Scheitelzopf' style (see Klaus
Wessel, *Archaeologische Anzeiger*,
1946–7, pp. 65–70, fig. III). In this
hairstyle, which started about AD 220,

the plait gradually grew longer until it
reached the forehead, where it re-
mained during the rest of the cen-
tury. At first sight the fairly straight
version shown here could be taken
as indicating a date in the fifth dec-
ade of the third century, when the
plait did not yet reach the crown of
the head (see for slightly waved
or straight versions of this coiffure,
dating from this decade, K. Fittschen
and P. Zanker, *Katalog der röm-
ischen Porträts in den Capitolin-
ischen Museen und den anderen
kommunalen Sammlungen der Stadt
Rom*, III, Mainz 1983, pp. 110–12,
nos. 164–6, 168–9, pls. 192–8), or even
in the following decade, when it
already reached the crown (cf Wes-

sel, p. 67, fig. III, Herennia Etruscilla and Sulpicia Dryantilla; R. Delbrueck, *Die Münzbildnisse von Maximinus bis Carinus, Das römische Herrscherbild*, III. 2, Berlin 1940, pl. 9; J. Inan and E. Alföldi-Rosenbaum, *Römische und frühbyzantinische Porträtplastik aus der Türkei. Neue Funde*, Mainz 1979, p. 193, no. 160, pl. 123), although this would hardly have been visible on a relief like ours. However, as will be shown below, the Toronto gable is at least a quarter of century later, and as a result the hairstyle has to be considered as a simplified version of the unwaved 'Scheitelzopffrisuren,' with a plait reaching to fairly near or even to the forehead, as was common in the second half of the third century (see Wessel, pp. 67–70, fig. III; J. Inan and E. Rosenbaum, *Roman and Early Byzantine Portrait Sculpture in Asia Minor*, London 1966, p. 188, no. 256, pl. 95,3–4; p. 194, no. 268a, pl. 147; p. 197, no. 271, pl. 148). It can be assigned more precisely to a sculptor whose known production includes at least five other stelae (in chronological order: (a) Pfuhl and Möbius, I, p. 175, no. 597, pl. 94, now in Ankara, wrongly identified with F. Miltner, *Jahrbuch des Oesterreichesches Archeologisches Instituts*, XXX, 1937, Beibl. 58, no. 62, fig. 36; (b) W.H. Buckler, *Journal of Roman Studies*, XV, 1925, p. 171, no. 164, pl. 24, SEG VI, p. 117, with a similar child between the parents; (c) an unpublished monument, again with a girl holding a pet bird between two adults, and cut off in a similar way to the present gable on all sides, on display at the exhibition of Anatolian tombstones near the Aya Sofya in Istanbul, May–December 1983, where it was wrongly identified with *Le Bas-Waddington* 808; (d) an unpublished monument in Izmir, Basmahane inv. no. 3583, allegedly 'bought from a dealer in Tavşanlı,' but certainly coming from the Upper Tembris Valley; (e) the Toronto gable; (f) an unpublished stele in Izmir, Basmahane inv. no. 6352, 'bought from an antiquarian in Bandırma'). Characteristic of his work are the egg-shaped heads of the figures and the high pilaster capitals,

where the stylized leaf decoration of the preceding period has developed into an unrecognizable linear motif, the basis consisting of a series of fillets and the vine tendrils without leaves. Most of the female coiffures are identical with that on the Toronto gable (see nos. (a), (c), and (f) above; this coiffure still occurs on a monument from Akçaköy, to be published in MAMA [cat. 14],X, which can be dated shortly after 284–5) and all women wear identical necklaces. The beards on one of the unpublished stelae (Izmir, Basmahane inv. no. 6352) of the group are rendered in a similar way to the present example. The palmettes of the series are recognizable as such. Traces of similar palmettes can still be seen on the top and in the upper left corner of our gable.

From the next group onwards, starting in 284–5 (its first monument is dated: E. Gibson, *Türk Arkeoloji Dergisi*, XXV, 1, 1980, p. 66, no. 7, fig. 20), these palmettes, especially those in the lower corners, become gradually unrecognizable curved lines, whereas the pilaster capitals grow smaller and deteriorate further. The pilaster bases and the folds of the clothes become even more linear and lose all relief. Their vine tendrils again show a leaf at the top of the tendril. This feature, as well as the linear pilaster bases, is already present on the last monument of our group (Izmir, Basmahane, no. 6352), whose figures (hair, beard, eyes, mouth) offer such close parallels to the present gable that they must be contemporary with it. The niche of the Izmir stele contains two bearded males, one holding a wreath, the other an open diptych, and one female figure holding a spindle and distaff. There is a comb to the left of her head. The socle has a pair of oxen yoked to a plough below the male, and a pair of sandals below the female figure. Owing to their place within the production of the workshop, the series of stelae carved by the Toronto master can be dated from circa 270–85. As the gable can be closely associated with the last stele of the group, a date around 280–5 is very likely. MW

INSCRIPTION

Letters 2 cm. The most remarkable is the beta of line 4 (left), with a very wide waist. The lettering suits a date in the late third century proposed by Waelkens.
Text:

Π	Ε
Φ	Ο
ΟC	·Z
4 ΒΙ	Μ
.Φ	Η
ΚΕ	Α
Ν	

8 [Τρ]οφίμῳ κὲ Ἀμμίᾳ κὲ Καλικάρπῳ / [τέκνο]ις ˅ γλυκυτάτοις ˅ κὲ ἑαυτῷ ζ[ῶν.]
(... and for Trophimos and Ammia and Callicarpos and for himself, while still living)
Line 1 right: possibly theta. Line 3 right: the dot before zeta seems deliberate. Lines 4–6 right: perhaps μ[νήμ.]ης χ]ά[ριν] (in memory). Line 7 right: there may have been one or more letters in this line (κέ?). There may have been more text on the lower part of the stone.

The text takes the usual form of a Phrygian funerary inscription of the Roman period, but the mutilation of the stone excludes a full restoration. Since only the masculine singular ἑαυτῷ seems possible in line 8, the father of the family must have set up this monument alone. He is presumably the person whose name ends in –ος in line 3 left, and the bearded man depicted on the left. His wife, and perhaps some of his children also, should have been mentioned in lines 1–7. Of the three surviving names, Trophimos and Ammia are common, while Callicarpos is comparatively rare. Here is it spelled with the common simplification of the double consonant. (The same spelling in T.B. Mitford, *The Inscriptions of Kourion*, Philadelphia 1971, no. 159.)

EXHIBITION

'Silk Roads: China Ships,' 10 September 1983 – 1986.

PUBLICATION

Silk Roads: China Ships, catalogue of the exhibition, p. 180 CPJ

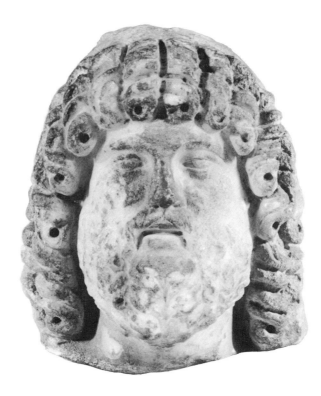

19 Head of Sarapis

Coarse grained white marble.
14 × 9.7 cm
Provenance unknown, Severan
period (?) M82.326

The piece is broken at the neck with
a small portion of the neck surviving.
The tip of the nose is apparently
restored. Apart from some bad in-
crustation, the head is well
preserved. The flesh parts were
polished. The modius is broken off.
There is drill work in the locks and
part of the beard. The rear is sum-
marily treated.

The head may have belonged to a
statuette of Sarapis, either seated
or standing. Of the headgear only a
fillet has survived. The hair has been
arranged in tight corkscrew curls
that are reminiscent of Isis locks.
They are all directed towards the
face, and their treatment is com-
parable to third-fourth century ren-
derings of the Seasons. The beard
is compact and much shorter than

usual for images of Sarapis. However,
a few parallels may be quoted. The
treatment of the corkscrew locks
is comparable to that of the beard of
a Sarapis head in the Prado in Mad-
rid (W. Hornbostel, *Sarapis: Studien
zur Überlieferungsgeschichte, den
Erscheinungsformen und Wandlun-
gen der Gestalt eines Gottes*, EPRO
[cat. 11], XXXII, 1973, 98 with note 4,
243 with note 1, pl. XXXIV, fig. 51).
Corkscrew locks appear on a little
terra cotta head in Rome, Santa
Prisca (ibid., 351, pl. LXXXI, fig. 143).
The locks, the compact beard, and
the shape of the face may be com-
pared to a marble bust in the
National Museum in Copenhagen
(ibid., 218 note 3, pl. XCIX, fig. 168).
Amongst the many Sarapis busts
of heads that have survived from the
Roman Imperial period, a bust from
the Athenian agora shows perhaps
the closest affinities in the treatment
of the locks (ibid., 81, note 2, 281,
note 5, pl. CLXXXI, fig. 294. There are
further parallels in Hornbostel's
exhaustive treatment of the Sarapis

iconography).

As to the date, the closest parallels
cited above have been assigned by
Hornbostel to the Severan period.
Such a date seems to me to be pos-
sible also for our present small head.

Unfortunately, there is no indica-
tion for the provenance of the head,
which makes a closer precision of
the date difficult. EAR

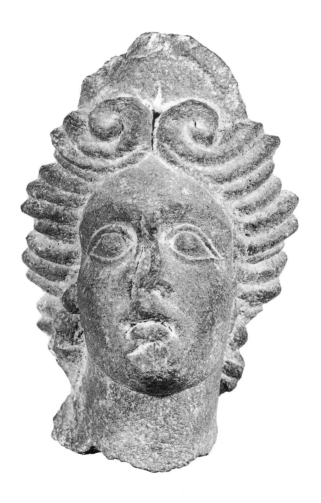

20 Female head with diadem

Grey / black basalt.
30 cm (face 10 cm) × 10 cm at eye level
Hauran (Bosra, Syria), 2nd century (?)
 M82.286

The head, which is slightly under life size, is slightly tilted to the side and upwards. The hair is swept back from the face, with a middle parting and two prominent curls over the forehead. Behind these curls is a diadem. The eyebrows are indicated by sharply cut lines which extend in an unbroken line into the nose. The eyes are large, undrilled, and framed by narrow bands to indicate the eyelids. The mouth is small and cut so that the corners turn down slightly. The hair continues in a thick sweep down the back of the neck. It is clear from this feature and the break at the neck that this bust was part of a larger piece, probably a full figure.

The hair style and upward glance may be seen in another example in Maurice Dunand, *Le Musée de Soueida*, Mission archéologique au Djebel Druze (Paris 1934), no. 100, p. 58. An unpublished standing figure in the Damascus National Museum (no. 14603) has the same hair style, diadem, and style of facial features. It is identified as a Victory. A third example, illustrated but described only as unpublished, is a second full standing figure with the same unusual hair style, the diadem, facial style, and it too has the windblown drapery associated with a Victory figure (see Sylvia Diebner, 'Bosra, Die Skulpturen im Hof der Zitadelle,' *Rivista di Archeologia*, VI, 1982, 56, note 22, pl. 42). I am grateful to Klaus Stemmer and Antje Krug, Berlin, for help with the identification of this head.

Purchased from Kelekian, New York, March 1976 SDC

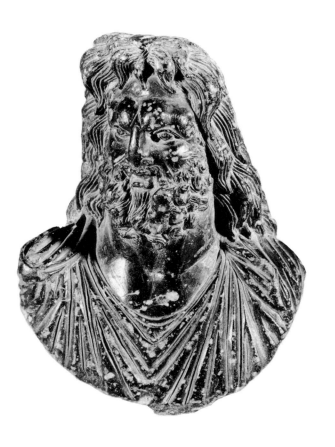
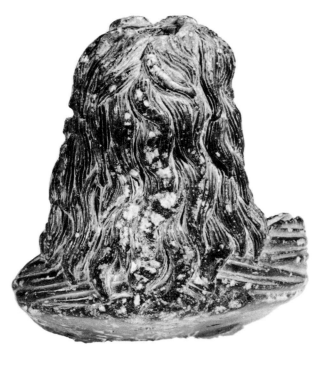

21 Bust of Sarapis

Dark green / black steatite.
12 × 9 cm at shoulder, 5.5 cm at eye
level
Provenance unknown, 3rd century
M82.343

The tip of the nose was broken off
and the broken surface later polished.
Minor chips are gone from all over
the surface. The underside shows
modern reworking: the surface is
partly scraped off and has been
treated with a chisel. On top of the
head is a cavity with a pin and a
smoothed surface all round, where
originally a modius was attached.
The flesh parts and garment are
highly polished. The hair and beard
have been worked mainly with a
chisel. The eyes have been plastically
treated with irises incised and pupils
slightly hollowed. The bust is draped
in a chiton and apparently a hima-
tion, of which only parts over the
shoulders are visible. The head is
strongly turned to its right. Long
locks descend to the shoulders and
three locks fall onto the forehead.
The full beard has been treated in the
same manner as the hair. The face
has been rendered with an astonish-
ing amount of exaggerated realism,
particularly the eyebrows and the
folds above the nose.

Hornbostel dates the bust to the
fourth century and cites it as an
example of the fourth-century image
of Christ influencing the iconogra-
phy of Sarapis [see Publications]. This
date appears to me to be too late.
The bearded Christ type with long
locks does not appear before the end
of the fourth century, and while it
is well possible that the iconography
of Sarapis and his worship were in-
fluential in the creation of the
bearded, long-locked type of Christ,
it seems to me that our small bust
preceded this particular type of Christ
and is not later than the third cen-
tury.

PUBLICATIONS
Hornbostel, W., *Serapis: Studien zur
Überlieferungsgeschichte, den Er-
scheinungsformen und Wandlungen
der Gestalt eines Gottes*, Etudes préli-
minaires des religions orientales,
XXXII, 1973, 17 with note 1, pl. 1, fig. 1.
Reynolds, N.G., 'New Evidence for
the Iconography of Sarapis' (PHD
thesis, Mount Holyoke College,
1948), p. 140, fig. 60

From the M. Abermayor Collection,
Cairo EAR

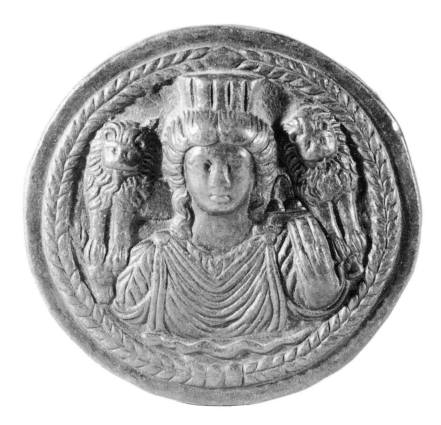

22 Plaque of Cybele

Bronze. 8.2 × 0.8 cm
Roman, early 3rd century M82.385

Cybele is accompanied here by most of her usual attributes. She wears a mural crown and holds a sistrum and cymbals in her left hand. The right is not shown. She is flanked at shoulder level by two lions, one of which stands on the head of a deer, the other on the head of a bull (?). In the small space under the bust is a snake and the whole is framed in a wreath of laurel. The cult of Cybele was imported to Italy from Phrygia in the second century BC, but the time of greatest popularity was during the Severan dynasty, particularly under Septimius Severus (193–214) and his Syrian wife Julia Domna. As shown by Margarete Bieber, 'The Images of Cybele in Roman Coins and Sculpture,' *Hommage à Marcel Renard* (Latomus 60, 1969), vol. 3, pp. 29–40, coins of Julia Domna have on their reverses images of Cybele, enthroned and in a chariot. The hairstyle of Cybele on this plaque echoes that of Julia Domna herself, with a central parting, multiple waves to shoulder length, and the rest of the hair pulled to the back of the head and not visible here. Bieber has suggested that some statues of Cybele may have had portrait heads of the relevant empresses, just as emperors were associated with gods and heroes. This small plaque may also have imperial portrait features, of Julia Domna herself.

Purchased from Blumka Gallery, New York, January 1966 SDC

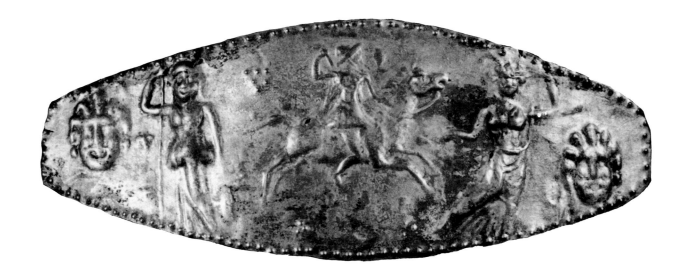

23 Repoussée diadem

Silver / tin (?) foil. 6 × 15 cm
Thracian, third quarter 3rd century
M82.190

This diadem bears a close
resemblance to one in the Hamburg
museum (Jorgen Bracker, 'Silbernes
Stirndiadem,' *Archäologische
Anzeiger* [AA], 1974, p. 79). The re-
poussé is achieved by pressing the
thin material over a mould, thus al-
lowing duplication and symmetry
in the design. The scene in this ex-
ample shows a figure on horseback,
possibly a woman. She wears a hel-
met and a short chiton, and with her
right hand reaches behind her back,
perhaps to draw an arrow from a
quiver. However, she does not hold a
bow in her left hand, nor is the left
arm very clear. The horse gallops
off to the right. A tentative identifi-
cation of the figure here, as in the
Hamburg example, would be Artemis
or an amazon. On either side of the
central rider is a standing figure.

The one on the left is a woman hold-
ing a staff or spear and wearing a
long chiton which is drawn up into a
fold around the hips. She may have
something in her left hand, but the
shaping is not clear, and she may
be wearing a helmet, in which case
the identification here, again tenta-
tive, could be Athena. On the right is
another standing figure, of indeter-
minate sex, even though the torso is
nude, because the metal is badly
shaped. It is probably female. The
right arm and leg are stretched out to
the side, the left arm is bent at right
angles at shoulder level. The head
is badly dented so that the hair, or
headdress or headgear, is indistin-
guishable. If this is a female figure,
then possibly it is Aphrodite. On
each of the two outer edges is a mask,
the head of a man with no particular
distinguishing attributes. They are,
however, very similar and could
have been made over the same
mould.

The example in the Hamburg
museum has a series of small holes in
the outer edges, for stitching it to a
fastening band or cloth. The Toronto
example has a series of raised dots,
only five of which are actually
pierced, which means that this par-
ticular example was never worn
or that it was fastened to the fore-
head in some other manner such as
ribbons or a cloth at the edges to
avoid obscuring the design.

The Hamburg example is dated on
the basis of the bust forms in that
piece, and the Gallienic revival of the
Helios cult, to approximately 260.
The same criterion cannot be used
here since these bust forms have not
been used and the two masks may
or may not be Helios, but the general
similarity of the two objects and
their iconography provides a reason-
able argument for applying the same
date to the Toronto example. On
the basis of the central figure of a
mounted figure, probably a deity,
they can be identified as Thracian.

Purchased from M. Komor, May 1975
SDC

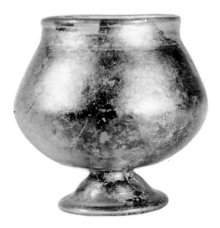

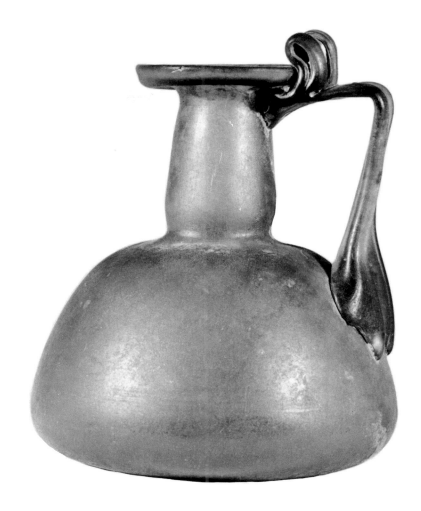

24 Footed beaker

Pale greyish-green glass of good
quality.
7.7 × 5.1 (rim), 7.2 (body), 4.1
(foot) cm
2nd-early 3rd century (?), Eastern
Mediterranean or Anatolia M82.391

The vessel is thin-walled, blown
(single paraison) with a foot created
by folding. There is a slight pontil
mark on the inside of the footring. It
has a broad, sack-shaped body with
the wall rounded below, sloping
inward above, curving up to a low,
vertical, fire-polished rim. There is a
slight tooling mark around the base
of the rim. The narrow conical foot-
ring has a tubular lower edge and
the folding of the foot creates a small
hollow at the centre of the floor.
The body is fairly symmetrical but
the foot is folded off-centre, causing
the vessel to tilt. There is an oily
irridescence and soil deposit on the
interior.

There are no known close parallels
for this vessel, but perhaps a footed
version of the type of baggy beaker
represented by J. Hayes, *Roman and
Pre-Roman Glass in the Royal
Ontario Museum* (Toronto 1975),
no. 193, fig. 6, p. 15 (Cypriot or Syrian
Type) may be used for comparison.
Our beaker, however, is unlikely to
be related to the later (fifth century)
stemmed Early Byzantine 'wine glass'
shape (ibid., nos. 381–3, pp. 84–5).

JH

25 Glass jug

Green glass of good quality, blown,
slight traces of pontil on the bottom.
13.3 (to rim) × 14.4 (with handle)
cm
Syro-Palestinian, or related Eastern
Mediterranean product, 2nd or early
3rd century M82.497

The vessel has a broad sagging body
of truncated conical shape, with
a broad flat base, slightly concave,
and a narrow flattened shoulder.
There is a narrow cylindrical neck,
almost as high as the body, with
a slight constriction from tooling at
the bottom and a wide, shallow,
splayed rim with an upright lip, cut
and roughly polished. The handle
is a trailed double-rib, from the ex-
terior of the rim to the body, angular,
with an upright loop against the
rim at the top end and two
pronounced 'fins' down the body at
the lower end. it is undecorated. The
base is indented off-centre, causing
a slight tilt. There are remains of
a creamy crust of decay in places on
the outside (mostly removed), and
patches of slight irridescence.

This seems to be a heavier and
earlier version of jugs such as Hayes
[cat. 24], pl. 25, no. 416. The rim
treatment is more akin to second-
century products. For the handle
treatment compare the smaller
Cypriot jug, ibid., pl. 33, no. 540,
which is probably contemporary.

JH

26 Fragment of painted wooden panel

Encaustic on wood. 10 × 23 cm
Romano-Egyptian, 4th / 5th
century (?) M82.339

The head, shoulders, and upper chest of a young man are shown on a fragment of a wooden panel which is framed, now just on two sides, by a rectangular wooden border. One piece of wood provides both panel and frame. The young man has a calm and steady, yet piercing gaze which follows the slight turn of his head to the left. He holds a shield at eye level. The direction of his glance, the position of his shield, and the fact that painted fragments of two other shields can be seen to his left suggest that he is one of several soldiers or armed guards who act in an honorary capacity flanking a central and more important figure, much like the figures on the Missorium of Theodosius of the late fourth century.

This panel probably included a full-length representation of this male figure and his cohorts, and, therefore, could have been part of a decorative arrangement of wooden panelling that covered a large area such as a wall or ceiling. The piece may be dated to the late antique period generally by the manner in which the head overlaps the frame, the vivacity of facial expression, the use of black dots for eyes, the strong use of dark outlines, and the contrasting highlights on the body parts and clothing. The limited colour scheme – black, pink, red, and white – is typical of late Roman art from Egypt. Compare, for example, a fragment of a painting on wood from Egypt and dated to the fifth century in the Dumbarton Oaks Collection: Marvin Ross, *Catalogue of the Byzantine and Early Mediaeval Antiquities in the Dumbarton Oaks Collection* [DOC] (Washington 1962), vol. I, p. 107, and pl. LIX, no. 126. A date in the fifth century, therefore, seems appropriate. The panel is now quite fragile, the wood dry and flaking, and much of its painted surface has disappeared, especially around the frame. Fortunately, the best preserved portions are those that make up the rather charming face.

Purchased from Royal Athena Gallery, New York, May 1964 MM

27 Twenty fresco fragments mounted in four modern panels

Fresco.
Panel one: 45.7 × 35.5 m
panel two: 30.5 × 45.7 m
panel three: 20.4 × 45.6 m
panel four: 45.7 × 76.4 m
Romano-Egyptian, said to be from
Alexandria, proposed date 400
M82.291

In panel one, in the larger fragment to the left, is a man of young to middle age who props or leans himself against a support that is no longer visible. In his right hand he holds a stick or rod. His distinctive appearance includes dark curly hair, moustache and beard, and a *pilos* on his head, a type of headgear often associated with sailors and other rustic types. To the right is a fragment with the head and shoulders of a woman. Both figures are painted against a light grey background. In a 'thinker's' pose, the female figure supports her head with her right arm and glances upwards. Above this piece is a small fragment of blank background.

The two figures might be identified as Odysseus and Penelope, and the scene, then, the confrontation between Antinous and Odysseus in the guise of a beggar (*Odyssey*, XVII, 458ff). In that scene, Antinous has struck Odysseus on the right shoulder with a footstool and so Odysseus has 'returned to the threshold' to ponder his situation, while Penelope remained above in her chamber contemplating the scene. Such an interpretation would account for the very prominent deformity on the male figure's left shoulder, which certainly should not be considered as poor technique on the part of the artist.

In panel two, against a background that varies from greyish white to pink, in the fragments to left and right, are warriors wearing, according to George Hanfmann (see below), helmets and curiasses of a late Classical-Hellenistic type. To the left

of the soldier in the left fragment is a bush or vine of some sort. The central fragment represents a simplified version of a Corinthian capital with part of the column shaft below, a yellow gold krater on top, and a piece of entablature to the right, all of which Hanfmann has compared favourably to the Corinthian columns and entablature of the tholos tomb of Agamemnon in House 16 at Hermoupolis Magna (see S. Gabra and E. Drioton, *Peintures et fresques et scènes peintes à Hermoupolis Ouest*, Cairo 1954, pl. 17). It is not possible to identify this scene other than to describe it as a battle, for it exhibits no distinguishing elements that would give it a literary or historical context.

In panel three are four fragments depicting guards with lances and oval ribbed shields. They stand in front of architecture which, from left to right, consists of a black corner of a building between the heads of the first two guards; a tall white masonry structure with eight visible courses, flanked by trees, behind the third guard; two rectangular structures, seen in elevation but laid flat as if in plan, behind the fourth guard; a brown band of architecture behind the sixth guard; a vertical brown pier to the left of the seventh

guard. Behind the fifth guard are five yellow baskets or vases filled with a red substance, perhaps wine. No certain interpretations of this panel can be made, but the architectural drawing convention certainly suggests that it was made in Egypt.

The upper row of fragments in panel four includes depictions of ships. In the upper left fragment is the bent arm of a man above the railing of a boat. Behind him a purple cloak flies out in the breeze. The small fragment just below includes the white tips of two steering oars and a patch of greenish-blue water. In the large fragment, second from the left, is part of a ship set in blue-black water. Two large steering oars and a bank of six thinner ones extend over the railing. A steersman holds on to one of the steering oars, while on deck are warriors with lances and shields. In the fragment second from right is a structure with a lattice pattern which Hanfmann has identified as a canvas deck cabin. Two soldiers stand to the right of it. The last fragment, at right, depicts parts of two ships separated by a strip of blue sea. On the upper ship is another canvas cabin, more armed soldiers, and two shields fastened to the railing. On the lower boat are, again, a canvas cabin and more

armed soldiers.

In the lower row of fragments soldiers dressed in late Classical-Hellenistic military gear take part in a battle on a beach. Especially interesting is the detail given to the headgear of the soldier in the fragment to the right – a white-silver helmet with curving cheekpieces and a tall crestholder. In the fragment to the far left is a tower-like structure in the lower corner, while the soldier's head in the central fragment overlaps both sea and shore. This painting could very well illustrate a scene from the *Iliad* in which a battle on the beach and incoming ships could appropriately be combined with views of more permanent architecture, either the camps or Troy itself, and, in fact, a similar combination of elements can be found in the Ambrosian Iliad dated to about 500 (see R. Bianchi-Bandinelli, *Iliad*, XXVIII, 63, and XXXVIII, 74).

The painted surfaces of the fragments in all four panels are in reasonably good condition, and the colours still quite vivid; however, the pieces are simply not numerous or extensive enough to identify their subject(s) with any certainty. The present arrangement of four panels, it must be remembered, is modern, and the only evidence that they may

all have come from one decorative scheme is the fact that they were all purchased together. Hanfmann suggests that the fragments in panel two may have been done by the same hand as those from panel one, and in this case they could represent another scene from the *Odyssey*, perhaps the battle of the Ciconians (or Cicones) (*Odyssey*, IX, 39–66), but he does not stress this relationship; nor does he suggest that panels three and four are linked to each other or to the other two. Certainly the difference in scale among the figures from the various panels, and the different colours of the backgrounds in each panel, do not permit one to assume a single monument as the source for all four. It is tempting to suppose that these fragments might

at one time have decorated different parts of a building, domestic or otherwise, that had a particular interest in Homeric epic, but this should be done with caution.

The expressive quality of the faces and gestures, the dark outline technique and limited colour scheme within each panel date these fragments generally to the late antique period. The similarities between the soldiers in panels two to four and those in the Vatican Vergil of about 400 and the *Vergilius Romanus* of about 500 suggest a date in the fifth century. The classical quality of the Odysseus and Penelope figures, however, must be considered, and if they are from the same monument as the soldier panels, a date of 400 is more likely for all four panels; other-

wise, we might date panel one to circa 400 and panels two to four to between 400 and 500.

PUBLICATION

Hanfmann, George M.A., 'New Fragments of Alexandrian Wall Painting,' *Alessandria e il mondo ellenistico romano. Studi in honore di A. Adriani*, in *Studi e materiali*, Istituto di archeologia Universita Palermo, v, Rome 1984. Hanfmann suggests a date of late third, early fourth century. MM

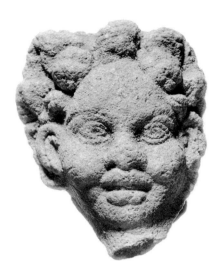

29 Votive dish

Serpentine. 2.3 × 8.9 cm
Romano-Egyptian, 2nd / 3rd
century M82.220

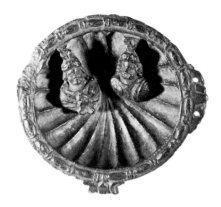

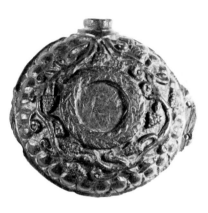

The vessel is intact with the exception of some chips missing from the rim and underside of the handle. The surface shows signs of wear, and the spout may have been drilled in modern times. The interior of the dish is decorated with nineteen scallop-shaped flutes. Busts of Isis and Sarapis, carved in high relief, are set within the dish at an oblique angle to each other. An Isis knot is tied at the front of Isis's drapery and she is wearing a crown surmounted by a solar disk between two horns. Sarapis is draped and crowned by a modius. The rim is embellished with a bead and reel design, executed in low relief, a spout-like projection and a handle perforated by two holes.

The exterior of the dish is richly decorated. The rim of the ring-shaped base is ornamented with a wreath, now very worn. A vine scroll with grape clusters and curled branches winds its way around the dish, starting and then terminating at the spout. A row of twenty-six petals is placed above the vine.

There are many examples of this type of dish exhibiting a number of variations of design and most of them dating to the Imperial period. The interiors are carved with a wide variety of representations, such as crocodiles, erotic scenes, and mythological figures. However, the most popular figures seem to have been those associated with the cult of Isis: Isis, Serapis, and Harpocrates. These gods are shown either singly or together in a group of two or three. In addition to the figures, the decoration of the interior of the dish ranges from a simple smooth finish to more elaborate surfaces consisting of subsidiary figures, rosettes, petals, scalloped fluting, and lotus flowers. Two essential features that appear on the rim are a non-functional spout and one or more handles. The flat surface of the rim is usually decorated with a wreath or with some other device, such as a bead and reel

design. The exterior of the dishes often exhibit a consistent scheme of ornamentation, frequently incorporating a central rosette within a ring base, a grape vine, and a row of petals. The actual function of these vessels seems to have been ritualistic in nature and some of them, because of their overt iconography, connected with the cult of Isis. PD

28 Head of a Nubian

Limestone. 7.6 × 6.2 cm
Romano-Egyptian, 2nd / 3rd century
 M82.257

The head represents a Nubian male, with thick lips, a broad nose, and hair arranged into rows of ringlets. Two clusters of berries are evident on his head, where the hair meets the forehead. The irises of his eyes are engraved and the pupils are drilled out. The evenness of the break at the back suggests that this head once may have belonged to a relief.

Purchased from Parke-Bernet, New York, April 1964 PD

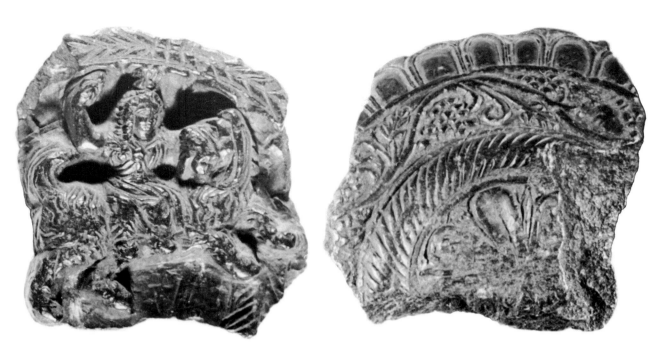

30 Fragment of a votive dish

Serpentine. 5.3 × 5.4 cm
Romano-Egyptian, 2nd / 3rd
century M82.221

Isis is shown riding on the back of
the Sirius hound, whose head is
turned facing the rider. Both figures
are carved in relief and set within
the interior of the dish, overlapping a
row of elongated petals. The goddess is
draped and an Isis knot is tied at the
front of her gown. Her headdress is
composed of a solar disk placed
between two horns and her hair is
arranged into long ringlettes. She
appears to be holding a sistrum in her
raised right hand. The surface of
the rim is decorated with a laurel
wreath. The exterior is ornamented
in the typical manner with a central
rosette framed by a cord-like ring
base, vines with grape clusters, curled
branches and leaves, and a row of
petals. For other examples see John
Evans, 'Notes of Some Vessels of
Steatite from Egypt,' *Proceedings of*
the Society of Antiquaries of London,
XXII, 1908, 89ff, and Klaus Parlasca,
'Griechisch-Römische Steinschalchen
aus Ägypten,' *Das römisch-byzantin-*
ische Ägypten, Akten des Interna-
tionalen Symposions, 26–30 Sept.
1978, Trier (Trier 1980), p. 151ff, pls.
20–7. PD

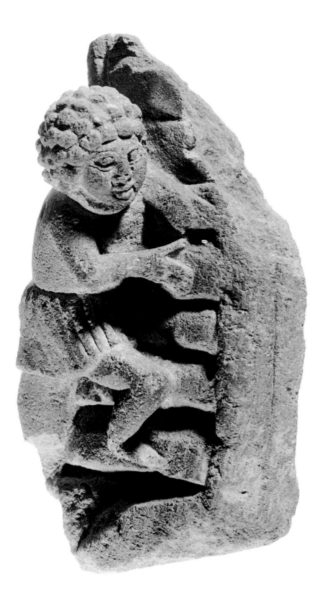

and the rear are visible although the figure as a whole is shown in profile.

Figures of similar proportions can be found on stone reliefs from Egypt and also on relief ceramic and ivory carvings usually associated with Egypt. A limestone relief from Sheikh Abada in the Louvre showing what has been termed a 'Dionysiac figure' may be compared, not only for the proportions of the body but also for the face and the curly hair (P.M. Du Bourguet, *The Art of the Copts*, Paris 1971, colour pl. p. 41; also a relief from Ahnas in the Coptic Museum, Old Cairo, ibid., pl. 14). Amongst ceramic reliefs a fragment found in the cemetery of Kom-esh-Shugafa (Alexandria) shows a gladiator with curly hair and a neck collar fighting a lion. He is seen from the back, but his movement is comparable (T. Schreiber, *Expedition Sieglin*, 1, Leipzig 1908, pl. LXIX, 6, text p. 313). The movement may also be compared to that of figures harvesting grapes on a clay flask from the Fayum in the Egyptian Museum in Cairo (G. Grimm and D. Johannes, *Kunst der Ptolemäer-und Römerzeit im Ägyptischen Museum Kairo*, Mainz 1975, no. 76, pl. 117). Ivory carvings such as a panel in the Museo Civico in Trieste showing Europa caressing the bull offer some points of comparison, such as the proportions of the figures both on the panel proper and the vine-scroll frame, and the 'skirt' worn by Europa (F.W. Volbach, *Elfenbeinarbeiten der Spätantike und des frühen Mittelalters*, Mainz 1952, no. 82).

The date is difficult to determine. For the stone relief in the Louvre and the ceramic reliefs the fourth century has been proposed, whereas the Trieste ivory and related pieces are usually dated in the fifth / sixth centuries.

The provenance Sheikh Abada given by the dealer is the same as that of the Louvre piece. Such dealer provenances are not reliable, but a site in upper Egypt seems possible.

Purchased from Michael E. Abemayor, New York, March 1966

EAR

31 Fragment of a relief: youth climbing a flight of stairs or ladder

Limestone. 13 × 6 × 6 cm; depth of relief 3 cm
Coptic, 5th / 6th century (?)

M82.493

The right edge with a coarse moulding and part of the lower edge appear to be intact. The piece is broken at the right upper corner and on the left side. The right leg of the figure is broken from about midcalf. (In an earlier photo, this leg appears to be complete.)

The youth wears a pleated short skirt and a rolled collar round his neck. The upper part of the body and the legs do not show any garment, but it is possible that clothing might have been indicated by paint. The youth has chubby limbs, almost like those of a putto, a round, puffy face, and thick curly hair. The outlines of the eyes, nose, and mouth have been deeply incised.

The figure is shown in the act of climbing a flight of stairs or a ladder, trying to grasp something with both hands. Unfortunately, the stone is damaged at this spot so that it is not clear what it is he is grasping. The body is twisted in the motion of climbing, so that parts of the front

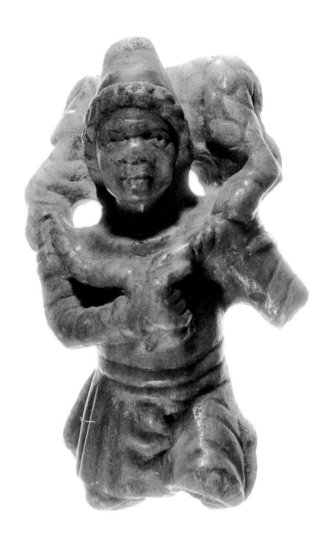

the other occurs on representations of the shepherd in the round, on sarcophagus reliefs, catacomb paintings, and gems from the third century on. See Cabrol-Leclercq, *Dictionaire d'archaeologie chrétienne*, 1938, 2272–390, s.v. Pasteur (Bon) (H. Leclercq); T. Klauser, *Jahrbuch für Antike und Christentum*, 1, 1958, 33ff, 45ff. Our shepherd's attire is unusual; neither the garment nor the Phrygian cap are, to my knowledge, paralleled in renderings of the shepherd. The Phrygian cap is worn in a Christian context by the Magi, the three Hebrew Youths, and Daniel, all of whom also wear Persian trousers but a different type of tunic. A close parallel to the garment worn by our shepherd is found on a relief in the Musée Calvet in Avignon (M. Bonicatti, *Studi di storia dell-'arte sulla tarda antichita e sull'alto medioevo*, Milan 1960, fig. 316, opposite p. 395), where the two men towing a boat with a cargo of barrels wear such a tunic. They also have a comparable hairstyle.

It is difficult to assign a precise date to the statuette. The drapery style is comparable to figures in stone and other material of the late third and fourth centuries.

The purpose of such a small figurine of the shepherd cannot be determined. Among the statuettes and figurines listed by Leclercq and Klauser only very few are of a comparable size, and they are of bone or bronze (Leclercq, p. 2347, no. 142, fig. 9908; Klauser, p. 45, no. 18, Leningrad, Hermitage, bone, 7.5 cm; Leclercq, p. 2352ff, no. 148, fig. 9912; Klauser, p. 45, no. 11, Florence, Museo Archeologico, bronze. Cf also two knife handles of bone, Klauser, p. 34, pl. 2e, f, museums in Bonn and Zug).

The provenance of the present piece must be considered as 'unknown', the negroid features not being any indication of an origin in Egypt.

Purchased from Kelekian, New York, December 1965 EAR

32 Statuette of a shepherd carrying a sheep

Gray and white marble. 5.5 × 3 cm
Provenance unknown, 3rd / 4th century (?) M82.206

The legs are broken off below the knees. The left arm is broken off just above the elbow. The head of the sheep is missing.

The shepherd is shown walking with his left leg put forward. He carries the sheep on his shoulders grasping its legs in front of his chest with his right hand. In the broken-off left hand he must have held something (a basket, stick, or even a syrinx would be possible). He wears a long-sleeved tunic reaching down to about the knees with some of the cloth arranged like a belt around his waist. In addition, he wears a Phrygian cap, and he may have worn tight trousers or leggings. His roundish fleshy face with broad nose is framed by thick curly locks. His wide-set eyes with thick lids have hollowed out circular irises and pupils, possibly meant to be inlaid. His features are in general negroid.

A fair number of statuettes of the sheep-bearer, commonly known as the 'good shepherd,' have survived. The type with the sheep's legs held in one hand while an object is held in

33 Part of a rim from a rectangular dish with relief appliqué depicting a hunting scene

Clay: medium grained, slightly gritty to the touch along the breaks, full of small dark grits, occasional small pieces of yellowish-white limestone and flakes of gold mica, orange (Munsell colour no. 2.5 YR 6 / 8). Maximum length preserved, 17.6 cm, width of everted rim from junction with wall to outside edge, 5.2 cm, thickness of wall, .07 cm
African Red Slip Ware, Hayes Form 56, Tunisian fabric, last quarter 4th – first quarter 5th century M82.352

The fragment has a thin matt slip applied over the inside wall, the top of the rim and the underside of the rim. Only a small piece from one corner of the vessel is preserved. On the extant portion are traces of an ancient repair consisting of part of a lead hook which originally passed through two holes bored through the rim on either side of the break. The large flat horizontal rim joins the straight flaring wall at an angle. The mould-made form was rectangular with a low foot set near the outer edge of the floor. Appliqué decoration is applied to the top surface of the rim and may have existed on the floor in the form of a large scene. A row of raised dots defines the outside edge of the rim. The surviving appliqué decoration consists of a vignette from the hunt or wild beast show. A leopard (lioness?) in running position moves to the right. A crouching hunter, (or bestiarius), whose lower half only is preserved, moves to the left, holding a spear in front about to pierce the animal's neck. The animal is carefully done with crisp outline and fine detail, including tufts of fur around the neck and legs.

For similar examples see J.W. Salomonson, 'Late Roman Earthenware with Relief Decoration found in Northern Africa and Egypt,' *Oudheidkundige Mededelingen*, XLIII, 1962, 53–95, for a general discussion of the form and its decoration; J.W. Hayes, *Late Roman Pottery* (London 1972), pp. 83–91, with full bibliography and list of known examples; J.W. Hayes, *Roman Pottery in the Royal Ontario Museum: A Catalogue* (Toronto 1976), nos. 99, 100, p. 23, and pl. 12, for two similar rims. CW

34 Bowl with relief appliqué depicting Abraham's sacrifice

Clay: fine grained, hard fired, orange (Munsell colour no. 2.5 YR 6 / 8). 16.7 × 4.7 cm; base diameter 6 cm African Red Slip Ware, Hayes Form 53A, Tunisian fabric, mid-4th – mid-5th century M82.359

The bowl has a flat base, with a curving wall ending in a plain rim, two carefully done grooves on the inside wall just below the rim, and two grooves on the floor. The slip is thin and matt with occasional glossy patches, applied over the interior and exterior. The vessel has been broken and repaired. It is complete except for a chip at the rim and two chips from the rim and wall which are restored in plaster. Four appliqués are placed around the wall on the inside: Abraham and Isaac, a ram, a lion, and a bear. Abraham strides to the left, towards the altar with a sword held upright in his right hand and his head turned back over

his right shoulder. He is depicted as a muscular, robust man with short, curly hair and a beard. He wears a short tunic gathered at the waist and apparently passing over his left shoulder, leaving the right side of his chest bare. His left hand presses the head of Isaac down towards the altar situated between the figures. Isaac kneels facing the altar with his hands tied behind his back. He wears a short tunic. The low, horned altar appears to be encircled by two wreaths and to have a four-tiered object on top. A ram of the fat-tailed variety strides towards the figured scene. A lion with the right paw raised appears to walk away from the figures. The figure of the bear was badly blurred, apparently during its transfer from the mould to the vessel. The head is down at ground level and turned back with the mouth open. The bear is in a walking position with the left hind leg advanced.

Such thin-walled bowls with appliqués were inexpensive substitutes for metal vessels with relief decora-

tion. A Judaeo-Christian scene such as Abraham's sacrifice is fairly common but pagan motifs such as Victories or scenes from the Mithras cycle are also found. The animals on this bowl could also be used on vessels whose decoration revolved around the theme of the hunt.

For comparative examples see J.W. Salomonson, 'Spätrömische rote Tonware mit Reliefverzierung aus nordafrikanischen Werkstatten: Entwicklungsgeschichtliche Unteruchungen zur reliefgeschmuckten Terra Sigillita Chiara "C," ' *Vereniging tot Bevordering der Kennis van de Antike Beschaving* [BA Besch], XLIV, 1969, pp. 18–25, pls. 24–6. This is the earliest and most important detailed discussion of the form and its decoration in general. Hayes, *Late Roman Pottery* [cat. 33], pp. 78–82, for form 53A in general, and for Abraham's sacrifice see p. 89 under form 56. Known examples and full bibliography to that date are presented here as well as the small amount of dating evidence for the form. See also catalogue of *Romans and Barbarians* [cat. 12], no. 144, applied decoration depicting Daniel in the lions' den; E.H. Williams, *Kenchreai, Eastern Port of Corinth*, V: *The Lamps* (Leiden 1981), p. 81, no. 424, for a discussion of the motif.

PUBLICATION

Weitzmann, K. ed., *The Age of Spirituality* (Princeton 1979), no. 379, p. 422 CW

35 Bowl with relief appliqué of shepherd and rams

Clay: fine grained, hard fired, orange
(Munsell colour no. 2.5 YR 6 / 8).
4.5–5.2 × 18 cm; base 6.5 cm
African Red Slip Ware, Hayes Form
53A, Tunisian fabric, mid-4th – mid-
5th century M82.360

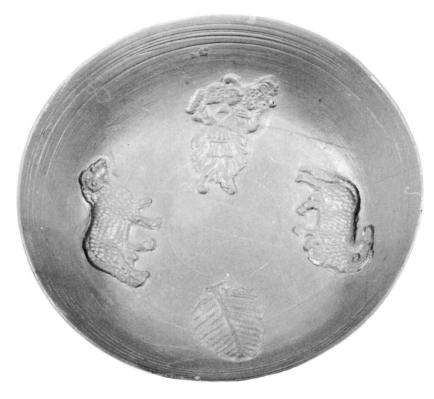

The vessel is similar to catalogue 34,
but is carelessly made, and the slip
is less carefully applied. The base
is slightly hollowed out with a tiny
moulding around the outside edge,
giving the suggestion of a ring foot.
The curving wall ends in a plain
rim narrowing to a point at the top.
There are four roughly executed
grooves on the wall just below the
rim on the inside and one shallow
groove on the floor. Turning marks
are visible on the interior and exte-
rior. The vessel has been broken and
mended. It is complete except for a
few chips from the rim and one piece
restored in plaster. Four appliqués
are placed around the wall on the in-
side: a figure carrying a ram, two
rams, and a large palmette. The male
figure stands in a frontal position,
feet apart and arms raised to shoulder
level grasping the forelegs and hind-
legs of a large ram of the fat-tailed
variety. His head is turned to the
right. A young man appears to be
intended since he is beardless and has
short curly hair. He wears a short
tunic whose soft folds fall in two tiers
over his midriff and thighs. A long
cloak, whose ends are tied over the
chest, billows out behind him. On
his head is a tall cap of Phrygian type.
Because both lower legs and feet
are thickened and smudged, it is
likely that low boots or sandals tied
around the legs were intended but
proved difficult to execute clearly.
On either side of the figure is a ram of
the same type as that carried on the
figure's shoulders. The ram on his
right walks towards him while the
ram on his left walks away but turns
his head back as though looking at
the figure. On the wall opposite the
figure is a large palmette with promi-
nent central rib and fronds pointing
upwards.

The figure is unparalleled on this

class of vessel. From the dress it is
clear that the type was taken from
pagan representations, but the con-
notations of the 'good shepherd' in a
Christian sense cannot be entirely
ruled out on a bowl of this type and
date.

For comparative examples see
catalogue 34. CW

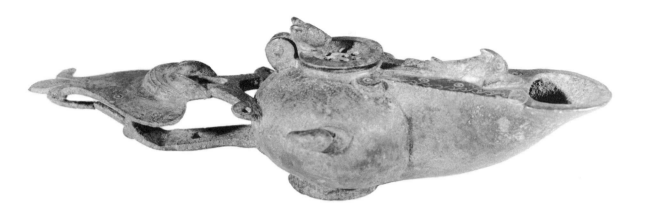

36 Lamp

Bronze. 25 × 9 × 7.5 cm
Late Hellenistic M82.431

The lamp has a globular body with
base ring and lugs in the form of
a dolphin on one side and a bossed
rosette on the other. There is a raised
ridge around the circular filling hole,
which is covered by a hinged strainer
lid with mouse-head decoration. It
has a long nozzle with volutes at the
root, impressed circles and wave
pattern along the edge, and a dolphin
in relief on top, facing a large wick
hole. The handle takes the form of a
Venus knot and leaf plate on top,
and a strap below; it is long and
heavy, to counterbalance the weight
of the nozzle.

See H. Walters, *Catalogue of the
Greek and Roman Lamps in the Brit-
ish Museum* (London 1914), no. 103;
Istanbul Archaeological Museum,
no. E 1262. Such lamps may reflect
the Hellenistic poetic conceit of the
poor man's house where the mouse

is reduced to drinking oil from the
lamps for want of other food. I owe
this reference to Professor Constan-
tine Trypanis. EHW

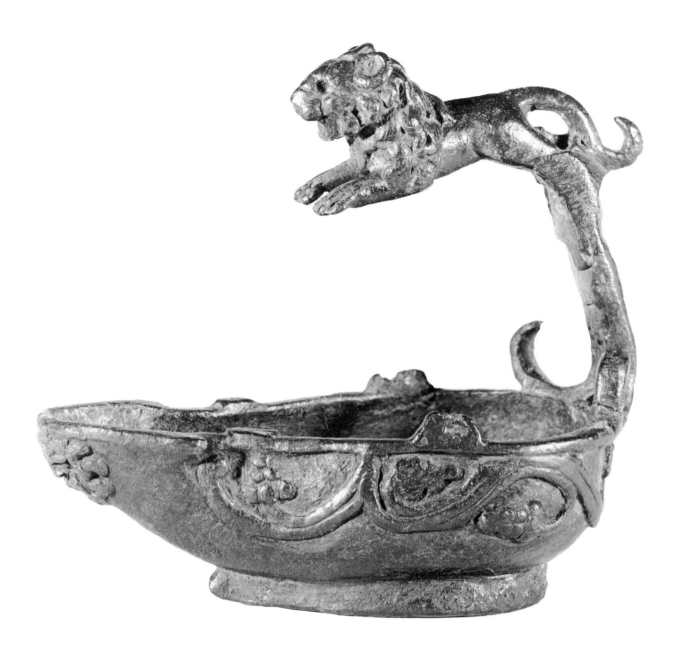

37 Lamp

Bronze. 14.5 × 8 × 14.3 cm
Roman, 1st / 2nd century M82.401

The lamp has a piriform body with
relief decoration of grape clusters and
ivy leaves on the outside and a pair
of prominent lugs in the middle of
the upper edge on each side. There is
no trace of the original cover or top
of the lamp. It has an ovoid, raised
base ring and a handle in the form of

a leaping lion curving over the lamp.

Basically this lamp seems to be-
long to a large class of piriform bodied
lamps that appeared in the late first
century AD (some are known from
Pompeii) and continued into the sec-
ond. See Walters [cat. 36], no. 115,
for something similar. For the class
generally see J. Hayes, *Greek, Roman
and Related Metalware in the Royal
Ontario Museum* (Toronto 1984),
no. 211, pp. 135–6. The Malcove
specimen is unusual for the relief

decoration on the body and for the
absence of a top, suggesting that
it was intended as a holder for a
clay lamp (at least in its present
condition). EHW

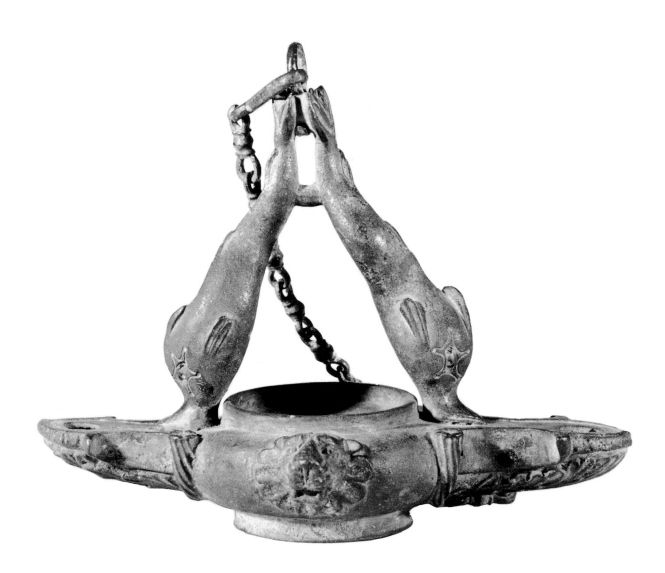

38 Lamp (bilychnos)

Bronze. 20.5 × 14 × 18 cm
Roman, 1st / 2nd century M82.435

This is a double-nozzled volute lamp
with rosettes at the heads of the
volutes and acanthus leaves in relief
on the undersides. It has a round
central body and a raised edge
around the top with several steps
down to a central filling hole. There
is a wide base ring with several steps

down to a central boss. Lion heads
in high relief with manes spread out
like flower petals appear between
the nozzles. The handle is made up
of two dolphins with their heads
at the roots of the two nozzles and
their tails joined by a strut. At the top
there is a suspension ring for a chain.

The double-nozzled volute lamp
is typical of a large number of clay
and bronze lamps produced from the
early first century after Christ to
the mid-second century (at least).

For a comparable dolphin handle see
Roux Barre, *Pompeii*, vol. 7 (Paris
1870), pl. 5 (with elephant protomes
on the sides); for lion protomes see
ibid., p. 299. For another bilychnos
with protomes see M. Bernhard,
Lampki Starozytne (Warsaw 1955),
no. 559, pl. CLXI. Also see C. Smith
and C. Hutton, *Catalogue of the
Antiquities in the Collection of the
Late W.F. Cook* (London 1908), pl.
42, no. 92. EHW

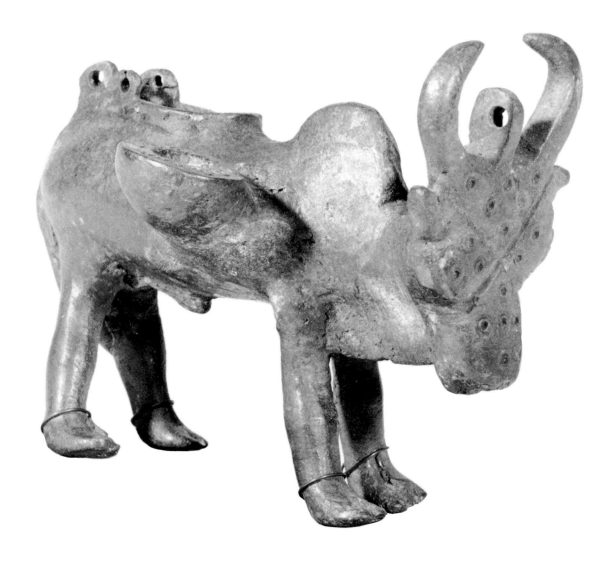

39 Lamp in the form of a hump-backed bull

Bronze. 12.5 × 10.5 cm
Date unknown, possibly 2nd / 3rd
century M82.195

The lamp is in the form of a bull
with a hump behind its neck, legs
stiffly extended, and its tail between
its legs. It has a flat spatulate nozzle
out of the right side of the bull,
matched by a lug on the left side.
There is a filling hole with a hinged
cover at the rear, and suspension lugs
between the horns and above the

tail. The head and top of the nozzle
are decorated with small impressed
circles.

No exact parallels are available for
this object, said to be from Asia
Minor. Perhaps it was meant to be
hung as an ex-voto. EHW

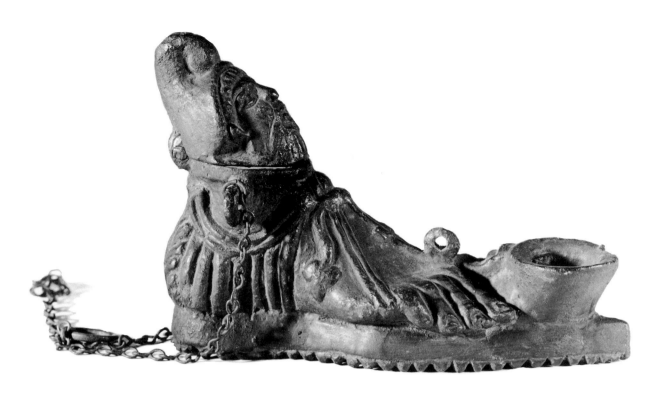

40 Lamp in the form of a foot

Bronze. 13.3 × 3.3 × 9.5 cm
Roman, 2nd / 3rd century M82.434

The lamp is in the form of a thick-
soled sandal and human foot, with a
large wick hole in front of the big
toe and ivy leaf termination of the
thongs that tied up the sandal. There
are lugs at the ankle level and on
top of the toes for a chain (modern).
The hinged filling-hole cover is in
the form of a bearded male head with
a Phrygian cap. The underside of
the sole has a pattern of studs.

A large number of lamps both in
clay and in bronze in the form of
sandal-clad feet is known and has
been connected with the worship of
the god Serapis. See F. Santoro L'hoir,
'Three Sandalled Footlamps: Their
Apotropaic Potentiality in the Cult of
Serapis,' AA [cat. 23], 1983, pp. 225–
46.

PUBLICATION
Sotheby-Parke-Bernet, Catalogue, p.
43, no. 129 (mistakenly identified
as Byzantine) EHW

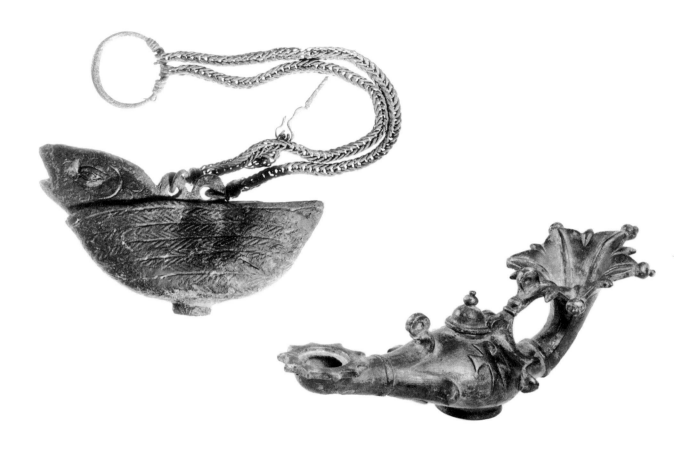

41 Lamp in the shape of a fish in a basket

Bronze. 2 × 10 cm
Date unknown M82.392

A fish lies in a basket engraved with herringbone pattern and squeezed together in the centre. From one end protrude the head and neck of an open mouthed fish, while at the other is a wick hole. Two rings for suspension hold chains (possibly ancient) at the centre. There is a small foot on the bottom of the basket. A slight repair appears on the front of the basket and a larger repair at the back, on top.

No parallels are known for this lamp. It is said to be from Alexandria and although the fish may suggest Christian symbolism, there is no proof that this lamp is so late. EHW

42 Lamp

Bronze. 20.9 × 30 cm
Byzantine, 5th / 6th century
 M82.430

The body of the lamp is bun shaped and drawn out to a long nozzle and an upcurving hollow handle. There is a cross monogram in shallow relief on each side, a conical hinged cover for the filling hole, and a circular base ring. The nozzle is linked to the body by petal-like objects, the top one of which terminates in a ring for hanging. Around the circular wick hole is a scalloped collar. The hollow tubular handle opens out like a calyx, each petal of which ends in a knob. Just above where it joins the body is another ring for hanging.

For a very similar lamp see O. Dalton, *Guide to the Early Christian and Byzantine Antiquities in the Department of British and Medieval Antiquities* (London 1921), p. 21, fig. 11. Also close but a bilychnos is no. 18 in A. Banks, *Byzantine Art …*

of the USSR (Moscow 1966). A similar type but with a griffin handle is present in many collections and may have originated in the western Empire: see DOC [cat. 26], p. 31, no. 30, and Weitzmann [cat. 34], nos. 560, 561, pp. 624–5 (dated too early to fourth century). EHW

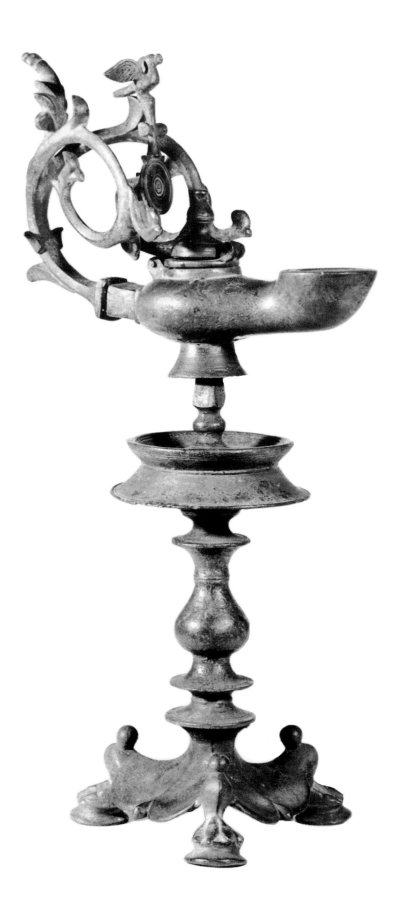

43 Lamp and stand

Bronze. 48 × 11.5 × 20 cm
Byzantine, 5th / 6th century

M82.437a,b

The lamp has a circular body and a
long round nozzle with a wide wick
hole. The domed lid with high finial is
hinged to a collar which is in turn
hinged to the back of the filling hole.
A high curving handle splits into
two branches with a leaf between at
the back and a small bird (dove?)
on a cross on the disk incised with
concentric circles at the front. A high
conical base with a square hole inside
fits onto a spike on the base stand.
The stand rises from three feet in the
form of lion paws resting on flat
round pads.

This lamp is representative of a
large class of late antique bronze
lamps, possibly from Egypt, with long
rounded nozzles and elaborate open-
work handles, often with explicit
Christian iconography as in this case.
For close parallels see Dalton [cat.
42], p. 18, fig. 9; DOC [cat. 26], pp. 36–
7, no. 38; Weitzmann [cat. 34], no.
556, pp. 620–1. Ross [DOC] points out
that the baluster elements have early
seventh-century connections but a
firmly grounded date for the type is
still to be sought. Cf Hayes [cat.
37], pp. 140–1, no. 217, for a probably
earlier version.

PUBLICATION
Ostrogorsky, G., *History of the
Byzantine State*, trans. Joan Hussey
(New Brunswick 1969), p. 84 EHW

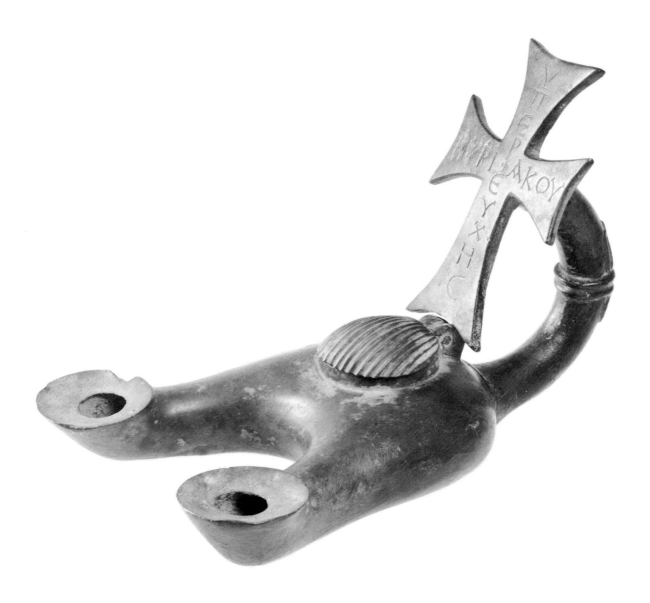

44 Bilychnos

Bronze. 30 × 20.9 × 19.7 cm
5th / 6th century
M82.432, base M82.389

The circular body has long twin rounded nozzles. There is a collar around the filling hole, and a hinged cover in the form of a shell. A hollow tubular handle curves up from the body to terminate in a cross with the Greek inscription YΠEP EYXHC KYPIAKOY (On behalf of Kyriakos' vow) and a small cross in the middle of the name. There is a square hole on the bottom to fit it on a further element.

This is a common type of late antique bronze lamp, a variant of catalogue 43. See Hayes [cat. 37], pp. 145–6, no. 225, for a similar lamp (although missing handle and cover), or no. 224, p. 145, for single nozzle with shell filling-hole cover and cross handle. See also Weitz-mann [cat. 34], p. 340, no. 320, and H. Menzel, *Antike Lampen ... Mainz* (Mainz 1969), p. 112, no. 696, pl. 92.5. EWH

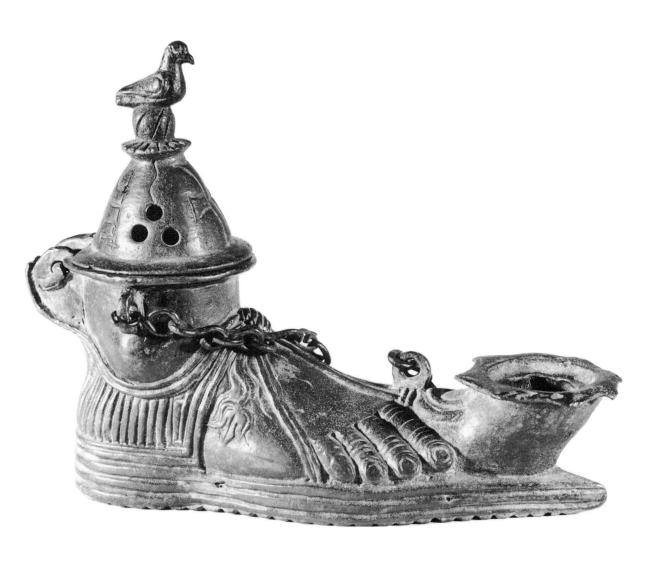

45 Lamp in the form of a foot

Bronze. 18 × 14 × 5.5 cm
5th / 6th century M82.433

This lamp is similar to catalogue 40, but the sole is made up of three elements, the circular wick hole has a scalloped edge, and the hinged conical cover of the filling hole is engraved with a cross, a palm branch, and a PE symbol, as well as being pierced by three groups of three

holes and topped with a bird finial. Some of the suspension chain is modern.

Christian versions of this type of lamp are much less common than pagan versions. The scalloped edge around the wick hole is another sign of a late lamp. See catalogue 40 for comparisons, and Weitzmann [cat. 34], p. 337, no. 317, for a parallel in the Metropolitan Museum, New York; also Smith and Hutton [cat. 38], pl. 42, no. 89.

PUBLICATION
Ostrogorsky, G., *History of the Byzantine State* (New Brunswick 1969), p. 32, fig. 10 EHW

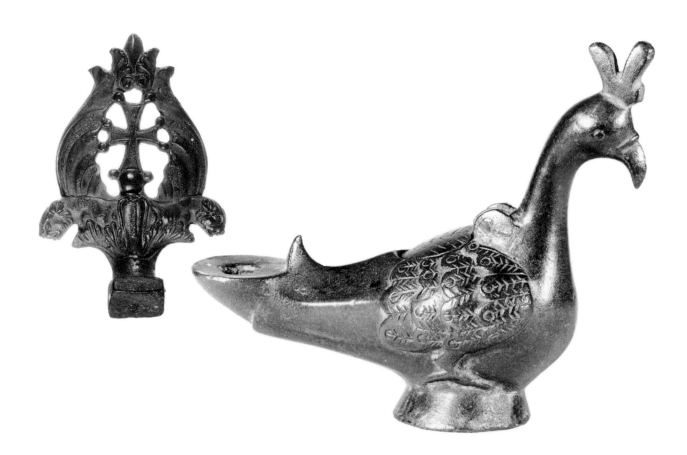

46 Lamp handle

Bronze. 10.5 × 16.2 cm
5th / 6th century M82.417

This is a splendid example of a lamp
handle in the form of an acanthus
with two leaves arching up to em-
brace a cross between them, while
above the cross two smaller leaves
clasp a pod. Springing from the acan-
thus below on either side are panther
heads.

 Such protomes are found as handle
terminations on many late first-
second-century Roman lamps with
piriform bodies but are rare in the
Christian period. See Smith and
Hutton [cat. 38], pl. 42, no. 93, for an
earlier example. For a similar cross
with globular bosses on the extremi-
ties compare DOC [cat. 26], p. 56,
no. 64, pl. XL. EHW

47 Lamp in the form of a peacock

Bronze. 14 × 5 × 12 cm
Found in Egypt, 6th century
 M82.398

The lamp has a rounded nozzle at
the end of the tail. The hinged cover
has a herringbone design incised
over the filling hole on the back. The
feathers of the wings are neatly in-
cised with herringbone pattern. The
front crest of the head feathers is
missing. There is a conical high base
with a square hole for the spike of
a lampstand inside.

 A large number of these peacock
lamps are known from the early
Byzantine world and have been espe-
cially associated with Egypt. See
DOC [cat. 26], pp. 39–40, no. 41, and
Hayes [cat. 37], no. 213, pp. 137–8, for
further discussion and bibliography.
 EHW

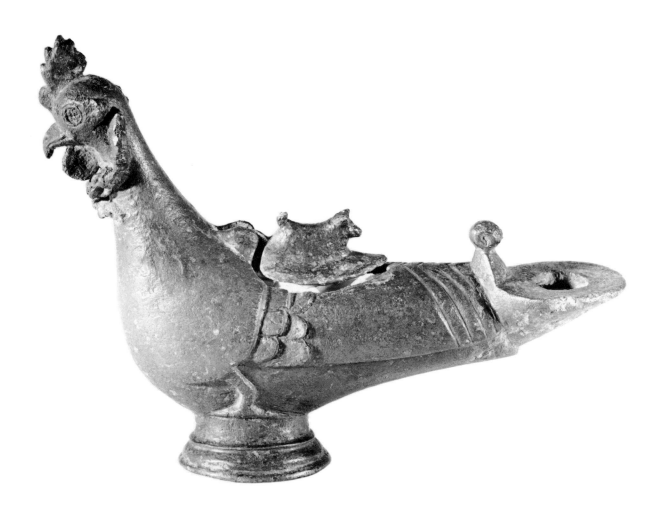

48 Lamp in the form of a rooster

Bronze.
15.5 × 4.0 × 12 cm; base 3.8 cm
6th century M82.399

This lamp has a rounded nozzle at
the end of the tail, and a hinged
filling-hole cover with a handle in
the form of a bull (?) on the back.
The two rows of wing feathers are
sketchily indicated, and there are
parallel lines of incision at the tail.
The base is high, recessed several
degrees, with a square hole inside for
a stand.

Roosters are much rarer than pea-
cocks among the bronze lamps of
the early Byzantine world and this
one is particularly remarkable for the
naturalistic detail of the coxcomb
and gorge compared to the sketchy
treatment of the body. Cf Menzel
[cat. 44], no. 698, p. 112, pl. 93.2, for
a rooster lamp. EHW

49 Lamp hanger

Bronze. 10 × 20.7 cm
3rd / 4th century, possibly 5th / 6th
century if Christian M82.402

The lamp hanger is in the form of a
tabula ansata with the Greek inscrip-
tion ΛΑΥΔΙΚΗ ΥΠΑΙΠΗΝΗ ΘΕΩ
ΥΨΙC ΤWΑΝΕ ΘΗΚΕΝ (Laudike
Upaipene, dedicated to the Highest
God). A suspension ring sits above
and a pair of dolphins, joined by tails
and separate struts to the base of
the tabula, hang below. In the
mouths of the dolphins are pierced
rectangular tabs for further suspen-
sion.

 It is possible that this object may
be the hanger for a large bronze
polycandelon set up as a dedication;
a similar but uninscribed example
is in the Metropolitan Museum in
New York (63.185.1). The dolphins
are reminiscent of one as handle
of an early Christian bronze lamp in
Mainz (see Menzel [cat. 44], p. 121,
no. 715, pl. 102). The name is a ver-
sion of Laodike and the second word
the adjectival form of the city of
Hypaipa in southern Lydia. I am
obliged to Professor C.P. Jones for the
opinion that the letter forms indicate
a date between the late second cen-
tury and early fourth century after
Christ and that the cult is that of the
well-known Theos Hypsistos,
although there is a possibility that it
might also be a Jewish dedication.
Given such a date, it may well be
that this object was not from a lamp
since such assemblies are early
Christian in date. EWH

50 Lamp with chi-rho monogram on disk

Clay: fine grained, hard fired, orange (Munsell colour no. 2.5 YR 6 / 8); slip: good quality, evenly applied, orange (Munsell colour no. 2.5 YR 5 / 8). 5 × 14 × 8 cm
African Red Slip Lamp, Tunisian fabric, mid to late 5th century

M82.354

The lamp has a keyhole-shaped disk and nozzle with reversed chi-rho monogram (jewelled) in relief above relief concentric circles. On the sunken rim are a series of relief triangles. There is a solid knob handle with a rib to the base ring.

This lamp (and catalogue 44 and 45) are typical of the great number of early Christian lamps produced in the factories of North Africa, especially Tunisia, from the second quarter of the fifth century on. They were exported widely, especially to Italy, Egypt, and Greece, and copied locally in many places.

For the most recent discussion see Williams [cat. 34], pp. 76–80; for a large body of comparative material see also A. Ennabli, *Lampes chrétiennes de Tunisie* (Paris 1976), especially no. 905, p. 184, pl. L. EHW

51 Lamp with cross on disk

Clay: softer and coarser than preceding example, orange (Munsell colour no. 2.5 YR 5 / 8); slip: heavily pitted, orange-red (Munsell colour no. 2.5 YR 4 / 4 to 2.5 YR 5 / 8), but burnt darker on top.
12.3 × 7.9 × 4.3 cm
Imitation African Red Slip Lamp, later 5th, possibly early 6th century

M82.356

The lamp has a keyhole-shaped disk and nozzle with jewelled cross in relief, and relief triangles on the sunken rim panels. In the circular relief in the centre of the cross is a bust with a cross to the left. There is a solid knob handle with a rib to the base ring.

See catalogue 44. For comparable crosses see Ennabli [cat. 50], no. 1072, p. 211, pl. LVII. EHW

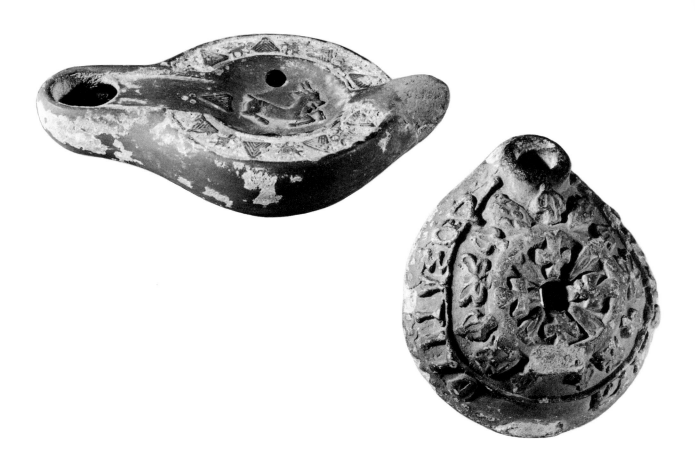

52 Lamp with goat on disk

Clay: hard but not visible under slip;
slip: orange / brown (Munsell colour
no. 2.5 YR 4 / 8). 14 × 8.5 × 3.2 cm
African Red Slip Lamp, mid-late 5th
century M82.355

The lamp has a keyhole-shaped disk
and nozzle with a goat couchant
(separately applied?) and relief tri-
angle. On the sunken rim panels
are relief triangles alternating with
patterns of small relief circles forming
rosettes. There is a solid knob handle
with a rib to the base ring and with
inscribed concentric circles inside.
The handle has been restored in
plaster.
 See catalogue 45. For disk decora-
tion cf Ennabli [cat. 50], no. 399,
p. 104, pl. XX. EHW

53 Lamp with relief decoration on body

Clay: light red (Munsell colour no.
10 R 6 / 3); slip: pale red (Munsell
colour no. 10 R 5 / 6).
8.5 × 7.5 × 4.8 cm
Egyptian, 5th / 6th century M82.488

The lamp has a round body with a
strap handle (missing) and slightly
raised nozzle. The base is flat. The
filling hole at the top has three lines
of relief decoration below: four
crosses separated by wedges around
the hole; a row of rosettes, leaves,
and grape clusters; and a series of
Greek relief letters forming the in-
scription Δοξατιτο Και το Φωζ.
 A large number of these lamps is
known from Egypt, although the
type has never been studied. Cf Hayes
[cat. 37], no. 509, p. 127, pl. 58. Hayes
attributes these lamps to the Aswan
region in upper Egypt and collects
the evidence for them on pp. 124–5.
 EHW

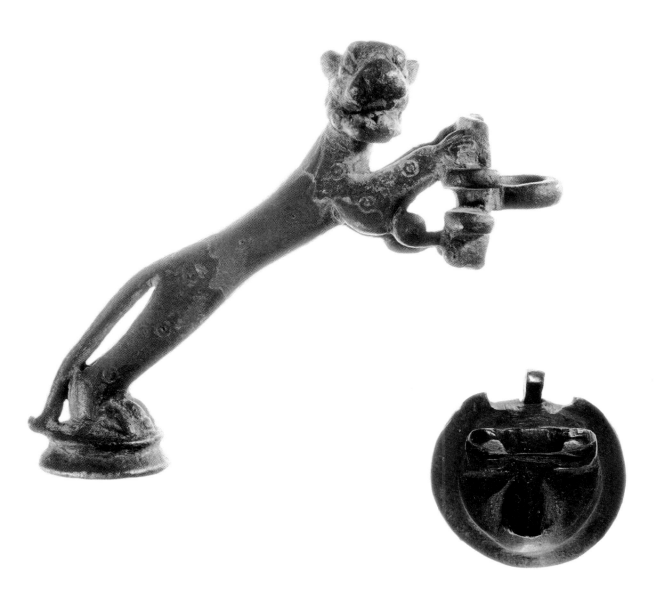

54 Handle of a lamp

Bronze. 10 × 2 cm
Byzantine, 3rd / 4th century M82.406

A leaping panther or leopard forms a
handle which was originally one
of three such handles forming a tri-
pod. A central candle stick or lamp
would have matching rings so that a
rod could pass through the three
rings. The panther is quite realis-
tically modelled, with an open
mouth showing teeth and claws on
the forepaws. The front legs are,
however, rather short in proportion,
as is the actual body of the animal. A
similar object may be seen in the
British Museum (O.M. Dalton, *Cata-
logue of the Early Christian Antiqui-
ties and Objects from the Christian
East*, British Museum 1901, no. 496).
Also, an almost identical figure,
differing only slightly in the bracket
under the forepaws, was found in
the excavations at Aphrodisias in
Caria in Asia Minor (unpublished).

Purchased from S. Motamed,
Frankfurt SDC

55 Filling-hole cover

Bronze. 3.5 × 2 cm
Date uncertain M 82.503

The cover is in the form of a feline-
like face in crude relief. Many bronze
oil lamps have small lids for their
filling holes to keep the oil from
evaporating (cf catalogue 40, 48, 49
above), although they have
frequently been lost from their origi-
nal lamps as is the case with this
example. Generally speaking we
might expect such figured forms to
be early Roman but the high degree
of stylization in this case makes such
assumptions risky. EHW

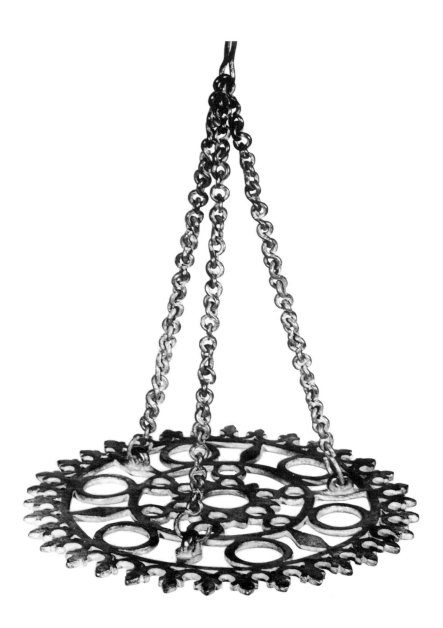

56 Polycandelon

Cast bronze. 38 × 27.5 cm
Byzantine, Constantinople, 6th
century (?) M82.400

This is a well-preserved bronze lamp holder. The six holes, and presumably the central one as well, would each hold a glass lamp. The lamp was probably conical in shape to enable it to slide easily into the holes. A wick holder, in bronze or lead, would be set into the oil in the lamp to prevent the flame from drowning.

The polycandelon is suspended by three chains made of bronze links. The outer edge is a row of stylized fleur-de-lis motifs, while the central motif is like a flower. A similar example, dated to the sixth century and assigned to Constantinople on the basis of the geometric pattern in the inner disc, has been published by Carmen Gómez-Moreno, *Medieval Art from Private Collections:*

A Special Exhibition at The Cloisters, 30 October 1968–30 March 1969 (New York, Metropolitan Museum of Art, 1968), no. 83. See also DOC [cat. 26], no. 43; *Spendeur de Byzance,* October–December 1982, Musée royaux d'Art et d'Histoire Bruxelles, 1982, p. 161. SDC

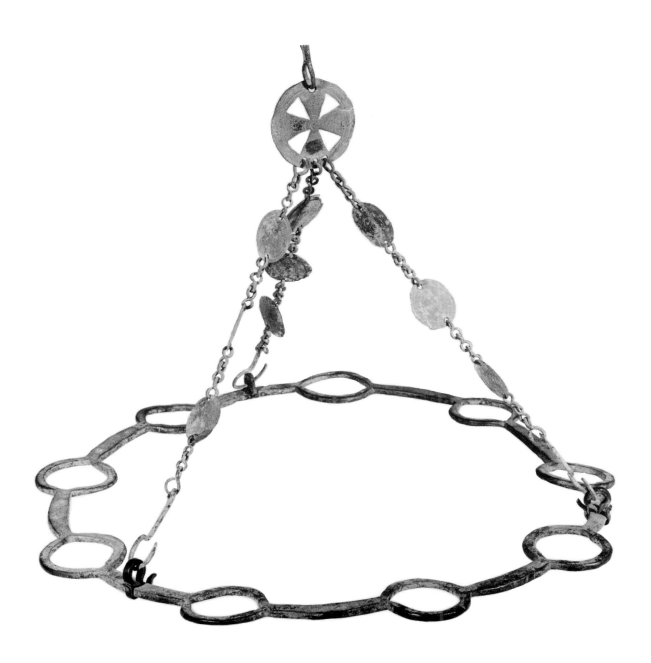

57 Polycandelon

Cast bronze. 40 × 35 cm
Egyptian / Byzantine, 6th / 7th
century M82.188

Compared to catalogue 58, this poly-
candelon is very basic and utilitar-
ian. It has nine spaces in the outer
ring for glass lamps and nothing
in the middle. The chains are inter-
spersed with thin flat discs, decorated
with circles. The three chains termi-
nate in a single flat disc, from which
four wedges have been cut to form
a cross. A censer with a similar chain
is illustrated in Gómez-Moreno [cat.
56], no. 84. Here the chains are
attached to a censer, but it is sug-
gested that those chains may have
belonged to a polycandelon as they
are longer than those usually found
on a censer. In the Toronto example
the decoration on the discs is almost
identical and the suspension disc
is sufficiently similar to enable us to
suggest the same date and
provenance. SDC

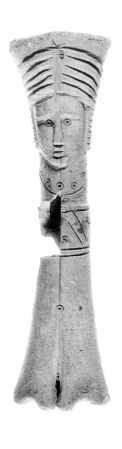
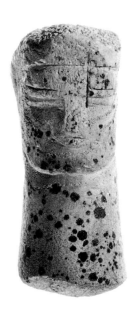
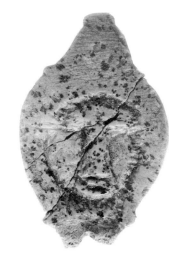
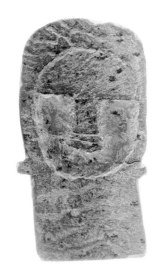

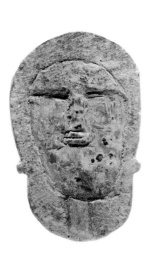
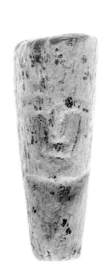
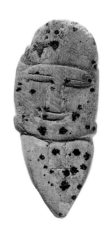

58–64 Amulets or dolls

Bone.
58: 13 × 3.5 × 2.3 cm
59: 4.3 × 1.5 × 2.5 cm
60: 5.8 × 3 × 0.6 cm
61: 5 × 3 × 0.6 cm
62: 5.2 × 3.3 × 0.5 cm
63: 5.5 × 2.2 × 3 cm
64: 6 × 2.5 × 1.2
Egypt, 6th–8th century (?)

M82.214;216;217;218;219;265;266

These seven bone carvings are very crudely carved and may represent amulets or simply toys. The carving is so rudimentary it is not possible to assign a firm date without a context of some kind. Bone carving of a similar type have been found in Egypt, in a context which suggests a sixth to eighth century date, and the same period is provisionally applied to this group. Oskar Wulff, *Altchristliche und Mittelalterliche Byzantinische und Italienische Bildwerke*, I:

Altchristliche Bildwerke (Berlin 1909), nos. 536–45, pl. XXII, pp. 133, 134

SDC

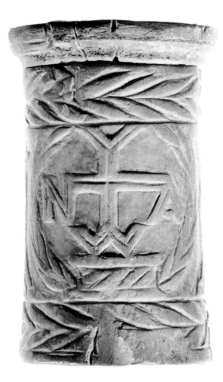

66 Ornamental rod from furniture

Ivory. 19 × 3.5 cm
Coptic, 4th / 5th century M82.337

This segment may have been from the support piece of a chair armrest or part of a bed. The style of carving is very coarse. The vegetation in the lower section is more deeply carved than that in the upper part but it is no more realistic. The two figures with their crossed rubbery legs are fairly typical of many such figures to be found in Coptic bone and ivory carvings and textiles, as is the very linear drapery. Comparable cylinders of bone and ivory, but without figured decoration, may be seen in Wulff [cat. 58], nos. 550, 551, pl. XXV, p. 135.

Purchased from Royal Athena Gallery, New York, 1963 SDC

65 Pyx, cylindrical box

Bone. 6.5 × 4 cm
Coptic, 4th / 5th century M82.336

The box is made from a single piece of bone which has been hollowed for the interior cavity and a piece fitted into the bottom for closure. At the top and bottom is a design of chevrons or stylized leaves. On one side of the box is an urn flanked by two animals which look like dogs, or donkeys, each wearing a collar. This is no doubt a poor copy of the more common iconography of a fountain or urn flanked by deer. On the other side of the pyx is a monogram ⳩ in a circle, the name Ioannou.

The box was probably used as a cosmetic or jewellery container.

Purchased from S. Motamed, Frankfort SDC

67

67 Decorative fragment of furniture inlay (?)

Bone. 10 × 7 × 2.5 cm
Byzantine / Coptic, 7th
century M82.263

A wide, slightly convex piece of bone
has been carved in a deep relief, to
the point of actual piercing. The
design is that of a simple vine scroll
enclosing flowers and the piece was
probably joined with others to pro-
vide inlaid decoration on a piece
of wooden furniture. See Wulff [cat.
58], pl. XXVII, especially nos. 619,
670, pp. 145, 152. SDC

68 Plaque with female figure

Ivory. 10 × 4.5 × 1.5 cm
Byzantine / Coptic, 6th – 7th
century M82.262

The plaque probably is part of a
Dionysiac scene showing a maenad,
as in L. Marangou, *Bone Carvings
from Egypt* I: *Greco-Roman Period*
(Tübingen 1976), no. 198f, p. 58. She
is carved in a very shallow relief,
is very static and frontally depicted.
In style the piece resembles Wulff
[cat. 58], no. 432, pl. XX, p. 120, and
is assigned to the same date and

68

provenance on the basis of the linear
drapery and simplicity of the facial
features.

Purchased from Kelekian, New York,
1963 SDC

69 Figured panel

Ivory. 9.8 × 4.3 × .2 cm
Byzantine / Coptic, 6th – 7th
century (?) M82.216

The panel was carved with a figure
of a dancing maenad carrying a thyr-
sus in her left hand. The swirling
line of the drapery folds suggests the
dancing motion. There are many
parallel examples for this kind of
panel. See Marangou [cat. 68], nos.

69

193a, 210a; Wulff [cat. 58], nos. 379,
380, pl. XCI, pp. 110, 111.

Purchased from Kelekian, New York,
1963 SDC

70 Amulet

Bone. 3.1 × 2.2 × .3 cm
Byzantine / Coptic, 7th / 8th century
 M82.214

This little amulet is highly polished
from much handling. It represents a
crudely carved figure on horseback
spearing something below. The scene
is barely identifiable, and it is impos-
sible to decide whether the figure
is meant to be St George, St Deme-
trius, St Theodore – all of whom may
be shown spearing dragons – or
something else altogether. For two
almost identical objects see Wulff
[cat. 58], nos. 436, 437, pl. XX, p. 121.

Purchased from Kelekian, New York,
1963 SDC

70

71 Incised panel with list of names

Ivory. 8 × 2.5 × 0.3 cm
Byzantine / Coptic, 5th / 6th
century (?) M82.264

Only one side survives of a very thin
panel of ivory. Surrounded by three
lines forming a frame is the left-hand
edge of ten lines of Greek letters, as
follows:

A ...
AM ...
AY ...
Kω ...
Δ̄AI ...
CAPI ...
AION ...
KOλλ ...
EPMO ...
ICIN ...

A similar panel from Egypt, dated
to the 5th–6th century, contains
what seems to be the initial letters of
a list of names (Wulff [cat. 58], no.
615, pl. XXIV, p. 143). This too could
be a list of names, and as the letter
forms are very close, a similar date is
proposed. The function of these lists
of names is not known. They may
be lists of saints' names, or lists of the
dead, to be recited in a liturgy. SDC

71

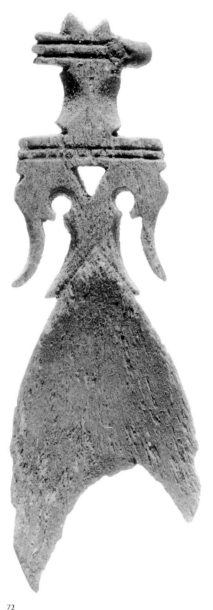

72

72 Spoon with decorated handle

Wood. 10 × 3.5 × 0.5
Byzantine / Coptic, unknown
date M82.537

The spoon has a long oval bowl. The
handle, which begins with wing
shapes, breaks off after a knob. A
narrower projection and the tip of
the bowl are also lost. Many such
bone or wooden objects are in mu-
seum collections, but without a
known context it is impossible to
date them. For additional examples
see Wulff [cat. 58], nos. 506–9, pl.
14, pp. 128, 129.

Purchased from Kelekian, New York,
1963 SDC

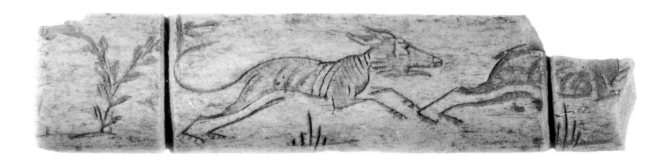

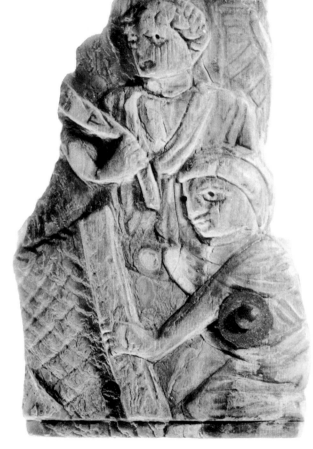

73 Fragment of a stylus case (?) or a handle

Bone. 9 × 2.5 × 1 cm
Coptic, 3rd / 4th century M82.219

This small fragment, which is oval but quite flat, has a small cylindrical opening, perhaps for a stylus or small knife, or the flange of a utensil. It is decorated on both sides with incised figures of a hound chasing another animal. The front half is lost on both sides, but the tail suggests that it was a deer or stag. Rudimentary plants provide a landscape setting for the hunt. A piece of worked bone of similar shape and incised decoration has been identified as Egyptian of the third / fourth century by Wulff [cat. 58], no. 347, pl. XIV, p. 104.

Purchased from Juergens, New York, December 1964 SDC

74 Fragmentary scene of the Entry into Jerusalem

Ivory. 8 × 5 × 0.5 cm
Byzantine, 6th century M82.267

The scene depicted is that of the Entry into Jerusalem. Christ on the donkey would be to the left and the city of Jerusalem to the right. (I am grateful to Dr Gary Vikan for the identification of this scene.) The figure in the foreground may be seen in two other five-part ivories, in the act of laying down something before Christ's path. W.F. Volbach, *Elfenbeinarbeiten der Spätantike und des frühen Mittelalters* (Mainz 1976), nos. 142 (Etschmiadzin) and 145 (Paris). What is being laid down is not a garment as in the New Testament account (Matthew 21:6), but a rolled carpet or a palm mat. This iconography is an innovation of the sixth century and has been discussed in detail by Erich Dinkler, 'Der Einzug in Jerusalem,' *Arbeitsgemeinschaft für Forschung des Landes Nordrhein-Westfallen*, Geisteswissen- schaften Heft 167, Westdeutscher Verlag, Opladen 1970, p. 32, pl. 30.

The size of this panel suggests that it too was part of a larger composition and probably formed a border panel, as in the Etschmiadzin and Paris examples.

Purchased from Royal Athena Gallery, New York, 1963 SDC

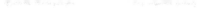

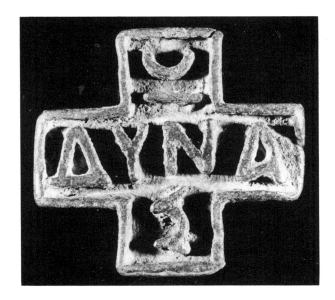

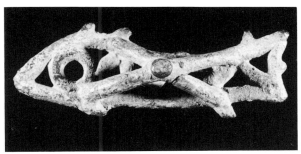

75 Cruciform bread stamp

Bronze.
7.2 × 6.9 × 0.08 cm; ring handle
2.0 cm
Byzantine, 5th century M82.420

Liturgical bread stamps came into
use in the Early Christian world from
the pagan use of stamped bread and
cakes, offered at temples and shrines.
It is not always possible to tell, in
the case of stamps of an early date,
whether the use was pagan or Chris-
tian. This stamp contains the inscrip-
tion ΔYNAMIC (power). In this,
and in catalogue 78, the inscription
has not been reversed. In catalogue
77 none of the letters need to be
reversed. This stamp is similar to four
others illustrated in George Gala-
varis, *Bread and the Liturgy* (London
1970), nos. 21, 23, 85, 86 – all dated
to the fifth century. The dating is
based mainly on the clarity and sim-
plicity of the legend. By similar rea-
soning, the same date could be
applied to catalogue 78, 79. See also
Weitzmann [cat. 34], no. 565.

Purchased from J. Malter, California,
1977 SDC

76 Fish shaped bread stamp (?)

Bronze. 8.5 × 3.0 cm
Byzantine, 5th century (?)

 M82.419

The shape is in the outline of a fish,
with the centre filled with a series
of zigzags and a circle for the eye.
The handle, which is not easily
grasped, is a series of four rods reach-
ing from tail to head and meeting
at a small knob. The use of this piece
as a bread stamp is a tentative sug-
gestion. If so, the iconography cer-
tainly suggests Christian usage.

Purchased from S. Motamed,
Frankfort SDC

77 Triangular bread stamp

Bronze.
5.58 × 5.8 × 9. cm; handle 2.6 cm
Byzantine, 5th century M82.422

The edges of the triangle have been
folded over to form the sides of the
stamp and enclose the letters Θαυμα (miracle). On the upper sur-
face, in each of the three corners,
a tiny cross has been punched.

Purchased from Peter Mol,
Amsterdam, 1969 SDC

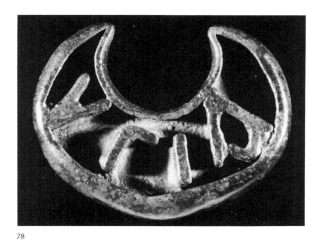

78

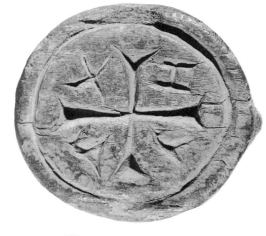

79A

79B

78 Crescent-shaped bread stamp

Bronze. 2.8 × 6 × 2.4 cm
Byzantine, 5th century (?) M82.421

As in catalogue 77, the edges have
been folded over to form the sides of
the crescent, surrounding the letters
ΥΓΙΑ [ὑγιεία] (health). This is a
symbol used by both Christians and
pagans and is frequently misspelled
(see Galavaris [cat. 75], p. 49). It is
not clear whether this stamp was in-
tended for Christian or pagan use.

SDC

79 Round bread stamp

Wood. 7.5 × 2.5 cm
Provenance unknown, suggested date
5th / 6th century M82.307

This stamp has been worked on both
sides and has on the rounded edge
a protrusion which may have been a
small bust, possibly a head of Christ.
On one side is a cross with flaring
ends, set within a circle. Inside the
four spaces formed by the arms are a
series of letters or symbols ⚙. The
top two are legible, Ι X, reversed,
abbreviations for Iesus Christos. The
bottom two are either too worn to
be legible, or were simply decorative.
On the reverse, the edge is marked
by a series of fourteen depressions
which would give a decorative

beaded edge to the bread. In the
centre is an alpha and omega, with
the inscription ΔΟC/ΘΕ. This may be
read as Δάς Θ(ε)ε (Grant O God).
For a stamp which is similar in sim-
plicity of design see Galavaris [cat.
75], p. 57, fig. 26.

Purchased from Royal Athena
Gallery, New York, 1963

SDC

80 Two-sided mould

Limestone. 13.8 × 3 cm
Palestine, 5th century M82.271

The mould is decorated on one side
with a scene of the Old Testament
Trinity, on the other with a pagan
goddess or Mary as Queen of Heaven.
The description of the mould is here
exerpted with permission from the
published account by M. Frazer: 'It is
decorated on one face with a scene
of the Three Angels under the Oak at
Mamre (Genesis 18:1–15) inscribed
ΕΙΛΕWC ΜΟΙ ΟΙ ΑΝΓΕΛΟΙ "May
the angels look propitiously upon
me," and on the other with a slightly
larger tondo of an enthroned goddess
inscribed ΔΕΧΟΜΕ ΧΑΙΡWΝ ΤΗΝ
ΟΥΡΑΝΙΑΝ: "I receive, rejoicing,

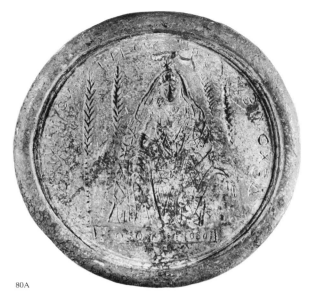

80A

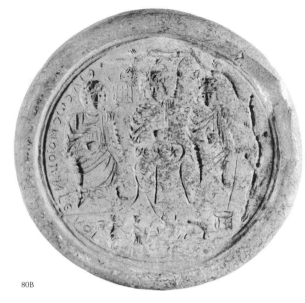

80B

the heavenly one." Incised circles ornament the side of the mould ... The angels, dressed in chiton and chlamys, sit around a three-legged table beneath the arching oak of Mamre. Three star-shaped loaves of bread rest on the table and from one of the oak's stunted branches hangs a rectangular cage. The angels are arrayed like reigning emperors in the manner of Constantine II and his brothers on a silver medallion of Constans in the Cabinet des Medailles in Paris. The central figure, the Lord, is similarly distinguished in importance from his companions by his larger size and gesture of imperial benevolent proclamation. All three figures hold cups or chalices in their left hands; two point their staffs at objects displayed in the exergue; the heifer served to them by Abraham and a bucket-like container representing Abraham's well, according to many sources it was located beneath the oak at Mamre. To the right of the heifer in the exergue are Abraham, facing left, dressed in a short tunic and carrying a basin (?), and Sarah in long dress holding a cantharos, turning to the right. At the very bottom is an enigmatic, E-shaped object.'

On the other side, 'A woman, wearing a calathos from beneath which falls a star-studded veil over a tunic, is seated (chair or bench not visible) resting her feet (hidden be-

neath her mantle) on a pedestal. Heavily jewelled, she raises her left hand to her cheek, and with a protective gesture she shelters (or blesses?) a mound of six balls under her right? Four trees, palms judging from the circular rings of their bark, flank her. As in Palmyrene art, they may indicate her sacred garden, which is her temple and sanctuary. The inscription addresses the woman as Urania, queen of heaven, an epithet given to several goddesses in the late Roman world: Isis, Astarte, Atargatis, and Aphrodite.'

Frazer has suggested that the mound of balls under the woman's right hand may represent the cakes or loaves of bread which were thrown into the well at Mamre (Abraham's well), according to pagan custom, along with other sacrificial offerings, during the harvest festival. Mamre was a site for the worship of several pagan deities until the practice was outlawed. This mould therefore may have served a dual purpose for stamping terracotta or earthenware medallions for both pagan and Christian customers.

In conclusion, Frazer states: '[this mould], no matter how humble its manufacture, presents a combination of scenes of extraordinary interest. It unites on one side a hieratic, symbol-laden Christian illustration of the Three Angels under the Oak at Mamre and on the other a cultic

image of a pagan goddess, Aphrodite Urania and / or Atargatis / Hera of Hierapolis, with whom the Virgin Mary may have been assimilated. Since the impressions made by the two sides differ in diameter, they were used for different objects, or rather most probably as stamps for different cakes of bread, carrying on a tradition of a pre-Constantinian cultic ritual performed at Abraham's well ... It preserves for us, by good fortune, a rare illustration of the syncretism of Christian and pagan imagery that so plagued church leaders of the fifth and sixth centuries in the Christian East.'

PUBLICATION
Frazer, M., 'A Synchretistic Pilgrim's Mould from Mamre (?),' *Gesta*, XVIII, 1, 1979, 137–45

EXHIBITED
'The Age of Spirituality,' Metropolitan Museum of Art, New York, 1970; catalogue: Weitzmann [see cat. 34], no. 522, pp. 583–4

Purchased from Abdul Mufti Suleiman, from Lebanon, who claimed the object was found in a cave outside Jerusalem and was in the family for a number of generations. SDC

81 Spoon

Copper / bronze. 17.5 × 4.2 cm
Byzantine, 4th / 5th century (?)

M82.423

This spoon seems to be a simple domestic object, devoid of any decoration at all. The bowl is quite wide and shallow and the stem very slim, with the result that the balance of the utensil is not good. The end of the stem terminates in a small two-pronged device which serves as a rudimentary fork. The dating offered here is tentative as there are few stylistic criteria in this object on which to base a date. An example of a fork which is dated to the late fourth to early fifth century may be seen in DOC [cat. 26], I, no. 3, p. 2, pl. XVI, with additional bibliography on the use of the fork in the Near East in the classical and late antique period. Alternatively, this may be the Roman type of spoon described as a 'cochlear' – one which has a rounded bowl and a long handle, with a point. It was used for eating shellfish and eggs, the point being used to break the shells. See Gladys R. Davidson, *Corinth*, XII: *The Minor Objects* (American School of Classical Studies at Athens, 1952), no. 1392, p. 189, pl. 85. SDC

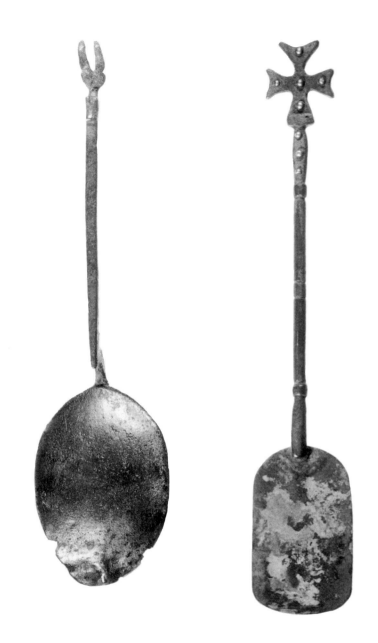

82 Incense shovel

Gilt bronze with gold beads.
16.5 × 3 cm
Byzantine, 5th / 6th century (?)

M82.429

The shovel has a small, spatula-shaped blade for transferring incense to a censer. Some traces of gilding remain on the blade. The stem is almost plain apart from a few ridges. It is topped by a small cross on a flange, decorated by eight tiny gold beads. The simplicity of the design and decoration suggest a date similar to that of catalogue 83.

Purchased from Blumka Gallery, New York SDC

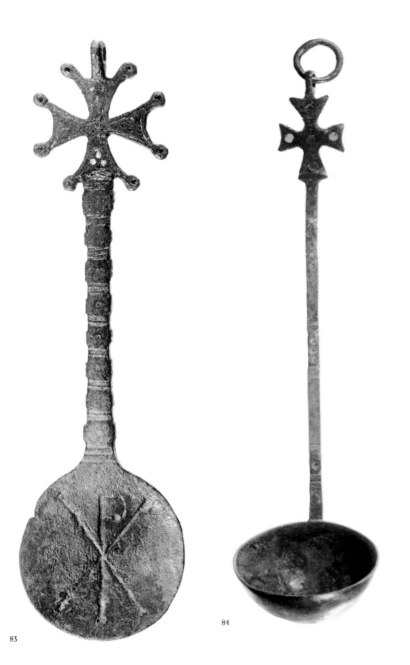

83 Liturgical spoon

Bronze and enamel. 22 × 6 cm
Byzantine, 5th / 6th century (?)
M82.427

The wide shallow bowl of the spoon is decorated with a large Chi Rho, confirming its liturgical use. The stem, which is quite thick, is decorated with a series of striations. It ends in a large flaring armed cross with pierced end discs. The surface has some traces of enamel in turquoise, red, and yellow. Originally there must have been more enamelling and / or gilding to cover the surface. The back is plain. Spoons with similar wide flat bowls have been found at Corinth and are dated to 'the Byzantine period.' Davidson [cat. 81], nos. 1508–10, p. 198, pl. 90.

Purchased from Royal Athena Gallery, New York, May 1964 SDC

84 Liturgical ladle

Silver and enamel. 15 × 4 cm
Byzantine, 5th / 6th century
M82.428

The function of this ladle was the same as that of the preceding liturgical spoon. The stem has some rudimentary decoration of lines and circles. The cross on top has some inlay of red and turquoise dots. There may have been more of this enamelling, or gilding on the stem and bowl. Above the cross is a small ring for suspension. The simplicity of design and decoration suggest a date similar to that of catalogue 83. SDC

85 Unidentified object

Bronze. 23 × 2 cm
Byzantine, 5th / 6th century (?)
M82.424

This object may possibly have had a liturgical use as there is a crudely formed dove on top and below that a perforated disc enclosing a cross. The rest of the stem is quite plain apart from a few zig zags and striations. The stem opens out into a ring and a small disc. A possibly related object of similar appearance, minus the disc, is in the Benaki Museum, Athens. *Collection Statathos*, IV: *Bijoux et petits objects*, G. Sotiriou, no. 51781, p. 109, pl. XX. The date of this object is given as the fourth to sixth century, but its use is unknown.

Purchased from S. Motamed, Frankfort SDC

86 Spoon

Silver. 25 cm
Byzantine, 6th / 7th century

M82.425

The bowl of the spoon is attached to
the handle by means of a disc. The
bowl itself is plain but has a very
elegant palm or feather design on the
back. The disc is engraved with a
monogramme ⳧ (Alexandros), a
common feature of many silver
spoons, and on the handle is the
inscription ΘΕΟΤΟΚΕ ΒΟΗΘΙ
(Mother of God, help [me]). Several
of these spoons exist, with names
of saints, apostles, and evangelists.
For further discussion of the possible
production of the spoons as com-
memorative objects related to pil-
grimage sites see DOC [cat. 26], no. 13,
pl. XVII.

Purchased from S. Motamed,
Frankfort SDC

87 Spoon

Silver. 25 cm
Byzantine, 6th / 7th century

M82.426

This spoon is slightly narrower than
catalogue 86, and certainly much
plainer. It is basically the same shape
and form with the exception of the
pointed end. The back of the bowl
has a slightly raised rib design. It is,
however, sufficiently similar to cata-
logue 86 to be assigned a similar
date and the same comparative ma-
terial applies.

Purchased from M. Komor, New
York SDC

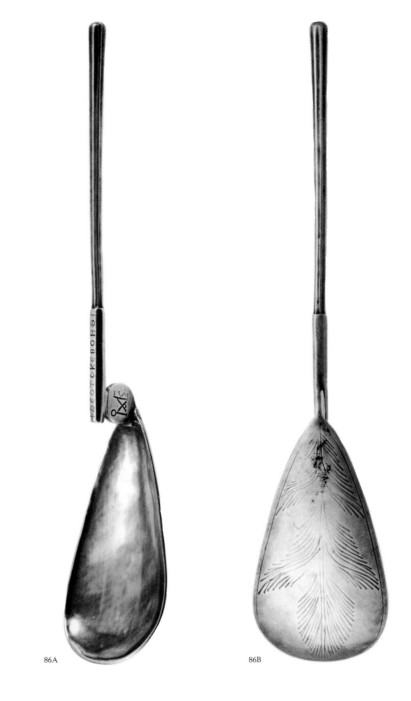

86A 86B

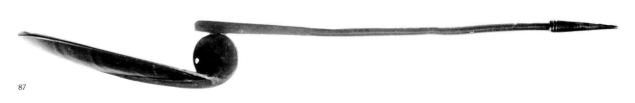

87

88 Triptych

Silver / lead and gold foil.
Central panel 6.5 × 7.5 cm; wings
6.2 × 2.8 cm
Provenance and date unknown

M82.198

The two side wings form a grid, three
rectangles across and five down.
There are a series of raised dots, one
on each intersection and one
between each intersection, suggest-
ing nail heads on a door. The back of
the wing is plain. Presumably these
wings originally fitted into the circles
on the four corners of the central
panel. That panel is an openwork
frame for the gold foil which is set
behind it. In the centre is a bust of a
young man with long curly hair,
probably Christ, modelled on Diony-
sus. The other openings alternate
between circles and semicircles and
contain various symbols. Reading
clockwise from top left these are:

N ½ ʌ⊤ ⫟ ⌖ ◌ ꙅ

The meaning of these symbols is not
apparent except for the cross at the
bottom. The leaves on the two lower
sides may refer to palm branches,
symbols of victory in Christian and
pagan art, and the object in the
top centre may be an ivy leaf, a sym-
bol of good fortune and of Dionysus.
The meaning of the letters is not
known. However, all of these sym-
bols appear as 'beizeichen,' or added
drawings on the Constantinian med-
allions known as contorniates (see
forthcoming study by S. Campbell in
A. and E. Alföldi, *Die Kontorniat
Medaillons*, vol. 3, Deutsches
Archäologisches Institut, Berlin).
The silver frame is decorated with a
series of circular indentations and
mesh-like lines. At the top is a pro-
jection shaped like the handle of
a tabula ansata and decorated with
criss-cross lines.
 This triptych was clearly used as a
devotional aid and the confused
iconography, Dionysiac and Chris-
tian, is typical of the Early Christian
period. A similar kind of confusion

may be seen in a bronze plaque in the
Dumbarton Oaks Collection, DOC
[cat. 26], vol. 1, no. 59, pl. XXXVII,
dated to the second half of the fourth
century, or the limestone bread stamp
(catalogue 80) dated to the fifth
century.

Purchased from S. Motamed,
Frankfort, December 1979 SDC

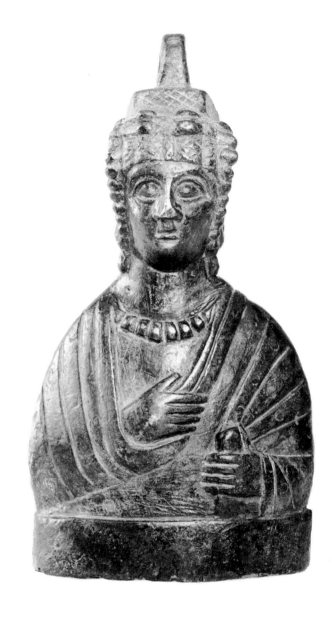

89 Weight (?)

Black stone (basalt?) and silver (?).
9 (minimum 6.7) × 3.5 cm
Provenance and date unknown
 M82.158

The stone is roughly circular with
sloping sides. On the bottom (the
larger, abraded surface) a series of
silver rods have been driven into the
stone to form a crude cruciform
shape:

On the upper surface, the metal
insertions form something closer to a
square:

In the centre is a depression contain-
ing a cross-shaped metal piece. All
the surfaces are pitted and chipped.
This condition, in addition to the
smoothness of the surface elsewhere,
implies a lot of handling and use,
but the precise function of the object
is unknown. SDC

90 Steelyard weight, bust of an empress

Bronze. 20.3 × 10.2 cm
Byzantine, 5th century M82.395a

Steelyard weights may take the form
of emperors, empresses, or deities.
This example has been identified as a
bust of the Empress Licinia Eudoxia,
wife of Valentinian III (425–55).

She is distinguished as an empress by
the jewelled diadem and necklace.
She wears on her head a diadem
which has pendant jewels or pearls
which extend below her ears, and a
necklace of large, graduated stones.
Her mantle, or palla, is decorated
with a series of incised circles,
probably meant to indicate a brocade
fabric. In her left hand she holds a
mappa or small scroll. For the most
recent discussion of this type of
weight see G.K. Sams, 'The Weighing
Implements,' in G. Bass and F.H.
Van Doorninck, *Yassı Ada, 1: A
Seventh Century Byzantine Ship-*
wreck (College Station 1982), p. 224.
For the identification of this bust
as Licinia Eudoxia see below.

PUBLICATIONS
Weitzmann, K., ed. *The Age of Spir-
ituality* (Princeton 1979), no. 327,
p. 344, Katherine Reynolds Brown.
Ostrogorsky, G., *History of the
Byzantine State*, trans. Joan Hussey
(New Brunswick 1969), p. 41

Purchased from J. J. Klejman, New
York, January 1966 SDC

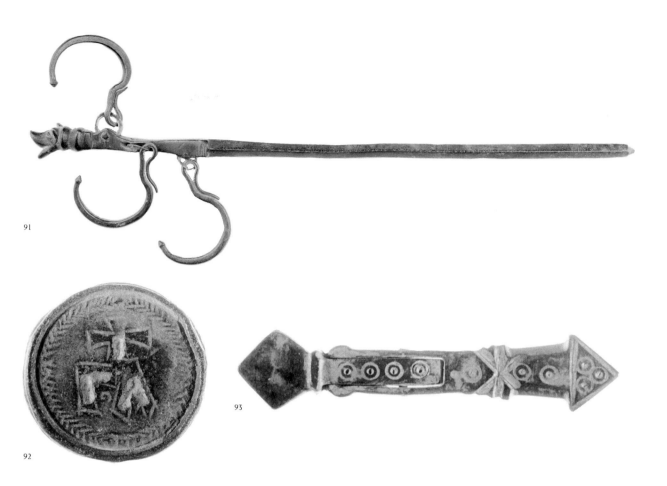

91

92

93

91 Steelyard

Bronze. 57.1 cm
Byzantine, 6th / 7th century
M82.395b

A steelyard is a weighing device
which could have as a counter bal-
ance a bronze weight such as cata-
logue 91. This example has three
hooks and a dog's head terminal. The
markings along the bar indicate the
weight, according to the placement
of the counterbalance. Weighing
devices of this type can still be seen
in operation in many villages in
the Near East and it is difficult to try
to assign a date. For a full discussion
of the use of these scales, and a simi-
lar example dated by context to
the seventh century, see Sams [cat.
90], p. 224ff.

Purchased from Blumka Gallery,
New York SDC

92 Weight

Bronze. 2.5 × 0.8 cm
Byzantine, 7th century M82.240

This weight is but one example from
what must have been a complete
set. The letters Γ and Δ were prob-
ably inlaid with silver, and also the
cross above the letters. Each of the
weights in a set would be labelled
with different letters to indicate their
value. For an extensive account of
a complete set of these weights see
Sams [cat. 90].

Gift from Zumpoulakis, Athens SDC

93 Scale

Bronze. 7 cm × 1 cm
Byzantine, 5th / 6th century
M82.248

Similar scales to this example come
in many sizes and varying materials,
such as bronze, ivory, bone. When
opened, a т-shaped balance is formed.
Obviously, with a predetermined
balance, different sizes of scale were
required for different weights. Since
they were used mainly for checking
coin weights or for gold, the fact that
they were not adjustable was not a
problem. Coin weights were fixed
units and gold too was bought and
sold in fixed units. An undecorated
bronze scale of this type has been
found at Corinth. See Davidson [cat.
81], p. 194, no. 1466, pl. 88.

Purchased from Peter Mol,
Amsterdam, 1969 SDC

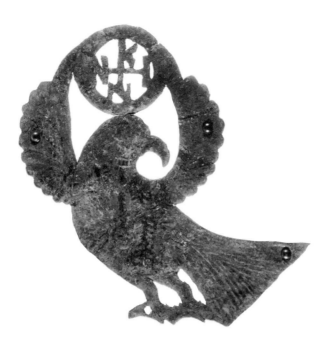

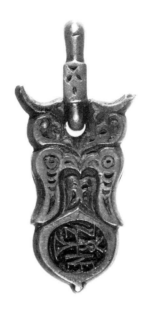

94 Plaque in the form of a dove

Gilded bronze or copper.
10 × 9 cm × 1 mm
Early Byzantine, 4th / 6th century (?)
M82.396

The plaque is in the form of an eagle supporting a monogram in a circle with its wing tips. The bird wears a bulla on a chain around its neck, and the feathers are indicated by additional incised lines. The cruciform monogram has the four letters NINK which could be read as either Latin or Greek. There are holes in the wings, the tip of the tail, and the feet for attachment to some object such as a box. The eagle and the bulla are evidence of Roman influence, and hence a tentative dating in the late antique period has been suggested. A similar bird with a bulla around its neck, this time showing a cross, appears in a textile (Klaus Wessel, *Koptische Kunst*, Recklinghausen 1963, p. 208, pl. XVII). Eagles were a popular decorative motif in the period 550–750, both as imperial imagery and as a reference to Christ (G. Zakos and A. Veglery, *Byzantine Lead Seals*, Basel 1969, fascicule 1, p. 40, and 1972, p. 489). This particular bronze appliqué was likely used in a Christian context. SDC

95 Belt buckle

Silver. 3.5 (minus hook) × 2 cm
Byzantine / Avar, 6th / 7th century
M82.256

This silver buckle has two loops on the back, and possibly a third broken one. On the front the main motif is two confronted birds' heads, probably eagles, with incised areas on the neck for decoration. These incisions seem to have been filled originally with niello. Above the birds are two more bird-like forms, while below there is a monogram in a roundel:

A similar buckle, in gold, may be seen in DOC [cat. 26], II, no. 2c, pl. VII.

Purchased from M. Ward, New York, June 1980 SDC

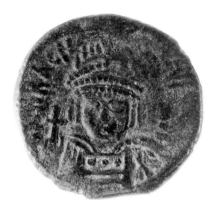
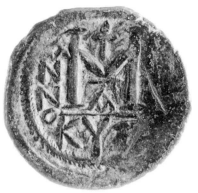

96 Follis of Heraclius
(5 October 610–1 January 614)

Bronze. 2.91 cm; 11.85 gm
Cyzicus, 610–14 M82.258

OBVERSE: A cuirassed bust facing,
with short beard, wearing a helmet
with plume and pendilia, and hold-
ing a cross on a globe with the right
hand, and shield with a horseman
device with the left hand.
REVERSE: A large M between A / N /
N / O and a defaced numeral repre-
senting the regnal year; above is
a cross; below ʌ ; in the exergue,
KYZ.
OVERSTRUCK: the coin was unevenly
struck, particularly in the area of
the regnal date. It was struck at offi-
cina A of the mint of Cyzicus between
610 / 11 and 613 / 14. See Alfred R.
Bellinger and Philip Grierson, eds.,
*Catalogue of the Byzantine Coins in
the Dumbarton Oaks Collection and
the Whittemore Collection*, II
(Washington 1966), part 1, 321–3.

AHE

97 Lamp or curtain hook

Bronze.
Shaft 17 × 2.5 × 2.5 cm; 'finger' 12
cm
Byzantine, 6th century or later
M82.416

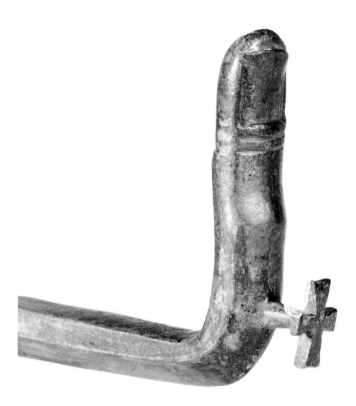

Objects similar to this example may
be seen in the Hagia Sophia in Istan-
bul (see Heinz Kähler and Cyril
Mango, *Hagia Sophia*, New York
1967, ill. 20, 21, 22, 23). They are
hooks, cemented into the walls over
doorways to hold a curtain. The
examples in the Hagia Sophia are
plain, not in the shape of a finger or
thumb, with a cross. Alternatively,
the hook may have been used singly
from which to suspend a lamp. There
does not seem to be any reason for
the finger shape other than pure
whimsy. The solidity of the hook
indicates that it was intended to hold
a substantial amount of weight.

Purchased from S. Motamed,
Frankfort SDC

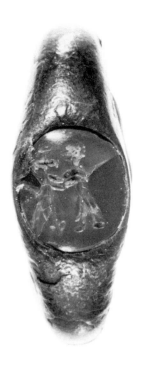

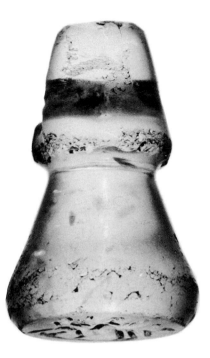

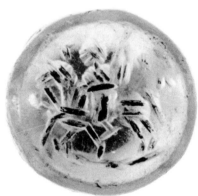

98 Ring with engraved gem

Silver, dark red Carnelian.
Gem 9 × 11 mm
Ring, first half of 1st century;
engraving, 5th century M82.233

The plain silver hoop with a vigour-
ously rounded shoulder and the mod-
erately convex, barely protruding
stone are characteristic elements of
rings of the early imperial period.
The stone is well polished but shows
signs of wear. The engraving is exe-
cuted crudely with only one cutting
wheel and left without its final pol-
ish. It is certainly later than the ring
itself.

The gem shows a human figure in
a long garment, standing upright
and holding a long stemmed cross.
Two strokes at its bottom end indi-
cate a kind of footing. The closest
parallels are a group of Sasanian seals
depicting a bearded man in a shirt-
like tunic holding a long cross. Since
on a few seals the man is called a
priest, they may be meant for the use
of Christian priests. Otherwise the
identification of Christian motifs on
Sasanian seals is quite controversial,
especially if the cross is disconnected
from a bearer and used like an orna-
ment. The public use of the cross

was possible when the mainly Zo-
roastrian Sasanian empire showed
tolerance towards the Christian
faith, for instance when receiving
the Nestorian Christians in the fifth
century.

The reuse of Greco-Roman gems is
well known. It may be observed
already in the early imperial period
when engraved stones were mounted
in more fashionable rings. Less fre-
quent and more difficult to trace are
stones originally not engraved which
have been engraved at a later time.
Decidedly rare is the use of a gem-
set ring of a comparatively early time
in such a late context. Yet the Sas-
anians have adapted quite a number
of earlier Roman gems and added
inscriptions or engravings. The ring
may have been taken from a tomb
and reused as a kind of venerated
antiquity.

For the shape of the ring see F.
Henkel, *Die römischen Fingerringe
der Rheinlande und die benachbarten
Gebiete* (Berlin 1913), p. 26, no. 167,
pl. 9 (Roman forms of the early
imperial period). For gold rings from
Pompeii in Naples see L. Breglia,
*Catalogo delle oreficerie del Museo
Nazionale di Napoli*, Libreria dello
Stato (Roma 1941), E.F. 20, pl. 33,
nos. 11–18. For the motif, in Sasanian
agate and chalcedony, in London
see A.D.J. Bivar, *Stamp Seals, II: The
Sassanian Dynasty* (London 1969),
BE 1 and 2, pl. 5. For the theme in
general see J.A. Lerner, *Christian
Seals of the Sasanian Period*,
Uitgaven 41 (Nederlands Historisch-
Archaeologisch Instituut te Istanbul
1977). For the reuse of stones see
Liselotte Kötzsche-Breitenbruch, 'Zur
Darstellung der Himmelfahrt
Constantins des Grossen,' *Jenseitsvor-
stellungen in Antike und Christen-
tum*, Gedenkschrift für Alfred
Stuiber, Jahrbuch für Antike und
Christentum, Erg.Bd. 9, Aschendorff,
Munster 1982, p. 221ff; R. Göbl, *Der
sasanidische Siegelkanon*, Klinkhardt
und Biermann, Braunschweig 1973,
pl. 36; C.J. Brunner, *Sasanian Stamp
Seals in the Metropolitan Museum
of Art* (New York 1978), p. 59, no. 9.

Purchased from J. Malter, California
AK

99 Stamp seal

Rock crystal. 13 × 2.5 mm
Byzantine, 5th century
M82.234

This stamp seal is in the form of two
superposed conoids, perforated for
suspension. The surface is well pol-
ished but worn and chipped, espe-
cially at the edges. A coarse
engraving has been done with a
broad cutting wheel for the large
parts of the animal and rider. The
details were added with a narrow
wheel. The interior is faintly pol-
ished.

A galloping rider spears a huge
snake underneath his horse through

the snake's open jaws. In the field are three cross-strokes, perhaps meant for stars or letters.

The motif of the triumphant horseman dates back to pagan antiquity. Influenced by the military heroes of its Macedonian population, rider heroes are very common in Thrace and Macedonia itself, as well as Greco-Roman Egypt. The enemy force may be represented as a snake or in human form. The representation of the enemy as snake met Jewish-Christian conceptions. Thus Christian characters as archangels or warlike saints follow the pagan prototype when shown killing evil or demons with their lance.

The Roman emperors adopted the image in a more secular sense. Eusebius (*Vita Const.* 3,3) describes a painting in the imperial palace at Constantinople showing Constantine riding triumphantly over a dragon which represents his adversary Licinius. A gold multiplum of Constantius II describes the emperor riding over a writhing snake as 'Debellator hostium.'

The cult of the rider saints was widespread in the eastern Mediterranean but which one is represented here remains uncertain. The foremost warrior saint, St George, can be identified only by inscription from the sixth century onward.

For comparative examples see C. Bonner, *Studies in Magical Amulets* (Ann Arbor 1950), p. 208ff; Klaus Parlasca, 'Pseudokoptische "Reiterheilige," ' *Studien zur spätantiken und frühchristliche Kunst und Kulture des Orients* (Göttinger Orientforschungen, Reihe II Bd. 6, Harrassowitz, Wiesbaden 1982), p. 19ff; R. Brilliant, 'Scenic Representations,' in Weitzmann [cat. 34], p. 62ff, fig. 12, p. 437ff, no. 395.

Purchased from J. Malter, California
AK

100 Stamp seal

Carnelian, pale orange.
Bezel 1.8 × 1.3 mm; stamp 2 cm
Sasanian (Northern Iran, area of Caspian Sea), 5th century

M82.204

The seal is ellipsoidal, perforated, nearly ring-shaped. It is polished but worn and chipped, with a large break at the rim of the bezel. The engraving is coarse with barely any interior polish. A broad cutting wheel has been used for the rendering of the head and body, a medium wheel for the details. The carved area shows a bearded figure in a long tasselled garment, standing upright and raising one hand in adoration. In front of him is a Greek cross, with distinctly rendered arms.

The seal repeats a current motif of Sasanian glyptics – the Magus worshipping. The fire-altar and other Zoroastrian symbols have been replaced by the cross. When introducing Christian elements into the repertoire of Sasanian gems, the gem

cutters did not create a completely new iconography. Only a few narrative scenes such as the Entry into Jerusalem or the Sacrifice of Abraham were taken over directly. Usually, the artist adapted a known typus by changing devices. The Christian meaning of many gems remains therefore doubtful, in spite of cross-shaped ornaments in the field. Since in the present case the cross replaces the fire-altar as the object of worship, it may be meant as a Christian symbol. See also the ring, catalogue 98.

For comparative examples of similar shape see Bivar [cat. 98], p. 142, shapes I EH 8 and MG 1; Göbl [cat. 98], form III. For similar style see Bivar, I C BE 1, 2 and CG 6; P. Zazoff, *Antike Gemmen in Deutschen Sammlungen*, vol. 4 (Hannover und Hamburg, Steiner, Wiesbaden 1975), no. 94, pl. 273. For similar subject matter see Lerner [cat. 98], with reviews by R. Göbl, *Jahrbuch für Antike und Christentum*, XXII, 1979, 225ff, and M.C. Root, *Journal of Near Eastern Studies*, XL, 1981, 61ff; R. Göbl, 'Christliche Siegel der sasanidischen Zeit: Ein erster Nachtrag,' *Wiener Zeitschrift für der Kunde des Morgenlandes*, LXXI, 1979, 53ff; P. Ginoux, 'Scéaux chrétiens d'époque sasanide,' *Iranica Antiqua*, XVI, 1981, 299ff.

Purchased from S. Motamed, Frankfort
AK

101A

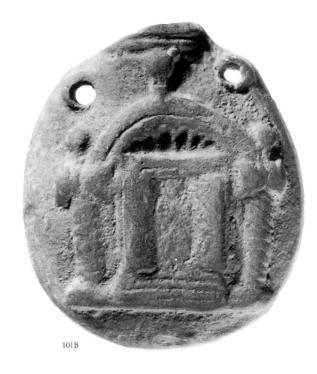

101B

101 Pilgrim flask

Terra cotta. 5.3 × 6 cm
Early Byzantine, Asia Minor, 6th
century M81.208

Small flasks filled with water or oil
which had been blessed by contact
with a relic were brought back by
pilgrims from the Holy Land. The
holes in the top were meant for sus-
pension so that the flask could be
worn about the neck to protect the
wearer. Alternately, the contents
could be used to heal the sick by
drinking the water or rubbing the oil
on the afflicted area. These flasks
were made in vast numbers, in
moulds, and it is therefore possible to
find more than one copy of the same
design, albeit at different stages of
wear on the mould. Thus the design
on this example of a cross on a round
altar, set within an architectural
niche on one side, and a similar niche
with a scallop shell enclosing a door-
way at the top of three steps on the
other side, may also be seen in an

example in Berlin (Wulff [cat. 58],
no. 1348, pls. LXVII, LXVIII). There is
also an unpublished example from
the excavations at Aphrodisias in
Caria. In the latter two examples a
small figure may be seen in the door-
way. In the Toronto example just
the bare outline of the figure may be
seen, an indication of wearing of
the mould. This may be intended to
represent the Holy Sepulchre, with
Christ emerging from the tomb, or it
may be meant to show the Raising
of Lazarus. This type of flask was
produced in Asia Minor in large
numbers in the sixth century but the
locations of these centres of produc-
tion have not been determined. For a
discussion of the Egyptian and Asia
Minor types see Catherine Metzger,
*Les Ampoules à Eulogie du Musée du
Louvre*, Éditions de la Réunions des
Musées Nationaux (Paris 1981), pp.
9–23, and for this particular iconog-
raphy nos. 120, 121, figs. 102, 103.

Purchased in Munich, June 1964 SDC

102 Pilgrim flask

Terra cotta. 4 × 3 cm
Early Byzantine, Asia Minor, 6th
century M82.209

This pilgrim flask is a smaller, slightly
plainer version of the type in cata-
logue 101. The decoration is the same
on both sides, a simple cross enclosed
in a double circle. See Wulff [cat.
58], nos. 1355, 1356, and Metzger [cat.
101], no. 132, fig. 112.

Purchased in Munich, June 1964 SDC

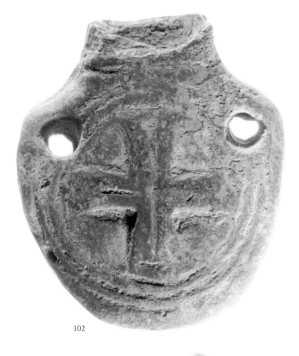

102

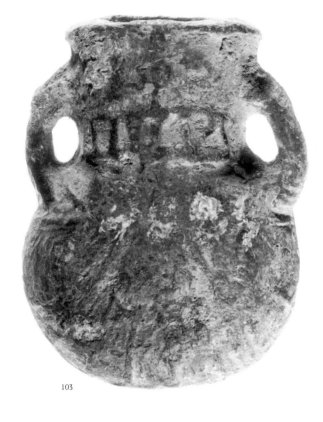

103

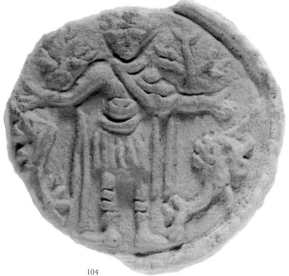

104

104 Pilgrim token or disc

Terra cotta. 7 × 0.8 cm
Early Byzantine / Coptic, Egypt,
5th / 6th century M82.260

In addition to pilgrim flasks and
small tokens, slightly larger discs
were also available as 'souvenirs' of a
pilgrimage. These objects would be
made of the local clay, and would
thereby automatically acquire a cer-
tain sanctity as being an actual part
of the holy site. The iconography
on this example is that of St Menas
again in his military garb and orans
position, flanked by camels. The
two camels are very stylized and
barely recognizable but this is the
standard iconography for the saint.
The back of this piece is completely
plain and there is no sign of any
kind of hole for suspension, nor is
there much evidence of actual wear
from handling. This type, as with
catalogue 105, are types known to be
manufactured in Egypt. Metzger
[cat. 101], p. 90. SDC

103 Pilgrim flask

Lead. 4 × 3 cm
Early Byzantine / Coptic, Egypt (?),
6th century M82.210

Some pilgrim flasks were made in
lead. This example is vase shaped,
since instead of suspension holes, the
spaces are more like actual handles.
The decoration is a simple cross,
the same on both sides. For other
examples in lead see Davidson [cat.

81], nos. 573–5. The manufacture
of lead ampullae at Corinth is at-
tested by the finding of a limestone
mould for such vessels, ibid., p. 75,
no. 576, pl. 53. Such a mould would
only be suitable for metal.

Purchased from Blumka Gallery,
New York, September 1966 SDC

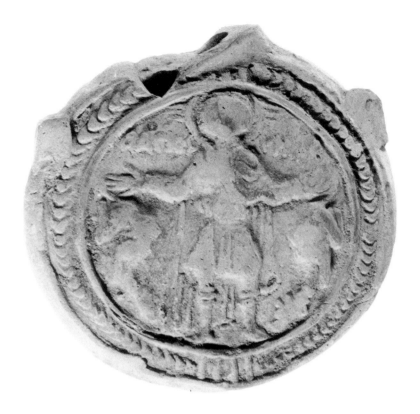

106 Pilgrim's token or 'eulogia' of St Simeon the Younger

Terra cotta. 2.4 cm
Early Byzantine, Syria, circa 600
M82.242

The saint is perched on a column flanked by long candlesticks. He wears a cloak and a hood, possibly surmounted by a cross. On either side of him are flying angels carrying crowns or wreaths and below them, on each side, the inscription ΑΓΙΟC. At the base of the column, on the left, is the baptism of Christ, on the right Mary and the Christ child. An almost identical example, minus the inscriptions, is illustrated in *Romans and Barbarians* [cat. 12], p. 196, no. 227.

For similar examples see also DOC [cat. 26], no. 92, pp. 76–7, pl. 50; W.F. Volbach, 'Zur Ikonographie des Styliten Symeon der Jungeren,' *Tortulae*, Römische Quartalschrift 30, Supplementheft 1966, p. 293ff. For further examples and a discussion of the use of these tokens see G. Vikan, *Byzantine Pilgrimage Art*, Dumbarton Oaks Byzantine Collection Publication no. 5 (Washington, DC 1982).

Purchased from Blumka Gallery, New York SDC

105 Pilgrim flask

Terra cotta. 10.5 × 10 × 3 cm
Early Byzantine / Coptic, Egypt,
480–560 M82.351

This pilgrim flask is somewhat larger than the preceding examples. In this example the neck portion and most of both handles have been broken off. The decoration, almost the same on both sides, consists of a representation of St Menas as the central orans figure, flanked by kneeling camels. The saint wears a short tunic, a long cloak, and boots, a reference to his position as a member of the Roman army. There is a pronounced halo around his head. Apart from the attributes of the camels which identify him as St Menas, there is also a very abraded inscription on either side of his head on one side of the flask only, O ΑΓΙΟC ΜΗΝΑC. This is a popular subject on pilgrim flasks, and probably implies an Alexandrian origin for the flask since the site of the

shrine to St Menas is near Alexandria. The scene on the vessel is then surrounded by two circles enclosing a chevron or stylized leaf motif. This type of flask was manufactured in Egypt, probably associated with the shrine of St Menas. Metzger [cat. 101], p. 16, figs. 10–12, nos. 1–3; Wulff [cat. 58], pl. LXVIII, nos. 1379, 1378.

SDC

107 Cart amulet

Bronze. 2.5 × 7.5 × 3.2 cm
Early Christian / Byzantine, date
unknown M82.387

The object is in the form of a minia-
ture cart with a sliding lid decorated
by a cross. When the ring with the
horse's head hangs down, the lid can
be moved, revealing a small com-
partment, probably intended for a
relic or sacred object. On the sides of
the cart / box are a series of letters,
implying a magical inscription:

� YIHI NΘN XPδ✕

The letters themselves do not form
sensible words, with the exception of
XP – the abbreviation for Christos.
The letters are accentuated with
dots, also part of the magical effect
of the inscription. Presumably this
amulet could be fastened to the har-
ness of a horse or a cart. A strap
passing through the ring would be
held in place by the small horse's
head. This way the horse, cart, or
both, would be protected by the
magical properties of the amulet, by
the inscription, and the contents
of the compartment. SDC

108 Ossuary / Reliquary

Marble, highly polished.
25 × 17 × 15 cm
Early Byzantine, Anatolia, 6th
century M82.462

In the Early Christian period small
marble chests were made in imita-
tion of large marble sarcophagi.
These chests were used for the
cremated bone fragments and ashes
of the deceased. When these bones
and ashes were the remains of saints
and martyrs, the ossuary, or
reliquary, would often be placed
under the altar of a church.

 This example is in the approxi-
mate shape of a house or simple
gabled building. The projections on
the four corners of the sliding lid
represent simple acroteria. The oval
depression in the centre, rather like a
chimney, is the vestige of an earlier
type which had a real opening here

for libations, or for pouring in oil,
which would then come out from a
hole in the bottom, sanctified by
contact with the sacred relics inside
(cf catalogue 101, 102, 103). By the
time of the fifth or sixth centuries, as
in this example, an opening is merely
suggested, but not actually pierced.
A slightly more elaborate version,
dated to the fifth century or later,
may be seen in Semavi Eyıce, 'Reli-
quaires en Forme de Sarcophage en
Anatolie et à Istanbul,' *Istanbul
Arkeoloji Müzeleri Yıllığı*, xv–xvı,
1969, pl. 1, p. 128. Another almost
identical example from Sardis, dated
to the sixth century, now in Munich,
Staatliche Antikensammlung, no.
10371, may be seen in Helmut Busch-
hausen, *Die Spätrömischen Metalls-
crinia und frühchristlichen
Reliquiaire*, 1, Teil Katalog, Österrei-
chische Akademie der Wissenschaf-
ten Kommission für Byzantinistik
Institut für Byzantinistik der Univer-

sität Wien, *Wiener Byzantinistische
Studien*, Band ix, c pl. 19, no. c35,
p. 295.

Purchased from George Zacos, Basel,
Switzerland, 1969 SDC

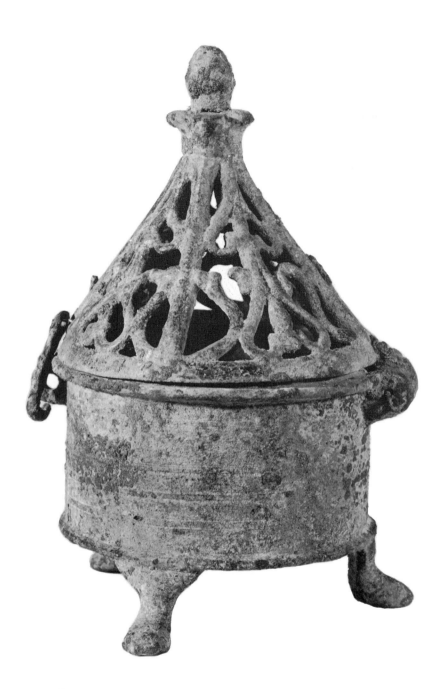

109 Censer

Bronze. 17 × 9 cm
Byzantine, 4th / 5th century

M82.405

The censer is small, free-standing, and supported on three paw-shaped feet. The body is cylindrical and the top, which is conical, is made of an openwork vine scroll motif. The top ends in a pine cone finial and is attached to the base by means of a hinge and large hook. The quality of the bronze, the style of the base, and the general shape of the feet are quite similar to those of catalogue 116 and therefore the same date is proposed. In addition, a censer from Rome which is very close in appearance and style is dated to the fourth / fifth century in the exhibition catalogue, *Frühchristliche Kunst aus Rom*, 3 September–15 November 1962, Villa Hugel, Essen, no. 264.

SDC

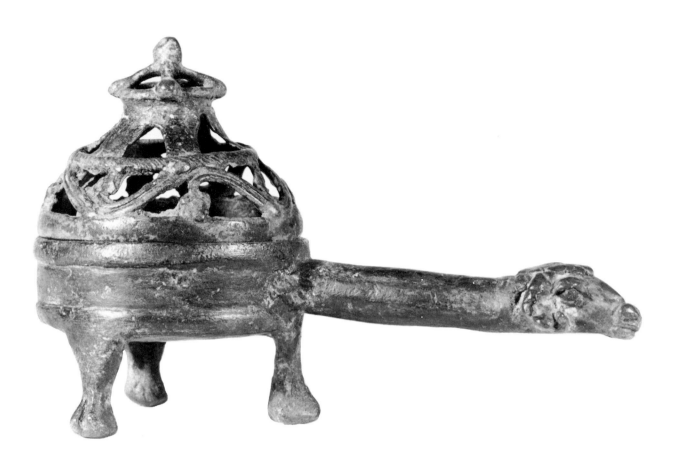

110 Censer

Bronze. 12 × 8 × 10 cm (handle)
Byzantine, 6th century M82.404

This small free-standing censer has a
handle which ends in a ram's head. It
is supported on three paw-shaped
feet and has a plain shallow cylindri-
cal base. The top is a dome shape
with an openwork vine scroll motif.
The openwork continues up to the
knob finial. The style of this open-
work is similar to that in catalogue
111 and the Dumbarton Oaks exam-
ple quoted there, and so a sixth-
century date is proposed here also.

Purchased from Blumka Gallery,
New York, January 1967 SDC

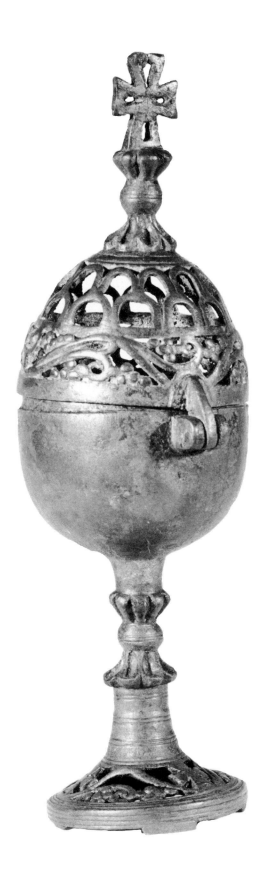

111 Censer

Bronze.
25 × 6.1 (diameter of base) cm
Byzantine, possibly from Syria, 5th /
6th century M82.407

This is a small, free-standing censer,
approximately egg-shaped. The
round base has an openwork vine
scroll motif which is repeated on the
hinged upper half of the body of
the censer. The motif on the stem is
repeated on the top finial which is
then surmounted by an openwork
cross. The top is fastened to the base
by means of a hinge and a small
hook. Because of its small size this
censer was more likely for domestic
than liturgical use.

 A censer in the Dumbarton Oaks
Collection has a similar design, espe-
cially in the part of the stem which
serves as a handle. That censer is
attributed to Syria in the sixth cen-
tury (DOC [cat. 26], no. 46, pl. XXXIII).
A second similar censer is in the
Benaki Museum in Athens, no. 11527
(Laskarina Bouras, 'ΕΠΤΑ
ΘΥΜΙΑΤΗΡΙΑ,' *Archaiologia*, 1,
Nov. 1981, p. 66).

PUBLICATION
Catalogue of the Brummer auction,
Zurich, October 1979, p. 38

Purchased from Brummer auction,
Zurich, October 1979 SDC

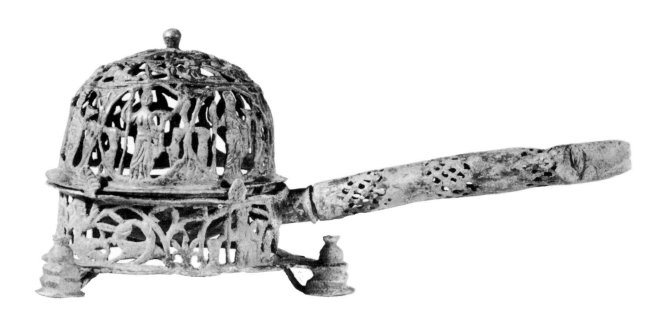

112 Censer

Bronze. 14 × 13 cm; handle 18 cm
Coptic, 8th / 10th century (?) M82.409

This censer is made in openwork
throughout. It is supported on three
feet consisting of three tiers attached
to the base by means of a small pro-
jection. The decoration on the base
and the domed top is a series of fig-
ures clad in long gowns, each holding
a staff in one hand and something
which may be a chalice in the other.
Between the figures there are trees
or scrolls. On the top is a row of
animals which may be felines or rab-
bits. The handle has grid-shaped
perforations and ends in a ram's
head. The design is not very practical
as this metal handle must have be-
come hot when the censer was lit.

Censers which are constructed in
the same openwork technique are
published in Wulff [cat. 58], nos. 980,
981, 982, pp. 205, 206, all from Cairo
but not dated. A third Coptic exam-
ple, also without date, occurs in

Louis Bréhier, *La Sculpture et les arts
mineurs Byzantine* (Paris 1936), pl.
XLIV. Two more which are incom-
plete, but of the same general type,
are dated sixth / eighth and fourth /
seventh centuries, respectively, by J.
Stryzgowski, *Catalogue général des
antiquités egyptiènnes du Musée
du Caire*, Koptische Kunst, Osna-
bruck 1973, Neudruck der Ausgabe
von 1904, nos. 9119, 9121, p. 284,
pl. XXXII. The Toronto example, be-
cause of the degree of stylization
of the design and figures, should be
placed at the later end of this group,
hence a tentative date of eighth to
tenth century is assigned.

Purchased from J.J. Klejman, January
1974 SDC

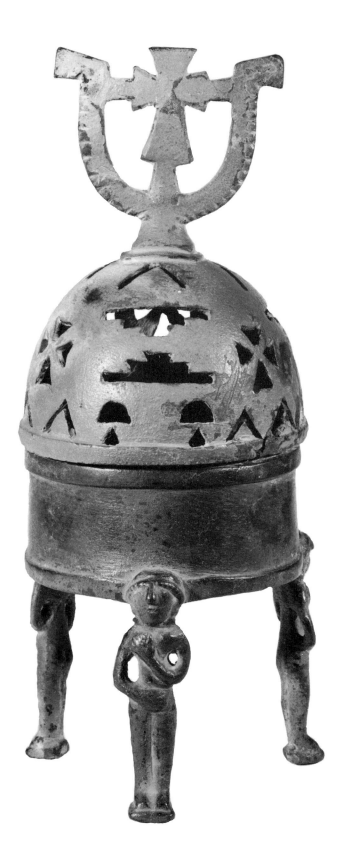

113 Censer

Bronze. 33 × 12 cm
Coptic, date unknown M82.408

This large, free-standing censer is supported on three feet in the form of stylized female figures in the classic pose of Aphrodite, with one hand over the genital area and the other covering the right breast. The legs have minimal shaping, the arms have the 'rubbery' appearance characteristic of much of Coptic art, and the heads have rudimentary eyes, a slit mouth, a large nose which starts at the hair-line, and a simple ridge to indicate the hair. Each of the figures is fastened to the base by the back of the head. The base is a plain shallow cylinder. The top has a series of cut-out motifs – crosses, vs, and stepped designs. A handle is formed by a horseshoe shape enclosing a flaring-armed cross. The combination of mythological figures and Christian symbols occurs elsewhere in Coptic art, especially in architectural sculpture, but I have been unable to locate any good parallels in bronze for the dating of this censer.

Purchased from Blumka Gallery, New York, September 1967 SDC

NOTE: The next four items are objects which are described by some scholars as lamps, by others as censers. Since they could have served either function in antiquity, and probably were used in both ways, their identification shall remain ambivalent here.

114 Suspended lamp / Censer

Bronze.
9 × 14 cm; chains plus finial and ring 40 cm
Byzantine / Coptic, 6th / 7th century
M82.412

The bronze vessel could have contained a glass or terra cotta vessel for the actual oil and wick of the lamp, or it may have been used as a censer. This example is a deep bowl on a short foot, almost a chalice in shape. The bowl itself is absolutely plain with the exception of some light incising on the rolled rim. It was suspended by three chains, here all intact, which terminate in a finial in the shape of three doves. The doves suggest a Christian element but that is not conclusive and the lamp may have been for liturgical or domestic use. A vessel of similar shape and simplicity which comes from Luxor, Egypt, is dated to the sixth / seventh century and the same dating and provenance may be applied to this object also. Wulff [cat. 58], III, 1, no. 972, p. 204.

Purchased from T. Zumpoulakis, Athens, 1961 SDC

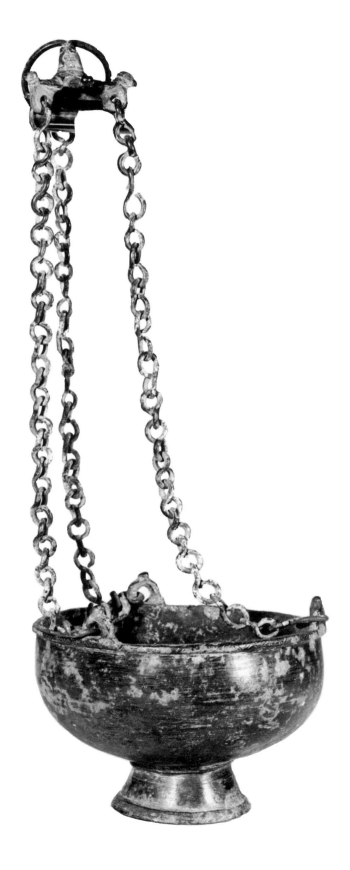

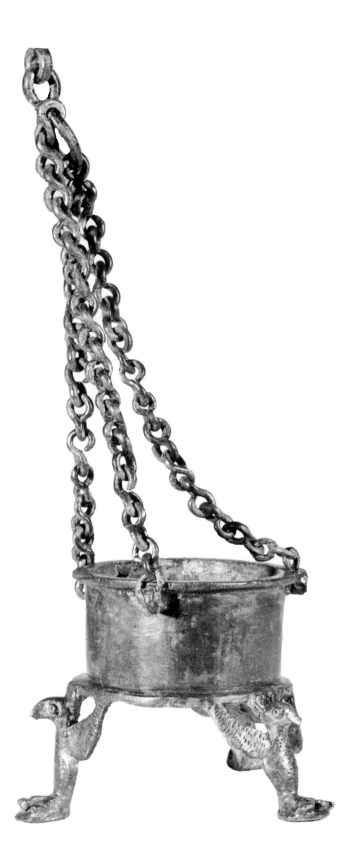

115 Lamp / Censer

Bronze.
9 × 8 cm; chains plus finial 28 cm
Byzantine / Coptic, 5th / 6th century
M82.414

The lamp / censer has a plain short cylindrical body supported on three feet in the shape of rather clumsy eagles. The feet of the birds are more like paws than bird claws. The attachment at the top is by means of the wing tips and ear-like projections from the top of the head of each bird. The feathers are indicated by incised lines on the wings and stippling on the bodies. The chains are made of quite dense s-shaped links. For comparative examples for dating, the discussion for catalogue 116 may be applied here also.

Purchased from S. Motamed,
Frankfort SDC

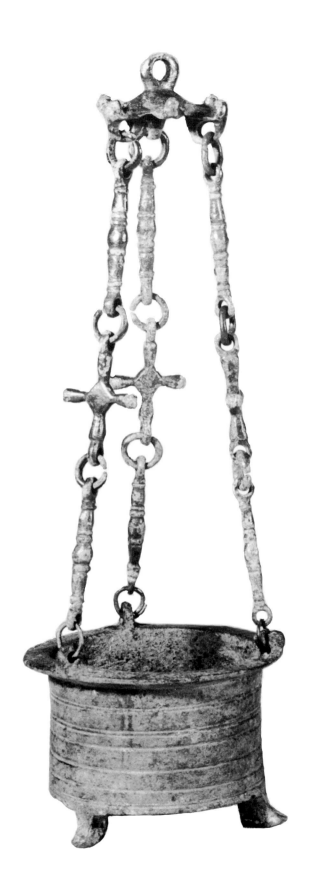

116 Lamp / Censer

Bronze.
7 × 9.2 cm; chains plus finial 22 cm
Byzantine / Coptic, 5th / 6th century
M82.415

This censer is very plain, the only
decoration being a series of horizon-
tal lines. The body is a short cylin-
der, supported on three squat feet. It
is suspended by three short chains
which each have a cross in the
middle. The chains are then attached
to alternate points of a six-point
star-shaped central hanger. Two sim-
ilar censers, supported on three small
feet, have been described by Wulff,
one of which comes from Egypt and
one from Turkey. Since these objects
are portable, the provenance is not
established, but it does seem that the
majority of these pieces have been
found in Egypt. Wulff [cat. 58], nos.
983, 985, p. 206. A censer very similar
to this and catalogue 115 may be
seen in the mosaic panel of
Justinian's group in the sanctuary of
the church of San Vitale in Ravenna.

Purchased from Blumka Gallery,
New York SDC

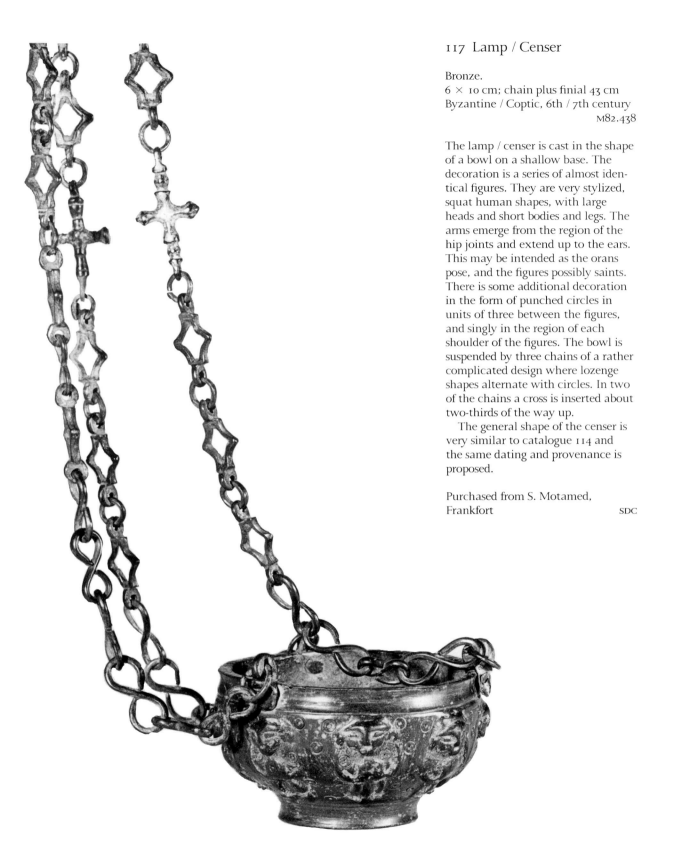

117 Lamp / Censer

Bronze.
6 × 10 cm; chain plus finial 43 cm
Byzantine / Coptic, 6th / 7th century
M82.438

The lamp / censer is cast in the shape
of a bowl on a shallow base. The
decoration is a series of almost iden-
tical figures. They are very stylized,
squat human shapes, with large
heads and short bodies and legs. The
arms emerge from the region of the
hip joints and extend up to the ears.
This may be intended as the orans
pose, and the figures possibly saints.
There is some additional decoration
in the form of punched circles in
units of three between the figures,
and singly in the region of each
shoulder of the figures. The bowl is
suspended by three chains of a rather
complicated design where lozenge
shapes alternate with circles. In two
of the chains a cross is inserted about
two-thirds of the way up.

The general shape of the censer is
very similar to catalogue 114 and
the same dating and provenance is
proposed.

Purchased from S. Motamed,
Frankfort SDC

118 Censer / Lamp

Cast bronze.
10.5 × 12.3 cm; base 5.4 cm
Byzantine, 6th / 7th century

M82.410

Censers or lamps of this type with figured scenes exist in great numbers. A major study of this group, identifying more than ninety-five examples, is currently in preparation by a scholar in Berlin. All have scenes from the Life of Christ but have variations in the choice of scenes and the styles in which they are presented. On this example the scenes are the Annunciation, Visitation, Nativity, a shepherd and some sheep, Baptism of Christ, Crucifixion, Empty Tomb, Noli me tangere. Below the scenes is an encircling band of angels. On the bottom of the tapered base is a scene of Christ enthroned, flanked by palms. On top of the rim are three projections with loops for the suspension chains. For some additional examples of this type see Wulff [cat. 58], nos. 967, 968, 969, 970, 971, pl. XLVII.

Purchased from Blumka Gallery, May 1964 SDC

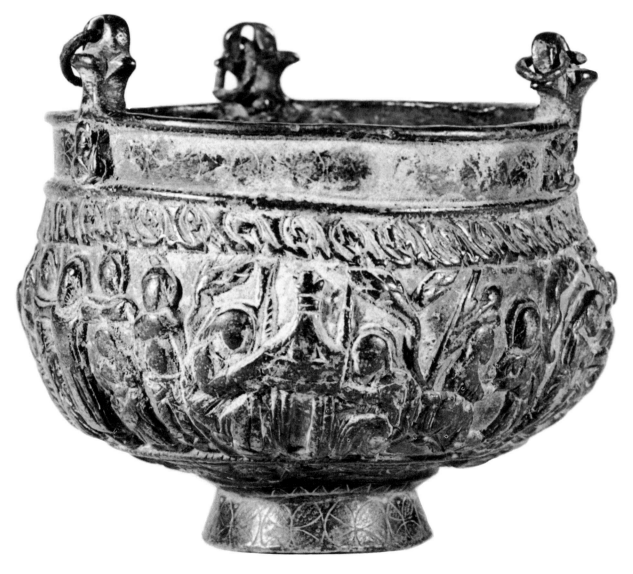

119 Censer / Lamp

Cast bronze. 7 × 9 cm; base 4.8 cm
Byzantine, 6th / 7th century

M82.411

As in catalogue 118, this censer or lamp has scenes from the Life of Christ but in a very different style. Here the figures are much more crowded and take up the full height of the band allotted to them, and the heads of the figures are very large in proportion to the body. The scenes are Annunciation, Visitation, Nativity, Baptism of Christ, Entry into Jerusalem, Crucifixion, and Empty Tomb. On the base is a striped rosette.

Similar examples may be found in the Louvre, Paris, and the Benaki Museum, Athens. See also O.M. Dalton, *Byzantine Art and Archaeology* (New York 1961), pp. 620–2, figs. 393, 394; or an example at the Museum of Fine Art, Tbilisi, Georgia, in Shalva Amiranashvili, *Georgian Metalwork from Antiquity to the 18th Century* (London 1971), fig. 21.

SDC

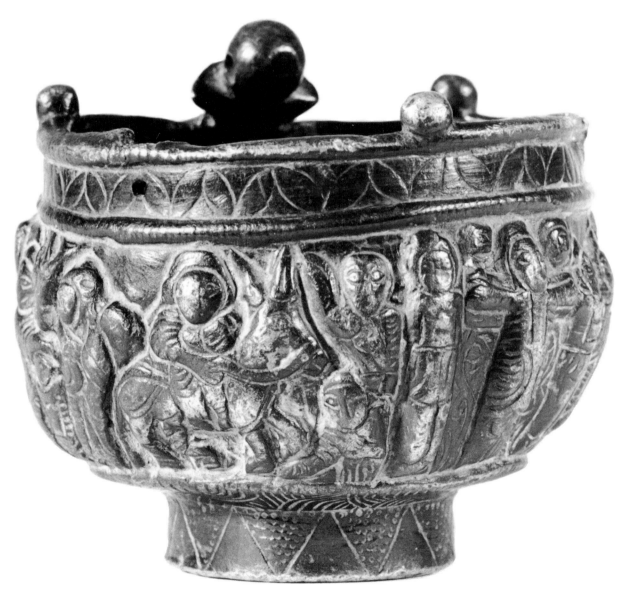

120 Chancel screen

Marble. 78 × 91 × 13 cm
Byzantine, 5th / 6th century

M82.327

In the early Byzantine period large slabs of carved stone were erected in churches as a division between the chancel and the nave. For large, wide churches more than one slab would be needed, while in small churches or chapels one would be enough. The decoration on these screens could be either ornamental or symbolic and the slab might be carved on one or two sides. This slab is carved on one side only. The lower two-thirds is filled with two panels of meander pattern, both deeply cut. The upper third has a cross in a wreath flanked by vine leaves and grapes in one panel; the other has a cross in a scallop shell flanked by doves. The discolouration on the stone has been caused by prolonged contact with red earth.

Purchased from J.J. Klejman,
September 1973 SDC

121 Segment from a chancel screen

Marble. 47 × 40 × 8 cm
Byzantine, 5th / 6th century

M82.288

This piece originally formed part of a chancel screen as in catalogue 120. The present shape is entirely modern, as this shape does not occur in any kind of Byzantine object. The fragment remaining was the central section. The basic shape of a lozenge in which the eagle stood can just be seen, as can a matching frame of lozenge shape below. The eagle carried something in its claws, a common scene being a rabbit or hare, but that part of the screen has been destroyed. On the reverse side is a large simple cross which probably would have faced the sanctuary or chancel, while the eagle faced the nave.

Purchased from George Zacos, Switzerland, 1969 SDC

122 Head of a young boy

Carved limestone with polychrome.
17 × 13 cm
Coptic, late 3rd century M82.153

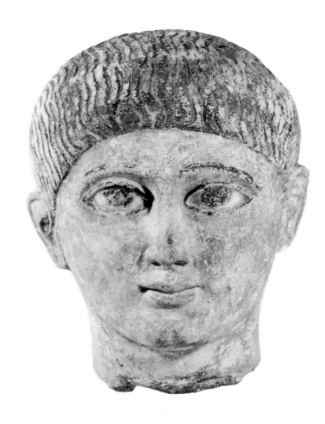

The young boy's face is dominated by large gazing eyes, with bulging almond-shaped lids slanting slightly towards the nose, which is thin and straight. The mouth has sensuous lines, the chin is well defined, and both ears are clearly outlined. The short wavy hair is incised in a zigzag pattern and arranged in a low fringe across the forehead.

This head shares many stylistic attributes with a group of painted limestone stelae belonging to Sheikh Abada / Antinoe (Middle Egypt) and dating from the end of the third and early fourth centuries AD. These figures, set in niches, represent young boys who are thought to be members of a cult that worshipped the child deity Horus and his mother Isis (H.W. Müller, 'Grabstelen eines Isis-mysten aus Antinoe,' *Pantheon*, XVIII, 1960, 266–71; K. Wessel, *Coptic Art*, New York 1965). The common characteristics can be seen in the convention of a round-shaped face, spherical eyes with large staring pupils, a faint smile, and the hair style. (A similar figure is on exhibition at the Royal Ontario Museum, no. 968.240.1.) Furthermore, this facial type is closely connected with the Antinoe carved mummy masks dating from the second and third centuries. The Malcove head itself seems to relate to the figural stelae from the later Roman period in Egypt, which display individualized realistic features. Nevertheless, the Malcove piece, with its stylised characteristics, marks a change from this type of naturalism. A similar change can be traced in the development of mummy masks, from real life portraits to mere sketches with not much individuality (A. Badawy, *Coptic Art and Archaeology*, Cambridge, Mass. 1978). This difference may be an indication of a provincial origin which could, in the case of the Malcove head, characterize Sheikh Abada.

The stylistic connections between the Isis cult figures and the Malcove head strongly suggest a contemporary dating. Although later examples from Sheikh Abada (mid-fourth to mid-fifth century) share with the Isis cult reliefs and the Malcove piece certain common elements such as the large eyes, the grooved hair style, and the large heads, they certainly mark a change in style from the Malcove head. In the Sheikh Abada examples the pupils were incised and holes drilled in place of the iris which was then filled with coloured inlay. Although eye inlay is an old method, previously used on mummy masks, it seems unprecedented on sculpture of that period. Other differences are reflected in the treatment of the hair in rows of curls and the complete disappearance of the ears (E. Kitzinger, 'Notes on Early Coptic Sculpture,' *Archaeologia*, LXXXVII, 1938, 184ff; L. Torok, 'On the Chronology of the Ahnas Sculpture,' *Acta Archaeologica, Academiae Scientiorum Hungaricae*, XXII, 1970, 163ff).

The Malcove head probably belonged to a frontal figure, presumably as a sepulchral stele. Generally, figural stelae in the Graeco-Roman tradition in Egypt were placed within an architectural niche and were characterized by a strict frontality in the pose (Wessel, p. 133, figs. 10–12). It would be difficult to determine whether the Malcove head was ever placed in a niche since there is no physical evidence on the back of the head or the neck to suggest that it may have been attached to a structure. It is definitely not an Isis cult figure, since all known examples are reliefs carved into niches.

The Malcove head seems to be a stylistic antecedent to the Isis cult figures. It is of better workmanship, and its details are treated more sensitively than those of the Isis devotées. A decline from the more realistic Roman stelae may be detected in the emphasis on the size of its eyes and the decorative treatment of its hair. The face lacks any individuality and could very well be a provincial

representation of a more sophisti-cated prototype. I would like to sug-gest that the Malcove head was part of an early stage of development in Sheikh Abada, away from realistic portraiture of the second and third centuries, despite a stylistic link with old artistic traditions of the Roman stelae, which pointed towards a more iconic mode of representation where the contact with the sculpture was through the gazing eyes.

Purchased from André Emmerich Gallery, New York NS

123 Coptic relief sculpture

Fine grained limestone.
24 × 37.4 × 4 cm
Probably from Antinoopolis (El-Sheikh 'Ibada), late 4th, early 5th century M82.320

The relief figure is carved from fine-grained, white limestone with a smoothed background surface. To the right of its centre the lower front of the stone is chipped, otherwise the surfaces and their adhering pigmen-tation are in a remarkable state of preservation.

The figure carved in high relief is that of a youthful male orant, clad in a red short-sleeved tunica. He occupies almost the entire space of the surface. He holds two objects. In his left hand is a benediction cross whose elongated pale is similar to that of the *crux hasta* (W. Crum, 'Coptic Monuments,' *Catalogue gén-érale des antiquités egyptiennes du Musée du Caire*, IV, 1902, nos. 8591, 8601; A. Hermann, 'Die Beter-Stelen

von Terenuthis in Ägypten,' *Jahr-buch für Antike und Christentum*, VI, 1963, pls. 20–1). In his right hand is a round greenish-blue pomegrante balanced on the tips of his extended fingers. The head itself approaches a perfect oval in shape and its domi-nant feature is the pair of wide ab-stract eyes, with exaggerated black outlines about their outer edges. This stylized definition is repeated about the edges of the pupils. On either side of the raised pupils are created areas of dark shadow that in effect detach the pupils from their solid back-ground. Enhancing this abstraction of eye structure, the centres of the pupils are similarly drilled to such a depth that their surface is defined by absolute shadow. By these means the eyes possess almost mesmeric intensity, doubtless an accurate evocation of the spiritual zeal of the Coptic *monachos*.

Stylistic qualities place this relief firmly in the tradition of the provin-cial Graeco-Egyptian sculpture that is well known in the *poleis* of Middle

Egypt (A. Westholm, 'Stylistic Features of Coptic Figure Sculpture,' *Acta Archaeologica*, LXXXVII, 1937, 233–6; Marangou [cat. 68], p. 78). Approaching normal skin tone, ochre pigment used on this figure lends a realistic aspect to the anomalies in its anatomy. The drapery folds do not reveal body form, rather they cloak the body in broad, symmetrical bands of a doughy consistency. This schematic fold system is typical of the Graeco-Egyptian 'Decorative Style' of the later third, fourth, and early fifth centuries (Kitzinger [cat. 122], 183–4; K. Parlasca, 'Der Übergang von der spätrömischen zur frühkoptischen Kunst im Lichte der Grabreliefs von Oxyrhynchos,' *Enchoria*, VIII, 1978, 115ff).

By the time of the carving of this relief, the orans motif was already a pan-Christian phenomenon. Here it is modified by the presence of hand-held attributes. The pomegranate, although frequently used as a symbol of immortality and fruitfulness, may here be an allusion to the literary topos of the marvellous fruit brought back from paradise by holy men (anchorites) who, through their faith, were translated physically to paradise and from which they returned with pieces of fruit of exceptional size and properties (N. Russell, *Lives of the Desert Fathers*, Oxford 1981, pp. 37, 108–9; *Historia Monachorum in Aegypto*, XXI.7).

On the ground of stylistic affinity, a date for this stele can be set within the period of the later fourth to the early fifth century. A workshop in the vicinity of the Hadrianic foundation of Antinoopolis is very likely.

Purchased from André Emmerich Gallery, New York, catalogue no. 96, September 1963 RM

124 Figurine of a seated goddess

Polychromed terra cotta.
22 × 7.5 × 10 cm
Provenance unknown, probably from the area of the Thebaid, Upper Egypt, late 4th / mid-5th century M82.338

The terra cotta figurine is seated on a four-legged stool, the back two legs of which are missing. The front of the figurine was covered in a wash of white paint, the back with a yellowish wash. Black paint was used to outline the decoration of the dress, a network of lines that contain medallions, found in pairs on the abdomen and the fronts and sides of the knees. Black paint was used to define the outlines of the eyes, eye-brows, and elaborate coiffure. Her footwear and the hem of her dress are black as is also the network of dots defining her necklace. A reddish wash was applied on the bracelets and what appears to be a cloth stretched between her hands, and also on the base of the figurine under the chair. There is evidence of a recent repair along a wide crack at the level of her neck.

The figure leans forward slightly, her hands on her knees, grasping a yellow cloth that is stretched between her clenched fists. From beneath her dress her painted shoes protrude. Her symmetrical pose can be characterized as hieratic and in the ancient Egyptian tradition of the seated figure. Her white face presents a somewhat amiable expression, an impression carried by her retroussé nose and 'bee-stung' lips. The rest of her facial features were modelled, the orbits of her painted eyes being indicated by two gently impressed hollows.

Most notable of the modelled forms is that of the elaborate headgear — a sort of stiffly formed (linen?) cowl that rests on the back of her skull. Another feature of this figure that seems to be an Egyptian usage is the pronounced emphasis of the bosom, where the bodice of the dress is drawn in tightly by means of drawstrings. This emphasis is accentuated by a massive pectoral medallion, of the type popular in the Late Antique period. Her jewellery is completed by her raised relief bracelets.

A clue to the identity of this figure is found in the cloth that is stretched across her lap. This attribute is recognized as the 'cloth of natron' that is carried by the goddesses Isis and Nephthys. They are the official mourners of the deceased, and in the funerary scenes of the Graeco-Roman period they form part of the entourage of Anubis, for whom they carry beakers of natron and mummy cloths impregnated with this essence (J. Osing et al., *Denkmaler der Oase Dachla*, Mainz 1982, pl. 22. The wall paintings of this tomb date to about the mid-second century. For a discus-

sion of their role in Egyptian funerary belief and practice see J. Vandier, *La Réligion egyptienne*, Paris 1949, pp. 112–3).

Stylistic considerations must be used to determine both the date and provenance of the Malcove goddess. Comparable specimens of terra cotta figurines have been found in Upper Egyptian excavations. One example from Kom Ishkau (ancient Aphroditopolis) was found in a house deposit that was dated by the associated papyri and ostraca to about 600 AD (J.E. Quibell, 'Kom Ishkau,' *Annales: Service des Antiquités de l'Egypte*, III, 1903, 87–8, pl. II). It is, however, more geometric and abstract in form, suggesting that the Malcove figurine is stylistically earlier by about a century or so. The probable source of this figurine would be the Thebaid region.

At the base of the goddess's back there are legible traces of what appear to be letters. They are written in black (ink?) and they appear to read cꟻⲧⱱ. The meaning, if any, remains obscure.

Purchased from Park-Bernet, New York, 30 April 1964 RM

125 Architectural fragment, half-length figure emerging from foliage

Limestone relief. 46 × 23 × 8 cm
Coptic, 4th century M82.316

The panel probably formed part of a frieze of a series of similar panels. This segment is framed across the top and bottom by rectangular strips, and partially framed on the two sides by the foliage. The relief is somewhat concave, as the foliage at the two top corners projects further than the rest of the panel. In the centre a little more than half a nude male figure emerges from two spiky leaves. He has short curly hair and holds an object (basket?) in his left hand and an unidentifiable object, or maybe a loop of the vine scroll, in his right hand. The configuration of the vine scroll is symmetrical on either side of the figure. This figure seems to be part of a vintaging or harvesting scene, although no grapes are visible. The sculpture is very stylized, with details of the anatomy of the figure indicated by simple grooves in the stone. The hair is a series of flat lumps, and the facial features have minimal distinction with the exception of the eyes which are deeply cut. There is practically no modelling in the foliage, where

shaping is limited to a simple outline and an internal groove. The head of the figure and the object in his right hand extend into the upper frame.

A similar relief fragment may be seen in Recklinghausen, Ikonenmuseum 525 (Emma Brunner-Traut, Helmut Brunner, and Johanna Zick-Nissen, *Osiris, Kreuz und Halbmond, Die drei Religiones Ägyptens*, Mainz 1984, no. 142). There the nude figure is framed by symmetrical vine scrolls, the head extends into the upper frame, and the carving style is very similar, with deep shadows but flat on the surface, and details of anatomy and foliage indicated by grooves.

PUBLICATION
Parke-Bernet sale catalogue, 14–15 February 1963, no. 191

Purchased from Royal Athena Gallery and C. Tauss, New York, December 1963 SDC

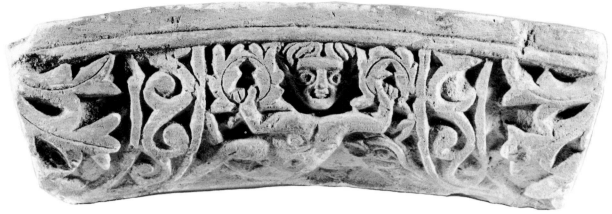

126 Architectural relief, segment of an arch, figure holding two wreaths

White limestone. 39 × 14.5 × 11 cm
Coptic, 4th / 5th century M82.322

The fragment is part of a gently curving arch. A central figure reclines between two bands of scroll-like foliage holding a circular object (wreath?) in each hand. The whole piece is slightly rounded, so this piece probably was placed immediately above the door or window opening or niche which it decorated. As in catalogue 125 the modelling of the figure and foliage is very cursory. The details of anatomy are indicated by simple grooves and there is no serious attempt at realism in the vegetation. The object below the central figure's left elbow is enigmatic. It might be another bit of foliage, but it might also be intended to represent some sort of animal or even a fish. The subject remains unidentified. However, for an example of a winged putto in foliage with a fish, from Oxyrhynchus, now in the Seattle Art Museum, see John Beckwith, *Coptic Sculpture 300–1300* (London 1963), pl. 58. The same comparative example for dating may be used here as in catalogue 125.

Purchased from Royal Athena Gallery and C. Tauss, New York, December 1963 SDC

127 Fragment of architectural sculpture, deer in foliage

White limestone with traces of paint.
22 × 20 × 4 cm
Coptic, 4th / 5th century M82.313

The fragment has one relatively straight edge, while the remaining edges are severely chipped and broken. A horned animal (deer?) may be seen in a scroll of foliage. It is moving from right to left, but looking back over its shoulder. Above the foliage, top left, may be seen the beginning of a rectangular strip and above that, the lower part of another vine scroll or a leaf.

In the main part of the panel there are traces of black paint on the edges of the leaves and outlining the deer. These lines appear to be part of the original artist's sketch rather than additions to a completed piece, since the veining on some of the leaves is only marked in paint and alone would not have been visible from any distance. Also, some of the veining is outlined in paint, as if the line had been cut through, since the line on either side of the vein is very thin. These lines suggest that the work is unfinished. The piece would have formed part of a continuous architectural frieze.

Similar work may be seen in the catalogue *Frühchristliche und Koptische Kunst*, Ausstellung in der Akademie der Bildenden Künste, Wien, 11 Marz bis 3 Mai 1964, pl. 12, and in John D. Cooney, *Late Egyp-*

tian and Coptic Art (Brooklyn Museum 1943), pl. 14, 'Limestone Relief with Animals in Acanthus Scrolls.'

 SDC

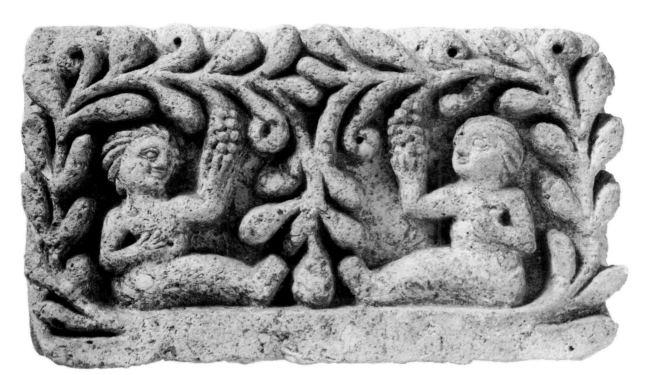

128 Architectural frieze fragment, two figures seated under a grape arbour

Greyish limestone.
36.4 × 21.5 × 8.4 cm
Coptic, 4th / 5th century M82.321

Two small nude figures sit under an encircling grape vine. Each one reaches up to a bunch of grapes. The figures are sketchily carved, and there is no separation of the legs or indication of toes. The hand seems to merge into the bunch of grapes rather than grasp it. There is a slight difference in the hairstyles of the two figures so that we might interpret them as one male, one female, but that is merely suggested. There is a curious roundness to the figures and the foliage rather than the more common 'wedge-like' linear style of Coptic sculpture. The scene of figures picking grapes is ubiquitous in the ancient and late antique period and it occurs in a variety of media – painting, sculpture, mosaic. So the

panel merely represents a vintaging scene rather than any identifiable figures. A similar compositional arrangement may be seen in a fragment in Recklinghausen, Ikonenmuseum (K. Wessel, *Koptische Kunst*, Recklinghausen 1963, pl. 44). There two 'rounded' mermaids are placed in a similar kind of M-shaped foliage and each one reaches up to a gourd, in the same kind of gesture. The hair is cut in much the same way, in a series of horizontal ridges to indicate waves or locks of hair.

EXHIBITIONS
'Coptic Stone Sculpture,' André Emmerich Gallery, New York, December 1962, reproduced in catalogue. 'The Hebrew Bible in Christian, Jewish and Muslim Art,' Jewish Museum, New York, February-March 1963, no. 96. Here the relief was dated to the fifth to seventh century and identified as representing the theme of Jonah on the shore.

Purchased from André Emmerich Gallery, New York, September 1963
SDC

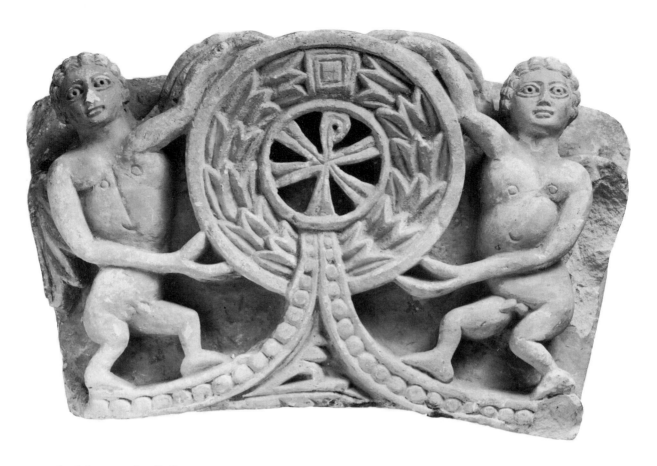

129 Architectural relief fragment, two angels / putti supporting a wreath with a reversed Chi Rho

White limestone. 54 × 36 × 18.7 cm
Coptic, 5th century (?) M82.505

Two nude, winged male figures are shown supporting a wreath enclosing a reversed Chi Rho. At the top of the wreath is a rectangle, imitating a gem stone. Hanging from the wreath are two ribbons, decorated with the 'pearl' motif. The two figures have distorted limbs, the arms being too long and the legs too short and thin, with an overall general 'rubbery' appearance. The eyes are large and deeply drilled, and the wing which is best preserved is more leaf-like than feathered. The piece is slightly curved on the bottom and may have formed part of a doorway. A similar composition may be seen in the Cairo Museum, two putti supporting a ribboned wreath enclosing a cross

(Beckwith [cat. 126], pl. 75). The composition is almost identical, as is the pose of the putti, with frontal head and torso, profile legs, the arm on top of the wreath greatly elongated, and the hand underneath barely touching the wreath. Otherwise this Cairo example is not quite as distorted. Another example, where the facial features and hair style are close to the Malcove fragment, is dated to the early fifth century from Sheikh Abadah (Arne Effenberger, *Koptische Kunst*, Ägypten in spätantiker, byzantinischer und frühislamischer Zeit, Wien 1975, pl. 14).

Purchased from the Royal Athena Gallery, New York, 1970 SDC

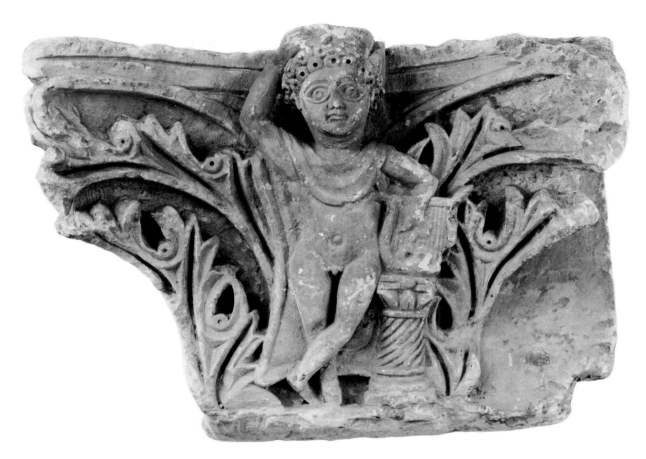

130 Part of column capital, Apollo with his lyre

White limestone. 51.5 × 38 × 21 cm
Coptic, 5th / 6th century M82.315

On this capital, Apollo leans on his lyre which stands on a much truncated spirally fluted column. His right arm reaches up to the top of his head. He is dressed in only a cloak which covers his shoulders and upper torso. He may be wearing some sort of crown or wreath on his head. His hair is delineated by a series of deeply drilled ovals and the eyes are enlarged and surrounded by deep cuttings. His pose, with one foot crossed over the other, is very relaxed and casual. Behind Apollo and the column are large leaves with deeply cut veins, giving strong contrasts of light and shade. The piece is concave in that the two outer edges project strongly forward.

A similar example may be seen in Effenberger [cat. 129], pl. 28 – a Dionysus in identical pose, leaning on an identical spirally fluted column. He too has a cloak behind him and is set in foliage. In the Dionysus the ridges around the eyes are the same, but he does not have the pupils drilled, as does the Apollo. However, the drilling in the eyes of the Apollo is very shallow. Both pieces reflect the continuity of the classical tradition in subject matter, albeit much altered in style.

Purchased from Royal Athena Gallery and C. Tauss, New York, December 1963 SDC

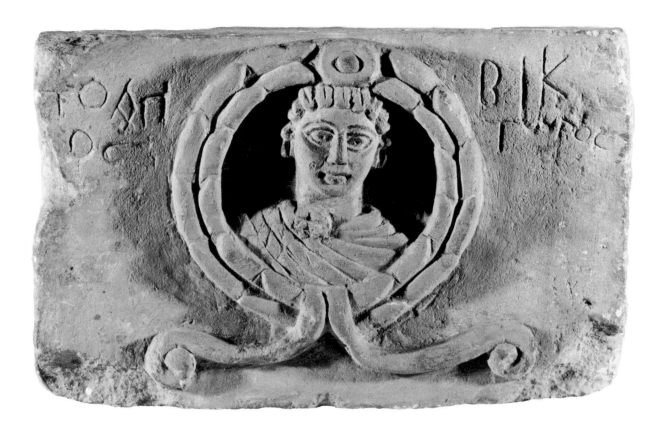

131 Relief fragment with St Victor

White limestone. 32 × 21 × 8 cm
Coptic, second half 5th century
M82.317

This fragment is hard to identify as to its function. Perhaps it came from an architectural frieze, or possibly formed part of a grave stele. A small bust appears, surrounded by a simplified wreath with ribbons. The figure has short wavy hair, which is indicated by lines. Many folds of drapery, as in a cloak, are gathered around the shoulders. There is black paint on the eyebrows, outlining the eyes, over the irises, below the eyes, and down the nose. There is a reddish ochre paint on the mouth and on the ears. This paint resembles earrings, but since the inscription identifies the figure as male, it must be highlighting for the ears. The presence of the paint suggests that the panel may have been placed in an elevated position and needed highlighting for

visibility from ground level.

The inscription says that this is O ΑΓΙΟC ΒΙΚΤΟΡΟC (St Victor). In the list of saints called Victor, the most appropriate one seems to be a Victor who lived in Egypt, was martyred during the Antonine persecution of the Christians, and is credited with many miracles (*Bibliotheca Hagiographica Latina, Antiquae et Mediae Aetatis*, Socii Bollandiani, Brussels 1900–1, vol. II, p. 1238). A similar bust in a wreath may be seen in the exhibition catalogue *L'Arte copte*, Petit Palais, Paris, 17 June–15 September 1964, no. 50. This piece is probably later, and is more deeply cut around the eyes, but the cutting of the drapery and the area around the mouth, the very simplified hair and wreath, and the drilled nostrils show stylistic similarities.

PUBLICATIONS
Cooney, J.D., *Late Egyptian and Coptic Art* (Brooklyn Museum, Brooklyn Institute of Arts and Sciences, 1943), p. 51

André Emmerich Gallery, sale catalogue December 1962, no. CC–39

Purchased from André Emmerich Gallery, New York, December 1962

SDC

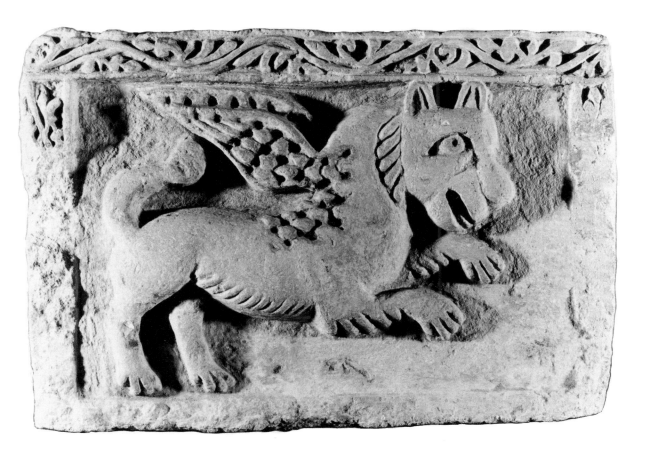

132 Architectural fragment, winged lion (St Mark?)

White limestone. 40 × 28 × 9 cm
Coptic, date unknown M82.318

The relief in this panel is quite high. It shows a winged lion, possibly meant to represent the evangelist St Mark, and the panel is surrounded on four sides by a vine scroll, although only the top part of the frame is well preserved. This panel probably formed part of a frieze which, if this is St Mark, could have contained the other evangelists as well. The lion has his front legs raised, as if leaping, but the stance of the back legs does not match this pose. His facial expression is quite benign, almost smiling. The mane of the lion and the feathers of the wings are indicated by deeply drilled holes, and the fur around the neck, belly, and legs is merely a series of grooves. This provides a rather decorative surface of contrasting areas of smooth parts and drilled parts. A similar use of the drill and contrasting plain and drilled areas may be seen in Beckwith [cat. 126], pl. 14. However, this comparison is not close enough to propose a similar date. The piece has been exhibited as fourth to seventh century AD.

EXHIBITIONS
Coptic Stone Sculpture: The Early Christian Art of Egypt, André Emmerich Gallery, New York, May–June 1962, no. c6
Dallas Museum of Fine Arts, 1962

Purchased from André Emmerich Gallery, New York, February 1965

SDC

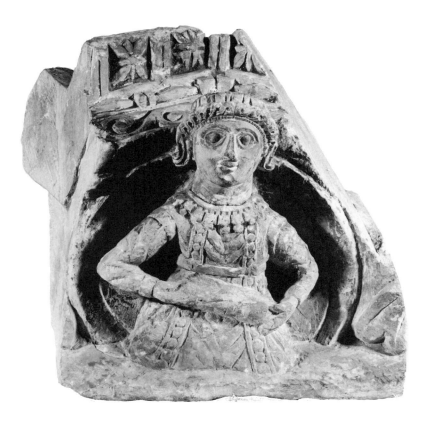

133 Architectural fragment, angel holding a scroll (?)

Chalky white limestone.
42 × 40 × 27 cm
Coptic, 6th century (?) M82.314

The figure comes from an architectural niche or a doorway. The head, which is sculpted in the round, has at some time been broken off and reattached. The nose of the angel is chipped but largely intact, and the object she holds is too damaged to be recognizable.

The figure is an angel surrounded by architectural mouldings. Her wings are painted red and there are traces of black paint on the eyebrows, irises, around the eyes, and on the nose. There are also black and brown lines on the vine scroll running behind her head.

The angel may be wearing a crown, or the lines may indicate smoother hair on top of the head, behind the row of tight curls framing the face. She wears a long-sleeved

pleated tunic over which is placed a jewelled necklace / collar, from which hang two ribbons with the 'pearl' motif. In her hands is a cylindrical object, perhaps a scroll. For a similar costume, seen in sixth-century mosaics, see Doro Levi, *Antioch Mosaic Pavements*, vol. 2, pls. 73b, 76b, 85a (Princeton 1947).

The architectural mouldings of bead and reel and coffering with rosettes may be seen in other Coptic stonework, for example, Effenberger [cat. 129], pl. 24, also dated to the sixth century, and Wessel [cat. 128], pl. 58, Cairo Museum. This latter example has the same kind of decorative qualities as the angel except that the Cairo figure (Dionysus) is embellished with bunches of grapes and a simple guilloche pattern on the drapery rather than simulated jewels.

Purchased from Royal Athena Gallery and C. Tauss, New York, December 1963 SDC

134 Architectural relief fragment, angel holding a wreath

Coarse limestone. 30 × 28 × 8.5 cm
Coptic, date unknown M82.312

The fragment formed part of a vertical panel. It shows the head, upper torso, and arms of an angel. The halo of the angel is cut off by the background framing of the panel and the head too seems slightly shortened. The hair is indicated by a series of grooves and ridges. The face is turned slightly to the left. The wings have rather odd sharp ridges for attachment to the angel's back. The feathers are indicated by a few semicircular grooves. The drapery is made up of a series of adjacent bands and the wreath is a very rudimentary oval, with no indication of what the wreath is made from.

A similar example, stylistically, is an ivory pyx in Wiesbaden (Beckwith [cat. 126], pl. 31) of the sixth century. Here the carving of the hair, the flattening of the nose, the lines around the mouth and the side of the nose are quite similar. But in the ivory the pupils are drilled and the eyes less exaggerated. The dating for this limestone is therefore very tentative and the piece could well be of a much later date, possibly in the ninth-to-twelfth century era. The pitting on the surface of the stone compounds the problem of trying to establish a date.

Purchased from Parke-Bernet, New York, 15 February 1962 SDC

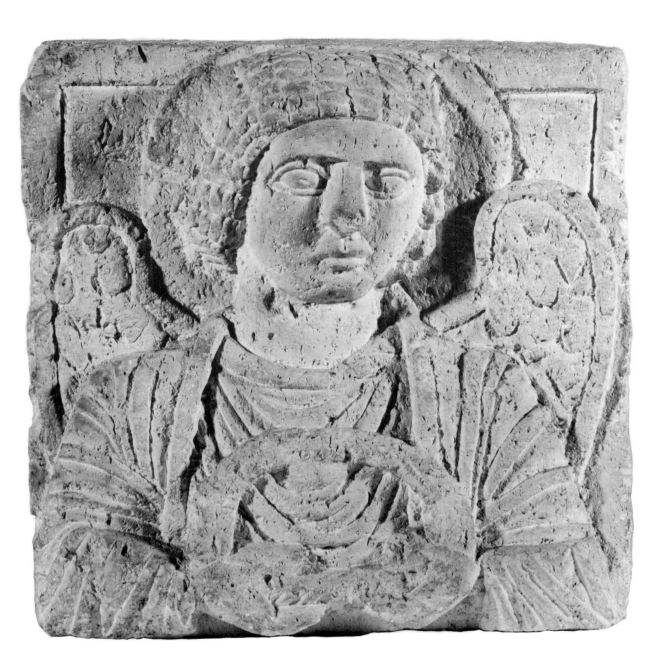

135 Architectural frieze block

Greyish-white limestone.
97 × 18 × 8.5 cm
Coptic, 6th century M82.324

The motif is a common one in mosaic
and textiles. It consists of a looped
pattern decorated with the 'pearl'
motif and enclosing, here, birds, rab-
bits, and baskets of fruit. This choice
of subject matter may be purely de-
corative or it may be intended
to suggest a paradise. The space be-
tween the loops of the guilloche
is filled with a trilobed leaf. The
space behind the loops is deeply cut
away, but the details of the 'pearls'
and the markings on the birds and
baskets are quite shallowly cut.

 This block would have formed part
of a continuous decorative frieze
set into a wall. The framing band is
open at one end, completed at the
other, suggesting that this part may
have fitted into a corner or the end
of a wall. A similar, if not identical,
frieze, in the south church at Bawit,
has been dated to the sixth century
on the basis of archaeological evi-
dence. See *Mitteilung des Deutschen
Archaeologischen Instituts, Abtei-
lung Kairo*, xxx, 1977, pl. 34b (I am
grateful to Dr Hans Georg Severin,
Staatliche Museun, Dahlem Berlin,
for this reference).

Purchased from Kelekian,
New York SDC

136 Relief panel; bust arising from foliage

Limestone. 47 × 23 × 10 cm
Coptic, date unknown M82.325

The original setting of this piece is
hard to reconstruct. It clearly was not
part of an architectural frieze, a
column, nor a stele. We can only
guess that it might have been part of
a bracket or console. Many other
features are unusual as well. The
stylized foliage is an isolated unit in
that it was not part of any other
sculptural element. The figure which
emerges from the foliage is also rather
plant-like. The drapery over the
shoulders has turned into two spirals
which suggest a vine scroll. Between
these scrolls, over the sternum, is a
series of deeply drilled holes which
may be read as flowers. The neck is
overly long and the face is quite
expressionless. The eyes and nostrils
are deeply drilled. On the sides of
the head, where we would expect
hair, there are small leaves and
winding plant tendrils. On top of the
head the hair or vegetation (?) has
the form of a cross, decorated with a
series of drilled holes. This may be
a reference to the occasional practice
among some of the early Christians
of branding (σφραγις) or physically
marking a cross on the body after
baptism. This would indeed be 'an
outward and visible sign of an inward
invisible grace.' For a further discus-
sion of 'sphragis' see Franz Josef
Dölger, 'Die Sphragis als religiöse
Brandmarkung im Einweihungsakt
der gnostischen Karpokratianer,'

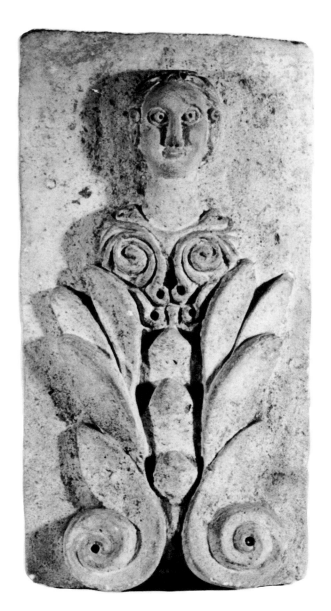

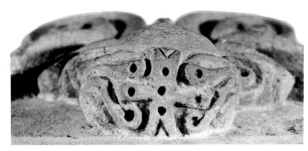

Antike und Christentum, I, 73–6; 'Zur Frage der religiösen Tatowierung im thraktischen Dionysoskult,' ibid., II, 107–16; 'Christliche Kreuztatowierung in der Herzegowina,' ibid., 160ff; 'Der Sinn der sakralen Tatowierung und Brandmarkung in der antiken Kultur,' ibid., III, 257ff. This cross obviously eliminates an identification of the figure as Daphne, in process of turning into a laurel tree.

Similar working of the eyes occurs in a stele from Sheikh Abada dated to the late fourth century, which shows a young boy in a niche (*Koptische Kunst: Christentum am Nil*, May–August 1963, Villa Hügel, Essen, no. 84). However, the other unusual features of the Toronto piece make it impossible for the present to assign a date.

PUBLICATIONS
Coptic Stone Sculpture: The Early Christian Art of Egypt, André Emmerich Gallery, New York, May–June 1962, p. 8
Cooney, John D., 'An Exhibition of Coptic Art,' *Art International*, VI,8, 1962, 52

Purchased from André Emmerich Gallery, New York, December 1962

SDC

138 Pendant, cross in a circle

Gold. 2 cm
Early Byzantine (?) M82.222

This small gold pendant may have
been the central decoration of a
necklace or merely a small part of
something much more elaborate. It
consists of a simple cross in sheet
gold enclosed in a frame decorated
with granulation technique and in-
corporating a loop for suspension.
In this incomplete condition it is dif-
ficult to try to fix a date for the
pendant. The Dumbarton Oaks Col-
lection contains a simple cross cut
from a sheet of gold, dated to the
sixth / seventh century (DOC [cat. 26],
no. bi, 3A,B), on a comparison with
a similar piece in the British Mu-
seum. The granulation technique
was used over a long period of time
and hence the dating of this piece, for
the present, cannot be more precise
than the Early Byzantine period.

Purchased from Blumka Gallery, New
York, September 1966 SDC

137 Earring

Gold. 4 × 1.3 × 1.2 cm
Coptic, 4th / 5th century M82.228

This single earring is in the shape of
a nude female figure with an elabo-
rate hairstyle and enormous spiral
earrings. She stands on a small cube
for a base, from which hangs a ring
for supporting, probably, a coloured
gem stone. Her hairstyle shows a
series of braids extending over the
entire skull and ending at the back of
the neck. The face is round and
placid, the arms only thin rudimen-
tary strips. From rather narrow
shoulders, the figure flares out to
very wide hips, then is dramatically
narrowed again in short, dwarf-like
legs. A fragment of limestone sculp-
ture from Sheikh Abada depicts
Daphne in a similar style – a large
head with placid face, wide hips, and
short, rudimentary legs. Both these
examples are representative of the
Coptic style of the late fourth, early
fifth century. Wessel [cat. 128], fig. 40.

Purchased from André Emmerich
Gallery, New York, September 1963
 SDC

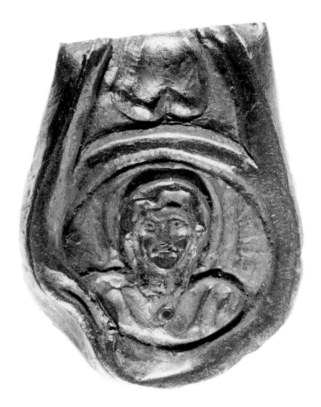
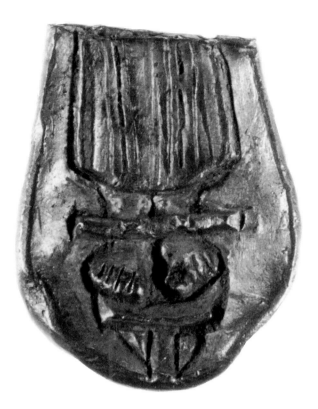

139 Fragment of a cross

Gold. 2.2 × 1.2 × 0.5 cm
Byzantine, circa 600 M82.236

The fragment is one tip of a flaring
armed cross showing the base of
a crucifixion scene on one side and a
roundel with a bust of Mary on the
other. The piece is hollow but now
squashed at the point where it has
been cut or broken. The relief is fairly
high. The side which has the cruci-
fixion scene shows that Christ was
wearing a long colobium and that the
feet are fastened by a bar across the
ankles, in addition to being supported
on a wooden platform. The bar has
two knobs on it, just over the ankles,
as if this was a misunderstanding
of the nails which should be shown
in the feet.

Purchased from Blumka Gallery,
New York, 1967 SDC

140 Pectoral cross

Gold. 5.7 × 4 × 0.5 cm
Byzantine, 7th century M82.224

The cross has depressed rosettes in each of the four arms and a small cross at the central point where the arms cross. Although similar examples in the Dumbarton Oaks Collection had an inlay in the centre, there is no evidence that this one did. The cross is hollow with a plain back and a small loop for suspension which was part of the original casting. Two similar examples at Dumbarton Oaks are dated on the basis of coin evidence found with those treasures to the seventh century and a similar date may be given to this example (DOC [cat. 26], nos. 4B and 6B). For a third example in the Heracleion Museum see the exhibition catalogue *Byzantine Art*, 9th exhibition of the Council of Europe (Athens 1964), no. 412, p. 373.

PUBLICATION
Ostrogorsky, George, *History of the Byzantine State*, trans. Joan Hussey (New Brunswick 1969), p. 85, fig. 25

Purchased from M. Komor, New York, March 1968 SDC

141 Inlaid cross

Pale green glass in stone or lead. 7 × 4.5 × 0.7 cm
Early Byzantine, date unknown
 M82.388

The cross is very heavy and has a solid whitish patina, both characteristic features of lead. At the top, where a projection has been broken off, the material looks like some kind of metal. However, it is hard to imagine that such an object would be made of lead, that anyone would go to the trouble of setting pale green glass 'cabuchons' into a material which is inexpensive, heavy if worn around the neck or waist, and not very durable. One answer might be that it was made for funerary purposes only, for inclusion in a tomb, in imitation of something more grand and elaborate.

The simplicity and rather crude manufacture of the cross suggest a date in the Early Byzantine period, but this is purely tentative as I have been unable to find any objects with which to compare it. SDC

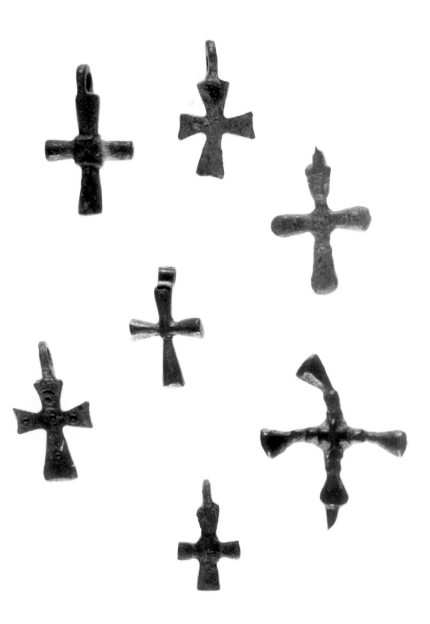

142–8 Group of seven tiny bronze crosses

Bronze, one of gilded bronze.
142: 2.2 × 1.2 cm
143: 3 × 1.7 cm
144: 2.3 × 1.5 cm
145: 2.7 × 1.5 cm
146: 2.7 × 1.5 cm
147: 2.8 × 2 cm
148: 3.3 × 2.8 cm
Byzantine, date unknown, possibly
7th / 8th century M82.160–6

These crosses are all quite plain. Two have a decoration of incised circles on one side. Two have a cube marked with an x at the juncture of the arms. The gilded one has slightly conical-shaped arms. The other two may have had some minimal decoration which is too worn now to be legible.

The crosses all have loops for suspension and were probably attached to the arms of a larger cross. Alternatively, they may also have been worn. Similar groups exist in other collections. See for example Franz Josef Dölger, *Antike und Christentum*, III (Munster 1932), especially no. 3, for one which hangs from another cross. In this latter group, several are almost identical to the Toronto group. The Berlin group is identified as 'Egyptian,' no date.

There are few, if any, criteria, stylistic or otherwise, on these crosses which we can use to establish a firm date. However, several similar pieces have been found in the excavations at Aphrodisias in Caria (publication in preparation), associated with tombs which are dated to the sixth to eighth century.

Purchased from Blumka Gallery, New York, September 1966 SDC

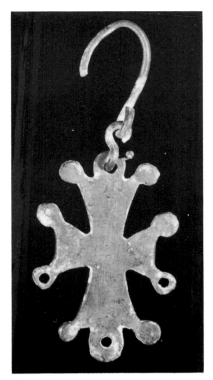

149

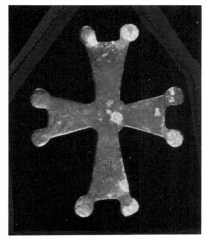

150

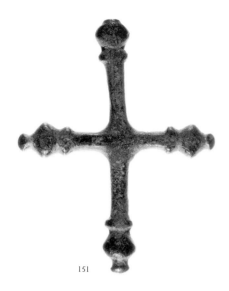

151

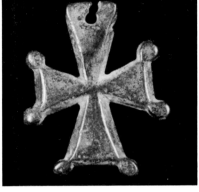

152

149 Cross with chain

Bronze.
7.7 × 5 cm, including hook, 5.5 cm
Byzantine, 6th–10th century (?)

M82.168

The cross is clumsily made and
devoid of any decoration. Each arm
ends in disc-like protrusions, while
the two vertical arms have a third
pierced disc as well. A single link of
chain and a hook are still attached at
the top. The lower discs on the hori-
zontal arm are also pierced. This
cross would have formed part of a
suspension chain for a lamp or
censer, probably one of three such
chains. See for example catalogue 57
or 116, or *Splendeur de Byzance*,
Musée royaux d'Art et d'Histoire,
Brussels, 2 October–2 December 1982,
p. 162, br. 5. SDC

150 Thin cross for appliqué (?)

Bronze. 8 × 6.5 cm
Coptic / Byzantine, date unknown

M82.173

The cross does not have any means
of attachment, no loops or holes
for chains, nor any nail marks. There
are a couple of spots on the back
where it may have been soldered or
glued to another object such as, for
example, a box or chest. There are no
features by which we can determine a
date other than the general shape,
which is usually associated with
Coptic and Early Byzantine work.

SDC

151 Small cross, finial (?)

Bronze. 6.2 × 4.8 cm
Byzantine, date unknown M82.170

This cross has rounded arms and a
slightly diamond shape over the
juncture of the two arms. It is deco-
rated on the ends with a series of
knobs and ridges. The outermost
knob is broken off on one of the arms,
suggesting that this was a point of
attachment to something else. Since
there are no loops for chains or sus-
pension, this cross seems to have
been a finial or top to something,
such as part of another cross (see for
example catalogue 170) or censer
(catalogue 111). SDC

152 Cross

Bronze. 4.8 × 6.5 × 0.6 cm
Coptic / Byzantine, date unknown

M82.169

The cross is quite thick and heavy.
The suspension loop at the top is
broken through and the bronze is cut
away to half-thickness behind this
hole. Possibly this cross was fitted
into the top of a wooden staff and
was fastened by means of a nail
in the area which is now broken. The
comments for catalogue 150 as regards
provenance and dating can be ap-
plied here, with the addition of the
'wedge-shaped' cutting of the arms, a
style which is also considered to be
Coptic. SDC

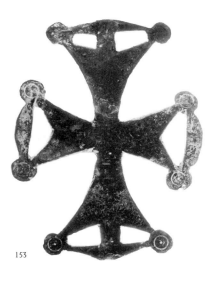

153

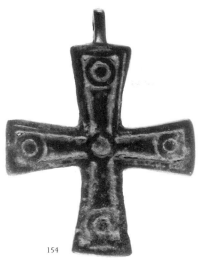

154

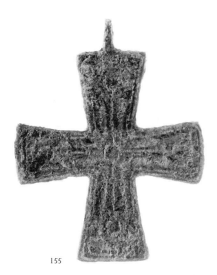

155

153 Cross

Bronze. 10.3 × 8.5 cm
Coptic, date unknown M82.177

The cross has a very unusual shape
and its function is not at all clear.
Since it has no loops for suspension,
it could not have been worn. It does
not have a flange, to have been a
processional cross, nor does it show
any signs of having been attached
flat to anything. One of the vertical
arms has been broken and repaired at
some point, as has the crossing point
of the arms. These repairs may have
removed some signs of a means of
attachment. Certainly with rounded
bars at the end of each arm the cross
could not have been free-standing.

Purchased from Kelekian,
New York SDC

154 Pectoral cross

Bronze. 7.3 × 5.5 cm
Coptic / Byzantine, 6th–8th century (?)
 M82.167

In style, this cross is very simple. A
cruciform shape is outlined inside the
cross and there is a small circle at
the end of each arm. This is perhaps
an over-simplification of the motif
of a bust in a roundel in each arm or
it may be a variation on the theme
of inscribed circles as a form of deco-

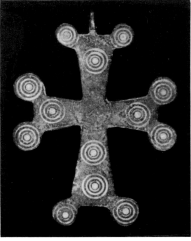

156

ration (see catalogue 156). The back
of the cross is completely plain and
very smooth, as if from prolonged
wearing. SDC

155 Pectoral cross

Bronze. 8 × 6 cm
Coptic / Byzantine, 6th–8th century (?)
 M82.178

The bronze of this cross is severely
corroded and the surface is hard to
read. However, the decoration seems
to be basically the same as that of
catalogue 154, with interior lines
forming a cruciform shape, circles at
the ends of the arms and over the
middle. This example is slightly

larger and the bronze is thinner. It
too was meant to be worn around the
neck. SDC

156 Pectoral cross

Bronze. 9 × 6.7 cm
Coptic, 6th–8th century (?) M82.173

The cross is a single thin piece of
bronze, plain on the back and deco-
rated on the front with a series of
inscribed multiple circles. Lines at
the crossing point of the arms suggest
that a roundel was attached there
once, probably glued on. This at-
tachment may have been a gemstone
or cameo, or even a metal roundel
perhaps containing a bust of a saint
or of Christ or Mary. It was probably
made of a relatively inexpensive
material, given the composition and
simplicity of the cross itself. SDC

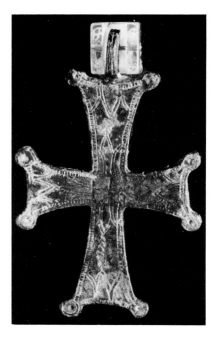
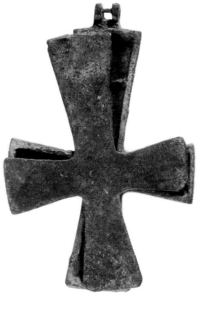
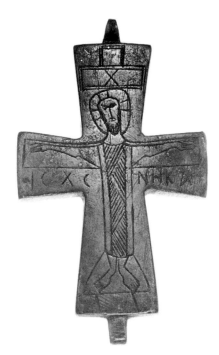

157 Pectoral cross

Bronze. 7.8 × 4.8 cm
Coptic / Byzantine, 5th / 6th century
M82.194

The cross is decorated with a series of
engraved lines consisting of stria-
tions, loops, and four unevenly
marked squares in the centre. A cross
with a somewhat similar type of
engraved decoration may be seen in
DOC [cat. 26], no. 64. That cross has
been dated stylistically to the fifth /
sixth century, a date which seems
appropriate here also.

Purchased from Kelekian,
New York SDC

158 Reliquary cross

Bronze. 8.5 × 5.5 cm
Byzantine, 8th / 9th century
M82.471

The cross is made in two pieces with
a hollow space between the two
parts, intended to hold a relic or holy
object. Usually these two pieces are
held together by a hinge, as may
be seen in catalogue 159–68. Here,
however, the thin flat piece seems to
have been held to the concave piece
by some other means such as solder
or glue. Both parts are completely
plain. This type of cross has been
found in many parts of the Byzantine
world – Asia Minor, Egypt, Syria,
Hungary, Yugoslavia, Greece. They
are frequently described as 'Coptic,'
but in fact their point of origin and
manufacture is not known. Problems
of dating persist since few examples
come from a firmly dated archaeo-
logical context. For further bibliog-
raphy see catalogue 159–64, and Alice
Bank, 'Trois croix byzantines du

Musée d'art et d'histoire de Genève:
Etudes sur les croix byzantines du
Musée d'art et d'histoire de Genève,'
Genava, Nouvelle série 28, 1980,
97–112, especially fig. 11. SDC

159 Reliquary cross, half only

Bronze. 8.8 × 4.9 cm
Byzantine, 8th / 9th century
M82.504

The scene shows Christ on the cross,
His arms outstretched, wearing a
long colobium and standing on a
platform. Above His head is the letter
X for Christos, behind His head the
crossed nimbus, and under the arms
of the cross the letters IC XC NHKA
(Jesus Christ conquers). Exactly
the same composition (with only a
couple of added details) may be seen
in a cross in Brussels. *Splendeur de
Byzance* [cat. 149], p. 168, br. 11 SDC

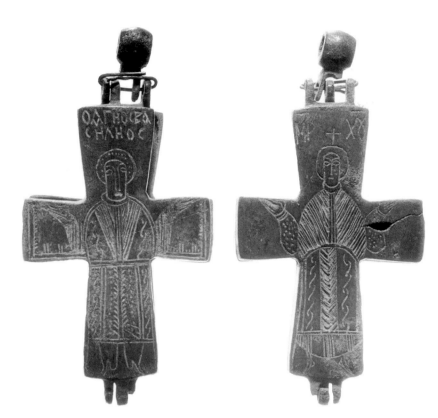

160 Reliquary cross

Bronze. 9.2 × 4.5 cm
Byzantine, 9th–11th century

M82.467

The crosses in catalogue 160–2 are
somewhat more stylized than cata-
logue 159, and hence the later date.
This group usually shows Christ or a
saint on one side and Mary on the
other. The drawing is very clumsy
and child-like. The drapery is merely
a series of patterned lines and the
anatomy is crudely depicted.

In this example we have St Basil
on one side, identified by an inscrip-
tion. He stands posed frontally in
the orans position. On the other side
is a similar figure, but with a cross
above her head, and identified by an
inscription as MP XY (Mother of
Christ), instead of the usual formula
of Mother of God. A reliquary cross
which also has the inscription
Mother of Christ has been found in
the excavations at Aphrodisias in
Caria (publication in preparation).
Examples which are stylistically
similar may be seen in *Splendeur de
Byzance* [cat. 149], p. 169, br. 12,
and in Effenberger [cat. 129], p. 160.

SDC

161 Reliquary cross

Bronze. 10 × 4.5 cm
Coptic / Byzantine, 9th–11th century

M82.465

The incised figures on this cross show on one side Mary, in orans pose, above her the abbreviation (mis-spelled) for Mother of God, and in front of her, seated in profile, a figure of Christ. On the reverse is a central roundel with an inscription on the left identifying the figure as Christ, as does the crossed nimbus and, to the right of the head, two letters Π ↑, which must refer to the bust set side-ways in the adjacent arm, namely Peter. On the left arm, a reverse inscription, ΟΛΒ ΑΠ, must be intended as Paul, and below, ΗΟΑΝΗ must be John. The figure above is not identified.

In this cross the hinge and pin are still intact, but there does not appear to be anything contained in the space between the two parts of the cross.

SDC

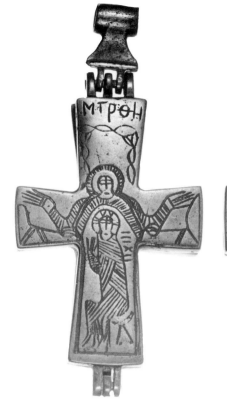
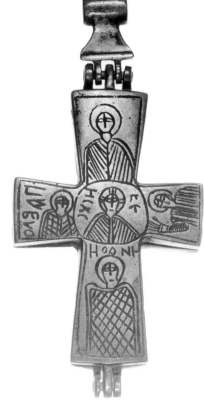

162 Reliquary cross

Bronze. 8.2 × 4.7 cm
Coptic / Byzantine, 9th–11th century

M82.469

On one side is an orant Mary (ΜΡΘΥ), flanked by palms, and on the other a figure identified as Ο ΑΓΗΟС ΤΕΦΑΛΟС (St Theophilus?). In the centre of the figure is a depression which probably once held glass paste or some col-oured stone. The garment of the fig-ure is decorated with a series of scrolls.

SDC

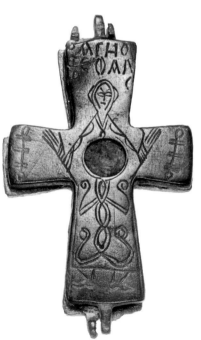
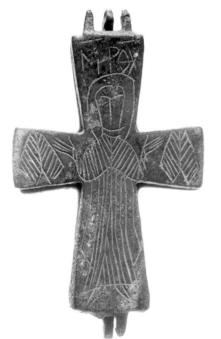

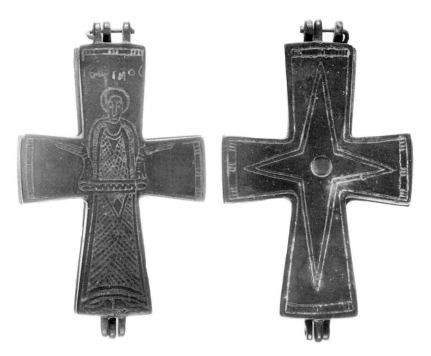

163 Reliquary cross

Bronze. 10.5 × 6 cm
Coptic / Byzantine, 11th / 12th
century M82.469

The crosses in catalogue 163–4 are of
another type. They have a figure on
one side and a geometric design on
the other. The drawing of the figures
is even more distorted. Here the arms
appear to emerge from the waist,
and the hands, which are extremely
large, are meant to indicate the or-
ans position. This figure is identified
as St George (ΓΗΟΡΓΗΟC). On the
reverse a four-point star has been
drawn and in the centre, as in cata-
logue 162, is a round depression for
some kind of inlay. SDC

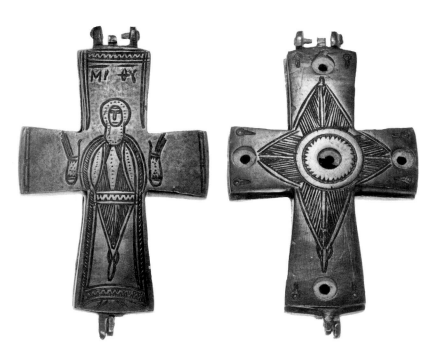

164 Reliquary cross

Bronze. 9.8 × 6 cm
Coptic / Byzantine, 11th / 12th
century M82.470

The figure is intended to be Mary
(MPΘY), but the costume is very
strange. The halo or veil around the
head extends under the chin and
covers the neck. The upper half of
the body is merely a set of geometric
shapes placed together – the arms
are not attached to the body at all.
The inverted triangle which deco-
rates the skirt of the garment repeats
the motif of one of the arms of the
four-point star on the reverse. The
star in this example is more elaborate
than that in catalogue 163, since
the interior is filled with a series of
striations. In the centre and in each
of the arms is a hole, intended for
some kind of inlay. SDC

165 Reliquary cross, relief

Bronze. 8.8 × 5 cm
Byzantine, 9th century (?) M82.466

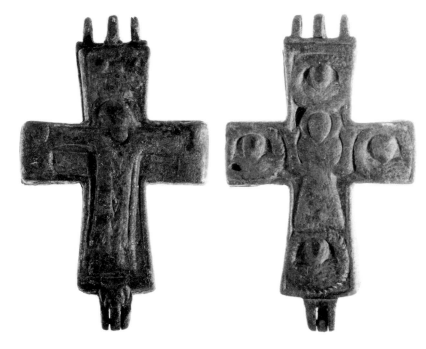

The items in catalogue 165–8 form
yet another group. They all have
relief decoration rather than incised,
but the same kind of iconography
is used.

On one side is a scene of the cruci-
fixion, with Christ wearing a long
colobium. Above His head is the tab-
ula ansata and above that the sun
and the moon. There is a bust, barely
recognizeable as such, in each end
of the horizontal arm, probably Mary
and St John. On the other side is a
central orans figure, probably Mary,
and four busts in wreaths, presum-
ably the four evangelists. There are
no inscriptions and the cross is very
worn, so that all the features of the
faces have been lost. For a group
of similar crosses see *Splendeur de
Byzance* [cat. 149], p. 170, brs. 13, 14;
Byzantinische Kostbarkeiten,
Staatliche Museen zu Berlin, Frühch-
ristlich-byzantinische Sammlung,
Ausstellung im Bode Museum, Feb-
ruary / April 1977, no. 107. SDC

166 Fragment of a reliquary cross, relief

Bronze. 6 × 5.7 cm
Byzantine, 9th century M82.507

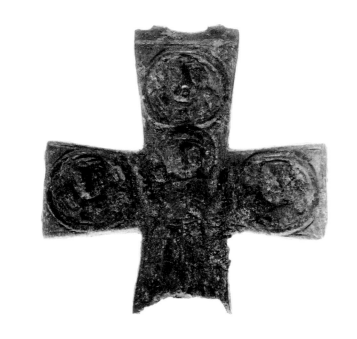

The surviving segment of this cross
shows exactly the same iconography
as the reverse of the cross in cata-
logue 165. There is a central figure
(Mary?) in orans position, and busts
in roundels in each of the three
extant arms. the fourth is lost. Al-
though this cross is very worn, we
can see that a little more attention
has been paid to the drapery folds
than in the preceding example. SDC

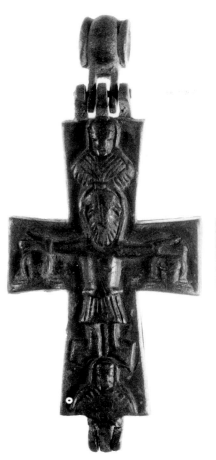

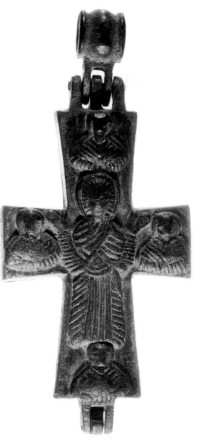

167 Reliquary cross, relief

Bronze. 9.4 × 4 cm
Byzantine, 9th century M82.468

Both the iconography and style of
this cross are unusual. The scene is
the crucifixion, but there is no sign of
the cross. Christ wears a long-sleeved
shirt and a short pleated skirt. He
stands on a platform, the foot support
of the cross, but His feet appear to
be more in front of it than on it. His
head is overly large. Small busts
appear under His hands, of Mary and
St John, but the figure below His
feet and the one above His head are
not so easily identified. Perhaps they
are merely following the formula of
the reverse which has four busts
(the four evangelists?) surrounding a
standing orans figure which is prob-
ably Mary.

The features of all the faces are
worn off, but the drapery is still
legible and the style of the drapery is
very similar to that of br. 14 in *Splen-
deur de Byzance* [cat. 149], as cited
in catalogue 165. SDC

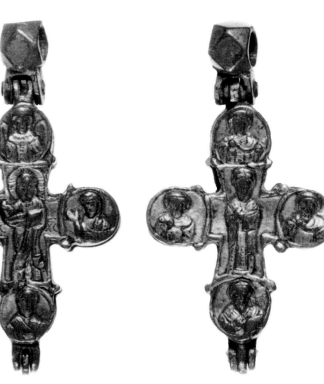

168 Reliquary cross, relief

Gilded silver (?). 7 × 3.6 cm
Byzantine, 12th / 13th century
 M82.506

This cross is smaller than the other
examples in this catalogue. The sur-
face is divided into a series of com-
partments, forming a cross and
roundels. On one side is a standing
figure of Christ, hand raised in a
gesture of blessing. Mary and St John
are in the roundels to either side,
an angel above, and an unidentified
male below. On the reverse, the
central section shows an unidentified
male figure holding a book. The
four roundels contain unidentified
male busts. There is no attempt at
differentiating their costumes, as
three seem to wear military garb
while the fourth is in clerical dress,
possibly that of a bishop.

The cross is dated to the twelfth /
thirteenth century on the basis of

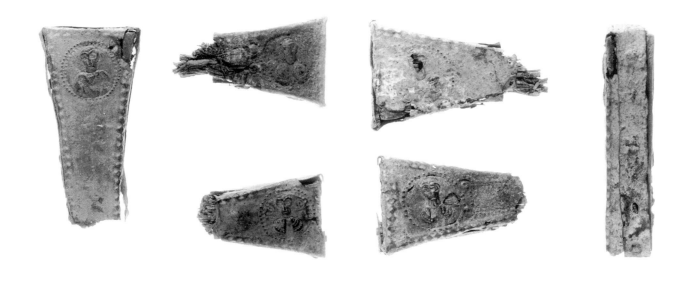

comparisons with two others, in the DOC [cat. 26], no. 99, and *Byzantinische Kostbarkeiten* [cat. 165], no. 114. SDC

169 Three fragments of a repoussée cross

Thin bronze sheet over a wooden core.
Byzantine, Asia Minor, 10th century
M82.508 a,b,c

The cross consisted of a wooden base covered with overlapping sheets of bronze held in place on the sides by small pins. One of the fragments has lost the bronze from the back but the cross seems to have had a bust in a roundel on each of the four arms and on each side. The figures, done in repoussée, are crudely drawn and badly worn so that it is impossible to identify any of them. On the largest piece there are traces of an engraved inscription, ΑΓΑ (αγιος Α ..., St A ...). One of the fragments also shows the beginning of a smaller cross, drawn in the space between the roundels. This is not repeated on any of the other fragments, so perhaps this piece is not part of the same object. It is, however, of exactly the same size and style.

When complete, the cross would have been hand held and is similar to other larger forms used as processional crosses. These crosses have been dated by Alice Bank [cat. 158], pp. 97–124, to the tenth / eleventh century. Bank's examples, however, are incised, not repoussée. The only other examples of bronze repoussée crosses known to me are in a private collection and as yet unpublished (see forthcoming exhibition catalogue, *Canada Collects the Middle Ages*, entries by S. Campbell). The figure style is reminiscent of the paintings of Cappadocia, and similar linear, mask-like faces can be seen in, for example, the church of St Theodore (Guillaume de Jerphanion, *Une Nouvelle Provence de l'art Byzantin: Les Eglises Rupèstres de Cappadoce*, Paris 1936, text vol. III, nos. 148, 149). These churches are dated to the early tenth century and the same date and provenance seems appropriate for these fragments.

Purchased from Peter Mol,
Amsterdam, 1968 SDC

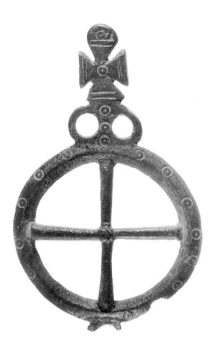

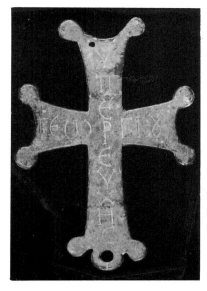

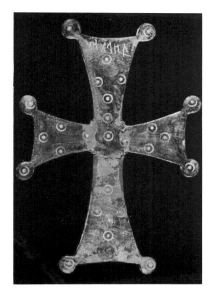

170 Cruciform finial

Bronze. 14 × 8.5 cm
Byzantine, 5th / 6th century

M82.394

This finial probably formed a top for either a processional cross or perhaps a censer. Handles for lamps are usually heavier. The decoration is a simple series of circles, such as may be found on some early crosses and censers (DOC [cat. 26], pl. XXXIII.48, 49). The piece terminates in a cross on the top, decorated with a few incised lines. There is no suggestion that this cross might have held suspension chains. The back of the object is completely plain, so it clearly was meant to be seen from one side only. SDC

171 Cross

Bronze. 15.5 × 10.8 cm
Coptic / Byzantine, 10th / 11th century M82.172

The function of this cross is not clear. There is a small hole near the top of the vertical arm and a large hole at the bottom of the same arm. On the back, over the crossing point, is a large rim (0.5 cm deep, 2.4 cm diam.), as if for attachment or insertion into something else.

The cross has knobs at the end of each arm, and an inscription, ΥΠΕΡ ΕΥΧΗC ΓΕѠΡΓΙ꙳ (in fulfilment of a vow, of George).

A cross with similar holes, forming part of the suspension chains for a polycandelon, is in Athens (*Splendeur de Byzance* [cat. 149], p. 162, br. 5), dated to the seventh century. The Toronto cross may have been used this way, but such use does not account for the attachment on the back. A cross in Corinth, of comparable simplicity and basic shape, and similar lettering style in the inscription, is dated to the tenth century *(Byzantine Art, 9th Exhibition of the Council of Europe*, Athens 1964, no. 555). SDC

172 Processional (?) cross

Bronze. 18.7 × 13.1 cm
Coptic / Byzantine, 10th / 11th century M82.174

The cross is the same basic shape as catalogue 171. It is decorated with a series of punched circles, as in catalogue 142–3 and 156, and at the top is a crudely scratched inscription ΜΗΧ4ΗΛ (Michael). The cross has been broken and repaired, probably in antiquity, and there was a small hole at the bottom which has been filled with a plug. This may have been a means of attaching the cross to a staff so that it could serve as a processional cross. The lettering, with the odd archaic alpha form, resembles the letters in catalogue 169. The dating proposed for this cross is based on the same comparative examples as for catalogue 171. SDC

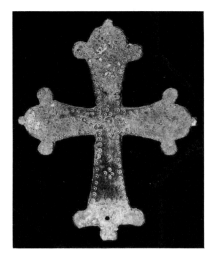

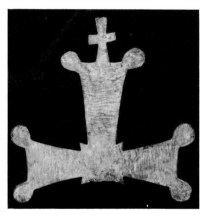

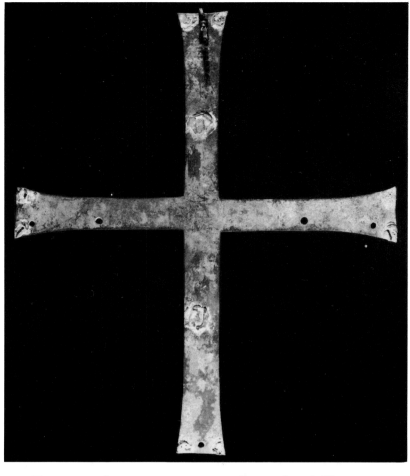

173 Processional cross

Bronze. 16 × 12.5 cm
Coptic / Byzantine, 10th / 11th
century M82.171

This cross has rounded arms extended
into knobs on the sides and a small
knob at the centre. There is the
stump of a flange at the bottom and
a small hole for a pin or nail so that
it could be fitted into a staff for use as
a processional cross. The cross is
decorated with a simple row of
punched circles along the edges and
clusters of dots in the centre and
the middle of each arm. The decora-
tion occurs on both sides of the cross,
as might be expected where both
sides were meant to be seen. Exam-
ples for comparative dating are the
same as those cited in catalogue 171.

Purchased from Kelekian, June 1964
 SDC

174 Fragment of a processional (?) cross

Bronze. 10.2 × 11.2 cm
Coptic / Byzantine, 11th / 12th
century (?) M82.175

The bronze of this cross is quite thin
and the piece seems to have been
cut from a sheet rather than cast.
There is a cross added to the top of
the arm and small pointed projec-
tions at the four corners of the cross-
ing point of the arms. The general
simplicity of design puts this cross in
the same time period as catalogue
171, 172, 173. SDC

175 Processional (?) cross

Bronze. 41 × 34 cm
Coptic / Byzantine, date unknown
 M82.191

The cross is completely plain with
the exception of an incised circle over
the crossing point. On the back, at
the end of each of the arms, and
in two places on the vertical arm are
lumps of solder. This may mean
that other pieces were attached here,
such as discs, or that the cross itself
might have been attached to another
metal object. There is a twisted piece
of bronze in the top of the arm which
could only have been used as a means
of suspension. The holes in the cross
arm, if the cross was free-standing,
may have had small crosses (such as
catalogue 142–8) or gemstones
attached. However, there is insuffi-
cient evidence here to try to establish
a date. SDC

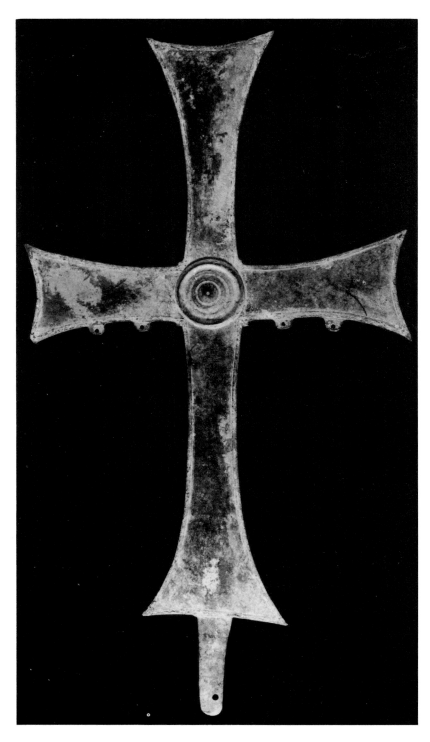

176 Processional cross

Bronze. 51 × 28 cm
Coptic / Byzantine, 10th–12th
century M82.193

This is a simple flaring-armed cross
with a central boss and attachments
on the cross arm for other small
crosses, gemstones, or the letters AW.
There is a long metal flange for inser-
tion into a socket. On one side is
an incised line following the lines of
the cross, which is not repeated on
the other side. A cross which is simi-
lar in simplicity and design may be
seen in Athens, dated to 899. Laska-
rina Bouras, *The Cross of Adrianople*
(Athens, Benaki Museum, 1979),
p. 52, fig. 30. SDC

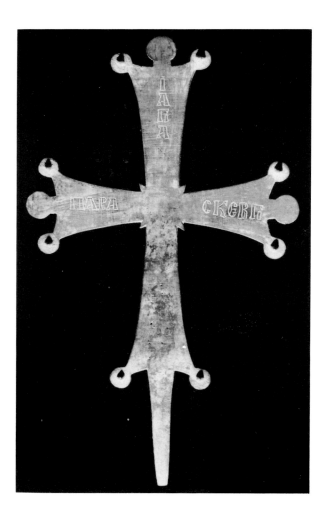

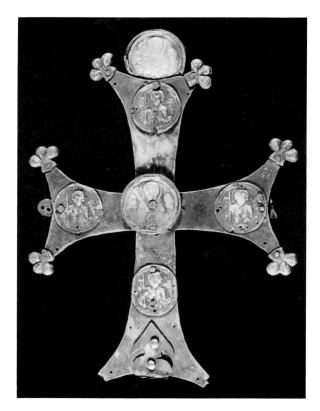

177 Processional cross

Bronze. 40.5 × 23.5 cm
Coptic / Byzantine, 10th–12th
century M82.192

This example is similar to the frag-
mentary cross in catalogue 174. Here
the arms end in three discs, the two
outside ones having additional pro-
trusion or bosses. There is a long
flange for insertion into a socket.
The cross bears the inscription, mis-
spelled, St Paraskevi. The back of
the cross is plain. See catalogue 176
for a comparative piece. SDC

178 Processional cross

Gilded bronze or brass. 30 × 21.5 cm
Byzantine / Georgian, 12th century (?)
 M82.203

This cross is made up of many pieces.
There is a basic cruciform shape
with round medallions added at the
top and over the crossing. Thin discs
are applied, clumsily with nails,
in each of the arms and there are
added finials on the points of the
cross arms. A narrower cross-shaped
piece is nailed on the back and it
had pieces which extended beyond
the cross arm, obviously for further
attachments. At the bottom on the
front is part of another piece of metal
which would have held the cross to
the supporting staff.

The two applied medallions have
identical busts of an angel with a
sceptre. The four smaller discs each
have a bust of a military saint. The
finials at the ends of the arms are
trios of tiny heads, perhaps cherubim.

This same kind of cross with medal-
lions may be seen in Bouras [cat. 176],
p. 51, pl. 29. Crosses with added
pieces on the ends of the arms are
shown in Bank [cat. 158], figs. 1, 2, 3.
In spite of its complexity of construc-
tion, this cross is crudely made, which
suggests that it is not the product of
one of the major centres of metal-
working, but is an attempt at copying
something of better quality. Probably
the closest dating which can be given
is the Middle Byzantine period. The
inscriptions in the discs, which are
too worn to be legible, have been
identified as Georgian.

Purchased from Blumka Gallery,
New York, January 1966 SDC

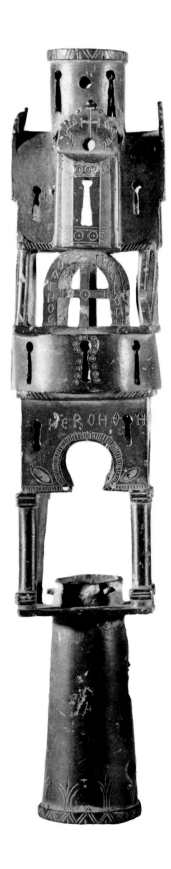

179 Base for a processional cross

Bronze. 29 × 5 cm
Byzantine, 10th / 11th century

M82.393

This piece formed part of the handle of a processional cross. A wooden rod would be inserted from below, and the cross placed on top. The form suggests architecture. There are inscriptions on each of the four sides. On the side illustrated, the top level shows an incised cross flanked by crudely drawn palms. Below that, in an arch enclosing a cross, is the inscription ΟΑΓΗΟС / ΠΡΟΚΟΠΗ (ὁ ἅγιος ΠΡΟΚΟΠΙΟS) (St Procopius), possibly the name of the church where it was used. On the opposite side of this base is the inscription z⚛H (light, life). On the lower level, running along all four sides, is the inscription Κ[ΥΡΙ]Ε ΒΟΗΘΗ ΠΡΕСΒΥΤΙΝ ΗΟΑΗΗΝ Κ[ΑΙ] ΝΙΚΙΤΑΝ (Lord help the elder (?) John and Niketas).

The bottom rim has an incised design of branches and chevrons. V.H. Elbern believes that this type of cross base was produced in the region of Constantinople in the middle Byzantine period. For two similar examples see the exhibition catalogue, *Bronzen von der Antike bis zur Gegenwart*, Eine Ausstellung der Stiftung Preussischer Kulturbesitz Berlin aus dem Bestanden ihrer Staatlichen Museen, Münster, 14 March– 18 November 1983, nos. 24, 25, pp. 48–50. No. 25, in particular, has the same keyhole shaped openings.

Purchased from Safani, New York

SDC

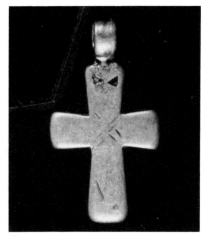

180

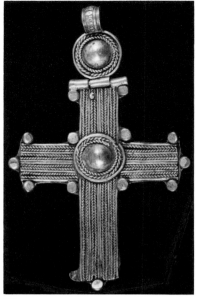

181

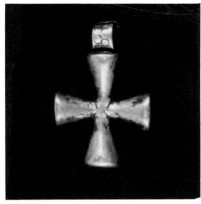

182

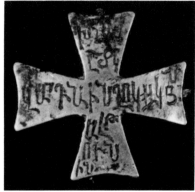

183

180 Pectoral cross

Silver. 4.5 × 2.5 cm
Provenance and date unknown

M82.186

This cross is a very simple one. The
arms are straight with only slight
indentations towards the crossing
point. There are two pairs of crossed
lines over the cross beam on one
side and two triangular depressions
near the suspension ring, both front
and back. Any other decoration
which may have been present is
completely worn away. SDC

181 Pendant cross

Silver. 11 × 7 cm
Provenance and date unknown

M82.183

The back of the cross consists of three
pieces of silver, the front is applied
separately in strips of a braid-like
decoration. There is a central boss
which is repeated as a hinge piece
just below the suspension ring. At the
end of the arms and at the junction
of the cross pieces are small round
discs which are thicker than the
applied strips. SDC

182 Pectoral cross

Silver. 3.2 × 2 cm
Ethiopian, date unknown M82.184

The cross is made up of four conical
segments which are completely
plain. There are a few inscribed
double circles on the suspension ring.
For a similar cross see *Religious Art
of Ethiopia* (Stuttgart 1973), no. 72.

SDC

183 Cross with hooks for attachment

Silver. 3.8 × 3.8 cm
Armenian, date unknown M82.182

This Greek cross has an Armenian
inscription which reads 'The cross is
a gift of Altoon to Vartan Zogag.'
On the back are four small hooks for
attachment to another object. The
cross was not intended to be worn.

I am grateful to A. Selyan, Sharkis
Tchilingurian, and Vartan Vartanian
for the translation.

Purchased from J. Malter, California

SDC

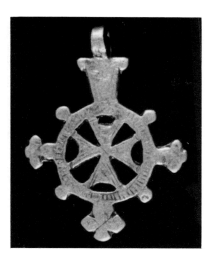

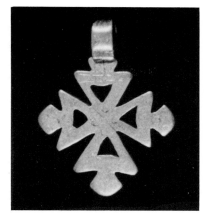

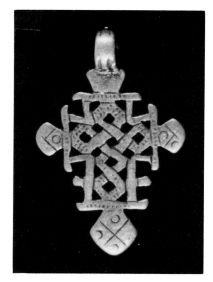

184 Pectoral cross

Silver. 4.8 × 3.5 cm
Ethiopian, date unknown M82.180

A Greek cross is enclosed within a
ring which has three trilobed cross
arms interspersed with discs and an
upper post with a ring for suspension.
The decoration consists of simple
incised lines on the ring and the arms
of the cross.

For similar examples to this cross
and catalogue 185, 186 and 187, see
the exhibition catalogue, *Koptische
Kunst: Christentum am Nil* [cat.
136], no. 519, and *Religious Art of
Ethiopia* [cat. 182], no. 63. SDC

185 Pectoral cross

Silver. 4 × 3 cm
Ethiopian, date unknown M82.181

This silver pectoral cross is made up
of four open-work triangles with a
semicircle in each of the four arms.
There was some incised surface deco-
ration in the form of circles and
lines but it is largely worn away.

SDC

186 Pectoral cross

Silver. 5 × 3.3 cm
Ethiopian, date unknown M82.187

The arms of the cross are rectangular,
with extensions of the outer surfaces,
stippled for decoration. The interior
is filled with interlace, which is also
stippled. On the three end pieces of
the cross arms there are incised xs
and circles. SDC

187 Pectoral cross

Silver. 3 × 2.7 cm
Ethiopian, date unknown M82.185

The main part of the cross is formed
by four triangles but the crudeness of
workmanship makes it look like a
square with notched corners. There
are three trilobed extensions to the
cross arms and a decoration of incised
circles. Four perforations also indi-
cate the arms of the cross. SDC

188–93 Six plaques

Copper or bronze repoussée.
Byzantine, second half 11th century (?)
M82.159

These six plaques are grouped together here but they cannot all come from the same context, even though there are certain similarities in decorative motifs and the quality of the metal seems to be consistent. For example, there are two plaques with the Angel Gabriel. These two plaques are stylistically very different, and there would not be any reason to have two representations of Gabriel on the same object. The plaques are unlikely to have been used as book covers as the edges are not wide enough, the metal usually being bent around the wooden boards. Also, at this time, only the Gospel lectionaries had metal covers and the subject of David and Goliath would not be appropriate for a gospel cover. An alternate suggestion has been that they come from an iconostasis beam, but again this would mean more than one source as only one Gabriel could be used. They may be plaques from a door, and one example of a door covered in repoussée bronze plaques has been published (C. Bouras, 'The Byzantine Bronze Doors of the Great Lavra Monastery on Mount Athos,' *Jahrbuch der Oesterreichischen Byzantinistik*, XXIV, bd. Wien 1975, 229ff. The panels are dated to circa 1000 AD. I am grateful to Laskarina Bouras, Benaki Museum, for this reference).

Alternatively, we may suggest that these plaques decorated a chest or box (see for example Buschhausen [cat. 108], A pl. 68, nos. 55–9 and passim), or that they served as plaques on an icon frame, or even part of an icon (cf Florens Deuchler, *The Year* 1200: *A Background Survey*, The Cloisters Studies in Mediaeval Art II, Metropolitan Museum of Art, 1970, figs. 224, 225, the wings). The shaping of the Gabriel plaques could then come from an outer wing of a triptych or dip- tych. Panel 191, especially, in the position of the angel and the speaking gesture of the hand, requires a panel with Mary, forming the left-hand wing of the diptych or triptych to complete the scene of the annunciation.

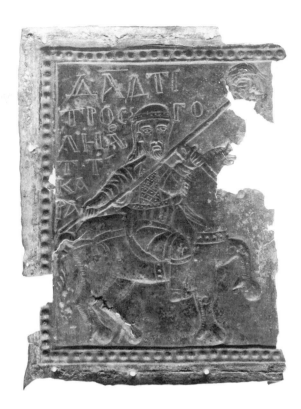

188: 14.2 × 19.5 cm
189: 13 × 19 cm

These two panels are virtually identical. Each one contains a spiral interlace made up of laurel (?) leaves, enclosing an eight-petal rosette. The rest of the panel is plain except for two plain borders enclosing a row of raised dots.

190: 13.5 × 18.8 cm

The panel has the same outer border as the preceding pair. The centre is filled with a foliate jewelled flaring armed cross. The centre of the cross, at the juncture of the two arms, has a small rosette, very similar to the two above.

191: 14 × 18.5 cm

The fourth panel has the same border. Within the border is a scene of David on horseback. He holds a spear and on its end the head of Goliath is impaled. The inscription identifies the scene: $\overline{\Delta}A^{(B)}\Delta$ TI / TPOC$^{(KWN)}$ ΓΟΛΗΑθ T$(ην)$ T KAPA (David piercing Goliath's head). The iconography is unusual. David is not normally shown on horseback. Also, at the time of the killing of Goliath he is usually depicted as a beardless youth, not a bearded adult. The drapery style in this panel is similar to that in catalogue 192.

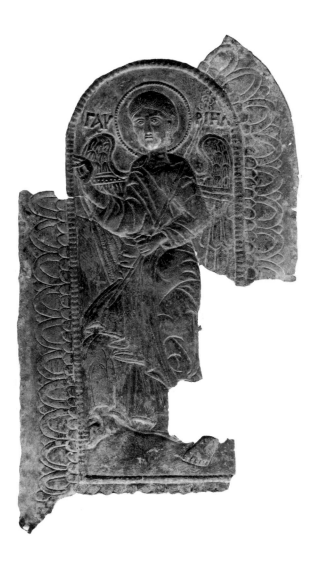

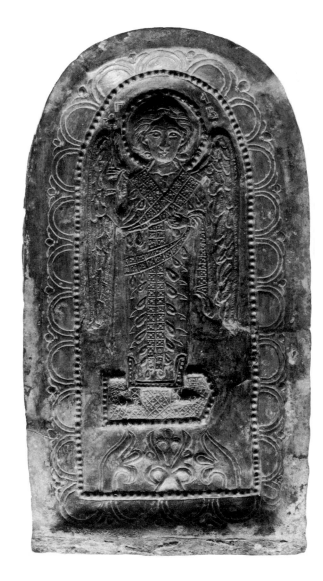

192: 12.5 × 24 cm (estimated restored height)

The panel is rounded at the top and was probably straight across the bottom. The outer border is a series of two sizes of petals, possibly intended as a stylized egg and dart motif. Inside the frame is the figure of an angel, identified by an inscription as Gabriel. He faces the viewer but at the same time seems to be striding from right to left. He holds a sceptre topped with a caduceus in the left hand, while making the gesture of speech or benediction with the right. Gabriel wears a long-sleeved full-length garment, covered by a plain mantle.

193: 12 × 23 cm

The subject matter of this panel is the same as the preceding one but the style is very different. The framing motif of petals is more carefully done and more decorative. The inner border is again a series of raised dots within which Gabriel stands frontally on a platform, above some stylized foliage. Gabriel's wings are more elaborately tooled than in catalogue 192, and he wears a jewelled and embroidered or brocade garment. The left arm rests easily at the waist while the right hand holds a staff which is barely visible. The feet are set at an impossible angle. This panel is considerably more decorative than catalogue 192, but the figure is less substantial, more two-dimensional.

On the basis of the drapery style of catalogue 191 and 192 and the flat, decorative features of 193, these panels are tentatively dated to the second half of the eleventh century. For comparative examples of this date see, for nos. 191 and 192, G. Vikan, ed., *Illuminated Greek Manuscripts from American Collections: An Exhibition in Honour of Kurt Weitzmann* (Princeton 1973), fig. 26. Here the drapery is simple, the folds just beginning to take on decorative linear qualities, and there is a moderate amount of three-dimensionality suggested. In fig. 30 (ibid.) a manuscript page shows Constantine in much

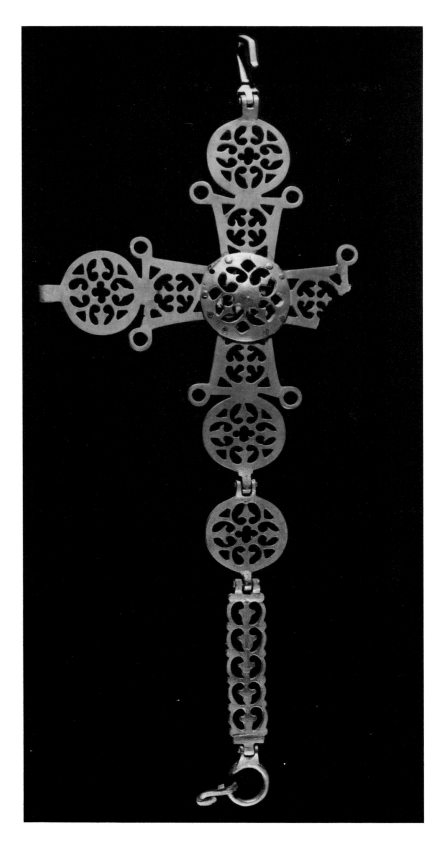

the same costume as catalogue 193, the pose is almost identical, and the frontality and two-dimensionality are very much alike. Both of these manuscripts are dated to the second half of the eleventh century.

Purchased from M. Komor, 1972

<div align="right">SDC</div>

194 Suspension chain for hanging lamp

Bronze. 66 × 26 cm
Byzantine, 14th century M82.189

The cruciform-shaped chain is intact except for part of one arm. The cross and discs are perforated with a cross and stylized floral elements. The chain is hinged in four locations. Other examples of this type of cross have an additional segment between the top disc and the main cross, suggesting that this was a way of adjusting the length of the cross / chain according to the location where it was used. On each side of the horizontal arms of the cross (only one here) is a cylinder to hold a candle, while the hook at the bottom would support a lamp. A very similar example from the Metamorphosis Monastery, Meteora, is illustrated in Laskarina Bouras, 'Byzantine Lighting Devices,' *Akten 11 / 3 der XVI Internationaler Byzantinkongress,* Jahrbuch der Oesterreichischen Byzantinistik 32 / 3, pp. 479–91, pl. 7.

Purchased from T. Zumpoulakis, Athens SDC

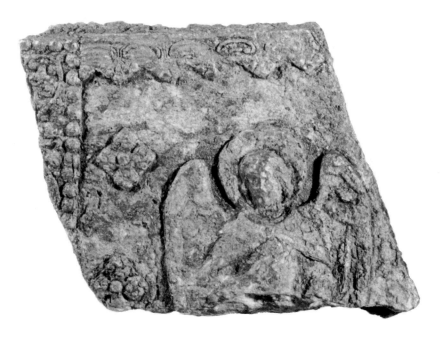

195 Fragment from a font (?)

Cast bronze. 13 × 15 × 3 cm
Byzantine, 10th / 11th century

M82.397

The fragment is a slightly curved piece of very thick, solid bronze. The concave side is plain. The outside has the upper half of an angel, who seems to be holding something (a book?). To the left of the angel are two rosettes and the whole is framed by stylized palmettes, a scroll motif, and a series of dots. This kind of border decoration may be seen also in catalogue 169 and is common in relief and engraved crosses of the tenth / eleventh century. The features and drapery of the figure are too illegible for any stylistic comparisons, but they certainly seem to be far less crude than the cross fragments referred to above. The piece is re-ported to have come from Constantinople and, if so, this provenance could explain that difference. Constantinople was a centre of major

artistic production, with imperial patronage, whereas the probable source of catalogue 169 was a provincial centre.

It is difficult to assemble a group of similar objects in this medium for stylistic dating. For an iconograph-ical and decorative comparison we may use a bronze cross in the Geneva Museum (Bank [cat. 158], p. 107, fig. 9), where there is an angel framed by rosettes and a dotted border, dated to the eleventh / twelfth century. However, the figures here are mainly incised rather than in relief. A figure on a cast bronze encolpion (ibid., fig. 11) shows a similar tilt of the head, rather than a straightforward frontality. This latter object is given a date and provenance of Syro-Palestinian, nine / tenth century. This type of comparison is not very satisfactory but given the lack of firmly dated sculptured or cast objects from Constantinople, it must suffice for the present.

Purchased from Kelekian, December 1968 SDC

196 Seal of Leo Skleros, magistros and praitor of Opsikion

Lead. 32 mm (diam.) 28 mm (field)
Byzantine, second half 11th century
M82.235b

The seal is cleanly struck and well preserved. There is a slight chip on the reverse.

OBVERSE: Bust of the Virgin orans, with the medallion of Christ in front of her. Inscription: M-P ΘV. Border of dots.

REVERSE: Inscription of seven lines preceded by an ornament: ΘKE BOH ΘEI TW CWΔ⟨OYΛW⟩ ΛEOVTI MA [Γ]ICTPWS ΠPETWΡITY OΨI [K]'CW CBAK·PW-

A similar seal, coming from a different context but which certainly belonged to the same owner, is now preserved at the Münzkabinett of Vienna (no. 215). It has been published by W. Seibt, *Die Skleroi. Eine prosopographisch-sigillographische Studie* (Vienna 1976), pp. 87–8, fig.

12. Several other seals of the same person are preserved. Leo Skleros, member of a Byzantine family most distinguished in the tenth and eleventh centuries, is not known from literary sources. He had the reasonably high honorific title of 'magistros' and assumed the office of praitor / judge / tax-collector and civil administrator, of the Bithynian theme of Opsikion. See N. Oikonomides, *Les listes de preséance byzantines des IXe et Xe siècles* (Paris 1972), pp. 294, 323, 344, 348. NO

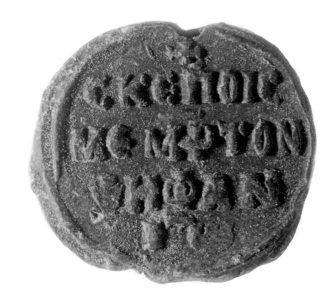

197 Seal of John Psephas

Lead. 23 mm (diam.), 21 mm (field)
Byzantine, 12th century M82.235a

OBVERSE: High relief bust of the Virgin
orans with the medallion of Christ
in front of her. Inscription: MP ΘV.
Linear border.
REVERSE: Inscription of four lines
preceded by a cross. Linear border.
CKЄΠΟΙC
MЄ MP TON
ΨΗΦΑΝ
IW

The inscription is metrical: one
twelve-syllable verse (iambic trime-
ter), very fashionable in the twelfth
century; the otherwise unknown
owner is asking for the protection of
the Virgin. He bears a family name
well attested in the eleventh to thir-
teenth century: C. Stathas, *Mesaion-
ike Bibliotheke*, v, pp. 490–3, and
two unpublished seals in the Dum-
barton Oaks Collection, Washington,
DC. NO

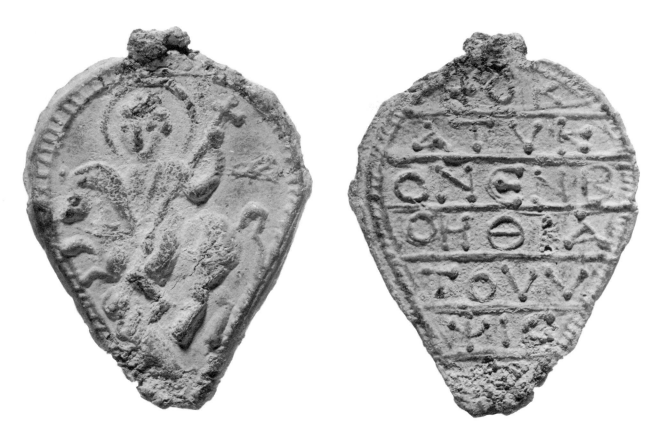

198 Pear-shaped amulet

Lead. 4 × 2.7 cm
Byzantine, 11th / 12th century (?)

M82.241

On the obverse is a haloed figure on
horseback, who holds a staff
surmounted by a cross. The amulet is
rather worn and partially illegible,
so it is not clear, but the man may be
spearing a creature beneath the horse.
The man is too large for the horse,
and if he is spearing something, he
does so with his left hand. On the
reverse is an inscription in seven
lines:

+ OK
A TYK
ONENB
OHΘ⟨I⟩A
TOYY
ΨIΣ
⟨TOY⟩

(He who dwells in the help of the
most High).

The amulet had a loop at the top
for suspension but that is now
broken. It is made from an inexpen-
sive material and is the type of ob-
ject which could be produced in large
numbers, quite cheaply, to be sold
as an object of popular piety,
intended to protect the bearer. A
steatite casting mould for a pear-
shaped amulet, and with the same
inscription, is in the Benaki Museum,
Athens (unpublished). I am grateful
to Dr Gary Vikan for this
information.
SDC

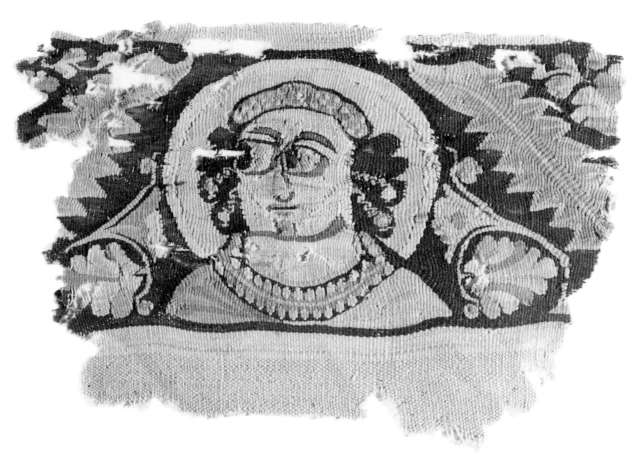

199 Polychrome tapestry band with a female bust betweeen stylized acanthus

Wool.
6.5 × 25 cm; tapestry band 14 cm
Coptic, 6th century M82.44

The fragment is from an all-wool textile with an inwoven polychrome tapestry band. It is from either a hanging or a pale pinkish-yellow woollen tunic. The design is oriented in the direction of the warp. All edges are raw.

GROUND CLOTH
Weave: tabby, with predominant weft
Warp: wool / pale pinkish-yellow, s; 9 ends per cm
Weft: wool / pale pinkish-yellow, s; 15 passes per cm

INWOVEN TAPESTRY BAND
Weave: tapestry; weft-faced tabby binding; slit and dovetailed; eccentric wefts; little vertical ground-weft wrapping. A limited use of supplementary wefts in a variety of differ-ent colours: vertical extra-weft wrapping only. Shading through dovetailed patches of colour and some hatching; also use of eccentric wefts for the contouring of facial features (the cheekbones, for example) without a change of colour
Warp: uses the warp of the ground cloth.
Weft: wool / dark blue, beige, pink-ish-beige, ecru, yellow, red, medium, green, light green, light blue and purple, s; 50 per cm

Concerning the technique of Coptic tapestries see Pierre du Bourguet, *Musée national du Louvre: catalogue des étoffes coptes*, vol. I (Paris 1964), and Nicole Viallet, *Tapisserie: méthode et vocabulaire* (Paris 1971).

On the basis of a more complete companion piece in the Brooklyn Museum (Deborah Thompson, *Coptic Textiles in the Brooklyn Museum*, New York 1971, no. 5, acc. no. 38.684), we may suppose that our fragment was originally part of a frieze of female busts separated by stylized acanthus, a fairly common motif in the Early Byzantine period. Both the monumental quality of the design and the weave direction suggest that these pieces were origi-nally part of the border of a tapestry hanging rather than an article of clothing. Neither the height of the band nor the use of a woollen ground cloth would, however, preclude their use as the clavi of a tunic. For hang-ings with comparable borders see James Trilling, *The Roman Heritage; Textiles from Egypt and the Eastern Mediterranean 300 to 600 A.D.* (Washington, DC 1982), nos. 17 and 20; for woollen tunics with similarly wide clavi see nos. 23 and 74.

The female figure is stocky, with a short thick neck and square face with dimpled chin. Enormous oval eyes gaze to the extreme left while the rest of the body remains frontal. Costume and hairstyle are elaborate. The long deeply curled dark hair is flattened at the top by a jewelled headband or cap and a similar jew-

elled band decorates the neck of her tunic. She wears intricate double pendant earrings displayed to either side rather than hanging naturally and her head is framed by a nimbus, implying dignified status.

This piece is closely related to a group of tapestry hangings attributed by Dorothy Shepherd to a single sixth-century workshop in Egypt. (Dorothy G. Shepherd, 'An Icon of the Virgin: A Sixth-Century Tapestry Panel from Egypt,' *Bulletin of the Cleveland Museum of Art*, LVI, 3, March 1969, pp. 90–120.) Included in the group are the tapestry icon of the Virgin Enthroned in the Cleveland Museum of Art, the Hestia Polyolobos in the Dumbarton Oaks Collection, and the Head of a Dancer in the Detroit Institute of Arts. The Hestia panel in particular bears a close comparison with our frieze, in the costume, jewellery, and hairstyle of the female figures and the multi-coloured stylized plant forms brilliantly contrasted against a dark blue ground. All the hangings are of a superb artistic and technical quality. Shading is achieved through the use of several different techniques (see above). The contouring of the facial features by a change in the direction or density of the weft threads (without resorting to a change in colour) is especially indicative of the skill of the weaver.

There are reasons for supposing that our piece is slightly later in date than the others listed above. The modelling is broader and more schematized, with very little use of hatching. The facial features are exaggerated, the colouring is more decorative than naturalistic, and the plant forms also are treated in a much more rigidly stylized manner.

In addition to the piece in the Brooklyn Museum, there is another in the Montreal Museum of Fine Arts (no. 952.Dt.38, unpublished). If not from the same hanging, they must at least come from the same workshop.

Purchased from Delacorte Gallery, New York, 1956 AL

200 Polychrome tapestry square with a galloping horseman brandishing a double axe

Wool and linen. 22 × 22 cm
Central panel: Coptic, 6th century; border: Coptic, 8th / 9th century
M82.45

The polychrome tapestry square is pieced together from fragments of two different textiles. The border, apparently cut from one long band, is technically and stylistically of a later date. The bird in the lower left-hand corner of the inner panel also does not belong. This is appliqued and of slightly different colour and design. It is probably from a pale-yellow woollen tunic. The design is oriented in the direction of the warp. All edges are raw.

INNER TAPESTRY PANEL
Weave: tapestry; weft-faced tabby binding; slit and dovetailed; eccentric wefts; little vertical ground-weft wrapping. A limited use of supplementary wefts, but these are in a variety of different colours: vertical extra-weft wrapping and 'flying' wefts. Shading through patches of colour (eg, the highlight of bleached linen at the knee)
Warp: wool / pale yellow, s; 12 ends per cm
Weft: wool / purple, beige, tan, pinkish-beige, pink, red, yellow, orange-yellow, light green, dark green, medium blue, dark blue, pale blue; s
 linen / bleached, s
 50 per cm

BORDER
Weave: tapestry; weft-faced tabby binding; slit and dovetailed; eccentric wefts. Use of a linen supplementary weft for the outlining of the roundels: curvilinear extra-weft wrapping, done in a double thread. Use of minimal amounts of 'flying' weft in a variety of colours in the bird roundels
Warp: wool / pale yellow, s; 12 ends per cm
Weft: wool / dark blue, red, green, yellow, pink, medium blue; s
 linen / undyed, s
 51 per cm

Another piece of exceptional quality (compare with catalogue 199) is the composite panel, probably a segmentum from the skirt of a pale yellow woollen tunic. Although the central section of such a panel is often done with greater attention to detail (cf Brooklyn Museum 57.41, in which the subtle drawing and illusionistic shading of the classical figure is in contrast to the rudimentary design and flat treatment of the border: Thompson [cat. 199], no. 9), the border in this case is definitely not only by a different hand but also from a later period. Sewing together parts of different textiles to make a more attractive whole was a common practice among commercial dealers. This unfortunately, however, destroyed all evidence of original use.

The central part of the panel consists of a roundel within a square. In each of the four corners of the square is a bird done in purple, with touches of light blue and pink, on a yellow ground. The bird in the bottom left-hand corner has been cut from another tapestry, one with a brown warp, and appliqued to complete the design. The central roundel has a late classical horseman wielding a double axe galloping to the right, silhouetted against a plain purple background. The rider, with curly blond hair and elongated oval eyes, is shown in three-quarter view, dressed in very colourful garb: a short green tunic girdled in yellow, a pink mantle fluttering over one shoulder, and blue riding boots trimmed in pink. His horse is white and tan, with a similar large oval eye, vivid red lips and pink tongue. The saddle is round, without stirrups, and the horse trappings have coloured pendant phalarae. There is some use of shading, including a rather awkward highlight at the rider's knee.

The border is much more sketchily done, with barely recognizeable trees and birds in roundels. The roundels seem to be interlaced (although the summary execution makes this uncertain), and placed within a pearl lattice framework on a dark blue ground. The roundels have a red ground, except for one which is

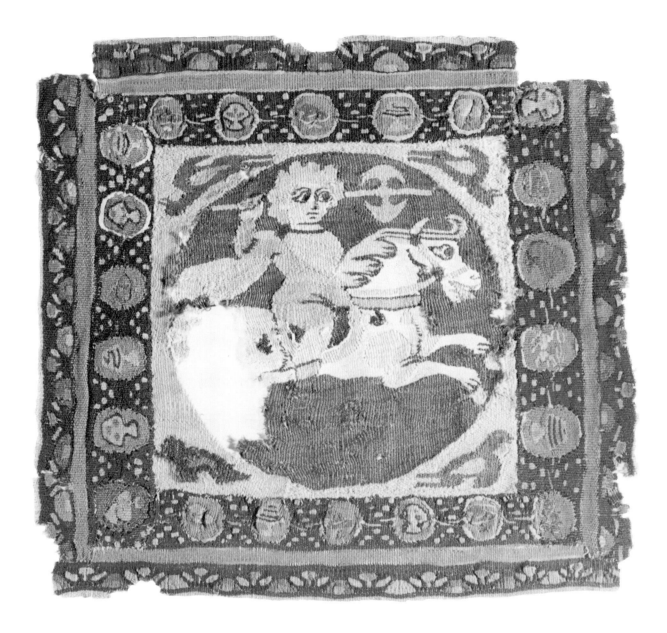

green, and each contains either a tree or a bird, except for one which has a quadruped. The outer border is decorated in similar fashion, with a staggered row of plants and demi-roundels.

The central panel is reminiscent of the riders and birds of the well-known Horse and Lion Tapestry, of the sixth century. Ernst Kitzinger, 'The Horse and Lion Tapestry at Dumbarton Oaks (a study in Coptic and Sasanian textile design),' DOP [cat. 93], no. 3,

1946, pp. 1-72, esp. fig. 40. The frame, in contrast, is much closer in style and technique to examples of the eighth and ninth centuries, such as Du Bourguet [cat. 199], F 17 and F 51.

Purchased from World House Galleries, New York, 1962 AL

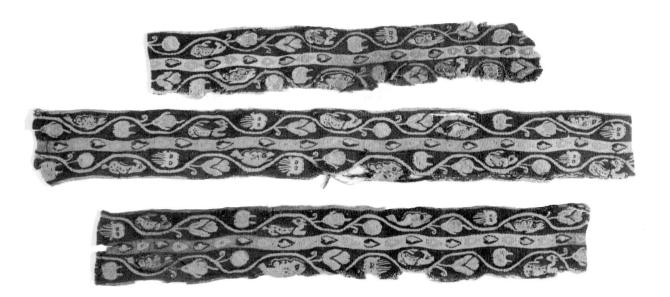

201 Polychrome tapestry band in three fragments, with a plant scroll inhabited by a variety of marine animals

Linen and wool.
4.7 × 31 cm; 4.7 × 38.2 cm;
4.7 × 25.2 cm
Coptic, 6th century M82.67

There are three fragments of a polychrome tapestry band. They are probably the clavus of an undyed linen tunic. The marine animals are oriented in the direction of the warp. All edges are raw.
Weave: tapestry; weft-faced tabby binding; slit and dovetailed; eccentric wefts; little vertical ground-weft wrapping. Extensive use of varicoloured supplementary wefts: vertical and curvilinear extra-weft wrapping and 'flying' wefts
Warp: linen / undyed, s; used in units of 2; 10 units per cm
Weft: wool / dark blue, dull faded, red, faded light green and yellow; s

linen, undyed, s
76 per cm

This small-scale, exquisitely detailed design consists of an inhabited plant scroll on a black background to either side of an undyed linen band decorated with a row of multicoloured hearts. The undulating stem of the plant bears stylized fruit and flowers and shelters a variety of marine animals. The whole is delicately worked and colouristically shaded. Cf Du Bourguet [cat. 199], C 37, C 46, and C 77, all of the sixth century.

From the Delacorte Collection

Purchased from Juergens, New York, 1964 AL

202 Two fragments of a polychrome tapestry band, with a succession of putti, animals, and plant motifs

Wool. 17 × 17.7 cm; 16.8 × 18 cm
Coptic, 6th century M82.61

The two fragments of an all-wool textile are decorated with an inwoven polychrome tapestry band. It is probably the clavus of a woollen tunic, perhaps green. Most of the design is oriented in the direction of the weft. All edges are raw. One fragment has a patch of mending (of the period).

GROUND CLOTH
Weave: weft-faced tabby
Warp: wool / brown, s; 9 ends per cm
Weft: wool / green, s; 34 passes per cm
INWOVEN TAPESTRY BAND
Weave: tapestry; weft-faced tabby binding; slit and dovetailed; eccentric wefts; little vertical ground-weft

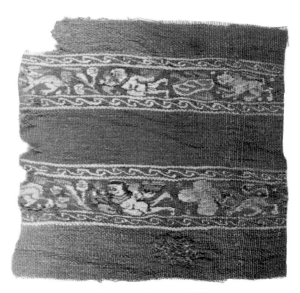

203 Polychrome tapestry roundel with a putto wrestling an animal

Linen and wool. 6.5 × 6 cm
Coptic, 6th / 7th century M82.83

The fragment of a polychrome tapestry roundel is probably from a bleached linen tunic. The design is oriented in the direction of the weft. All edges are raw.
Weave: tapestry; weft-faced tabby binding; slit and dovetailed; eccentric wefts; vertical ground-weft wrapping. Some use of supplementary wefts, dark blue, white, and red: curvilinear and vertical extra-weft wrapping and 'flying' weft. For the hair of the putto, 1 green and 1 yellow thread are used together per pass.
Warp: linen / bleached, s; used in units of 2; 9 units per cm
Weft: wool / red, medium blue, dark blue, green and yellow; z
 linen / bleached, s; 2 threads used together for the border
 58 per cm

Set against a plain red background and framed with a running wave border is this tiny figural composition of a putto wrestling with an unidentifiable animal. The putto is woven in white bleached linen, with both hair and mantle done in yellow and green. The animal is blue, with white legs and yellow mane or horns and tail. Cf Du Bourguet [cat. 199], D 44 and D 154–7 of the seventh century.

Purchased from Kelekian, New York, 1963 AL

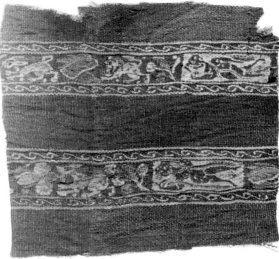

wrapping. Use of varicoloured supplementary wefts for the details of the design: vertical extra-weft wrapping and 'flying' wefts.
Warp: uses the warp of the ground cloth.
Weft: wool / purple and ecru, with details in yellow, green, dark blue, light blue, red, and orange, s; 44 per cm

This purple tapestry band in two fragments is decorated with a tripartite design. The middle section is left plain, while to either side is a figural frieze done largely in ecru wool, enlivened with touches of colour. The design of both figural bands consists of a row of swimming putti, plants, lotus blossoms, and animals between narrow borders of running waves. Both friezes ae interrupted by panels containing single Dionysiac figures in negative image, dark on a light ground. On the left is a dancing nude female holding a scarf, on the right a warrior with a shield, also naked except for a mantle. Cf Du Bourguet [cat. 199], C 75 and C 76 of the sixth century.

From the Delacorte Collection

Purchased from Juergens, New York, 1964 AL

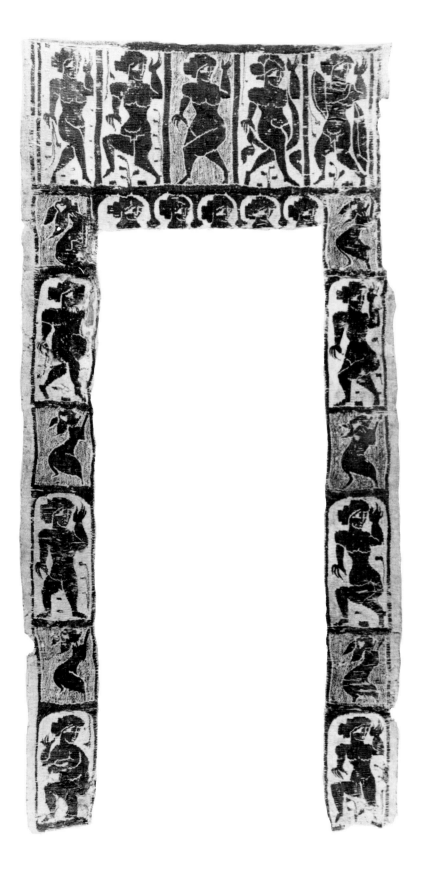

204 Monochrome tapestry decoration from a linen tunic, with Dionysiac motifs

Linen and wool.
41 × 90 cm; clavi 7 cm
Coptic, 6th century M82.43

The textile is part of an undyed linen tunic with neck and sidebands (clavi) inwoven in monochrome tapestry. The design is largely oriented in the direction of the weft. It is raw at all four edges, although the tapestry decoration is complete except for the bottom edge.

GROUND CLOTH
Weave: tabby, with predominant warp
Warp: linen / undyed, s; 19 ends per cm
Weft: linen / undyed, s; 9 passes per cm

INWOVEN TAPESTRY DECORATION
Weave: tapestry; weft-faced tabby binding; slit and dovetailed; eccentric wefts; vertical ground-weft wrapping. Use of an ecru supplementary weft for the inner detail of the design: vertical extra-weft wrapping and 'flying' weft. Some sections of the design have a mixed ground formed by the use of 2 lats per pass, 1 purple and 1 ecru ('battage de couleurs').
Warp: uses the warp of the ground cloth in units of 2 and 3; 8 units per cm. The warp ends are crossed at the point of juncture between tabby and tapestry.
Weft: wool / purple, s
 linen / undyed, s
 29 per cm

This major portion of the decoration of either the front or back of an undyed linen tunic has Dionysiac figures in a series of rectangular panels, some with rounded heads suggesting an arcade. (Judging by the number of similar examples that survive, this decorative scheme seems to have been a popular style for Coptic tunics. See R. Shurinova, *Coptic Textiles*, Moscow 1967, no. 5, for a complete tunic ornamented in similar fashion.) A single dancing male or female figure, nude except for a mantle or scarf, is placed in each compartment, with a few shrubs

as only the merest indication of landscape background. In the clavi, the dancers alternate with panels containing a running rabbit on a 'hatched' ground (formed by the use of a purple and an ecru thread together in each pass). Beneath the row of panels forming the neckband is a series of short busts within an arcade. Cf Du Bourguet [cat. 199], C 32–4 of the sixth century.

Purchased from Royal Athena Gallery, New York, 1970 AL

205 End of a double band of monochrome tapestry with two warriors

Linen and wool.
16.5 × 11.2 cm; each tapestry band 6.7 cm
Coptic, 6th / 7th century M82.51

This fragment of linen cloth is decorated with a double band of monochrome tapestry. It is most probably the armband of an undyed linen tunic. The design is oriented in the direction of the weft. One end of the tapestry band is intact, but all four edges of the linen cloth into which it was woven are raw.
GROUND CLOTH
Weave: tabby, with a band of more loosely woven tabby with predominant warp between the two tapestry bands
Warp: linen / undyed s; used singly except for the area between the tap-

estry bands, where it is used in units of 2; 12 ends (or 6 units) per cm
Weft: linen / undyed, s; an estimated 12 per cm, but 9 per cm between the tapestry bands
DOUBLE INWOVEN TAPESTRY BAND
Weave: tapestry; weft-faced tabby binding; slit and dovetailed; eccentric wefts; vertical ground-weft wrapping. Use of an ecru supplementary weft for the inner detail of the design: vertical extra-weft wrapping and 'flying' weft only
Warp: uses the warp of the ground cloth in units of 2; 6 units per cm. The warp ends are crossed at the point of juncture between tabby and tapestry.
Weft: wool / purple, s
linen / undyed, s
34 per cm

This fragment is in the same dark on light mode so popular throughout the history of Coptic textiles. It is probably from the armband of a tunic similar to catalogue 204. Again we have two warriors in a niche, nude except for a mantle worn over one shoulder, and bearing a shield. Here the landscape background has been reduced to only a couple of dots. Cf Du Bourguet [cat. 199], D 94–7 of the seventh century; D 94 and 97 have very similar borders, while D 95 and 96 have similarly abbreviated landscape elements.

From the Delacorte Collection

Purchased from Juergens, New York, 1964 AL

206 Monochrome tapestry roundel with a horseman

Linen and wool.
10.2 × 12.3 cm; roundel 9 cm
Coptic, 6th / 7th century M82.41

The fragment is of linen tabby with an inwoven monochrome tapestry roundel. It is probably from an undyed linen tunic. The design is woven parallel to the warp. All four edges are raw.
GROUND CLOTH
Weave: tabby
Warp: linen / undyed, s; 19 ends per cm
Weft: linen / undyed, s; 14 passes per cm
INWOVEN TAPESTRY ROUNDEL
Weave: tapestry; weft-faced tabby binding; slit and dovetailed; eccentric wefts; little vertical ground-weft wrapping. Extensive use of a linen supplementary weft to produce the inner detail of the design: vertical, horizontal, diagonal, and curvilinear extra-weft wrapping and 'flying' weft.
Warp: uses the warp of the ground cloth in units of 2; 11 units per cm
Weft: wool / dark blue, z
linen / undyed, s
47 per cm

Distorted at the sides by a loss of weft and consequent separation of the warp, this roundel has a dark blue design against a plain ecru background. A variety of supplementary weft wrapping techniques provide more inner detail than seen

heretofore. A horseman, his shield fallen to the ground, gestures with one hand while galloping off to the right. The border is a solid dark blue band. Details of the design are otherwise obscured by the poor condition of the textile. Cf Du Bourguet [cat. 199], D 105–6, D 109, and D 112, all of the seventh century.

Purchased from Blumka Gallery, New York AL

207 Monochrome tapestry roundel with a stylized tree

Linen and wool. 24 × 28.3 cm
Coptic, 7th century M82.69

The monochrome tapestry panel is woven into a linen cloth, remnants of which appear at the edges. It is probably from an undyed linen tunic. The design is oriented in the direction of the weft. All edges are raw.
GROUND CLOTH
Weave: tabby
Warp: linen / undyed, s; 21 ends per cm
Weft: linen / undyed, s; 9 passes per cm
INWOVEN TAPESTRY ROUNDEL
Weave: tapestry; weft-faced tabby binding; slit and dovetailed; eccentric wefts; vertical ground-weft wrapping. The detail of the design is largely produced by a linen supplement weft, most of which has worn away: vertical extra-weft wrapping

and 'flying' weft.
Warp: uses the warp of the ground cloth in units of 2 and 3; 7 units per cm. The warp ends are crossed at the point of juncture between tabby and tapestry.
Weft: wool / dark purplish-blue, s
 linen / undyed, s
 52 per cm

The roundel is slightly elongated, with a plain border containing a single polylobate leaf with jagged edges, dark purplish-blue on an ecru ground. Inscribed within this large-scale leaf is a tree with curving branches bearing cordiform leaves, again with jagged edges, drawn in largely with the aid of an ecru supplementary weft, much of which has worn away.

This motif of a leaf 'inhabited' by a tree is to be compared with that of leaves 'inhabited' by fruit. See Doro Levi, *Antioch Mosaic Pavements*, Princeton 1947, vol. I, pp. 484–6, for a discussion of this motif, and vol. 2, pl. XC, for examples in sixth-century floor mosaics. Examples abound also in polychrome tapestries. Du Bourguet [cat. 199] dates these from the sixth to the eighth century. Our tapestry fragment is similar to another seventh-century example in the Louvre, ibid., D 28; but see also C 46 of the sixth century, D 145 of the seventh century, and E 91 of the eighth century.

From the Bacri Collection

Purchased from Blumka Gallery, New York AL

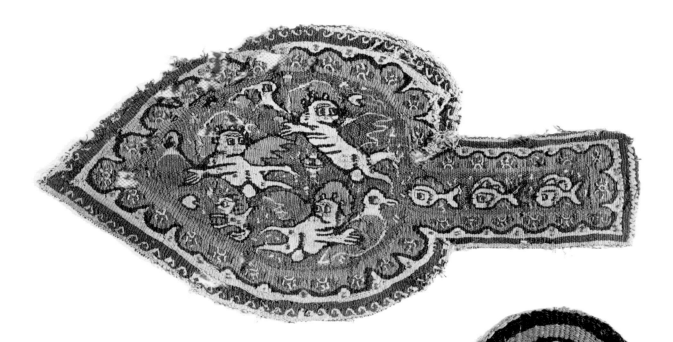

208 Spatulate polychrome tapestry panel with Nilotic motifs

Wool and linen. 15.5 × 30 cm
Coptic, 7th / 8th century M82.80

This spatulate tapestry ornament has a polychrome figural design. It is probably from a woollen tunic, perhaps brown. The design is oriented in the direction of the warp. All edges are raw.
Weave: tapestry; weft-faced tabby binding; slit and dovetailed; eccentric wefts; vertical ground-weft wrapping. Extensive use of varicoloured supplementary wefts: vertical extra-weft wrapping and 'flying' wefts. The dark blue and white are sometimes used as double, even triple threads. Two linen 'flying' wefts are used together for the green and white rosettes of the inner border.
Warp: wool / brown, s; 9 ends per cm
Weft: wool / purplish-red, 3 shades of blue, yellow, green, and pink, s
 linen / bleached, s
 36 per cm

Another example of the ever-popular Nilotic motifs already seen in catalogue 201 and 202 is this spatulate ornament with swimming putti grasping ducks. Intermingled with

them are fish, plants, and, comically, a basket of fruit and a rather astonished lion. The impression of a more advanced date given by the awkwardly drawn figures is supported by the extensive use of supplementary wefts as a quick and easy means of providing inner detail. Note especially the elaboration of the border with its design in several sections, including the usual running wave design and also a less common row of rosettes within a polylobate inner border. Cf Du Bourguet [cat. 199], E 54 of the eighth century.

Purchased from Kelekian, New York, 1963 AL

209 Polychrome tapestry roundel containing a male bust

Linen and wool. 5.6 × 5.2 cm
Coptic, 8th century M82.82

The roundel is a polychrome tapestry, probably from an undyed linen tunic. The design is oriented in the direction of the warp. All edges are raw.
Weave: tapestry; weft-faced tabby binding; slit and dovetailed; eccentric wefts; vertical ground-weft wrap-

ping. Very little use of supplementary wefts; only a touch of 'flying' weft in the eyes
Warp: linen / undyed, s; 7 ends per cm
Weft: wool / orange, black, and red; s
 linen / undyed, s
 42 per cm

This tiny roundel with a male bust is perhaps one of several from the border of a tapestry square (see Du Bourguet [cat. 199], E 50–2, for various possible arrangements). The figure is shown wearing a cap and mantle, the latter in ecru with drapery folds indicated in red. The plain orange background is heavily framed in black. Cf especially Du Bourguet, E 50 of the eighth century.

Purchased from Kelekian, New York, 1963 AL

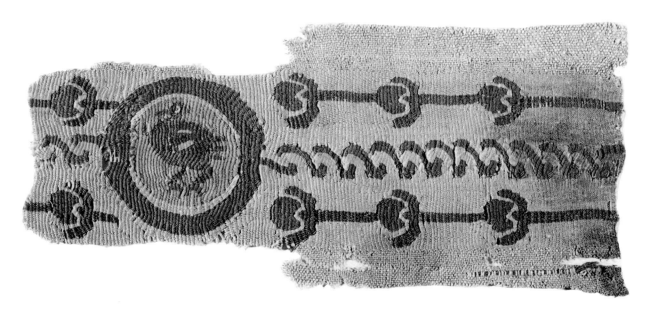

210 Polychrome tapestry band with florets and guilloche to either side of a bird roundel

Linen and wool. 9.2 × 20 cm
Coptic, 8th century M82.65

The fragment of linen cloth is decorated with an inwoven polychrome tapestry band. It is probably from the clavus of an undyed linen tunic. The bird is oriented in the direction of the warp. There is a plain selvage at the top, but the other three edges are raw.

GROUND CLOTH
Weave: tabby
Warp: linen / undyed, s; 17 ends per cm
Weft: linen / undyed, s; 16 passes per cm
INWOVEN TAPESTRY BAND
Weave: tapestry; weft-faced tabby binding; slit and dovetailed; eccentric wefts; vertical ground-weft wrapping. Very little use of an ecru supplementary weft: vertical extra-weft wrapping (largely worn away) and a touch of 'flying' weft for the eye of the bird
Warp: uses the warp of the ground cloth in units of 2; 9 units per cm. The warp ends are crossed at the point of juncture between tabby and tapestry.
Weft: wool / purplish-red, green, yellow, and medium blue, s
 linen / undyed, s
 55 per cm

A band of florets and guilloche incorporating a bird roundel is woven into an undyed linen cloth without any delimiting border. Such open designs do occur sometimes in tunics (Du Bourguet [cat. 199], D 16 of the seventh century and E 1 of the eighth century), but are much more frequent in hangings, curtains, and covers (ibid., E 81, and E 116 of the eighth century). The florets, guilloche, and roundel frame are red, the stems green, the bird green with blue and red details on a yellow ground.

From the Delacorte Collection

Purchased from Juergens, New York, 1964 AL

211 Polychrome geometric design in weft-loop pile

Linen and wool.
41.5 × 26.3 cm; square panel
16 × 16.5 cm
Coptic, 8th century M82.71

The fragment is from a linen cloth with pattern areas of weft-loop pile in polychrome wool. It is probably from a hanging or cover. All edges are raw.

GROUND CLOTH
Weave: tabby, with predominant warp
Warp: linen / bleached, s; 16 ends per cm
Weft: linen / bleached, s; 8 passes per cm
INWOVEN PILE DECORATION
Weave: uncut weft-loop pile
Supplementary weft: wool / dark purplish-blue, dark blue, purple, yellow, green, and red, s
 linen / bleached, s

The design consists of a square panel accompanied by a few rows of badly worn weft-loop pile in yellow, purple, and dark blue. At the centre of the dark purplish-blue panel is a rosette in ecru, dark blue, and red. In each corner is a circle divided into four wedges, the opposing pairs of which are either yellow or green.

Textiles done in this technique, of which this is the only example in the collection, are particularly difficult to date. Certain figural panels, such as the Dionysos in the Pushkin Museum (Ludmila Kybalova, *Coptic Textiles*, London 1967, no. 6), and the Nilotic scene in the British Museum (John Beckwith, 'Coptic Textiles,' *Ciba Review* XII, 133, 1959, pl. p. 6), with their classical spirit, subtle colour gradations, and impressionistic effects, are often given an early date because of close parallels in Late Roman mosaics. Simple ubiquitous geometric designs such as ours, however, provide few clues as to dating. Similar examples in the Louvre, such as E 157, 159, 161, and 163, are assigned by Du Bourguet [cat. 199] to the eighth century. Examples in the Vatican Museum are given a date in the fourth to fifth

centuries (Dorothée Renner, *Die koptischen Textilien in den vatikanischen Museen*, Wiesbaden 1982, nos. 2 and 8).

Purchased from Juergens, New York, 1963 AL

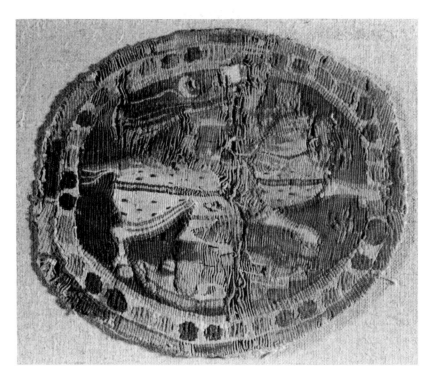

212 Polychrome tapestry roundel with a horseman

Linen and wool. 17 × 18.5 cm
Coptic, 9th century M82.47

This polychrome tapestry roundel is probably from an undyed linen tunic. Traces of the ground cloth into which it was woven are turned back at the edges. The design is oriented in the direction of the warp. All edges are raw.

GROUND CLOTH
Weave: tabby
Warp: linen, undyed, S,2Z; 10 ends per cm
Weft: linen, undyed, S; too little remains for further analysis.

INWOVEN TAPESTRY ROUNDEL
Weave: tapestry; weft-faced tabby binding; slit and dovetailed; eccentric wefts; extensive vertical ground-weft wrapping. Use of varicoloured supplementary wefts: vertical extra-weft wrapping and 'flying' wefts
Warp: uses the warp of the ground cloth.
Weft: wool / purplish-red, beige, dark greenish-blue, medium green, yellow and brown, S

 linen / undyed, S
 49 per cm

A third horseman roundel demonstrates the continuing popularity of this motif throughout the history of Coptic textiles (see catalogue 200 and 206, also 224 and 232. For further examples see Rudolf Berliner, 'Horsemen in Tapestry Roundels found in Egypt,' *Textile Museum Journal*, I, 2, Dec. 1963, 39–54). Equally popular in the art of both East and West, the significance of the motif varies from a depiction of the pleasures of the hunt to a symbol of victory over the enemy, be it animal, human, or spiritual. See Suzanne Lewis, 'The Iconography of the Coptic Horseman in Byzantine Egypt,' *Journal of the American Research Centre in Egypt*, X, 1973, 27–62. Lewis draws mostly on examples in Roman, Early Byzantine, and Coptic art. For examples in Sasanian and Early Islamic art see Prudence Oliver Harper, *The Royal Hunter: Art of the Sasanian Empire*, catalogue of an exhibition held at the Asia House Gallery, New York, winter 1978.

In this case, much of the detail of the rider has unfortunately been obliterated. He seems to be holding up a large stone in his left hand, while his right arm is held back and down, perhaps simply resting on

his horse's croup as in a companion piece in the Louvre (Du Bourguet [cat. 199], F 186). Over his flying mantle is a disembodied head, oddly human in appearance. This perhaps represents an animal of the hunt used as a filler motif, as are the two florets at the right. Beneath the feet of the galloping horse is another animal difficult to identify, probably either a hunting dog or a wild animal. Both the rider's head and the horse's foreleg overlap the multicoloured jewelled border.

This textile belongs to a series of Coptic tapestries directly inspired by a well-known group of Middle Byzantine drawloom-woven textiles generally referred to as the Alexandrian Silks. This group of silks was discussed at length by Von Falke (Otto von Falke, *Kunstgeschichte der Seidenweberei*, Berlin 1921, pp. 6–9, and especially figs. 43, 44), who attributed them to sixth-seventh century Alexandria. The generally accepted date nowadays, however, is the late eighth or ninth century and their place of manufacture cannot be localized more specifically than somewhere within the Byzantine Empire (see John Beckwith, 'Byzantine Tissues,' *Actes du 14e Congrès international des études byzantines à Bucarest, 1971*, Bucarest 1974, pp. 347–8; and Donald King, 'Patterned Silks in the Carolingian Empire,' *Bulletin de liaison du Centre International d'Etude des Textiles Anciens*, no. 23, Jan. 1966, p. 47). Characteristic of the group, which includes a number of hunting subjects, are monumental polychrome designs on a red background, most often within a framework of roundels. The distinctive floral border of these silks is replaced by a jewelled border more reminiscent of Sasanian prototypes, although here we have multicoloured stones rather than pearls (see Michael W. Meister, 'The Pearl Roundel in Chinese Textile Design,' *Arts Orientalis*, VIII, 1970, 255–67). Cf Du Bourguet [cat. 199], F 186 of the ninth century.

Purchased from Kelekian, New York

AL

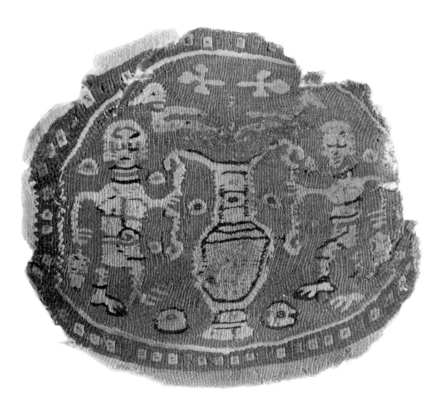

guished by an unusual method of
outlining. In the torsos of the nude
male figures, for example, the mus-
culature of one half of the chest is
outlined in one colour while the
other half is detailed in a contrasting
colour. In similar fashion, the out-
lines of the horseman roundel are
green in the left half of the design and
yellow in the right half. Cf Thomp-
son [cat. 199], no. 25.

As with catalogue 212, there are
many parallel examples to be found
in Early Islamic art.

Purchased from Daniel Brooks, New
York AL

213 Polychrome tapestry roundel with two male figures flanking an amphora

Wool. 13.8 × 15.3 cm
Coptic, 9th century M82.79

The fragment is from an all-wool
textile with an inwoven polychrome
tapestry roundel. It is probably from a
pale yellow woollen tunic. The de-
sign is oriented in the direction of the
warp. All edges are raw.

GROUND CLOTH
Weave: weft-faced tabby
Warp: wool / pale yellow, s; 9 ends
per cm
Weft: wool / pale yellow, s; 37 passes
per cm

INWOVEN TAPESTRY ROUNDEL
Weave: tapestry; weft-faced tabby
binding; slit and dovetailed; eccentric
wefts; little vertical ground-weft
wrapping. Extensive use of varicol-
oured supplementary wefts for out-
lining and inner detail: vertical,
diagonal, and curvilinear extra-weft
wrapping and 'flying' wefts; used

doubly for the pale yellow inner
border.
Warp: uses the warp of the ground
cloth.
Weft: wool / red, pale yellow, purple,
dark blue, medium blue, green, pink,
and orange, s; 62 per cm

Related to the example in catalogue
212 is this jewelled roundel with a
design suggestive of a drinking party
after a successful day at the hunt
or on the field of battle, perhaps even
in the afterlife. Two servants clad
only in loincloths, but wearing an-
klets and heavy collars, carry a large
amphora between them while dan-
gling a bunch of grapes (?) from their
free hand. Two birds are perched
on the amphora while between them
is a branch with two leaves, again
suggestive of paradise. Any free space
is filled with jewels or stylized flow-
ers sprinkled over the red ground.

Although differing from catalogue
212 in that the design is done mostly
in pale yellow with only details
picked out in colour, both are distin-

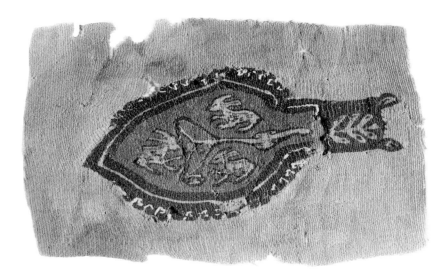

214 Spatulate polychrome tapestry panel with three rabbits encircling a stylized tree

Wool and linen.
13.3 × 21 cm; tapestry panel
8.2 × 16.7 cm
Coptic, 9th century M82.58

The fragment is from a woollen cloth with inwoven polychrome tapestry decoration, probably a pale yellow woollen tunic. The rabbits are oriented in the direction of the warp. All edges are raw.

GROUND CLOTH
Weave: weft-faced tabby
Warp: wool / pale yellow, s; 10 ends per cm
Weft: wool / pale yellow s; 31 passes per cm

INWOVEN TAPESTRY PANEL
Weave: tapestry; weft-faced tabby binding; slit and dovetailed; eccentric wefts. Extensive use of varicoloured supplementary wefts, often used as double (s,2z) plied threads: vertical extra-weft wrapping and 'flying' wefts. Linen used in the border only.
Warp: uses the warp of the ground cloth.
Weft: wool / purple, orange, pale yellow, dark blue, red, and dark green, s
 linen / bleached, s
 54 per cm

A spatulate or leaf-shaped ornament with a purple and yellow border decorated with a white running wave design contains a highly stylized Tree of Life encircled by three rabbits. The motifs within the frame are done largely in pale yellow wool, with only touches of other colours, on an orange ground. Technically and stylistically this piece is close to catalogue 213 and 215, both of the ninth century. Compositionally, however, all similar pieces in Du Bourguet [cat. 199] happen to date from the tenth and eleventh centuries. The spatulate shape is echoed by G 96 and G 137–9, while the single animals on three sides of the plant or tree are echoed by G 44, G 94, and H 186–7.

From the Delacorte Collection

Purchased from Juergens, New York, 1964 AL

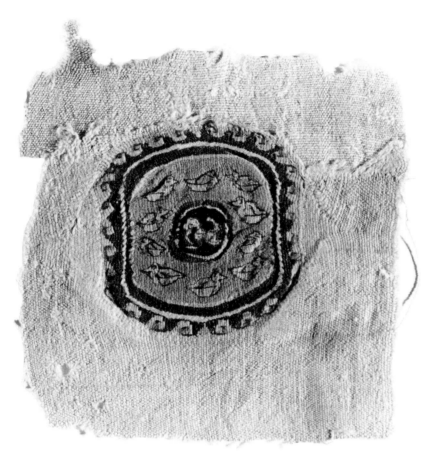

215 Polychrome tapestry roundel with ducks

Wool.
17.2 × 16 cm; roundel 9.5 × 8. 2 cm
Coptic, 9th century M82.77

The fragment is an all-wool textile, in two pieces, decorated with an inwoven polychrome tapestry roundel. It is probably from a pale yellow woollen tunic. The design is oriented in the direction of the warp. All edges are raw.

GROUND CLOTH
Weave: tabby with predominant weft
Warp: wool / pale yellow, s; 10 ends per cm
Weft: wool / pale yellow, s; 19 passes per cm

INWOVEN TAPESTRY ROUNDEL
Weave: tapestry; weft-faced tabby binding; slit and dovetailed; eccentric wefts. Extensive use of varicoloured supplementary wefts: vertical and curvilinear extra-weft wrapping and 'flying' wefts. The pale yellow used for the supplementary weft wrapping of the border is s,3z.
Warp: uses the warp of the ground cloth.
Weft: wool / orange, dark purplish-blue, dark blue, green, red, and pale yellow, s; 50 per cm

A roundel with a running wave border is decorated with a row of ducks swimming around a central medallion containing a running lion (?). The outer border is purple, the inner medallion dark blue framed in medium blue, and the main field orange. The design is mostly in pale yellow, with outlining and inner detail in a variety of colours. Technically and stylistically this roundel is similar to catalogue 213 and 214. Cf Du Bourguet [cat. 199], F 124–5 of the ninth century.

Purchased from Juergens, New York, 1963 AL

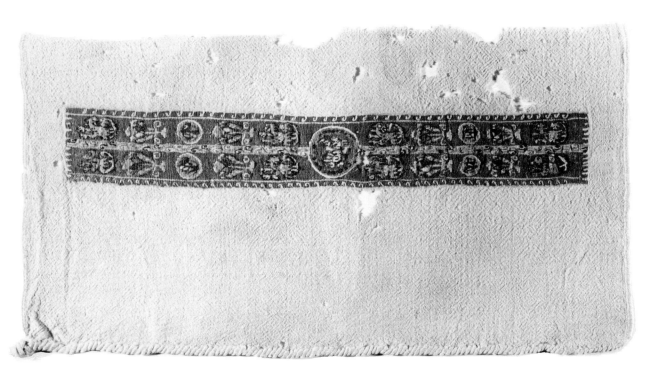

216 Polychrome tapestry band with Nilotic motifs

Wool and linen.
17.3 × 31.4 cm; band 4 × 26.6 cm
Coptic, 9th / 10th century

M82.64

This fragment of woollen cloth decorated with an inwoven polychrome tapestry band is probably from the sleeve of a pale yellow woollen tunic. The design is largely oriented in the direction of the warp. Three selvages are intact: both lateral edges are reinforced with two bundles of multiple warps; the terminal edge is finished with a cord twisted in s.

GROUND CLOTH
Weave: tabby, with a slight textured design of irregular broken diagonals produced by the occasional use of 2 lats per pass
Warp: wool / pale yellow, s; 18 ends per cm
Weft: wool / pale yellow, s; sometimes 1, sometimes 2 lats per pass; 15 passes per cm

INWOVEN TAPESTRY BAND
Weave: tapestry; weft-faced tabby binding; slit and dovetailed; eccentric wefts; vertical ground-weft wrapping. Use of supplementary wefts in a variety of colours, both singly and doubly: curvilinear and vertical extra-weft wrapping and 'flying' wefts
Warp: uses the warp of the ground cloth.
Weft: wool / purplish-red, orange, 3 shades of blue, 2 greens, yellow, and pink, s
 linen / bleached, s
 68 per cm
Even without the added evidence of three finished edges, it is possible to determine that this tapestry band must have come from the sleeve of a tunic simply because of its composition. Short double bands such as this, sometimes with a central section unifying the two zones, seem to be the most common choice of decoration for this spot, judging by countless numbers of relatively intact tunics (Trilling [cat. 199], nos. 26, 66, 74, and 103). The double band is

here decorated with two rows of marine animals, conventionalized flowering plants and bird medallions to either side of a central jewelled roundel containing a nereid (?). The red ground is divided by a narrow beige band decorated with a plant scroll bearing pairs of curling black and blue leaves to either side of an undulating orange stem. The whole is framed by a running wave border.

The workmanship is very fine, the polychromy much more than line drawing. The marine animals, for example, are worked with great attention to detail, their heads alternately facing front or back, their forequarters spotted, their tails curled up and over, coloured in zigzag bands and ending in a trefoil. Cf Du Bourguet [cat. 199], F17–19 and F 45–6 of the ninth century, and G 193 and G 224 of the tenth century.

From the Delacorte Collection

Purchased from Juergens, New York, 1964

AL

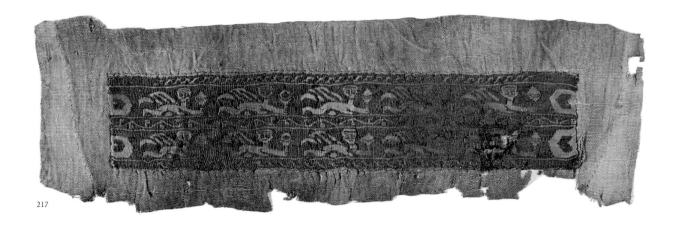

217

217 Monochrome tapestry band with swimming putti

Linen and wool.
10.5 × 33 cm; band 5.5 × 25.5 cm
Coptic, 10th century M82.60

A monochrome tapestry band is appliqued to a linen cloth, almost certainly the sleeve of an undyed linen tunic. There are signs of sewing at either side, probably forming the seam of the sleeve. A plain selvage is at the left, the other three edges are raw. The appliqued tapestry band has signs of an undyed linen tabby ground cloth turned back at the edges. The design is oriented in the direction of the warp.
LINEN CLOTH
Weave: tabby with predominant warp and occasional cut supplementary-weft loops (on the reverse)
Warp: linen / undyed, s; 33 ends per cm
Weft: linen / undyed, s; 14 passes per cm
APPLIQUED TAPESTRY BAND
Weave: tapestry; weft-faced tabby binding; slit and dovetailed; eccentric wefts; vertical ground-weft wrapping. Only a very slight use of supplementary wefts: 'flying' wefts in both colours and minor amounts of vertical extra-weft wrapping in linen only.

Warp: linen / undyed, s; used in units of 2; 11 units per cm
Weft: wool / purplish-red, s
 linen / undyed, s
 83 per cm

Another armband is decorated with a single Nilotic motif repeated ten times without change – a swimming putto grasping a lotus blossom, done in ecru on a purplish-red ground. At either end of the double row is a heart. The outer border is decorated with a running wave, while the median strip is decorated with an ever more stylized plant scroll. Cf Du Bourguet [cat. 199], G 112 and G 114.

From the Delacorte Collection

Purchased from Juergens, New York, 1964 AL

218 Mainly monochrome tapestry roundel with swimming putti

Wool and linen.
14.5 × 17 cm; roundel 7.3 × 6. 2 cm
Coptic, 10th century M82.84

The fragment of woollen textile is decorated with an inwoven tapestry roundel. It is probably from a pale yellow woollen tunic. The design is in ecru on purple with touches of pale yellow, and is oriented in the direction of the warp. All edges are raw.
GROUND CLOTH
Weave: tabby with 3 bands of multiple wefts at the top
Warp: wool / pale yellow, s; 13 ends per cm
Weft: wool / pale yellow, s; 24 passes per cm
INWOVEN TAPESTRY ROUNDEL
Weave: tapestry; weft-faced tabby binding; slit and dovetailed; eccentric wefts. Use of supplementary wefts in both ecru and purple, the former used triply in the border (s,3z): vertical and curvilinear extra-weft wrapping and 'flying' weft
Warp: uses the warp of the ground cloth.
Weft: wool / purple and pale

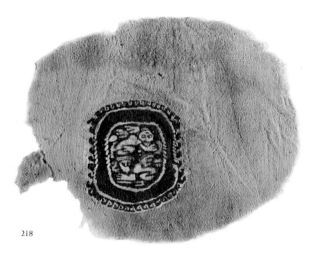

218

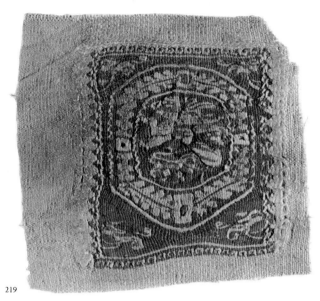

219

yellow, s
 linen / undyed, s
 45 per cm

This roundel, with two swimming
putti within a running wave border,
is similar in style and subject matter
to catalogue 217. The design is done
in two tones of beige on a purple
ground. The putti hold what appear
to be ducks, but the advanced state
of distortion, disintegration, and
reorganization of forms does not per-
mit an exact reading of the design.
Cf Du Bourguet [cat. 199], G 79, G 82,
and G 112 of the tenth century.

Purchased from Juergens, New York,
1963 AL

219 Monochrome tapestry square with putti framed by a jewelled wreath

Wool. 14 × 14 cm; panel 11 × 9 cm
Coptic, 10th century M82.81

The piece is a fragment of all-wool
textile decorated with an inwoven
monochrome tapestry square. It is
probably from a pale yellow woollen
tunic. The design is oriented in the
direction of the warp. All edges are
raw.

GROUND CLOTH
Weave: tabby with predominant
weft
Warp: wool / pale yellow, s; 11 ends
per cm
Weft: wool / pale yellow, s; 30 passes
per cm

INWOVEN TAPESTRY PANEL
Weave: tapestry; weft-faced tabby
binding; slit and dovetailed; eccentric
wefts; vertical ground-weft wrap-
ping. Extensive use of supplementary
wefts in both colours, often used
doubly (s,2z): vertical, horizontal,
diagonal, and curvilinear extra-weft
wrapping and 'flying' wefts
Warp: uses the warp of the ground
cloth.
Weft: wool / purple and pale yellow,
s; 45 per cm

This tapestry panel is decorated with

a combination of Nilotic and hunt-
ing motifs. Within the central roun-
del, encircled by a jewelled wreath,
are what appear to be two putti.
The one above swims while holding
onto a lotus blossom, the one below
appears to be wrestling with an ani-
mal. In the angles of the square are
four single running animals, probably
hunting dogs, and the whole is framed
by a running wave border. The de-
sign is again in pale yellow wool
on a purple ground. Cf Du Bourguet
[cat. 199], G 82 and G 109 of the
tenth century.

Purchased from Juergens, New York,
1963 AL

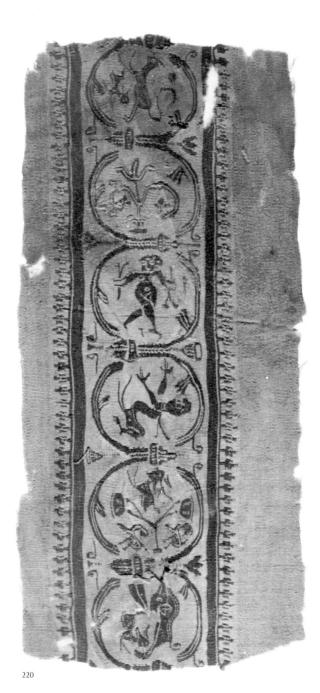

220

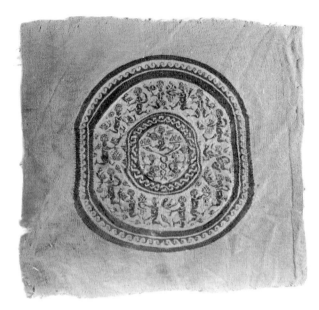

221

ping. Extensive use of supplementary wefts in both colours, often with double or plied (s,2z) threads; vertical, horizontal, and curvilinear extra-weft wrapping and 'flying' wefts; 2 double pale yellow supplementary wefts are used together in countered vertical extra-weft wrapping.
Warp: uses the warp of the ground cloth.
Weft: wool / pale yellow and purple, s; 56 per cm

This fragment of a band is decorated with an inhabited plant scroll in negatlve image, purple on a pale yellow ground. The highly stylized leaves, barely recognizable as such, form circular compartments for Dionysiac motifs – centaurs and nude female dancers playing castanets or cymbals, animals, and formal plant motifs. The whole is framed by a conventionalized border, perhaps representing a stylized floral wreath.
Cf Du Bourguet [cat. 199], G 48, G 50, and G 57 of the tenth century.

From the Delacorte Collection

Purchased from Juergens, New York, 1964 AL

220 Monochrome tapestry band with an inhabited scroll

Wool. 18.2 cm × 42 cm; band 12 cm
Coptic, 10th century M82.56

The fragment is from an all-wool textile decorated with an inwoven monochrome tapestry band, probably the clavus from a pale yellow woollen tunic. There is some patching with fragments of the same textile and there are some loose fragments. All edges are raw.
GROUND CLOTH
Weave: tabby
Warp: wool / pale yellow, s; 11 ends per cm
Weft: wool / pale yellow, s; 25 passes per cm
INWOVEN TAPESTRY BAND
Weave: tapestry; weft-faced tabby binding; slit and dovetailed; eccentric wefts; vertical ground-weft wrap-

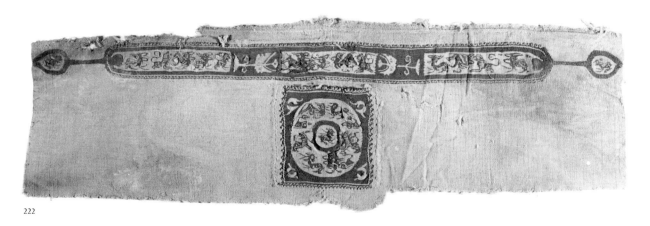

222

221 Monochrome tapestry roundel with putti carrying birds or baskets of fruit

Wool.
32 × 32 cm; roundel 23.2 × 20 cm
Coptic, 10th century M82.78

The fragment is from an all-wool textile decorated with an inwoven monochrome tapestry roundel. It is probably from a pale yellow woollen tunic. The design is oriented in the direction of the warp. All edges are raw.

GROUND CLOTH
Weave: weft-faced tabby
Warp: wool / pale yellow, s; 10 ends per cm
Weft: wool / pale yellow, s; 32 passes per cm

INWOVEN TAPESTRY ROUNDEL
Weave: tapestry; weft-faced tabby binding; slit and dovetailed; eccentric wefts; vertical ground-weft wrapping. Extensive use of supplementary wefts: vertical, curvilinear, and diagonal extra-weft wrapping and multiple 'flying' wefts, including crossovers with double 'flying' wefts and countered vertical extra-weft wrapping.
Warp: uses the warp of the ground cloth.
Weft: wool / pale yellow and purple, s; the supplementary wefts often s,2z; 79 per cm

A series of lively putti, their legs twisted to left and right, busily occupy themselves with ducks, baskets of fruit, and cornucopiae on a field strewn with twigs and fish. The purple design on a pale yellow ground

is framed by a running wave, while the central medallion has a guilloche border. Cf Du Bourguet's group G of the tenth century [cat. 199].

Purchased in Cairo AL

222 Monochrome tapestry decoration from a tunic, with animals and palmettes

Wool.
23 × 68.8 cm; band 4.7 cm, square 12.2 cm
Coptic, 10th century M82.39

The fragment is an all-wool textile with inwoven monochrome tapestry decoration. It is probably from the shoulder of a pale yellow woollen tunic. The design is largely oriented in the direction of the warp. All the edges are raw.

GROUND CLOTH
Weave: tabby with predominant weft. There are 4 bands of countered horizontal extra-weft wrapping of varying length at the neck edge of the garment.
Warp: wool / pale yellow, s; 11 ends per cm
Weft: wool / pale yellow, s; 31 passes per cm

INWOVEN TAPESTRY DECORATION
Weave: tapestry; weft-faced tabby binding; slit and dovetailed; eccentric wefts; vertical ground-weft wrapping. Supplementary wefts in both colours used singly and doubly: vertical, horizontal, and curvilinear extra-weft wrapping and 'flying' wefts

Warp: uses the warp of the ground cloth.
Weft: wool / purple and pale yellow, s; 58 per cm

The shoulder ornament of this tunic makes effective use of the contrast between areas of dark pattern on a light ground and areas of light pattern on a dark ground. The former has a row of animals of the hunt, the latter stylized formal plant motifs. Both are close in style to catalogue 220 and are paralleled by Du Bourguet [cat. 199], H 97 and H 188 of the eleventh century.

Purchased from Juergens, New York 1963 AL

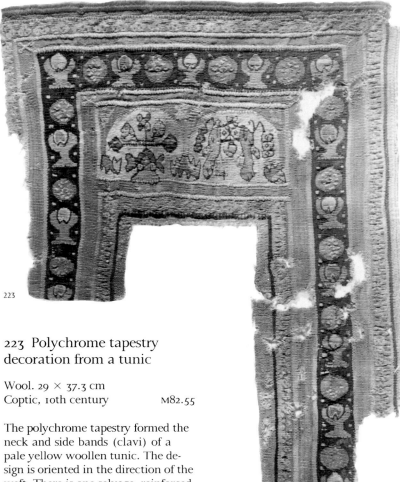

223

G 258–9 of the tenth centry.

From the Delacorte Collection

Purchased from Juergens, New York, 1964 AL

224 Polychrome tapestry band with horsemen and nereids within roundels

Wool and linen.
15 × 63.5 cm; band 10 cm
Coptic, 10th century M82.40

The woollen textile is decorated with an inwoven polychrome tapestry band. It probably formed the clavus of a pale yellow woollen tunic. The design is largely oriented in the direction of the weft. All edges are raw.

GROUND CLOTH
Weave: weft-faced tabby
Warp: wool / pale yellow, s; 10 ends per cm
Weft: wool / pale yellow, s; 39 passes per cm

INWOVEN TAPESTRY BAND
Weave: tapestry; weft-faced tabby binding; slit and dovetailed; eccentric wefts; vertical ground-weft wrapping. Extensive use of supplementary wefts of every colour, one or more threads used at a time: vertical, horizontal, diagonal, and curvilinear extra-weft wrapping and 'flying' wefts. Countered vertical extra-weft wrapping and crossovers with double 'flying' wefts
Warp: uses the warp of the ground cloth.
Weft: wool / red, orange, dark blue, green, pink, yellow, and brown, s
 linen / undyed, s
 44 per cm

A broad red band is framed by a dark blue running wave heavily outlined in an undyed linen supplementary weft. A central frieze is decorated with a series of horsemen and roundels on an orange ground. The equestrian figures, with short striped tunics, comb-like thatches of hair, and one arm upraised, appear to be wedged into the backs of their gorgeous multicoloured steeds. Within the roundels are nereids (?) holding dishes or

223 Polychrome tapestry decoration from a tunic

Wool. 29 × 37.3 cm
Coptic, 10th century M82.55

The polychrome tapestry formed the neck and side bands (clavi) of a pale yellow woollen tunic. The design is oriented in the direction of the weft. There is one selvage, reinforced with two bundles of multiple warps. The other edges are raw. The inwoven tapestry band is finished at the right with a line of countered horizontal extra-weft wrapping; the left-hand side would probably have been finished in like manner.

GROUND CLOTH
Weave: tabby with predominant weft
Warp: wool / pale yellow, s; 10 passes per cm
Weft: wool / pale yellow, s; 20 passes per cm

INWOVEN TAPESTRY DECORATION
Weave: tapestry; weft-faced tabby binding; slit and dovetailed; eccentric wefts; vertical ground-weft wrapping. Some use of supplementary wefts, mainly in pale yellow but also in dark blue and red, the first used both singly and doubly: vertical extra-weft wrapping and double 'flying' wefts; includes crossovers and count-

ered horizontal extra-weft wrapping.
Warp: uses the warp of the ground cloth.
Weft: wool / red, pale yellow, darker yellow, dark blue and light blue, s; 39 per cm

Broad red bands from a pale yellow tunic are decorated with a series of stylized flowers alternating with roundels on a dark blue ground dotted with pearls. The roundels contain rosettes done only in a pale yellow supplementary weft on a red ground. The neckband incorporates also a panel with barely recognizable formal plant motifs, one with fish, in a double niche. Only the dark blue bands and the central panel are done in polychromy, the rest is pale yellow on a red ground. Cf Du Bourguet [cat. 199], G 40–1, G 171, and

containers of some sort. Cf Du Bour-
guet [cat. 199], G 195–206 of the tenth
century. See also Irmgard Peter, *Tex-
tilien aus Agypten in Museum Riet-
berg Zürich* (Zurich 1976), no. 86. AL

225 Polychrome tapestry band with a nimbed figure, lion, and plant motif

Linen and wool.
6 × 29.5 cm; band 5.6 cm
Coptic, 10th century M82.62

The fragment is from a linen cloth
with an inwoven polychrome tapes-
try band. It is probably the clavus
from an undyed linen tunic. The de-
sign is largely oriented in the direc-
tion of the weft. All edges are raw.
GROUND CLOTH
Weave: tabby with predominant
weft
Warp: linen / undyed, s,2z; 11 ends
per cm
Weft: linen / undyed, s; estimated 28
passes per cm
INWOVEN TAPESTRY BAND
Weave: tapestry; weft-faced tabby
binding; slit and dovetailed; eccentric
wefts; vertical ground-weft wrap-
ping. No use of supplementary wefts
Weft: wool / orange-red, dark blue,
light blue, dark green, light green,
pink, yellow and purple, s
 linen / undyed, s
 34 per cm

A common motif of the period is this
standing saint in Byzantinizing jew-
elled costume within a border of
interlocking multicoloured L shapes.
Below are the animal and plant mo-
tifs so richly represented in Coptic
tapestries of all periods. Cf Du Bour-
guet [cat. 199], G 305, G 328–32, and G
341–3 of the tenth century. See also
Peter [cat. 224], no. 102, perhaps
part of the same tunic ornament.

From the Delacorte Collection

Purchased from Juergens, New York
1964 AL

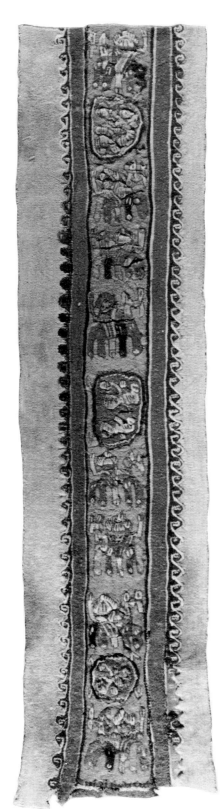

224

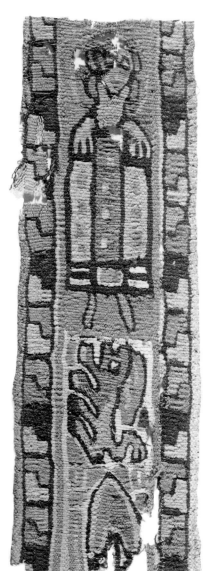

225

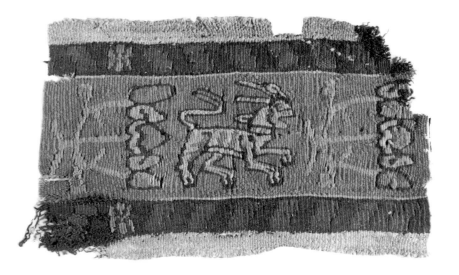

226 Polychrome tapestry band with a stylized animal between plants

Linen and wool.
9.8 × 15.3 cm; band 7.8 cm
Coptic, 10th century M82.59

The fragment is from a linen cloth decorated with an inwoven polychrome tapestry band, probably the clavus of an undyed linen tunic. The design is largely oriented in the direction of the weft. All edges are raw.

GROUND CLOTH
Weave: tabby with predominant weft
Warp: linen / undyed, s,2z; 11 ends per cm
Weft: linen / undyed, s; estimated 24 passes per cm
INWOVEN TAPESTRY BAND
Weave: tapestry; weft-faced tabby binding; slit and dovetailed; eccentric wefts; vertical ground-weft wrapping. Slight use of a linen supplementary weft: vertical extra-weft wrapping and 'flying' weft
Warp: uses the warp of the ground cloth.
Weft: wool / orangey-red, dark blue, light blue, yellow, pink, green, and purple, s
 linen / bleached, s
 46 per cm

This fragment with a horned animal between two flowering shrubs, framed by diagonally striped bands

with occasional rosettes, is similar to catalogue 225. The checkered bands detailing the horns, collar, and stomach of the animal are to be found in many examples of the period (see also catalogue 228). Cf Du Bourguet [cat. 199], G 132, G 226, G 251–2, and G 329 of the tenth century.

From the Delacorte Collection

Purchased from Juergens, New York, 1964 AL

227 Polychrome tapestry band with a row of three winged figures

Wool. 5 × 20.7 cm
Coptic, 10th century M82.63

The polychrome tapestry band has some of the ground cloth into which it was woven turned back at the edges. There are traces of another tabby cloth on the back, perhaps indicating that the tapestry band was used or reused as an applique. It is probably the clavus from a woollen tunic. The design is oriented in the direction of the weft. All edges are raw.

GROUND CLOTH
Weave: tabby
Warp: wool / brown, s; 10 ends per cm
Weft: wool / pale yellow, s; estimated 19 passes per cm
INWOVEN TAPESTRY BAND
Weave: tapestry; weft-faced tabby binding; slit and dovetailed; eccentric wefts; vertical ground-weft wrapping. Little use of supplementary wefts: varicoloured 'flying' wefts
Warp: uses the warp of the ground cloth.
Weft: wool / dull faded red, light green, dark green, pale yellow, and dark purplish-blue, s; 50 per cm
CLOTH TO WHICH IT WAS APPLIED
Weave: loosely woven tabby
Warp: wool / pale yellow, s; 11 ends per cm
Weft: wool / pale yellow, s; 15 passes per cm

This band has nude winged beings within a jagged border. The lack of more precise detail and the general obscurity of the design unfortunately do not allow a more exact identification of the subject matter.

From the Delacorte Collection

Purchased from Juergens, New York, 1964 AL

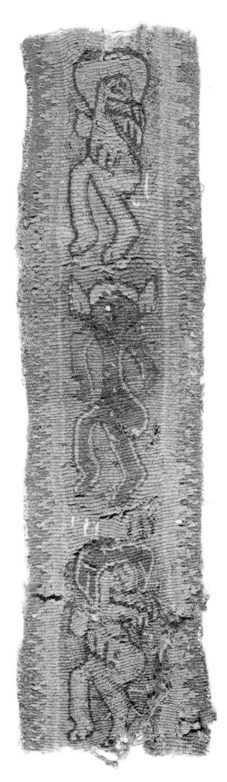

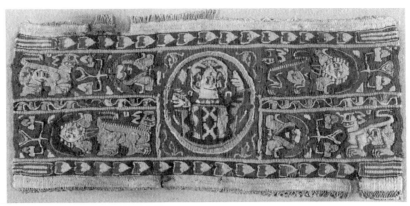

228 Polychrome tapestry band with a central medallion containing a nimbed bust flanked by a double row of stylized lions and plant motifs

Linen and wool. 14.7 × 30.6 cm
Coptic, 10th century M82.46

This polychrome tapestry band was almost certainly the armband of an undyed linen tunic. The design is oriented in the direction of the warp. A narrow band of well-faced tabby above and below (the ground cloth?) is followed by a band of loosely woven tabby, followed again by weft-faced tabby. All edges are raw.
GROUND CLOTH (?)
Weave: weft-faced tabby
Warp: linen / undyed, s,2z; 10 ends per cm
Weft: linen / bleached, s; estimated 38 passes per cm
NARROW BAND OF LOOSELY WOVEN TABBY
Warp: uses the warp of the ground cloth.
Weft: linen / undyed, s,2A; estimated 8 passes per cm
INWOVEN TAPESTRY BAND
Weave: tapestry; weft-faced tabby binding; slit and dovetailed; eccentric wefts; vertical ground-weft wrapping. Very extensive use of supplementary wefts of every colour, one or more threads used at a time: vertical, horizontal, diagonal, and curvilinear extra-weft wrapping and 'flying' wefts
Warp: uses the warp of the ground cloth.

Weft: wool / purplish-red, 3 shades of blue, yellow, green, black, brown and white, s
 linen / bleached, s
 48 per cm

In contrast to catalogue 227, this tapestry armband has been woven with a wealth of attention to detail. Within a dark blue border decorated with a row of red and white hearts is a purplish-red field divided into five sections; a central roundel within a square, with the bust of a saint; two short friezes to either side, each with a lion and a composite formal plant motif. Separating the friezes is a narrow black band with a floral plant scroll, and similar blossoms are woven into the corners of the central square. An interesting feature of the design is the incorporation of human heads, two as the blossoms of a flower, another two by the hind legs of a lion. The checkered stripe across the back of the lion may be compared with catalogue 226, and the saint in Byzantinizing court costume with catalogue 225. Cf Du Bourguet [cat. 199], G 132 of the tenth century and F 169 of the ninth century. A similar armband and clavi are in the Brooklyn Museum: Thompson [cat. 199], no. 27.

Purchased from Kelekian, New York, 1965 AL

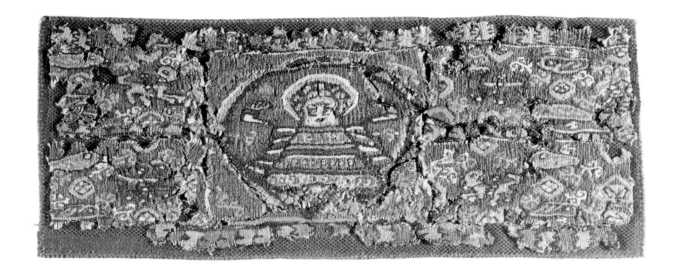

229 Polychrome tapestry band
with a central medallion
containing a nimbed bust
flanked by a double band of
lattice containing animal and
plant motifs

Linen and wool. 11 × 27 cm
Coptic, 10th century M82.72

This very fragmentary polychrome
tapestry band is patched together
from many small pieces. It was al-
most certainly the sleeveband of
a bleached linen tunic. The design is
oriented in the direction of the warp.
All edges are raw.
Weave: tapestry; weft-faced tabby
binding; slit and dovetailed; eccentric
wefts; vertical ground-weft wrap-
ping. Extensive use of supplementary
wefts in a variety of colours, often
used as double or plied (s,2z) threads:
horizontal, vertical, curvilinear, and
diagonal extra-weft wrapping. Very
little use of the 'flying' weft. Crossed
vertical extra-weft wrapping (of
which very little remains) forms the
border of the central panel.
Warp: linen / bleached, s,2z; 9 ends
per cm
Weft: wool / purplish-red, orange,
pink, dark blue, light blue, dark
green, light green, yellow, beige and
brown, s
 linen / bleached, s
 44 per cm

This armband, with a central saint
in orans position, has, in the two
narrow bands to either side, segments
of a lattice design. Within the loz-
enge-shaped compartments formed
by springs and rosettes are single
animals, fish, and composite flowers.
Cf Du Bourguet [cat. 199], H 6 of
the eleventh century. See also cata-
logue 228.

Purchased from Kelekian, New York,
1963 AL

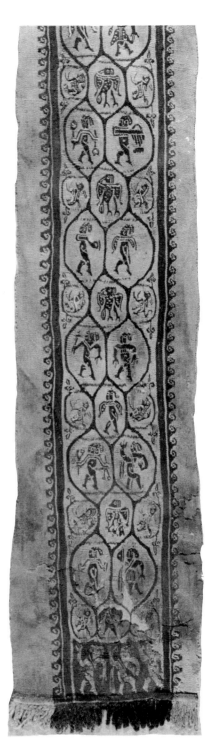

230 Largely monochrome tapestry band with figures within a stylized vine-scroll

Wool.
15 × 102 cm; 2.5 cm of weft-loop fringe; band 11 cm
Coptic, 11th century M82.38

The fragment is from an all wool textile decorated with an inwoven tapestry band, probably the clavus of a pale yellow woollen tunic. The largely monochrome design is enlivened by touches of colour. The design is oriented in the direction of the weft. One selvage is intact, forming the bottom hem of the garment; the selvage is reinforced by the use of three bundles of multiple warps and is finished with an uncut weft-loop fringe. The other three sides are raw.

GROUND CLOTH
Weave: weft-faced tabby
Warp: wool / pale yellow, s;
12 ends per cm
Weft: wool / pale yellow, s; 37 passes per cm

INWOVEN TAPESTRY BAND
Weave: tapestry; weft-faced tabby binding; slit and dovetailed; eccentric wefts. Extensive use of supplementary wefts, both purple and pale yellow, as both single and double threads: vertical, horizontal, diagonal, and curvilinear extra-weft wrapping and some 'flying' weft
Warp: uses the warp of the ground cloth.
Weft: wool / pale yellow and dark purple, with some touches of dull faded red and dark green, s; 60 per cm

This broad band decorated with an ever more unrecognizable plant scroll inhabited by Dionysiac figures, displayed eagles, and animals of the hunt is similar to catalogue 220. The female dancers and musicians are shown nude, while the male figures are dressed either in tunics or military garb. As in catalogue 222, there is an effective contrast between the major part of the decoration done in negative image (purple on a pale yellow ground) and the panel at the hem done in the reverse. Cf Du Bourguet [cat. 199], H 110–13 of the eleventh century; Peter [cat. 224], no.

26; and Trilling [cat. 199], no. 74, a complete tunic with similar decoration and fringe at the hem.

From the Delacorte Collection

Purchased from Juergens, New York, 1964 AL

231 Double tapestry band with mythological figures

Wool.
22 × 29 cm; band 19 × 26.5 cm
Coptic, 11th century M82.74

The fragment is an all-wool textile, almost certainly the sleeve of a purple woollen tunic. It is woven in tabby with a double inwoven tapestry band. The pattern is largely oriented in the direction of the weft. The top of the photo shows the remains of part of the line of vertical extra-weft wrapping in beige that marks the end of the tapestry band, giving us its complete width. But all four edges of the tabby are raw.

GROUND CLOTH
Weave: weft-faced tabby
Warp: wool / purple s; 11 ends per cm
Weft: wool / purple, s; 32 passes per cm

INWOVEN TAPESTRY BAND
Weave: tapestry; weft-faced tabby binding; slit and dovetailed; eccentric wefts; vertical ground-weft wrapping. Liberal use of supplementary wefts in beige only, used singly for inner drawing and doubly to accentuate the frame of each individual compartment of the design: vertical, horizontal, curvilinear, and diagonal extra-weft wrapping and 'flying' weft.
Warp: uses the warp of the ground cloth.
Weft: wool / dark blue, beige, and two shades of purple, one made slightly darker than the other by the admixture of some dark blue fibers, s; 35 per cm

A strikingly decorative armband has two rows of three square panels finished by demiroundels containing a floral motif. Four of the panels repeat exactly the same motif, a representation of Dionysos beside a pillar. The other two are inscribed by circles with leafy offshoots in the angles. One of the roundels contains a Tree of Life flanked on three sides by animals, the other has a nereid (?) seated on the back of an animal, grasping another by the neck.
Cf Du Bourguet [cat. 199], H 105–7

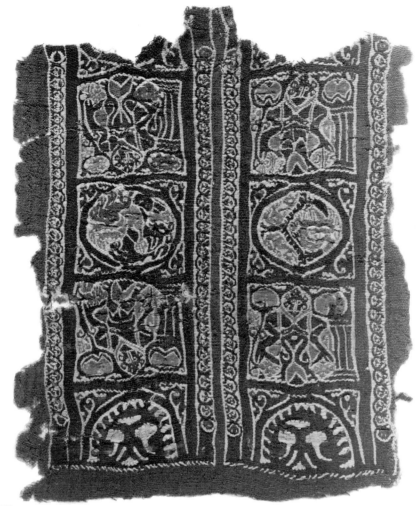

231

and H 115 of the eleventh century; Thompson [cat 199], no. 37.

Purchased from Juergens, New York, 1963 AL

232 Monochrome tapestry square with a horseman within a geometric lattice frame

Wool. 12.5 × 13.7 cm
Coptic, 11th century M82.48

The monochrome tapestry square has a border pieced together of four separate trapezoidal sections. It is probably from a woollen tunic. The design is oriented in the direction of the weft. All edges are raw.

Weave: tapestry; weft-faced tabby binding; slit and dovetailed; eccentric wefts; vertical ground-weft wrapping. Liberal use of supplementary wefts for the inner detail of the design, in both pale yellow and dark blue; vertical extra-weft wrapping and 'flying' wefts, the latter used four at a time in the border.
Warp: wool / brown, s; 8 ends per cm
Weft: wool / dark blue and pale yellow, s; 67 per cm

The last of our series of Coptic horsemen had a curly-haired rider with one arm raised, wedged into the back of his horse, galloping across a field strewn with plant elements. The border consists of a lattice design contrasting rows of light and dark lozenges. The former are decorated with dark blue rectangles on a pale

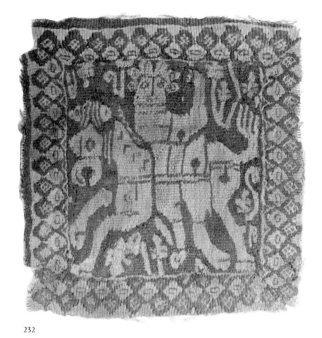

232

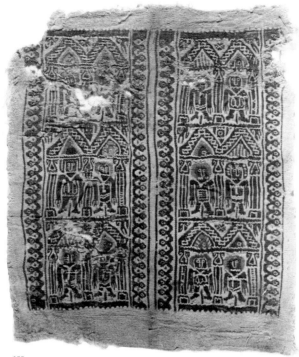

233

yellow ground. The latter have loz-
enges formed of four pale yellow
'flying' wefts used together on the
dark blue ground. It is this last tech-
nical feature which confirms the
late date of at least the border. Cf Du
Bourguet [cat. 199], H 65–73 and
H 177–8 for the central panel; and H
98 for the geometric border, all of
the eleventh century; Peter [cat. 224],
no. 31.

Purchased from Daniel Brooks, New
York AL

233 Double tapestry band with a largely monochrome design of human figures within a colonnade

Wool. 24 × 29.4 cm
Coptic, 11th century M82.75

The fragment is from the sleeve of a
pale yellow woollen tunic, tabby
with a double inwoven tapestry
band. The design is largely mono-
chrome, black on a pale yellow
ground, enlivened by touches of col-
our. The design is oriented in the
direction of the weft. One selvage is
largely intact: it is reinforced with
two bundles of multiple warps. The
other three sides have raw edges.
GROUND CLOTH
Weave: weft-faced tabby
Warp: wool / pale yellow, s; 15 ends
per cm
Weft: wool / pale yellow, s; 26 passes
per cm
INWOVEN TAPESTRY BAND
Weave: tapestry; weft-faced tabby
binding; slit and dovetailed; eccentric
wefts. Liberal use of supplementary
wefts, mostly pale yellow but also
red and green, for the inner detail and
outlining of the design: vertical ex-
tra-weft wrapping (some done with
double threads) and 'flying' weft
Warp: uses the warp of the ground
cloth.
Weft: wool / pale yellow and black,
with touches of red, orange, and
green, s; 64 per cm

Two rows of three double columnar
niches, each containing a human
figure, form the design of this arm-
band. The figures, wearing short
girdled tunics, stand in frontal posi-
tion with arms hanging limply to the
sides. The architectural framework
consists of fluted columns with bases
and carved capitals supporting trian-
gular pediments decorated in a vari-
ety of colour and design, surmounted
by a cornice band of angular guil-
loche. Filling the space above the pe-
diments are leaves and rosettes. Cf
Du Bourguet [cat. 199], H 104, H 124,
and H 181 of the eleventh century;
Peter [cat. 224], no. 32; Shurinova
[cat. 204], no. 136; Trilling [cat. 199],
no. 109.

Purchased from Kelekian, New York,
1963 AL

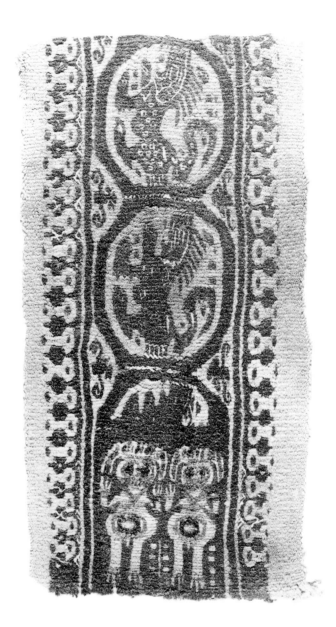

INWOVEN TAPESTRY BAND
Weave: Tapestry; weft-faced tabby binding; slit and dovetailed; eccentric wefts; vertical ground-weft wrapping. A limited use of woollen supplementary wefts in all five colours: vertical, horizontal, diagonal, and curvilinear extra-weft wrapping. Extensive use of bleached linen 'flying' wefts, although much of this surface detail has worn away: including crossovers of double 'flying' wefts and the use of four 'flying' wefts together.
Warp: uses the warp of the ground cloth.
Weft: wool / pale yellow and purple, s; wool; red, green, and dark blue, s,2z
 linen, bleached, s
 60 per cm

A row of tangent octagons enclosing lions ends at the hem in a panel containing a couple of nude orans figures. Empty spaces are filled with plant motifs, often reduced to simple dots. Related to catalogue 235-41, it differs from them basically in the lack of interlace on the borders of the octagonal compartments. Cf Du Bourguet [cat. 199], H 123 of the eleventh century.

From the Delacorte Collection

Purchased from Juergens, New York, 1964 AL

234 Largely monochrome tapestry band with figural panels

Wool and linen.
11 × 22.8 cm; tapestry band 9.2 cm
Coptic, 11th century M82.52

The woollen textile is decorated with an inwoven tapestry band, probably the clavus of a pale yellow woollen tunic. A largely monochrome design is enlivened by touches of colour.

The animals are oriented in the direction of the warp. There is the beginning of a selvage, forming the bottom hem of the garment: two bundles of multiple warps. The other three sides are raw.

GROUND CLOTH
Weave: weft-faced tabby
Warp: wool / pale yellow, s; 7 ends per cm
Weft: wool / pale yellow, s; 32 passes per cm

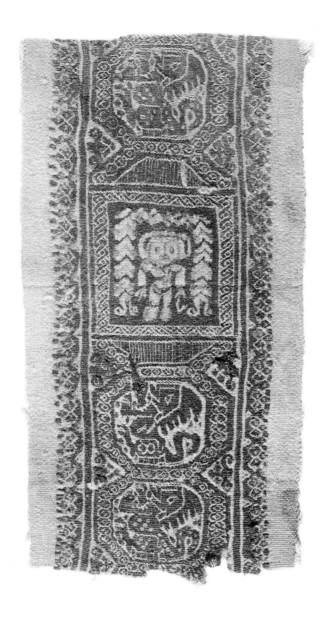

wefts, mostly pale yellow, but also in each of the other four colours: vertical and diagonal extra-weft wrapping and 'flying' wefts. The 'flying' wefts are often used four at a time.

Warp: uses the warp of the ground cloth.

Weft: wool / purple and pale yellow, with some dull faded red, darker yellow, and dark green, s; 70 per cm

This example (see the series in catalogue 234–41) demonstrates that panels containing human figures do not occur only at the hem. In this case the single nude female musician – identifiable as such by the musical instrument dangling from her left hand (see catalogue 230 and 236 for clearer representations) – interrupts the row of octagonal compartments containing lions in mid course. The frames of the compartments are covered in a heavy guilloche pattern. Cf Du Bourguet [cat. 199], H 123 of the eleventh century and I 22–63 of the twelfth century; Trilling [cat. 199], no. 92.

From the Delacorte Collection

Purchased from Juergens, New York, 1964 AL

235 Tapestry band with figural panels enclosed by interlace

Wool. 15 × 40 cm; band 11.5 cm
Coptic, 11th / 12th century M82.57

The fragment from an all-wool textile is decorated with an inwoven tapestry band, probably the clavus of a pale yellow woollen tunic. The largely monochrome design is enlivened by touches of colour. The animals are oriented in the direction of the warp. All edges are raw.

GROUND CLOTH
Weave: weft-faced tabby
Warp: wool / pale yellow, s; 9 ends per cm
Weft: wool / pale yellow, s; 31 passes per cm

INWOVEN TAPESTRY BAND
Weave: tapestry; weft-faced tabby binding; slit and dovetailed; eccentric wefts; vertical ground-weft wrapping. Extensive use of supplementary

236 Tapestry band with figural panels enclosed by interlace

Wool.
21 × 32.5 cm (plus 0.7 cm of selvage finished by 0.9 cm of cord)
Coptic, 11th / 12th century M82.50

The fragment is an all-wool tapestry band, the clavus of a pale yellow woollen tunic. Nothing remains of the ground cloth into which the tapestry band was woven. The largely monochrome design is enlivened by touches of colour. The animals are oriented in the direction of the warp. One selvage is intact, forming the bottom hem of the garment; the selvage is reinforced by the use of three bundles of multiple warps, and is finished with a cord formed of multiple dark blue wefts. The other three sides are raw.
Weave: tapestry; weft-faced tabby binding; slit and dovetailed; eccentric wefts; vertical ground-weft wrapping. Extensive use of supplementary wefts, mostly pale yellow but also in each of the other colours: vertical, diagonal, and curvilinear extra-weft wrapping and 'flying' wefts. The design of the borders is produced largely through the use of multiple pale yellow supplementary wefts in a combination of weft wrapping and 'flying' weft that covers much of the surface in a dense pattern of interlace. The designs of the hem and some vertical borders are drawn with the aid of double pale yellow threads (not plied).
Warp: wool / pale yellow, s; 10 ends per cm
Weft: wool / dark blue and pale yellow, with touches of a dull faded red and dark green, s; 56 per cm

Greater emphasis is given to interlace patterns in this clavus, which is otherwise similar to catalogue 234 and 235. In addition to the guilloche borders of the octagonal animal compartments, there are broad bands of four-strand interlace to either side, forming circles (some containing a cross) within hexagons and octagons. Among the various devices decorating the bodies of the lions is

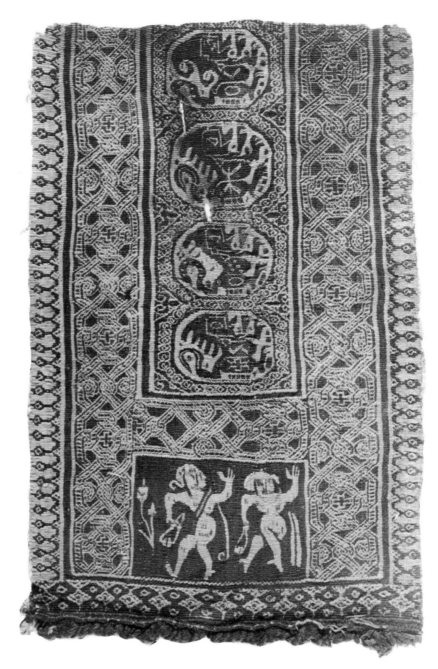

another cross. The musicians in the lower panel are once more recognizable as such, as is the flowering shrub, forming the only indication of a landscape setting. The geometric border at the hem may be compared with that of catalogue 232. Cf Du Bourguet [cat. 199], Group H or Group I of the eleventh or twelfth century; Peter [cat. 224], no. 30.

From the Delacorte Collection

Purchased from Juergens, New York, 1964 AL

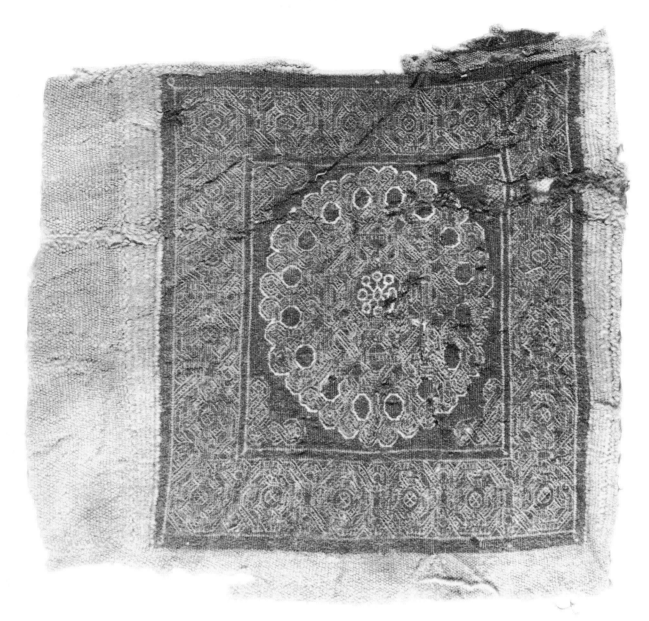

237 Tapestry square with interlace design

Wool and linen.
25.3 × 25.1 cm; square 21 × 18 cm
Coptic, 12th century M82.70

The fragment is from a woollen textile with an inwoven monochrome tapestry square and another tiny fragment of tapestry in the top left hand corner. It was probably the square panel and clavus decorating the shoulder or hem of a pale yellow woollen tunic. All edges are raw.
GROUND CLOTH
Weave: weft-faced tabby
Warp: wool / pale yellow, s; 8 ends per cm

Weft: wool / pale yellow, s; 26 passes per cm
INWOVEN TAPESTRY PANEL
Weave: tapestry; weft-faced tabby binding. The design is produced largely through the use of multiple pale yellow supplementary wefts in a combination of vertical extra-weft wrapping and 'flying' weft that covers much of the surface of the textile in a pattern of dense interlace. A small amount of bleached linen supplementary weft is used to outline parts of the central rosette.
Warp: uses the warp of the ground cloth.
Weft: wool / purple and pale yellow, s

linen, bleached, s
50 per cm

In this example interlace has taken over as the most important element of the design. The square panel has a central rosette composed of an intricate arrangement of interlace, while the border consists of circles within octagons, the former containing tiny rosettes. Cf Du Bourguet [cat. 199], Group H or Group I of the eleventh or twelfth century; Trilling [cat. 199], no. 96, for a similar shoulder square with clavus.

Purchased from Juergens, New York, 1963 AL

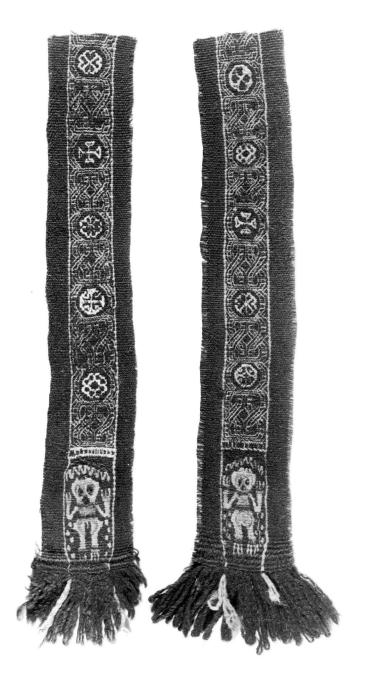

238 Two tapestry bands with figural panels and interlace

Wool and linen.
A: 4.6 × 30.2 cm (plus 0.8 cm of selvage and 4.2 cm fringe);
B: 4.6 × 29.3 cm (plus 1.2 cm of selvage and 4.2 cm fringe);
tapestry band 2.5 cm
Coptic, 12th century
M82.53 (A), M82.54 (B)

The two fragments are from a woollen textile decorated with inwoven tapestry bands, probably the clavi of a brown and purple woollen tunic. The design is largely monochrome, pale yellow on purple, enlivened by touches of colour. The pattern is oriented in the direction of the weft. Each fragment has one selvage intact, forming the bottom hem of the garment; the selvage is reinforced (fragment A with three bundles of multiple warps, fragment B with four bundles of multiple warps) and finished with an uncut weft-loop fringe (purple, brown, and pale yellow, s,3z). The other three edges are raw.

GROUND CLOTH
Weave: weft-faced tabby
Warp: wool / dark brown, s; 8 ends per cm
Weft: wool / dark brown or purple, s; 25 passes per cm

INWOVEN TAPESTRY BAND
Weave: tapestry; weft-faced tabby binding; slit and dovetailed; eccentric wefts. Use of supplementary wefts in all but one of the weft colours (purple): vertical, diagonal, and curvilinear extra-weft wrapping and 'flying' wefts. A small amount of bleached linen is used for the crosses and rosettes within the interlace and as a border to separate the band of interlace from the figural panel.
Warp: uses the warp of the ground cloth.
Weft: wool / purple, dark brown and pale yellow, with touches of golden yellow, red, green, and dark blue, s (the golden yellow, green and dark blue wefts are sometimes used as a double thread.)
 linen / bleached, s
 35 per cm

Another variation on the theme omits the large animal octagons, leaving much narrower bands of interlace ending in a single figural panel. The interlace forms small circular compartments containing a variety of rosettes and crosses. Nude male and female figures in orans position have a zigzag line curving above their heads, indicative either of hair or of an architectural niche. Dots to either side of an undulating line suggest a landscape setting. Cf Du Bourguet [cat. 199], I 58–63 of the twelfth century.

From the Delacorte Collection

Purchased from Juergens, New York, 1964 AL

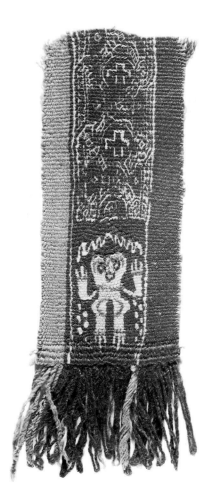

239 Tapestry band with figural panel and interlace

Wool and linen.
6.2 × 4.8 cm (plus 0.8 cm of selvage
and 5 cm of weft-loop fringe); band
3.8 cm
Coptic, 12th century M82.49

The fragment is from a woollen tex-
tile decorated with an inwoven tap-
estry band, perhaps the clavus of
a golden yellow and purple woollen
tunic. The largely monochrome de-
sign, pale yellow on purple, is enli-
vened by touches of colour. The
pattern is oriented in the direction of
the weft. One selvage is intact, form-
ing the bottom hem of the garment;
the selvage is reinforced by the use of
three bundles of multiple warps and is
finished with an uncut weft-loop
fringe, purple and golden yellow,

s,3z. The other three sides are raw.
GROUND CLOTH
Weave: weft-faced tabby
Warp: wool / golden yellow, s;
7 ends per cm
Weft: wool / golden yellow or purple,
s; 26 passes per cm
INWOVEN TAPESTRY BAND
Weave: tapestry; weft-faced tabby
binding; slit and dovetailed; eccentric
wefts. Extensive use of supplemen-
tary wefts in all six colours: vertical
and curvilinear extra-weft wrapping
and 'flying' wefts. The interlace de-
sign is produced largely through the
use of multiple pale yellow supple-
mentary wefts in a combination
of vertical extra-weft wrapping and
'flying' weft that densely covers
much of the surface of the textile. A
small amount of bleached linen sup-
plementary weft is used for the
crosses within the interlace and to
separate the band of interlace from
the figural panel.
Warp: uses the warp of the ground
cloth.
Weft: wool / purple, golden yellow,
and pale yellow, with touches of
red and green, s
 linen / bleached, s
 36 per cm

Little separates this narrow band
from catalogue 238. Only a further
simplification of the interlace and the
use of yellow and purple rather than
brown and purple warps show that
it must come from another tunic. Cf
Trilling [cat. 199], no. 94.

From the Delacorte Collection

Purchased from Juergens, New York,
1964 AL

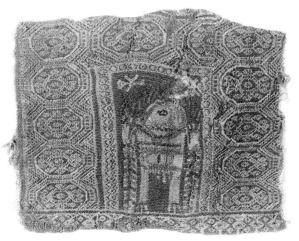

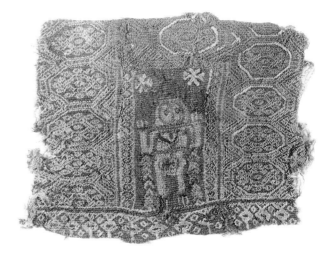

240

240 Two tapestry bands with figural panels and interlace

Wool and linen.
17 × 15 cm; 17.5 × 14.7 cm
Coptic, 12th century M82.86

The two fragmentary tapestry bands are probably the clavi of a pale yellow woollen tunic. The design is in pale yellow on a purple ground, with outlining and some details in bleached linen, and touches of polychromy in the figural panel. The pattern is oriented in the direction of the weft. Both pieces are raw on all four sides.
Weave: tapestry; weft-faced tabby binding; slit and dovetailed; eccentric wefts. Use of supplementary wefts in all colours except purple, often used as double threads: vertical and diagonal extra-weft wrapping and 'flying' wefts. The interlace design is produced by a combination of vertical extra-weft wrapping and multiple 'flying' wefts that densely covers much of the surface of the textile.
Warp: wool / pale yellow, s; 10 ends per cm
Weft: wool / purple and pale yellow, with touches of red, orangey-yellow, brown, and dark blue, s
 linen / bleached, s
 42 per cm

The ends of both bands show a figural panel framed by an irregular three-and-a-half rows of interlace. Below, at the hem of the garment, is a lattice design similar to that of catalogue 232 and 236. The nude figures, one male, one female, stand frontally in orans position within a compartment containing also two crosses in the upper corners. The interlace forms a simple octagonal grid with rosettes. Cf Du Bourguet [cat. 199], I 26–32 of the twelfth century.

Purchased from Juergens, New York, 1963 AL

241 Tapestry band with figural panel and interlace

Wool and linen.
15.4 × 19 cm (plus 1.2 cm of selvage and 1.1 cm of weft cord); tapestry band 4.8 cm
Coptic, 12th century M82.76

The fragment is of a woollen textile decorated with an inwoven tapestry band, probably the clavus of a pale yellow and purple woollen tunic. The design is in pale yellow on a purple ground, with outlining and some details in bleached linen and touches of polychromy. The pattern is oriented in the direction of the weft. One selvage is intact, forming the bottom hem of the garment; the selvage is reinforced by the use of three bundles of multiple warps and is finished with a cord composed of an uncut weft-loop fringe (s,3z) twisted together in s. The other three sides are raw.
GROUND CLOTH
Weave: weft-faced tabby
Warp: wool / pale yellow, s; 8 ends per cm
Weft: wool / pale yellow or purple, s; 37 passes per cm
INWOVEN TAPESTRY BAND
Weave: tapestry; weft-faced tabby binding; slit and dovetailed; eccentric wefts. Extensive use of supplementary wefts in all colours except purple: vertical, diagonal, and curvilinear extra-weft wrapping and 'flying' weft

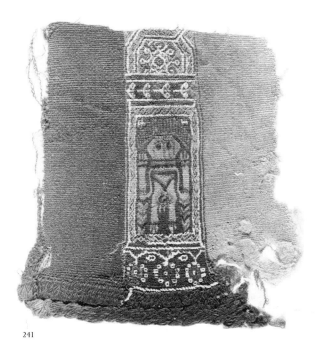

241

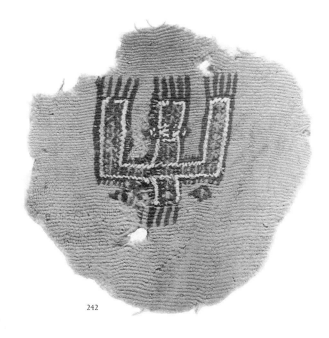

242

Warp: uses the warp of the ground cloth.
Weft: wool / purple and pale yellow, with touches of dark blue, green, red and golden yellow, s; sometimes two threads of the same colour are used together
linen / bleached, s; used two together throughout
34 per cm

Much narrower but otherwise very similar to catalogue 240 is this clavus decorated with a single row of interlace forming octagonal compartments and rosettes, ending in a nude orans figure with crosses.

Purchased from Juergens, New York, 1963 AL

242 Fringed tapestry motif

Wool and linen.
11 × 11.5 cm; tapestry motif
5.1 × 6 cm
Coptic, 12th century M82.85

The piece is from a pale yellow woollen textile decorated with an inwoven tapestry motif. The design is in purple, pale yellow, and white, oriented in the direction of the weft. All edges are raw.
GROUND CLOTH
Weave: weft-faced tabby
Warp: wool / pale yellow, s; 10 ends per cm
Weft: wool / pale yellow, s; 32 passes per cm
INWOVEN TAPESTRY MOTIF
Weave: tapestry; weft-faced tabby binding; slit and dovetailed; eccentric wefts; vertical ground-weft wrapping. Very extensive use of supplementary wefts, both white and pale yellow: vertical extra-weft wrapping and 'flying' wefts, the latter used several at a time
Warp: uses the warp of the ground cloth.
Weft: wool / purple and pale yellow, s

linen / bleached, s
42 per cm

This tiny tapestry motif, the significance of which escapes us, is overloaded with a good deal of surface detail, much of which has worn away. It clearly belongs to Du Bourguet's Group 1 of the twelfth century, for technical reasons [cat. 199].

Purchased from Juergens, New York, 1963 AL

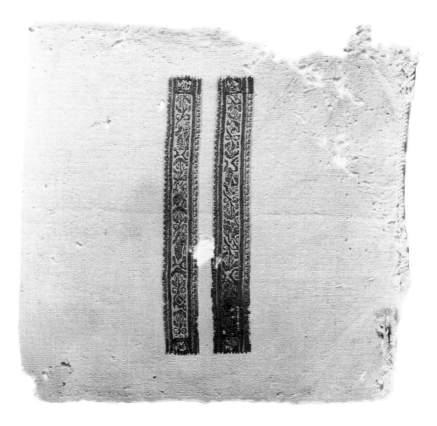

lower frieze shows the same motifs in inverse order, facing right. Cf Du Bourguet [cat. 199], 1 3 and 1 12 of the twelfth century; Peter [cat. 234], no. 53.

Purchased from Juergens, New York, 1963 AL

244 Fragment of tiraz, with a frieze of birds above a line of Kufic script

Linen and silk.
25 × 32 cm; solid weft band 0.8 cm; figural band 2 cm; inscription 8 cm
Islamic, Egypt, Abbasid period, first half of 10th century M82.68

This is a fragment of loosely woven undyed linen tabby decorated with an inwoven figural tapestry band above a tapestry-woven inscription and a narrow solid weft band across the top. The design is oriented in the direction of the warp. All edges are raw.
GROUND CLOTH
Weave: very loosely woven tabby
Warp: linen / undyed, s; 20 ends per cm
Weft: linen / undyed, s; 15 passes per cm
SOLID WEFT BAND ACROSS THE TOP
Weave: tabby with predominant weft
Warp: uses that of the ground cloth.
Weft: silk / tan, no appreciable twist; estimated 16 passes per cm
INWOVEN TAPESTRY DECORATION
Weave: tapestry; weft-faced tabby binding; slit and dovetailed; eccentric wefts; vertical ground-weft wrapping. No use of supplementary wefts
Warp: uses that of the ground cloth; the warp ends are crossed at the points of juncture between tabby and tapestry.
Weft: a) The figural band: silk / two shades of green, yellow, white and tan, no appreciable twist; 64 per cm
b) Kufic inscription: silk / tan, no appreciable twist; linen / undyed, s; 40 per cm

This fragment and catalogue 245 belong to a particular type of Early Islamic textile – one bearing an inscription – customarily referred to as

243 Double monochrome tapestry band with a row of animals, birds, and plant motifs

Wool and linen.
30 × 31 cm; band 2.8 × 22.5 cm
Coptic, 12th century M82.73

The fragment is from a woollen textile with two inwoven monochrome tapestry bands, almost certainly the sleeve of a pale yellow woollen tunic. The design is largely oriented in the direction of the warp. Three selvages are intact. Both lateral edges are reinforced with two bundles of multiple warps. The terminal edge is finished with a twisted cord consisting of multiple s threads twisted together in s, three of which are twisted together again in z.
GROUND CLOTH
Weave: tabby with predominant weft
Warp: wool / pale yellow, s; 11 ends per cm

Weft: wool / pale yellow, s; 30 passes per cm
INWOVEN TAPESTRY BANDS
Weave: tapestry; weft-faced tabby binding; slit and dovetailed; eccentric wefts; vertical ground-weft wrapping. Extensive use of supplementary wefts of both colours, used both singly and doubly: vertical, horizontal, diagonal, and curvilinear extra-weft wrapping and 'flying' wefts. Countered vertical extra-weft wrapping.
Warp: uses the warp of the ground cloth.
Weft: wool / purple, s
 linen / undyed, s
 74 per cm

This armband is decorated with a delightful variety of plant and animal motifs (cf catalogue 242). Birds in demiroundels mark the ends of the two friezes. Between are, from the upper left, a plant, a bird facing left, another plant, an upsidedown running rabbit, a plant, a lion striding to the left, a plant, another upsidedown running rabbit, and a plant. The

tiraz. (This unfortunately ambiguous term is commonly used to refer to the band of inscription itself, to the textile bearing the band, or to the workshop in which the textile was manufactured. For the origin of the term and its use see A. Grohmann, *Encyclopaedia of Islam*, Leiden, 1913–27, pp. 785–93. For a more recent discussion of the problems associated with the use of the term see Lisa Golombek and Veronika Gervers, 'Tiraz Fabrics in the Royal Ontario Museum,' *Studies in Textile History: In Memory of Harold D. Burnham*, ed. Veronika Gervers, Toronto 1977, pp. 82–125.) Since a complete tiraz inscription will ideally give not only the names of the ruling caliph, the vazir, and the intendant at the workshop, but also the place and date of manufacture, the study of this group is of special interest to textile historians. It provides a useful frame of reference for other textiles in which the inscription is either lacking or illegible.

In this case the inscription is clearly too fragmentary to permit a reading, but its style and technique point to a date in the late Abbasid period in Egypt. The tall, elegant Kufic is closest in style to examples from the reign of al-Muttaqi (940–4

AD), but most of the remaining examples from this period are done in the embroidery rather than the tapestry technique. One of the few remaining tapestry examples from the time of al-Muttaqi is illustrated by Nancy Pence Britton in *A Study of Some Early Islamic Textiles in the Museum of Fine Arts Boston* (Boston 1938), fig. 25. Tapestry examples from the reign of al-Muti, the last Abbasid caliph of Baghdad to reign over Egypt (946–74 AD), already have letters in the early foliated Kufic style, but they do have in common the distinctive round undyed linen 'eyes' at the tops of the tall vertical silk staffs. The 'eyes' are difficult to see in our example because the undyed linen has discoloured to a shade barely discernable from the tan silk of the lettering. For more easily visible examples from the reign of al-Muti see Golombek and Gervers, nos. 7–8; Britton, figs. 29–32; or Ernst Kühnel and Louisa Bellinger, *Catalogue of Dated Tiraz Fabrics: Umayyad, Abbasid, Fatimid* (Washington, DC, 1952), pls. 22–3. Contrary to later examples, the letters are individually woven directly into the fine linen tabby ground. In the Fatimid period it becomes customary, at least by the eleventh century,

to enclose the inscription within a solid tapestry band, producing tapestry letters on a coloured silk tapestry ground.

In Abbasid tiraz pride of place is given to the inscription. Many of the textiles of this period are decorated only with an inscription of monumental proportions and a series of plain coloured bands. (That these solid weft bands are often multiple suggests that the area of free warps at the top of our textile, just above the plain tan silk band, is the remains of another such band, perhaps wider than the remaining one, from which the coloured silk wefts have worn away completely. For other examples of this group of Abbasid textiles with solid weft bands see Golombek and Gervers, nos. 7–9.) In the Fatimid period the figural band gains in importance and the inscription correspondingly diminishes in scale. The latter comes to frame the figural band both above and below, and eventually, by the twelfth century, often even loses its meaning to become a largely decorative adjunct.

In the narrow figural band we find a row of birds facing right, each with a stylized flower over its back. The design is in white and yellow outlined in tan on a ground that changes in colour from dark green to light green to yellow. The whole is framed by narrow bands of white, yellow, and tan. Because of the dearth of examples remaining from this period, it is difficult to find parallels among other Abbasid silk tapestries. See, however, a well-known fragment from the period of al-Muti in the Montreal Museum of Fine Arts (no. 952.Dt. 2), with a row of animals between two rows of script of monumental proportions; here both the letters and the animals are individually tapestry woven into a loose tabby ground (Hayat Salam-Liebich, *Islamic Art: Objects for Daily Use*, Montreal 1983, no. 57). An early date is suggested by the restricted and sober colouration and the simplicity of the repeat design. In the Fatimid period designs become more and more elaborate, with birds, often in pairs, enclosed in a framework of greater and greater complex-

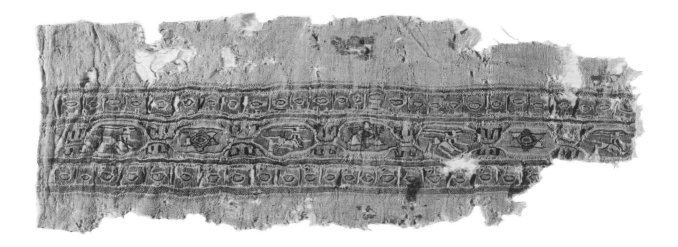

ity. The colouration too becomes more brilliant and varied (Britton, figs. 25, 29, 30, 32, 34, 36–8).

The use of such textiles is uncertain. The material of the period is much too fragmentary and the artistic depictions of custume too rare to show how this ornament was used in garments. Our example could conceivably have decorated either a sleeve, a turban, or a shawl. For a concise discussion of mediaeval Islamic costume see Veronika Gervers, 'Weavers, Tailors and Traders: A New Collection of Medieval Islamic Textiles in the Royal Ontario Museum, Toronto,' *Hali*, II, 2, summer 1979, 125–33. For depictions of tiraz sleevebands and turbans see Britton, figs. 96–8.

This piece differs from contemporary Coptic textiles in the use of silk wefts, the more sober and restrained design, the much finer more loosely woven linen ground cloth, and the emphasis on the Arabic inscription. Also of note is the lack of supplementary wefts so prevalent in the Coptic tapestries of the period.

From the Delacorte Collection

Purchased from Juergens, New York, 1964 AL

245 Fragment of tiraz, with a frieze of rabbits and stars in lozenges framed by two bands of Kufic

Linen and silk.
14.5 × 40 cm; band 8 cm
Islamic, Egypt, Fatimid period,
second half of 11th century M82.42

The fragment is of undyed linen tabby with an inwoven polychrome tapestry band. The design is oriented in the direction of the warp. There is a plain selvage at the left; the other three sides are raw.
GROUND CLOTH
Weave: tabby
Warp: linen / undyed, s; 20 ends per cm
Weft: linen / undyed, s; 16 passes per cm
INWOVEN TAPESTRY BAND
Weave: tapestry; weft-faced tabby binding; slit and dovetailed, with long slits used for decorative effect; eccentric wefts. No use of supplementary wefts.
Warp: uses the warp of the ground cloth.
Weft: silk / salmon pink, green, golden yellow, and black, no appreciable twist
 silk(?) / purple, z; used 2 together throughout
 linen(?) / turquoise and dark blue, s
 linen / undyed, s
 47 per cm

The piece is a tripartite tapestry band, with a central figural frieze framed by two lines of pseudo Kufic script.

The frieze is decorated with a row of joined hexagonal lozenges on a golden yellow ground. Within the lozenges are ecru rabbits on a salmon pink ground alternating with multi-coloured six-point stars on a turquoise blue or green ground. The lozenges are framed in yellow and ecru outlined in black, with black hook-shaped devices (perhaps stylized leafy shoots) branching off to fill the interspaces.

The kufesque decoration is bordered by mutlicoloured bands. The square angular letters are done in ecru and black on a salmon pink ground. Between the tall verticals of the script are small lozenges echoing the decoration of the central band.

This piece is similar to one in the Boston Museum of Fine Arts, no. 15.382 (Britton [cat. 244], fig. 70).

PUBLICATION
Koechlin, Raymond and Gaston Migeon, *Oriental Art* (New York 1928), pl. 56

Purchased from Kelekian, New York
 AL

**246 Pair of cross-shaped
ornaments from an
omophorion (?) embroidered
with two scenes from the
Passion of Christ: the Ascent
to the Cross (below) and the
Deposition (above)**

Silk, metallic thread.
25.5 × 27.5 cm each cross.
Russian, second half of 17th century
M82.451

The embroidered panels are each in
the shape of a square cross and may
have come from an omophorion,
a long scarf-like strip traditionally
decorated with five appliqued crosses
or circles, the insignia of a bishop
in the Orthodox church. The silver-
gilt, silver, and polychrome silk em-
broidery is on an ivory satin ground.
The inscriptions are painted.
GROUND CLOTH
Weave: satin
Warp and weft: silk, ivory, s; the
surface of the textile is too puckered
by the embroidery to allow the tak-
ing of a thread count.
Embroidery: largely done in silver-
gilt and silver thread, in the form of a
thin metal wire. Laid and couched
work, done over an underlay of silk
threads coloured to give a slight nu-
ance to the metal thread, and giving
also a slight relief effect to the de-
sign. The varicoloured silk couching
threads, faded on the face but still
bright on the reverse, produce small
geometric patterns in colour on the
metal. There is very little use of
silk embroidery, basically only for
the skin, facial features, and hair;
this is in split stitch, worked in a uni-
form vertical direction.

Each cross-shaped panel bears a nar-
rative scene within a quatrefoil at
the centre, flanked by four cherubim
in the arms. The lower panel shows
the scene of the Ascent to the Cross,
with Christ being hauled upward
by two executioner's servants in the
presence of a Jewish priest and Ro-
man soldiers. Above is the scene
of the Deposition, with the dead
Christ being gently lowered from the
Cross by Joseph of Arimathaea and

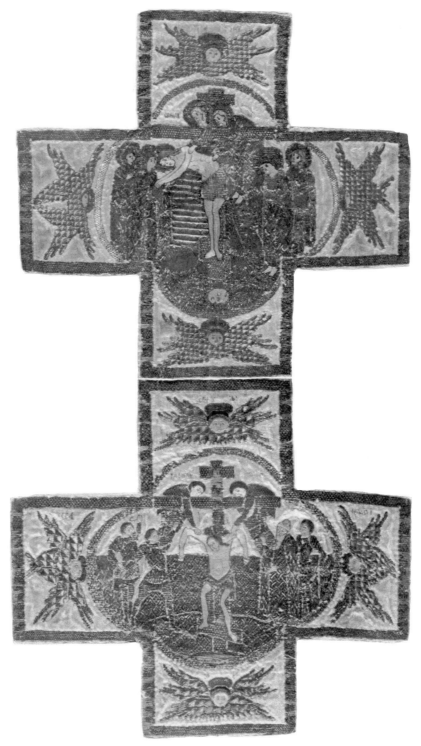

Nicodemus, into the waiting arms of
Mary, His mother, with the Apostle
John raising his hands in a gesture
of grief to the other side. For similar
examples see the omophoria illus-
trated in Pauline Johnstone, *The
Byzantine Tradition in Church Em-
broidery* (London 1967), pls. 49, 50;
see also pp. 18, 104–5, and, for tech-
nique, pp. 65–73.

Purchased from A la Vieille Russie,
New York, 1962 AL

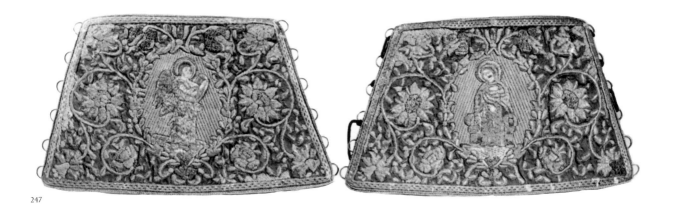

247

247 Pair of embroidered cuffs (epimanikia) decorated with the Annunciation and a floral scroll

Silk, metallic thread, and cotton.
16.7 × 26.3 cm
Russian, 18th century M82.490, 491

Stiff embroidered cuffs were worn by bishops in the celebration of the orthodox liturgy. Silver-gilt, silver, and polychrome silk embroidery is applied on a purplish-red satin ground. There is a greenish-yellow satin lining. Each epimanikion has a row of metal rings to either side, allowing it to be fastened around the wrist with silk ties.

GROUND CLOTH
Weave: satin
Warp: silk / purplish-red, slight s twist; the surface of the textile is too puckered by the embroidery to allow the taking of a thread count.
Weft: silk / yellow, no appreciable twist; no thread count possible
LINING
Weave: satin
Warp: silk / greenish-yellow, s
Weft: cotton / green, z
Embroidery: the major portion of the design is accomplished in laid and couched work, done in various types of metal thread: silver-gilt and silver

thread, either used alone or wound around a coloured silk core to produce subtle differences of tone, in the form of a fine metal wire, or flat metal strips (lamella) or coils of wire with a hollow centre giving a beaded effect; sometimes twisted to form a rope, or braided. Undyed cotton threads are used for couching and for padding, to give a greater relief effect to the design. There is very little use of silk embroidery, basically only for the skin, facial features, and hair; this is in split stitch, following the natural contours of the flesh.

Epimanikia are frequently embroidered with the Annunciation motif, often with the Angel Gabriel on one cuff and the Virgin Mary on the other. Mary is seated on a bench covered with a large cushion, wearing a tunic and a mantle drawn over her head and shoulders. According to legend, she has been surprised in the act of spinning wool for a new curtain in the Temple. She holds a spindle in her left hand, while with her right she expresses her astonishment at the angel's greeting. Gabriel approaches from the left, raising his hand in a gesture of speech. Both figures are nimbed and the background striped in gold as if to indicate rays of heavenly light. Each is contained in an oval compartment

framed by a symmetrical floral scroll on a red satin ground.

The depiction of the Annunciation is so traditional as to give little indication of date. It is left to the character of the floral scroll and the use of coiled wires to point to the eighteenth century. See Johnstone [cat. 246], pls. 19–28. AL

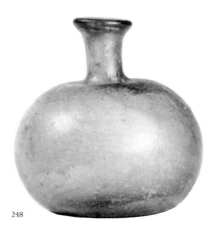

248

249

248 Globular bottle

Blue-green glass, some bubbles and
blowing marks, no trace of pontil.
9.5; diameter mouth 2.8, body 9.0 cm
Early Islamic, Eastern Mediterranean,
7th–10th century M82.306

The vessel has a globular body,
somewhat truncated, with a small
indented base and slight flattening
around the base of the neck. There is
a short, tubular neck with a rounded
rim moulding, folded inwards on
top and pressed flat. The finish is un-
even and undecorated. There is a
slight soil deposit and faint irides-
cence in places.

The shape is common in the early
Islamic period in the eastern Medi-
terranean area, continuing Roman
glass-blowing traditions. JH

249 Fragment of a Persian lustre bowl

Overglaze pottery painted in
greenish-brown lustre.
11 × 13 × 3.9 cm
Islamic, Iran, Seljuk period, 13th
century M82.350

This Persian lustre fragment shows
an unusual scene involving two hu-
man figures placed against a back-
ground of scrolls and spirals. They
stand behind a pool with ducks,
while birds seem to be flying around
them. The figure sitting on the right
is a woman with a braid and a
looped earring. The standing, beard-
less male figure facing her wears a
peculiar headdress and strapped leg-
gings. Both have armbands and have
haloes around their heads. The wom-
an's dress is decorated with speckles
while the man's garment has a scroll
pattern. The exterior of the fragment
reveals some remains of an
arabesque design composed of curv-
ing strokes and dots. The action
taking place between the two char-
acters is of a violent nature. The man
points the sharp end of a sword at
the woman while grasping at her
neck with his left hand. In the mean-
time, the woman holds an unidenti-
fiable object in one of her hands with
which she tries to defend herself

against her attacker.

This scene may be identified with
two remarkably similar stories in
the Persian epic, the Shahnamah.
Amongst the adventures of the two
national heroes, Rustam and Isfandi-
yar, are seven dangerous trials. In
their fourth trial, each encounters a
witch disguised as a beautiful maiden
who tries to seduce them. The hero
in both accounts, manages to defeat
the sorceress who is immediately
transformed into an old hag before
losing her head to a swift blow of the
blade (A.G. Warner and E. Warner,
trans., *The Shahnama of Firdausi*, 9
vols., London 1905–25; for Rustram's
trial see vol. 2, pp. 50–2, for Isfandi-
yar's see vol. 5, pp. 128–31). The
artist here decided to protray the ac-
tion while the witch was still an
attractive young woman, in contrast
to one of the earliest representations
of Isfandiyar's trial from a fourteenth-
century manuscript of the Shahna-
mah which shows the sorceress al-
ready transformed (M.S. Simpson,
*The Illustration of an Epic: The Ear-
liest Shahnama Manuscripts*, New
York 1979, figs. 9 and 10). The icon-
ography reflected in the Malcove
piece is obviously different from the
imagery in the miniature painting
despite the strong links that existed
between those two forms. Whether
the prototype for the Malcove lustre

fragment is a manuscript painting or not will remain unclear until similar examples are brought to light. Nevertheless, among the single heroic exploits associated with the Persian epic and frequently represented on ceramics, this particular lustre piece is so far a unique example.

Purchased from Kelekian, 1970 NS

250 Fragment of a Persian minai bowl

Overglaze pottery painted in polychrome colours. 6.8 × 2.8 cm
Islamic, Iran, Seljuk period, 13th century M82.358

This fragment from the centre of a minai bowl is decorated with two figures seated cross-legged on either side of a stylized tree. They are encircled by a red band, and only the figure on the left is complete. A halo appears behind the head of both beardless men. The one on the right wears a red cap and a striped blue dress, while the one on the left has a blue headdress with flowing ends and a red and blue garment. The drawing is schematic and the choice of colours is limited to red, blue, black, and purple over a cream glaze.

Minai technique was developed in twelfth-century Persia and consisted of using overglaze colours and firing the pot several times (G. Fehervari, *Islamic Pottery: A Comphrehensive Study based on The Barlo Collection*, London 1973, p. 99; J.W. Allen, *Medieval Middle Eastern Pottery*, Oxford 1971, p. 30). It has long been established that minai pottery has

strong connections with the miniatures in contemporary manuscripts. The style of painting and colouring, as well as the choice of subjects, suggests that miniature painters participated in the decoration of the minai pottery. The subject theme represented is generally confined to courtly scenes, such as pairs of seated couples engaged in leisurely conversation (E.J. Grube, *Islamic Pottery of the Eighth to the Fifteenth Century in the Keir Collection*, London 1976, pp. 204–6; A. Lane, *Early Islamic Pottery*, London 1947, p. 42; for a comparative example see A.U. Pope, *A Survey of Persian Art*, London 1939, vol. 10, pl. 694A). The Malcove fragment is an example of this popular imagery.

Purchased from Kelekian NS

251 Plain glazed brazier

Brownish clay, lead glaze.
12.5; diameter rim 14 cm, foot 6.5 cm
Byzantine, 11th century M82.353

The almost colourless lead glaze applied over a reddish-brown biscuit appears warm brown. The brazier

252 Sgraffito bowl

Pale orange clay, transparent lead
glaze over cream slip.
8.5; diameter rim 25.5, foot 11 cm
Byzantine, 12th century M82.332

A cream slip covers a large complete
bowl on the interior and along the
rim of the exterior. Most of the heavy
incrustation which was on the inte-
rior and exterior surfaces has been
removed. However, some patches re-
main. Small traces of the transparent
yellowish covering glaze of the inte-
rior surface survive. The incised fig-
ure of a fish surrounded by two
branch-like designs fills the interior
of the bowl. Similar designs have
been recorded in the Athenian agora
excavations (A. Frantz, *The Middle
Ages in the Athenian Agora*, no.
26, pl. 2319; no. 27, pl. 0638) at Cor-
inth (Morgan [cat. 251], pl. XLII, i,
no. 1153; pl. XLII, j, no 1119) and on
plates which form part of a large
horde of ceramic material from a By-
zantine shipwreck off Pelagos in
the Aegean Sea (C. Kritzas, 'To By-
zantinon Navagion Pelagonnisou-
Alonnisou,' *Athens Annals of Ar-
chaeology*, IV, 2, 1972, p. 179, fig. 8).
 TT

is incomplete. Of the original two
strap handles on the side, only the
upper part of one survives. A perfo-
rated attachment on top of the sur-
viving handle suggests that the
brazier may have been suspended.
Part of the rim is missing. The body
of the vessel gently curves inwards
towards a small ridged foot. Rectan-
gular perforations are located on
either side of an arched opening on
the body of the vessel. The opening,
which is outlined by a groove ridge,
frames a cross, cut out of the body.
The cross has a circle at the intersec-
tion of the arms; cross hatchings
are incised into the arms. A vertical
ridge indented by hatchings, extends
from the rim to the bottom at both
ends of the perforated rectangles.
In comparison with material from
Athens (A. Frantz, 'Middle Byzan-
tine Pottery,' *Hesperia*, VIII, 1938,
434, 459, fig. 22) and Corinth
(C. Morgan, *The Byzantine Pottery*,
Corinth XI, Athens 1942, p. 37,
fig. 24c no. 8, fig. 24d no. 18; p. 39,
fig. 27 no. 18; pl. II BC no. 21;
pl. II BD no. 23; p. 180, no. 18;
p. 180, fig. 163 no. 19; p. 181, no. 23),
the shape of the brazier indicates
an eleventh-century date.

Purchased from Kelekian, New York,
February 1963 TT

253 Lead glazed sgraffito bowl

Pale orange clay, transparent
yellowish glaze over cream slip.
8.5 cm; diamater rim 25.5 cm,
foot 11 cm
Byzantine, 12th century M82.329

This large bowl is complete, with
some chips off the rim. A cream slip
covers the interior surface and the
rim on the exterior. A transparent
yellowish lead glaze has been par-
tially removed from the interior, and
traces of heavy incrustation are still
visible on the exterior, with burned
patches on the interior.

The design of a bird grasping a
palm (?) branch in its beak and
surrounded by palm-like fronds is
incised on the interior surface of the
bowl. Similar bird compositions have
been used on bowls from Corinth
(Morgan [cat. 251], pl. XLII, a–c),
Athens (Franz [cat. 251], p. 444, fig.
7, A 47; p. 445, fig. 8, A 49–51; p.
452, fig. 13, A 71–2; p. 453, fig. 14, A
74), the Pelagos shipwreck (Kritzas
[cat. 252], 17u, fig. 2; p. 181, fig. 10),
as well as examples in the Dumbar-
ton Oaks Collection (D.T. Rice, 'Late
Byzantine Pottery at Dumbarton
Oaks,' DOP [cat. 93], XX, 1966, 211;
p. 218,3,4; text fig. 6, text fig. 7).
Catalogue 252 and this bowl show a
marked similarity in form and size
to the Dumbarton Oaks bowls (ibid.,
p. 212, C,D) and some Corinthian
examples (Morgan, p. 129, fig. 103,
j–1; p. 285, no. 1207), which have
been dated to the mid-twelfth
century.

The appearance of this bowl and
catalogue 252 suggests that they may
have been part of the vast cargo
and ceramic products from the
twelfth-century Byzantine shipwreck
off the island of Pelagos in the north-
ern Aegean Sea (Kritzas, p. 176ff). TT

254 Lead glazed sgraffito bowl

Pale orange clay, transparent lead
glaze over cream slip.
10 cm, diameter rim 22 cm, foot
10 cm
Byzantine, 12th century

M82.330

The bowl is complete, with upward
flaring sides, and a slightly flaring
foot. There is a cream slip on the in-
terior and on the rim of the exterior.
No trace of glaze survives. There is
a heavy incrustation on the exterior.

The sgraffito design consists of a
band of debased spirals below the rim
on the side of the bowl, and the
figure of a bird surrounded by chev-
ron patterns in the centre. The band
of debased spirals has parallels on
sgraffito fragments from Aphrodisias
(Teresa Tomory, 'A Study of Medie-
val Glazed Pottery from Aphrodisias
and Cilicia,' PHD thesis, University
of Toronto, 1980, pl. 11, figs. 4–6)
and Corinth (Morgan [cat. 251], pl.
XLIV, b, no. 1185). The chevron mo-
tifs have occurred on fragments from
Corinth (ibid., pl. XLIII, b, no. 1259; d,
no. 1211). In addition, the form of
the bowl is comparable to twelfth-
century finds at Corinth (ibid., fig.
103, N, no. 1252). In overall composi-
tion the bowl is similar to catalogue
252 and 253 and to the Dumbarton
Oaks examples previously listed. TT

255 Lead glazed sgraffito bowl

Pale orange clay, transparent
yellowish glaze over cream slip.
7.5 cm, diameter rim 20 cm, foot
9 cm
Byzantine, 12th century

M82.331

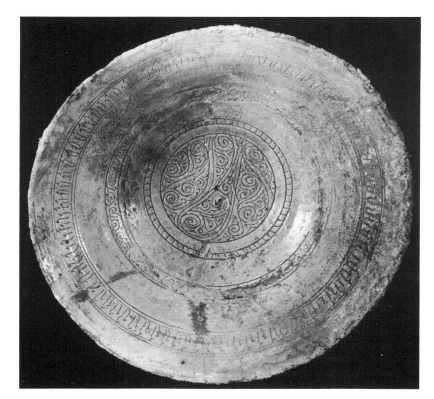

The bowl is complete, but restored.
There is heavy incrustation on the
exterior. The shape is an upward
flaring side, with a small ring foot.
The sgraffito decoration on the inte-
rior of the bowl consists of a central
medallion filled with an elaborate
rinceau design, surrounded by three
progressively wider bands of hatch-
ing, running spirals, and pseudo-
Kufic design on the side.

In shape and composition this
example is similar to bowls from the
Athenian Agora excavation found
in Group A, Period II, which date to
the time of Alexius I, 1081–1118,
and Manuel I, 1143–80 (Frantz [cat.
251], p. 432; p. 466, fig. 32, A 31;
p. 444, fig. 7, A 31, A 45, A 41; p. 445,
fig. 8, A 32, A 35; p. 447, fig. 9, A 44,
A 43, A 42, A 39, A 37). From Corinth
the shapes of bowls of the Spiral
Style are comparable. The origins of
this type of bowl can be found in
the Spiral Style, group II, at Corinth,
and the type continues into the mid-
dle of the twelfth century (Morgan
[cat. 251], p. 121, fig. 95, D; p. 129, fig.
103, L; p. 131, fig. 105, no. 1234).
Further Corinthian parallels are evi-
dent in the use of the running spiral
and the debased Kufic design (ibid.,
p. 33, fig. 22, D, no. 998; E, no. 1443; p.
32, fig. 21, B, no. 952). TT

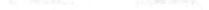

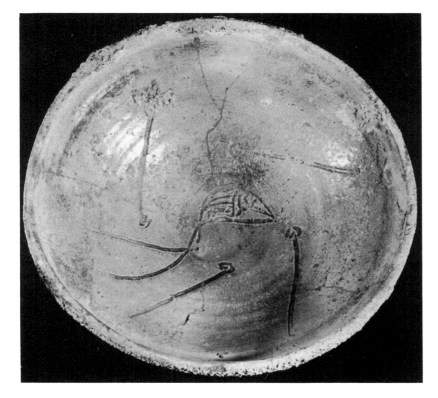

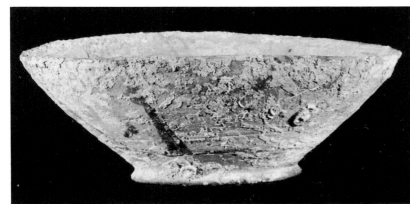

256 Lead glazed coarse incised bowl

Light brown clay, transparent
yellowish lead glaze over cream slip.
8.5 cm, diameter rim 26 cm, foot
11.5 cm
Aegean, 13th century M82.333

The bowl is complete but restored. It
is made of a brownish clay, covered
by transparent yellowish lead glaze
over a cream slip. There is a heavy
incrustation on the exterior of the
bowl, and small traces of it visible on
the interior.

A pattern of a few random lines
around an obscure (fish?) central
motif has been gouged out of the in-
terior of the bowl with a broad tool.
This bowl corresponds closely to a
number of bowls which have been
identified as a distinct group labelled
'coarse incised ware' by Megaw
(A.H.S. Megaw, 'An Early 13th Cen-
tury Aegean glazed Ware,' *Studies
in Memory of David Talbot Rice*,
1975, p. 34ff). The following charac-
teristics of the bowl link it to coarse
incised ware: its shape and size, a
rather coarsely potted open bowl; the
low wide foot ring, common to all
the bowls of the group; the pale
yellow glaze, sometimes with a
greenish tinge; and the decoration
consisting of coarse incisions which
have been executed with a broad
tool. This bowl belongs to the group
with free field designs. Comparative
bowls have been found at Paphos
(ibid., p. 36, fig. 1, pl. 15, 1, 2, 6; pl.
16, 4) on Cyprus, Anemurium in
Cilicia (Tomory [cat. 254], vol. 1, p.
306, vol. 11, pl. 96), and at Cherson in
the Crimea (A.L. Yakobson, *Sredne-
vekovyy Khersones: Materialy i issie-
dovaniya po arkheologii SSSR* 17,
1950, pl. xxx, 121; pl. vii, 37; pl. xxx,
122, 123). A similar composition of
a few gouged lines radiating from a
central motif is present on a bowl
from Cherson from the twelfth to the
thirteenth century (ibid., pl. xxx,
121). TT

257 Polychrome lead glazed sgraffito bowl

Buff clay, lead glaze over slip.
6 cm, diameter rim 21.5 cm, foot 7.5 cm
Byzantine, Eastern Mediterranean, late 13th, early 14th century M82.512

The bowl is complete, with wide flaring sides and low ring foot. The exterior is white slip, with green glaze to the foot. The interior is white slip covered by transparent lead glaze. Intense green and brown (copper and iron oxides) pigments colour the incised decoration. A band of simplified spirals is incised on the side. A circle incised on the centre of the well is surrounded by three rows of adjoining circles. The circles are variously coloured green and brown. The spaces between the circles are filled by crudely drawn spirals.

This bowl belongs to a classification of thirteenth-century polychrome sgraffito ware called Port Saint Symeon ware (A. Lane, 'Mediaeval Finds at Al-Mina in North Syria,' *Archaeologia*, LXXXVII, 1937, 45–6) which was manufactured in the eastern Mediterranean, especially at al-Mina. Port Saint Symeon ware has been found at al-Mina (ibid., pls. XXI and XXIII), Tarsus (F.E. Day, 'The Islamic Finds at Tarsus,' *Asia*, March 1941, pp. 143–6, fig. 8), Misis (Tomory [cat. 254], pp. 342–64), Hama (*Hama, Fouilles et recherches de la Fondation Carlsberg, 1931–38, IV, 2: Les verrières et poteries mediaevales*, Riis 1957, pp. 233–4, figs. 809 and 811), Anemurium (Tomory, p. 307), and Korykos (W. Volbach, 'Byzantinische Keramik aus Kilikien,' E. Herzfeld and S. Guyer, 'Meriamlik and Korykos,' MAMA [cat. 14], II, 1930, 200, J9507, J9500, J9495, and J9494 a,b), and examples are located in the Dumbarton Oaks Collection (N. Patterson Ševčenko, 'Some Thirteenth Century Pottery at Dumbarton Oaks,' DOP [cat. 93], XXVIII, 1974, 356ff, figs. 9–12). The composition, which consists of an incised band with an all-over design on the interior body of the vessel, recurs on a number of Port Saint Symeon bowls (Tomory, pl. 109.3; F.

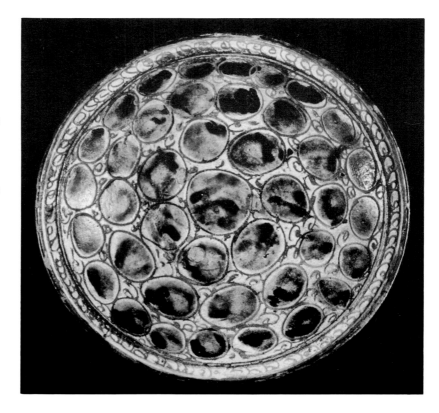

Waage, *Antioch on the Orontes*, IV, pt. 1: *Ceramics and Islamic Coins*, p. 1048, fig. 65). The shape of the bowl is similar to other Port Saint Symeon examples. Especially characteristics of the ware is the everted rim with the double ridge (Tomory, p. 347). TT

258 Fragment of polychrome lead glazed sgraffito bowl

Medium buff clay, covered by a transparent lead glaze over cream slip.
8.5 cm, diameter rim 16.5 cm, foot 8 cm
Cypriot, late 13th, early 14th century M82.495

The fragment consists of about half of a deep bowl, or one vertical side. The exterior of the bowl, from rim to foot, is covered by cream slip, with a greenish glaze on the rim. There is a random distribution of copper and iron oxides over a sgraffito drawing, covered by a transparent yellowish lead glaze. A series of concentric circles are incised at the upper and lower boundaries of the interior rim. The remaining well of the bowl retains the upper torso of a human figure, rather crudely sketched. The figure grasps in his right hand what appears to be a sword, in his left, a shield (?), surmounted by a bird.

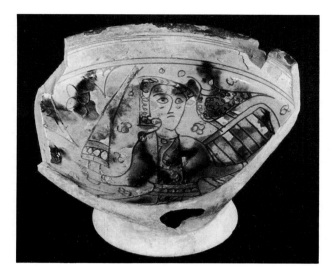

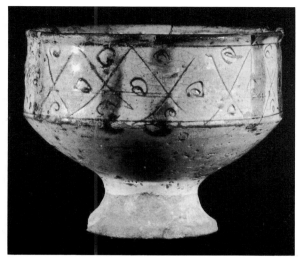

Triangular configurations adjoining the side, circles, and scattered quatrefoils complete the sgraffito decoration in the space surrounding the figure. The shape of the bowl is characteristic of common glazed pottery in the eastern Mediterranean at the close of the thirteenth century and early fourteenth centuries. (J. Du Plat Taylor and A.H.S. Megaw, 'Cypriot Medieval Glazed Pottery,' *Report of the Department of Antiquities of Cyprus*, 1937–9, pl. I, 16, 17, 18, 21). The bowl belongs to a Cypriot group of sgraffito pottery influenced by and closely related to Port Saint Symeon ware. The representation of the human figure occurs on Port Saint Symeon ware (Lane [cat. 257], pl. XXIV, 1, A, B; pl. XXIV, 2; pl. XXII, 1, E, F; Hama [cat. 257], p. 233; Tomory [cat. 254], pl. 106,1,2) as well as on Cypriot glazed ware (DuPlat Taylor and Megaw, pl. V, 9; pl. VI, 13–16; pl. X,3,4; pl. XI, 1). The figure in this example is seated in a manner similar to that found on Port Saint Symeon ware bowls in the Adana Museum, Hama, and al-Mina (Lane, pl. XXIV, 1, A; Hama, p. 233; Tomory, pl. 106.2). However, the rendering of the facial details establishes a link with Cypriot glazed ware as illustrated by fragments from Anemurium and bowls from Cyprus (Tomory, pl. 102, 1, 2,; DuPlat Taylor and Megaw, pl. X, 3, 4). The seated figure

on Port Saint Symeon ware examples holds a drinking beaker in his hand; this figure holds a sword as seen on other Cypriot examples (ibid., pl. X, 4). The quatrefoils and triangular configurations are to be found both on Port Saint Symeon ware and Cypriot ware. The bird also occurs in conjunction with other human figures on a number of Cypriot bowls (DuPlat Taylor and Megaw, pl. VI, 16; pl. X, 3). The presence of the sword, the shield, and the bird (perhaps a falcon?) gives rise to the suggestion that the figure on this bowl represents Digenes Akritas. However, no positive identification of the figure can be made since features such as the sword, shield, and bird are common items on other Cypriot bowls with no apparent connection to the epic hero. TT

259 Polychrome lead glazed sgraffito bowl

Buff clay, white slip, transparent glaze.
10 cm, diameter rim 12.7 cm, foot 7 cm
Cypriot, 14th, early 15th century
M82.490

This small, complete bowl has parts of the foot chipped and the side repaired. It has a high foot and vertical sides. The exterior has white slip to the junction of the foot, covered by transparent greenish lead glaze, with alternating stripes of green (copper oxide) and brown (iron oxide) on the side. The interior has white slip, transparent glaze, and random subtle applications of iron and copper oxides. The rim is green. The sgraffito design extends over the exterior, side, and interior. The exterior design is composed of a wide band of adjoining diamonds. All the spaces thus formed are filled by crudely drawn spirals. The interior sgraffito composition in the well consists of a small circle divided into four parts by a cross; each quarter contains a spiral. Surrounding the small central circle are radiating wavy lines and four triangular configurations filled with floral motifs within a larger circle. On the side is a narrow band of crudely executed

zigzag patterns.

The high foot of this bowl is typical of Cypriot glazed pottery manufactured in the fourteenth and fifteenth centuries. At this time the use of exterior sgraffito decoration was common (Du Plat Taylor and Megaw [cat. 258], pp. 8, 9, group v, vi, vii; pl. ii, 26–35, pl. vi; J. Du Plat Taylor, 'Mediaeval Graves in Cyprus,' *Ars Islamica*, v, 1938, p. 83, 34, fig. 19; p. 67, i). Other comparable types of design on Cypriot pottery of this period include a band of crude zigzag (Du Plat Taylor and Megaw, pl. vi, 12, 13, 14, 15, 16), a band of diamonds with spirals (ibid., pl. viii, 55, p. 79, fig. 45, 1), and crudely drawn spiral motifs (ibid., pl. viii, 56, 57, 58) and floral-filled spaces (ibid., pl. x, 2; xi, 2; vi, 17). TT

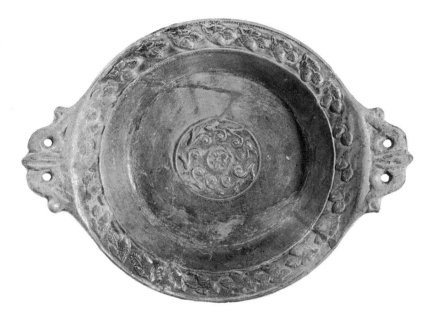

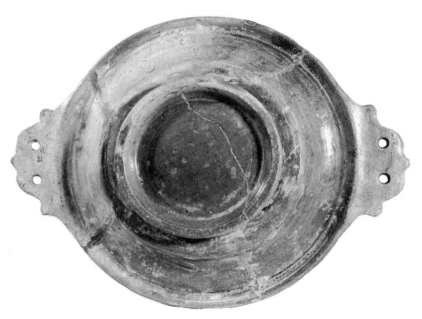

260 Shallow dish with relief decoration

Clay with monochrome green glaze.
19.5 × 3.5 cm, handles 3.5 cm
Islamic (?), Eastern Mediterranean,
date uncertain M82.334

The shallow dish is similar in shape to a patera or a paten, and is clearly modelled on a metal vessel. The everted rim has two protrusion which are handle-like. Two holes have been punched into each of these handles. The wearing of the glaze in these areas implies much handling. A monochrome green glaze covers both surfaces of the dish. The centre has a circle enclosing a series of scroll motifs in relief, while a band of moulded relief design consisting of a row of acorns and leaves decorates the rim of the vessel. This type of glaze existed in the Near East from second to the third century onward, and as there do not seem to be any good published comparanda for this piece, the date must remain uncertain for the present. TT

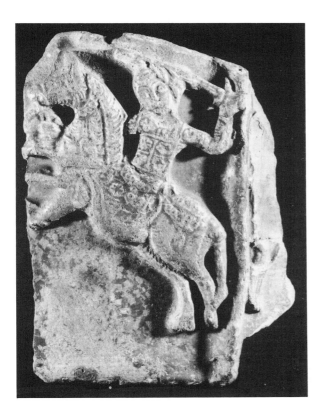

261 Glazed ceramic fragment

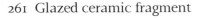

Buff clay, green glaze.
14.5 × 11.5 × 1 cm
Reported to be found in Fustat, date
unknown M82.348

This piece appears to be a fragment
of the side and part of the base of
a large clay vessel. The buff clay is
covered by a green glaze on both
interior and exterior surfaces. There
is sculptural decoration in deep relief
on the exterior. The surviving frag-
ment depicts part of a panel showing
an armoured rider, brandishing a
sword, and mounted on a rearing
horse. He holds a very small shield,
visible just under the head of the
horse. Traces of part of a leg of an-
other human figure are visible on the
adjacent panel.

Purchased from Kelekian, New York
 TT

262 Clay vase

Clay vessel, slip painted decoration,
unglazed. 27 × 11 cm
Meroitic, Nubia, 3rd / 4th century
 M82.500

The two-handled orange clay jar was
broken into numerous fragments
and is now reconstructed. The top of
the neck is missing, but the interior
of the neck contains a horizontal
piece with three holes, acting as a
coarse strainer. The base of the vessel
is missing. A cream-coloured slip
covers the body of the jar. A horse
and rider, crudely painted in black
and red pigments, are depicted on the
upper part of the vessel. The horse-
man holds a cruciform staff in his
right hand and his head is surrounded
by a nimbus. Wide red bands and
narrow black bands surround the
lower part of the jar.

Purchased from Kelekian, New York
 TT

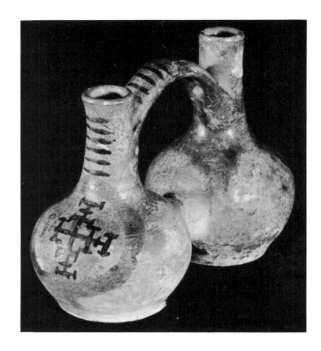

263 Clay vase

Clay vessel with slip painted
decoration, unglazed. 32 × 16 cm
Meroitic, Nubia, 3rd / 4th century
M82.349

The pale orange clay vase has two
handles which extend from the bot-
tom of the neck to the upper third
of the body. The rim has been re-
paired. The foot is damaged, and the
bottom of the vessel has a hole. A
cream slip serves as the base for the
black and red painted designs. A
quail-like bird is painted in black and
red on the upper half of the body of
the vessel on one side. The design
on the other side is badly eroded, but
traces of three fan-shaped leaves
remain. On the lower part of the
body the painted bands of scrolls and
large dots are divided by protruding
ridges.

A similar vessel may be seen in the
Brooklyn Museum. See exhibition
catalogue, *Romans and Barbarians*
[cat. 34], no. 53.

Purchased from Peter Mol,
Amsterdam, 1969 TT

264 Small stirrup jars

Buff clay, glazed, painted.
9.5 × 14 cm
Provenance and date unknown
M82.501

The two small jars are joined at the
body and by a strap handle at the
necks. One jar is covered by a light
brown glaze, the other by a green
glaze. The brown jar has dark brown
painted horizontal stripes on the
top of the handle and on the one side
of the neck. A lighter brown circle
encloses a dark brown cross-like con-
figuration with small crosses on its
arms.

From the Osen Foundation Collec-
tion

Purchased from Kelekian, New York,
1977 TT

265 Three hanging ceramic eggs

Painted glazed clay.
11.5 × 9 cm; 10 × 8 cm; 7.5 × 7 cm
Armenian, Kütahya (Turkey), 18th
century M82.499

The three egg-shaped balls, in de-
creasing size, are attached by means
of a bronze hook on a chain. Each
egg has three stylized seraphim-like
faces, flanked by crosses at the top
and bottom, painted in green, yel-
low, blue, and aubergine on a cream-
coloured base. The crosses and the
seraphim are characteristic features
of the Christian Armenian potteries
of Kütahya. These eggs are usually
suspended above the altar in a
church. For similar examples see Ar-
thur Lane, *Later Islamic Pottery*
(London 1957), pp. 64–5, pl. 50B;
*L'Islam dans les collections natio-
nales* (Paris 1977), exhibition
2 May – 22 August 1977, pp. 256–7,
no. 608.

Purchased in Egypt TT

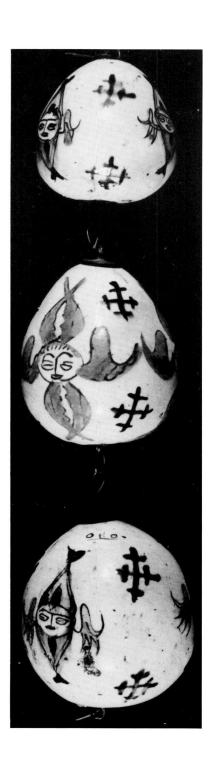

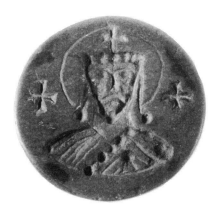

266 Semispherical seal with bust

Steatite, green. 2 × 1.5 cm
Byzantine, 9th / 10th century
<div align="right">M82.249</div>

The seal is semispherical, and is pierced through laterally so that it could be hung on a thin cord. The cutting is moderately shallow and shows the bust of a crowned bearded male with a lightly incised halo. There are crosses on either side of the head and on top of the head, within the halo. The cross seems to be on the front of the flat crown from which streamers hang almost to the shoulders. The upper torso is indicated by the drapery but the arms do not show. The bust may be intended as Christ or as an imperial figure. There are no other identifying attributes.

The proposed date is offered on the basis of coin portraits of this general period, see for example, G.E. Bates, *Byzantine Coins*, Archaeological Explorations of Sardis, 1971, pl. 8, no. 1109, a copper follis of Theophilus (829–42). However, there are many imperial portraits of this frontal crowned type, and no specific comparison is possible here. SDC

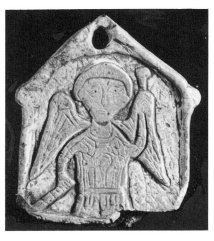

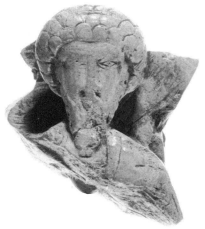

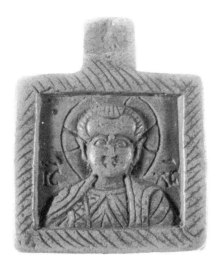

267 Pendant, Archangel Michael

Steatite, beige-grey. 5.1 × 4.5 cm
Post-Byzantine M82.253

The rectangular plaque, which apparently was made as a pendant, has a gabled top through which a hole has been bored. The plaque has several chips around the border, including one at the lower right that has taken the whole corner off. The surface is also worn.

An angel is shown frontally in three-quarter length. He stands under an arch indicated by a single thin incision. The inscription on either side of his head is barely recognizable. The work is of very low quality. Because of its simplicity, it is difficult to date precisely. It is presumably post-Byzantine. IKM

268 Fragment of an icon, St Theodore

Steatite, grey-green. 3.5 × 1.7 cm
Byzantine, 14th century M82.255

The fragment represents the head of St Theodore. It is the only part of the icon that survives. It should be reconstructed with the warrior saint standing frontally in full armour similar to an icon now in Paris representing St Demetrios (Publication, no. 127). St Theodore can be identified by the shape of the beard. Originally the beard was finely carved with incisions indicating the individual strands. The hair is in the customary circular locks that St Theodore and St George still wear in the fourteenth century, whereas the hair of St Demetrios has become straight and falls forward on the forehead. The plaque was very thick. The background thickness is 0.9 cm and the relief itself high. High relief carving is typical of icons of the fourteenth century. The high relief leads easily to breakage. The head has broken off because the stone could not withstand the weakpoint at the neck, where abruptly the stone becomes much thinner. This is an example of a head severed from its body. An example of a body without a head from the same period survives in Paris (IKM, no. 128), although they do not fit together.

PUBLICATION
Kalavrezou-Maxeiner, I., *Byzantine Icons in Steatite*, Byzantina Vindobonensia 15 (Vienna 1985), no. 129
IKM

269 Pendant, Christ Emmanuel

Steatite, light green.
2 × 1.9 × 0.5 cm
Byzantine, 13th century M82.250

The pendant, still in good condition, is almost square with a pierced boss at the top which has been slightly chipped. The cross nimbus and the IC XC identify the figure as Christ. He is shown from the chest up without His arms visible. The work is plain. The hatching of the border and the simple drapery suggest a date in the thirteenth century.

PUBLICATION
Kalavrezou-Maxeiner, I., *Byzantine Icons in Steatite*, Byzantina Vindobonensia 15 (Vienna 1985), no. 113
IKM

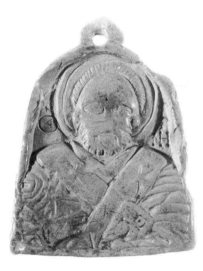

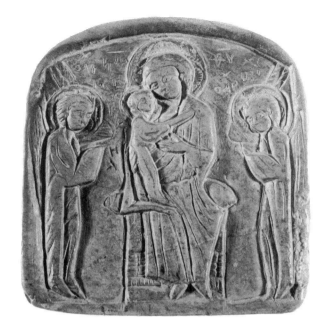

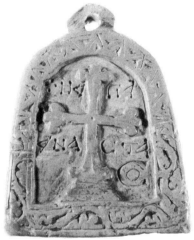

270 Pendant / Plaque

Steatite, light green. 4 × 3 × 0.7 cm
Post-Byzantine (?) M82.25

The pendant is approximately bell
shaped, carved on both sides and
on the curved edge. It has an
attached pierced knob at the top for
suspension. On one side is the bust
of a bearded saint. He wears a crossed
stole with 'embroidered' crosses and
with his right hand makes the sign
of benediction. He holds a book in his
left hand. there is an inscription on
either side of his head. One identifies
him as a saint ⊚, but the other
is incomplete и. On the reverse is a
cross with trilobed arms, set up on

a four-stepped platform. The inscrip-
tion proclaims the resurrection:
Н4 Гі4 АNА СТ4 ⊙
The letter forms are rather crudely
cut and the unusual alpha is like
that in catalogue 169. This cross is
framed by a narrow band enclosing a
vine scroll on the lower half, and a
v-shaped design on the upper half.
The sides are carved with a pattern
of stylized palmettes or acanthus
leaves, placed in alternating direc-
tions. The piece is not of the best
quality workmanship and the sur-
faces are worn smooth from han-
dling. This makes a more precise
dating very difficult.

Purchased from Kelekian, New York,
December 1965 SDC

271 Pendant, Virgin and Child

Steatite, mainly beige, with the upper
third darker, in parts almost black.
5.1 × 4.7 × 0.6 cm
Byzantine, 12th century M82.230

The small plaque is rectangular with
an arched top. Its surface is partly
worn and scratched. There are major
chips at the upper left corner, along
the lower right side of the border,
and at the bottom left corner. A vein
traverses the stone from left to right

on an angle beginning at the feet
of the left angel and reaching the
upper part of the legs of the other.
The Virgin is enthroned and flanked
by two angels standing in veneration
with their hands covered. She is
shown frontally with the Christ child
standing on her right leg. He is
extending his right arm to reach her
shoulder, while she inclines her head
to embrace him. The haloes of the
Virgin and angels are incised, with a
simple fretsaw motif. The incised
inscriptions M P ϴU, IC XC, O ARX
ABPIH, O ARX MIX (AH) are rather
clumsily distributed around the
figures. The relief is low. The figures,
especially the angels, are carved
with very few incisions. Those still
recognizable mark the folds which
indicate the major parts of the bodies.
The Virgin's face has features typical
of the twelfth-century steatites: a
broad face, wide cheeks, and a slight
indentation at the temples. The piece
is simply worked with the
standardized twelfth-century
formulas for carving figures and
drapery.

PUBLICATION
Kalavrezou-Maxeiner, I., *Byzantine
Icons in Steatite*, Byzantina
Vindobonensia 15 (Vienna 1985), no.
101 IKM

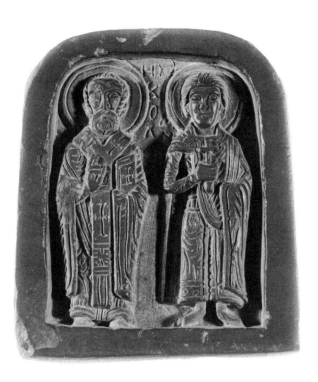

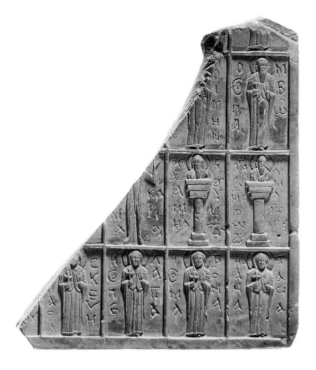

272 Icon with two saints

Slate. 6.2 × 5 × 0.7 cm
Byzantine / Russian (?), date
unknown M81.231

The icon is carved on one side only.
It has a plain band forming a self
frame. Inside that frame is a deeply
cut relief of two frontal standing
saints. The one on the left is identi-
fied as St Nicholas and is dressed as a
bishop. He makes the gesture of
blessing and holds a book in his other
hand. The one on the right also has
an inscription but it is not clear what
name is intended. He is younger
and beardless. He holds a cross in his
right hand while his left is covered
by drapery. The folds of the drapery
are deeply cut and linear but there is
some sense of anatomy under the
folds, particularly with the younger
man. The figures have a squat ap-
pearance and the heads are large in
proportion to the rest of the body.
It is stylistically unlike the other fig-
ured steatites in this group (cata-
logue 270, 271).

Purchased from A la Vieille Russie,
New York, December 1962
 SDC

273 Icon, rows of saints

Steatite, light green.
10 × 7.6 × 1.3 cm
Byzantine, 12th century M82.254

Although the plaque has lost more
than half its area, is scratched, and
has been chipped around the border,
nevertheless the relief is in rather
good condition with most of its
original detail intact. The fragment
is the lower right corner of an icon
with representations of saints. The
surface is divided into zones of
rectangular compartments for the
individual figures. Five horizontal
and four vertical compartments are
preserved. It is tempting to think that
the piece originally had thirty such
compartments and was a calendar
icon, but the commemorative dates
of the saints represented fall
throughout the year. The saints are,
from top to bottom and left to right:
[O OCIO]C OIMHN (27 August),
O OC(IOC) AMBW (18 July); [O
OC(IOC)] MAKAPIOC (1 April), O
OC(IOC) ANIH O CTY ITHC (11
December), O A(IOC) CYME(ON)O
EN TW OAYMACTW OPOC (24
May); [H A(IA)] APACKEYH (26
July), H OC(IA) E A IA (8 October),

H OC(IA) MATRONA (27 March),
H A(IA) ANACTACIA (22 Decem-
ber). All are shown completely fron-
tal. Each standing saint holds a cross
in front of the chest, except Maka-
rios, who is praying. The two stylites
are shown only as busts on top of
identical columns.

The plaque is rather thick but the
relief is low. Its carving style is similar
to that of the well-known large
twelfth-century icon of the Twelve
Feasts in Toledo (IKM [cat. 268], no.
52). For example, the hood of the
female saints has been scalloped in
the same manner as the hood of the
Virgin on the Toledo icon. The heads
of the male saints can also be com-
pared to those of the apostles on the
Toledo icon. Although much smaller,
they have the same rounded eyes
with the clearly defined lid and
slightly rounded brow. The beards
and hair are incised with fine lines.
However, since the saints are all
frontal and wear monastic garments,
it is difficult to make figure-to-figure
comparisons between the two icons.

The combination of saints is
unusual: the bottom row, on which
women tend to be placed when
shown, preserves four female saints,
and there are two stylites, a hermit

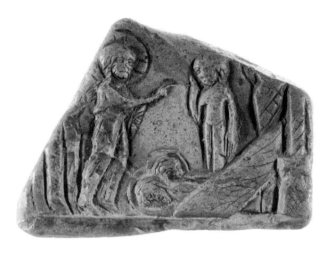

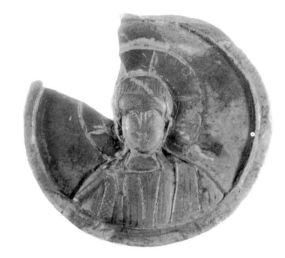

and several other male saints. All come out of monastic backgrounds – that is, the saints are monks or nuns during their lives, since several are designated as Hosios or Hosia. The selection of saints indicates that the icon was made for a monk or monastic community. While we assume that most icons are made in response to individual requests, here this is clear from the category of saints chosen.

PUBLICATIONS
Casson, S. 'A Byzantine Steatite Relief,' *Burlington Magazine*, LII, 1928, 88–93
Ostrogorsky, G. *History of the Byzantine State*, trans. Joan Hussey (New Brunswick 1969), fig. 54
Kalavrezou-Maxeiner, I., *Byzantine Icons in Steatite*, Byzantina Vindobonensia 15 (Vienna 1985), no. 51
IKM

274 Icon fragment, Raising of Lazarus

Steatite, dark green.
3.95 × 5.1 × 0.7 cm
Byzantine, 12th century M82.252

The fragment is the right bottom corner of a plaque which contained the first six of the twelve scenes of the Feast Cycle. The scene represented here is the Raising of Lazarus, the last of the sequence. The original icon should be reconstructed as a diptych and this scene as a fragment

of the left wing. Such a wing of a diptych icon survives intact on Cyprus (IKM [cat. 268], no. 62). Like the icon on Cyprus, the Toronto piece had small columns which framed the scenes on either side. The pine-cone base, common in steatites, and part of the spiral column are still visible. The original width of the scene should be reconstructed to about 5.5 cm. This would bring the whole wing to about 11 cm in width and 16–17 cm in height. In carving technique and style the fragment is comparable to the Cyprus piece and to a fragment in the Benaki Museum which has the Lazarus as well as three earlier scenes from the Twelve Feasts (IKM, no. 64).

PUBLICATION
Kalavrezou-Maxeiner, I., *Byzantine Icons in Steatite*, Byzantina Vindobonensia 15 (Vienna 1985), no. 65
IKM

275 Medallion, Christ Emmanuel

Steatite, uneven areas of ligher and darker green with veins of white.
4.8 × 0.55 cm
Byzantine, 11th century M82.247

The medallion is broken into two pieces, now glued together. The crack, which can be seen better from the reverse, runs along the left side of the figure. A triangular section has been lost and the border has been

chipped in various places, primarily at the top and lower left. The relief is in relatively good condition, although rubbing around the nose and mouth has distorted the face. No carved inscription identifies the figure. The cross nimbus, however, leaves no doubt that Christ Emmanuel is represented. The face is not that of a young child but rather is reminiscent of the apostle John as he usually appears at the Crucifixion. The figure is shown as a bust without arms. Cross hatching distinguishes the clavis of his tunic, over which the himation is worn.

The very low relief can be compared to that of a medallion with St Demetrios in the Virginia Museum in Richmond and of a plaque with St Panteleimon in the Walters Art Gallery in Baltimore, both of the eleventh century (IKM [cat. 268], nos. 16, 19). Christ's long ears are typical of the eleventh century. The upper lid of the eyes is prominent and the eyeball is small with a tiny hole in its center. The reverse has been roughened to receive glue more easily. The piece could have been set in an encasement and worn as a pendant, but its thinness suggests that it more likely was a medallion which decorated the frame of an icon.

PUBLICATION
Kalavrezou-Maxeiner, I., *Byzantine Icons in Steatite*, Byzantina Vindobonensia 15 (Vienna 1985), no. 17
IKM

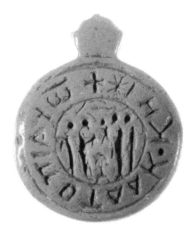

277–9 Crosses

Steatite, pale grey to pale green.
277: 2.5 × 2.5 × 0.5 cm
278: 2.3 × 1.7. × 0.6 cm
279: 2 × 1.5 × 0.5 cm
Byzantine, date unknown

M82 244, 245, 246

The tiny steatite crosses in this group may be compared to the bronze crosses in catalogue 142–8, except that these are pierced for suspension. One has a decoration of circles and lines (see catalogue 187), the other two have a box with a cross over the juncture of the arms and a few additional striations. As with the bronze and silver examples, there is little here on which to base a date or provenance.

Purchased from Blumka Gallery, 1966

SDC

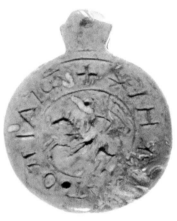

280 Engraved gem-stone

Carnelian, bright red-orange.
17 × 28 × 3 mm
Provenance unknown, 12th–15th century

M82.238

The medallion is oval, flat on both sides. The surface and interior of the engraving are carefully polished, with few signs of wear. The main parts of the letters are very shallow, cut with a broad wheel, the hastae with a conoid and the central circle with a narrow wheel.

The Christogram, the Greek letters Chi Rho, are the first letters of the name of Christos. The sign was introduced by Costantine after the battle at the Milvian Bridge, in 312 AD, as the official imperial device. It remained throughout antiquity and the early Byzantine period as a symbol of Christian faith and was used in many contexts as a meaningful ornament. The large circle marking the intersection of the Chi and Rho is unusual. Together with the elongated form of the letters, it recalls the shields displayed by the imperial guard in the mosaics of San Vitale in Ravenna. There the shield buckle is in place of the circle, explaining

276 Incised medallion

Steatite, light green. 2.5 × 0.5 cm
Byzantine, date unknown M82.243

The medallion has a pierced knob at the top for suspension. It has been cut as if meant to be used for a seal. On one side are four very rudimentary figures and a fifth tiny one. This may be interpreted as a scene of the Presentation in the Temple. The scene is surrounded by a retrograde inscription which has a cross and a star between the beginning and end. On the other side is a figure on a galloping horse. Over his shoulder he holds a banner which streams out behind him. The same retrograde inscription surrounds the scene. The way of indicating the figures is similar to that in catalogue 281.

Purchased from Blumka Gallery, New York, 1966 SDC

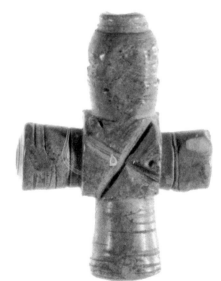

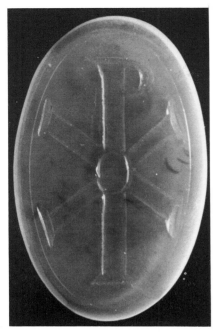

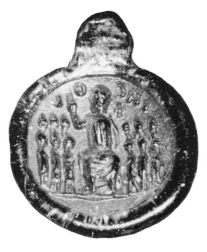

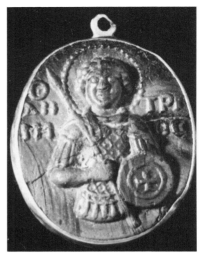

it as a functional motif. The decorative christogram on a prominent place may have been copied for ornamental purposes.

The large and laminated stone is not the usual ring-stone, but may have been designed for a gem-studded bookcover or cross in some post-antique period, maybe as late as the sixteenth or seventeenth century. For comparative examples for the motif see F.W. Deichmann, *Ravenna, Hauptstadt der spätantiken Abenlandes*, Kommentar, 2, Wiesbaden 1976, p. 185; ibid., *Frühchristliche Bauten und Mosaiken von Ravenna*, Baden-Baden 1958, pl. 368. For the christogram in general see A. Alföldi, 'The Helmet of Constantine with the Christian Monogram,' *Journal of Roman Studies*, XXII, 1932, p. 9ff; ibid., 'Hoc signo victor eris. Beitrage zur Geschichte der Bekehrung Konstantins des Grossen,' *Pisciculi*, Studien zu Religion und Kultur des Altertums. Festschrift F.J. Dölger, Aschendorff, Münster 1939, p. 1ff. On shields see R. Delbrück, *Die Consulardiptychen und verwandte Denkmaler* (Berlin 1929), p. 41. On gems, yellow carnelian, see *Romans and Barbarians* [cat. 34], no. 142.

AK

281 Medallion with Christ and apostles

Amber glass. 2.2 cm
Byzantine, date unknown M82.239

This small glass medallion shows Christ seated, with the apostles. Christ is seated in the middle, much larger than the other figures, and with the right hand raised. He is identified by a somewhat garbled inscription. On the right are the reverse letters ꓛ H I for Jesus. On the left are the letters X C for Christos. It is not likely that his medallion was intended as a seal, but rather that the maker of the original die did not reverse the inscription properly. Over Christ's left shoulder is a small cross.

The piece has been made by a simple stamping process. This is a less expensive version of a carved gem. Such objects could be made cheaply in great quantity and would be sold as amulets and devotional aids. The small projection at the top of this piece is not pierced so it could not have been worn, but was carried in a pouch.

Purchased from Blumka Gallery, New York, September 1966 SDC

282 Pendant medallion of St Demetrius

Glass paste.
Byzantine, 12th century M82.223

In the middle Byzantine period glass paste medallions of this type were very common and it is possible to find identical examples which have been produced from the same mould. This oval medallion has been cast in a red and black glass paste. It shows a three-quarter length frontal military figure. He holds a spear in his right hand and a small round shield decorated with a cross in his left. There is a halo of raised dots around his head. The inscription on either side of his head and shoulders reads OΔHMH TPIOC, St Demetrius. There is a gold frame around the medallion, pressed over the edges to hold it in place, and on the top a ring for suspension. Another example which could well be from the same mould can be seen in the Kanellopoulos Museum, Athens, no. 2289 (unpublished). A second similar piece is discussed in DOC [cat. 26], p. 87, no. 105, pl. LVII.

Purchased from Mathias Komor, 1978
SDC

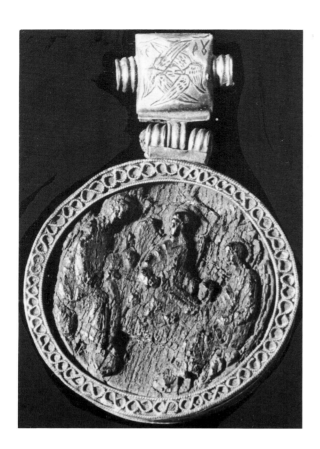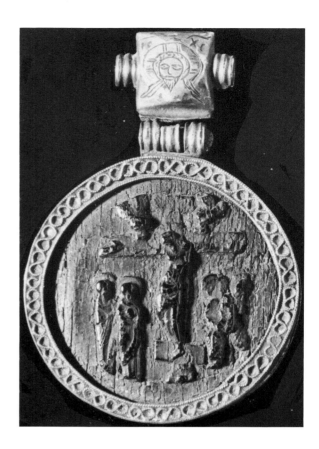

283 Circular Panaghia

Carved wood, framed in silver
filigree. 3.8 cm
Russian, 15th-century Novgorod
School M82.261

The silver mount has a box-like at-
tachment at the top, probably for at-
tachment to a chain. On one side
a seraphin / cherubim is engraved,
with the inscription X E I P Ȣ, on
the other a cross-nimbed head of
Christ with the abbreviations
I C X C. The wooden disc, to which
it is attached, has a scene of the
crucifixion with three attendant hal-
oed figures, presumably a deesis with
one extra person and two descending
angels above. The figures are very
worn and barely legible for any sty-
listic details. On the other side is
a scene of the Old Testament Trinity,
but once again none of the details
are legible. The piece is similar to one
from the Kirillo-Belozersk monastery
and in spite of the loss of clear legi-
bility, the format and general

makeup of the object suggest a simi-
lar date and provenance. See *Treas-
ures from the Kremlin: An Exhibition
from the State Museums of the Mos-
cow Kremlin, Metropolitan Museum
of Art* (New York 1979), col. pls. 27–9
and p. 137.

Purchased from A La Vieille Russie,
New York, November 1965 SDC

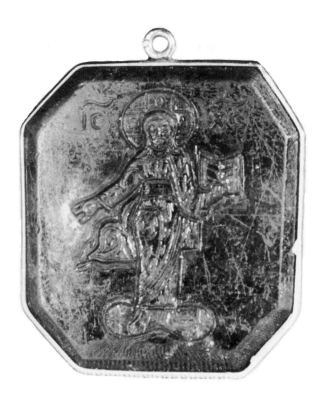

284 Carved gemstone amulet

Tourmaline mounted in gold.
3 × 3.5 cm
Byzantine, 10th century / Russian,
17th century M82.229

The figure of Christ is carved in a
tourmaline which is then mounted
in gold with a loop for suspension.
The frame does not extend across the
back and thus the light can pass
through the stone. Christ stands on a
cushion, of the type usually found
on a throne. However, a similar
cushion-like footstool may be seen in
a fifteenth-century icon from Patmos
(*Byzantine Art*, Council of Europe
[cat. 171], no. 204). He holds an open
book in His left hand and makes
the sign of benediction with His right
hand, although His hand is stretched
out to the side, not raised. Behind
His head is a halo with the inscrip-
tion ὁ ὠν, and on either side of His
head, the abbreviated Ιησους Χριστος.
His garments are difficult to identify.
The fluttering drapery under His

right hand does not seem to belong
to anything else, except a tiny fold of
fabric which barely catches the right
shoulder. The mantle which hangs
over the left arm is not part of the
same garment. The fluttering piece
also seems to have a 'shadow line' cut
around it. One possible explanation
could be that this is a later recutting,
that the figure was perhaps originally
shown seated and for some unknown
reason, at a later date, the piece
was redesigned. The drapery is char-
acterized by little internal lines like
commas or dashes. Something similar
may be seen in a tenth-century plaque
of carved jasper, belonging to the
Victoria and Albert Museum, show-
ing the crucifixion (ibid., no. 109,
tenth century). There is a similar
roundness to the bodies here as well.
On the other hand, the gem is almost
identical to a painted icon, Russian,
dated to the seventeenth century
(Ulrich Fabricius, *Ikonen: Jesus
Christus*, Verlag Aurel Bongers Reck-
linghausen, Bd. III, 1957, vol. 2).
There Christ stands on a cushion,

with similar fluttering draperies,
except that the piece on the right
shoulder makes more sense. His right
hand is held in front of the body
and the left hand holds an open gos-
pel. If the stone had been recut,
and there is evidence on the stone
when examined very closely which
might be interpreted as reworking,
then the revised form may have been
modelled on something such as this
later icon. Stylistic details on an
object of this size are too ephemeral
to be used for firm dating.

Purchased from Parke-Bernet, New
York, 1977 SDC

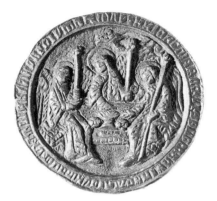

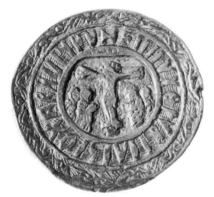

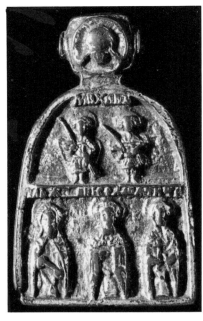

285 Medallion with Old Testament Trinity and Crucifixion

Bronze. 4.5 cm
Russian, 17th / 18th century (?)

M82.227

The medallion is slightly convex. The side with the Old Testament Trinity is in high relief. The three angels are placed one behind and one on either side of a table on which is placed a chalice or dish and two smaller dishes or round loaves of bread. Each of the angels holds a long staff. An inscription frames the scene, but unfortunately is no longer legible. The other side is quite flat. The figures are not raised, rather the background is cut away. This side is much cruder than the other, and the figures are rudimentary and coarse. An illegible inscription surrounds the scene. SDC

286 Arched plaque with figures

Gilt bronze. 6.5 × 4 cm
Russian, 16th century (?) M82.225

The plaque is very worn and the gilding has been lost from the faces and inscriptions. At the top is a knob, pieced for suspension, and on it, barely legible, is a bearded head of Christ in a crossed nimbus. The plaque itself has two registers. In the upper part are two angels, fully represented in frontal pose and what may be a military dress. The inscription Michael can be read for one, the other may be Gabriel. In the lower register the figures are three-quarters represented, also completely frontal. The inscriptions, from left to right, are Elias, Nicholas, and Paraskeva. The date proposed is tentative only, as the stylistic features are impossible to see.

SDC / MD

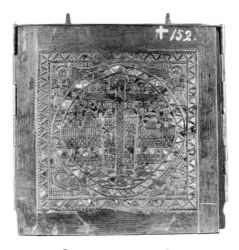

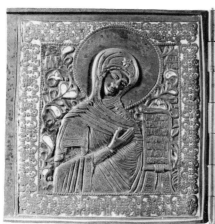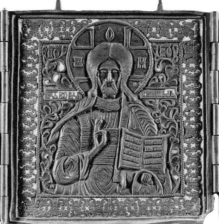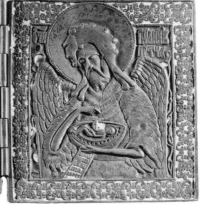

287 Triptych with Virgin, Pantocrator, Winged St John

Champlevé enamel on bronze.
14 × 13.5 cm closed, 38 cm open
Russian, 18th century M82.141

Only a few traces of enamel, in dark blue and white, remain on the outside cover. Inside a zigzag border is an oval, also subdivided by zigzag patterns. In the four corners are the evangelist symbols, with inscriptions, but the captions for Mark (top right) and John (bottom left) have been reversed from the traditional arrangement. The symbol for Mark is usually the lion and for John the eagle, not vice versa as given here. This alternate arrangement is in accordance with the vision of St Irene. Up to the end of the sixteenth century in Russia both traditions were common. Thereafter, the traditional Mark (lion) and John (eagle)

were used. This icon, therefore, follows an earlier model. Inside the oval is a landscape scene of domed and arcaded buildings, and in front a cross decorated with chevrons, two spears, several flowers, and a series of inscriptions. At the foot of the cross is a skull, lying on its side. The inscriptions, reading from the top are : 'Lord' (of the heavenly hosts?), and, left to right, 'spear,' 'son of God,' 'sponge,' 'victory,' and the remainder is illegible. At the top right is the mark + 152, reported to be the number of a previous owner.

On the interior, each of the three panels has an outer frame of a scroll / palmette design on white enamel, while the space around each figure is filled with a foliate scroll in dark blue and white enamel. To the left is Mary with a scroll; in the centre Christ Pantocrator with an open book; to the left a winged John the Baptist with the Christ child in a

chalice. He also holds a scroll which reads: 'Behold, this is the lamb of God.' The inscriptions in the other two panels are illegible, but probably have a similar content to those in catalogue 288. The relief on these interior panels is high and the figures quite mannered and elegant in style, in keeping with the decorative background. An almost identical piece has been published in W. Volbach, Bildwerke des Kaiser-Friedrich Museums, *Mittelalterliche Bildwerke aus Italien und Byzanz* (Berlin 1930), no. 6429.

Purchased from Blumka Gallery, New York, November 1968

SDC / MD

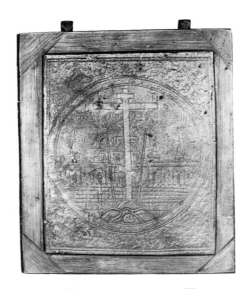

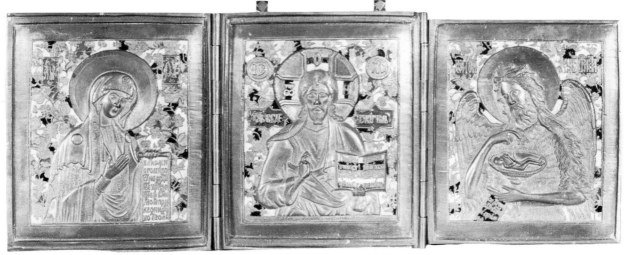

288

288 Triptych with Virgin, Pantocrator, Winged St John

Champlevé enamel on bronze.
16 × 13 cm closed, 39 cm open
Russian, 19th century M82.274

This icon is almost identical in format to catalogue 287. The exterior has the same basic arrangement but is a little more simplified. The relief is very low, it is not enamelled, and the evangelist symbols do not appear in the corners. The interior is also nearly identical except that the child in the chalice held by John the Baptist faces in the opposite direction. The three interior panels are done in high relief. The background and inscriptions are done in enamel in light blue, dark blue, green, white, and yellow. The colours are applied in a random fashion. On the left the Virgin holds a scroll which reads: 'Lord all merciful and Lord Jesus Christ my Son and my God, I unite my offering to yours.' In the centre Christ holds a scroll with the words 'Come to me all you who labour and are burdened, I shall give you rest' (Matthew 11:28). On the right John the Baptist displays the quotation: 'Behold this is the lamb of God who takes away the sins of the world.'

Purchased from Collectors' Corner, New York, 1968 SDC / MD

289 Plaque / Icon with Christ, Mary, and St Iukhin

Bronze. 7 × 10 cm
Russian, 17th / 18th century (?)
 M82.278

The plaque is made of plain bronze, with several frames around the main picture. Loops on the four corners suggest that the piece originally was a triptych, similar to catalogue 292. This too has a scene of the Old Testament Trinity on top flanked by cherubim or seraphim, and above that a square projection with a head of Christ. The main scene of the icon is Christ as Pantocrator seated on an elaborate throne holding an open book in His left hand and the scroll

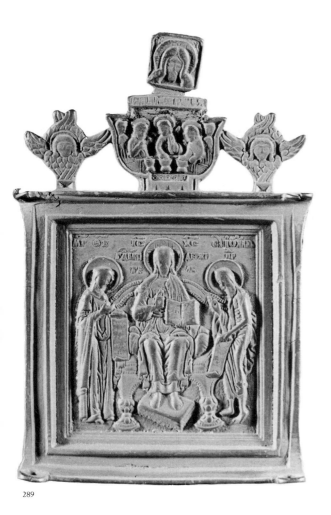

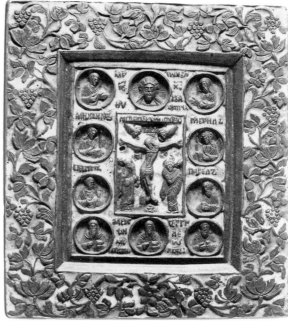

289

290

of the apocalypse in His right hand. On His right are Mary, Mother of God, and on the left, a figure identified as St Iukhin, preacher. The figures are elongated and the perspective distorted, especially in the throne and footstool. The facial features of all the figures are worn quite smooth, presumably from handling, and only fugitive images may be seen for any hint of style.

SDC / MD

290 Icon with Deesis and Saints

Champlevé enamel on bronze.
10 × 9 cm
Russian, 17th / 18th century (?)
M82.275

The raised leaves and grapes of the frame are plain, with incised details. The background is filled with enamel in light blue, dark blue, green, yellow, and orange, applied in a fairly random manner.

The frame of roundels has a general light green background with dark blue in each of the roundels. The background of the crucifixion and deesis scene is yellow. Inscriptions identify each of the roundels. Across

the top are Mary, the Mother of God, Jesus Christ, John the Baptist. The next row down are, left, archangel Michael, right, archangel Gabriel. Below are St Peter, left; St Paul, right. The bottom row are St Aleksi, Metropolitan, left; St Sergius, centre; St Leonti, right. The central panel is labelled 'Crucifixion of Christ.'

The drapery on the figures is linear and the hair and facial features are rudimentary. Nevertheless, there is some sense of three-dimensional modelling in the figures and busts.

Purchased from Blumka Gallery, New York, September 1967

SDC / MD

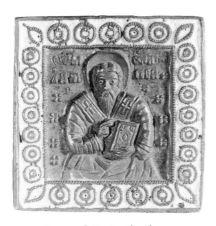

291 Icon of St Antipei

Champlevé enamel on bronze.
4 × 4.2 cm
Russian, 18th / 19th century
 M82.281

The champlevé enamel has a series
of spirals and leaves on a light blue
background for the outer frame. The
background of the central panel is
dark blue. The haloed saint is identi-
fied by the inscription as St Antipei,
Saint, Priest. He holds a book in
his left hand while making the sign
of benediction with his right.

The piece does not seem to have
been part of a larger object, nor is
there any sign of an attachment for
suspension. However, there is little
sign of wear such as might be ex-
pected from a hand-held object, with
the possible exception of the raised
areas of the arms and nose. In com-
parison to catalogue 290 this piece is
somewhat flatter, with less realistic
modelling of the body but more real-
istic modelling of the face. On that
basis a slightly later date is proposed.

Purchased from Connoisseurs' Corner,
New York, 1964 SDC / MD

292 Triptych with Virgin and Child

Champlevé enamel on bronze.
10.2 × 5.5 cm closed, 9 cm open
Russian, 19th century M82.282

The background enamel, applied in
alternating patches of colour, is light
blue and dark blue. The outside of
the triptych is plain.

The central panel shows Mary and
the Christ child. This is the Hodege-
tria type, and the child holds a scroll
and makes the sign of benediction.
Around this panel is an inscription in
Russian which reads as follows, be-
ginning top left: 'All my hope is
in you'; right: 'We entrust the divine
lord'; bottom: 'into your keeping …
whom you carried'; left: 'in your own
blood.' The left wing depicts the
entry into Jerusalem and the presen-
tation in the temple. On the right
the top scene is not clear, nor is the
inscription legible. It may be the

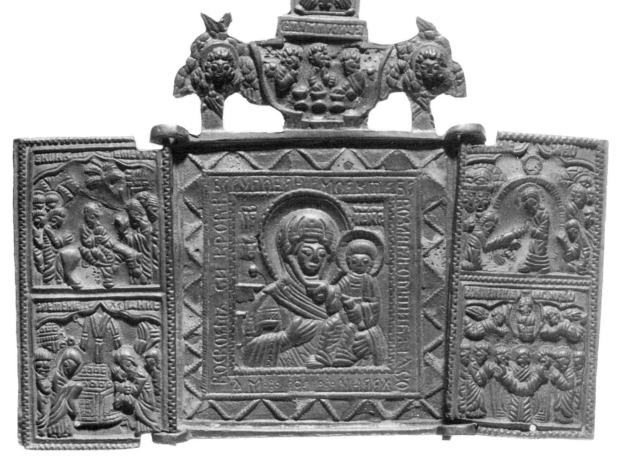

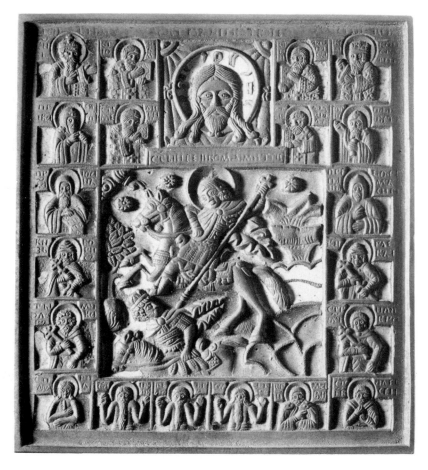

ὁ ων. Reading clockwise are, top, Holy Athanasius; below, illegible; right top, Constantine the Great; bottom, blessed Pafnuti; right side, blessed Efrem the Syrian, Prince Gleb, Holy Martyr Laurus (?); bottom, Holy Aleksei (?), Holy Marom; the next three figures to the left all have very long beards, but their inscriptions are illegible, corner, Holy Mary of Egypt; left side, Holy Martyr Flor / Florian, Prince Boris, Blessed John, Blessed John Stylite (bottom), Prince Vladimir (?) (top); to the right, top, Holy Joachim, bottom, Holy Melitus. The central panel is labelled Holy Martyr Dmitri. St Dimitri (Demetrius of Thessalonike) is shown on horseback, blessed by the hand of God above, while he thrusts his spear into the back of another figure on horseback, below him. This second figure may represent the devil, as that convention in known (see catalogue 359). Stylistically this plaque is very similar to catalogue 292 and can therefore be assigned to the nineteenth century also. SDC / MD

raising of Lazarus, the healing of the woman with the issue of blood, or some other healing miracle. The bottom is a scene of the Ascension. On top of the central panel is a scene of the Old Testament Trinity flanked by cherubim and above that a head of Christ with a crossed nimbus and the usual Greek inscription, barely legible, IC XC. The figures are simple and rudimentary and the features and hands very clumsy. SDC / MD

293 Plaque with St Demetrius

Champlevé enamel on bronze.
10.2 × 10.8 cm
Russian, 19th century M82.280

The plaque has a series of shallow relief panels on three sides, a slightly deeper relief at the top for the head of Christ, and much deeper relief for the central scene. The background for each of the small figures on three sides is blue enamel, and behind the head of Christ it is white. The background for the central panel is green, blue, white, and black applied without any consideration of landscape. For example, the upper part, or sky, is green, below that is blue, while the area to be read as ground is white, black, and green. In the upper part are three high relief rosettes.

Across the top is a narrow band of inscription, now illegible. The figures are named as follows: at the top, Christ with halo and the inscription

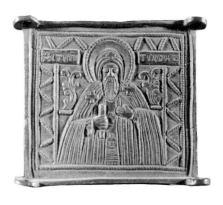

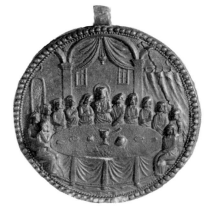

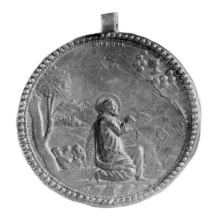

294 Plaque / Icon of St Tikhon of Zadonsk

Bronze with traces of laquer or
enamel. 4.7 × 4.7 cm
Russian, 19th century M82.279

The plaque has loops at all four cor-
ners and was probably a triptych.
The central figures is labelled as St
Tikhon, a writer and bishop born
near Novgorod in 1724, canonized by
the Russian Orthodox church in
1860. This date provides a secure *ter-
minus post quem* for the object and
a stylistic comparison can thus be
offered for catalogue 291, 292.

SDC / MD

295 Relief medallion of Gethsemane and the Last Supper

Amber. 6.5 × 0.8 cm
Russian, 18th / 19th century (?)
M82.226

The medallion, which is slightly
concave / convex, has a pierced loop
at the top for suspension. Both sides
have a 'pearl' border. The convex
side contains a scene of the Last Sup-
per where Christ and nine of the
disciples stand behind a large round
table, while the other three are
shown seated. The background is a
prominent archway which frames
Christ and four of the disciples. A
lamp is suspended over His head be-
tween two swags of drapery which do
not extend beyond this archway.
To the side is another curtain. A few
dishes and utensils are placed on
the table, while in the exergue, be-
low the table cloth, are a series of
scattered stars. The folds of the table
cloth reflect those of the drapery
above.

 The concave side shows Christ
kneeling in prayer in the Garden of
Gethsemane. Above and in front
of Him is a chalice suspended in a
ring of dots, representing a cloud (?).
Above His head is a small inscription
labelling the scene as 'Petition to
the Father' (Matthew 26:39). Christ
is depicted in high relief, while the
three sleeping disciples behind him
and the landscape are in a much
shallower relief.

Purchased from A la Vieille Russie,
New York SDC / MD

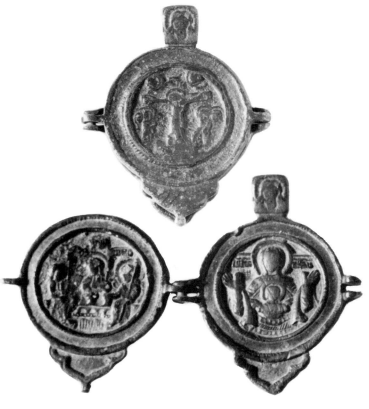

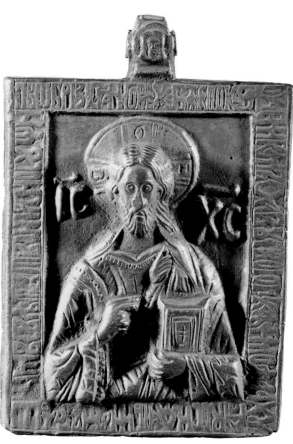

296 Diptych with Crucifixion, Old Testament Trinity, and Virgin Orans

Bronze.
3.5 cm (minus hinge and catch)
Russian, 16th century (?) M82.207

The diptych is very worn but seems to have had irregularities in the original casting. There is a small broken loop on the back so it could be worn. The outside has a Deesis, plus additional unidentifiable figures, and on the inside is an Old Testament Trinity and a Virgin Orans with the child. All three surfaces are very smooth from much handling.

Purchased from A la Vieille Russie
1978 SDC

297 Plaque with Christ blessing

Bronze. 9.8 × 7.5 cm
Bulgarian, 18th / 19th century (?)
 M82.277

The plaque has a pierced knob on top for suspension. A small head of Christ appears in shallow relief on the knob. Around the self frame is an inscription in Old Church Slavonic. The central panel is a bust of Christ in high relief. Christ holds a gospel with a double-barred cross and makes the sign of benediction.

The distortion and flattening of the nose of Christ seems to be a fault of the original casting rather than wear.

A bronze plaque which is identical in form, but much more worn, has been identified as Bulgarian and dated by means of an inscription to 1594 (T.R. Wortman, *Ikonen uit de collectie van Ikonengalerie Wortmann Zeist*, Slotlaan, Zeist, Holland 1980, no. 65). The Toronto example cannot possibly be as early, but it clearly belongs in the same milieu.

 SDC

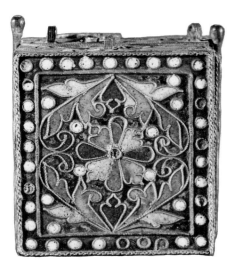

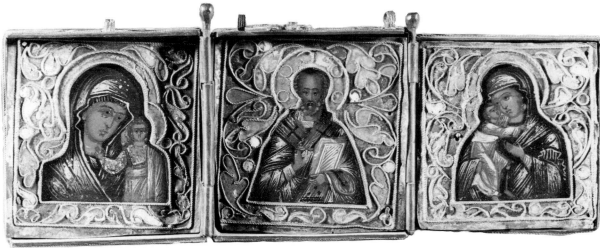

298 Triptych, St Nicholas, Virgin and Child

Enamel on copper and oil paint on wood.
6.3 × 3 cm closed, 6.3 × 17.2 cm open
Russian, 18th century M82.276

The triptych is encased in poly-chrome cloisonné enamel in a floral design, white, light blue, dark blue, yellow, and green on a copper base. The exterior is completely covered with the enamelling, including a small enamelled clasp on top. There are two small rings as if for suspension. On the interior the enamelled areas act as frames for three tiny icons painted on wood. This type of filigree and enamel frame is called 'phiniphti.'

On the left wing the tiny figure of Christ stands in front of Mary's left shoulder. His hand may be in a position of blessing, but that is not clear. In the centre is St Nicholas, who clearly makes the sign of benediction, while holding a gospel in his left arm. On the right wing is another Virgin and Child, this time the Gly-kophilousa type. SDC

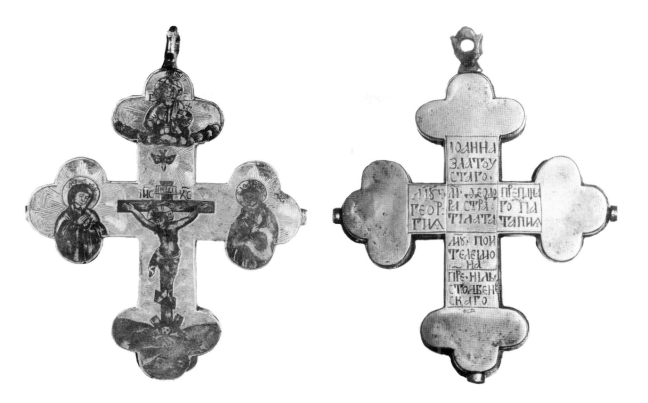

299 Reliquary cross

Silver. 9 × 7 × 1 cm
Russian, 17th / 18th century

M82. 151

On the front are a Deeisis and Trinity combined. In the centre is a crucifixion with the dove of the Holy Spirit above. In the arms of the cross, clockwise from the top, are God the Father in a bank of clouds, St John, the skull of Adam, and the Virgin Mary. These figures are done in a niello technique and the background is filled with incised lines in radiating rays around the figures, a scale motif elsewhere. On the back piece are a series of inscribed rectangles, each containing a name in Russian. Each of these rectangles corresponds to a compartment on the interior which presumably held relics of the saints named. These are, top, St John Chrysostom; middle row left, the Martyr George; centre, the Martyr Theodore the Warrior; right, the Venerable Patapius; below, Theo-

dore, the Martyr Poiteleimona; bottom, the Venerable Nilus Stylite.

Comparable pieces for style and dating may be seen in *Treasures from the Kremlin* [cat. 283], no. 25, p. 63; no. 55F, p. 86.

Purchased from A la Vieille Russie, New York, November 1965

SDC / MD

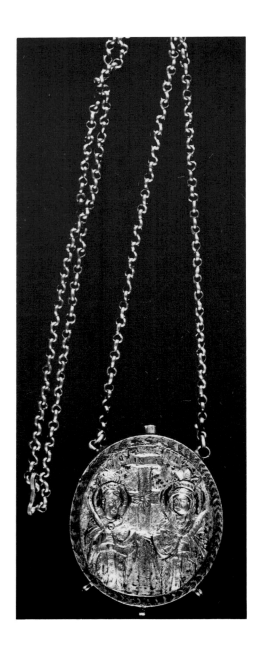

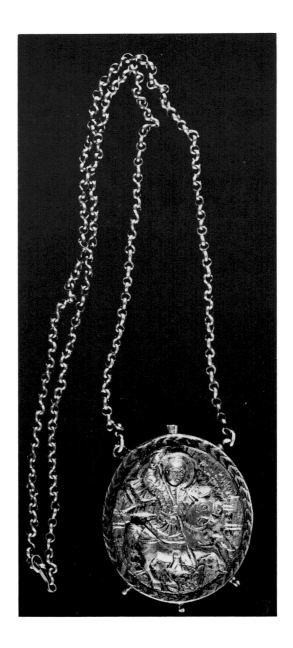

300 Oval reliquary locket

Silver. 6 × 5 × 1 cm
Provenance unknown, suggested date
18th / 19th century M82.37

There are two rings near the top of
the locket for suspension and three
more near the bottom. On one side,
in répoussée, are Constantine and
Helena, identified by inscriptions,
flanking a cross. They both carry
sceptres and have haloes and crowns.

On the other side is St George killing
a dragon. He too is identified by
an inscription. The chain is probably
modern. The only stylistic elements
which give any hint of date are the
crowns worn by Constantine and
Helena. These suggest a relatively
late date, in the eighteenth or nine-
teenth century. SDC

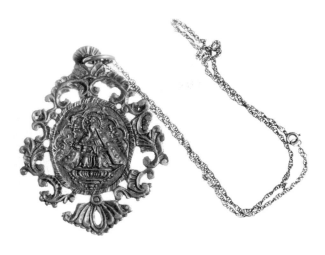

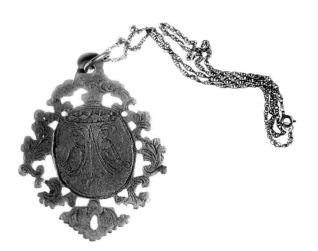

301 Pendant

Silver (?) 8 × 6 cm
Provenance and date unknown
M82.272

A pierced foliate border surrounds a
central medallion depicting the
Pieta. Mary is crowned and has a
radiate halo. Christ lies across her
knees and under her feet is a wide
conical shape, rather like a chalice.
On either side of Mary's head is a
tiny putto. Under the one on the left
are the letters NSDA and on the right
HC. On the reverse, the border copies
the leaf pattern of the front, but in
thinly etched lines rather than relief.
The central part of the medallion
has what may be very stylized M or a
foliate motif, surmounted by four
tangent lozenges. The chain, which
is very fine, is probably not contem-
porary with the medallion.

SDC

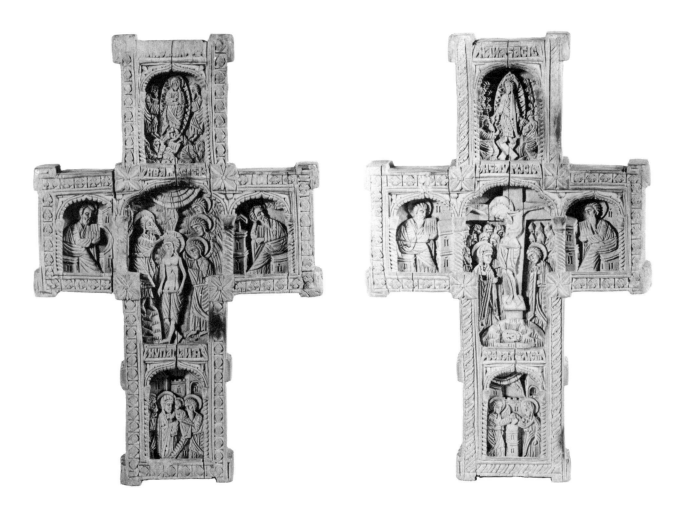

302 Relief carved cross

Boxwood. 13.5 × 8.2 × 2 cm
Greek, 17th century M82.380

The cross is carved on both sides in a series of relief panels, set behind a carved frame. The scenes are of six events in the life of Christ, plus the four evangelists. On the front, reading from bottom to top, the Annunciation, in an architectural setting; the Crucifixion, crowded with figures behind Mary and St John; and the Anastasis, also crowded with tiny heads, behind Adam and Eve. Each of these scenes has a Greek inscription to identify the scene. The two panels of the arms have seated evangelists in front of very architectural lecterns or writing desks. On the back, the same kind of division occurs, again reading from bottom

to top, the Presentation in the Temple; the Baptism, with Christ, St John, and three angles; and, in the topmost panel, the Transfiguration. the cross-arm panels again have evangelists, seated at even more elaborate writing desks.

The style of the figures is rather mannerist and elongated. In the crucifixion panel the outstretched arms of Christ are little more than thin sticks, yet the strain and tension on the tendons of the muscles of the neck are very graphically shown.

At the base of the cross is a threaded hole for attachment to a pedestal or handle. Similar crosses have elaborate metal frames and may be free standing or hand held. They may be used on an altar or as private devotional aides.

The cross may be dated by comparison with a similar cross, dated by

means of an inscription, now in the Staatliche Museum, East Berlin (*Byzantinische Kostbarkeiten* [cat. 165], no. 119. See also the exhibition catalogue *Frühchristliche Kunst aus Rom*, 3 September – 15 November 1962, Villa Hügel, Essen, no. 250).

Purchased from A la Vieille Russie, New York, 1960 SDC

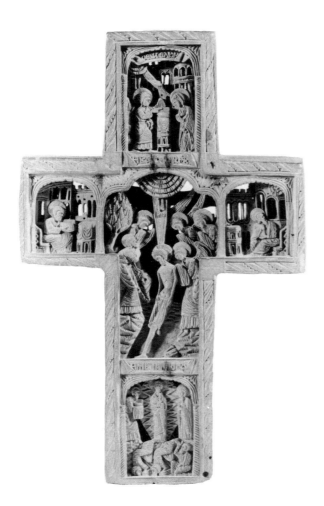

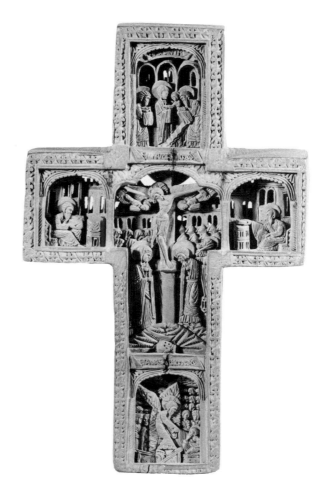

303 Pierced relief carved cross

Boxwood. 12.1 × 7.8 × 2 cm
Greek, late 17th century M82.381

This cross is very similar to catalogue 302, except that the carving pierces through the block. Inside cutting has been done from the ends of the arms as there are rectangular openings in all four arms. Those on the horizontal arm have been closed with pieces of wood. The same group of scenes occurs on this cross as in catalogue 302, but in a different order. On the front, top to bottom, are the Annunciation, Baptism, Transfiguration, with two evangelists in the horizontal panels. On the back are Presentation in the Temple, the Crucifixion, the Anastasis. The sides are completely plain. Here too the Anastasis and Crucifixion scenes are very crowded. The Anastasis scene includes David and Solomon as well as Adam and Eve.

The architectural settings are more elaborate and the drapery has finer folds. The figures have a mannered elegance in their poses and some, but not all, are very elongated.

The differences between catalogue 302 and 303 are more likely differences of skill rather than of style or date. Catalogue 303 was carved by a more skilled sculptor. The comparison for dating for catalogue 302 therefore applies here also. Catalogue 303 shows less sign of wear or handling, and this preservation, along with the totally plain edges, suggests that it was probably set in a silver mount.

Purchased from Delacorte Gallery, New York, 1959 SDC

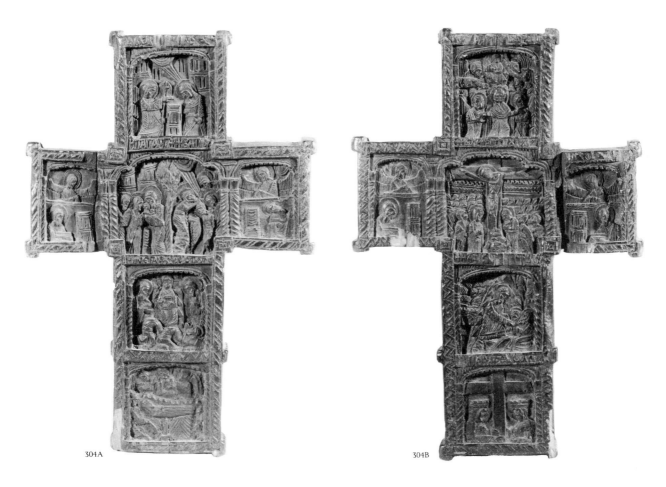

304A 304B

304 Relief carved cross

Boxwood (?) with a dark stain.
17.5 × 11 × 2 cm
Greek, late 17th century M82.384

This cross is chipped in several places
and one of the horizontal arms has
been broken off at some time and
rather crudely reattached with nails.
The carving in this cross is very shal-
low and more sketchily done than
either catalogue 302 or 303.

On the front, top to bottom, are
the Annunciation, Presentation in
the Temple and Baptism in one cen-
tral panel, Transfiguration, and Dor-
mition of the Virgin. The horizontal
panels each show the bust of an
evangelist at a writing desk and an
angel with outspread wings taking up
the other half of the panel. On the
back, top to bottom are the Ascen-
sion. the Crucifixion, Anastasis, and,
in the bottom panel, flanking a large
cross, Helena and Constantine. The

two vertical panels again show
seated, writing evangelists, each
with an angel with outstretched
wings.

This cross is comparable in style
and date to catalogue 302.

Purchased from Zumpoulakis,
Athens, 1964 SDC

305 Carved cross

Olivewood mounted in silver.
21.2 × 13.5 × 2.5 cm
Cross, Mt Athos, Greece, 17th
century; silver mount, Russian, 19th
century M82.382

The cross is carved in deep relief on
both sides with a series of scenes from
the life of Christ, many of which are
put into architectural settings. On
the front are top Annunciation; mid-
dle, in one panel, the Annunciation
to the three Magi, who appear on
horseback, Annunciation to one
shepherd, the Nativity, in a central
'grotto,' and the first bath, right Pre-
sentation in the Temple; left Bap-
tism; below centre Transfiguration;
bottom Resurrection of Lazarus. On
the back the chronological order
is less consistent. At the top is the
Ascension; middle, Crucifixion (with
the two thieves); right, Anastasis;
left, Dormition of Mary; below

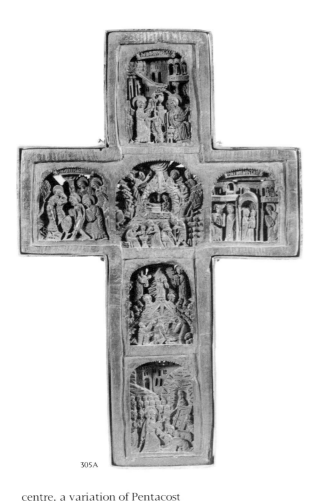

305A

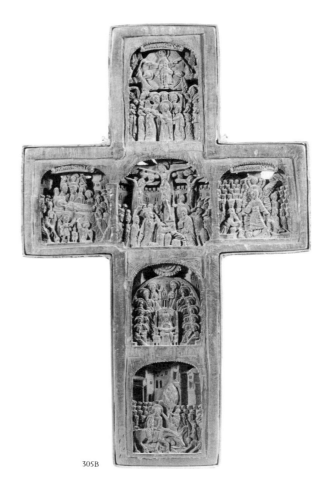

305B

305C

centre, a variation of Pentacost showing the emperor with the apostles; bottom, Entry into Jerusalem. The emperor is Constantine, his scroll symbolizing the many languages of the 'gift of tonges' received by the apostles at Pentecost.

The carving style of this cross is similar to catalogue 303 and there seems to be no good reason, on stylistic grounds, to date this cross any earlier than the late seventeenth century.

The silver mounting has an inscription on top which reads: 'For darling Olga, Christmas 1907, Papa and Mama.'

The reported history of this cross is that it was carved at Mt Athos in Greece in the sixteenth century. In the eighteenth century Grand Duke Sergei, governor of Moscow, made a pilgrimage to the monastery and was reported to be miraculously cured of a leg ailment. On this occasion the cross was given to him. It

was then mounted in silver at the end of the nineteenth century by Gratchov, silversmith by appointment to the Russian Imperial Court. After the duke's death in 1905 his widow Grand Duchess Elizabeth gave it to her sister, Czarina Alexandra Feodorovna, wife of Nicholas II, the last Czar of Russia. Grand Duchess Olga was the eldest daughter of Nicholas II.

Purchased from A la Vieille Russie, New York, November 1965 SDC

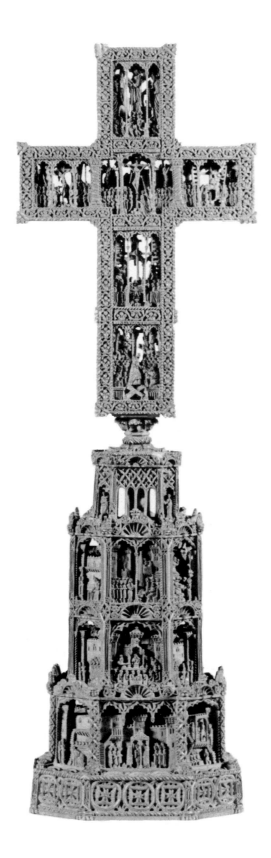

306 Elaborately carved cross on a base

Boxwood.
Height 31 cm, cross 15 × 9.5 × 2.3 cm,
base 15 × 8.2 × 6.2 cm
Italo-Byzantine, 16th century
M82.377

This intricately carved cross is made from two pieces of wood. The cross is joined to the base by a small piece of dowelling. All sides of the cross and base are carved, with the exception of the under surface of the horizontal arms and, of course, the bottom. On the top, left to right, are St Peter, a grotesque mask, and St Paul. Front surface, top to bottom, Annunication, Nativity with Annunciation to two magi on horseback and Annunciation to the Shepherds, Presentation in the Temple, Entry into Jerusalem. The panels on the cross arm are, right, St John preaching and the Baptism of Christ; left, unidentified (Christ teaching?). Back surface, top, Transfiguration; across the arm, left to right, Ascent of the Cross, Crucifixion and Piercing of the Side of Christ, Descent from the Cross, lower scenes, entombment (?), Anastasis. On the sides, left, top, Flight into Egypt, Christ teaching or as a child among the elders (identified by inscription as Christ teaching); below, Christ addressing a group of women (the inscription says Christ teaching the Marys); bottom, the Raising of Lazarus, right side, Entombment, unidentified – two groups of men facing each other, Ascension, Pentecost with Constantine with a scroll (catalogue 305). The inscriptions on this cross are in Latin, whereas those on the preceding examples are in Greek.

On the base are twenty-four additional scenes, including the Washing of the Feet, the Last Supper, Garden of Gethsemane, the Arrest, and several of the trial. The scenes on the base do not have any inscriptions. The setting or background of many of these scenes recurs repeatedly – suggesting that they may represent the performance of a play, based largely on the events of the Passion. The framing of each of the panels is deli-

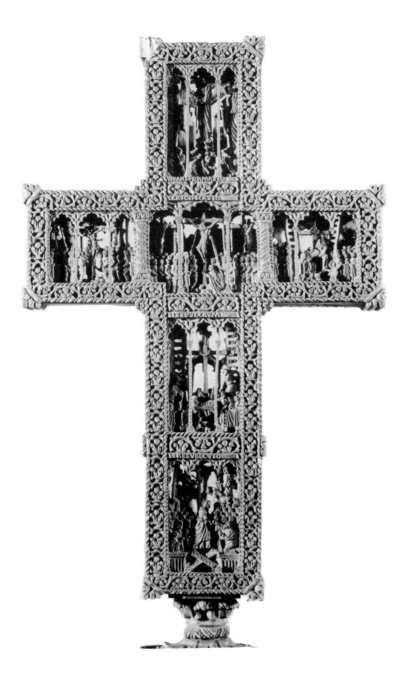

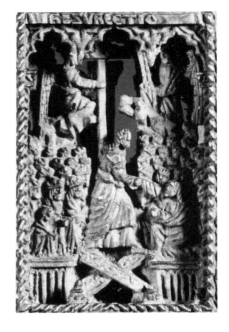

cately and intricately carved, to provide almost flamboyant architectural surrounds for the internal architectural settings.

The model for this type of cross is certainly Byzantine, but this cross was probably made in northern Italy. This is confirmed by the details of the case, but its western origin is also clear from the fact that the inscriptions are in Latin rather than Greek.

Other examples of similar crosses, dated to the mid-sixteenth century, exist in Athens and Berlin (Volbach [cat. 287], p. 115, 793, s.109).

The dating of this cross is also confirmed by the leather case which was made for it. See catalogue 307.

Purchased from Hartman Galleries, March 1969 SDC

307 Cruciform box

Wood covered with parchment and
varnish, lined with red silk.
33.1 × 10.1 × 8.1 cm
Northern Italian, circa 1500 M82.377

This box is divided into two halves
parallel to the faces of the cross it
contains. The inside of one half is fit-
ted with thin projecting slips of wood
which fit inside the other half. The
presence of four pairs of holes through
the parchment and wood, filled with
black fibre along the edges of the two
halves of the box, suggests that some
sort of clasps or other fastening de-
vices, now missing, once held the box
closed more firmly. The silk lining,
cut in a number of pieces to the
shape of the various inner surfaces, is
pulled around the edges of the box
and glued beneath the parchment
covering.

The method used here of covering
the box with parchment and var-
nishing the whole suggest the work
of a book binder. The practice of
making use of discarded sheets of pa-
per or parchment to cover up plain
wooden boards was, apparently,
a cheap way to provide a little more
than simply serviceable protection
for a book which was not intended as
a luxury item. The varnish obscures,
to some extent, the legal text printed
on the parchment. The box is further
ornamented with embossed lines
along each edge of the base as well
as embossed floral-type designs on the
faces of the cross.

It is the printing on the parchment
which provides a clue to the date
of the box. Although barely visible
in natural light, its legibility is spec-
tacularly increased under infra-red
light. Several sections of the text
were scrambled during the printing
process, which explains why the
sheets were discarded. The letter
forms are those of the 'rotunda'
Gothic type-faces of the last quarter
of the fifteenth century and the early
years of the sixteenth, and this ex-
ample most closely resembles prod-
ucts of presses in northern Italy
during that period. Assuming that
the box was made not long after the
text had been printed and the sheets

discarded, the box can be presumed
to have been made sometime in
the last quarter of the fifteenth
century.

The text itself is from the Com-
mentary on the Decretals of Gregory
IX, written by Nicholaus de Tedeschi
(Panormitanus) around the middle of
the fifteenth century. This work of
canon law was printed several times
before 1500, most often by Venetian
presses, and was used in the law
schools of the time. NM / DT

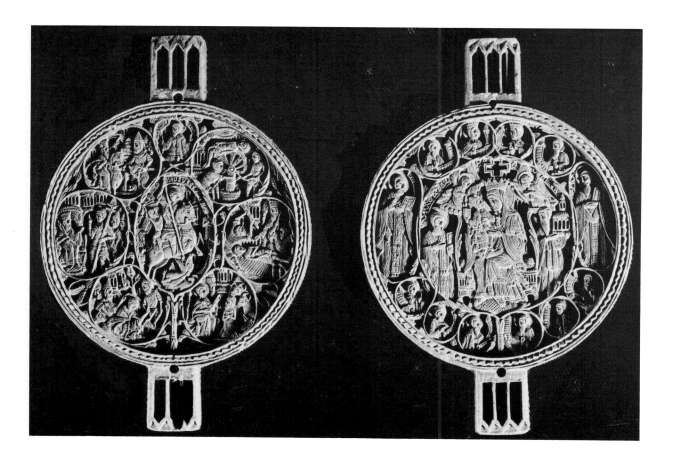

308 Panagia / Medallion

Olive wood with traces of gilding,
red, black, and green paint.
11 × 7 × 1.2 cm
Greek, Mt Athos (?), 16th / 17th
century M82.362

Both pieces would have been
together in a frame, probably silver
which also formed a stand. The
whole piece would then serve as a
private devotional aid. In part (a), a
crowned Virgin and Child are seated
on a throne with angels above and
a bearded male figure on each side,
one of whom holds a book, the other
a model of a church. These may be
meant to represent Peter and Paul.
This scene is enclosed in a circle
which is extended into a series of
loops containing busts and two
standing figures. These latter are
identified by inscriptions as St Nicho-
las (of Myra) and St Kharalampos.
In the ten smaller roundels are eight
prophets and two kings.

In part (b) the centre is a scene of
a saint spearing a dragon. There is
an inscription over the saint, which
is barely legible, and may possibly
be read as St George. The surrounding
vignettes would then represent scenes
from his life.

The linear, decorative qualities of
the drapery are quite similar to those
in catalogue 309, especially if the
two saints spearing dragons are com-
pared, and a similar date is proposed
here.

Purchased from Neufert, Munich, St
James Church Art Auction, 9 May
1965 SDC

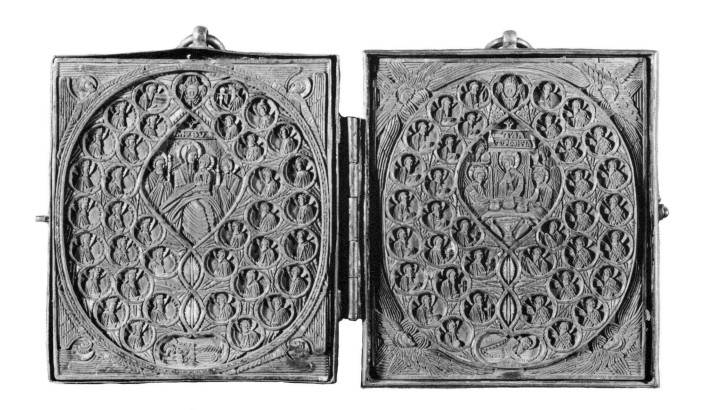

309 Carved diptych

Boxwood, framed in silver, traces of
gilding, red and blue paint, framed
in silver.
8 × 6.8 cm closed, 14 cm open
Greek, 17th century M82.379

The two panels are each set into a
plain silver frame with a clasp and
two rings for suspension. On the left,
the main scene is the enthroned
Virgin and Child, with the abbrevi-
ated inscription MP ΘV. The throne
is flanked by a man and a woman,
probably Joachim and Anna. This
scene is then enclosed by a series of
small figures enclosed in a circle
supported on each corner by an angel
with outstretched wings. The figures
inside are each enclosed by a loop
forming a segment of the Tree of
Jesse, whose figure lies at the bottom.
On the left are crowned busts and
on the right uncrowned busts holding
scrolls. These represent the kings
and prophets in the geneology of
Christ. On the right wing the Tree of

Jesse is supported by four seraphim.
The main scene is the Old Testament
Trinity, with the three angels being
served by Abraham and Sarah. The
busts in the loops are of saints, with
crosses or books on the left and bish-
ops on the right.

On the outside the silver mount
forms a filigree frame of seraphim and
flowers. Behind the frame – backing
the diptych – is a plain light brown
velvet. An earlier example (sixteenth
century) of this kind of diptych,
very similar iconographically, may
be seen in *Byzantinische Kostbarkei-
ten* [cat. 165], no. 118. In that exam-
ple the carving pierces the wood,
and stylistically it seems to be earlier
than the Toronto example.

From the Oscar Bondy Collection

Purchased from Blumka Gallery, New
York, 1961 SDC

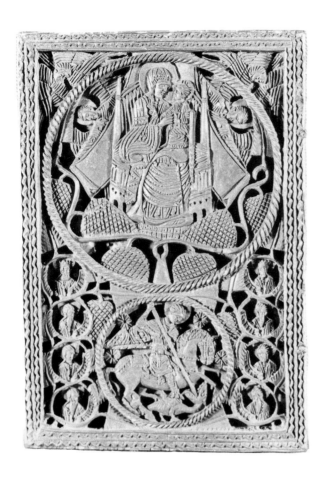

310 Carved plaque

Boxwood and red paint.
7.8 × 5.2 cm
Greek, 16th / 17th century M82.383

The plaque is carved in deep relief, even pierced through on one layer, with a simple zigzag border. The interior has a large circle supported by angels from above. Inside the circle is another pair of angels supporting an enthroned Virgin and Child. Below is a smaller circle surrounding a saint on horseback, St George or St Demetrios, spearing a dragon. The remaining space has four loops on each side, as if from an abbreviated Tree of Jesse. In the top two are kings, in the lower section three pairs are prophets, holding scrolls. The form of the throne is very similar to one in the comparative example (Berlin) used in catalogue 309, though the style of carving of the drapery is somewhat less geometric. However, the exaggeration of the drapery folds and the elongation of the figure of Mary suggest a date closer to the seventeenth century whereas the Berlin example is dated to the sixteenth century on the basis of an inscription on the silver case.

From the Oscar Bondy Collection

Purchased from Blumka Gallery, New York, 1961 SDC

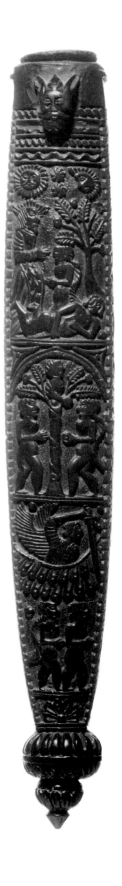
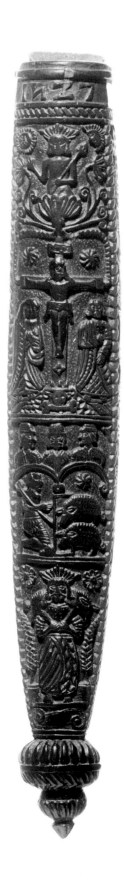

311 Sheath for a knife or stylus

Wood. 19 × 3 cm
Greek (?) or European folk art, date
unknown M82.378

Each side of the sheath has three scenes. On one we see God creating Eve from Adam's rib, Adam and Eve being tempted by a humanoid serpent, and lastly being expelled from paradise by an angel with a huge sword. On the other side a crucifixion with Mary and St John and, above, emerging from flower, a figure which resembles the figure of God on the other side. The middle scene is a man kneeling before two animals which may be sheep or pigs, and above, that, set on two arches, are three male busts wearing jackets and hats. At the bottom is a figure with the same kind of peculiar headdress as the two earlier figures of God. Presumably this is meant to indicate rays of light or an aureole. He holds something unidentifiable. On the right it looks like the head of a lamb, but the part on the left does not look like the legs and hindquarters of an animal. Perhaps it is meant to be Christ as the Good Shepherd. At the very top is what seems to be a date, but the second letter is unclear ꟾꟾꟾꟾ. On one side at the top a small protrusion is carved into a mask; as this is pierced, the object could have been suspended on a cord or loop. The two short sides have stylized trees, fruit, and vases. The interior is half lined with a scrap of red velvet.

The piece is probably an example of folk art, but none of the stylistic features are sufficiently distinct to identify a provenance or date.

Purchased from M. Komor, New York SDC

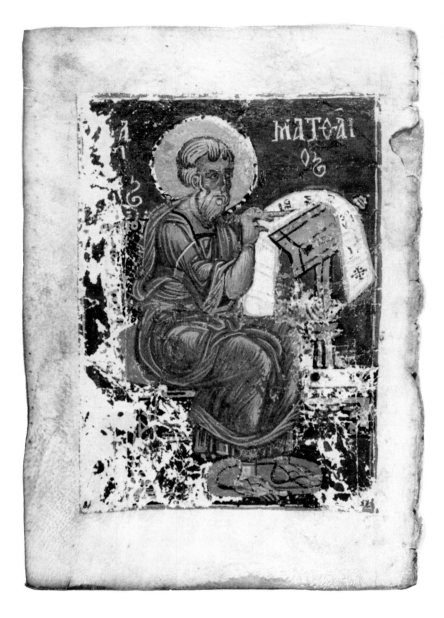

figure, and the flowing drapery motifs are also quite naturalistic, suggesting that the figure may have been copied from a Constantinopolitan model.

Gary Vikan has noted the close resemblance of this portrait of Matthew to portraits of John and Luke in a Gospel book in the Metamorphosis Monastery in Meteora, Greece, cod. 540 (this connection was noted in a personal communication to Dr Malcove. For Metamorphosis cod. 540 see N.A. Bees, *Les Manuscripts des Météores*, Athens 1967, pp. 533–5, pl. LVI, LVII, LXXVIII, LXXIX). The style of the inscriptions on these evangelist portraits is also quite similar. Therefore, Metamorphosis cod. 540 may be the parent manuscript of the Malcove leaf. This manuscript has been dated to the eleventh century by Bees (ibid., p. 533), although the plastically modelled drapery folds in the evangelist portraits and on the Malcove leaf suggest a slightly later date, perhaps early twelfth century. Similar three-dimensional drapery motifs can be seen in several early twelfth-century Byzantine manuscripts. See, for example, the Codex Ebnerianus in Oxford (Bodleian Library, cod. Auct. T, inf. 1.10; I. Hutter, *Corpus der byzantinischen Miniaturenhandschriften*, 1: Oxford, *Bodleian Library*, Stuttgartt 1967, no. 39. For a discussion of drapery style in eleventh- and twelfth-century Byzantine manuscripts see Vikan [cat. 188–93], pp. 17–18).

Purchased from Victor Spark, New York, 1958 EL

312 Leaf from a Byzantine Gospel book

Painted on parchment.
18.2 × 12.7 cm
Greek, late 11th or early 12th century
M82.450

The leaf, showing an evangelist portrait of Matthew, is in fairly good condition, although the right edge of the leaf has been ripped and several sections of the paint have flaked off, particularly along the left side of the illustration. Some cleaning and restoration have been done.

The figure of Matthew is placed against a blue background. He is dressed in a blue tunic with a greyish-brown mantle, and is seated in three-quarter pose, facing right. He sits on a high-backed chair with a red cushion, and his feet rest on a red footstool. He is engaged in writing on a long scroll which is draped over a lectern. The lectern is placed on a low table. The pose of the figure is rather stiff, betraying a provincial origin. However, there is a strong sense of three-dimensionality in the

313 Leaf from a post-Byzantine Gospel lectionary

Ink and paint on paper.
40.5 × 26.2 cm
Moscow, 1596 M82.446

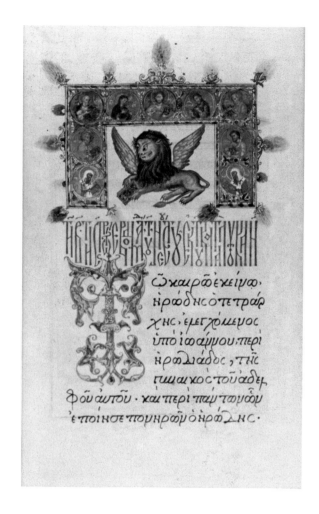

The page is a headpiece to readings from Luke. The leaf is in very good condition, although the paint of the headpiece is slightly rubbed and the page is ripped along the left side.

The text is written in a Greek minuscule script with a Slavonic title. There is one column of eighteen lines. The text of the recto and the upper two-thirds of the verso is Luke 3:19–22, which describes the arrest of John the Baptist and the Baptism of Christ. This text was probably read on 29 August, the date on which the Beheading of John the Baptist was commemorated in the Byzantine liturgical calendar. On the bottom one-third of the verso is the text of Luke 3:23, which begins the next reading from Luke.

The decoration consists of a ⊓ shaped headpiece with nine small roundels containing the busts of the Deesis (Christ flanked by the Virgin and John the Baptist) in the centre, the four evangelists, and two saints. The interior of the headpiece is also decorated with foliate ornament, and more foliate motifs project from the exterior of the headpiece. Particularly notable are the large brush-like plants which are painted in shades of yellow, green, and orange. The headpiece frames the figure of a winged lion holding a codex, the symbol of the evangelist Luke. (The association of evangelist symbols with the evangelists varies in Byzantine art. For a discussion of the various combinations see G. Galvaris, *The Illustrations of the Prefaces in Byzantine Gospels*, Vienna 1979; R.S. Nelson, *The Iconography of Preface and Miniature in the Byzantine Gospel Book*, New York 1980). Below the title is an elaborately decorated initial τ, painted in tones of green, orange, purple, and gold. This initial begins the incipit τῷ καιρῷ ἐκείνῳ (In that day). Another initial τ, similarly decorated, begins the incipit for

the reading on the verso of the leaf.

Gary Vikan has identified the Malcove leaf as the missing headpiece to Luke from a manuscript which is presently in Jerusalem, in the church of the Anastasis, cod. 5. (This identification was made in a personal communication to Dr Malcove. For Anastaseos cod. 5 see A. Papadopoulos-Kerameus, *Hierosolymitikē bibliothēkē*, III, Moscow 1897, pp. 200–3; K.W. Clark, *Checklist of Manuscripts in the Libraries of the Greek and Armenian Patriarchates in Jerusalem*, Washington, DC 1953, pp. 15, 30). The Malcove leaf was folio 174 of the parent manuscript. Other leaves have also been excised from this manuscript: the headpieces to John and Matthew are in the Art Museum, Princeton University, cod. acc. no. 54.67, 68 (G. Vikan, 'Two Leaves from a Lectionary' [cat.

312], pp. 207–10; W.H. Bond and C.U. Faye, *Supplement to the Census of Medieval and Renaissance Manuscripts in the United States and Canada*, New York 1962, p. 305) and the portraits of the four evangelists are in the Pierpont Morgan Library, cod. M654 (Vikan, p. 207; K.W. Clark, *A Descriptive Catalogue of Greek New Testament Manuscripts in America*, Chicago 1937, p. 161. The portrait of John is illustrated in Vikan, fig. 110). In the parent manuscript the portrait of Luke faced the Malcove leaf.

According to an inscription at the end of the Anastaseos cod. 5, the manuscript was written in Moscow in 1596 by Metropolitan Arsenius at the order of Tsar Fedor (1584–98), son of Ivan the Terrible (Vikan, p. 207; Papadopoulos-Kerameus, pp. 200–1). The manuscript was dedi-

cated to the monastry of San Saba near Jerusalem.

Purchased from Parke-Bernet, New York, 1963 EL

314 Double-sided page from a hymnal

Vellum with inks and tempera.
14.5 × 10.9 cm
Armenian, mid to late 16th century
M82.440

The manuscript page, extrapolated from a hymnal, contains a morning song for monastic use. The markings above the words are musical notations, designed to guide the singer in the chant (Bezalel Narkiss, *Armenian Art Treasures of Jerusalem*, New Rochelle, NY 1979, p. 84, figs. 103 and 105, both illustrating examples of manuscripts with musical markings identical with ours. Both are hymns from Sargis Pidzah's Hymnal

of 1322, MS 1644. With thanks to A. Selyan, Vartan Vartanian, and Sharkis Tchilingurian for the reading and translation of this text). The single marginal decoration, a foliate ornament next to which is a bird with elongated neck, occurs to the left of the hymn. Both are typical of Armenian decoration, although in our example they seem to be abbreviated and much less elaborate than one usually finds. The pendant ornament resembles closely one of the sanctuary lamps from an Armenian church (ibid., p. 125, figs. 157c and 170, which show very fine examples of such hanging lamps from St James Cathedral), but it must surely have been taken from a 'living cross,' which frequently occurs in the margins of liturgical manuscripts (ibid., p. 87, fig. 106, which illustrates the frontispiece to Pidzah's Hymnal of 1335, MS 1578, showing the 'living cross,' symbolic of Christ. This folio contains a foliate cross that has a central element almost identical to the ornament on our page). If our

example was so derived, it is truncated and without the cross surmounting the foliage. the bird, too, is considerably less elongated and interwoven with the script lines than is often the case (ibid., p. 117, fig. 153, which illustrates the Incipit of the Gospel of St Matthew from fol. 388r of the Istanbul Bible of 1653, containing both the 'living cross' and, atop the headpiece of the folio, birds much like ours. The opening of the hymnal from Pazentz, p. 108, fig. 131 of the same volume, decorated in 1553 by Sargus Khizantzi, shows a bird with an elongated neck forming part of the initial line and a pendentive shape in the right margin that is reminiscent of our ornament, although here it is quite clearly a 'living cross'). Although the practice of repeat designs, patterns, and illustrations was common and therefore complicates the dating of these examples, the tendency towards a more austere use of decoration and the kinship with the later liturgical manuscripts suggests a relatively late date.

TRANSLATION OF THE ARMENIAN TEXT
O God of Spirit, who came from the heavens, with tongues of fire and the sign of the Trinity and who spewed fire from the lips of your earthly creatures.
With a showering of flames and your ever-present fiery appearance to us earthly creatures, you descended from the heavens as though spilling from a fiery chalice.
Seven-day canons. Blessings.
Ever-flowing brook from an ever-rushing fountain. Be thou blessed and vitalized with the Holy Spirit. Holy Truth.
The Disciples who, gathered in the upper sanctuary, with faith you bedecked them with the light of your glory and with the joy and bliss you filled them, exalting your Supreme Light.
Your Son, who rose to your right side, exhalted the Apostles who bowed and blessed the Lord, the purveyor of the Holy Spirit.
Then in the upper sanctuary, where the saintly legions gathered, they mysteriously lifted their eyes, awaiting the Holy Spirit. MH

315 Stone icon

Slate (?). 17 × 6.5 cm (4 sides)
Ethiopian, 19th / 20th century (?)

M82.457

The icon is cut from a single block of
pinkish-grey stone. The centre is
hollow and there are four arched
doors attached by means of thread
hinges on the right-hand edge. Four
'feet' are carved from the block and
the top is shaped like a small dome
with a projecting drum and finial. On
the dome, at each corner between
the doorways, is a head flanked by
wings. On the inside of each door is a
figured scene. The remaining sur-
faces are all covered with hatching,
geometric, or interlace motifs. The
door scenes are a winged figure with
a sword; a bearded figure beside a
column and holding a long serpent
which rises up over his head (this
may represent Abba Hor, an anchor-
ite who is shown elsewhere throt-
tling a serpent with his left hand; see
Stanisław Chojnacki, 'The Iconogra-
phy of St. George in Ethiopia,' part
II, *Journal of Ethiopian Studies*, XI, 2,
June 1973, 52, no. 371); an orans
figure with a long flowing beard (a
prophet?); and a crucifixion with
Mary and St John. On the base is an
inscription.

 The icon is free-standing and could
be used in the same way as any
icon, as a devotional aide. The archi-
tectural form is probably meant to
imitate a church or chapel. SDC

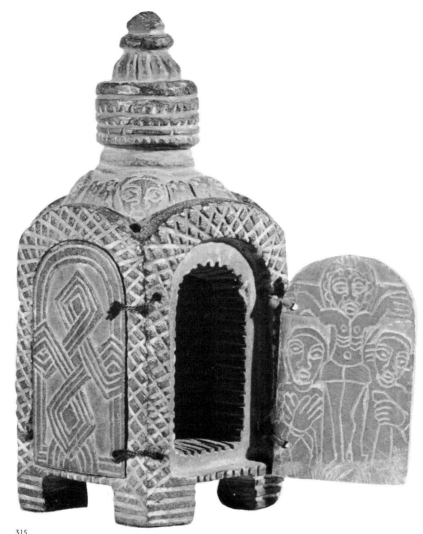

315

316 Stone icon

Slate. 21 × 12 × 3 cm
Ethiopian, 19th / 20th century

M82.458

This icon is not free-standing. It is
basically rectangular, with an arch
and cross on top, but it is too narrow
to stand by itself. There is a door
on either side, held in place by thread
hinges on the right side and inside
each door are two more smaller doors
with hinges on the left side. The
exterior is covered with geometric and
interlace designs. The areas inside
the doors are figured. On one side, the
interior of the large door shows St
George (see catalogue 318 for further
examples of this motif). Above the
two smaller doors is a head flanked
by large wings which fill the arched
space and extend down the frames
of the door. On each small door,
on the outside, is the bust of a figure
with a high headdress or crown,
and holding a sword (?). On the inner
side of the doors are two more simi-
lar busts but with different head-
dresses. The panel revealed by these
doors each has a bearded figure,
arms raised in the orans position.

 On the other side, the outer surface
of the large door has the symbols of
the four evangelists, spaced around
an interlace knot. Inside the door
is the crucifixion with Mary and St
John (Deesis). The two small doors
are like those of the other side, both
inside and out, and the background
panels are two busts, one of a female
with a radiate halo, and the other
a male figure, also with a radiate
halo, making the sign of benediction.
These must be Mary and Christ. SDC

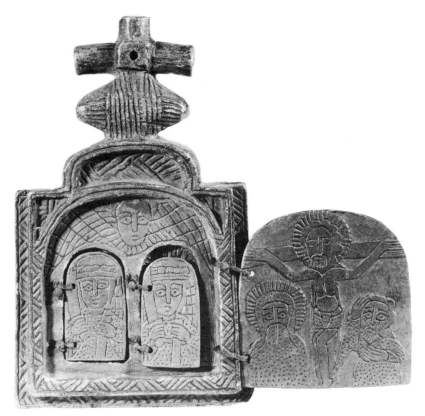

316

317 Stone icon

Slate. 21 × 14 × 2 cm
Ethiopian, 19th / 20th century

M82.456

This version of the stone icon main-
tains an architectural imitation.
The surface is divided into two regis-
ters, the lower with three doors
which open, the upper, relief carvings
of arched and gabled openings. The
same arrangement occurs on both
sides. In fact, the icon seems to be
imitating the facade of the seven-
teenth-century Aksum Cathedral
(Jean Doresse, *Ethiopia*, London
1959, p. 35, pl. 5). The projection on
the top has five pierced holes from
front to back, and one from side to
side. On one side the middle door
is missing. The two smaller side doors
are decorated with representations
of Ethopian hand crosses. On the
central door is an interlace rosette
surmounted by an angel. Inside the
three doors are, left to right, the
'prophet' figure with long flowing
beard, three women, one of whom is
supported by the others, and an an-
gel with a staff. The background
panels have, left to right, an angel,
crucifixion (Deesis), and a woman
seated beside a tree. On the other
side the backs of the doors have, on
the left, a man holding a serpent (see
catalogue 315), and the bearded
'prophet.' The background panels on
the left and right repeat the images
of the doors, in reverse order, and
in the centre, in very shallow relief,
are three women. SDC

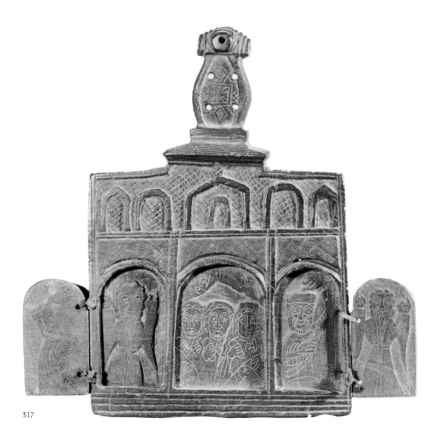

317

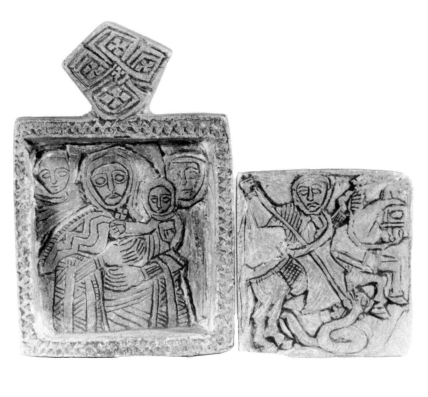

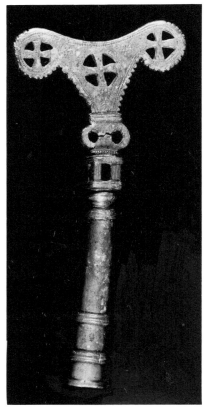

318 Stone icon

Alabaster (?). 14 × 9 × 2 cm
Ethiopian, 19th / 20th century

M82.459

This icon is a simple rectangle with a
diamond-shaped finial. The centre
is cut out as a separate piece, but
unlike the preceding three examples,
this one does not have thread hinges
to attach the panel. All the exterior
surfaces are covered with geometric
designs and variations of the cross
motif. On the inside, the larger piece
shows Mary and the Christ Child,
with two figures of indeterminate sex
behind them. The interior of the
smaller piece, or 'door,' has St George
on horseback killing the dragon.
For similar scenes and a discussion of
this motif see Chojnacki [cat. 315],
part I, Jan. 1973, 57–73; part II, June
1973, 51–92. SDC

319 Prayer stick finial

Bronze. 22 × 10.2 cm
Ethiopian, 19th / 20th century

M82.386

The crozier top has three pierced
holes containing crosses, all of which
are decorated with incised lines and
punched circles. Similar punched
circles decorate the intervening
spaces as well. The whole object is
rather crudely made. The punched
decoration is common in Coptic
art but is also common in Ethiopian
art of more recent manufacture.
This crozier, or prayer stick, has been
published as Coptic, fourth or fifth
century, but the quality of the
bronze, which is well preserved with
almost no traces of patina, precludes
such an early date. Similar prayer
sticks, nine / tenth century in date,
may be seen in Elisabeth Cross Lang-
muir, Stanislaw Chojnacki, and Pe-
ter Fetchko, *Ethiopia: The Christian
Art of an African Nation* (Langmuir

Collection, Peabody Museum of
Salem, Salem, Mass. 1978), no. 43.

PUBLICATION
Ostrogorsky, George, *History of the
Byzantine State*, trans. Joan Hussey
(New Brunswick 1969), fig. 12 SDC

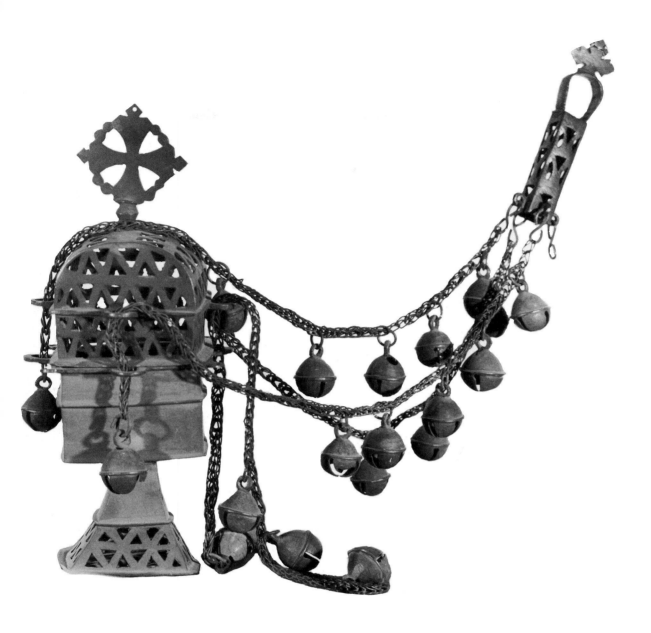

320 Censer

Bronze. 35 × 84 (with chains) cm
Ethiopian, 18th century M82.494

The censer has a square openwork
base tapered upward to a narrow
join. A square solid box held the
coals, and the top, which is pierced,
is barrel shaped. Above that is a
pierced cross-shaped finial. Four
chains (three are intact) lead up to a
handle which has a similar pierced

design. There are twenty bells fas-
tened along the chains.

Two similar Ethiopian censers,
both dated to the mid-eighteenth
century, may be seen in *Christliche
Kunst aus Äthiopien und Nubien*,
catalogue of an exhibition held in
Vienna, 11 March – 3 May 1964, no.
80, and *Religious Art of Ethiopia*
[cat. 182], no. 89, p. 261.

Purchased from Antique Fair, New
York, 1962 SDC

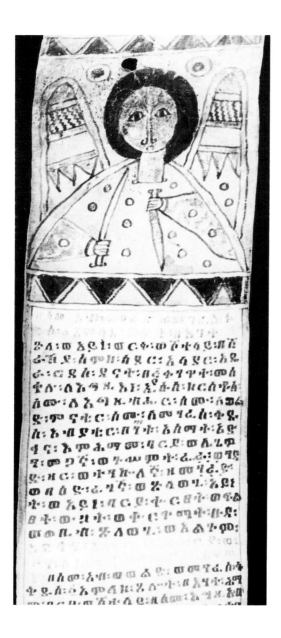

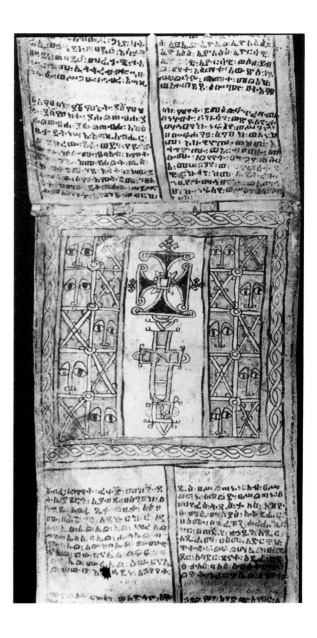

321–4 Scrolls with magical prayers or formulae

Leather / parchment
The scrolls are a metre or more in length, made up of strips of parchment sewn together. This group varies in width from 8 to 13.5 cm.
Ethiopian, 19th / 20th century
M82.441, 442, 443, 444

These scrolls show the evidence of continuity from antiquity and the middle ages. They were and are produced in the ancient liturgical language of Ge'ez, containing repetitive phrases, intended as magical formulae or prayers to ward off evil. The illustrations had the same intentions and the scrolls would be carried about in a leather case or box for the bearer's protection. Modern versions are straightforward copies of the older versions.

In one of these four examples the text is written in two columns. In the others, it is done across the roll in one column. For further examples see *Ethiopie millénaire, préhistoire et art religieux*, Petit Palais, November 1974–February 1975 (Paris 1975), nos. 287–91, and Doresse [cat. 317], p. 99, fig. 45.
SDC

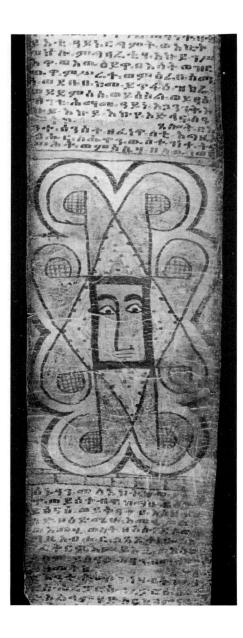
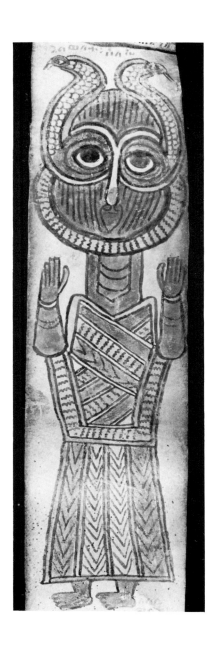

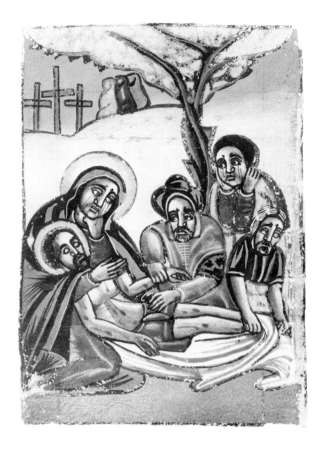

325 Manuscript page, Descent from the Cross

Paint on parchment. 16 × 11 cm
Ethiopian, late 18th century

M82.515

The painting has script on one side and, on the other, a scene of the Lamentation over the Crucified Christ. In the foreground, stretched across the page, is the limp figure of Christ, supported by a weeping Mary, Joseph of Aramethea, one of the disciples, and a second weeping woman. In the background are the silhouettes of three seated figures and three empty crosses. The landscape is done in tones of yellow and orange with a deep sienna-coloured sky. There is a feeling of limitless space as well as a sense of mystery in the painting. The figures have prominent and expressive eyes, and the tears are indicated by black streaks down the faces.

Paintings with similar stylistic features, such as the use of colour in the landscape and the ways of depicting faces and drapery, may be seen in two examples, both dated to the eighteenth century. See *Religious Art of Ethiopia* [cat. 182], no. 27, p. 139, and no. 28, pp. 156–7. SDC

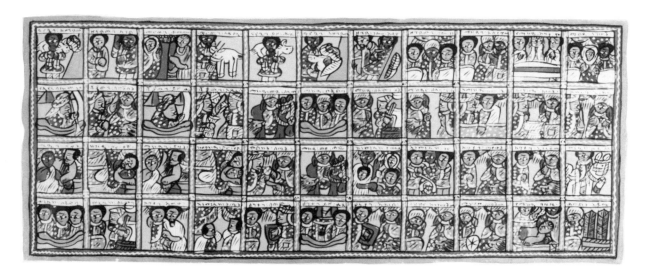

326 Painting of the story of Solomon and the Queen of Sheba

Polychrome and silver paint on fabric. 1.10 × 44 cm
Ethiopian, 20th century M82.514

The biblical account of the Queen of Sheba (1 Kings 10:1–13) and her meeting with King Solomon plays an important role in the history of Ethiopia. The Ethiopians believe that the Biblical Queen of Sheba was Makeda, an important ruler in antiquity, and that after her visit to Solomon in Jerusalem she bore him a son, named Ebna-Habim. He ruled under the name Menelik and is considered to be the ancestor of all subsequent Ethiopian emperors (for further discussion of this legend see Doresse [cat. 317], pp. 13, 14).

The story is depicted in comic-strip fashion, and is a popular contemporary subject. It may be painted on wood, parchment, walls, paper, or, as here, on textile. For some similar examples see *Handicrafts of Ethiopia*, Ethiopian Tourist Organization, Addis Ababa, pp. 28, 31. SDC

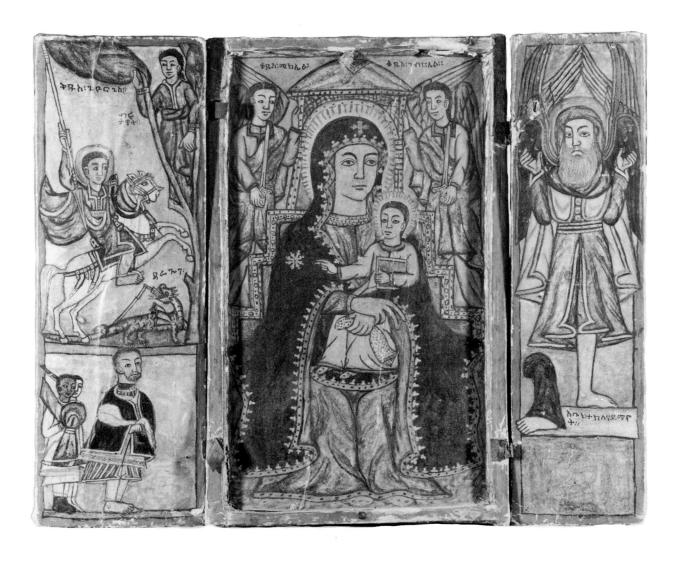

327 Icon

Paper, gesso, tempera (?) over cloth,
on wood, traces of leather hinges.
36 × 21 cm closed, 42.5 cm open
Ethiopian, 19th century (?) M82.139

The triptych is plain on the outside,
except for a layer of gesso over the
cloth. The hinges are no longer intact
but fragments remain to show that
they were made of leather.

The central panel shows Mary
seated on a high-backed throne,
Christ on her lap, and an angel with
a sword on either side behind the
throne. Both Mary and Jesus have
radiate haloes. The left wing is di-
vided into two registers. On the top,
St George (see catalogue 318), with

flying cape, sits astride a rearing
horse, about to spear a dragon who
already has one broken spear in his
mouth. This action is watched by
a figure in a tree. The lower register
contains three people, one larger
than the other two. Of the smaller
figures, one has a green face and
feet. On the right wing is a figure
popular in Ethiopian art, St Hekle-
Haymanot. He usually wears a long
shirt with a cloak over it, has wings
and one leg. He is credited with
the development of the monastic life
in Ethiopia (*Religious Art of Ethio-
pia* [cat. 182], no. 30, p. 164).

The icon has a feeling of calmness
and serenity about it, even in the
attack on the dragon. The features
are placid and gentle, drawn with

fine lines which contrast effectively
with the broad areas of colour for
drapery.

The dating of this icon is probably
in the nineteenth century. Earlier
figures are more rigid and flat, with a
greater emphasis on the eyes, in
that the irises are painted very large
so that there is a dramatic contrast
with the surrounding whites. The
closest stylistic parallels for this icon
seem to be of the seventeenth cen-
tury (see, for example, *Ethiopie mil-
lénaire* [cat. 321], p. 126, no. 124),
but the state of preservation of the
paper in this icon precludes such
an early date. On purely technical
grounds, a date of mid to late nine-
teenth century is tentatively offered
for this painting. SDC

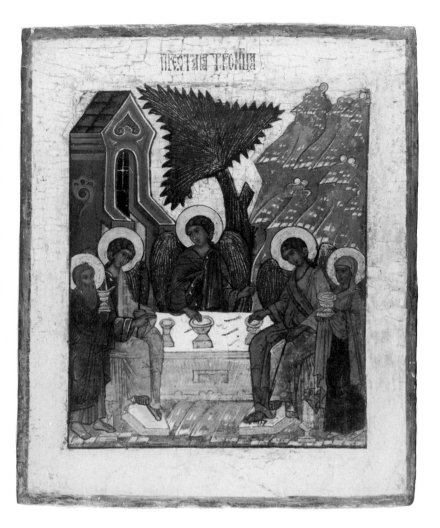

328 Icon, Old Testament Trinity

Paint and gesso on wood.
30 × 24 × 2.5 cm
Russian, 17th century M82.121

The panel shows the Three Angels of the Old Testament Trinity (Genesis 18:1–8) seated under the oak tree at Mamre and being served by Abraham and Sarah. The central angel, behind the table, wears a dark brown tunic and blue cloak, the other two are in olive green and red, as is Abraham, while Sarah is in red and dark blue / black. Each of the angels has delicate fluttering ribbons in his hair and each holds the right hand in the gesture of blessing. All the faces have a gentle, somewhat dreamy expression. The angels have olive-green wings, the same colour as the foliage of the tree, and the gold lines on the wings to indicate feathers are duplicated in the tree to suggest leaves. The lines fan out from a focal point and, together with the slanting lines of the landscape, provide the only motion in an otherwise static composition. The lines of the foliage and the line from the opposite direction of the landscape converge just to the right of the central angel, to give a visual focus to the panel.

The landscape is depicted in rigid geometrical units, but the units have odd little curlique's on top. A similar motif may be seen in a diptych with the head of John the Baptist, attributed to the Novgorod School (sixteenth century). See Wortman [cat. 297], no. 10.

Purchased from A la Vieille Russie, New York, November 1965 SDC

329 Archangel Michael

Gesso, paint, gold leaf on wood.
17 × 25.8 × 2 cm
Greek, 15th century M82.128

St Michael stands in a militant yet relaxed pose, with outstretched arms and wings. In his right hand he holds a sword, which is barely visible, and in his left hand he once held a scroll, now badly damaged. His costume is that of a soldier – high boots, a green tunic, scabbard, and a fluttering red cloak. His wings are attached by horizontal bars and originally had deails of the feathers in yellow and gold paint, most of which is now lost. His hair is painted as a series of tiny tight curls, encircling the head and extending down his neck. The features of the face are very small and delicate, very understated in comparison to the colourful and detailed costume. The halo behind his head has been marked with a series of rosette or star-shaped punch marks. The inscription at the top in Greek identifies him as St Michael.

Michael stands with one foot slightly forward. The position of the arms is determined by the objects which he holds, yet the pose is inviting, even embracing. The multiple folds of the red cloak supply a sense of grandeur to the figure, and the extra bunching up of these folds on the left prevents the panel from being rigidly symmetrical.

A panel in the Benaki Museum, Athens (Heinz Skrobucha, *Meisterwerke der Ikonenmalerei*, pl. VI, p. 73), of the Old Testament Trinity is dated to the mid-fourteenth century and provides a starting point to determine a date for the St Michael icon. The hair style, depiction of the wings, and delicate features are similar to the Toronto panel. However, the latter is more frontal and has less modelling in the face. It is difficult to compare the drapery folds because of the loss of detail in the Toronto icon, but a slightly later date is offered for St Michael in the early fifteenth century. SDC

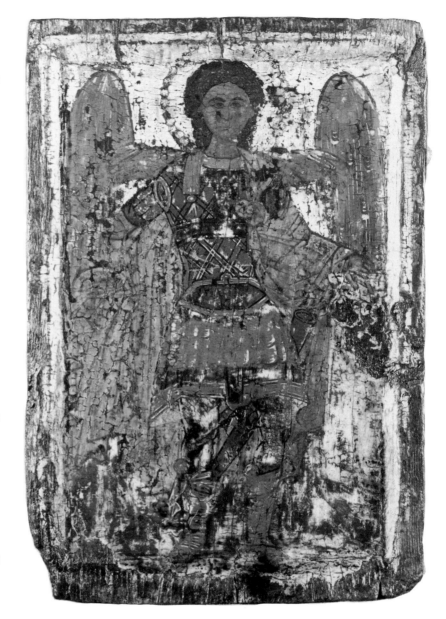

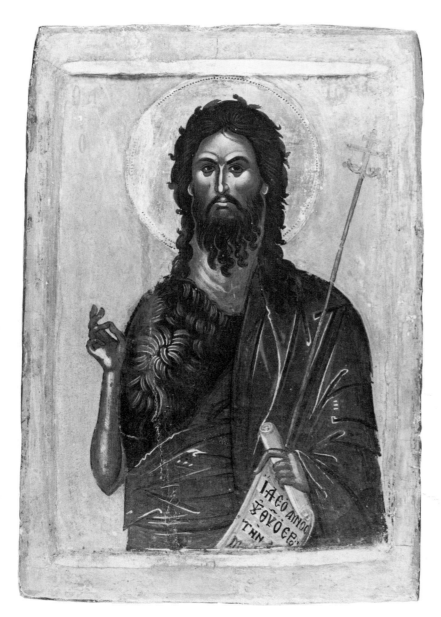

330 John the Baptist

Gesso, paint and gold leaf on wood.
29 × 43.5 × 3.5 cm
Greek, 16th century M82.102

The panel has been covered with gesso on the back and sides as well as the front. The red underpainting extends slightly onto the sides. The mustard yellow background does not quite reach the edges, thus leaving a narrow red border. The figure depicted on the panel is a three-quarter length frontal bust of St John the Baptist. He is dressed in a dark greenish-blue fur under an olive-green cloak. His long dark hair is shaggy, reaching down over his shoulders, and contrasts dramatically with the gold nimbus behind his head. He holds a crossed staff and scroll in his left hand while making the sign of benediction with the right.

The figure is a powerful one in spite of the anatomical distortions. The neck is thick, there is no shaping or anatomy suggested by the fur and drapery over the upper torso, and the right arm is very thin, even frail and delicate looking. Nevertheless, the face commands attention. There are swirling lines on the forehead and cheeks, which move upwards in contrast to the downward lines of the moustache and beard. Similarly, the agitated lines of the shaggy hair and fur are balanced by the serene expression of the face. In spite of the heavy eyebrows and deep shadows under the eyes, there is a touch of softness and kindness in the face, probably achieved by the tiny white highlights. These white highlights are used sparingly on the fur, drapery, and arm as well.

This icon is a masterful combination of expressiveness and restraint, power and serenity. It may be assigned to the mid to late sixteenth century on stylistic grounds. The dealer purchased it from a private collector in the vicinity of Athens, where it is reported to have been in the possession of one family 'for a very long time.'

Purchased from M. Komor, New York, February 1969 SDC

331 Winged St John the Baptist (Prodromos)

Gesso, paint, traces of gilding on
wood panel. 81 × 48 × 4.5 cm
Greek, 16th century M82.103

The panel has suffered from extensive
worm damage and overcleaning. St
John the Baptist is shown winged, in
his aspect as messenger (Prodromos),
the forerunner of Christ. At the same
time his own fate is depicted in the
severed head in a chalice at his feet.
He wears a blue fur tunic under an
olive-green himation. His wings are
orange and blue with traces of gild-
ing. The right arm, which also has
traces of gilding, is raised in the ges-
ture of benediction while the left
holds an opened scroll.

He stands in a severe v-shaped
landscape of an orange hillside on
the left, red on the right. The severed
head with a half nimbus in a chalice
on the left is balanced visually by
a stunted tree on the right. Across the
trunk of the tree an axe may be
seen, a reference to Matthew 3:10:
' … Already the axe is laid to the
roots of the trees, and every tree that
fails to produce good fruit is cut down
and thrown on the fire.' The space
above this rudimentary landscape
may possibly have held some other
details which were lost in a past
cleaning of the icon.

Many of the details are incised
into the gesso, such as the locks of
the beard, the outline of the right
arm, the folds of the drapery, and two
haloes.

The icon in general is stylistically
very similar to catalogue 330, if we
compare the drapery, the hair, and
the way in which the facial model-
ling has been painted. There is also a
similar lack of anatomical model-
ling. However, this John does not
meet the viewer in nearly so striking
a fashion – in fact, his glance seems
to be focused slightly to the viewer's
right. The serious losses of pigment
and gilding have drastically reduced
the aesthetic and dramatic qualities

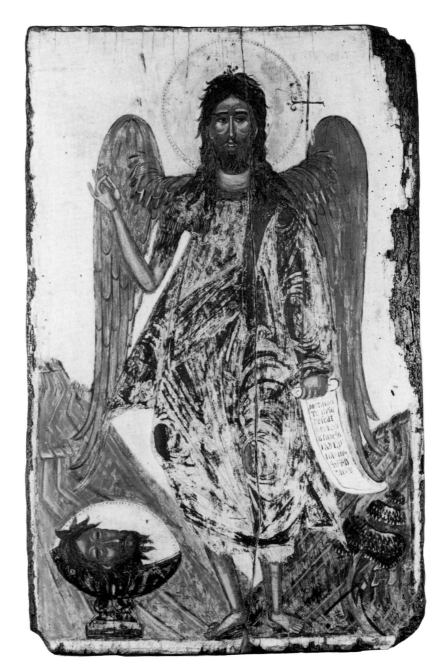

of the figure. Nevertheless, the sub-
ject still retains an intensity of gaze
which is consistent with the role
of John the Baptist.

Purchased from A la Vieille Russie,
New York SDC

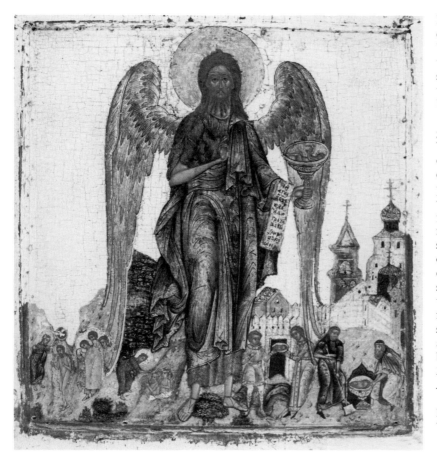

her mother and that 'John's disciples came and took away the body and buried it' (Matthew 14:12). Above these last figures is an architectural setting including a domed church, topped by a Russian cross and flanked by a bell tower complete with bells.

The style of the painting is elogated and somewhat mannerist. There is a touch of elegance to the depiction of John's right hand and the delicate yet tactile folds of the drapery and feathers. The hair is somewhat less shaggy than in catalogue 330 and 331, but the beard is separated into a number of wispy strands spread over the neck. The emphasis on linear qualities and elegance are characteristic features of the Moscow school and of the seventeenth century. Another icon which is identified as seventeenth-century Moscow school, with similar stylistic features and an identical wispy beard, may be seen in Norway (Helge Kjellin, *Ryska Ikoner, I Svensk och Norsk Ägo*, Stockholm 1956, pl. XXXIX).

Purchased from A. Winter, New York, January 1963 SDC

332 Winged St John the Baptist

Gesso, gilding, paint on wood.
32 × 27 × 3 cm
Russian, 17th century (Moscow school?) M82.122

The panel is dominated by a full-length figure of a winged St John the Baptist who towers over four tiny scenes below. His fur garment is blue and the over-garment olive-green, but as most of the gilding is intact these colours appear diffuse. John blesses with his right hand, displays a scroll over his left wrist, and holds a chalice in his hand containing the infant Christ. Unlike in catalogue 331, John here wears sandals with very thin straps. The drapery bunches around his right knee as if wind-blown or of a very stiff texture. The wings sweep dramatically from top to bottom, extending almost the full length of the panel, alternately fram-

ing and pointing out the scenes below. From left to right these scenes are the Baptism of Christ in the river Jordan, with the dove of the Holy Spirit in a disc above, the scene watched by three angels on the right; baptism of the people by John. The landscape is enveloped by the wing and the drapery of the large figure of John, but the green patch must be intended to be the hillside of the river valley ('They flocked to him from Jerusalem, from all Judea and the whole Jordan valley,' Matthew 3:5). The next scene to the right shows a very youthful, rather sheepish Herod passing the head of John the Baptist in a dish to Salome. They are placed in front of some architecture, rather than an interior which would be more appropriate. The last scene is of two men, one of whom digs, the other holds a chalice with the head of John. This must be a burial scene, though the biblical account says only that Salome took the head to

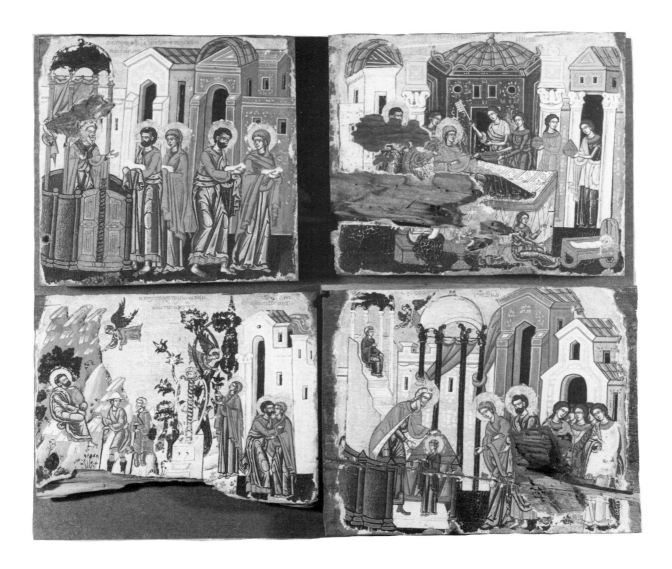

333 Scenes from the Life of the Virgin

Gesso, gilt, paint on wood.
A: 20 × 20 × 2.3 cm
B: 24.5 × 20 × 2.5 cm
C: 23 × 20 × 2.3 cm
D: 22.5 × 17.5 × 2 cm
Greek, 17th century M82.112

All four panels have serious losses of paint and wood but it is clear that they belong together. When mounted together they tell the story of events from the Life of the Virgin. The whole cycle is much longer and it is impossible to tell how many more of these panels there may have been. These events are taken from the apocryphal Protevangelium of St James. For an extensive discussion of this iconography see P. Underwood, *The Kariye Djami*, vol. 1 (New York 1966), p. 60ff, and J. Lafontaine-Dosogne, 'The Cycle of the Life of the Virgin,' in *The Kariye Djami*, ed. P. Underwood (Princeton 1975), vol. 4.

In panel A Joachim and Anna, the parents of Mary, carrying white lambs, approach the high priest who holds out his hands in a gesture of refusal. He is shown in an enclosure, under a baldachino or ciborium. This scene frequently includes an altar, but one is not shown here. To the right Joachim and Anna depart, their offerings still in their hands, rejected because they were childless. In panel B Joachim has departed to the wilderness accompanied by his shepherds, determined to fast until God should appear to him. The shepherds appear in a rather deferential attitude before Joachim while, above, a tiny angel, as a messenger of God, appears to him. In the middle is the Annunciation to Anna. She stands before a doorway and near a fountain, the usual attributes of this scene. Above is another angel, announcing that the Lord had heard her prayer for a child. Finally to the right is the meeting of Joachim and Anna, an event commemorated in the Orthodox Church on 9 December as the Conception of St Anna, Mother of the Theotokos (Mother of God). In panel C the top half is taken up with the Birth of the Virgin (also one of the feasts of the church, 8 Septem-

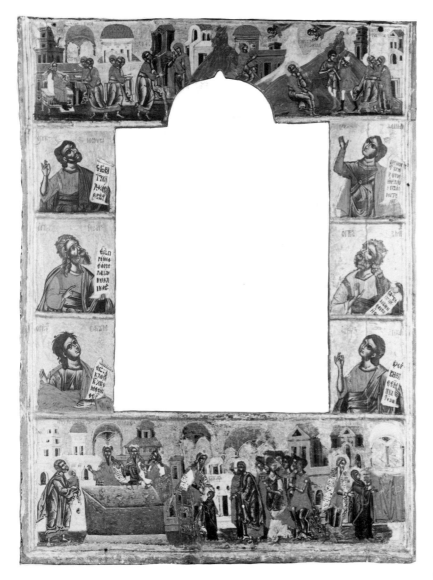

After the priest received her he kissed her and blessed her and sat her on the third step of the altar. That part of the story is here combined with the next scene, in the top left, of Mary being fed by an angel. These scenes are frequently merged, and although Mary is here seated on something which is not very altar-like, it is covered with a ciborium and portrays the message that she was divinely fed. Being elevated, it also tells us that she was removed to the holy place of the temple, safe from contamintion and impurity.

The story is told in traditional iconography, with predominant colours of red and blue. The drapery folds are rendered in a rather dry, rigid fashion. An icon of the same subject matter, and stylistically very similar, is in the Beograd National Museum, dated to the sixteenth century (S. Radojcic, *Icones de Serbie et de Macedoine* (Belgrade nd), unnumbered, 'La Naissance de la Vierge). The Toronto icon is slightly more rigid in the drapery styles and should probably be dated to the late sixteenth or early seventeenth century.

Purchased from Athens, 1964 SDC

334 Icon frame, scenes from the Life of the Virgin

Gesso, paint, gilt on wood.
83 × 57.5 × 6 cm
Greek, 17th / 18th century M82.96

The frame, which has a domed opening, once surrounded an icon and is an icon itself. The back is shaped to hold the central panel in place. The subject matter is much the same as that of catalogue 333, with some variations in the details. The scenes begin in the top left with Anna and Joachim presenting their offerings (only one lamb) and being rejected. In fact, the bottom red band in Joachim's garment is continuous in both figures, and this gives an impression of a swift turning about and departure. Anna exists here as only a partial figure blended into Joachim's shoulder. To the right,

ber). Anna lines on the bed while Joachim stands behind. One servant helps Anna to sit up while another fans to her with a rectangular fan, and three more approach carrying vessels of various shapes. In other examples of this scene, these vessels are shown to contain food. In the lower portion, barely legible because of extensive loss of the wood, is a scene of the First Bath of the infant. One figure holds the newborn Mary in swaddling clothes on her knee while another servant (lost) pours water into a basin. All of this iconography is taken directly from scenes of the Nativity of Christ. In the right-hand corner another servant twirls

a spindle while rocking a cradle with her foot – a small genre scene inserted to complete the scene of domestic harmony and bliss. In panel D two more events are shown, the Presentation of the Virgin in the Temple and The Virgin Fed by an Angel. The former scene takes up the greater part of the panel and is another feast of the church, 21 November. In front of a gate is a group of maidens, the daughters of the Hebrews, holding lighted candles. Before them Anna and Joachim urge Mary forward. At this point of the story we are told that Mary is three years old. She stands before the priest who opens his hands to receive her.

Anna and Joachim discuss the problem, centre is the Annunciation to Anna, then Joachim in the wilderness with his shepherds, then the meeting of Joachim and Anna. On the bottom register, left to right, Mary is presented by Joachim to the three high priests, a rite normally reserved for male infants, thus emphasizing the uniqueness of Mary. In the centre is the Presentation of the Virgin in the Temple, watched by Joachim and Anna and a group of women holding lighted tapers – the undefiled daughters of the Hebrews, and to the right, the same priest directs Mary towards an altar, presumably to place her on 'the third step.' However, at this point Mary is considerably larger than in the middle scene. On the sides, between the two narrative registers, are six prophets, facing toward the centre (now missing) panel.

The figures in this icon frame are not as elongated as in catalogue 333. The drapery still has rather hard, geometric folds, the colour scheme is predominantly red and blue on gold. This icon is probably slightly later than catalogue 333, in the late seventeenth or early eighteenth century.

SDC

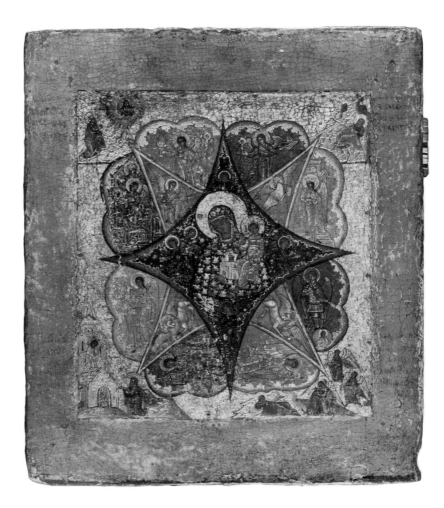

335 Our Lady of the Burning Bush

Gesso, fabric, paint on wood.
26 × 31 × 2.5 cm
Russian, late 16th century Moscow
School M82.130

The icon has been reinforced on the back with wedges to prevent or minimize warping. There are traces of inscriptions top and bottom of the sides of the frame of the panel, but these are no longer legible. Nevertheless, it is still possible to identify the icon as Russian because of the popularity of the subject in Russian icons. Our Lady of the Burning Bush refers to the vision of Moses (Exodus 3:2) and the Burning Bush which symbolizes the Glorification of the Virgin and the Incarnation of Christ. The first icon of this subject was created at Mt Sinai at the monastery

of St Catherine which was originally dedicated to the Virgin, and was also the site of Moses's vision. The subject eventually became, in popular belief, a protection against fire.

In the centre is a green star, symbolizing the bush, over a red star, symbolizing the fire. Inside the green star Mary holds the Christ Child with her left arm and a model of a church in her right. She is surrounded by angels on a star-studded background. In the red star are the four evangelist symbols, painted in white and red on red, to produce a kind of transparent grisaille effect. Behind that is a series of angels in alternate red and green compartments. The four corners contain additional visions, Moses, Isaiah, Ezekial, and Jacob.

The icon is finely and delicately painted. The thin flowing lines of drapery and feathers are characteris-

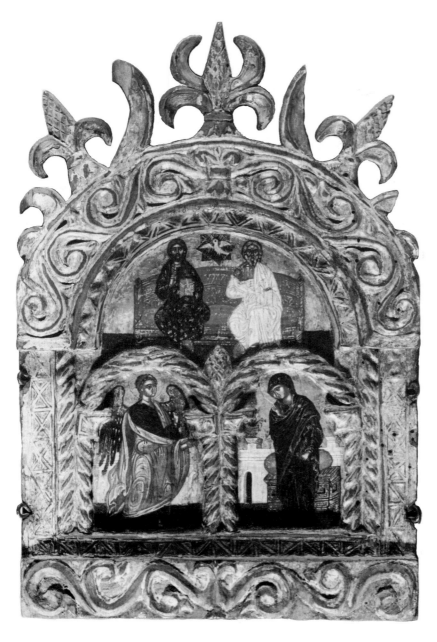

336 Central panel of a triptych, Trinity and Annunciation

Gesso, paint, gilt on carved wood.
29 × 18.5 × 2.2 cm
Greek, 17th century (?) M82.101

The two side wings of this triptych have been lost. The remaining panel is carved into a series of framing units. There are scroll borders at the bottom and over the arch, which is surmounted by pine cones in stylized foliage. Within the panel, on a shallower plane, is a pair of arches, imitating rope, with another pine cone between them and dividing the surface into three parts. In the top, seated on a wide throne, is God the Son, left, God the Father, right, and between them the dove of the Holy Ghost, thus representing the Holy Trinity. Below is a scene of the Annunciation, set in front of an architectural frieze. Mary stands in front of a gilded chair (?) with a red cushion, her right hand raised in a gesture of surprise.

The drapery, particularly that on the angel Gabriel and God the Father, is both soft and voluminous. There is extensive use of white highlights on the hands and faces. The degree of sculptural modelling of the faces suggests a connection with the Cretan School. The drapery, although far less rigid than in catalogue 333 and 334, is nevertheless consistent with a seventeenth-century date, which is tentatively offered for this panel.

SDC

tic of the 'calligraphic' style of the Moscow School.

Purchased from A la Vieille Russie, New York, November 1965 SDC

337 Royal doors, Annunciation

Very thin gesso layer, paint, gilt on wood. 138.5 × 36 (left), 39 (right) × 3 cm
Greek, 18th century M82.140

The traditional format of an iconostasis has doors in the centre which open onto the sanctuary. The subject on these doors is usually, as here, the Annunciation.

The angel Gabriel steps forward from the left with one hand raised to address Mary. He has a slight smile and there is an overall gentleness of manner. Mary, on the right, responds with a similar gentle smile, slight nod of the head, and raised right hand. The event takes place in front of buildings, perhaps suggesting a church or temple. Above the buildings on each side, as if perched on the roof in puff-ball clouds, are on the left, a bust of David and, on the right, a bust of Solomon. Each is identified as a prophet and wears a jewelled crown. Above them, reaching into the points of the doors, are blue curved strips representing the spheres of heaven.

The predominant colour scheme of these doors is blue and deep orange. The angel is dressed in blue and white with touches of orange, as is Solomon, obliquely above. Mary is dressed in blue and dark orange, as is David in the opposite panel above. The cushion on her chair is in two layers, one blue, one orange. The grey blue tones of the buildings in the background adds to the softening effect of the gestures of Gabriel and Mary.

An almost identical set of doors, dated to the seventeenth century, is in the National Gallery of Art, Sofia Bulgaria (K. Weitzmann et al., *A Treasury of Icons 6th to 17th Centuries*, New York 1966, no. 144). However, the Toronto pair have more modelling in the anatomy of all the figures and should probably be dated to the eighteenth century. SDC

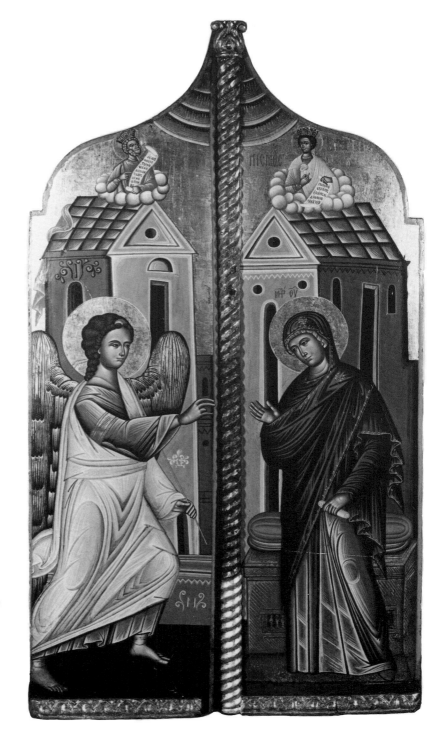

ό Ευαγγελισμός.

1867.

339 Virgin and Child, the martyrdom of St Lawrence

Gesso, tempera, gilt on wood.
34 × 16.5 × 2 cm
Venetian / Croatian, circa 1320
M82.119

On the left edge are two holes from fastenings for hinges and on the back are two flattened hooks. Therefore this panel was probably the right wing of a triptych. The panel is almost intact, but there is some serious paint loss on the right, and, on the lower border, a fragment missing from the lower right corner and worm holes on the left edge. The gesso on the front, applied in several layers, is approximately three mm thick and on the back is a very thin layer of gesso, painted a dark colour (green / black?). There is some inpainting around the lower legs of St Lawrence, the head and right shoulder of the kneeling figure, left foreground, plus a few small spots on the face of Mary and forehead of the child.

The front surface is divided into two equal panels, separated by a thick black line. In the upper half Mary, in a dark blue mantle, holds the reclining Christ Child, dressed in a red garment with gold highlights. In the upper corners are busts of saints Peter and Paul, while on the left is a figure of St Francis, bearing the signs of stigmata, and on the right just the nimbus and a fragment of the head of a second monk.

The lower half of the panel shows the martyrdom of St Lawrence, watched by the emperor whose canopied throne projects into the band separating the panels, and also by a group of soldiers and a tiny angel hovering in the upper right. St Lawrence was martyred by being roasted on a grid in Rome in 258 AD. His feast day is 10 August.

The panel has a gold background and the predominant colours are red and blue. In the upper panel a pale green has been used for the shading on the faces and hands of all five figures. The same colour is repeated in the lower panel both for shading on the exposed skin areas,

338 The Annunciation

Paint on wood. 15.3 × 10.5 × 1 cm
Greek, 1867 M82.496

The panel is a simple depiction of the Annunciation. The angel Gabriel, holding a branch of white lilies, the symbol of purity, addresses Mary who greets him with downcast eyes, her right hand placed over her heart. Above and between them a rather odd-looking bird represents the descent of the Holy Spirit. Mary is dressed in royal blue with a pink mantle. The angel wears a yellow shirt over a dark green long-sleeved tunic, colours which are repeated in the stem of the lily, and the yellow is used again in the table cloth and the cloud above from which the 'dove' emerges. The angel's dark orange mantle balances the strangely suspended piece of curtain in the top right corner, of the same colour. The date 1867 is painted into the panel, bottom centre.

The piece is a delightful example of folk art, incorporating many of the traditional elements of a more formal icon. SDC

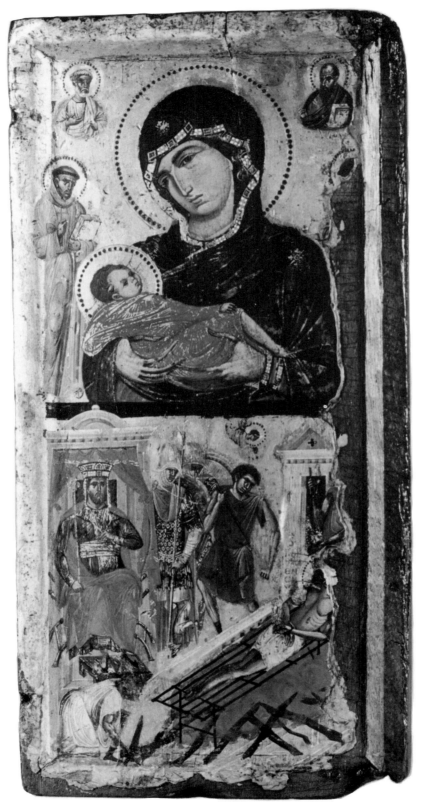

but also for the area surrounding the scene of St Lawrence's martyrdom.

The faces of the emperor, two of the soldiers, and the man with the spear all have deep small scratches across the nose or eyes, and since these are all 'bad' figures, this seems like intentional mutilation rather than mere coincidence.

For comparative dating, an icon of the Virgin and Child in the Tretyakov Gallery has similar delicate features of the face, shadows, long fingers, and fine gold lines on the drapery (D.T. Rice, *Byzantine Icons*, Faber Gallery of Oriental Art, New York nd, pl. 10).

PUBLICATION
The panel has been published and illustrated in Leo S. Olschki, *Italian Romanesque Panel Paintings*, ed. B. Garrison (Florence 1947), where it is referred to as the Zara Madonna and linked to several other panels painted on the Dalmation coast circa 1320. The others are now in the Hermitage Museum, Leningrad.

From the Minniapolis Institute of Arts Collection

Purchased from V.D. Spark, New York, January 1959 SDC

340 Virgin and Child enthroned (Pantanassa)

Gesso, paint, gilt on wood.
70 × 34.5 × 3.3 cm
Greek, 15th century M82.111

All four edges are irregular in shape because of shrinkage of the wood. The panel is made of two pieces of wood, one being much smaller than the other. It is held in place by a large iron nail, a wooden peg, and a large wooden wedge. There are several burn marks on the front from candles which were placed too close to the surface. On the front the wood has been carved to produce its own frame. Originally this had a flat outside border painted red, then the rope-like carving which was painted gold, the colour of the background.

The red is part of the original under-painting.

The scene is Mary seated on a throne with Christ on her left knee. Mary as Pantanassa (Queen of all) is dressed in a dark blue garment with a red mantle. In her right hand she holds a mappa, reminiscent of the Roman emperor. Christ on her knee holds a scroll in His left hand while making the sign of benediction with the right. His halo has the inscription ὁ ὤν (the one who is), the divine name revealed to Moses for Jehovah (Exodus III: 14) and hence a reference to the divine nature of Christ. The throne on which Mary is seated takes up exactly three-quarters of the height of the painting, but the head of Mary which then dominates the remaining quarter, with a gold backgound, is curiously not centred. On either side of her head is a medallion, painted in red with gold decorative lines. These lines do not form any recognizable shape or letter forms, although they almost appear to be imitating Arabic. The throne is really quite decorative, with shaped spindles, 'carved' bearded heads at the top of the three visible legs, and an elaborate painted scroll ornament.

The folds of the drapery are indicated by gold lines which are more decorative than illusionistic. They are applied in fairly thick lines. The prominent stylistic features of this icon are the elongated neck, 'pinched' nostrils, deep shadows under the eyes, prominent ears, and the rather coarse folds of the drapery. Similar features may be seen in a number of fifteenth-century icons, particularly from Cyprus (see for example, A Papageorgiou, *Icons of Cyprus*, New York 1970, p.45). SDC

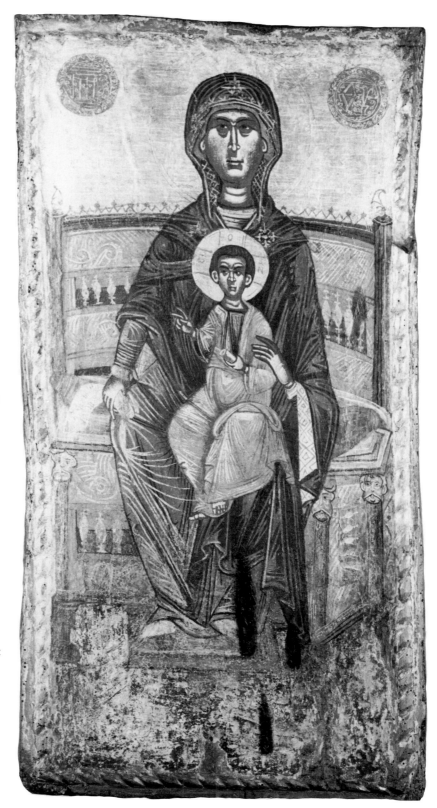

341 Virgin and Child (Glykophilousa)

Gesso, fabric, paint on wood.
22 × 18.5 × 2.5 cm
Serbian, 15th / 16th century

M82.108

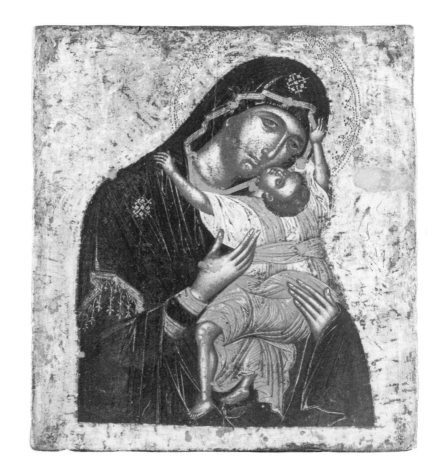

The Glykophilousa icon is one in which the child reaches up with one or both arms around His mother's neck and the cheeks of mother and child touch. It is a traditional icon type and exists in countless versions. This particular example is clearly modelled on one in Serbia where many details are very similar (Oto Bihalji-Merin, *Byzantine Frescoes and Icons in Yugoslavia*, New York 1958, pl. 75, fourteenth-century icon in the monastery of Dečani). Mary leans forward slightly to touch her cheek to the child. Her expression is pensive, even slightly sad, as if she sees what is in store for her son. In both examples she wears a dark blue tunic with gold bands at the wrist. Over the tunic and covering her head is a mantle in a deep reddish-purple with a knotted fringe which encircles the upper arm. Her hair is bound in a kerchief underneath the mantle. The child is dressed in a white tunic with a red sash and gold / yellow himation. In the Toronto panel the child tugs at Mary's mantle with His left hand in a very naturalistic fashion. Around her head is a halo which has been punched into the gesso.

The flesh areas, where visible in this icon, have an olive-coloured base on which a series of fine lines in white, grey, and pink have been painted to provide modelling and highlights. The drapery folds are rather sharp, painted in black and white, and some of these lines are quite jagged. There are deep shadows under the eyes on both Mary and Christ and a strongly emphasized line from across the eyebrow down to the end of the nose. These stylistic features, the punched halo, and the greater sculptural modelling of the figures suggest a later date for this panel than the one on which it is modelled, a date in the late fifteenth or early sixteenth century.

Purchased from H. Wohl, March 1961

SDC

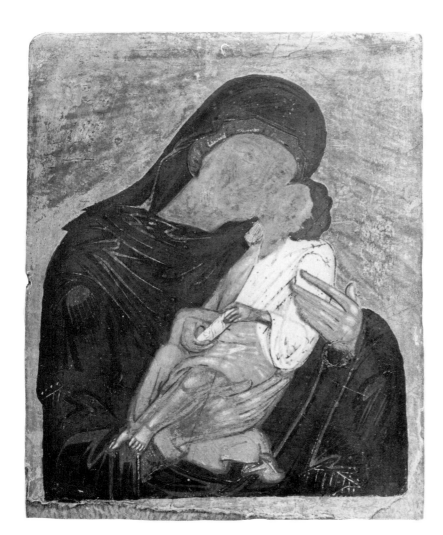

342 Virgin and Child (Eleousa)

Gesso, paint, gilt on wood.
15 × 12 × 0.9 cm
Serbian (?), 16th century (?)

M82.99

There has been extensive paint loss in the faces of both Mary and the Child, now filled with a neutral in-painting. The pose here (Eleousa) is also a traditional one of Mary and Christ touching cheeks, but unlike the Glykophilousa, the Child does not have his arm around His Mother's neck. Instead He tolds a scroll in both hands.

The loss of the features of both figures and the gilding on the drapery make it very difficult to establish any stylistic features on which to base provenance and dating. However, the somewhat jagged lines of the drapery folds may be likened to those of catalogue 341, and a similar provenance and date are tentatively proposed.

On the back of this thin panel is an inscription: 'Pitore Ebreo incognito.'

Purchased from Medina Gallery, New York, June 1963 SDC

343 Virgin and Child enthroned (Pantanassa)

Gesso, fabric, paint, gilt on wood.
54.5 × 37 × 3.5 cm
Greek / Serbian, 16th century

M82.106

Mary and the Christ Child are seated on a wide Byzantine-style throne which takes up the entire width of the panel. On the throne are two cushions, one red, one green, both with knotted ends. Mary is seated on the throne, her feet resting on a red footstool. The infant Christ is seated, not on her lap, but on her left arm. He makes the sign of blessing with His right hand and holds a scroll in His left. Mary, her head tilted slightly to one side, gestures with her right hand towards Christ. This is almost the Hodegetria type, Mary pointing to Christ as 'The Way.'

Mary wears a dark blue / green tunic under a deep reddish-purple mantle which forms an unusual loop over her right hip. Christ wears a tunic in grey with orange flowers and a himation in orange striped with gold. Both figure have punched haloes. There are two double incised circles near the top, placed just above the height of Mary's head, as in catalogue 340. These may have held inscriptions or some other details which are now lost.

The geometric u-shaped folds of the drapery are reminiscent of those in catalogue 341, as are the shadows under the eyes and the heavy line of the eyebrows. Also, the painting of flesh areas has been done in a similar way, although the narrow stripes are not so evident here. Parts of the faces have been repainted, but the two paintings may be considered as approximately contemporary.

The reverse side of this icon was also originally covered with gesso and linen, but large amounts have been lost.

From the Vontetsianos Collection

Purchased from Parke-Bernet, New York, April 1962 SDC

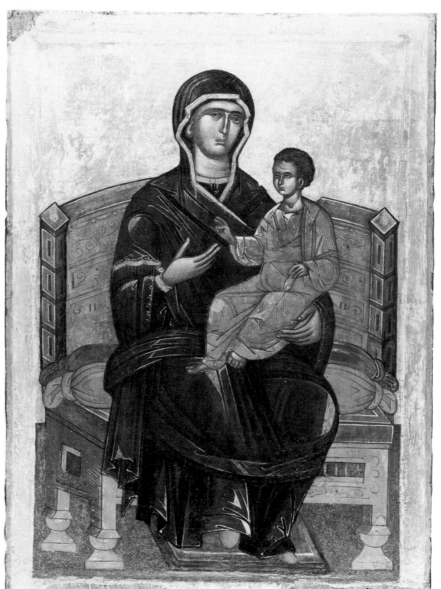

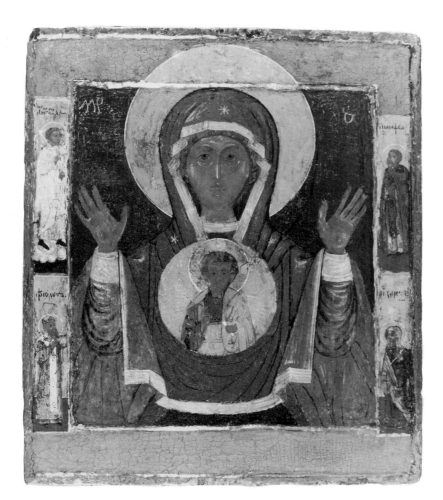

344 Our Lady of the Sign

Gesso and paint on wood.
27.5 × 23 × 3 cm
Russian, 17th / 18th century (?)

M82.90

The icon type known as 'Our Lady of
the Sign' is named for the statement
in Isaiah 7:14, 'Therefore the Lord
himself shall give you a sign; behold
a Virgin shall conceive in the womb,
and shall bring forth a son, and thou
shalt call his name Emmanuel.'
Christ is displayed in a red mandorla
in front of a half-length figure of
Mary whose arms are raised in the
orans (praying) position. The child is
displayed as if held by her mapho-
rion / mantle.

The warm red of Christ's robe and
mandorla contrast effectively with
the pinkish purple of Mary's mapho-
rion. Both haloes have been painted
in greenish-yellow. Gold has not
been used in this icon. The facial fea-
tures have been drawn with light,
delicate lines. The inscription on
either side of Christ's head is IC XP
instead of the more common IC XC.
The lines of the drapery have been
incised into the gesso.

The icon has a raised edge forming
a frame. Mary's halo extends onto
the frame and on the two sides are
four small figures. On the top, named
by inscriptions, are a Guardian An-
gel, left, and Timothey, right, while
on the bottom are Theodot, left,
and the martyr St Katarina, right.
The combination of this particular
group is probably associated with a
local cult.

Purchased from A la Vieille Cité,
Paris, June 1964 SDC / MD

345 Virgin and Child (Our Lady of Kazan)

Gesso (very thin), silver, paint on wood. 35.2 × 30.5 × 2.5 cm
Russian, 18th century M82.133

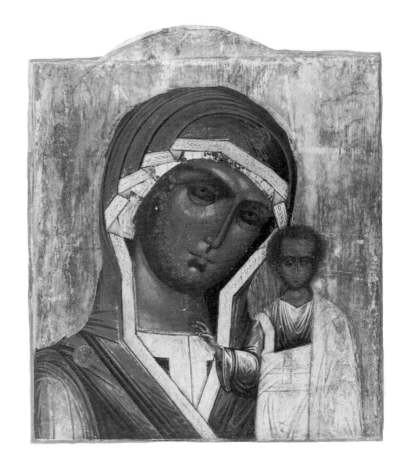

The icon type called Our Lady of Kazan is a very popular one amongst Russian icons. The original was one which appeared miraculously, in Kazan, and thereafter was associated with several supernatural events, mainly for military victories. The type shows a bust of Mary, with no arms or hands showing, and a standing three-quarter length frontal figure of Christ.

In this version Mary inclines her head slightly towards the figure of Christ. She does not look at Him. Instead she seems to be very introspective. Christ stands in front of her left shoulder and makes the sign of blessing. The green of his tunic is repeated in the medallions on Mary's right shoulder and forehead (these ornaments are usually stars). The orange of His himation is the same as that on the border of Mary's gown and maphorion. The haloes behind both figures have been lost in past cleaning of the icon and there appears to have been an undercoating of silver. The drapery around Mary's head is painted in rigid pattern folds, yet that of Christ's tunic appears to be much softer.

Much of the original background of this composition has been lost – the haloes, the edges of Mary's mantle, the area between Christ and Mary. But the degree of expressiveness and modelling in the face of Christ suggest a fairly late date such as early eighteenth century.

Purchased from A la Vieille Russie, New York, October 1963 SDC

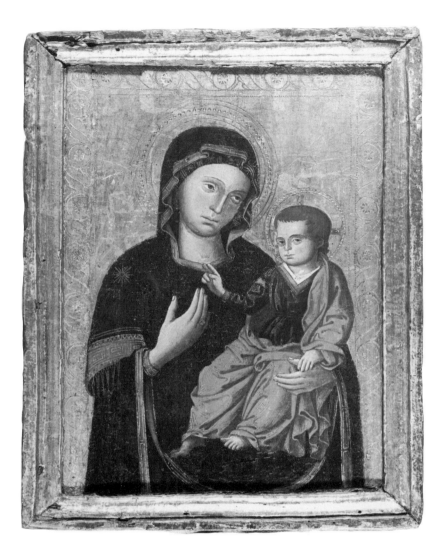

346 Virgin and Child

Gesso, paint, gilt on wood.
30 × 23 × 2.5 cm
Italian, date unknown M82.98

This painting is a mixture of eastern and western elements. The technique and composition are eastern (Byzantine) while the style is western (Italian). The work could also be called a panel painting rather than an icon.

The Christ Child is balanced in the crook of Mary's left arm, and, since she appears to be standing, there is no visible means of support for Him. He makes the gesture of blessing with the right hand, while gently holding Mary's left thumb with His other hand – a very naturalistic touch. Mary gestures slightly with her right hand but does not quite assume the pointing position of the Hodegetria. This composition is a type known as La Madonna del Popole (Corrado Ricci, 'La Madonna del Popolo di Montefalco,' *Bolletino d'arte*, IV, Sept. 1924, 97–102), a popular image in Italy which seems to have originated in Rome.

In addition to the punch-work of the haloes, there is an interior frame imitating a guilloche motif. The back of the panel has been gessoed and painted in imitation marble, in green. There are traces of a four-line inscription at the bottom, painted in black in that same 'marble' layer, but only occasional individual letters may be deciphered. In addition, near the top left is a signature, *Due Luiza*.

Purchased from E. Hollstein Gallery, New York, February 1963 SDC

347 The Raising of Lazarus

Gesso, paint, gilt on wood.
37.5 × 27 × 3.3 cm
Greek, 17th century M82.97

The panel has suffered extensive
worm damage but the painted sur-
face is reasonably intact. The icon
portrays the Raising of Lazarus. The
setting is provided by three large
jagged 'hills,' in front of a gate, no
doubt suggesting burial outside the
city. The landscape dominates the
upper half of the panel, while the fig-
ures are confined to the lower half.
To the left of centre, Christ stands in
front of a group of apostles. He holds
a scroll in His left hand and with
the right makes the gesture of bene-
diction which at the same time serves
to call Lazarus from the tomb. In
front of Christ, kneeling before Him,
are Mary and Martha, the sisters
of Lazarus, and behind them two
men who hold the sarcophagus lid.
The intrusion of western influence
should be noted here as the tradi-
tional Byzantine iconography for this
scene shows Lazarus emerging from
an upright architectural tomb, or
from a cave, not a sarcophagus. In
fact, John 11:38 describes the grave as
a cave with a stone placed against
it. Many observers stand watching,
hands raised in awe at the miracle.
One of them, oddly enough, gestures
not to Lazarus but to the men mov-
ing the sarcophagus lid. At the same
time, many of them hold a fold of
cloth over their noses, in anticipation
of a bad smell since Lazarus had
been buried for four days. Lazarus
himself is a rather insignificant, al-
most forgotten part of this painting.
He stands in the middle of the sarco-
phagus, wrapped in the white grave
clothes, at the far right of the panel.
His figure is small, and he looks rather
startled by the proceedings, appropri-
ate to someone who has just been
wakened from sleep.

The predominant colours are red
and blue. The figures are elongated
and the faces are more like masks
than anatomically attached. If we
compare this icon to catalogue 333,
especially the drapery styles of the
lower register, we can see that there

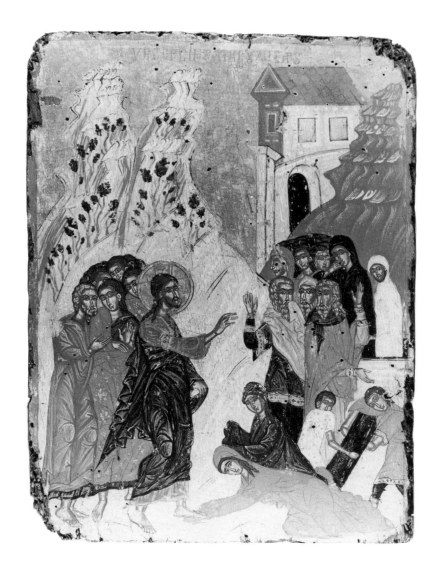

are similarities, although the figures
of the Lazarus icon are much more
elongated and stylized. A similar
date is proposed for this icon, the sev-
enteenth century.

Purchased from T. Zumpoulakis,
Athens, July 1959 SDC

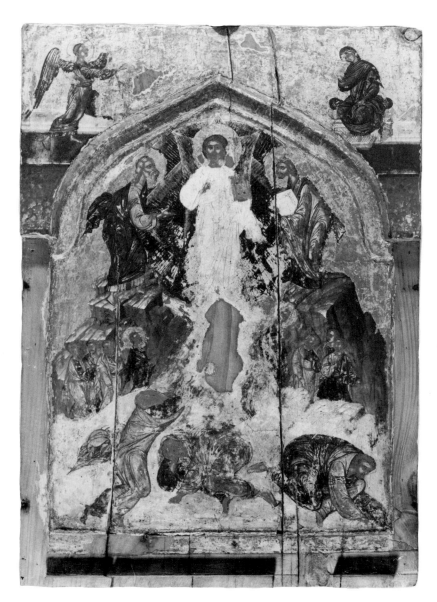

groups of four smaller figures. Since no one else was present at the scene of the Transfiguration, we can easily identify these scenes as, on the left, the climb up into the mountains (' ... Jesus took Peter, James and John ... and led them up a high mountain where they were alone') and, on the right, the descent from the mountains, when Jesus told the disciples not to tell anyone what they had seen until after His Resurrection.

The pyramidal arrangement of this composition fits well into the domed shape of the panel. The sequence of scenes, before and after, is not always included in icons of the Transfiguration, but when it is, that part of the narrative is usually minimized, as here, by diminished size.

The loss of large areas on the surface of this icon makes it difficult to say much about the style as shown in facial features and drapery. However, the fluttering drapery and its extended point on the green himation of Elijah, for example, is vey similar to that of the figure of Christ in catalogue 347, as is the 'masklike' angle of the faces of Elijah and Moses.

Purchased from Ephron Gallery, New York, April 1968 SDC

348 The Transfiguration (central panel of a triptych)

Gesso, paint, gilt on wood.
34 × 23.5 × 2.5 cm
Greek / Serbian, 17th century
M82.100

The panel represents the central portion only of a triptych, with two wings which would have fitted into the domed space. The Annunciation scene, therefore, formed part of the outer surface of the overall program of the icon. The scene is the Transfiguration (Matthew 17:1–7) in which St John, St James, and St Peter have a vision of Christ transfigured: 'his face shone like the sun and his clothes became white as the light. And they saw Moses and Elijah appear, conversing with him.' At the top, Christ appears in the centre, dressed in dazzling white and surrounded by a large blue mandorla with gold rays. Elijah (left) and Moses (right) each stand on their own piece or rock or mountain and encroach only slightly on the mandorla. At the bottom, in poses depicting their awe and astonishment at the scene, are, left to right, St John, St James, and St Peter. Between these two groups of figures are two more

349 The Last Supper

Gesso, paint, gilt on wood.
45 × 32 × 2.5 cm
Serbian (?), 18th century

M82.120

The scene of the Last Supper is set around a large table, probably meant to be round, and in an elaborate architectural setting. There are tall towers on either side and, in the centre, over the figure of Christ, a baldachino or canopy such as might appear over an altar.

The disciples are seated casually about the table. One (St John?) leans forward on to the table. The others are relaxed and observant. On the table are six loaves of bread, three wide vessels, and some smaller flasks and knives. It does not, however, look like a meal in progress or just finished. Some attention is focused on Judas who is seated in the foreground, his back to the viewer, his face in profile. As an 'evil' figure, the presence of Judas is thus reduced. If the viewer cannot make eye contact with the person represented, that person is not 'there.' Thus only evil figures such as Judas, Satan, or Roman soldiers will be shown in profile or from the back on an icon. In this case, he is also separated physically from the others. There is a clear space on either side, between him and the two disciples in the foreground. The hand gesture of the disciples seems to be one of questioning, so the precise moment intended must be that when Christ has announced that one of them would betray him and the disciples ask 'Lord, can you mean me?'

The icon has an unusual contrast of vivid reds and somber greys. The draperies are nearly all bright red and blue, while much of the architecture, the table cloth, and the skin tones are grey. It has been identified in a previous publication as circa 1700.

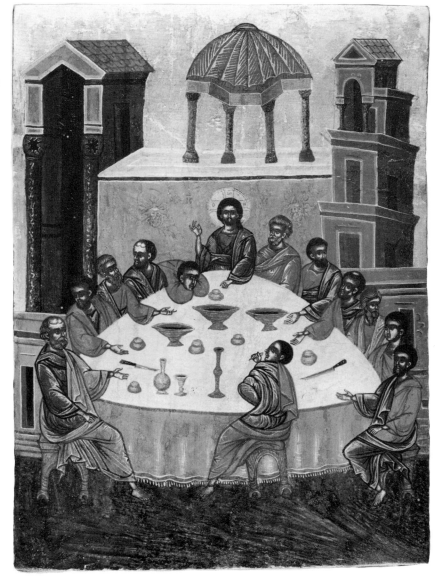

PUBLICATION
Kjellin, Helge, *Ryska Ikoner, I Svensk och Norsk Ägo* (Stockholm 1956), p. 194, ill. 92

From the V. Ebbesen Collection, Oslo

SDC

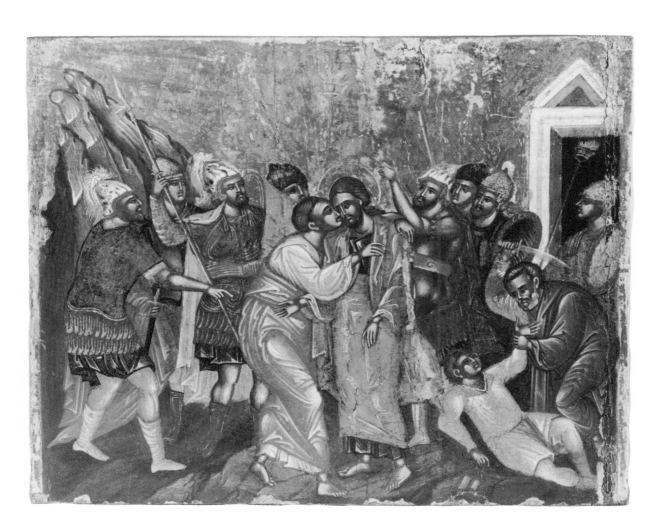

350 Icon, Betrayal of Christ

Fabric, gesso, paint, gilt on wood.
16.5 × 20.5 × 2.5 cm
Croatian, 16th century M82.109

The scene is the moment when Judas
betrayed Christ to the guard of the
high priest by greeting Him with
a kiss. Christ and Judas occupy the
centre foreground while the armed
men crowd around them. In the right
foreground Peter has raised his sword
and is about to cut off the ear of
the servant of the high priest. The
scene takes place in a stark barren
landscape rather than a garden, and
the small building at the side is not
relevant to the story.

Christ is distinguished only by a
lightly incised halo and by being in
the centre of the composition. He
wears a long purple himation under

his chlamys, but the soldiers, surpris-
ingly, are also dressed in purple (the
short tunics under their armour).
Judas is the most outstanding figure,
dressed in red and white, but he is
shown in profile, as is usually the
case. He stands partially in front of
the figure of Christ, whose pose is one
of submission and resignation.

The style in general is 'soft.' Al-
though the action depicted is violent,
there are no harsh angles or poses.
The backs, elbows, and knees are all
bent, and drapery prevents any angu-
larity. Even the landscape has soft
edges. The facial expressions are calm
as well.

On the back of the icon a number
is painted which corresponds to a
note in Dr Malcove's files: Mr E.
Pinkus said, 'According to my recol-
lection the number denoted on var-
ious parts of the picture and frame

show that the painting was in the
collection of Baron Louis de Roths-
child, Vienna, No. 57989X.'

Purchased from E. Pinkus Antiques,
New York, June 1960 SDC

351 Icon, Anastasis

Gesso, paint, gilt on wood.
30.2 × 27.7 × 2.5 cm
Russian, late 16th century M82.131

The icon is painted in several regis-
ters, portraying Christ's descent into
hell and His resurrection. In the
lower half Christ may be seen sur-
rounded by a pale green mandorla.
He stands on the broken gates of
hell and with His right hand raises
Adam from the dead. Beside Adam is
Eve. To the right a group of angels
bind Satan and other demons with
the broken chains of hell. Christ
gestures with His left hand towards
another group of figures amongst
whom are John the Baptist, the fore-
runner, David, Solomon, and the
prophets. In the upper register Christ
appears again in a mandorla, of the
same colour, and stands on one foot
on the orb of earth, flanked by hosts
of angels and saints. Above that
are three haloed figures behind a cre-
nellated wall. One of them holds a
cross. This must be a depiction of the
Holy Trinity. To the lower left is a
rather strange red area and, near the
corner, an eye. This is an abbrevi-
ated version of the more usual icon-
ography which shows a huge monster
in this corner. The monster repre-
sents the jaws of hell and is usually
shown devouring large numbers of
people. For examples of this scene see
V.I. Antonova, *Drevnerusskoe
Iskusstvo v Sobranii Pavla Korina*
(Moscow nd.), nos. 61, 123.

In both mandorlas, traces of lines
of gilding may be seen around the
figure of Christ. This refers to the ra-
diance of the risen Christ as distinct
from Christ in His earthly life when
such rays are not shown. The two
almond-shaped mandorlas dominate
the panel, but instead of being read
as two distinct scenes, the panel
is visually unified by the colour red
which is used on the roofs of the
architecture, the muzzle and jaws of
the monster, and in clothing
throughout all the various groups.
The frame of the icon is painted in a
monochrome olive tone.

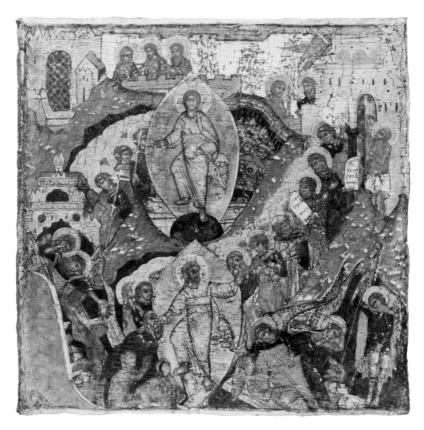

Purchased from A la Vieille Cité,
Paris, May 1968 SDC

352 Icon, Christ Pantocrator

Fabric, gesso, paint on wood.
31 × 25 × 2.2 cm
Russian, 16th century M82.116

The icon depicts Christ as Panto-
crator, ruler of all. The bust is a
simple frontal presentation of the
head and neck. Christ wears a dark
green himation and a red chiton
with an embroidered band. His dark
brown hair frames His face and
extends onto the left shoulder. He
has a halo, painted in silver, which
extends up onto the frame of the
icon. Christ gazes out at the viewer
with a serious expression. The nose
has been painted as if from a less
frontal view. The beard and parts of
the cheeks have been obscured by
old inpainting on repairs. For com-
parable examples see Skroboucha

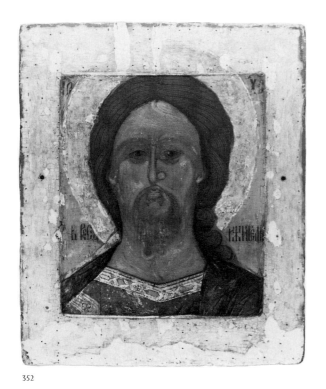

352

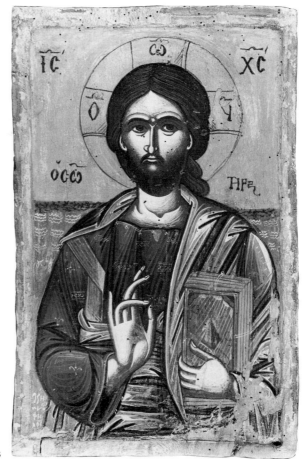

353

[cat.330], pl. LVII, and New Grecian
Gallery sales catalogue, November/
December 1973, no. 156.

The icon is reported to have
belonged to John R. Mott. Mr Mott
attended the 1917 Ecumenical
conference in Moscow and was given
the icon by the Moscow Patriarch
as a gift. It was taken from the
Ouspensky Cathedral of Moscow.

Purchased from John R. Mott SDC

353 Icon, Christ Pantocrator

Gesso, paint on wood.
58.5 × 35.2 × 3 cm
Greek, 17th century M8.113

This icon of the Pantocrator shows
more of the figure than catalogue
352, extending to half-length. He
makes the sign of benediction with
the right hand and holds a closed
book in His left hand. He wears a
dark brown chiton with touches of
bright yellow and a blue himation
with highlights in white and black.
The background is divided into a
rudimentary landscape and, by
means of an inscription, Christ is
identified as ὁ σωτήρ, the saviour.
His expression is calm and thought-
ful. The hair once again frames the
face and extends onto the left shoul-
der. The painting of the face, neck,

and hands has been done with large
patches of off-white over dark brown,
giving the illusion of a strong light
emanating from Him. This technique
also enhances the dark shadows un-
der the eyebrows and makes the
gaze intense but gentle.

The comparative examples for
dating in catalogue 352 may be ap-
plied here, although the provenance
is quite different.

Purchased in Athens, 1964 SDC

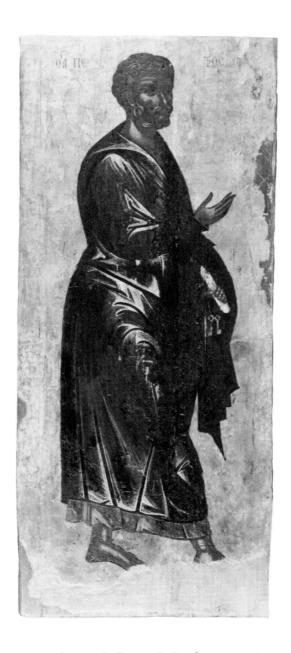
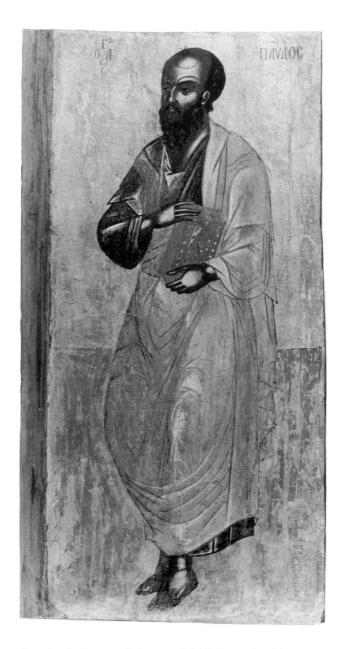

354–5 Icons, St Peter, St Paul

Fabric, gesso, paint, gilt on wood.
St Peter: 75.3 × 31.6 × 2.5 cm
St Paul: 71.8 × 35.5 × 2.3 cm
Greek, 16th century M82.104a,b

The two panels form a pair, depicting
St Peter and St Paul who symbolize
the church of the Jews and the
church of the Gentiles. The two
panels belong together, as may be
seen from the lettering and the back-
ground division. The discrepancy
in size may be explained as later al-
terations to the panels or by their
placement in an iconostasis. The two
saints face one another. St Peter has
a scroll and two keys on a ring in
his left hand, while gesturing and
stepping towards St Paul. In the other
panel St Paul holds a book with both
hands. He turns towards St Peter,
listening, and is about to make a
small step. (For the same iconogra-
phy of a conversation between St
Peter and St Paul see New Grecian
Gallery [cat. 352], pl. 17.) St Peter is
dressed in a dark blue chiton and
dark green himation with white and
light green highlights, St Paul in a
dark blue chiton and pink himation.
This latter colour was probably high-
lighted with a lot of white but much
of that has been lost in a past clean-
ing. The style of modelling and shad-
ows may be compared to that in
catalogue 353.

Purchased from Zumpoulakis,
Athens, 1961 SDC

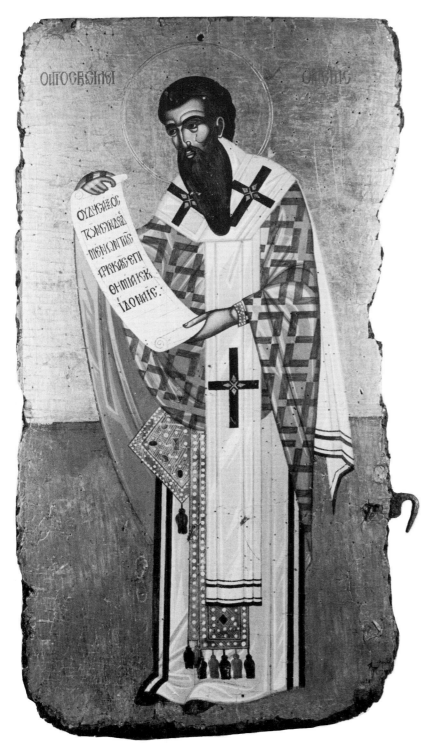

356 Icon, St Basil the Great

Gesso, paint, gilt on wood.
70.5 × 36 × 2 cm
Greek, 17th century M82.114

The icon of St Basil the Great has suffered serious worm damage on all sides, but most extensively on the right. A large iron band ending in a hook has been fastened to the back of the panel. Several of the nails holding it in place have pierced the front painted surface. The back of the panel has also been gessoed and painted in a red, green, and yellow pattern, in imitation of marble.

St Basil is dressed as a bishop. He wears a long white sticharion (chiton/alb) with red clavi (see catalogue 201). Over this is the square epigonation, painted as if it were embroidered with jewels. The epigonation is worn on the right-hand side and is an approximate equivalent to the maniple in the western church. In matching 'embroidery' is the epitrachilion or stole. Over these he wears a grey and white phelonion (chasuble) or cloak, and finally the white omophorion 'embroidered' with dark red and gold crosses. This last vestment is a particular indication of a bishop. Between his two hands St Basil holds an open scroll. The background is divided into a lower blue area and an upper gold area. St Basil stands in or on an unspecified space. The outlines are sharp and clear, as would be necessary for the visibility of the icon in a church. The hair and beard are stiff and stylized. The modelling of the face is becoming quite compartmentalized, but this is softened by the use of a stippling technique for shading.

On the back of the panel is a label which says 'Church of St Helena, Nadaba [Madaba?] Transjordan.' The icon was reported to have been taken to London 'between the two world wars.'

Purchased from M. Komor, New York, 1969 SDC

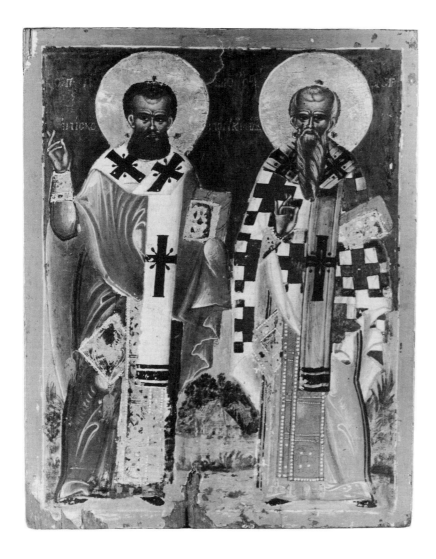

From the Vontetsianos Collection

Purchased from Parke-Bernet, New York, April 1962 SDC

358 Icon, St Demetrius of Thessalonika

Gesso, paint, gilt on wood.
33 × 29.5 cm
Greek, 16th century M82.107

The panel has been reinforced by two thick crossbars on the back. Unfortunately the nails attaching those bars have pierced the surface in several places.

Demetrius stands with his right hand raised to a tiny figure of Christ, his left hand holding his torn garment away from the wound in his right side. His tunic is blue-grey, ochre, and magenta with white highlights. It is cut open to show the wounds of his martyrdom. Over this he wears a grey cloak with pale green highlights. This is a modified version of the military costume which St Demetrius usually wears. Christ wears a dark red chiton and blue himation and holds an open scroll while another scroll appears at the left of the saint's arm. These refer to his martyrdom. Demetrius suffered martyrdom in the fourth century under Diocletian. As a soldier he was or-

357 Icon, St Anthemios and St Anthony

Gesso, paint, gilt on wood.
23 × 17 × 2 cm
Greek, 18th century M82.87

These two saints are identified by an inscription as bishops of Nicomedia. They both wear the episcopal vestments described in catalogue 356 even though St Anthony was not a bishop, with the addition of the epimanikia (embroidered cuffs, see catalogue 247). They both have broad, prominent foreheads, a device in icon painting which is used to indicate intelligence and wisdom. Both make the sign of benediction. They are set against a green background, a particular feature of the Macedonian school. An unusual item here is the landscape which is painted in the lower part of the panel between and beside the two men. The landscape has been done in a completely different style from the rest of the icon. The two men are painted in strong solid areas of colour. The landscape is more like a grisaille sketch. In spite of this difference there is no technical evidence that this might have been a late addition. This feature, together with the high degree of modelling of the faces, suggests a date in the eighteenth century.

Twenty fresco fragments mounted in four modern panels (catalogue 27)

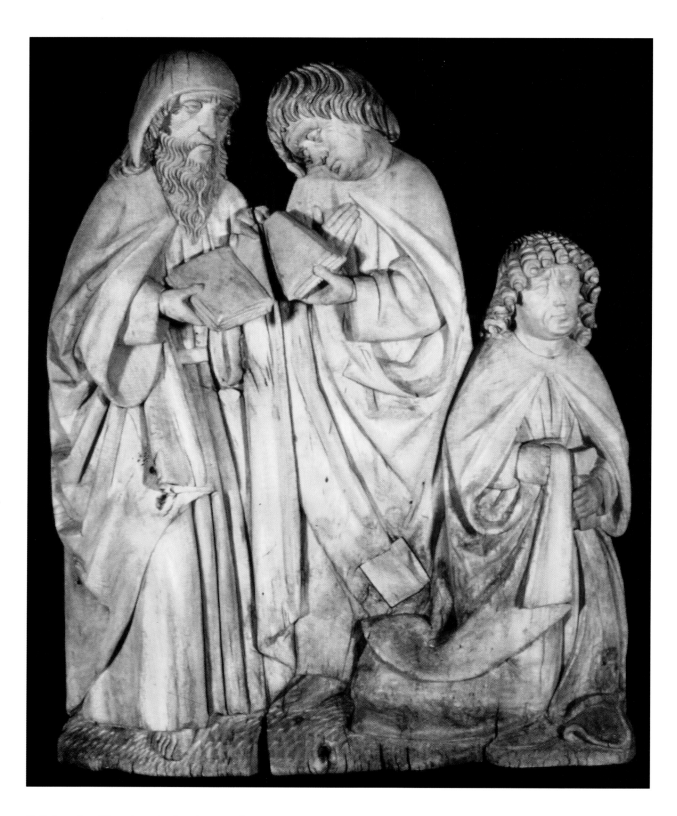

Relief carving, Three Apostles (catalogue 421)

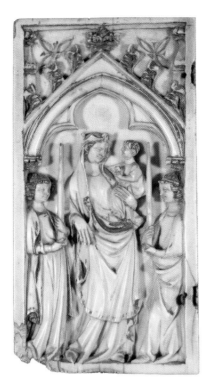

Diptych wing with the *Vierge
Glorieuse* (catalogue 418)

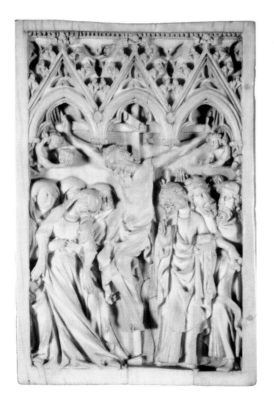

Ivory panel, probably a diptych wing,
with Crucifixion (catalogue 419)

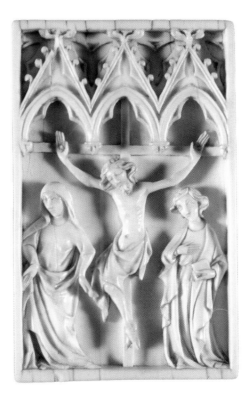

Panel with crucifixion (catalogue 420)

Three double-sided pages from a Book of Hours (catalogue 405)

Portrait of Duke Wolfgang Wilhelm of Pfalz-Neuberg, Lucas Vorsterman the Elder (catalogue 473)

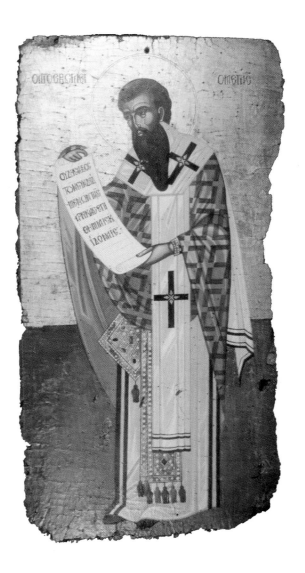

John the Baptist (catalogue 330)

Icon, St Basil the Great (catalogue 356)

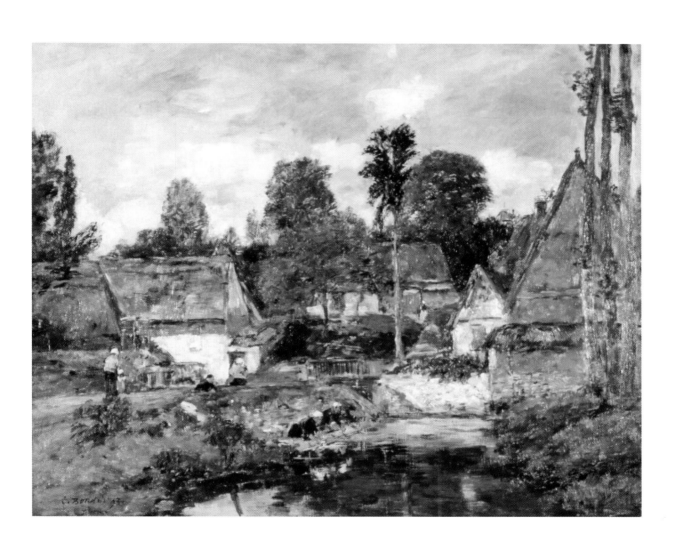

Paysage à Oisème 1893, Louis-Eugène Boudin (catalogue 484)

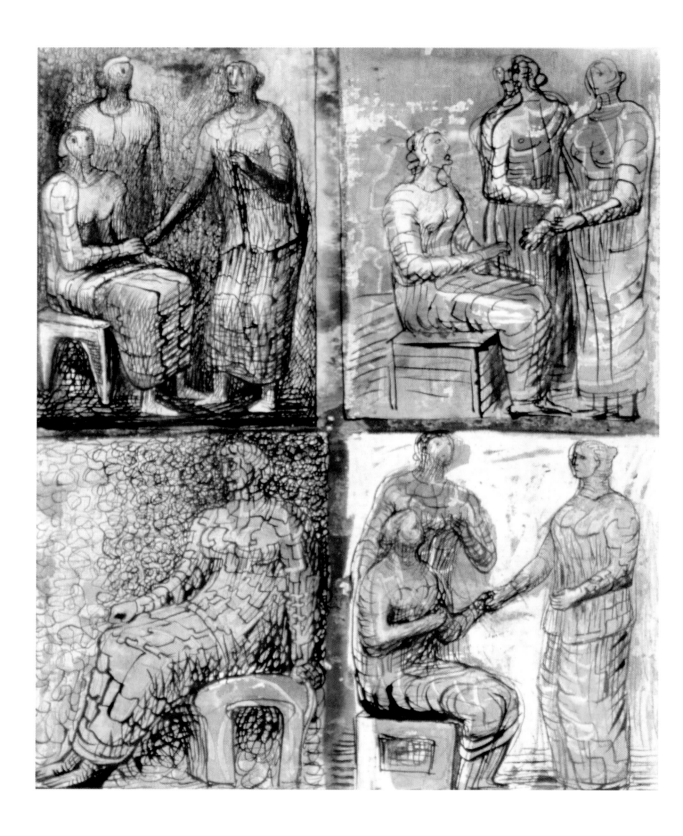

Studies of Standing and Seated Figures, Henry Moore (catalogue 497)

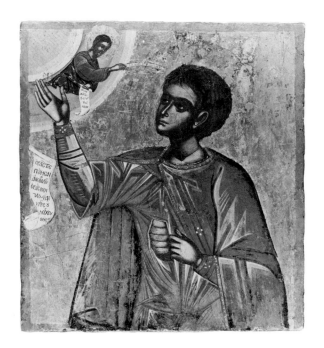

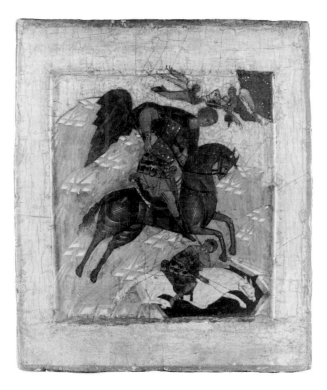

dered to participate in the execution of Christians. Instead, he preached the Gospel and was executed on the order of Maximianus, the co-emperor. His feast day is 26 October. The figure of Christ above offers the martyr's crown to Demetrius. It is a fairly simple gold band with white dots, probably meant to indicate pearls.

There is some suggestion of real anatomy and movement here. The stylized drapery folds are jagged and hard, in sharp contrast to the delicate features and soft gestures of Demetrius and Christ. For similar treatment of drapery and highlights see St John Evangelist, Monastery of St John the Evangelist, Patmos, mid-sixteenth century, illustrated in Weitzmann [cat. 337], pl. 94.

Purchased from Zumpoulakis, Athens, July 1959 SDC

359 Icon, St Demetrius on horseback

Gesso, paint on wood.
27 × 22 × 1.7 cm
Russian, 16th / 17th century M82.115

In this icon St Demetrius is shown on horseback spearing a smaller figure who is also on horseback. This figure represents the emperor Maximianus, as a symbol of evil. He and his horse are about to disappear into a large black cave in the landscape, an appropriate fate for a personification of evil. Both St Demetrius and the emperor are appropriately dressed as warriors (see catalogue 358). Over the saint's head are two angels who hold the crown of victory and of martyrdom. He rides through a landscape of sharp, angular hills painted in grey with white highlights, similar to the landscape in catalogue 328. Demetrius and his horse are magically suspended in mid-air while the saint's long spear pierces the neck of his enemy. The horse is wooden, and stylized, but there is an elegance to the curve of its neck and the pose of St Demetrius.

A similar example may be seen in Kjellin [cat. 332], no. 174.

Purchased from A la Vieille Cité, Paris, March 1965 SDC

360 Icon, St Demetrius on horseback

Gesso, paint, gilt on wood.
46.5 × 31 × 2 cm
Greek, 18th century M82.127

The Greek icons of St Demetrius are, in general, more sedate than the Russian examples. We may see this contrast in catalogue 359 where the saint gallops across the panel, whereas in this painting the horse trots gently in a less forbidding landscape. Here the dragon, or evil emperor, is missing and St Demetrius rests his spear casually across his shoulders. A tiny figure sits behind him, almost enveloped in his cloak. The man is dressed as a biship (note the omophorion) and rides with his arms crossed, hands on his shoulders. Other icons exist which show Demetrius accompanied by a priest or monk. The exact meaning of this iconography is unclear, especially why the figure should be dressed as a bishop (C.J. Walter, *Warrior Saints*, New Grecian Gallery catalogue, London, December 1972-February 1973, nos. 16, 17, 18). This group is framed by columns and an arch which separates the panel into two registers. The upper register is further divided into two architectural niches with two additional figures. There are tiny flecks of red paint near their heads, and these were probably inscriptions, now lost. On the right is a half-length figure of a female dressed in a white gown and red cloak. On her head is a jewelled crown and in her hand a palm branch, both symbols of victory and martyrdom. She also holds a red cross in front of her, another symbol of martyrdom. She is tentatively identified as St Paraskeva, partly because of the lack of other attributes, partly because of the way she prominently displays the cross and also because her feast day, 28 October, is very close to that of St Demetrius, 26 October. The other figure is a male, dressed as a bishop, and he can more confidently be identified as St Nicholas on the basis of his receding hairline and high forehead. In addition, one of the legends associated with St Nicholas tells of

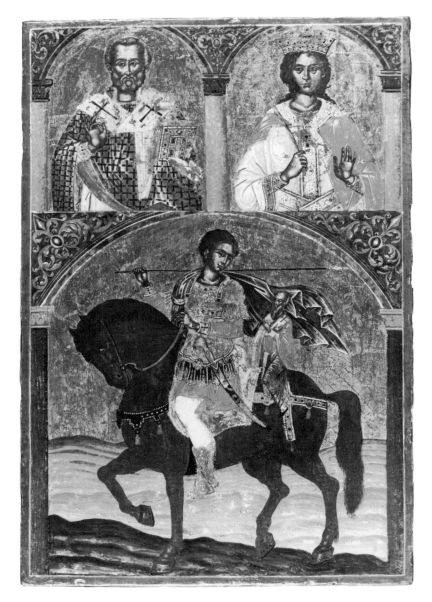

his rescuing Demetrius from drowning. For an eighteenth-century icon which is similar stylistically see ibid., no. 20.

Purchased from Parke-Bernet, New York, 1963 SDC

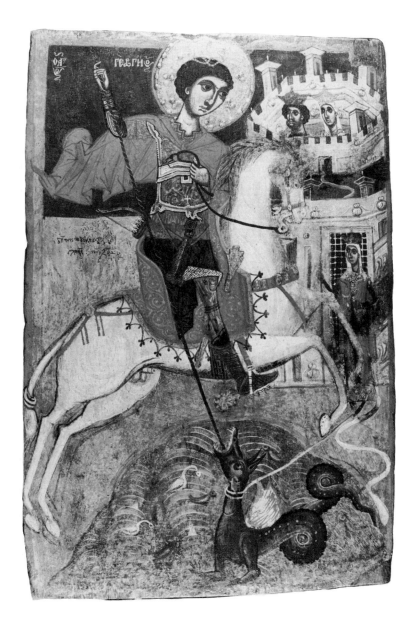

361 Icon, St George and the Dragon

Gesso, paint, gilt on wood.
56.5 × 36 × 3 cm
Greek, 18th century M82.105

St George may be distinguished from St Demetrius by his hair, which is generally shown as much curlier. Here, astride a rearing white stallion, he plunges his spear through the mouth and throat of a winged dragon. Attached to the dragon by a long cord is the maiden who is being rescued. She stands in front of a doorway closed with a grid. This must indicate the place where she was imprisoned. St George dominates the panel both in size and by means of fluttering red cape. He is dressed as a soldier, but there is a tiny white cross attached to his breastplate at the waist. Several elements have been raised in relief by the addition of more gesso – the dots in his halo, parts of the harness, the holder for the spear, and the spur attached to his right foot. The dragon is placed in or at the edge of a small pond with water birds and fish. At the top right corner, set into a bird's eye view of a city wall, are the busts of two crowned figures, a king and queen. These may be the parents of the damsel being rescued, or they may represent the multitudes who watched the rescue and were then converted to Christianity.

The dark green used in the upper background of this icon frequently indicates a Macedonian origin. Certainly the general crudity of style, the additional relief moulding, and the undisguised pentimenti of the back legs of the horse all suggest a provincial provenance. There is an inscription centre left which is unfortunately damaged over the date. It says 'The Deesis of the servant of God, Michael, year … '[1710?]

Purchased from T. Zumpoulakis, Athens, July 1959 SDC

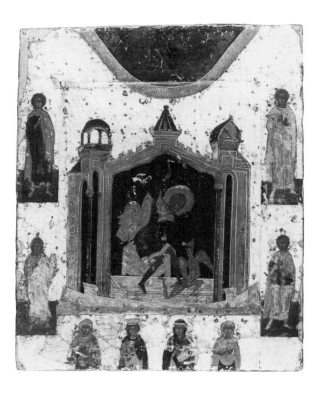 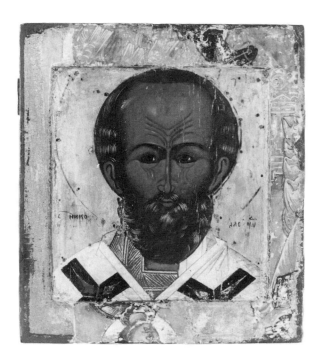

362 Icon, St Nikita slaying a demon

Gesso, paint on wood.
34 × 27 × 2 cm
Russian, 16th century M82.123

St Nikita, bishop of Novgorod, is reported to have wrestled with demons in a cave. Here the cave is replaced by an elaborate architectural setting. The cave-like atmosphere is retained by the dark interior. St Nikita stands with one foot on the demon. He grasps its hair with his left hand while his right is raised over his head. The object in his hand is no longer legible but it might have been a weapon. A crenellated wall surrounds the base of the architecture. At the top is a 'sphere of heaven' with the Old Testament Trinity of three angels drawn in grisaille. On the vertical parts of the frame are four male saints and, at the bottom, four female saints. There are inscriptions on the edges of the panel which identify these figures as, top, St George and St Dimitry; bottom, prophet Elias; and, right, illegible. The women are Paraskeva, Catherine,

Barbara, and Anna or Anastasia. However, these inscriptions may be later additions and an alternative identification is tentatively offered for the four male figures, at the top, Boris and Gleb; at the bottom, St Theodosius of the Caves (Caves Monastery in Kiev) and Aleksander Nevsky.

The back is painted dark green. Over that paint is an inscription which reads: 'According to the last will and testament of the priest Ioan Matveyevich Yastrebou, who died on 19 December 1853, this icon is the property of Peter Fedorovich Sukhov.'

From the Erickson Collection, Oslo

PUBLICATION
Kjellin, Helge, *Ryska Ikoner, I Svensk och Norsk Ågo* (Stockholm 1956), pp. 138 and 297

Purchased from A la Vieille Russie, New York, March 1962 SDC/MD

363 Icon, St Nicholas Thaumaturgos

Fabric, gesso, paint on wood.
31 × 26.7 × 25 cm
Russian, 17th century M82.88

St Nicholas Thaumaturgos (miracle worker), bishop of Myra, Asia Minor, is one of the most popular saints of the Orthodox church, second only to John the Baptist. He is recognizeable by the receding hairline, high forehead, furrowed brow, and the lines which run from below his eyes through the cheeks. There is also an identifying inscription in this case. On the self frame of the icon are the remaining fragments of other paintings, oriented in the opposite direction. There is part of a head in a halo, a hand and sleeve, some drapery (?), architecture, and part of a horse. These were revealed when a late coat of dark brown paint was removed. The original icon, of unknown date, was probably much larger. In keeping with the veneration of the icon as a holy object, when the first painting was damaged or lost its surface, the sides were

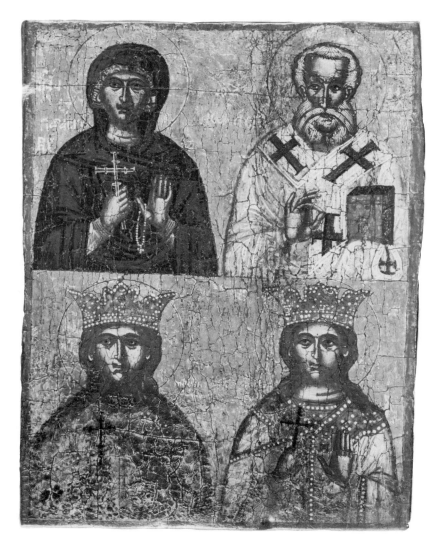

364 Icon, Four saints

Gesso, paint on wood.
31.6 × 24.5 × 2.2 cm
Greek / Russian, 18th century

M82.125

The panel has half-length figures of four saints, identified by barely legible inscriptions. On the top to the left is St Paraskeva (see catalogue 360) and on the right St Athanasius, one of the four great Fathers of the Church. On the bottom are the brothers Boris and Gleb, sons of St Vladimir who were murdered by their half brother Soyatopolk in order to consolidate his princely power. The inclusion of these two saints would identify the icon as Russian, but the inscriptions are in Greek. Stylistically this painting should be compared to catalogue 360 for similar treatment of highlights and shadows around the eyes. Perhaps the icon was commissioned by a Russian but was actually painted by a Greek. On the back of the panel there was also a layer of gesso with a large painted inscription in Greek. Unfortunately, most of that is lost and only a few disconnected letters remain. The feast day of Paraskeva is 28 October, that of Athanasius, 2 May, and Boris and Gleb, 24 July, so there does not seem to be any obvious reason for combining this particular group of saints in one panel other than the wishes of the owner.

Purchased from Athens, 1964 SDC

cut down and the central area cut away to provide the surface on which St Nicholas is now painted. The remaining painted areas were then covered up and were revealed only in 1967 when the icon was cleaned.

Purchased from F. Lustig, New York, January 1963 SDC

365 Icon, Virgin appearing to Prince Bogolubski

Gesso, paint, gilt on wood, silver riza, metal frame, fabric backing.
31.2 × 26.5 × 2.5 cm
Russian, 18th century M82.92

A kneeling figure dressed in a dark green tunic and a dark red cape is shown having a vision of the Virgin who appears on the left on a green and gold cloud. She wears red shoes, a dark blue gown, and a brown and gold mantle. Her arms are slightly extended towards the kneeling saint. In the top right corner, also on a green and gold cloud, is a half-length figure of Christ, making the gesture of benediction towards the scene which takes place in a very simplified landscape. The space between the two clouds and around the figures is covered with a silver riza. There are additional filigree haloes added to all three figures. Over the head of Mary is the traditional 'Mater Theou,' and over the head of the kneeling figure is the inscription 'St. Prince Andrei Bogolubski.' The icon is surrounded by a metal frame on which is the inscription 'Mother of God of Bogolubovo.' The back of the panel is covered with brocade fabric.

Purchased from E. Hollstein Gallery, New York, February 1964 SDC/MD

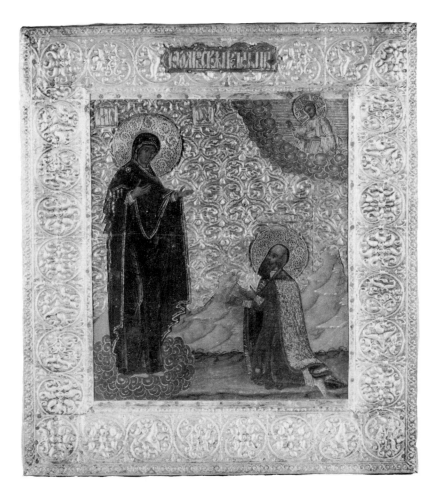

366 Icon, St Anthony of Padua

Gesso, paint, gilt on wood.
44 × 32 × 2.3 cm
Italo-Byzantine, 18th century
 M82.94

St Anthony was born in 1195 in Lisbon, Portugal, but eventually became a follower of St Francis, working in Italy. He may be identified by the Franciscan habit and the lily he holds in his right hand. In this icon he stands on a chequered floor while behind him is a landscape, presumably of Padua. This floor and landscape are features of western panel painting and definitely not of eastern icon painting. The surrounding units are scenes from the life of St Anthony who was credited with many miracles of healing and resurrection. He was particularly noted for his preaching. This latter is illus-

trated in the bottom left corner. He brought thieves to repentance, possibly the scene just above the bottom left. He is said to have rejoined a severed foot, illustrated here bottom line, second from right, and the right corner shows another of his famous miracles, where he displayed the eucharist and a donkey (here two) knelt before it. He was once viewed in his cell holding a radiant child, the Christ Child. That must be the scene second from the top on the right. On the opposite side he is shown casting out a demon.

The style of clothing, the interiors, even the subject matter is all western. The concept of an icon is eastern. Thus this panel is an interesting combination of the two traditions and demonstrates the influence of icons on western panel painting.

Purchased from Heritage, New York, August 1968 SDC

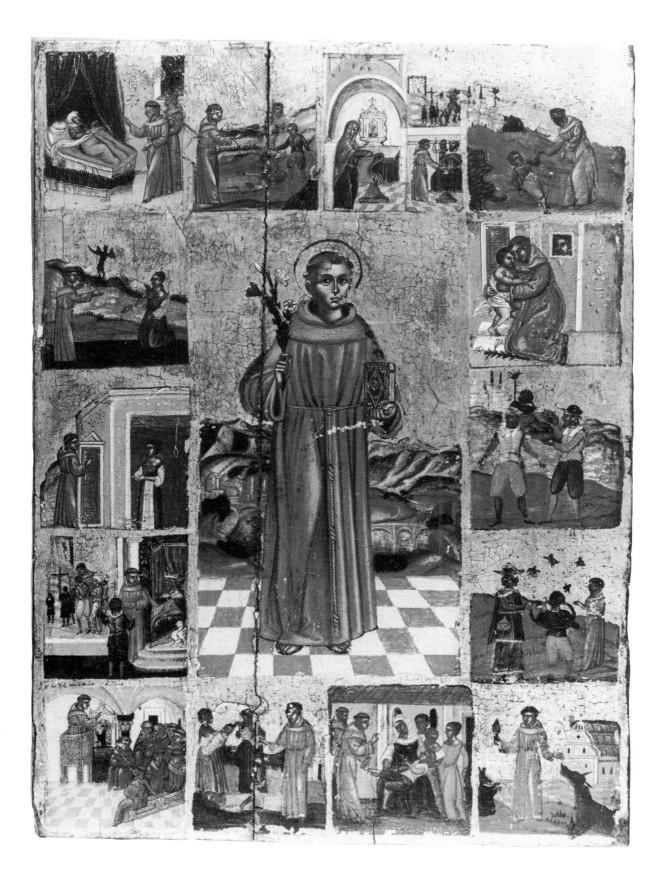

367 Icon, St Maxim the Greek

Gesso, paint, gilt on wood.
31.7 × 27.5 × 38 cm
Russian, 18th century M82.91

St Maxim (580-662) the confessor
was born at Constantinople. He was
an important theologian and mystic
and is noted for his writings. He
disputed a decree of the Emperor
Constans II and was sentenced to be
flogged and to lose his tongue and
right hand. This sentence was carried
out on the eighty-two-year-old man
and he died soon after. The figure
on this panel is dominated by an
enormous beard. On either side of his
head is an inscription which reads
'Image of the Saint Maksim the
Greek.' Above his head is the 'achei-
ropoeitas' image (made without
hands) of Christ. The image is de-
scribed as miraculously appearing on
a cloth in at least two instances:
on the veil of Veronica which she
offered to Christ to wipe His face on
the road to Calvary, and on the im-
age sent to King Abgar of Edessa after
Christ had wiped His face with the

cloth. In both cases the cloth was
associated with miraculous events.
 An almost identical icon of Maxim
the Greek may be seen in Antonova
[cat. 351], no. 140, Pomor painting.

From the Erickson Collection, Oslo

Purchased from A la Vieille Russie,
New York, March 1962 SDC/MD

368 Icon, Three metropolitans

Gesso, paint on wood.
17.5 × 13.3 × 1.5 cm
Russian, 17th century M82.118

Three unidentified bishops stand
frontally, making the sign of bene-
diction. They all wear vestments
of different colours and therefore rep-
resent different times of the liturgical
calendar. A metropolitan is a pri-
mate over an ecclesiastical province
with jurisdiction over a number of
bishops. The icon has been identified
as belonging to the Novgorod School.
For a comparable icon see New Gre-
cian Gallery [cat. 325], no. 115.

Purchased from Parke-Bernet, New
York, November 1963 SDC

369 Icon, Arrival of the Virgin of Vladimir in Moscow

Gesso, paint on wood.
31 × 27.3 × 2.5 cm
Russian, late 16th century M82.117

The Virgin of Vladimir is the most famous and the holiest of Russian icons. In fact, it was not painted in Russia but rather in Constantinople. It was taken to Vyshgorod (14 km north of Kiev) to a monastery and later, in the 1130s, was moved by Andrey Bogoluyubskiy to Vladimir. Eventually the icon was transported to Moscow. This Toronto panel is an icon of an icon, showing the arrival of that famous twelfth-century painting in Moscow. The inscription on the frame says 'Meeting of the icon of the Very Holy Mother of God of Vladimir.' The incoming group, indicated by the rough landscape background, carry the venerated painting. A group of priests has come out from the church and through the gates of the city on the right in procession, carrying an icon to greet the Vladimir icon, which must be the one on the left, as all attention is focused on that one. However, this poses a problem. The Virgin of Vladimir is distinct from other Virgin and Child types in that the child is held in Mary's right arm and the sole of His left foot is exposed to view. That is reversed here, but is correct in the icon carried out from the church. A stylistic comparison for dating may be seen in New Grecian Gallery [cat. 352], no. 26, an icon of John the Evangelist.

Purchased from A la Vieille Cité, Paris, December 1965 SDC/MD

370 Icon, Canonical calendar, centre panel of a triptych

Gesso, paint, gilt on wood.
45.5 × 27.5 × 4.5 cm
Greek, 16th century M82.93

This is the centre panel of what must originally have been a triptych. The nail marks from the hinges may be seen and the small piece of wood which acted as a catch is still in place. An archangel holding a spear and globe stands at each side. On the left is M(ichael) and on the right, G(abriel). Within the stepped arch is a half-length figure of Christ against the 'spheres of heaven,' indicated by bands of several shades of blue. He makes the sign of benediction with both hands. Below that are painted three arches, intended for canon tables – that is, the compilation of comparable passages from the gospels for use during services. Ghost images of that writing remain and become slightly more legible with the use of ultra-violet light. Otherwise the original inscriptions have been lost to overzealous cleaning in the past. On the back of the panel a large red cross is painted and the letters IC XC NI KA (Jesus Christ conquers). The face of Christ has been painted similar to that in catalogue 353, with large areas of highlighting to suggest light radiating from Him. The faces of the archangels are painted in the same way. A comparable use of highlights and drapery style may be seen in a sixteenth-century icon from Athens, Skrobucha [cat. 329], pl. XVII.

Purchased from T. Zumpoulakis, Athens, 1961 SDC

371 Icon, The Holy Week

Gesso, paint, gilt, wood.
32.7 × 27.2 × 2 cm
Russian, Stroganov School, 17th century M82.129

An icon of the Holy Week, or Six Days, depicts a series of events to correspond to six days. Here, in the top register, are Resurrection, Emmanuel the Christ Child, Beheading of John the Baptist, Annunciation. The second register has the Washing of the Disciples' Feet, Deesis, Crucifixion. The lower half of the panel has a central altar flanked by angels. On the altar is an open book. This is identified as the Word of God on the Altar of Sacrifice. Below this are four groups of people. The top left are hermits and patriarchs, on the right, Blessed Tsars and Princes, Blessed Priests/Abbots. The lower row has, on the left, Desert Fathers, Doctors of the Church, prophets. In the centre are the Blessed Innocents. On the right are apostles, monks, nuns.

The figures are all painted as miniatures, with delicate, meticulous attention to detail. The colours are

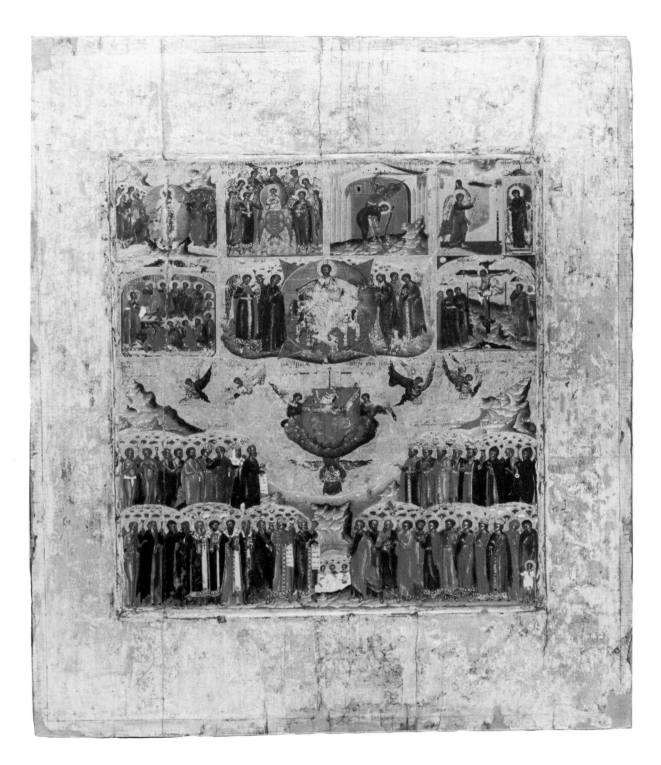

vivid and there is extensive use of gold. These are characteristics of the Stroganov School of Novgorod, particularly of the sixteenth century.

EXHIBITIONS
Exhibition of Russian Art (London 1935), no. 79
Russian Icons, A la Vieille Russie, New York, November / December 1962, no. 46

Purchased from A la Vieille Russie, New York SDC/MD

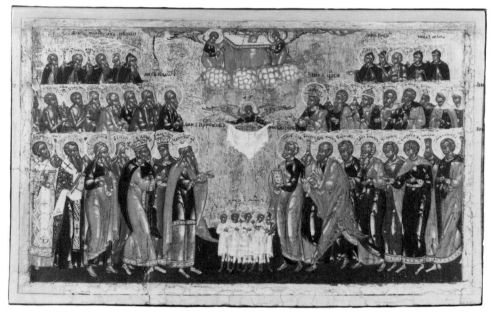

372 Icon, The Holy Week

Gesso, paint, gilt on wood.
10 × 8.2 cm; 10 × 14.5 cm; 10 ×
8.2 cm; 17 × 26 cm
Russian, Stroganov School, 17th
century M82.124

These four panels have been
remounted in a modern frame. They
originally formed part of a composi-
tion such as catalogue 371, except
that they might have been a frame
for a larger icon with rows of saints.
As they are mounted now, the top
three are the Christ Child Emman-
uel, Deesis, Crucifixion. The large
bottom panel is the same as the lower
half of catalogue 371. In this case
the figures are less colourful and less
delicately painted, although there
is still much attention to fine detail.

The qualities of 'exquisite minia-
tures' are lacking but there is more
rhythm and movement here than in
371. This panel also belongs to the
Stroganov School. Many Stroganov
artists signed their works. This panel
does not have a signature but a sug-
gestion has been made that it closely
resembles the work of Nikiphor Savin,
who lived at the beginning of the
seventeenth century.

EXHIBITIONS
Albany Institute of History and Art,
nd
Russian Icons, A la Vieille Russie,
New York, November / December
1962, no. 47

Purchased from A la Vieille Russie,
June 1957 SDC

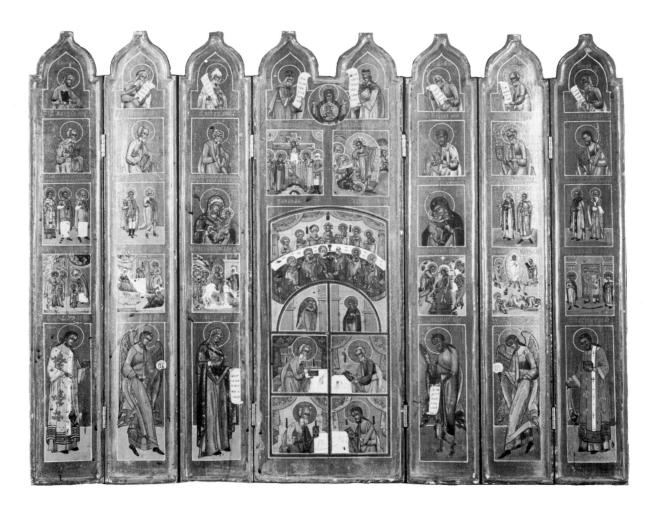

373 Icon polyptych

Gesso, paint, gilt on wood.
53 × 18 (closed), 66 (open) cm
Russian, late 18th century M82.136

The polyptych as it now stands has a
double central panel and three wings
on each side. However, there are
marks from hinges on the last panel
on each side, so there were at least
two more units originally. The cen-
tral double panel is concerned with
events from the Life of Christ. The
smaller panels are a mixture of sub-
jects. The central scenes, top to bot-
tom, are King David, King Solomon,
Our Lady of the Sign; Crucifixion
with Martha, Mary, St John, St Logii;
Resurrection with Abraham, Adam,
Eve and John the Baptist; Last Sup-
per; Annunciation; St Matthew,
St Mark, St John, St Luke. The regis-
ters of the narrower panels are to

be read laterally across all six pieces.
Row 1: prophets – Moses, Elias, Za-
charius, James, St Lot, St Sith (?);
row 2: St Matthew, St John the
Evangelist, St Peter, St Paul, St Mark,
St Luke; row 3: 'If a man hates his
wife in all innocence,' St Aviv, St
Samon, St Gurii, 'Concerning the eat-
ing of livestock by wild beasts,' St
George, 'Concerning icon painting,'
St John, Prayer of the Blessed Mother
of God of Tikhvin, 'Concerning the
giving of birth by women,' Prayer of
the Blessed Mother of God of Feodo-
rovsk, 'Concerning grapegrowing,'
Prayer of Blessed Moses and Viipantii,
'Concerning evil spirits in men and
herds,' Prayer of Niphont and Mar-
oth; row 4: Presentation of Mary
in the Temple, Joachim, Anna,
Mary, Zacharias, Birth of the Mother
of God, Entry into Jerusalem, Bap-
tism of Christ, Transfiguration, Ven-
eration of the Blessed Cross,

Constantine, Sylvester (?) Makarius,
Helena; row 5: St Stephen, St Mi-
chael Archangel, Mary Mother of
God, John the Baptist, St Gabriel-
Archangel, St Lawrence Archdeacon.

Row three, with its very specific
intercessionary prayers, suggests that
these scenes were particular requests
from one or more patrons. The pre-
dominant colours of the icon are red,
green, and gold. In fact, the gold is
achieved by placing varnish over
silver, thus reducing the cost. The
icon is completely plain on the back
and was probably mainly displayed
fully opened.

Purchased from a private collection
in Romania, through a family
member of the owner in Montreal,
1967 SDC/MD

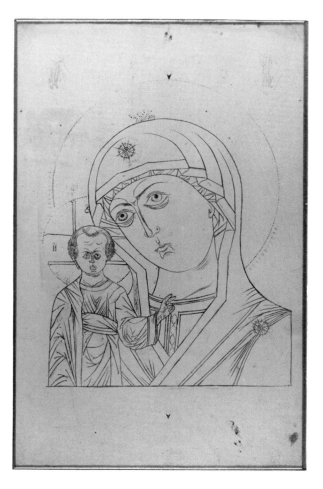

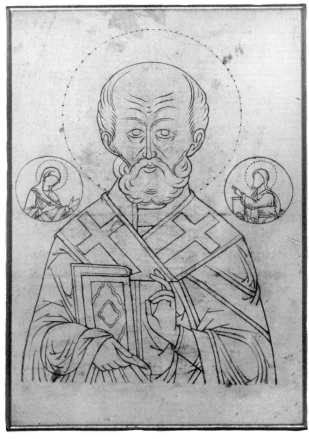

374 Icon cartoon (Podlinik), Our Lady of Kazan

Pencil and ink on paper.
35.8 × 22.6 cm
Russian, 17th century (?) M82.135

The cartoon is an artist's preparatory drawing for an icon of Our Lady of Kazan (see catalogue 345). The image is, of course, reversed (Christ blesses with His left hand) as it would probably be applied to the prepared and gessoed panel either with wet ink or with pin pricks from the reverse side. Part of the drawing, the two haloes and the ornamental strips on Mary's gown and maphorion, seem to have been done with some type of printing process, possibly a block. In the upper part of the drawing are two incomplete roundels. These may have been similar to the ones in catalogue 340.

Purchased from A la Vieille Russie, New York, October 1963 SDC

375 Icon cartoon (Podlinik), St Nicholas

Pencil and ink on paper.
28 × 19.5cm
Russian, 17th century (?) M82.134

The drawing is a preparatory one for an icon of St Nicholas (see catalogue 363). It seems to be entirely pen and ink without any of the 'printed' areas in catalogue 374. It too is reversed. Over the shoulders of St Nicholas are incomplete roundels with busts of Mary and St John.

Purchased from A la Vieille Russie, New York, October 1963 SDC

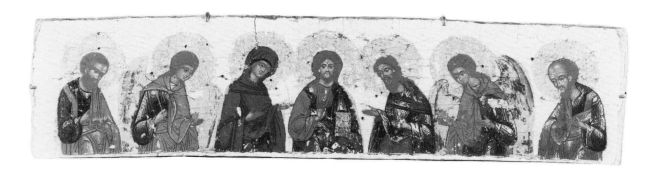

376 Icon, Deesis

Gesso, paint, gilt on wood.
9 × 34.5 cm
Russian, 17th century M82.126

The Deesis is a Byzantine iconographic form which originally consisted of a crucifixion scene with Mary and John the Baptist on either side. Gradually this grouping was extended to Christ without the cross, Mary, John, and other saints. This was a formula which was used in a prominent place on the iconostasis. Here, in addition to the central group, there are two angels as well as St Peter and St Paul on the ends. All except Christ have their heads slightly bowed and turn to Him, in an attitude of prayer and listening. The features are delicately painted with considerable modelling. The drapery folds are naturalistic and soft, suggesting the shape of the bodies underneath. This panel probably formed part of a larger icon, most likely an upper register or frame.

Purchased from A la Vieille Russie, New York SDC

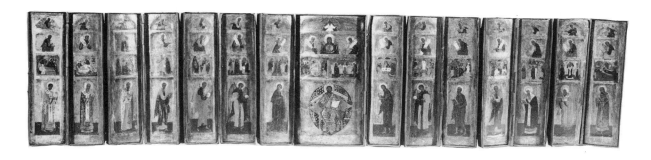

377 Icon, portable iconostasis polyptych

Gesso, paint, silver on wood, brass and fabric frame.
17.7 × 10 (closed), 77.3 (open) cm
Russian, Moscow School, 1650–1700 M82.132

The whole program is arranged like an iconostasis, as in catalogue 373. There is a central double panel and seven wings on each side painted in four registers. The top row has a series of unidentified but probably Old Testament figures all facing towards the central panel, which has a scene of Christ Pantocrator. The second row of figures are all slightly larger. They hold scrolls and represent Old Testament prophets. The central panel has Our Lady of the Sign (Blachernitissa). The third row has a series of narrative scenes, from left to right: Annunciation to Anna, Birth of Mary, Presentation of Mary in the Temple, Annunciation to Mary, Adoration of the Magi, Presentation in the Temple, Baptism of Christ, Anastasis, Crucifixion, Old Testament Trinity, Transfiguration, Raising of Lazarus, Entry into Jerusalem, Empty Tomb, Veneration of the Cross, Dormition of the Virgin. Across the bottom register are Fathers of the Church, apostles, angels, and the central panel along with the two adjoining side panels has a Deesis, Mary, Christ, and John the Baptist. Here Christ is shown in majesty, seated on a gilded throne surrounded by a blue mandorla shot through with the rays of stars.

Red is a predominant colour of this icon. The effect of gilding is achieved by using varnish over silver. The case is made in a scroll pattern for the top two panels, and on the back of the central panel is a cross in a circle. The other wings are simple rectangles. The fabric backing the panels was brocade, faded now to a yellowish beige.

An almost identical icon may be seen in G. Galavaris, *Icons from the Elvehjem Art Centre* (Madison 1973), no. 13.

Purchased from A la Vieille Russie, New York, October 1963 SDC

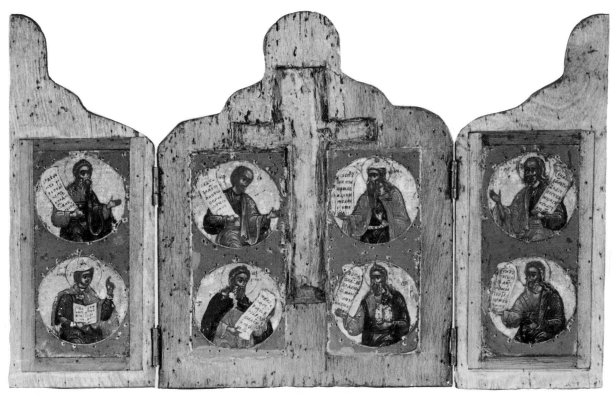

378

378 Icon triptych with eight prophets

Gesso, paint, gilt on wood.
22 × 16.5 (closed), 33.5 (open) cm
Russian, School of Moscow, late 16th
century M82.89

The icon consists of four reused
panels. Each panel has two roundels,
each with a figure of an Old Testa-
ment prophet holding a scroll. There
is a cut-out space in the central panel
which is reported to have held a
nineteenth-century silver crucifix,
now removed. The area around the
roundels was covered with a riza,
also now removed. These panels may
once have formed part of a larger
composition such as catalogue 373 or
377. The colours used are clear and
vivid, the faces are well modelled
and soft. Each of the prophets was set
on a gilded background. The outside
of the triptych is plain except for
a shallow cross cut into the wood
where the two wings close. There is
also an incised inscription giving
the date 15 June 1902.

PUBLICATION
Parke-Bernet catalogue, November
1963, no. 331

Purchased from Parke-Bernet, New
York, November 1963 SDC/MD

379 Icon triptych with scenes of Moses and St Catherine

Gesso, paint, gilt on wood.
25 × 13 (closed), 28.5 (open) cm
Russian, 16th century M82.138

The format of this icon is slightly
different from the other triptychs. In-
stead of two wings or doors which
meet in the middle, there are three
panels of the same size which fit over
one another. Unfortunately, about
a third of the outermost panel has
been lost. The icon has been gessoed
and painted front, sides, and back.
The sides and back were plain. The
orange/red undercoat may now be
seen, which once may have been
gilded. The front frame for the three
panels has traces of a scroll motif
and this surface was gilded. The out-
side panel has at the top a scene of
the Annunciation. Below that there
are three bishops, with room for a
fourth in the missing portion. These
were probably Fathers of the Church.
The back of this panel shows the
hand of God presenting the law to

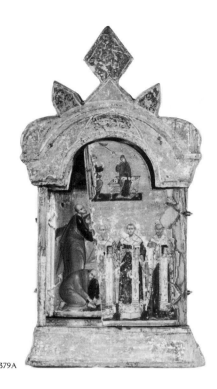

379A

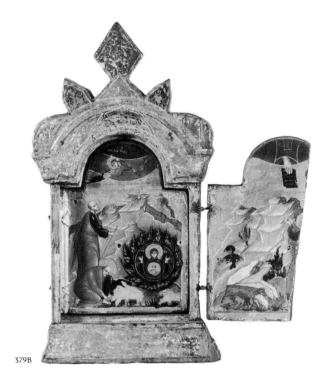

379B

Moses. The object in God's hand appears almost like a book, instead of the more usual stone tablets or a scroll. An additional unusual feature is that Moses reaches up with uncovered hands. In the middle panel an angel appears from heaven to Moses with the inscription 'Angel of God reveals to Moses the Mother of God.' A second figure of Moses shows him kneeling and removing his shoes before the burning bush in which is a roundel with Our Lady of the Sign (see catalogue 335). The landscape is harsh and forbidding, as on the back of the outside panel, and is meant to show the arid region of Mt Sinai. Inside this middle panel, at the top, is 'The Prophet Ilias,' and in the lower register, two angels who are laying out the body of St Catherine. The legend of the life of St Catherine of Alexandria tells that after her execution she was carried by angels to Mount Sinai to the site of the monastery and of her shrine. The third panel shows an Old Testament Trinity above and below, Christ in Majesty surrounded by Mary, St Peter, Archangel Michael, Archangel Gabriel, St Paul and St John the Evangelist.

In spite of the somewhat crude carving of the general shape of this icon, the painting is very delicately done. As in catalogue 378, there is a softness to the modelling of the features, and the drapery is naturalistic.

Purchased from Zumpoulakis, Athens, 1961 SDC/MD

380 Icon triptych with Life of Christ

Gesso, paint, gilt on wood.
30.4 × 25 (closed), 44.5 (open) cm
Greek, 1641 M82.110

The triptych has two fitted doors which are inset on a larger panel. Above the doors is a scene of the Annunciation with David and Solomon placed between Gabriel and Mary. The panels are to be read beginning with the central one, then, inside left, inside right, outside left, outside right. The scenes are the Nativity with the Adoration of the Magi and the shepherds flanked by two Old Testament prophets. Below this is the Presentation in the Temple and the Baptism of Christ. On the inner left door is the Transfiguration and the Raising of Lazarus. On the inner right door is the Entry into Jerusalem and the Road to Calvary. On the outer left door is the Crucifixion with Deesis and the Empty Tomb. On the outer right door is the Anastasis and Ascension. The triptych has separate pieces attached to the top and bottom, forming part of the frame. On the top piece is an inscription which is badly damaged, mainly

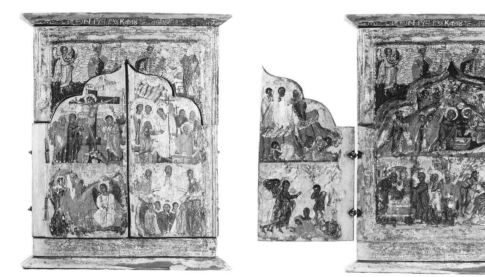

380

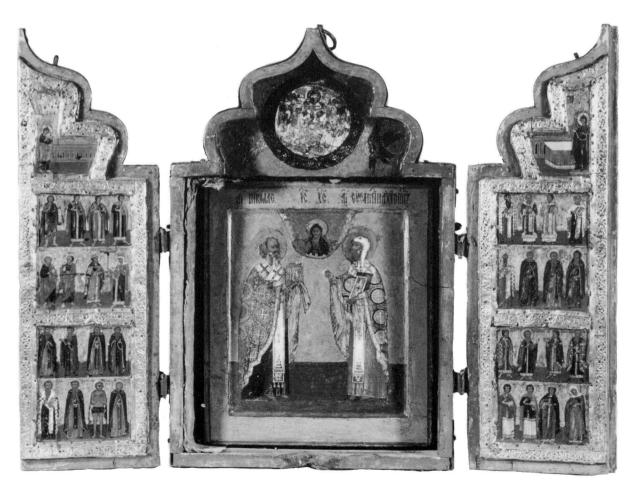

381

illegible. On the back is painted a cross, the inscription IC XC NI KA (Jesus Christ conquers), and the date 1641. This date is quite in keeping with the style of the painting and may be accepted as a completion date for the icon.

Purchased from Zumpoulakis, Athens, July 1959 SDC

381 Icon triptych, portable tabernacle

Gesso, paint, silver on wood; metal riza, fabric, leather.
52 × 32 (closed), 66 (open) × 10 cm
Russian, 17th /18th century M82.137

The frame for this icon is a large wooden box with two doors and an 'onion dome.' It is covered with leather and held together with large metal bands and hinges. The interior of the central section is lined with a blue and gold brocade. Over the central rectangle is a roundel of seraphim enclosing the Holy Trinity. There has been some paint loss here making it hard to read but the Trinity seems to be represented by a young man and an old man enthroned, and a dove for the Holy Spirit. Beneath this is a separate panel, a free-standing icon of St Nikolai and St Euthymius, archbishop, surmounted by Christ who blesses with both hands. There are five registers on the two doors. The top scene on both sides together forms a scene of the Annunciation. The rest on the left are, row 2, St John the Baptist, St Michael Archangel, St Gabriel Archangel, Holy Martyr Dimitri; row 3, St Peter Apostle, St Paul Apostle, Constantine, and St Helena; row 4, Blessed Zosima, illegible, Blessed Eustasius, Blessed John; row 5, illegible, Blessed Dimitri, St Basil (?), Blessed Daniel. On the right wing are, row 2, St Basil the Great, St Gregory, illegible, St Nicholas; row 3, St Leonid, illegible, Blessed Cyril, Blessed Barlaam; row 4, St Boris, Holy Prince Vladimir, St Gleb, St Andrew; row 5, St Cosmas, St Damian, illegible, St Barbara.

The overall program of this icon is similar to catalogue 373 and 377. The central panel may not be contemporary with the paintings of the wings. The figures in that panel are slightly less stiff and formal than the wings. Also, in the centre of the floor of this box there is some fire damage, probably from a candle which was placed too close. In that case the painting originally made for this location may have been destroyed, and would explain the unusual duplication of St Nicholas on the central panel as well as the right wing.

Purchased from A la Vieille Cité, Paris, June 1964 SDC/MD

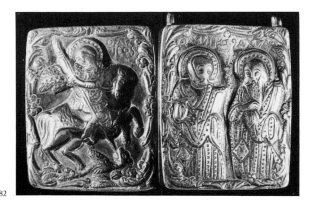

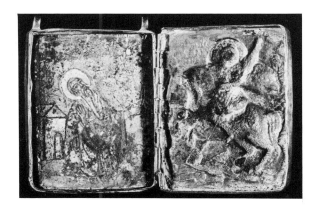

382 Icon, St Kharalampos

Gesso and paint on wood; silver case.
6.6 × 5.2 (closed), 10.5 (open) × 1.6 cm
Greek, 18th century (?) M82.361

The case for this icon is repoussée silver and has on one side St George slaying the dragon, on the other two frontal saints identified as St Nicholas and St Kharalampos. Nicholas of Myra was accompanied on his travels by Kharalampos. The figures are very simplified and show signs of wear on both sides from handling. There are also two loops for suspension attached to the back of the case. On the interior is a tiny wooden panel (6 × 4.5 × 0.8 cm) painted with a scene of a kneeling saint in front of a small building. He is identified by an inscription as St Kharalampos. The style of the painting is rather crude and there has been some damage to the surface so it is impossible to say anything about date and provenance from this panel. The style of the figures on the case provides a tentative dating for the icon of the eighteenth century.

Purchased from A la Vieille Russie, New York SDC

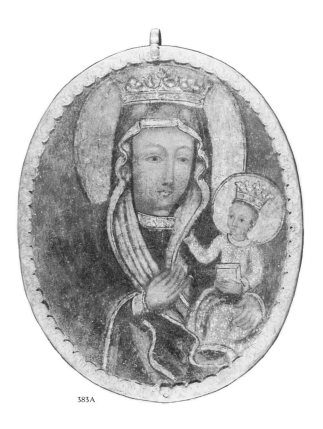

383A

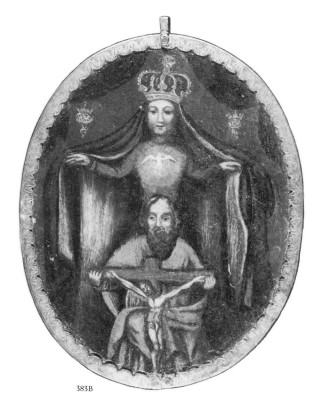

383B

383 Icon, oval two-sided painting

Paint on tin, pewter (?) frame.
19.5 × 15.2 cm
Polish, 18th century M82.199

The painting has a loop at the top for suspension so that both sides could be easily visible. On one side is a scene of Mary and the Christ Child in the Hodegetria pose. The unusual feature here is that both Mary and the child wear crowns. On the other side is a depiction of the Holy Trinity with Mary, again crowned, surmounting all. At the bottom is Christ on the cross, God the Son. Holding up the cross is God the Father. Above that is the dove, God the Holy Ghost, which appears to emerge from Mary's breast. The maphorion which falls from her head is almost like a cloak which she spreads out with her hands in a protective gesture to enfold the Trinity.

Purchased from Collectors' Corner, New York, March 1968 SDC

384 Reliquary box

Lead.
16 × 8.6 cm, height of lid 5.7 cm.
Italian, 8th / 9th century M82.363

This small reliquary chest is formed of lead sheets held together by rivets, only a few of which are still in place. Chests of this shape, which derive their form from sarcophagi, were in use as Christian reliquaries by at least the fifth century, and one appears on the Trier ivory plaque depicting a translation of relics. Although most such reliquaries which have survived are made of more precious materials, the use of lead is not unknown, and a chest of this metal, containing a human heart, was found in January 1901 during the excavation of the church of Santa Maria Antiqua in Rome.

The exteriors of the chest and of its lid are decorated with repoussée reliefs. On the front is a medallion bust of an unidentified male (presumably the saint whose relics were contained in the chest), flanked by four rosettes and two large candlesticks. The back is decorated with two Greek crosses, and the sides with stylized birds. The two long sides of the lid each have the chi-rho monogram of Christ contained in a medallion, and the short sides a rosette design. While the crosses and monogram belong to the general context of Christian symbolism, other details of the decoration allude more pointedly to the chest's funerary function. These include the depiction of the deceased in a medallion, or *imago clipeata*, as was a common practice on Late-Antique sarcophagi, and the two flanking candles. A good comparison for the latter may be found in the mural over the fifth-century tomb of Cominia and Nicatiola in the catacomb of San Gennaro at Naples. Also appropriate are the two birds, presumably meant to represent peacocks, a popular Christian symbol for immortality owing to the ancient belief that the flesh of the peacock did not decay.

There are no details or attributes which assist in identifying the saint in question. The suggestions for date and origin are proposed on the basis of the rosette designs and the form of

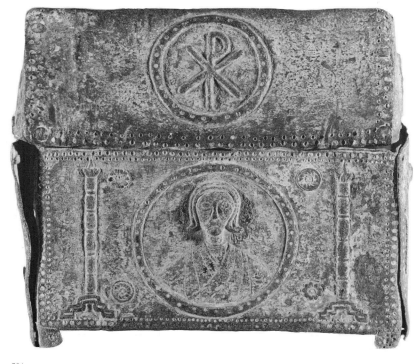

384

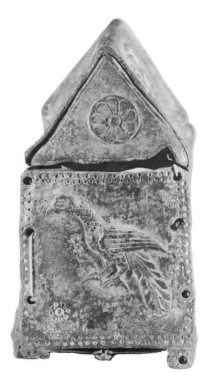

the crosses. These rosettes have nu-
merous parallels in eighth– and
ninth–century relief sculpture from
both northern and central Italy,
while the cross with arms terminat-
ing in volutes resembling Ionic capi-
tals is a peculiar characteristic of
Carolingian Rome. This period also
witnessed an enormous flowering
of interest in the cult of relics. JO

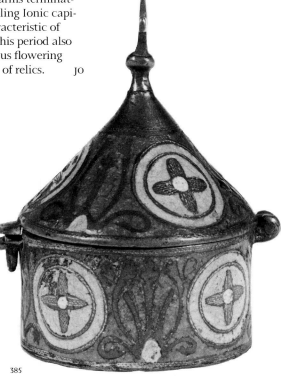

385

385 Champlevé enamel pyx

Enamel on bronze. 11 × 6.8 cm
Limoges, France, mid–13th century
M82.368

The pyx is cylindrical with a conical
lid topped by a cross. The back-
ground is dark blue, and on it are
engraved gilded four-petalled flowers
with white centres, set on turquoise
discs surrounded by a yellow border.
In between are reserve stems which
were once gilded. The lid and the
body have the same pattern. The
gilding on the interior is intact. There
is a small hole in the base and on the
bottom is painted the number 5164.
This pyx bears a very close resem-
blance to one publised by Marie
Madeleine Gauthier and Geneviève
François in *Mediaeval Enamels*, Neil
Stratford, ed. and trans. (British
Museum Publications 1981), no. 26,
fig.5.

Purchased from Blumka Gallery,
New York, January 1966 SDC

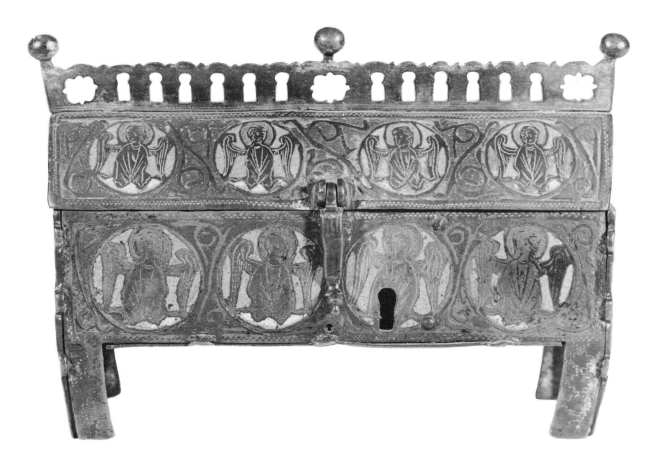

386 Chasse / Reliquary

Enamel on bronze.
12 × 16.3 × 5.5 cm
Limoges, France, 1280–95 M82.369

The chasse is shaped like a casket
with a pitched roof. The pierced
cresting consists of two sets of six
keyholes with a lobed motif on each
end and in the middle. There are
three knob projections on top. The
lid and the base are decorated with a
series of half-length angels. The
background is dark blue, the angels
are gilded and engraved, have red
haloes, and arise from white clouds.
Each angel motif is set on a turquoise
disc, with scrolls between which
may have been gilded once. The legs,
which are rectangular, have the
remains of a grid motif in gilding.
There are two hinges on the back and
on the front a clasp and a keyhole,
but no joining mechanism. This
reliquary closely resembles one de-
scribed as a type which was produced
in large quantities in the second
half of the thirteenth century in Lim-
oges. See Gauthier and François [cat.
385], no. 28, fig. 6, dated 1280–95.

Purchased from Walter F. Altschul,
New York, December 1962. SDC

387 Censer

Bronze. 18 × 11.5 cm
Western Mediaeval /Italian(?), 12th–
14th century M82.418

The general shape of this censer is
spherical, the top part being slightly
larger. It would have had chains
to hold the top and bottom together.
The dome-shaping of the top is al-
tered by projecting arches, cones, and
knobs. The conical base does not
provide a stable surface but this type
of censer was not meant to be free
standing. It would have been sus-
pended and swung by the chains. The
base has a few T-shaped and circular
openings to provide air for the char-
coal on which the incense is burned.
Otherwise the decoration is confined
to the lid of the censer and consists
of rectangular and circular perfora-
tions and projecting knobs. A censer
of generally similar shape but with
relief decoration may be seen in the
exhibition catalogue *Bronzen von*

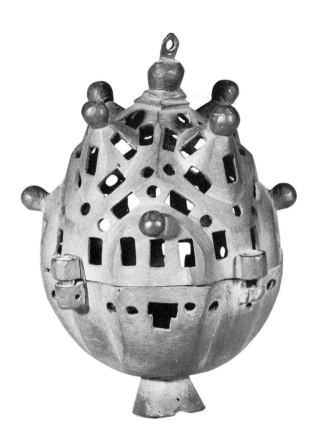

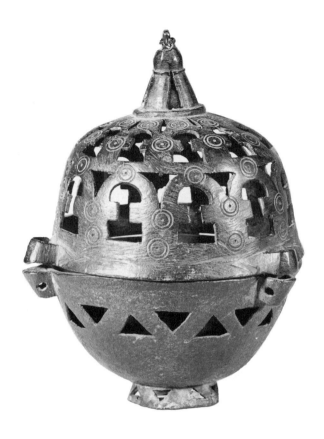

der Antike bis zur Gegenwart, Eine
Ausstellung der Stiftung Preussischer
Kulturbesitz Berlin aus den Bestan-
den ihrer Staaatlichen Museen,
Münster, 14 March–18 November
1983, no. 47, p. 83. This type of censer
is described as 'italienischen Typus'
and dated to the thirteenth century.
The Malcove censer, although much
less decorative, seems to belong to
this category and may be assigned to
the same date or possibly slightly
earlier, as a less well-developed ex-
ample. Alternatively, a censer with
similar shapes of perforations has
been described as 'Italian, 14–15th
century' in the exhibition catalogue
Frühchristliche Kunst aus Rom, 3
September–15 November 1962, Villa
Hugel, Essen, no. 328. SDC

388 Censer

Bronze. 16.5 × 12 cm
Western Mediaeval / Italian (?),
12th / 13th century M82.413

The foot and base of this censer are
perforated with triangular openings.
The top, which is domed, has a row
of arched openings with keyhole
openings and double-punched circles
on the arches. Three sets of matching
loops on the top and the base indi-
cate that these loops were held to-
gether with chains, rather than a
hinge and clasp. The top would slide
up on the chains when the censer
needed to be filled and, when low-
ered, would be held in place by
the position of the chains. Unfor-
tunately, these chains have not
survived with the censer. This is a
western type of censer rather than
eastern, although the decoration on
this example suggests Byzantine or
Coptic influences. The comparative
example in catalogue 387 may be

applied here as well, and, again, an
earlier date is tentatively suggested.
 SDC

389 Ciborium

Copper gilt. 28.5 × 12 cm
German or Italian, mid (?)–15th
century M82.370

The hexagonal casing and lid are
made of separate panels and the stem
is fitted with polygonal, flat collars.
The circular, flattened knop is deco-
rated with a narrow beaded band.
The lid is hinged on two sides. Above
one hinge on the lid is an incised
cross. On the opposite inside panel of
the case is another small incised
cross.

Ciboria are used to contain com-
munion wafers or breads. The form of
the foot and stem of ciboria follow
closely the forms used on chalices,
monstrances, and reliquaries. The
foot and stem of the Malcove cibor-
ium are close to those which appeared
throughout the fourteenth century,
for example on chalices (cf Hein-
rich Kohlhausen, *Nürnberger Gold-
schmiedekunst des Mittelalters und
der Dürerzeit 1240 bis 1540*, Berlin
1968, no. 212). Circular footed chal-
ices and ciboria, however, were made
throughout the fifteenth century
(cf ibid., no. 163), some examples
dating from as late as circa 1500
(ibid., no. 297), though on such late
examples the knop is generally of
a different type. Polygonal collars,
like those on the stem of the Malcove
ciborium, appear on German mon-
strances throughout the fifteenth
century (ibid., nos. 325, 308), but are
usually slightly contoured on the
upper and lower surfaces rather than
completely flat. Ciboria with polygo-
nal cases and steeple-like lids – simi-
lar in general shape to the Malcove
ciborium – are frequently given a
German attribution. They vary in
detail, some having engraved and
applied ornament, the applied orna-
ment of architectural form as seen
on an example in the Germanisches
Nationalmuseum, Nuremberg (ibid.,
no. 161). The polygonal casing and
spire of the Malcove ciborium recall
many German examples (eg, Soth-
eby-Parke-Bernet, *Medieval, Renais-
sance and Baroque Works of Art*, 11
December, London 1980, no. 60, a
German gilt copper ciborium or pyx

of the fifteenth century), but the
overall lack of decoration and the
planar severity of the Malcove cibor-
ium also resemble certain items of
ecclesiastical metalwork which are
regarded as Italian, for example,
a chalice and reliquary seen at Soth-
eby's in 1981 (Sotheby-Parke-Bernet,

*Medieval, Renaissance and Later
Works of Art and Related Reference
Books*, 8th–9th July, London 1981,
no. 260, a North Italian chalice circa
1500, and no. 263, a North Italian
reliquary of the late fourteenth cen-
tury). While the polygonal case and
lid of the Malcove ciborium are per-

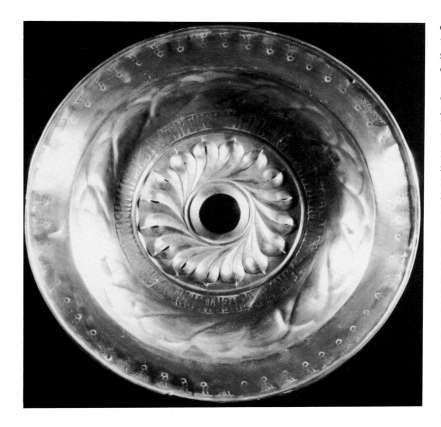

haps closest to German examples, the knop and foot are closer to certain gilt copper chalices, ciboria, and monstrances regarded as Italian, for example, to the knop and foot of an Italian monstrance of circa 1500 sold at Sotheby's in 1981 (ibid., no. 265). KCK

390 Dish or basin

Light gauge yellow brass with repoussée and stamped decoration.
36.6 cm
German, early 16th century

M82.150

The dish has repoussée decoration and a border of stamped trefoils on the rim. The rim is reinforced by a wire under the turned over edge. The spiral lobing at the centre is worn through in several places.

The best-known brass dishes produced in Europe during the Late Middle Ages are those of the South Netherlands, specifically associated with Dinant. They were frequently decorated with punched borders and low relief motives in the centre (cf William D. Wixom, *Renaissance Bronzes from Ohio Collections*, Cleveland 1975, no. 8). The Malcove dish has a border of punched trefoils similar to the punched borders of some Dinant dishes but is of a type generally regarded as German and

dated to the early years of the sixteenth century. Two dishes of the same type as the Malcove dish were offered for sale by Christie's in 1980 (Christie Manson and Woods, *Medieval, Renaissance, Baroque and Later Sculpture and Works of Art*, New York, 21 May 1980, nos. 200, 201), both described as alms dishes, German, sixteenth century. Dishes of the same type appear from time to time in the auction catalogues of both Sotheby's and Christie's. The spiral lobing of the Malcove dish is of a type that occurs frequently on Late Gothic metalwork, ceramics, and glass, and which remained fashionable into the period of the Renaissance. Ceramic examples are provided by some Italian maiolica, and by large Hispano-Moresque tin-glazed earthenware dishes of the period around 1500 (cf Tjark Hausmann, Majolika, *Spanische und italienische Keramik vom 14. bis zum 18. Jahrhundert*, Berlin 1972, no. 6). In glass, spiral motives are seen on some Gothic-inspired Venetian glass of the late fifteenth-early sixteenth century (cf Wilfred Buckley, *European Glass*, London 1926, p. 35), while Gothic-inspired spiral designs also appear on some rock crystal vessels of the same period, for example a rock crystal dish attributed to the Italian artist Giovanni dei Bernardi (Christina Piacenti Aschengreen, *Il museo degli argenti a Firenze*, Milan 1967, no. 292).

Purchased from Medina Gallery, New York, November 1962 KCK

391 Processional cross with attached Corpus

Copper, decorated with incised
copper gilt (gilding very worn)
embellished with incised ornament.
54.6 × 27.7 × 0.2 cm
French, Limoges, circa 1300 (?)

M82.375

The cross is decorated with incised
ornament and fitted to a knopped
socket. The ornament consists of, on
the obverse, a border of incised paral-
lel bands enclosing a matt ground,
at the top, a haloed half figure hold-
ing a crescent and three quatrefoils
immediately below. Further down is
a band sloping downward from left
to right containing the sacred mono-
gram 'IHS' in Gothic letters. The
left arm of the cross is decorated with
an incised half-length figure of the
Virgin and three quatrefoils. The
right arm is decorated with an incised
half-length figure of a haloed, ton-
sured (?) saint holding a book and
with three quatrefoils. At the bottom
of the cross are an incised half-length
figure of St Peter with a key plus
three quatrefoils. On the reverse are
incised symbols of the Evangelists: at
the top, an eagle (St John); left, a
winged lion (St Mark); right, a bull
(St Luke); and at the bottom, an
angel (St Matthew). The circular
area where the arms of the cross meet
contains an incised figure of Christ
in glory, one hand raised in benedic-
tion.

The socket of the cross is decorated
with an incised zigzag or wavy band
above and below the knop, while
the knop is decorated with an incised
radial band of beading and ovals
suggestive of gadrooning.

The Corpus is a separate casting,
with incised lines on the drapery
around the hips and on the torso and
crown. The Corpus is held to the
cross by three pins. There is an in-
cised halo on the cross, just behind
the head of the Corpus.

The incised figure on the front of
the cross, on the right, should repre-
sent St John the Evangelist, though
the way in which the figure is incised
suggests a tonsured monk. The in-
cised decoration, while similar to

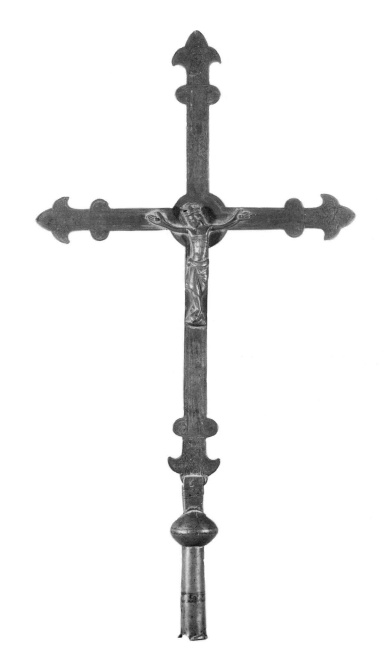

thirteenth-century incised decoration
on Limoges work, is somewhat coarse
and lifeless. It is possible that the
designs have been reworked, and that
the incised decoration may be of
comparatively modern origin. The
Corpus is of a standard French type of
the thirteenth century of which nu-
merous examples have been
preserved. The Malcove Corpus may
be compared, for example, with one
of the same type which appeared
at Sotheby's in London in 1980 (*Me-
dieval, Renaissance and Baroque
Works of Art* [cat. 389], no. 46). The
Corpus at Sotheby's was attached
to a fragment of a cross, of the same
general type as the Malcove, with
similar incised and punched decora-
tion. The overlapping feet of both
figures are typical of examples dating
from the late thirteenth-early four-
teenth century.

Purchased from Peter Mol,
Amsterdam, 1969 KCK

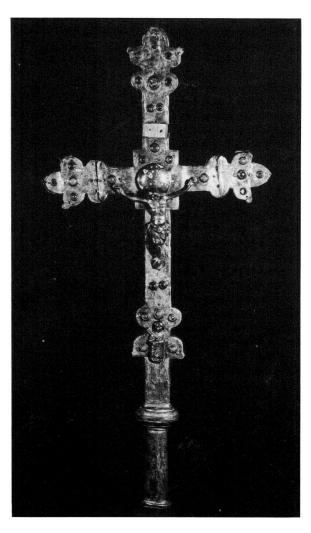

392 Processional cross

Copper gilt and enamel with
enclosed cabochon gems, the
separate plates making up the cross
mounted on a modern wooden core.
Separate from the cross are a cast
Corpus and half-length figure of
St Peter.
78.7 × 36 cm
Western European (France?,
Rhineland?, Spain?), early (?) 14th
century M82.373

The copper plates are of relatively
thin gauge and are embellished with
incised and punched decoration.
The remaining cabochons are red and
blue in colour. The back of the cross
is in a more fragmentary state than
the front. Five separate copper panels
are missing from it, and cabochons
missing from the remaining panels on
the back. On the front of the cross
there is only one small copper section
missing. There are traces of enamel
in the incised decoration of the cir-
cular boss directly above the Corpus.

The Corpus is of fourteenth-
century type, but its configuration is
anticipated in depictions of the Cru-
cifixion of the thirteenth century,
some of them in manuscript illumi-
nations and stained glass (cf Paul
Thoby, *Le Crucifix des origines au
Concile de Trente*, Nantes 1959, pl.
XCIV, fig. 210, an illumination from a
missal in the Bibliothèque munici-
pale at Arra showing curvature of the
arms, delineation of the anatomical
features of the torso, gathered dra-
pery, and crossed feet similar to those
of the Corpus of this example,
and pl. CII, fig. 224, a detail of a
thirteenth-century window in Le
Mans Cathedral with a Crucified
Christ of similar type). Examples of
sculptural crucifix figures similar
to the example on the Malcove cross
are known in both metal and wood.
A distinguishing feature they share in
common is the positioning of the
drapery around the loins – low on
the hip making the torso appear
elongated and the legs shortened in
comparison (ibid., pl. CXL, fig. 301, a
wooden French Corpus of the four-
teenth century cited in the
A. Lambert Collection in Paris).

Gilded copper crosses with cabo-
chon gems and enamel decoration
were produced at Limoges during the
thirteenth and fourteenth centuries,
if not earlier, and the Malcove cross
is roughly similar in shape to some
crosses which have been ascribed to
Limoges (cf Paul Thoby, *Les Croix
limousines de la fin du XIIe siècle au
debut du XIVe siècle*, Paris 1953,
no. 74, an early fourteenth-century
processional cross in the Cluny Mu-
seum, Paris). The little figure of St-
Peter at the bottom of the front
of the Malcove cross does have paral-
lels with cast metal figures of St
Peter on crosses ascribed to Limoges
(Thoby, *Les Croix*, no. 45, a cross
in the collection of the Musée de la
Société polymathique at Vannes),
but it may be argued that neither the
form of the Malcove cross, nor such
features as the attached St Peter,
are sufficiently close to Limoges ex-
amples to justify a Limoges attribu-
tion for the Malcove processional
cross. Enamelled gilt copper artefacts
were produced in other parts of Eu-
rope – many for example are attrib-
uted to Spain – and it is at present
difficult to ascribe the facture of the
Malcove cross to a specific European
locale. What may be said is that
the cross is of a coarse, probably pro-
vincial type, that it shares character-
istics of gilt copper enamelled crosses
attributed to areas including Lim-
oges, and that the form of cross and
Corpus are not likely to be of a date
earlier than the late thirteenth cen-
tury and conform more closely to
examples of early (?) fourteenth-cen-
tury type. KCK

393 Base of a reliquary

Copper gilt.
6.2 – 6.5 × 13.1 × 15.2 cm;
maximum length across buttresses
16 cm, maximum width 14.8 cm
French or Flemish, 15th century

M82.371

The base is rectangular in form with
angled sides, composed of a gilded
copper panel at the top, eight side
panels of gilded copper with a con-
tinuous band of engraved Gothic
letters on a hatched ground, four
solid cast brass lions as supports, at-
tached gilt copper buttresses at the
angles of the side panels (two miss-
ing), attached gilt copper architec-
tural mouldings, and an attached gilt
shield decorated with champleve
enamels. The top plate of the base is
slotted for the fitting of a superstruc-
ture. The gilding overall is badly
worn and the top panel scratched.
The enamels are worn, but form
an impaled coat of arms with a label
in the left upper quarter.

Reliquaries were sometimes fitted
with bases of architectural form.
One of the most outstanding exam-
ples of the fifteenth century is the
silver gilt and jewelled 'Goldenes
Rossel' of 1403 at Altotting (cf Theo-
dor Müller, *Sculpture in the Nether-
lands, Germany, France and Spain
1400 to 1500*, Harmondsworth, Mid-
dlesex 1966, pl. 14). Crenellated bases
were already in evidence on reliquar-
ies by the late 1300s (Müller, pl.
13), and crenellated architectural
mouldings appear on a wide range of
Late Gothic gilt metalwork, ranging

from chalices to monstrances and
reliquaries. One of the most elaborate
uses of miniature crenellated or bat-
tlemented architectural forms for
the decoration of Late Gothic metal-
work is provided by the copper gilt
and enamelled covered cup, attrib-
uted to Sebastian Lindenast, in the
collection of the Victoria and Albert
Museum in London (cf Hugh Hon-
our, *Goldsmiths and Silversmiths*,
New York 1971, pp. 58–60). The base
in the Malcove collection conforms
in style with Late Gothic metalwork
of the fifteenth century and is closest
to French and Flemish examples.
The lion supports are like miniatures
of those supporting Flemish brass
lecterns of the fifteenth century, such
as those on a lectern of circa 1500
attributed to Aert van Tricht the
Elder, in the collection of the Clois-
ters, New York (cf Vera K. Ostoia,
*The Middle Ages: Treasures from the
Cloisters and the Metropolitan Mu-
seum of Art*, Los Angeles 1970, no.
106). The combination in the Mal-
cove base of a crenellated parapet
and a broad band of Gothic letters on
a hatched ground recalls similar
decoration on a French reliquary cas-
ket which appeared at Sotheby's in
1980 (*Medieval, Renaissance and
Baroque Works of Art* [cat. 389],
no. 63), and on similar examples
of metalwork variously ascribed
to France and the Netherlands.

From the Brummer Collection

Purchased from Blumka Gallery,
New York, 17 April 1961 KCK

394 Monstrance

Copper gilt. 53.3 × 17 cm
German or Flemish, 15th century

M82.374

The gilding is worn in several areas.
The hexagonal spire and stem are
decorated with incised ornament
simulating tiles and masonry. Tiles
are also simulated on the gable roofs
on the flanking buttresses. The latter
are decorated at the sides by incised,
simulated niches with cross hatch-
ing. At the front of the lower section
of each buttress is a separately cast

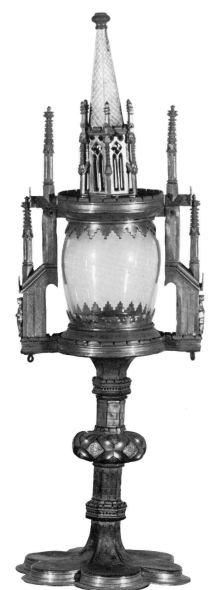

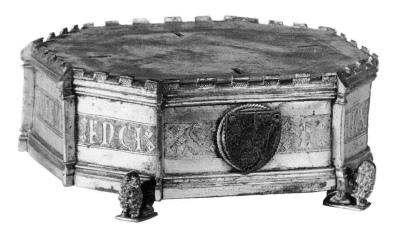

figure of a female saint. It has a hollow hexagonal stem with a knop decorated with incised mouchettes and lozenges with incised quatrefoils. There is a sexfoil, lobed foot with a flat flange-like rim around the base. Under each buttress is a metal suspension loop or ring for the attachment of an ornament, probably a bell. The barrel-shaped glass liner is modern.

Monstrances are used for the exposition of the circular Communion wafer, known as a Host, most conspicuously during the service of Benediction. Monstrances are fitted with a crescent-shaped receptacle for containing the Host, distinguishing them from reliquaries, where the receptacles – conforming in outline to the relic mounted in them – are more usually of asymmetrical section. A variety of monstrance forms was known in Late Mediaeval Europe, among them structures of tower or cylinder shape imitating in miniature the salient features of Late Gothic architecture. The Malcove monstrance conforms to a general type most usually regarded as German. While some are of silver, many others are of gilded copper. Late Gothic monstrances, to which the Malcove example is similar, are preserved in museums both in Europe and North America. Among them are examples in the Victoria and Albert Museum in London. The spire form of decoration on the top, the buttresses with incised ornament on their sides, the battlemented borders, and the tab-like projections for containing the glass liner of the Malcove monstrance are similar to those of a richly ornamented monstrance in the Victoria and Albert Museum illustrated by Tavenor-Perry in his book on Dinanderie (J. Tavenor-Perry, *Dinanderie: A History of Mediaeval Art Work in Copper, Brass and Bronze*, London 1910, pl. XI). A monstrance of related but more elaborate form with fleurs-de-lys cusps instead of crenellated battlements and angular tabs, in the collection at Coburg, Germany, is regarded as of Nuremberg origin and dated to the third quarter of the fifteenth century (Kohlhausen [cat. 389], no. 311). The simpler form of

the Malcove monstrance compares with examples of similar plainness which are dated to the middle and second third of the fifteenth century, as may be seen in examples preserved at Nuremberg in the collection of the Germanisches Nationalmuseum (ibid., nos. 309, 310). Assuming the Malcove monstrance to be substantially genuine, it would most probably have been made sometime between 1450 and 1475. Copper gilt monstrances, somewhat analagous in form and decoration to the Malcove example, turn up from time to time at auction, such as one regarded as German which was sold by Sotheby's in London in 1980 (*Medieval, Renaissance and Baroque Works of Art* [cat. 389], no. 59).

Purchased from Blumka Gallery, New York, 1961 KCK

395 Document box (?)

Lead or pewter.
Lid: 3.4 × 31.1 – 31.8 cm, lion masks 4.5; box: 22.3–22.5 × 31.4–31.9 cm
Netherlandish or French, late 15th, early 16th century (?) M82.156

The widths of the side panels of the octagonal box vary, as do the widths across the top of the lid. The Gothic buttresses along the sides of the box at the angles are cast separately. Two of the side panels of the box have attached cast lion heads for carrying rings, and the lion head mounts on the top of the lid were also cast separately. One of the buttresses is detached from one of the corners of the box. On the lid the roped border, like the side panels of the box, is made of separate sections which have been soldered together. There is a paper label, modern, on the underside of the lid with the number '9492' written in pen. One of the lion heads of the lid is broken at the side. On top of the lid are pins at the corners, and also four stamped circles grouped around the centre. Both the inside and outside parts of the box show considerable pitting and wear.

The specific function and origin of

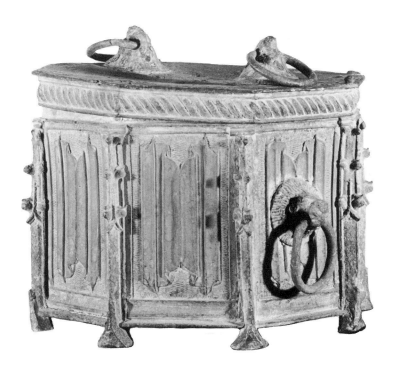

the box are not known. The simulated linenfold panelling on the side panels is of the same type associated with wooden panels made in many parts of Western Europe during the late fifteenth and early sixteenth centuries. The cast buttresses and lion heads have parallels in some other forms of metalwork, in the decoration of reliquaries and monstrance in brass and silver. The zoomorphic mounts for the carrying rings on the sides and lid are related to the larger mounts made for Mediaeval church doors (cf Tavenor-Perry [cat. 394], pp. 189–203, figs. 61–2, and pl. XLV).

The cabled ornament of the lid of the box already shows a progression beyond Gothic to Renaissance forms, while the crockets and mouldings of the buttresses at the corners of the box are similar to those frequently found in French and Netherlandish Late Gothic architectural decoration at least into the first decade of the sixteenth century. A parallel though by no means the best example is afforded by the crockets and pinnacles at the sides of the canopied tomb of 1507 of Raoul de Lannoy at Folleville, Somme (cf Anthony Blunt, *Art and Architecture in France 1500 to 1700*, Harmondsworth, Middlesex 1954, pl. 1). More research will be necessary to determine with greater certainty the origin, date, and function of this interesting base metal item.

Purchased from Medina Gallery, New York, 17 June 1963 KCK

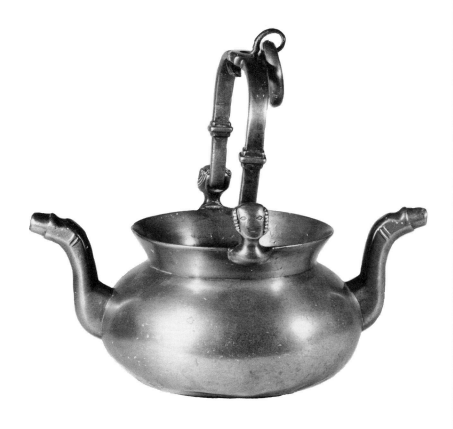

396 Lavabo or ewer

Cast brass, yellowish in colour.
18 × 21 × 32.2 cm
Flemish, 15th century M82.149

The ewer has a large brass patch on the underside of the bowl, a few smaller patches, and some pitting on the outside surface and greenish patination on the inside. There is incised decoration on the anthropomorphic heads which serve as swivel mounts for the handle. The handle is of rectangular cross-section, curved in the form of an inverted U, and is fitted at the top with an iron hook and brass carrying ring.

Double-spouted ewers of the same general type as the one in the Malcove collection are depicted in fifteenth-century Flemish paintings and are represnted by surviving examples in museum collections. The best-known example in painting is the one shown suspended inside a niche in the upper left corner of the scene of the Annunciation, the central panel of the Merode Altarpiece by the Master of Flemalle (cf Erwin Panofsky, *Early Netherlandish Painting*, Cambridge, Mass. 1966, vol. 2, pl. 91). A ewer of the same basic type is in the collection of the Cleveland Museum of Art, no. 65,22 (cf Wixom [cat. 390], no. 7). Wixom has noted that many ewers of this type are preserved both in Belgian museums and in churches. All are characterized by a globose body with flaring rim, zoomorphic headed spouts, swivel sockets of anthropomorphic form, and handles for carrying with suspension rings attached. Slight differences are to be observed in the form and decoration of the zoomorphic heads on the spouts and the busts forming the swivel sockets. The swivel sockets are in the form either of male or female busts. Though highly stylized, many of them record hair styles of the late fourteenth or early fifteenth century. On the basis of an analysis of fashions of hair styling and dress, it is probable that the original models for

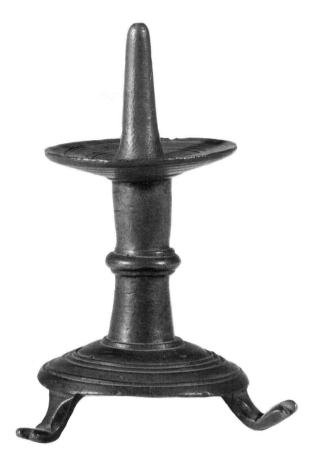

the swivel supports of the Malcove
ewer dated from that period, though
the actual date of casting of the
Malcove ewer was probably later.

This form of double-spouted ewer
is sometimes assumed to have been
used for liturgical purposes
(cf Wixom) during the Mass. In
fifteenth-century Flemish paintings,
such as the Merode Altarpiece by
the Master of Flemalle and the An-
nunciation of the Ghent Altarpiece
by Jan van Eyck (cf Panofsky, pl.
144), these ewers appear in domestic
settings, though their appearance
in paintings of the Annunciation is
held by some authorities to serve
a symbolic purpose. It is probable,
however, that such brass vessels were
used in the fifteenth century both
for liturgical and everyday domestic
purposes. It is interesting to note
the similarity of form between lavabo
basins like the Malcove example
and Flemish brass cooking pots,
which were of larger size than the
ewers but had the same kind of
swivel sockets and handles (cf T.B.

Husband and J. Hayward, *The Secu-
lar Spirit: Life and Art at the End
of the Middle Ages*, New York 1975,
no. 16a, b).

From the Baron Cassel van Doorn
Collection

Purchased from Blumka Gallery,
New York, 1961 KCK

397 Pricket candlestick

Brass, yellowish metal with dark
natural patina.
12.7 × 6.5 cm; the tripod feet extend
an additional 1.7 cm beyond the
circumference of the base.
Netherlandish, 14th–15th century (?)
 M82.389

The surface of the candlestick is
covered with granular pitting. There
is a flaw in the stem below the knop,
and nicks and dents in the great
pan. Traces of a clay core may be
seen in the underside of the base. The
grease pan is decorated with sets of
concentric lines or grooves. There are
three incised concentric lines on
the underside of the grease pan. The
base is stepped in sections with con-
centric ridges and grooves.

The cylindrical shaft with central
knop in the form of superimposed
rings recalls Dinanderie candlesticks
of various forms and sizes dated to
the fourteenth and fifteenth centures
(Tavenor-Perry [cat. 394], figs. 38,45).
The tripod base, with its incised
concentric rings and bands, is similar
to those of a variety of Dinanderie
candlesticks usually dated to the
fourteenth century. On some of these
examples there is no knopped shaft
and the candlestick consists of a
tripod-footed, slightly domed base, as
with this candlestick, but with the
pricket or spike for holding the candle
directly on top of the base (cf Soth-
eby-Parke-Bernet, *Catalogue of Me-
dieval, Gothic, Renaissance, and
Baroque Works of Art and Tapestries*,
London, 17 April 1980, no. 28). While
the Malcove candlestick may be an
authentic work of the fourteenth-
fifteenth centuries, the possibility of
a later origin cannot be discounted
as very convincing copies of these
items have been made in compara-
tively recent times. KCK

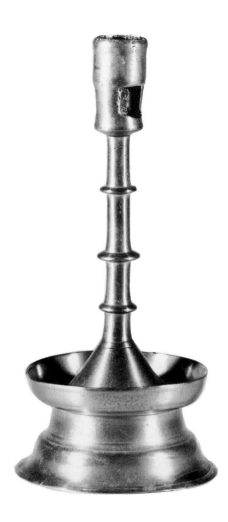

398 Socket candlestick

Cast brass, yellowish in colour.
22 × 9.9 cm
Flemish, 15th century M82.148

The base of this candlestick is hollow, the socket and stem are pitted with corrosion. There is a rough-edged flaw along the edges of one of the openings in the wall of the socket and a brazed repair on the foot. The shaft or stem was made separate from the base.

Candlesticks of almost the same form as the Malcove example are shown in fifteenth century Flemish paintings, for example in the centre panel of the Merode triptych by the Master of Flemalle (cf Panofsky [cat. 394], pl. 91). Surviving candlesticks of this type are found in numerous museum and private collections. They vary in the number of shaft rings, in precision of casting, and in the presence or absence of incised ornament. Examples similar to the Malcove candlestick are generally re-garded as Flemish in origin and dated to the fifteenth century. One of the finest examples in North American collections is that in the Cloisters in New York, no. 57.135 (cf Husband and Hayward [cat. 396], pl. 22). A candlestick of plainer form than the Cloisters example, and thereby closer to the Malcove candlestick, was included in a special exhibition of bronzes at the Cleveland Museum of Art in 1975, catalogued as South Netherlands, Valley of the Meuse, first half of the fifteenth century [cat. 390], no. 6). Additional examples are cited by Wixom in his catalogue notes for the Cleveland exhibition.

Such candlesticks were obviously produced over a relatively long period of time and are therefore difficult, if not impossible, to date with any degree of precision. Generally, how-ever, it may be assumed that owing to the gradual wearing of the models or moulds used for casting, the rougher the casting, the greater the likelihood of a more recent date of origin.

From the Baron Cassel van Doorn Collection

Purchased from Blumka Gallery, New York, October 1962 KCK

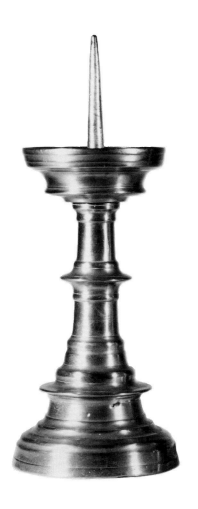
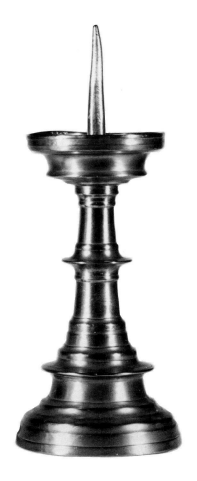

some proportional features of candle-sticks of earlier date but without the pronounced classically derived mouldings on base and shaft rings that characterize later sixteenth-century candlesticks. Though the Malcove candlesticks probably repre-sent an early sixteenth-century type, their dating is more a matter of con-jecture than fact. Similar candle-sticks must have been made over a comparatively long period, with the reuse of old moulds. All that can be safely said about them is that they represent a type associated with the early years of the sixteenth century.

From the Baron Cassel van Doorn Collection

Purchased from Blumka Gallery, New York, April 1961　　　KCK

399 Pair of pricket candlesticks

Yellow brass, hollow cast
36.5 × 14 cm, 37 × 14 cm
Flemish, early (?) 16th century
M82.340

In this pair of candlesticks the prick-ets are also of brass and the grease pans are cast separately. The surfaces show some pitting and denting.

The Malcove candlesticks are of a type used as altar candlesticks. Many examples are known in private and public collections. While altar candlesticks show considerable vari-ety of form, Flemish candlesticks of the fifteenth-sixteenth century, in terms of proportion, the number of knop-like shaft rings, and the form of the mouldings under the grease pans and on the feet, exhibit some com-mon characteristics. Typical of ear-lier candlesticks, dated to the

fifteenth and early sixteenth centu-ries, are concave mouldings instead of the convex mouldings suggestive of Classical influence that are common features on many later sixteenth-century brass candlesticks – for ex-ample, a pair of south Netherlands candlesticks in the Royal Ontario Museum, nos. 929.14.2a-b (K. Corey Keeble, *European Bronzes in the Royal Ontario Museum*, Toronto 1982, no. 53). The Malcove candle-sticks are derivatives of Late Gothic types featuring rather massive feet and comparatively short stems with a pronounced upward taper, as evi-denced in two examples in the Kress Collection (cf John Pope-Hennessy, *Renaissance Bronzes from the Samuel H. Kress Collection*, London 1965, no. 557, described as 'Flemish, late fifteenth or early sixteenth century'). The Malcove candlesticks are proba-bly to be correctly regarded as a sixteenth-century type, preserving

400 Candle stand

Wrought iron. 166 cm
Spanish or Netherlandish, early 16th
century (?) M82.436

The vertical shaft, which tapers to a
point, is of squared section with
angled corners, as are the tripod legs,
the collar of iron just below the ta-
pered point, and the knop half-way
down the vertical shaft. At the base
of the shaft is a plain disc of wrought
iron. The whole surface of the candle
stand has been painted and shows
traces of black paint over much of its
surface.

Wrought-iron stands, or standards
on which candlesticks were
mounted, were used not only in
mediaeval times but continued well
into later periods in Europe. Their
basic shape, a tripod base with tall
central shaft for candle mounts, re-
mained substantially unchanged
through the seventeenth and even
eighteenth centuries (cf J. Seymour
Lindsay, *Iron and Brass Implements
of the English House*, London 1964,
figs. 465, 464). The example in the
Malcove Collection, with its tripod
legs bent into cusps, is typical of
Late Gothic forms associated with
the fifteenth and early sixteenth
centuries throughout much of Eu-
rope. In many of these examples,
however, the usual form of the legs
follows an ogee or reverse curve (cf
Mr and Mrs G. Glen Gould, *Period
Lighting Fixtures*, New York 1928,
figs. 4, 16). Cusped legs on wrought-
iron candle stands, recalling the
cusping of Gothic tracery, appear on
some candle stands of the early 1500s,
of which a particularly elaborate
example is recorded in the church of
St John in Cologne (cf Otto Hoever,
An Encyclopaedia of Ironwork, Lon-
don 1927, pl. 62). The place of origin
of the Malcove stand is not definitely
known, but the stand conforms in
type with those of the early sixteenth
century and is most likely of Western
European facture, possibly from Spain
or the Netherlands. KCK

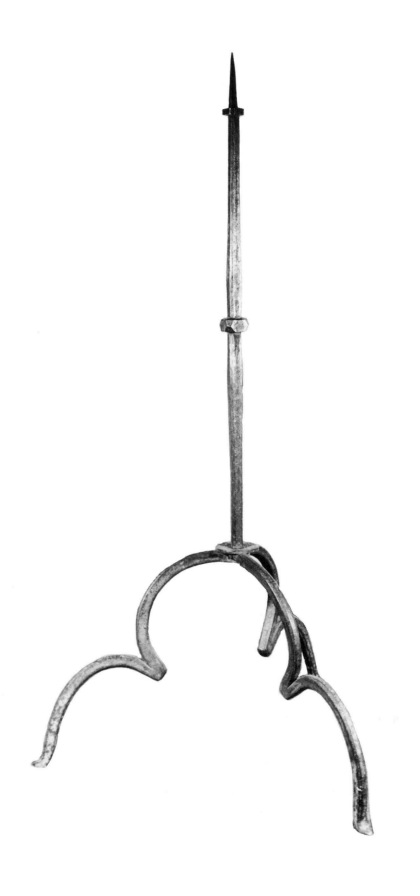

401 Door knocker (?)

Bronze. 20 × 2 cm
Western Mediaeval, date unknown
M82.502

The object is in the shape of a stylized animal, possibly a lion or panther, connected to a long pin which would have been inserted into a door. The animal's body is extended into a coiled tail and there are hatchings over the shoulders and neck to indicate fur. The forelegs are consolidated into a block-like projection, as is the head. The face and the 'feet' thus form the striking area for a plate which would be on the door. These two areas do show the signs of wear, which might be expected from prolonged use. SDC

402 Small casket (cofanetto)

Wood, gessoed, painted and gilded.
56 × 59 × 18.5 cm
North or Central Italian, 14th–15th century M82.463

Small boxes or caskets, miniatures of large storage chests, were designed for a variety of functions. Some were probably used as jewel boxes. The Malcove example is of typical Italian type, comparable with painted lidded boxes and boxes with gessoed relief ornament in well-known public collections such as the Victoria and Albert Museum in London (cf Frida Schottmüller, *Furniture and Interior Decoration of the Italian Renaissance*, Stuttgart 1928, p. 66, figs. 155, 158). While the Malcove box is decorated with stylized floral, tendril, and quatrefoil ornament in low relief, some similar Italian domed boxes of the early fifteenth century are embellished with human figures, as seen in the relief decoration of a box of possible Paduan make preserved at Milan (Gilda Rosa, *I mobili nelle civiche raccolte artistiche de Milano*, Milan 1963, no. 38, with decoration in green and red). Boxes of similar form are represented in the collections of some North American museums, including one regarded as of Sienese origin of the fourteenth century, no. 54.600 in the collection of the Cleveland Museum of Art (*Handbook: The Cleveland Museum of Art*, Cleveland 1966, p. 55). Typically, the ornament of most of these gessoed boxes is of Late Gothic style and often incorporates armorials, as on the Malcove box.

From the Baron Cassel von Dooren Collection

Purchased from Blumka Gallery, New York, 17 April 1961 KCK

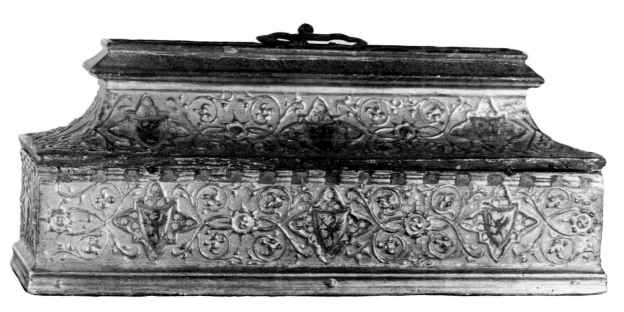

403 Small casket or box (cofanetto)

Wood, gessoed, painted and gilded, the inside of the lid and box lined with green cloth.
Box: 16.6 × 39.1 × 20.5 cm; lid: 9.5 × 38.2 × 20.2 cm
Italian, early 16th century M82.464

The box is decorated only on three of its four sides and was obviously intended to be seen only from those sides. The box and lid are composed of thin slabs of wood with attached mouldings at the edges and corners. On top of the lid is a copper gilt handle for carrying (the gilding worn). Depressions at the top edge of the back of the box indicate the position of hinges for the lid, which are now missing. There are two keyholes in the front of the box, but the locks that may once have been behind them are missing. The back of the box is painted a dull red. The front and end panels are gessoed and gilded. The panels have been covered with black paint and the design scratched through to the gilding.

In the front panel is a central lobed cartouche showing a scratched design in gold of a monk kneeling at the feet of the Dead Christ. In his right hand the monk holds a cross. Behind the figure of Christ is a woman, probably the Blessed Virgin Mary, wailing. In the left background are the bases of the three crosses of Christ and the two thieves at Calvary. To the left and right of this central cartouche are panels in red with gold arabesques and gold-lined rondels in black. On the left rondel are the remains of an inscription, SANCTOR / RELIQUIAE, and at the right, HIC– / RE–?–ITVE(?).

The left end panel shows a triple arch in gold with arabesques above, the central round-headed arch slightly taller than those to left and right. The arches contain three figures at the left: a bishop, the figure scratched through the black paint of the panel to reveal the gold surface underneath, is haloed, wears mitre, cope, and alb, an holds a pastoral staff in his left hand and a book in his right. In the centre is a seated bishop (?), with pastoral staff in his

right hand and a book (?) in his left. In the right a young man in tunic and buskins, a lamb beside him, holds a staff in his hand. The right end panel shows a Nativity scene with the Virgin, left, and St Joseph, right; the Christ Child is in a manger, overlooked by an ox and ass.

On the lid the front panel is decorated with a cartouche enclosing a depiction of St Lawrence on a gridiron. Above and outside the cartouche are scrolls painted in green and white. The left end panel is decorated with a male figure wearing a short tunic and carrying a staff – possibly a St Christopher, though the details are faint, hindering a positive identification. On the right end panel is a depiction of Christ crucified, and on the back panel a bound figure on a palette with an executioner holding a curved rod or stick. The top of the lid is decorated in red, gold, and black. The gilding is much rubbed, with the gesso ground showing through over several areas of the surface of the box and lid. There are numerous splits in the wood, and, generally, the box and

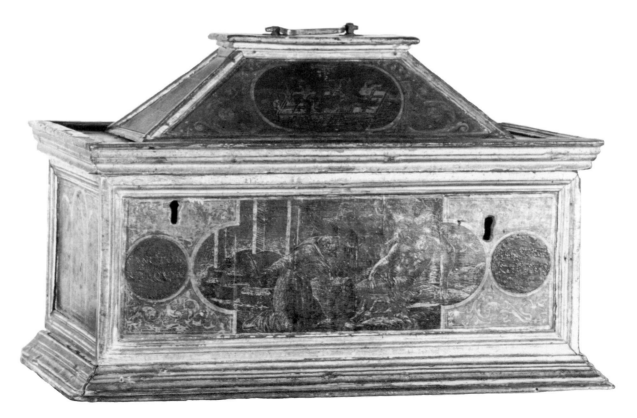

top are in only fair condition.

The simplicity of construction and the incorporation of rondels as part of the decoration of the box have some parallels in Italian chests or cassoni of the early sixteenth century, some of which are regarded as North Italian in origin and ascribed to Venice and Verona (cf Schottmüller [cat. 402], p. 42, fig. 92). The lid of the small box or cofanetto in the Malcove Collection parallels in the simplicity of its construction – flat trapezoidal lanes with mouldings along the edges – other examples of North Italian woodworking and furniture design of the late fifteenth and early sixteenth century. Somewhat similar, though on a much larger scale, is the panelled top of a large piece of case furniture in the Castello Sforzesco in Milan (Rosa [cat. 402], no. 13).

Assuming all parts of the box to be genuine, it should probably be dated to the early years of the sixteenth century. The figure decoration is certainly of a type that does not seem to antedate the early 1500s. KCK

404 Triangular ceramic container

Tin glazed clay. 15 × 4.5 cm
Spanish or Italian, 15th century (?)
M82.498

The triangular-shaped vessel has three small circular wells approximately 1.5 cm deep on the top surface. A yellow lion's head in relief, within a brown-painted medallion, projects from the middle of each of the three sides. Floral sprays painted on the white tin-glazed surface in green, yellow, and brown flank the leonine motifs. Green, yellow, and brown floral sprays surround the wells on the top surface. The function of the dish is unknown. The wells may have been used to hold ink or salt. TT

405 Three double-sided pages from a Book of Hours

Vellum with inks and tempera.
15 × 10.5; 15 × 10.2; 14.5 × 10.5
Flemish, second half 15th century
M82.447, 448, 449

The three folia come from the same Book of Hours, a devotional volume of a type that was widely produced for lay use (Victor Leroquais, *Les Livres d'heure manuscrits de la Bibliothèque Nationale*, 1, Paris 1927, p. XXI). The examples here contain several prayers directed to saints that are indicative of the pietistic vein deriving from the *devotio moderna* found in the Netherlands during the fifteenth and sixteenth centuries (Albert Hyman, *The Christian Renaissance*, Grand Rapids, Michigan 1924. The author presents a history and explanation of the *devotio moderna*).

In the first folio the recto illustrates, in the initial 'O,' Michael slaying the dragon and, at the bottom of the folio, the archangels Gabriel and Raphael. All three are mentioned in the prayer that comprises the text. At the top of the folio are a columbine and two daisies: the first is symbolic of the seven gifts of the Holy Ghost (E. Kirschbaum, *Lexikon der Christlichen Ikonographie*, Freiburg im Breisgau 1970, col. 73), the latter of the innocence of the Christ Child and the Virgin (ibid., pp. 123, 214). In the left margin of the folio is a thistle stalk, interpreted as the sorrow of the earthly life and also of the sorow of

405

the crucifixion of Christ (J. Seibert, ed., *Lexikon der Christlichen Kunst*, Freiburg im Breisgau 1980, p. 78). On the verso of this folio is another image of St Michael, this time pulling a soul from the flames of hell. Since the archangel is present at the Last Judgment, this is a frequent representation of him. Below the prayer, which is a continuation of the one on the recto of the folio, a hunter points his arrow at the hart, possibly an indication of Psalm 426 ('As a hart longs for flowing streams, so longs my soul for thee, O God'), although there is no textual reference to this passage. There are again, in the marginal decoration, daisies, columbines, and also strawberries, the symbol of the Virgin, the Passion, and of the martyr's blood (Seibert, pp. 101–2), and carnations, the symbol of pure love and Christ's Passion (ibid., p. 233).

Folio iir contains a fragment of a prayer to a saint unnamed in this portion of the supplication and, below this, beginning at the initial 'W,' a prayer to St John the Evangelist. At the bottom of the folio is the saint, holding the chalice that is one of his symbols (Kirschbaum, p. 7, cols. 119–21. The chalice, filled with poison, was given to St John by the Emperor Domitian, who had twice attempted to take his life. When the saint took up the cup, the poison assumed the shape of a serpent and left the chalice). To his left is a stylized iris, indicative of the sorrow that pierced the Virgin's heart when her Son was crucified (Seibert, p. 286. The iris is also called the 'sword lily,' because of its sharpness). To the left of the Evangelist is a foliate stalk which bears at the bottom the eagle, another of St John's symbols (ibid., p. 126; the eagle symbolizes the highest inspiration), a rose (Louis Réau, *L'Iconographie de l'art chrétien*, Paris 1955, p. 133; the rose usually indicates chastity (white), martyrdom (red), and the 'rose without thorns,' the Virgin), a personified sun, and a columbine. The verso of the folio has the continuation of the prayer, which must have terminated on yet another folio, and no decoration of any type.

The third folio begins with the final section of a prayer for 'good death' that will lead the suppliant to the Father, Son, and Holy Ghost after a life of pious good works and devotion. The star of Bethlehem, located in the initial 'O' of the opening of the prayer to the three kings, Jasper, Melchior, and Balthasar, is placed above the head of one of the kings. The three figures below the text bear golden vessels in their hands, their gifts to the Child. There is a stylized iris to their right of the text. The verso of the folio continues the prayer to the kings and ends with the versicle and collect for the Feast of the Epiphany. There is no decoration. (My thanks are due to D.J.K. MacGillavry, The Hague, for his kindness in transcribing and identifying the text and suggesting comparative materials.)

The script for the texts of the three folia is the type identified as *littera bastarda textualis* (M.G.I. Lieftinck, 'Pour une nomenclature de l'écriture livrèsque de la periode dîte gothique,' *Nomenclature des Écritures livrèsque du IXe au XVe Siècle*, Paris 1954, p. 29ff). This is a term to denote a late Netherlandish book hand.

All of the figure and decorations of the folia focus on the virtues of a pious life, which would have been strictly in keeping with the practices of the Netherlandish inhabitants at the time of production. The figures of the three folia, with their short, stubby, and doll-like appearance, coincide almost exactly with those of 'The Pilgrimage of Human Life' by Guillaume de Deguileville (Zimilien, *Abenlandische Mss des Mittelalters aus den Sammlungen der Stiftung Preussischer Kulturbesitz, Berlin*, Berlin 1976, p. 157, no. 114, fig. p. 179. Also J. Deschamps, *Middelnederlandre Mss mit europese en amerikaanse bibliotheken*, Brussels 1970, pp. 220–1, no. 79). If our pages were not done by the same hand, which seems likely, then they must have come from the same atelier. MJH

406 Page from a Book of Hours

Vellum with inks and tempera.
18.8 × 12.5 cm
Franco-Flemish, circa 1500 M82.439

On the recto of the folio the Virgin and Christ Child stand on a low pedestal. There is a low-arched frame around them, supported by slender colonnets and bearing carved oak leaves on the arch. The figure of the Virgin stands in a corner, casting a shadow on the wall to her left. She radiates an aureole of light. Around the framed figures there is a blue background with yellow stars (Heaven) and superimposed upon this design are columbines, indicating the seven gifts of the Holy Spirit (Kirschbaum [cat. 405], col. 73), roses, symbolic of the Virgin as the 'rose without thorns' (Réau [cat. 405], p. 133), and a violet, symbolizing her humility. The Christ Child holds, in His left hand, an orb and cross and, with His right, makes the sign of benediction.

The placement of the Virgin upon the pedestal denotes her position as elevated beyond the purely human plane, yet the simplicity of the platform indicates that she is modest. This particular type of pedestal was used by both French and Flemish artists, although it is likely to have originated in Flanders ((Charles D. Cuttler, *Northern Painting from Pucelle to Breugel*, New York 1973, p. 235, fig. 294. The outer leaves of the 1476 'Altarpiece of the Burning Bush' by Nicholas Froment show the same type of pedestal as in our folio for the figures of the 'Annunciation.' Rogier van der Weyden used the same pedestals for the outer panels of his 'Altarpiece of the Last Judgement,' 1444–8, for the elevation of Saints Sebastian and Anthony, p. 116, fig. 132). The light that emanates from her body is usual in this context, for it is most often found in depictions of the Virgin as the Apocryphal Woman (Apocalypsis 12:1, 'Et signum magnum apparuit in caelo: mulier amicta sole et luna sub pedibus eius, et in capite eius corona stelarum duodecem': and 12:5. ' ... Et peperit filium masculum ... qui

406

recturus erat omnes gentes in virga ferrea: et raptus est filius eius ad Deum'), or after she has been crowned in Heaven. The radiance denotes her position as Theotokos, or God-Bearer, thus she acquires divine status. This concept of the Virgin dates from the Council of Ephesus, 431, which established the position of the Mother as God-Bearer. Despite the popularity of the presentation of the Virgin and Child standing in this manner, the use of the aureole sets this example apart from the standard type.

The verso of the folio contains a portion of a prayer in Latin, a supplication is indicated by the inscription in French at the bottom of the folio: 'Oroison contemplative a la vierge marie.' This particular formula occurs quite often in Books of Hours, after the section of prayers dedicated to the Virgin, which would have been only one of many such sections found within the whole book (Leroquais [cat. 405], pp. III–IX. See in particular p. XXIX for comments on the use of the Books of Hours for lay worship). To the right of this prayer is a long rectangular panel containing roses with buds and blossoms and a vine pattern resembling the acanthus. The script is a clear Gothic, with minimal use of abbreviations.

Although the style, both figure and script, could have been found in either the French or Flemish Books of Hours, the mixture of the elements and the French inscription would serve to lean more heavily towards the artist having worked from a French atelier, but having perhaps been trained in Flanders (Guilio Bologna, *Miniature Francesci e Fiamminghe della Biblioteca Trivolziana*, Milan 1976, pp. 78–83. Although the script and the decoration in our example are certainly not uncommon, there are very close correspondences both in figures and in the script types in MS 481, a Franco-Flemish Book of Hours in the Biblioteca Trivolziana Library collection). MJH

and terre verte; red in the middle-range tint of minium only appears in the rays above the head of Christ, otherwise it is used in the staves and calligraphic initials. Both the figure of Christ and the mound of water in the historiated initial H(odie) are modelled in terre verte, a hue commonly used at this time in under-painting and indicative of an unfinished work.

The text, in Gothic miniscule, is from the divine office for the feast of Epiphany celebrated on 6 January. More precisely, the fragment is the first of three nocturns comprising the office of Matins recited sometime between midnight and dawn. Only the 'responsorium' and verse are set to musical notation. Thus, while this sequence would have been in-cluded in the office breviary along with psalms and lections, the sole use of responds points more directly to an office antiphonary which would have been employed by the choir. (A discussion of the text is found in J. LeMarie, 'Textes Épiphaniques d'Antiphonaires et breviares du Moyen Age,' *Ephemerides Liturgicae*, *CXXV*, 1961, p. 6–9.) Such responds were generally sung in two parts. A solo chanting of the 'responsorium' was initiated by the precenter and reiterated by the choir; the same procedure was again repeated for the versicle (P. Batiffol, *History of the Roman Breviary*, London 1912, pp. 79–80). The content of these phrases was generally related to the day's feast and, in this respect, the refer-ence to Christ's baptism is not excep-tional. Although the major event associated with the feast was the Ad-oration of the Magi, the episode of the Baptism was incorporated into this liturgy already in the early Christian period and frequently in-terpreted as another sign of God's manifestation to mankind.

At the top of the page is a histo-riated initial depicting the Baptism of Christ in the Jordan by John the Baptist. While textual references to the Baptism for 6 January were long standing, the illustration of the event in the context of the feast was more sporadic. The earliest surviving pic-torial examples of the Baptism for

407 Office antiphonary leaf

Tempera on parchment. 36 × 52 cm
Italian, circa 1260–1330 M82.445

RECTO: Omnis terra adoret te et psal-lat tibi Psalmum dicat nomini tuo domini. Hodie in Jordane babtizato domino aperti sunt celi sicut columba super eum Spiritus mansit et vox patris intonuit. hic est filius meus dilectus in quo michi compla-cui. Descendit spiritus sanctus cor-porali spe–
VERSO: cie sicut columba in ipsum et vox de cel facta est. hic est In col-umbe spe[c]ae spiritus sanctus uisus est paterna vox audita est. hic est filius meus dilectus in quo michi bene complacui. Celi aperti sunt super eum et vox patris intonuit. hic est. Reges tharsis et insule munera offer-ent. Re–

Overall the condition of the leaf is very good, although the porous parchment has been trimmed along the sides and bottom. Colours in the historiated initial are limited to blue (lapis lazuli?), burnt siena,

Epiphany occur in the Ottonian period, yet it was not until the thirteenth and fourteenth centuries that the inclusion of the image into liturgical contexts became nominally more common, particularly in Italian antiphonaries. (These appear in sacramentaries produced by the Fulda school, see E.H. Zimmermann, 'Die Fuldaer Buchmalerei in karolingischer und ottonischer Zeit,' *Kunstgeschichliches Jahrbuch der K.K.Zentral Kommission für Erforschung und Erhaltung der Kunst und Historischen Denkmale*, IV, 1910, 1–105.) These antiphonaries, as with the Malcove leaf, usually depict solely the Baptism or combine the Baptism with the Adoration of the Magi. (Generally, the pattern observable in Italian antiphonaries parallels that of Gothic office breviaries wherein Baptism miniatures are appended to the Epiphany prayers. However, breviaries also employed the image for the feast of the Trinity, see V. Leroquais, *Les Breviares manuscrits des Bibliothèques publiques de France*, Paris 1934, vol. III, pp. 187, 207, 276, 291, 292, 306.)

In its main lines the iconography of the historiated initial is traditional, recalling early Christian and early Mediaeval precedents, wherein Christ is portrayed standing in a 'mound' of water with His arms to the side while John, standing to the left, lays his right hand on the head of Jesus; above, rays stream from the mouth of the dove. (As G. Schiller has pointed out, the 'mound' and the compliant pose of Christ were particularly characteristic of Carolingian production, *Iconography of Christian Art*, vol. I, 1969, trans. J. Seligman, 1971, p. 137, fig. 367.) Although the pose of Christ was not new it was, nevertheless, unusual to the Gothic period, which favoured gestures of prayer and blessing. Consequently, the strikingly conservative character of the iconography strongly suggests the influence of a Western model.

Both the linear treatment of the drapery and the two-dimensional angularity of John the Baptist are reminiscent of Romanesque mannerisms which, in Italy, survived the thirteenth century and occasionally filtered into provincial scriptoria of the Trecento. The scale of the figures and the painting technique – notably the green underpainting and the highlight system which are distant reflections of Byzantine formulae – are again features that coincide with the Gothic years. The few details in the scene, however, make a more precise dating tenuous.

Additional clues to the question of dating might be sought in the ornamental style of the Baptism initial. The stems of the 'H' each contain a single file of beads and the vertical shafts are set against a blue ground. The stem terminals, which are collared, form the springing point for pairs of profile acanthus leaves that splay to the left and right of each shaft. Each leaf is finely scalloped and concludes with a point. In terms of ornamental vocabulary (the beading and the scalloped acanthus) the initial coincides with motifs commonly found in northern Tuscany, Emilia, the Veneto, and Friuli in the period between 1260 and 1330 (see for example R. Passalacqua, *I Codici Liturgici Miniati Dugenteschi Nell'Archivio Capitolare Del Duomo di Arezzo*, Florence 1980, fig. 291).

LC

408 Leaf from a Gradual

Tempera on parchment.
38 × 59 cm
North Italian (Padua?), second half
15th century M82.452

RECTO: Incipit proprium sanctorum de graduale. In vigilia sancti andreae apostoli. Introitus: Dominus secus mare gahlilee vidit duos fratres petrum et andream et vocavit eos venite post me faciam vos fieri VERSO: piscatores hominum. At illi relictis retibus et nam secuti sunt dominum. CLXIX. Gloria. Nimis honorati. CLXXXII. Offertorium. Gloria et honore. Gloria. Communio. Dicit andreas simoni fratri suo invenimus messiam qui dicitur Christus et adduxit.

Both the recto and verso are written in Gothic miniscule and set to musical notation in neumes. The recto is decorated with a foliate border and a historiated initial D(ominus). Above the rubric at the top of the page some numbers or letters have been whitewashed and replaced by a I whose red pigment coincides with the tint found elsewhere on the page. The colour used for the ornament and miniature include ochre, terre verte, vermillion, and blue (Blue Bice?). Several areas remain unfinished, particularly the birds and heads in the borders whereas the hair of Christ and the apostles' garments require finishing highlights. The overall condition of the folio is very good. Flaking is limited to a few thick impasto passages and some hairline cracks in the gold ground.

The text contains the variable parts of the mass (introit, gradual, offertory, and communion) for the vigil service celebrating the feat of St Andrew on 30 November. Since these prayers were to be chanted they could belong either to a mass antiphonal or a gradual; however, the heading indicates a gradual (A. Gastoue, *Le graduel et l'antiphonaire romains*, Lyons 1913; *Antiphonale Missarum Sextuplex*, ed. R.J. Hesbert, Brussels 1935, vol. Introduction). The feast of St Andrew usually initiates or terminates the Proper of

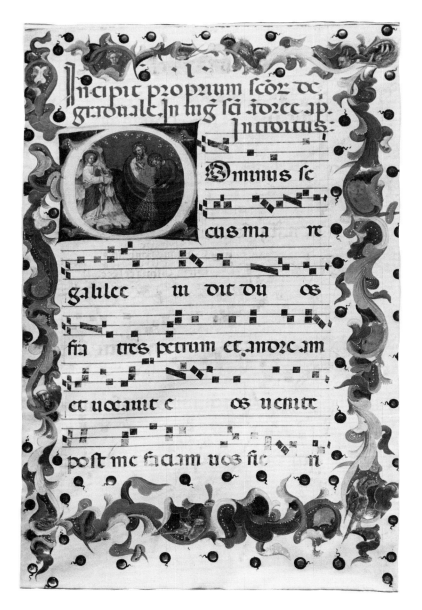

shore in a small boat (Matthew 4: 18–19). Andrew is usually depicted tending to the fishing net. (The iconography is discussed in the following: Schiller [cat. 407], vol 1, p. 311ff; and G. Kaftal, *Saints in Italian Art*, Florence 1978, vols. 2–3.) In this case he is positioned at the bow, which accords him a prominence found only in contemporary works from the Veneto-Padua area. (A similar positioning occurs in Lorenzo Veneziano's panel in Berlin (Staatliches Museum) in R. Pallucchini, *La pittura Veneziana del Trecento*, Venice-Rome 1964, fig. 536.) Furthermore, Andrew appears in a unique crossed-arm (x) gesture indicative of prayer. The significance of this unusual attitude is probably related to the pericope reading for the vigil mass (John 1:35–51), which recounts how Andrew's faith and vocation were influential on his brother Peter. In effect, while centring on the theme of vocation, the image highlights the spiritual enlightenment prefacing St Andrew's apostacy.

The miniature combines a courtly Gothic figure and drapery style with naturalistic passages in modelling and characterization, particularly in the apostles' heads. Related tendencies appear in monumental works from the Padua-Veneto region starting with Guariento (active 1338–70), followed by Lorenzo Veneziano and Guisto da Menabuoi. (For the literature on these artists see Pallucchini. The attribution of Paris, B.N. lat. 5059, to Altichiero rather than Guariento is discussed in G. Fiocco, 'Una Miniatura di Altichiero,' *Scritti di Storia dell'Arte in Onore di Mario Salmi*, Rome 1962, pp. 126–32.) The Malcove leaf displays a system of soft highlights that emphasize the cheeks and repetitive curly locks of Andrew and Peter, a device frequently employed by these artists; however, they generally retain a Giottesque breadth in figural proportions and drapery which contrasts with the delicate treatment of the Malcove leaf. Closer analogies with the more attenuated figures of the leaf appear in a group of manuscripts made in association with the humanist court of Francesco da Carrara in Padua which produced

Saints organized from December through November. As a title page there is little doubt that it prefaced the Proper of Saints, although its location within the gradual remains unclear because several alternatives are possible. One option would have the page (and related sequences) integrated into the major feasts (Proper of Time), which was the most common arrangement. Alternatively, it might have followed the Proper of Time as a separate section, or the page might have been placed at the beginning of a second volume containing mainly the Proper of Saints.

In more lavishly illustrated choral books the feast of St Andrew is usually illuminated with an image of his martyrdom; nevertheless, the 'Calling of Andrew and Peter' depicted here is typically used for the vigil liturgy, although it appears infrequently. (This pattern is generally true for different types of liturgical manuscripts, see for example Leroquis [cat. 407]. The 'Calling of Andrew' already appears depicted in the eleventh-century Antiphonary for the vigil liturgy in *Antiphonale Missarum* Paris 1981.) The scene portrays a youthful Christ beckoning to Andrew and Peter, who stand off-

works like Petrarch's *De Viris illustribus*, Paris, B.N. lat. 6069. The stylistic orientation of this workshop synthesized the characteristics of the artists cited with new courtly realism found in Guariento's successor Altichiero. In effect, the page reflects most closely traits found in both monumental and miniature painting from the Padua area during the last decades of the fourteenth century.

The decorative border of broad, conch-shaped acanthus leaves accented by ball ornament compares most readily to the school of Nicolo di Giacomo of Bologna (circa 1330–1402), whose workshop is distinguished from the others in Italy by its voluminous and multiple acanthus petals. (The literature on Nicolo is extensive; for an overview see P. D'Ancona, 'Nicolo da Bologna miniaturists del secolo XIV, *Arte Lombarda*', *XIV*, 2, 1969, 2–22.) At the same time, this 'Bolognese' style was influential on regional production throughout northeast Italy; since several elements in the page – notably the use of single petals at the corner of the historiated initial, the rays in the border, and the rounded, curvilinear style of the border acanthus – are alien to Nicolo and his Bolognese successors, it is likely that the leaf originated elsewhere. A close parallel in both ornamental style and vocabulary appears in a group of late fourteenth-century liturgical manuscripts assigned to Monteselice near Padua. For example, Antiphonary I, now in Padua (B.C., Monteselice Ant. n.1), displays the same mannerism in both the historiated initial and the style of the border foliage (Pallucchini, fig. 466. Some Monteselice manuscripts are discussed in *Codici Miniati della Biblioteca Capitolare della Citta de Padova*, 2 vols., ed. A. Barzon, Padua 1950.) This affinity also extends to other motifs and lends further support for a Paduan provenance.

Purchased from Laurence Witten, New Haven, 11 September 1959 LC

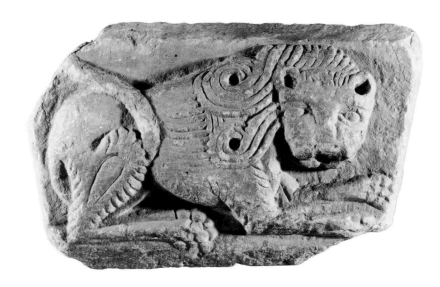

409 Relief sculpture, crouching lion

Fine grained white marble.
35 × 25 × 5 cm
Italo-Byzantine, 11th / 12th century (?) M82.311

The lion is carved in a relatively shallow relief and shown in a crouching position, head turned towards the viewer. The back of the panel is completely flat, polished smooth. The rendering of the fur and mane of the animal is very schematic and is reduced to a series of patterned lines. The pupils of the eyes are not drilled although there are large drill holes for the nose / mouth, the ears, and the curls of the mane. The fur of the back leg is equally schematized and the indication of the thigh muscles is reduced to a pointed oval shape. This shape is a stylistic feature which occurs frequently in Byzantine sculpture and earlier, so it does not assist in establishing a provenance. The tail is shown passing underneath the body and up over the back. This seems to be a characteristic arrangement in Western sculpture and much less popular in Byzantine sculpture. Two similar lions may be seen in the Lecce Museum, south Italy (Tessa Garton, *Early Romanesque Sculpture in Apulia*, New York 1984, pl. 117

a,b). They are badly damaged in the area of the heads but are sufficiently similar stylistically to enable us to propose a similar eleventh–twelfth century date for this panel.

Purchased from M. Komor, New York, 1972 SDC

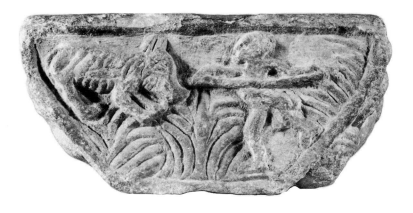
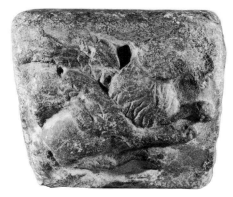
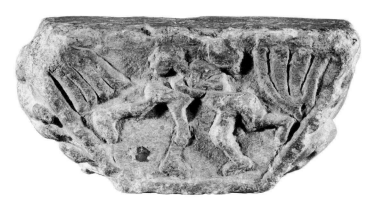
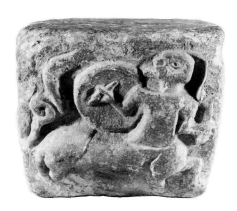

410 Relief carved capital

Coarse greyish white marble or
crystalline limestone.
16.5 × 33 × 19 cm
Provenance and date unknown (11th
century?) M82.287

The capital is rectangular in shape
and has figured scenes on all four
sides. The four scenes, however, do
not appear to be connected in any
narrative. They are a hunting scene,
a centaur with a shield, two wres-
tlers in foliage, and a rather illegible
scene which may be a winged lion.
The hunting scene contains a small,
dwarf-like figure of a man who
thrusts a spear into a wild boar (?).
Indeed, the point of the spear may be
seen emerging from the side of the
animal. This is set into crudely
carved, oversized foliage. The cen-
taur holds a shield – we are shown a
view of the interior – and a sword.
The head is either incomplete or
badly damaged. There is no further
legible context for this scene. The

wrestlers are set into the same kind
of coarse outsize foliage as the hunt-
ing scene. The winged lion – both
wings are shown – is too big for the
space available, and probably the
hindquarters were not entirely in-
cluded. He appears to be leaping
obliquely upward, out of the small
space in which he is contained. All
four sides thus show vigorous action,
albeit somewhat crudely portrayed.

 The subject matter and style of the
carving could by Byzantine or Cop-
tic, whereas the idea of a capital
with multiple scenes is of western
origin. Rather than a capital, the
piece may be an impost block, carved
in Italy but imitating a Byzantine
style. Similar impost blocks may be
seen in the crypt of S. Nicola at Bari.
I am grateful to Eunice Dauterman
Maguire for this suggestion.

Purchased from Kelekian, New York
 SDC

411 Fragmentary pillar with relief carving

Greyish-white marble.
93 × 13.5 × 9.5 cm
Italo-Byzantine (?), 12th century (?)
M82.518

The pillar is carved on one side only, the other three being smooth and the back edges bevelled. This suggests that the block was part of a corner piece, perhaps one of the decorative corner blocks of a rectangular pulpit, as in the example at Troia, Italy (Garton [cat. 409], pl. XXIII d, p. 118). The motif is a common one in Roman and early Byzantine art, a vine scroll emerging from a vessel such as a vase or chalice. It occurs in stone sculpture and frequently in mosaics. Here the vine is interspersed with birds (doves?) placed in alternating poses, as if pecking at the leaves, but not the grapes as would be expected. The motif itself is an eastern one, but its use in this way is not Byzantine. Here the vine and birds have been forced into a rigid, upright format. The birds are barely distinguishable from the foliage and are almost of the interlace variety so popular in the West in the early Middle Ages. The pulpit in Troia

cited above is dated 1169. It has some similar stylistic features – the dry manner of cutting the leaves and the symmetrical arrangement of the bunches of grapes – and may be used as a general comparison for dating. Similarly, the combination of eastern and western elements suggests a possible provenance of Italy at a time of strong Byzantine influence. This is the same sort of problem as is discussed in catalogue 410.

Purchased from Kelekian, New York

SDC

412 Architectural fragment

Limestone. 295 × 290 × 188 cm
English or northern French, mid-13th–14th century M82.155a

This architectural fragment of two gables at right angles, with trefoil arch and pierced trefoil above, and at left the base of the springing of a moulded arch or small vault, appears to have been placed at the corner of an aedicule or arched niche. From the scale, it is probable that it once formed part of a freestanding tomb canopy, or the inset superstructure of an ornate wall-tomb. The right edge

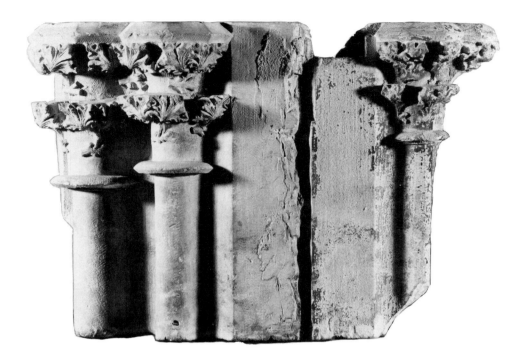

and back show relatively freshly cut surfaces, indicating that it was originally engaged at that side to a wall or other structure.

Although the fragment is blackened as with soot, and shows considerable surface flaking and pitting, details are still precise and chisel marks on the surface are visible. The lack of weathering and the small scale of the piece indicate that it was part of an interior, not an exterior, structure.

Purchased from Medina Gallery, New York, 17 June 1963　　EPM

413　Architectural fragment: column cluster

Limestone. 28.8 × 43 cm
France, late 13th–14th century
M82.155b

This fragment was possibly part of a window embrasure. The uncarved central area and the groove, which appears to have been chipped away on the left and mended roughly with cement, suggest that provision was made for something to be inserted vertically in this slot. The single column at the right is worn and blackened, while those on the left are in virtually pristine condition, which suggests the contrast between interior and exterior exposures. The summary treatment of the top edges and surfaces of the capital leaf-clusters, in contrast to the fine detail of their undersides, suggests that they were meant to be viewed only from below, while the differing depth of the 'interior' capitals may be seen as corresponding to the slanting base of a window embrasure. The piece may be compared with a pair of thirteenth-century colonnettes in the Museum of Art of the Rhode Island School of Design (D. Gillerman, 'Gothic Sculpture in American Col-

lections, The Checklist: I, The New England Museums (Part 2),' *Gesta*, XX, 2, 1981, 363 no. 18), though the more naturalistic and precise detail of the Toronto capitals' foliage suggests a slightly later date. See D. Jalabert, *La Flore sculptée des monuments du Moyen Age en France* (Paris 1965), pls. 76d, 87b. Compare also the colonette cluster in the Jewett Art Museum, Wellesley College, ibid., 360, no. 15.

Purchased from the Medina Gallery, New York, 17 June 1963　　EPM

414 Seated Virgin and Child

Wood with traces of gesso and
polychromy, originally provided with
a metal crown, for which attachment
sockets are visible. 88 × 36 × 26 cm
Northern Spanish (?), 13th century
M82.285

This seated Virgin and Child, of the
Sedes Sapientiae type (cf Ilene H.
Forsyth, *The Throne of Wisdom*,
Princeton 1972), though now dam-
aged and incomplete, is still a work
of freshness and some charm. The
strongly projecting veil and the cloak
which falls over the arms in a deeply
pocketed contour, enclosing the Vir-
gin's upper torso and the body of the
child who is perched on her left arm,
give a strong three-dimensionality
to the figure. The folds of the upper
part of the tunic, though shallow,
and those over the knees and
hanging below the Virgin's left arm,
are broad and fairly naturalistic.
A touch of precise detail is provided
by the slender belt with tongued
buckle and long end which hangs
down centrally from the Virgin's
waist, the end disappearing beneath
the horizontal sweep of the cloak
over her knees. The breadth and nat-
uralism of the drapery folds, together
with the genre detail of the belt
and buckle, place the work definitely
into the thirteenth century, while
the stiffly projecting head-veil,
smooth face, and rather straight,
thinly carved lips suggest Spain
rather than France (cf the 'type 2'
Virgin and Child sculpture in
C.-J. Ara Gil, *Esculture Gotica en
Valladolid y su Provincia*, Valladolid
1977, p. 131ff, and the catalogue of
the Museo Federico Mares,
Barcelona, 1979).

Purchased from W.F. Altschul, New
York, December 1962 EPM

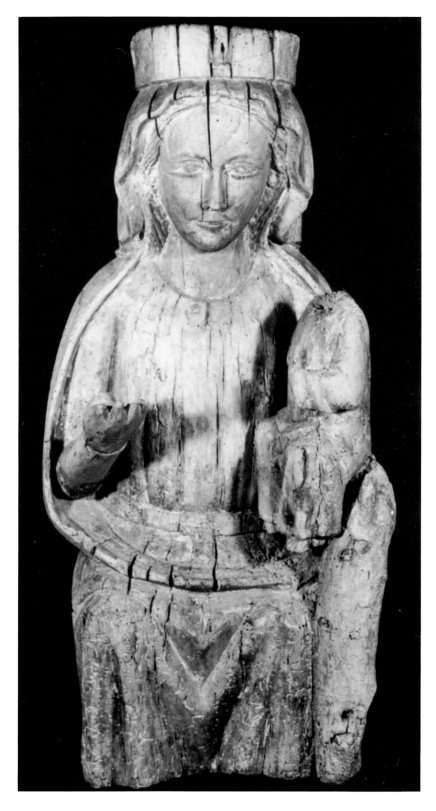

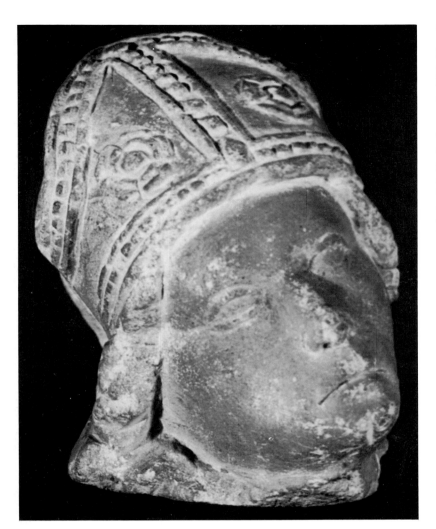

415 Head of a bishop

Limestone with traces of reddish
pigment. 100 × 95 cm
Southern French (?), Toulouse or
Avignon, 13th / 14th century

M82.289

The small scale and tilted attitude of
this head suggest that it is that of a
donor bishop figure from a tomb
or other commemorative monument.
The unfinished areas at the back of
the head, neck, and shoulder indicate
that it was originally attached to a
backing as part of a relief composi-
tion. Despite the thin, downturned
mouth which gives the face some
character, the summary treatment of
eyes and hair indicate that it is the
work of a less than first quality
workshop. The nose, chin, and mitre
are damaged.

Purchased from Robert Behrman,
Paris, 1976 EPM

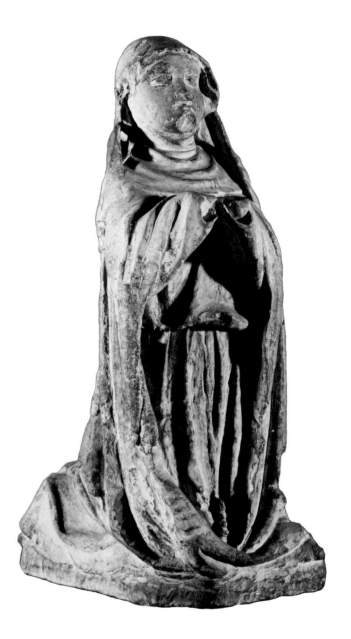

chin (now damaged), and heavy-lidded eyes may be found in other examples from those regions (cf *Sculptures romanes et gothiques du nord de la France*, Lille 1978–9, no. 60).

Purchased from the Medina Gallery, New York EPM

417 Relief of St Nicholas with the boy Basilios

Marble. 127.6 × 42.5 × 7
South Italian, probably Naples, circa 1400 M82.290

The slab shows the standing figure of a bishop in full and elaborately embroidered regalia with gloves, mitre (damaged), and crozier. The rays of a nimbus are visible between the right side of the bishop's head and the crozier, though not on the other side of the crozier. Some recutting may have been done in this area. The bishop's face is strongly modelled in broad, flat planes, with half-open eyes and mouth, high cheekbones, and linear strands of beard, eyebrows, and hair. The folds of his chasuble, though shallow, are fluent and sophisticated, suggesting the echoes of the French-influenced Naples court art of the fourteenth century. In contrast, the figure of the boy, suspended by his hair from the Bishop's right hand, is rigid and awkward, imprisoned in very shallow relief and appearing almost as an afterthought.

The unusual iconography apparently illustrates one of the miracles of St Nicholas, the legend of the kidnapped Basilios, son of a Cretan farmer. The boy was kidnapped by Arabs from the church of Hagios Nikolaos at Myra during the night-time panegyris on the 6 December holiday. The Emir of Crete, struck by the boy's good looks, made him his cupbearer. The boy's mother, meanwhile, was inconsolable, and the next year at first refused to celebrate the holiday but was at last persuaded by her husband to do so. As the guests sat at table there was talk of the absent Basilios, when suddenly the dogs began to bark. The farmer, look-

416 Kneeling female figure

Limestone with traces of reddish-brown pigment on the cloak, tunic, and sleeves. 39 × 22 cm
Northern French (?) or Flemish, circa 1400 M82.154

This piece comes possibly from a tomb or altarpiece and could be either an adoring Virgin from a nativity or (more probably) an entombment, a donor figure, or a *priant* from a tomb. (For format and size compare the *priant* figure of Duke John II of Bourbon in the Walters Gallery, Baltimore: W. Wixom, *Treasures from Medieval France*, Cleveland 1967, no. VIII. 9, pp. 310–11.) The soft, loopy folds which define deep space at the front as they fall over the praying arms and the equally heavy, bulky folds of the undertunic, as well as the originally deeply enclosing veil (now damaged), suggest an origin in northern Europe, possibly Flanders of the Western Rhenish region but equally possibly northern France. The egg-shaped head, strongly rounded cheeks and

ing outside, beheld his son in Arab garb with a full cup in his hand and standing as though paralyzed and abstracted. Restored to his senses, Basilios then recounted how, in the middle of his work, he had been borne off by some invisible force, obviously St Nicholas, who subsequently comforted and encouraged him. The boy was welcomed back into the family amid great rejoicing.

This legend, recounted in a ninth-century Greek manuscript, had spread to Italy in the eighth and ninth centuries, and is found in later Italian paintings (K. Meisen, *Nikolauskult und Nikolausbrauch im Abendlande*. Dusseldorf 1931).

In the absence of any identifying or commemorative inscription around its frame, the Toronto slab is difficult to identify or date, although it most closely resembles a tomb slab. It is related to a type of tomb slab produced in southern Italy in the late Middle Ages and well represented in American collections, for example that of Lady Francesca de Lasta in the Worcester Art Museum, Worcester, Mass. (cf Gillerman [cat. 413], no. 12) with somewhat similarly fluent drapery. A number of tomb slabs particularly close to the Toronto relief in style are found in the churches of Naples, for example that of Bishop Ursillo Afflitto (d. 1405) in S. Lorenzo Maggiore (R. Mormone and O. Morisani, *Scultura Trecentesche in S. Lorenzo Maggiore a Napoli*, Naples 1973, pl. 39 (XXIII) and p. 40).

The relief is described by Dr W.R. Valentiner (in a handwritten statement dated Detroit, 5 January 1930, on the back of a photograph of the slab) as related in style 'to the Florentine masters Giovanni and Pace de Firenze, who worked at this period in Naples. Several tombstones of the same type can be found in S. Domenico Maggiore and in the Cathedral in Naples.'

PUBLICATION
Classical and Near Eastern Antiquities, Gothic and Renaissance Art, Old Master Drawings and Paintings, Property of Mrs. Gladys Olcott, Edward J. Smith and Other Owners, Parke-Bernet, New York, 15 February 1962, no. 204, pp. 42–3

Purchased from Parke-Bernet, New York EPM

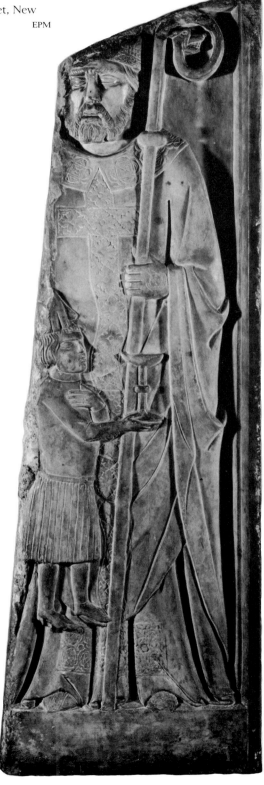

418 Diptych wing with the *Vierge Glorieuse*

Ivory with remains of extensive
polychromy and gilt. 14 × 6.9 cm
Ile de France, mid-14th century

M82.201

The figures are set under an architec-
tural canopy consisting of a trilobed
arch surmounted by a crocketed
gable with fleur-de-lys finial. There
are pinnacles on either side. Behind
the gable each spandrel is carved
with a trefoil. The style of this deco-
ration suggests a date in the mid-
fourteenth century; the same fleshy,
foliate crockets adorn a series of
mid-century French diptychs, includ-
ing four, discussed below, whose
figural style is close to that of the
Malcove piece (R. Koechlin, *Les
Ivoires gothiques français*, Paris 1924,
nos. 533,120,566, and O.M. Dalton,
*Catalogue of the Ivory Carvings
of the Christian Era in the British
Museum*, London 1909, no. 270); the
pinnacles are to be found in conjunc-
tion with these crockets, as seen in
our panel, on two slightly earlier
ivories of circa 1330–1340 (Koechlin,
nos. 470, 524).

The Virgin stands beneath the
canopy in an elegant contraposto
whose sinuous curve lacks the exces-
sive mannerism common in the pe-
riod. She bears the Christ child on
her left arm and a flowering stem in
her right hand. This iconography
of the *Vierge Glorieuse*, with slight
variations, is extremely common,
and several examples may be seen in
Koechlin's corpus of French Gothic
ivories (Koechlin, nos. 533, 536, 560).

The figural style of the panel is
closely related to that of an ivory in
the Mege Collection in the Louvre
(Koechlin, no. 533); the facial details
in particular are very comparable,
with characteristic puffy eyes and
pointed noses. The drapery of the
Malcove panel is in general some-
what more naturalistic and less brit-
tle than that of the Mege ivory,
which is carved in rhythmic, semi-
circular folds across the body, but
this moderation is consonant with
the more moderate stance of the
Malcove Virgin. In both the Louvre

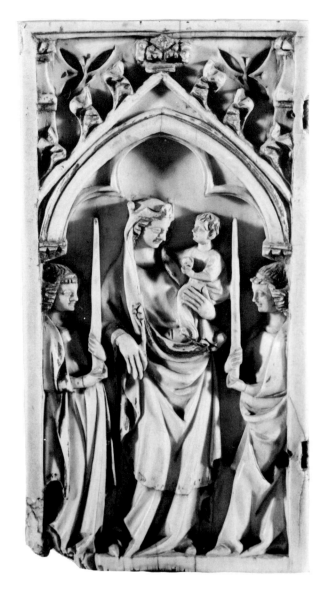

ivory and our piece the Virgin wears
the 'apron' style of mantle common
from 1340–50. Furthermore, the de-
tails of both pose and drapery of the
right-hand angel of the Malcove
ivory are almost exactly matched by
those of the same figure in the Mege
panel. Similar comparisons of both
facial and figural style may be made
with Koechlin, nos. 120 and 566,
also from the mid-century, and with
a related diptych wing in the British
Museum. All are most likely Pari-
sian.

The panel is generally in good
condition, but there is damage to the
left lower corner, extending two
centimetres horizontally and verti-

cally. There is a one-centimetre de-
fect on the back edge of the lower
frame, in the centre. The panel is
drilled for two hinges on the right,
and there are two holes through the
panel at the level of the hinges and
just inside the frame.

Purchased from Mathias Komor,
New York, April 1960 KMO

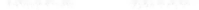

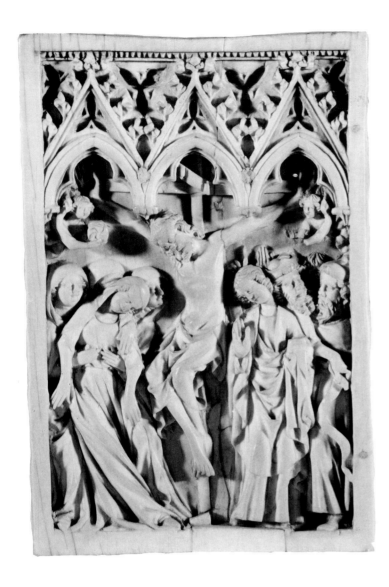

419 Ivory panel, probably a diptych wing, with Crucifixion

Ivory. 12.9 × 8.2 cm
French (North), Rhine / Meuse
region, third quarter of 14th century
M82.202

The figures are set beneath an architectural canopy consisting of three trilobed arches surmounted by steep gables. There are foliate crockets and fleur-de-lys finials. A trefoil is carved on each gable and in each spandrel behind the gables, and there is a fine beading carved inside the top of the frame. This decoration can be matched on several ivories of the second half of the fourteenth century (Koechlin [cat. 418], nos. 600 and 488, the latter reproduced without its gaudy polychromy by D. Gaborit-Chopin, *Ivoires du Moyen Âge*, Fribourg 1978, pp. 158, 210).

Beneath the canopy Christ hangs crucified. On his right the fainting Virgin is supported by three holy women. On his left stands St John the Evangelist, behind whom are three altercating Jews, two of them gesticulating towards the cross. Two of the Jews are capped, and one, a prophet, bears a scroll in his left hand. Over the heads of the women a half-length angel bears the symbol of the sun; on the right a similar angel is damaged, but would have born a symbol of the moon as com-

monly found in representations of the crucifixion. This iconography with four figures on each side of Christ is not unusual, and is one product of the tendency for ivories to become more crowded as the century progressed.

The Malcove panel can be compared with several others on stylistic grounds, exhibiting perhaps the closest relationship to a diptych wing with the crucifixion in the Musée de Cluny in Paris (Koechlin, no. 600). The drapery style of the two is virtually identical, and we note in particular the use of pronounced diagonal folds across the legs of the Virgin and the treatment of the mantle of St John. Other points of comparison are the facial characteristics of the Jews and of John, and the manner in which the torso of Christ is rendered, with its sharply tensed abdominal muscles. These two pieces, alike in their decorative detail, show considerable affinities with a diptych wing in the Louvre which Gaborit-Chopin has located to the region of France flanked by the Rhine and the Meuse. The workmanship of the Louvre panel is more refined, and the facial features are sharper, with noses more pointed, yet similarities of decoration, treatment of drapery, hair, female facial shape, and minor iconographic detail such as the Capuchin veil of the left female and the ankle-length gown of the right hand Jew suggest for our piece an origin in the same region as the Louvre panel.

The condition of the panel is fair; it is rubbed and the facial features of John and Christ are damaged. The damage to one angel has been noted. The frame is drilled on the right side for three hinges, with two holes, filled, to the front of the frame. On the left are five horizontal holes in the frame connected to horizontal grooves in the back, possibly for some sort of catch. There are four filled holes in the canopy, and a vertical crack from top to bottom is filled with filler in the upper part, and with ivory in the lower half.

Purchased from Georges Seligmann, New York, 1958 KMO

420 Panel with crucifixion

Ivory. 10 × 6 cm
English, Nottingham (?), late 14th
century (?) M82.200

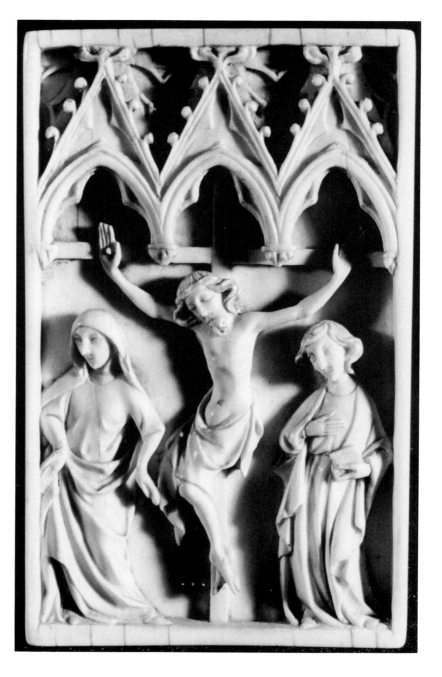

Although superficially in the mode of many mid-fourteenth century French diptych wings, this panel does not appear to be stylistically related to published Gothic ivories and presents problems of attribution. The work is of a provincial character, and the quality of the workmanship is uneven, particularly the carving of the heads and faces; awkward handling of the iconography reinforces the impression of a derivative work.

The figures are placed under a triple-arched architectural canopy whose three gables are surmounted by small, spherical, bud-like crockets and somewhat attenuated fleur-de-lys finials. The gables and the spandrels behind them are carved with trefoils which fill the available space. This canopy cannot be matched in its particular combination of details. Thus the steeply pointed, triple gables with carved trefoil are usually decorated with foliate crockets like those in the Crucifixion panel, catalogue 419, while spherical, bud-like crockets are most commonly found in association with a different combination of architectural forms, for example, on a series of Parisian diptychs of the second quarter of the fourteenth century with wide, heavy arches (R.H. Randall, 'A Parisian Ivory Carver,' *Journal of the Walters Art Gallery*, XXXVIII, 1980, 60–9; the author publishes a series of ivories with this decorative feature, including Koechlin nos. 584, 585, 400), and on a series of somewhat earlier polyptychs whose free-standing upper gables are not contained within a frame (Koechlin [cat. 418], nos. 172, 198, 203, for example). In view of the possible English provenance of our panel it is worth noting that of the few Gothic ivories securely attributed to England, most are marked by a more florid architectural style, often characterized by the ogee arches seen in the Grandisson triptych (Dalton [cat. 418], no. 245; also Koechlin, no. 209).

Beneath the canopy is a simple grouping of the crucified Christ, his mother, and John the Evangelist. The top half of the figure of Christ is elegant and conventional, and apart from details of physiognomy could be paralleled in many fourteenth-century ivories; the distortion of the legs, though considerable, is not unusual. The iconography of the Virgin is not that which is regularly seen when she stands alone at the cruci-

fixion; in such instances she is most often represented making some gesture of grief, usually with clasped hands, sometimes with raised, open hands, and in one instance, on a diptych in Lyons, with one hand raised and the other dropped in despair (Koechlin, no. 435).

The gesture of the Malcove Virgin, with hands splayed out, is that associated with the swooning Virgin who is found in multi-figured cruci-

fixion scenes, supported by the holy women around her. The identical pose in its correct context may be seen on several French ivories of about 1370 (for example, a French diptych wing, circa 1370, now in the Walters Art Gallery, no. 118 in *The International Style: The Arts in Europe Around 1400*, Baltimore 1962), and it is a commonplace of late four-teenth-century English iconography, being found in manuscript in the contemporaneous Missal of Nicholas Litlyngton (F. Harrison, *English Manuscripts of the Fourteenth Century*, London, New York 1937, pl. 21), in sculpture on alabaster reliefs from Nottingham (W.L. Hildburgh, 'English Alabaster Tables of about the Third Quarter of the Fourteenth Century,' *Art Bulletin*, XXXII, 1950, no. 23), and in more dramatic form, in ivory, on the Grandisson triptych. In isolation the gesture loses its logic, an impression enhanced by the Vir-gin's vacant face – here Mary neither faints nor grieves. Indeed, the faces of both the Virgin and John are usu-ally devoid of expression, and the two protagonists do not participate in the event depicted; many Gothic ivories lack profound emotional expression, but most strive to convey the anguish of the crucifixion rather than cool detachment.

As noted, no adequate stylistic counterpart to these two figures has been found in the medium of ivory, and they differ in detail as well as in spirit from fourteenth century French works. The figural style is cu-rious; the narrow shouldered bodies bend as if made of rubber, with inse-cure centres of gravity uncommon even in highly mannered Gothic sculpture; the drapery is con-ventional though far from elegant. Certain details of style can be matched in English ivory carving and sculpture of the second half of the fourteenth century. Though quite different in overall aspect from our work, and of infinitely superior qual-ity, Exeter ivories exhibit pro-nouncedly oval faces with linear, sharply incised, almond-shaped eyes, the latter most notable in the figure of Christ in Majesty on the Grandis-son triptych; in related stone sculp-

ture can be found draperies and head shapes comparable with those of our piece (E.S. Prior, *An Account of Medieval Figure Sculpture in England*, Cambridge 1912, pp. 352, 357, 358). Our ivory carver could have been familiar with such work, though he obviously was not of the Exeter school. There are also certain affinities of style and temperament with some Nottingham alabaster reliefs of the late fourteenth and early fifteenth centuries. Among this large and eclectic group, related by Prior to the Exeter school (Prior, p. 357, notes that sculptural style in Not-tingham related more to that of the west of England than to nearby York), can be found figures with the same upper bodily proportions of narrow shoulders surmounted by proportionately large heads, though the Nottingham figures are far longer in the lower body. These carvers often produced oval faces with di-minutive chins and with blank expressions, which were then painted, but which bear a closer general relationship to the faces of our panel than those of extant ivory works, though they lack the linear eyes of our piece. The Virgin of an early fifteenth-century Annunciation relief now in the Walters Art Gallery is one example which may be cited, in which there are also similarities of drapery with our ivory, and this is also true of a related Virgin of the Assumption (see *The International Style*, no. 85, for the Annunciation relief; W.L. Hildburgh, 'Seven Medie-val English Alabaster Carvings in the Walters Art Gallery,' *Journal of the Walters Art Gallery*, XII, 1954, 19–33, fig. 1, for the Assumption re-lief). Somewhat less satisfactory are the comparisons with the four-teenth-century reliefs, although indi-vidual features of hair treatment, facial shape, and drapery style do foreshadow the fifteenth-century work to which our panel approxi-mates (Hildburgh, figs, 30, 28, 15, 7).

In conclusion, the format and architecture of this panel would, with reservations, have suggested a mid-century work from France, but such features could easily have been copied. In the light of the derivation

of the iconography of the Virgin from the type of crowded crucifixion popular late in the fourteenth cen-tury, and the stylistic affinities with Nottingham reliefs of the early fif-teenth century, which themselves drew upon an established tradition, a date late in the fourteenth century must be suggested for this work, and a tentative and very open-minded attribution made to Nottingham.

The condition of the panel is ex-cellent, indeed pristine, and there is no indication of mode of use.

Purchased from Mathias Komor, New York, April 1960 KMO

421 Relief carving, Three Apostles

Limewood. 41 × 32 × 4.5 cm
Kassa region of Slovakia (formerly
North Hungary), circa 1490 M82.372

This limewood relief would certainly
have been richly polychromed in
its original state. Although no evi-
dence of colour survives on its ex-
posed wooden surface, traces of the
white gesso base to which colour was
applied may be detected in the dra-
pery folds as well as in the hair of the
kneeling figure. In spite of the ab-
sence of identifying attributes, we
may safely deduce that the figural
group represents three apostles. In-
deed, the solemn, meditative aspect
of the figures, their priestly garments
and holy books, as well as their in-
formal grouping suggest they were
once part of a larger composition rep-
resenting the Death of the Virgin, a
common devotional subject of late
fifteenth-century central European
altarpieces or retables. Although
a three-centimetre plug has been used
to repair a hole in the lower drapery
folds of the middle figure and a deep
vertical crack has appeared in the
thin surface, splitting the book
jointly held by the two standing
figures, overall the condition of the
relief is good and presents us with a
remarkably fresh provincial interpre-
tation of a medium and genre central
to late mediaeval culture. For a fur-
ther discussion of the limewood
scupture of central Europe see M.
Baxandall, *The Limewood Sculptors
of Renaissance Germany* (New Ha-
ven 1980), and T. Müller, *Sculpture
in the Netherlands, Germany, France
and Spain 1400–1500* (Hammond-
sworth 1966).

Although the acknowledged
centres for the production of lime-
wood sculpture were the great Upper
Swabian cities of Ulm and Augsburg,
the considerable reach of south Ger-
man commercial colonization car-
ried the products of their workshops
to regions south of the alps and into
the eastern territories of the old Aus-
tro-Hungarian empire. Müller notes
that reciprocal influences between
Upper Rhenish and Bohemian work-

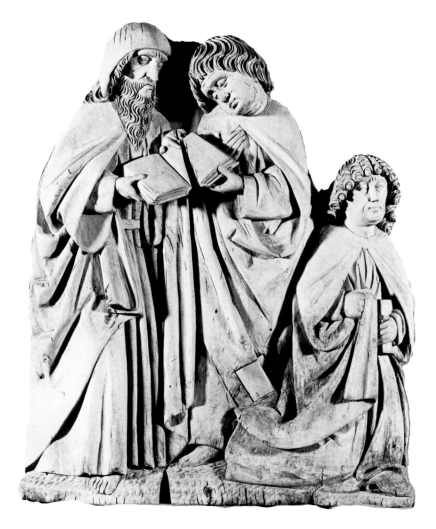

shops may be detected as early as
the fourteenth century (Müller, p.
36). By the mid-fifteenth century
workshops among the Germans of the
Zips in northern Hungary (now
Czechoslovakia) were well estab-
lished and assimilating stylistic im-
pulses from Austria and Silesia as
well as Bohemia (see for a general
discussion Müller, p. 45; A. Agghazy,
Early Woodcarvings in Hungary,
Budapest 1965; D. Radocsay, *A Kö-
zépkori Magyarország faszobrai*,
Budapest 1967). It is to this cultural
region that our Three Apostles be-
longs. While the physical type of the
figures reflects generally the widely
diffused Upper Rhenish style, a sim-
plification of form and an archaizing
quality characteristic of the stylistic
revivals occurring at the turn of the
century assert a conservative local

influence. The highly stylized and
symmetrical arrangement of sausage-
like curls in the coif of the kneeling
figure, his heavy squared features,
flat cheek, and full throat find a
striking parallel in a limewood figure
of St John the Evangelist, today in
the Christliches Museum in Eszter-
gom, Hungary (M. Boscovits et al.,
*Das Christliches Museum von Eszter-
gom*, Budapest 1964, no. 49). This
work of circa 1480 has been associ-
ated by Radocsay to the active pro-
duction centre around Kolcise
(Kassa, Kaschau) where, by the end
of the fifteenth century, the highly
influential styles of Jakob Kasschauer
and Hans Multscher were giving
way to a classicizing impulse possibly
reflecting Italian influence (Rado-
csay, pp. 60–73). From the same cul-
tural region of North Slovakia, and

dated to circa 1490, the wooden altarpiece of the Death of Mary in the Cathedral in Szepeshely (Zipser Capitel), Czechoslovakia, offers several points of comparison (G. Barthel, *Die Ausstrahlungen der Kunst des Veit Stoss im Osten*, Munich 1944, no. 43, and Radocsay, fig. 142). A similar figural type to our kneeling apostle and the Esztergom figure may be observed in the figure depicted in the left foreground. Evincing a strong stylistic relationship with the Malcove relief is the treatment of the draperies, in particular the blunted, v-shaped folds, the broad open loops describing the fall of a mantle caught up under an arm or over a lap, and, finally, a curious flattening to the plane of a drapery flourish as it meets the ground. Here again, we observe a heavy, simplified treatment of form, gestural restraint, and a tendency to particularize heads through an exaggerated physiognomic interest. A further group of sculpted figures from the predella of the Issenheim altarpiece, associated with the workshop of Niclas Hagower and recently redated by Recht to circa 1490 (R. Recht, 'Les sculpture du retable d'Issenheim,' *Cahiers alsaciens d'archéologie d'art et d'histoire*, XIX, 1975–6, 27–46), exhibits similarities in facial type and style of execution to the Malcove group, and thus may point to the importance of work radiating from Vienna on the sculptural production of the former northern Hungarian province of Slovakia.

Purchased from Blumka Gallery, New York, 1961 KAT

422 Architectural canopy / baldacchino

Wood, carved, gessoed, gilded and painted. 220 × 114 cm
Italian, early to mid-15th century
M82.284

At the top of the canopy are carved figures of four crouching 'dragons' with foliage in their mouths. In the arched and gabled niches along the sides are four painted figures. Top left: an old man, bearded, his hair falling to his waist, his loins bound with leaves, a ⊤-shaped staff in one hand. Top right: A woman, her body covered by her long flowing hair, three globe-shaped objects in her right hand. Bottom left: A woman, cloaked and wimpled, a small purse or basket over her right wrist. Bottom right: A man in Dominican attire, a knife imbedded in his skull, a book in his right hand.

The central panelled section of the canopy is decorated with stylized floral motifs in oblique, wavy bands.

There are numerous gilding losses, where the gilding is worn or flaked, as well as losses to the gesso ground. The painted decoration is worn, so much so that the four figures along the sides are difficult to see with clarity. Three of the four figures are easily identified as, top left, St Humphrey / Onuphrius or Onofrio, the patron saint of weavers; top right, St Mary of Egypt with her three loaves; and, bottom right, St Peter Martyr, greatly venerated in the Italian city of Verona (Helen Roder, *Saints and their Attributes: With a Guide to Localities and Patronage*, London, New York and Toronto 1955, pp. 183, 182, 224). The details of the dress and attributes of the female saint, bottom left, are difficult to make out, but if the object held over her right wrist is intended to represent a basket, she may depict St Dorothy (Roder, pp. 54–5), who is frequently depicted carrying a basket of fruit and flowers. Positive identification of this figure, however, has not yet been made.

The stylized floral pattern of the central section of the canopy is based on textile designs, and is a copy of a brocaded silk. The undulating form of the repeats and their oblique layout suggest that they are copied from textiles of the fifteenth century. Their closest parallel is to be found in Italian textiles of the Quattrocento. In general, the floral pattern of the canopy parallels that of Venetian silks which have been ascribed to the second quarter of the fifteenth century by some authorities (cf Otto von Falke: *Decorative Silks*, London 1936, 3rd edition, figs. 446–55). Patterns very close to those of the Malcove canopy appear on brocaded silks in the Metropolitan Museum in New York and in other collections such as the G. Sangiori Collection in Rome, and although they are generally regarded as Venetian, are dated as far apart as the second half of the fifteenth century (cf Adele Coulin Weibel: *Two Thousand Years of Textiles*, New York 1952, pl. 232, of a brocaded silk in the Metropolitan Museum), and the early years of the fifteenth century (cf Fanny Podreider: *Storia dei tessuti d'arte in Italia*, Bergamo 1928, fig. 134, referring to a brocaded silk in the G. Sangiori Collection).

The architectural features of the canopy – the Gothic tracery, crockets, pinnacles, and gables – are all generally similar to forms of Gothic architectural decoration found in Northern Italy in the late fourteenth century and early fifteenth century. Some obvious parallels are provided by the decoration of Milan cathedral, begun in 1386, as noted in the features of the tracery of the windows of the east end of the sanctuary, and in such interior details as the gables and crockets of the decoration of the 1930s by Giacomo da Campione over the door of the North Sacristy (cf John White: *Art and Architecture in Italy 1250 to 1400*, Harmondsworth, Middlesex 1966, pl. 160, 188b). Similar Gothic decoration in the context of the applied arts is to be noted on examples of North Italian metalwork of the early Quattrocento, for example on the Voghero monstrance of 1406 in the collection of the Castello Sforzesco, Milan (White, pl. 185b).

All of the features of the Malcove

canopy – the architectural details, the simulated textile pattern, and the four painted figures of saints with their attributes – point to it as having originated in Italy, probably in Northern Italy, sometime after the end of the fourteenth century. It is not likely that the figures were painted later than the first third of the fifteenth century, though it is possible that the simulated brocade decoration might have been added as late as the middle years of the century. There is no reason, however, why all of the painted decoration could not have been added at the same time. Assuming this to be the case, it is reasonable to assume that the canopy and its decoration are to be dated to the first half of the fifteenth century, possibly as early as the first quarter or first third of it.

KCK

ENGLISH
ALABASTERS

For almost two hundred years, from soon after the middle of the fourteenth century until the Reformation reached England during the second quarter of the sixteenth, devotional images carved from alabaster quarried at Chellaston in Derbyshire and nearby in Staffordshire at Tutbury were among the most abundantly manufactured works of art produced by English craftsmen of the late mediaeval period. Although alabaster was very occasionally used locally at an earlier date for architectural ornament (as is the case at Tutbury, for example, where a twelfth-century Norman door incorporated a moulding made of the material), it was not until the 1330s that it was employed at all extensively, initially for the effigies and embellishments of tombs – those of Edward II in Gloucester Cathedral and John of Eltham in Westminster Abbey being particularly splendid examples which also demonstrate that by then presumably London artificers working in the court style were using the material. The more elaborate tombs were generally lavishly enriched with additional figures of weepers (small statues representing mourners usually placed in niches around the chest on which the effigy rests), angelic or patronal guardians, finely wrought ornamental details, and sometimes panels carved in relief portraying appropriate religious subjects. It must have been from these developments in the use of alabaster that there evolved around the middle of the fourteenth century an independent tradition of carving religious statuary and pictorial reliefs to set

up on altars. A plentiful supply of the stone and the ease with which it could be worked – alabaster is a sulphate of lime which is relatively soft and polishes to an attractively translucent finish – led eventually to the creation of a flourishing industry producing standardized images for altarpieces. Its principal centre was at Nottingham, a few miles from the main quarries at Chellaston, and there may also have been workshops in London and York.

By the beginning of the fifteenth century there were already clearly defined formal patterns and iconographical conventions to which the alabasterers generally adhered. Usually the relief panels were incorporated into wooden frames to make up altar retables of five or seven scenes, the central one somewhat taller than the others. At each end of an altarpiece there would often be added the figure of a saint. The majority of alabaster retables seem to have conformed to one of three stereotyped configurations: a Passion series comprising four or six scenes together with a central Crucifixion (or sometimes a Trinity group including Christ on the Cross), a Life of the Virgin sequence with perhaps a Trinity, Resurrection, or Assumption panel at its centre, or a set of reliefs illustrating the life of a particular saint. Most completely surviving retables consist of a single row of panels, but there are two double-tiered examples dating from the end of the fifteenth century which suggest that some of the latest examples were rather more elaborately conceived. Some smaller triptych groups

were also probably made for private devotional use, and a few individual panels showing the head of St John the Baptist – a particularly frequently recurring subject – still preserved in their original frames with painted wood must similarly have been personal possessions.

A number of completely surviving Nottingham alabaster retables have remained *in situ* in the churches where they were originally set up, though none of them are to be found in England where thousands must have perished or been dismantled during the wholesale removal and destruction of such images that occurred under Edward VI (1547–53). The presence of completely preserved altarpieces in France, Italy, Spain, Holland, Poland, Austria, Norway, and Iceland, as well as the vast number of individual panels from dismembered retables for which continental European provenances are recorded, testify to the enormous export market that existed for English alabasters. Although all these complete retables date from after about 1440, documentary sources indicate that already by the end of the fourteenth century alabaster images were being sent abroad from England. In 1382 Richard II granted a licence to the papal collector for the export of four sculptures, and from 1390 there is a reference to a consignment of 'ymagez d'alabastre' that formed part of the cargo of a ship sailing for Seville from Dartmouth (F.W. Cheetham, *Medieval English Alabaster Carvings in the Castle Museum, Nottingham*, Nottingham 1973, 12–13). Clearly there

was a flourishing international trade in the carvings from quite early in the development of the industry, and many more images and retables may have found their way to the Continent at the Reformation. A report by the English ambassador to France in 1550 refers to several ships 'lately arrived from England laden with images, which have been sold at Paris, Rouen and other places' (ibid., 16–17). Apparently, following the enactment of legislation proscribing religious images, quantities of devotional sculpture (no doubt including many Nottingham alabasters), were illicitly transported for sale abroad despite stipulations that they were to be desecrated and destroyed.

Only one retable – a *Life of St James* altarpiece presented to the Cathedral of Santiago de Compostela in 1456 – can be dated from a contemporary document (W.L. Hildburgh, 'A Datable English Alabaster Altar-piece at Santiago de Compostela,' *Antiquaries Journal*, VI, 1926, 304–7). Consequently, a precise chronology for the stylistic development of alabaster sculpture in England is difficult to establish, although some conclusions may be drawn from comparisons with carvings in the same material on tombs which can generally be more accurately dated. The problem of chronology is compounded, however, by the standardization of style and iconography which is such a prevalent feature of English alabasters, a consequence of the concentration of mass production in a few workshops in the same provincial centre. The constant repetition of the same patterns and stock themes led to a uniformity of design and execution which in turn resulted in the late survival of earlier conventions of representation, costume details, and other features which might be used for dating purposes in other art forms but can be misleading in this context. Certain physical characteristics and technical properties do serve as general indicators, however. The depth of relief and the degree of crowding in a composition, for instance, and the relative refinement of the carving (later examples being more deeply cut and summarily finished) are broadly reliable guidelines. The earliest panels may be recognized by their low relief and rounded modelling of figures with flowing draperies, the edges of the tablet chamfered to frame the scene. These were succeeded around 1400 by an elegantly proportioned figure style, still quite softly rendered though in higher relief, the scenes canted forward beneath a projecting embattled top. The standard vertical format was adopted and iconographical types became firmly established. From about 1430 / 40 the final style emerged with a sharper and more angular treatment of figures, much more deeply undercut, and more densely crowded compositionally. Later in the fifteenth and early sixteenth centuries the quality of carving became progressively more desultory and crude, probably because the continual replication of standard themes led to artistic stagnation and stylistic deterioration. However, in assessing the technical qualities of English alabaster carvings it should be remembered that they were invariably coloured and some of their apparent sculptural deficiencies would have appeared rather less obtrusive than they now seem without their original polychrome finish. Their colourful appearance was further enhanced by the gilding and painted inscriptions which decorated the wooden frames in which the carved reliefs were displayed beneath elaborately contrived alabaster canopies. For a general survey of English alabasters the most useful sources are *Illustrated Catalogue of the Exhibition of English Medieval Alabaster Work* (London 1913); A. Gardner, *English Medieval Sculpture* (Cambridge 1951); and Cheetham, above. At the time of writing, Francis Cheetham, *English Medieval Alabaster. With a Catalogue of the Collection in the Victoria and Albert Museum* (Oxford 1984), is forthcoming. MJHL

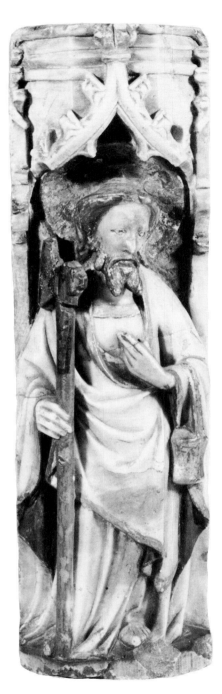

423 English alabaster, St James the Great (?)

Relief carving with extensive remains of original painted colouring and some gilding. 8 × 26.9 cm
Nottingham (?), mid-15th century

M82.367

Two very similar figures, both standing in niches under crocketed ogee canopies exactly as in the Malcove examples, belong to the Metropolitan Museum in New York (Augusta S. Tavender, 'Mediaeval English Alabasters in American Museums,' *Speculum*, xxx, 1955, 66–7, nos. 22, 23). They have been identified as the apostles St Matthew and St Jude, and since they are of much the same size as the figure published here and are closely comparable to it in their sculptural treatment and architectural detail, it is possible that they belong to the same series or at least were produced in the same workshop. Small canopied figures such as these were generally placed between the pictorial panels of a retable. An example at Yssac-la-Tourette in France comprising a central Crucifixion with four Passion scenes and terminal images of St Peter and St Paul at either end has twelve little relief statuettes of the kind set in pairs one above the other between each of the larger panels (the Yssac-la-Tourette retable is reproduced in the *Illustrated Catalogue of the Exhibition of English Medieval Alabaster Work*, London 1913, pl. VIII, fig. 19). If, as seems possible, the Malcove and New York figures formed part of the same series, they could well be from a set of the Twelve Apostles that was originally deployed on an altarpiece in something like the configuration that occurs on the Yssac-la-Tourette retable.

The Malcove figure may tentatively by identified as St James the Great, the brother of St John the Evangelist. The various attributes – the staff, wallet, and hat – are those generally associated with the apostle, but his most distinctive and familiar symbol, a scallop shell, is not shown. However, the symbol does not always appear, and it should be remembered that 'at times it is almost impossible to tell an Apostle by his emblem alone,' *Burlington Magazine*, XLII, 1923, 134, where it is also pointed out in relation to the representation of the Apostles and their emblems that 'the tradition on which the medieval artist worked must have been very vague and uncertain.' It may be that the shell is used to refer specifically to St James as a patron of pilgrims, whereas in this instance he is represented primarily as one of the Apostles. The hat, staff, and wallet are, in any case, sufficient to identify this as a pilgrim figure.

Stylistically, the treatment of the figure and drapery suggests a date near the middle of the fifteenth century. There are general similarities with some of the small statues decorating Henry v's Chantry in Westminster Abbey (1440s), and in technique and conception the figure is close enough to others on the documented retable of 1455–6 in Santiago de Compostela to postulate a date somewhere around 1450. The Malcove figure is a particularly finely carved and sensitive example of English alabaster sculpture of the period. The rendering of the draperies, unusually delicate execution of the features, and reflective quality the figure conveys are evident when it is compared to the coarser execution that prevails by the middle of the fifteenth century in the products of the Nottingham workshops. The possibility that this figure may have been made elsewhere – perhaps in London, where alabastermen are recorded and imagers may be assumed to have worked in a more sophisticated style – cannot be excluded.

Purchased from Blumka Gallery, New York, 1971 MJHL

424 English alabaster, The Holy Trinity with Angels

Relief carving (incomplete), with traces of original painted colouring and some gilding. 23.5 × 28.6 cm
Nottingham, 1450–1500 M82.366

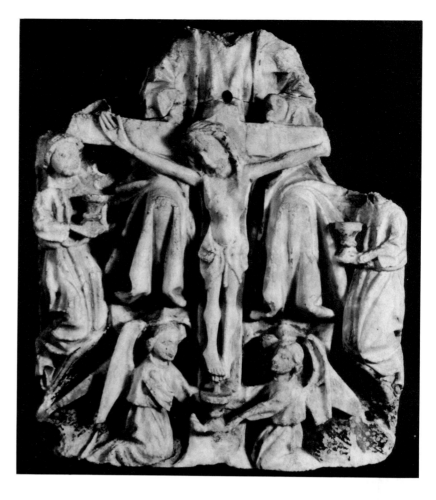

Stylistically and compositionally this fragment corresponds to other late fifteenth-century alabasters of the Trinity. It may be inferred that the missing upper portion of the panel would have shown God the Father crowned and, in each corner at the top, angels holding censers. The Dove representing the Holy Spirit was separately made from metal and attached by means of a laten wire passed through the hole above the crucifix. A complete Trinity relief which is very similar to the Malcove example belongs to the Musée des beaux arts in Montreal (Montreal, Musée des beaux arts, 955.Dv.1, Horsley and Annie Townsend Bequest: A.S. Tavender, 'Medieval English Alabasters in American Museums, II,' *Speculum*, XXXIV, 1959, 439, no. 79; *The Montreal Museum of Fine Arts Guide*, Montreal 1977, p. 53, fig. 34). Usually, the subject seems to have occurred as the larger central panel in a retable made up of five or seven alabaster carvings set in a wooden frame, but in this instance that appears not to have been the case. Complete retables incorporating an enlarged Trinity relief as the centrepiece are to be found at Chatelus-Malvaleix in France (E.S. Prior, 'The Sculpture of Alabaster Tables,' *Illustrated Catalogue of the Exhibition of English Medieval Alabaster Work*, London 1913, p. 48), the Victoria and Albert Museum, London (the Swansea Altarpiece: F.W. Cheetham, *Medieval English Alabaster Carvings*, Nottingham 1973, p. 59), and the Castle Museum and Art Gallery, Nottingham (Sotheby's, London, *Medieval, Renaissance and Baroque Works of Art*, 24 June 1982, p. 39). The Chatelus-Malvaleix and Nottingham examples both have accompanying Passion scenes, whereas the lateral panels of the Victoria and Albert Museum retable illustrate the Life of the Virgin. The

measurements of the Malcove piece are consistent with a tablet approximately 40 centimetres high, roughly the normal size for one of the standard lateral panels in a typical altarpiece. By contrast, like others of the same subject, the Montreal relief is taller, some 49.5 centimetres, indicating that it was probably once at the centre of a retable. Since it is inconceivable that a representation of the Trinity would not be centrally placed in the grouping of an altarpiece, a likely explanation for the small scale of the Malcove example might be that it never formed part of a multiple image arrangement but was perhaps originally placed in its own wooden frame for private devotional use.

Despite the mutilated state and worn condition of the carving, it is possible to determine from its style and general quality that the relief

belongs to the latest phase in the development of English alabaster art. The high relief with deep undercutting and the angular treatment of draperies are typical of the second half of the fifteenth century, while the standard of craftsmanship displayed reflects something of the declining artistry that characterizes much of the work produced during the period.

Purchased from M. Glueckselig and Son, New York, December 1962

MJHL

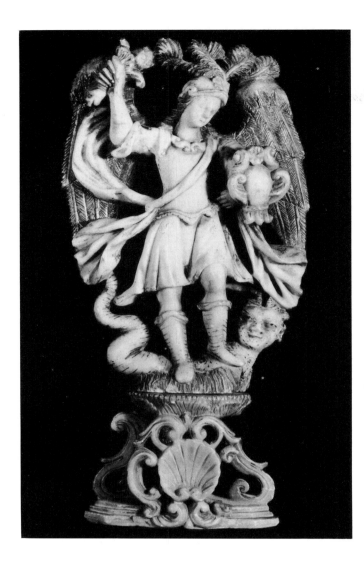

425 St Michael and the Dragon

Alabaster, partly gilded.
45.5 × 22.7 cm
Sicilian, 17th century M82.489

The gilding is worn off in several areas of the surface, and there are traces of polychrome. The group is made in two sections, the upper part with St Michael and the Dragon, and a separate base. The top section is attached to the base by an iron pin set in the base.

The pseudo-classical armour in which St Michael appears represents a post-Renaissance adaptation of a previously existing type. The pose relates back at least as far as the fif-teenth century, to an iconographic type widely circulated in the form of German engraving, notably those by the Master E.S. and in engravings by such artists as Israhel van Mecke-nem after originals by the Master E.S. (cf Alan Shestack, *Fifteenth Century Engravings of Northern Europe from the National Gallery of Art, Washington D.C.*, 3 December 1967–7 January 1968, Washington, DC 1967, no. 172). Depictions of St Mi-chael in armour, in a pose clearly relating to those shown in engravings by the Master E.S. and his imitators, appeared in many parts of Europe. Among them is a late fifteenth-cen-tury painted panel by the Spanish painter Bartolomme Bermejo, which shows the archangel Michael holding a circular shield (cf the *Larousse Encyclopedia of Renaissance and Baroque Art*, ed. René Huyghe, London 1964, fig. 124). It is perhaps due to the presence in the Iberian peninsula of works iconographically related to Bermejo's treatment of the subject that the Malcove St Michael has been regarded as originating in the Iberian peninsula, though from Por-tugal, not Spain. While the Malcove St Michael has been considered to be Portuguese, alabasters of the same iconographic type, with the same kind of scrolled base, stylized Dragon, pseudo-classical armour, and oval shield with scrolling acanthus border, are now more frequently regarded as Sicilian, with dates ranging from the sixteenth century to the seven-teenth and eighteenth centuries. Typical of these alabasters was a St Michael, described as sixteenth cen-tury in date, which was illustrated in the catalogue of a Christie's sale in London in 1982 (Christie, Manson and Woods, *Important Sculpture and Works of Art*, 21 April 1982, no. 42). It was of the same type as the Mal-cove alabaster, though it was consid-erably more refined in its manner of carving. Nevertheless, it repre-sented an obvious antecedent of the Malcove alabaster both iconographi-cally and stylistically. The Malcove alabaster, here recatalogued as Sicil-ian, is essentially a Baroque rework-ing of a traditional type. The pseudo classical armour, of a type that be-came common in European art after the Renaissance, features a tunic with sleeves and skirt consistent with a date either in the seventeenth or early years of the eighteenth century.

KCK

426 The Last Supper, relief

Alabaster, with traces of gilding
9 × 9.5 × 1.2 cm
Flanders, Malines, late 16th–early
17th century M82.364

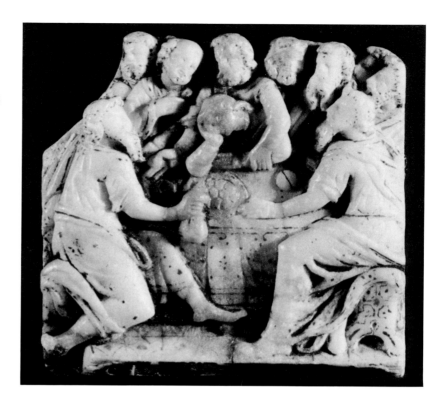

The relief conforms in size and detail to common types of alabaster reliefs made in Malines during the sixteenth and early seventeenth centuries. These reliefs were normally mounted in wooden frames. The frames were usually ornamented with gessoed and gilt borders of stamped low relief arabesques, strapwork, masks, and garlands. Some larger alabasters were fitted into carved frames of architectural form with attached columns, entablatures, and pediments flanked by strapwork and grotesques. The subjects of the alabaster reliefs were normally derived from scripture, many of them depicting scenes from the Life of the Virgin and Life of Christ. They were almost certainly derived from contemporary woodcuts and engravings. Many Malines alabasters of the late 1500s–early 1600s have been preserved. A small collection is in the European Department of the Royal Ontario Museum. Among the most important published examples are those of the museums of Brussels and of Trier (cf Musées royaux d'Art et d'Histoire: *Exposition de sculptures anglaises et malinoises d'alabâtre*, Brussels, 28 September–5 November 1967).

The subject of the Malcove alabaster is of Christ giving bread to Judas at the Last Supper. It is a frequently found subject in Malines alabasters and may be compared with an iconographically related, though larger and more detailed relief of the same theme in the collection of the Rijksmuseum in Amsterdam (cf Jaap Leeuwenberg and Willy Halsema-Kubes, *Beeldhouwkunst in het Rijksmuseum*, Amsterdam 1973, no. 176) and with another relief, also in the Rijksmuseum, in which the arrangement of figures is reversed from the Malcove relief, and shows Judas on the right side rather than on the left (ibid., no. 177). Slight variations occur in the compositions of subject matter in Malines reliefs, such as the addition or omission of architectural details in the backgrounds and minor variations in the positions of the major figures.

Purchased from Motamed, Frankfort

KCK

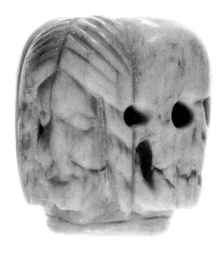

gems, because of their portability, are particularly hard to locate geographically. The degree of emotional expressiveness also suggests a late mediaeval date, but the relatively poor quality of the carving makes it impossible to be more specific.

Purchased from Blumka Gallery, New York, September 1966 SDC

427 Rosary bead

Ivory. 3 × 2.3 cm
German (?), 17th century
M82.365

The bead is from a rosary or the girdle of a religious habit. On it are represented four heads: Christ with a crown of thorns (the Man of Sorrows), Mary, Christ without the crown of thorns, and a skull. The latter segment was a 'memento mori,' a reminder of man's mortality, a common feature on such rosary beads. There is a high polish on the protruberant features of the bead from handling. But this same handling has worn the surface and blurred the features. As a traditional and conservative class of object, rosary beads are not subject to much change and variation. They are also very portable. Consequently, it is hard to pinpoint a time and date for them. A very similar bead is in the National Museum in Munich and identified as West German or Belgian. See R. Berliner, *Die Bildwerke des Bayerischen National Museum*, vol. XIII, Die Bildwerke in Elfenbein, UJW 1926, nos. 316, 317, 318.

Purchased from Glueckselig, February 1965 SDC

428 Incised gem with Bust of Christ

Dark green jasper / bloodstone in gold frame. 2 × 1.5 × 0.5 cm
Provenance and date unknown
M82.237

The stone has been cut in a very shallow relief, then mounted in a gold band with a ring for suspension. Lightly carved on it is a half-length figure of Christ. It is obviously meant to be a crucifixion because of the short bar behind His head, but His hands are crossed in front. His arms and chest are bare, but the line across the waist suggests a loin cloth. His hair and beard are long and shaggy, and the facial expression, with its closed eyes and open mouth, is clearly one of fatigue and anguish. There is a sense of size and bulk in this figure, in spite of the shallow carving. The shoulders are broad and the pectoral muscles are clearly marked. Yet the hands have been reduced to a series of little scratches. The background is filled with diagonal hatching. The style of the hair and beard on this figure of Christ suggests a Western rather than a Byzantine provenance, but it is not possible to be more specific as to the actual country of origin. Carved

STAINED GLASS

The four pieces of stained glass in the Malcove Collection present a typical example of the problems facing collectors, curators, or scholars who want to study glass painting of European origin, which eventually came to the North American continent. Most often those pieces have been acquired through art dealers, as is the case here. They, in turn, might have found them either at auction sales of former collections or through another dealer or a glass-painter who collected them out of artistic as well as professional interest. If the English collector of the eighteenth century depended on dealers who gathered the pieces on the continent, often in the location of origin, and speculated on the new antiquarian fashion, the North American collector of the late nineteenth and twentieth centuries was even more dependant on the art dealers, as the number of intermediaries had vastly increased in the meantime.

Forgeries or tampering, though not a new problem, developed to an astonishing degree in the nineteenth century. In the field of glass-painting there can be good copies, made as such by honest glasspainters, which later passed as genuine antique pieces, knowingly or not. Or there can be willful imitation, often painted on old glass. Another frequent occurence involves tampering with old glass fragments, more or less carefully assembled, often mixed with modern glass, in order to produce a piece which might appeal to the unknowing collector.

This is why the North American collections must be subjected to a very critical examination which has to follow two main lines. The first is a matter of connoisseurship, taking into account the artistic evidence (draughtmanship, composition, style, and comparing it to well known and documented works in Europe) as well as the technical evidence (quality of the glass and the leading, signs of corrosion, eventually analysis of the enamels and varnishes). The second line is an effort to retrace the succession of ownership through the dealers, the sales catalogues, or the collectors' catalogues, in hope of finding the place of origin. Both lines of research are long and painstaking but can be rewarded with the occasional finding of good original pieces, or even with 'the' piece missing in a known group.

The following entries give only preliminary indication on these lines of research. See also Jean Lafond, 'The Traffic of old Stained Glass from Abroad during the 18th and 19th century in England,' *Journal of the British Society of Master Glass-Painters*, XIV, 1, 1964, 58–67; Réau [cat. 405]; N.H.J. Westlake, *A History of Design in Painted Glass* (London 1881–94).

429 A Saint / Bishop resurrecting a child

Stained glass panel, grisaille and silver stain on white glass.
20.7 × 14 cm
German or Lower Rhine, 16th century M82.157

A saint / bishop stands, holding a bejewelled cross-staff (the cross attached to the staff by a tabernacle) in the left hand and blessing a child arising from a small plain sarcophagus. The figure may be St Nicholas, but he is usually shown with three children. One might suggest St Peter resurrecting Theophil's son (Réau [cat. 405], III, 3, pp. 1083, 1090, 1094). In the background, a few village buildings are seen across a river. The glass is slightly greenish, with some elongated bubbles and wavelets. A few cracks in the lower part of the panel have been carefully repaired with thin leading which looks old, while a missing triangular piece, near the lower right corner, has been replaced and painted with a grisaille of a different, darker brown – evidently a modern repair. The original grisaille paint is brown, slightly reddish, with two tones of lighter wash, the modelling done with the brush (putois) and the lights being taken with the stick. The quality of the piece seems to indicate a good example of popular glass painting of the sixteenth century. Note especially the negative outline in white, taken with the stick, which marks the edges of the bishop's cloak and a few pleats, as well as the black outline of the child.

Purchased from Glueckselig and Son, New York, December 1963 AI

430 A Vision to a bishop of God the Father, surrounded by angels

Stained glass panel, pot-metal glass and white glass painted with grisaille and silverstain. 59 × 80 cm
Flemish (?), 15th century (?) M82.283

This interesting panel is a typical product of much tampering. It seems to have been completely releaded and a great proportion of the glass is modern, but the result is to put at a certain advantage a few genuine parts of good quality and very fine draughtmanship in grisaille and silverstain, dating probably from the fifteenth century, for example, the head and the hands of the bishop, part of the head and the hands of God and two of the angels. Parts of the decorative and architectural borders seem genuine too and remind us of similar ones in St Ouen de Rouen

(fourteenth century), although they can be found also in Flemish or English glass of the fifteenth century.
It should be noted that it is unusual for a figure to impinge on the architectural border, as does the bishop's head.

Purchased from Glueckselig and Son, New York, December 1963 AI

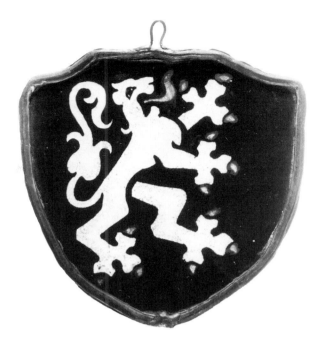

431 Quatre-feuilles

Stained glass panel, pot-metal glass,
murrey, yellow and red. 13 × 13 cm
Provenance and date unknown

M82.197

This piece seems to be a modern
attempt at imitating a *boss*, a small
decorative piece used to join different
medallions in a window or as centre-
piece in large grisaille windows. The
general outline reminds us of a simi-
lar boss of the fourteenth century
(N.H.J. Westlake, *A History of De-
sign in Painted Glass* (London 1881–
94), II, fig. XCIC, p. 109), but the
crudeness and flatness of the leading,
the sketchiness of the painting (pur-
plish enamel, the outline taken with
the stick, the inside by brushwork),
and above all the matte varnish
covering the back point either to a
modern piece or to a much altered
old one. AI

432 Heraldic shield

Stained glass panel, black and red
enamel paint on white glass.
11 × 11 cm
British, modern M82.196

The shield holds a silver lion rampart,
armed and langued in gules.
Although the glass seems ancient
(wavy and unequal), the thickness
of the black paint and the careless
way in which the red enamel is ap-
plied on the back point to a modern
origin, perhaps British, as these sub-
jects are common in Great Britain. It
is to be noted also that the shape of
the shield is unorthodox and that the
modelling of the lion, by brushwork, is
not usual in heraldry. AI

433 Large chest

Oak, strengthened with iron bands; iron lock and lockplate.
62 × 176 × 68 cm
Northern German, late 15th–early 16th century M82.297

Chests were among the most numerous and important forms of mediaeval furniture. In addition to being used for storage, they were also used to decorative effect, and in some instances were used for seating and as beds. The Malcove chest is of a standard type associated with the north of Germany during the 1400s and early 1500s. While the Malcove example is severely plain, some were decorated with carving in low relief, as shown by a chest of circa 1400 in the collection of the Museum für Kunst und Gewerbe in Hamburg (cf Heinrich Kreisel, *Die Kunst des deutschen Möbels*, vol. 1, Munich 1968, fig. 36). Ironwork, providing additional strength and serving a decorative purpose as well, is a prominent feature of chests of the Malcove type. In some examples, ironwork and carving are combined, as on a fifteenth-century chest with carved supports of Northwest German origin, now in the collection of the Kurpfalzisches Museum in Heidelberg (Kreisel, fig. 42). During the sixteenth century the use of carving for ornamental purposes increased on north German chests of the same general type as the Malcove example. By the 1540s such carved ornament had taken on a recognizable German Renaissance character, as seen on a Luneberg chest of 1545 in the Hamburg Museum für Kunst und Gewerbe (Kreisel, fig. 281). The Malcove chest conforms in its proportions and in the decorative features of its ironwork to North German chests of the late 1400s and perhaps early 1500s. While it is possible to recognize the Malcove chest as conforming in every respect to those of North German origin, its specific region of manufacture is at present impossible to define in more precise terms. Chests of the same general construction and decoration appear to have been made in many parts of northern Germany, from Westphalia eastwards through the whole Bremen-Lüneberg-Lübeck-Hamburg region.

A chest of the same period, approximately, as the Malcove chest, also of North German origin, is in the collection of the European Department of the Royal Ontario Museum in Toronto, but is less well preserved.

Purchased from Parke-Bernet, New York, February 1963, catalogue, 14–15 February 1963, no. 395. KCK

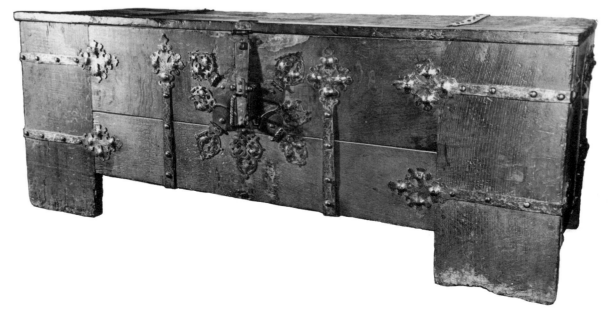

434 Cupboard or armoire

Wood. 102 × 76 × 38 cm
English (?), late 15th–early 16th
century (?) M82.296

The doors are pierced with Gothic
tracery and rosettes. Cupboards with
pierced doors were often used for
the storage of food, but in the absence
of documentation it is not possible
to assert absolutely that because
a cupboard exists with pierced doors
it must have been used for food stor-
age (Penelope Eames, *Furniture in
England, France and the Netherlands
from the Twelfth to the Fifteenth
Century*, London 1977, p. 9). Cup-
boards similar to the Malcove cup-
board are found in numerous public

collections. The arrangement of doors
varies. Some, such as an English
cupboard of the fifteenth century in
the Metropolitan Museum in New
York, have a single hinged door
(Katherine Morrison McClinton, *An
Outline of Period Furniture*, New
York 1972, p. 16). On some others –
also regarded as English but dated as
late as the middle years of the six-
teenth century – there are two doors
arranged vertically, one above the
other (cf Hermann Schmitz, *The En-
cyclopaedia of Furniture*, London
1926, pls. 56–7, examples in the Vic-
toria and Albert Museum, London).
The tracery on the Malcove cup-
board is of a type that survives on
examples of English furniture into
the sixteenth century, and the carved

and pierced rosettes have parallels
on examples of English furniture of
th early sixteenth century, such as
that on the side of a carved oak panel
of a side table in the Victoria and
Albert Museum, London (Schmitz,
pl. 138, and Louise Ade Boger, *The
Complete Guide to Furniture Styles*,
New York 1969, enlarged ed., fig. 24).

The authenticity of the cupboard is
a moot point. Many surviving exam-
ples of similar 'mediaeval' furniture
have been subjected to extensive
restoration and repairs. Some are
composites made up from pieces from
different sources and indeed from
different periods, while others have
even been regarded as forgeries (cf
Hervert Cescinsky, *The Gentle Art of
Faking Furniture*, London 1931, pp.
41–51, and pls. 30–1). The possibility
that the Malcove cupboard includes
restored or replaced parts, or that
it is in its present form a pastiche,
cannot be entirely discounted. KCK

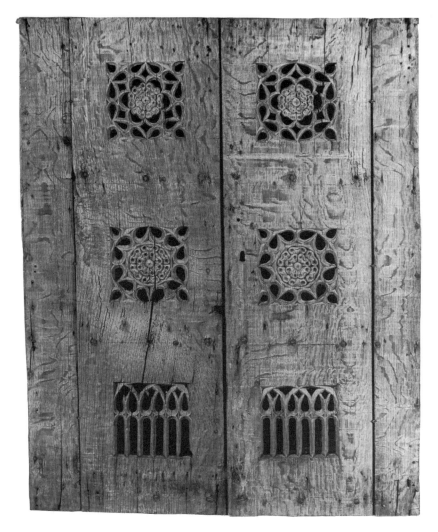

435 Cupboard or armoire

Wood. 116 × 117 × 45 cm
English (?), 16th century (?) M82.293

This is one of two related types of
cupboard in the Malcove Collection
distinguishable by the presence of
piercings on the front, probably in-
tended for the purpose of ventilation.
This example is similar to a general
Late Mediaeval type with a single
hinged door and pierced tracery in
two zones or levels on the front
panels on each side of the door. Cup-
boards with pierced tracery are
sometimes referred to as 'food cup-
boards' or 'livery cupboards' (Boger
[cat. 434], fig. 22, and Ralph Edwards,
*The Shorter Dictionary of English
Furniture*, London 1964, pp. 291–3).
As Penelope Eames has noted, how-
ever, pierced sections on a cupboard
are not in themselves conclusive
proof that the cupboard was used for
food storage (Eames [cat. 434], p. 9),
although they may indicate any
general use for which air circulation
was desired.

The date and origin of this second
Malcove cupboard of so-called 'liv-
ery' type are difficult to ascertain
with certainty. Most surviving pieces
of this type are extensively restored,
and in some cases are pastiches of
elements from different sources. The
cupboard may be of English origin,
but of course similar cupboards were
also made in France, the Nether-
lands, and elsewhere in Gothic Eu-
rope. Gothic tracery is found on some
examples of case furniture into the
first third at least of the sixteenth
century, and it is possible from the
stylized form of the traceried open-
ings on this cupboard that they are
closer in style to examples of six-
teenth- rather than fifteenth-century
type.

Regardless of any restoration to
which this cupboard may have been
subjected, it preserves in its present
state the general shape and over-
all appearance of single-doored
cupboards of Late Mediaeval type
that are known both from illustra-
tions in Late Mediaeval art and from
surviving examples in various public
and private collections. KCK

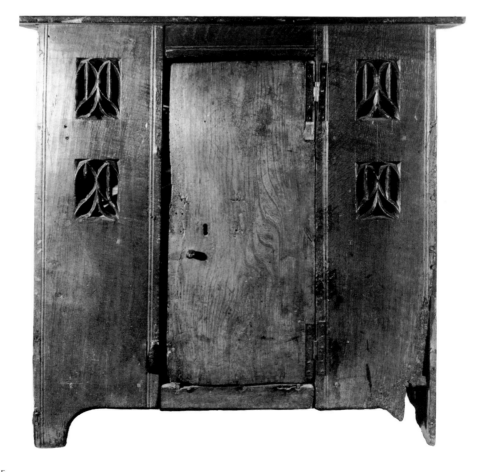

436 Cupboard and wall panelling

Oak, panels and frames weathered, some worm (?) damage visible. Doors, lids, and drawers provided with iron mounts.
Netherlandish or French, late 15th– early 16th century M82.292

The assemblage of panels and frames represents a composite or pastiche, the separate elements combined in the former Malcove residence to form a panelled wall section, closet, cupboard, and bench. The traceried doors and drawer front of the cupboard are similar to examples of carved architectural tracery associated with fifteenth- and indeed early sixteenth-century wooden panels of French and Netherlandish origin (Schmitz [cat. 434], pls. 42–50). The post on the right side of the cupboard – with spiral decoration – is similar in its ornamental form to examples of Late Gothic architectural carving which were in fashion through the fifteenth century into the early years of the sixteenth, as shown for example by the carved posts of 1511 from the benches of the Rolzaal at The Hague now preserved in the collection of the Rijksmuseum, Amsterdam (Rijksmuseum Amsterdam, *Catalogue van Meubelen*, Amsterdam 1952, no. 14, fig. 8). The linenfold panels also compare with French and Netherlandish examples of the late 1400s–early 1500s. The horizontally mounted linenfold panel of the cupboard front looks incongruous at first glance, but it appears that both horizontal and vertical arrangements of linenfold panels were known during the fifteenth and early sixteenth centuries, and authentic furniture of the period with both dispositions of linenfold panels is known (Eames [cat. 434], Appendix IX, p. 274). The panels over the cupboard and over the door of the closet are of types that are frequently dated to the early 1500s and may be compared with examples regarded as Netherlandish in origin – both Flemish and Dutch (Rijksmuseum, no. 168, 182, fig. 5–6).

Considering the provenance of the panels, it is reasonable to assume that they are of Netherlandish origin, though they could as easily have emanated from eastern France. As assembled for the Malcove residence the panels and frames appear to be a mixture of genuine and restored parts. The majority of the panels, however, are perhaps rightly to be regarded as genuine, though it is possible that they were assembled from different sources. This would be typical for much surviving work of this type, and the Malcove panels

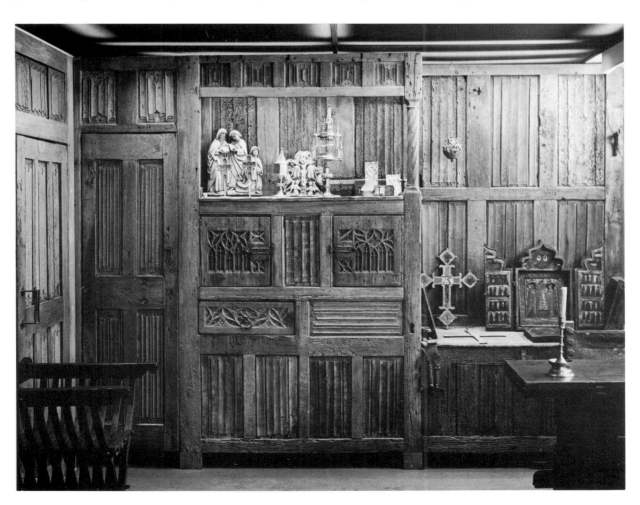

and frames, regardless of how they have been assembled, constitute an impressive collection. Surviving records refer to conservation work carried out on this panelling in 1961 and 1962.

From the Baron Castle van Doorn Collection

Purchased from Blumka Gallery, New York, 1961 KCK

437 Cupboard

Wood, oak. 149.5 × 134 × 59.5 cm
French or Netherlandish, late 15th–
early 16th century M82.294

There are splits in some of the boards along the top and along other boards or panels of the cupboard, some worm damage, and some minor losses of material (eg, one small piece of molding near the right corner of the base is missing). The cupboard is held together with wooden dowels or pegs. The doors and drawers are provided with iron hinges and pulls.

This piece of furniture is of a type variously termed a cupboard, dresser, dressoir, or credence. Cupboards of

this form are related to mediaeval sideboards in the form of shelves used for serving purposes at meals and banquets and for the display and storage of plate. A sideboard of that type is seen in the *Très Riches Heures* of Jean Duc de Berry, while a sideboard of Flemish type of the early sixteenth century is seen in one of the illuminations of the *Grimani Breviary* in the Biblioteca Marciana, Venice (cf Stefan Bursche, *Tafelzier des Barock*, Munich 1974, pl. 2). Shelved structures with doors, as in the Malcove Collection cupboard, are also shown in Late Mediaeval works of art, in paintings and manuscript representations, and are recorded in extant examples in public

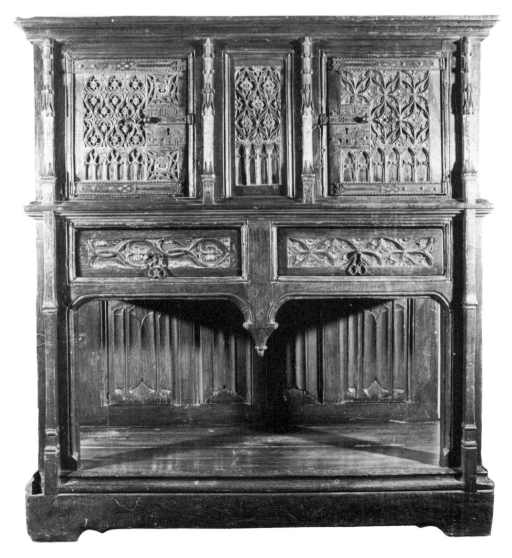

and private collections. Many of these cupboards which survive in public and private collections have been subjected to considerable restoration, and this may be the case with the Malcove example. The differences in style and workmanship of the blind tracery of the doors and drawers point to this possibility. While the Malcove cupboard is probably a composite, it preserves the general features of cupboards made in Gothic Europe at the end of the Middle Ages, including such miniature architectural features as crocketed pinnacles used as decorative features and blind tracery of types associated with the late fifteenth and early sixteenth century. It may be assumed that the Malcove cupboard conforms in general to the stylistic features of Late Gothic cupboards attributed to France and the Netherlands. The tracery of the doors of the cabinet is perhaps closest to examples considered to be of French origin (cf Schmitz [cat. 434], pls. 43–5). The presence of linenfold panels is a feature common to cupboards of this type, and here again the detailing is often associated with French examples (cf Boger [cat. 434], fig. 31).

While cupboards similar to this one were used in Late Mediaeval domestic interiors, others were used in church sanctuaries for the storage and provision of ecclesiastical plate during Mass.　　　　　　KCK

438 Chair

Wood, leather, brass.
100 × 50 × 37 cm
Spanish, late 16th, early 17th century (?)　　　　M82.302

The wooden parts of the chair show some splitting and minor worm damage. The leather seat covering, attached to the frame with brass rosettes, is dry and cracked, with some minor surface losses along the front. This chair is in its construction and decoration typical of a class of Spanish chairs which is usually associated with the sixteenth century, though the oval and rectangular

panels of the back are features that could as easily be dated to the early years of the seventeenth century. Examples which, like the Malcove chair, have aditional decoration in the form of armorial devices are recorded in both private and public collections (cf Schmitz [cat. 434], pl. 159).

The leather seat covering attached by nails with large brass rosettes is another feature of this chair which bears comparison with similar features of Spanish chairs of the sixteenth century (cf Harold Donaldson Eberlein and Roger Wearne Ramsdell, *The Practical Book of Italian, Spanish and Portuguese Furniture*, Philadelphia and London 1927, pls. 110c and 111c), and early seven-

teenth century. As research on the furniture of the Malcove Collection is still in its early phase, it has not yet been possible to identify fully the armorials on the back of this particular chair.

Purchased from Charles Tauss, New York, 1963　　　　KCK

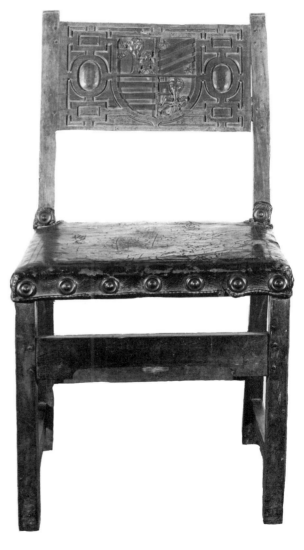

439 Trestle table with folding top

Oak (?), some parts showing worm damage. 80 × 146 × 51 cm
German (?), 16th–17th century

M82.299

Attached to the vasiform end supports of the table are projecting wings with moulded edges. The wings provide support for the top panel of the table when it is in an open position. When the folding top is closed, the hinged upper panel is held in position by hooks and eyes.

The vasiform shape of the uprights supporting the hinged top shows the influence of classical form, and may have been made in emulation of Italian table types (Schottmüller [cat. 402], figs. 293–304). In spite of the similarity of the shape of the uprights to those of some Italian Cinquecento tables, it is likely – indeed probable – that this table is of northern facture, and may be of German origin. The chamfered edges of the crosspiece connecting the uprights recall those of numerous German trestle tables of dates extending to the end of the sixteenth century. The moulded profiles of the 'wings' recall the profiles of the late sixteenth- and early seventeenth-century German furniture, for example of the upper structures of small altarpieces known as house altars, and the construction of the table itself, with extending wings to support the folding panel of the top, is close to that of a type of German table known as a 'Wangentisch' or 'Flügeltisch' of which examples dated to the sixteenth century are documented in German museum collections (cf Kreisel [cat. 433], fig. 342, a table in the Städtisches Museum, Flensburg; fig. 242, a 'Hausaltar' of circa 1560–70 in the Munich Schatzkammer; fig. 268, a 'Flügeltisch' in the Hessisches Landesmuseum, Darmstadt). The moulded lower edges of the wing supports, though based on cross-sections of mouldings of classically derived type, recall the moulded edges of the supports of some Late Gothic tables of German origin where the sections are based on Gothic mouldings (cf Eric Mercer, *Furniture 700-1700*, New York 1969, pl. 81, showing a table of circa 1500 from the Abbey at Rheingau). The Malcove folding-top table would seem to conform to a German type of the late sixteenth or early seventeenth century. Tables with folding tops, however, were made in many parts of Europe from the sixteenth century onward. Their shapes varied, and in addition to those with rectangular or square tops there were others which were semi-circular, polygonal, and triangular in shape (S.W. Wolsey and R.W.P. Luff, *Furniture in England: The Age of the Joiner*, New York and Washington 1969, p. 52, and figs. 67, 69–72, 74–6). At least one example, considered to be of French origin, and with Late Gothic linenfold and tracery decoration, is considered by some commentators to be of even earlier date and has been regarded as a work of the fifteenth century (cf Boger

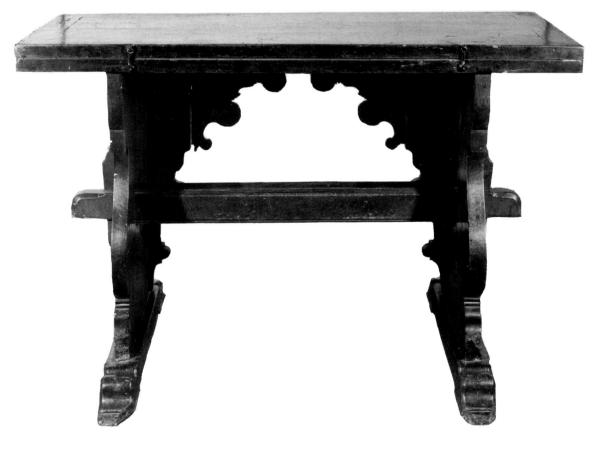

[cat. 434], fig. 26). Generally, however, tables with folding tops did not become common in Europe until the sixteenth century and later.

From the Figdor Collection KCK

440 Chair

Wood with tooled leather seat and back, leather mounts attached by metal (brass or iron?) rosettes.
92 × 48 × 37 cm
Spanish, 17th century M82.301

The leather shows various areas of wear. At least one of the metal rosettes is missing. There is obvious wear to the legs and stretchers. The chair is of a common seventeenth-century type. The front stretcher with shaped underside is found on many Spanish chairs of the period (cf Eberlein and Ramsdell [cat. 438], fig. 26c). The punched and tooled leather fittings are typical of Spanish work of the same period, as are the incised metal rosettes (ibid., fig. 19).

KCK

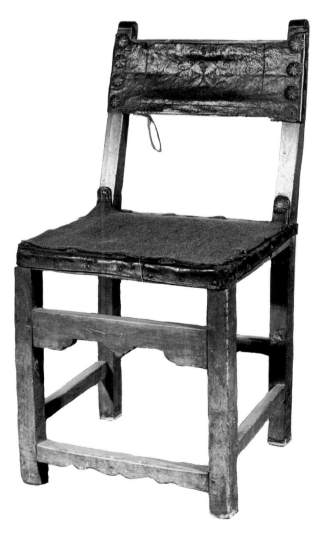

441–3 Three chairs

Walnut decorated with gouge
carving and baluster-shaped spindles.
80 × 35 × 37 cm
Spanish, 17th century

M82.303, 304, 305

The chairs are of Spanish type. Chairs
of this form, with similar gouge-
carved and spindle ornament, are
usually dated to the seventeenth
century. It is difficult to date the
Malcove chairs, as they are of a rela-
tively conservative type made over
a long period of time. Their propor-
tions, however, suggest that they
may date from as early as the middle
years of the century, possibly even
somewhat earlier. Chairs of the same
form and decoration are illustrated
in most anthologies of Spanish furni-
ture (eg, Eberlein and Ramsdell [cat.

438], pl. 128). The arched cutouts
along the top section of the back are
a common feature found on many
Spanish chairs of this type (cf Boger
[cat. 434], fig. 63).

Purchased from Charles Tauss, New
York, 1963 KCK

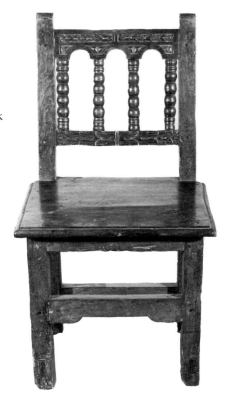

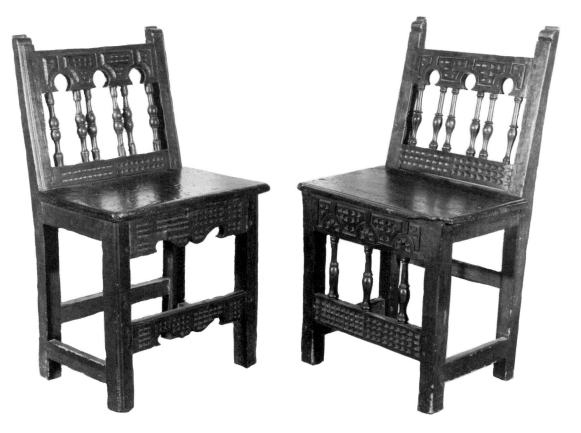

444 Savonarola chair

Walnut, decorated with gouge
carving. 80 × 60 × 56 cm
North or Central Italian, late 15th–
early 16th century M82.300

The Savonarola chair, with its gently
curving crossed supports and overall
lightness of construction, is one of
the most elegant forms of furniture
associated with the Early Renais-
sance in Italy. Most surviving chairs
of the same form are dated to the
late 1400s and early 1500s. The x-
shaped supports relate to earlier
forms of folding chairs and stools,
dating back through mediaeval fold-
stools to the folding stools of Roman
military commanders. A related form
of Renaissance chair is the
'Dantesca,' which has, however,
fewer cross pieces and is of more
massive construction. Decoration of
Savonarola chairs is minimal, often
confined to light gouge carving along
the front of the seat and supports.
The arm rests sometimes show a
slightly curved profile. The back
rests, normally pivoted on one side,
and removable, are sometimes noth-
ing more than a rectangular board
though many feature simple shaping
along the top and bottom edges and
shallow geometric carving.

The Malcove chair is similar to
one in the European Department of
the Royal Ontario Museum, no.
938.16.3 (David McTavish, K. Corey
Keeble, Katharine Lochnan, and
Sybille Pantazzi, *The Arts of Italy in
Toronto Collections 1300–1800,* To-
ronto 1981, no. 227). Comparable
types are in numerous public collec-
tions and private collections (Schott-
müller [cat. 402], p. 175, fig. 405).
Both the Malcove and ROM chairs are
of a plainness of manufacture that
places them among those types re-
ferred to in Italian museum cata-
logues as 'art popolare' (Rosa [cat.
402], no. 281).

Purchased from Glueckselig and Son,
New York, 1963 KCK

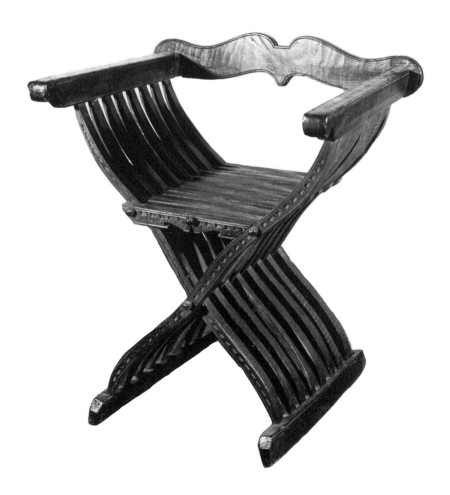

445 Stool

Oak. 52 × 39 × 24.5 cm
Western European, late 15th–early
16th century M82.295

The seat has an s-shaped opening cut
through its centre. The component
parts of the chair are held together by
wooden pegs and wedges. The seat
shows considerable worm damage
along its edges and one of the end
panels is split.

Stools of this form are sometimes
referred to as 'board-ended' stools
or stools of 'trestle form,' and are typ-
ical examples of joiners' work of
Late Gothic Europe. While some ex-
amples are dated to the fifteenth
century, others in the same style
have been dated to the early years of
the sixteenth century (John Gloag,
The Englishman's Chair, London
1964, pl. 16). It is evident that stools
of this type were made over a long
period of time with little stylistic or
constructional change. They are
shown in paintings of the fifteenth
and early sixteenth centuries, and

examples are seen in the Altarpiece
of the Sacrement of Dieric Bouts
in the church of St Pierre at Louvain,
and in a Holy Family by Joos van
Cleve in the collection of the Kunst-
historisches Museum in Vienna, to
cite only two examples (cf Max
J. Fiedlaender, *From Van Eyck to
Bruegel*, London 1956, rev. ed. 1965,
pls. 81 and 199). The moulded cross-
pieces under the seats of stools of
this essentially Late Gothic type were
sometimes decorated with carved
ornament in low relief (Ralph Ed-
wards, *The Shorter Dictionary of
English Furniture*, London 1964,
p. 500, fig. 2).

It is possible that this stool is of
Netherlandish origin, but stools of
similar form and construction were
also made in England, in France,
Germany, and other parts of Western
Europe. While it may be of specifi-
cally Netherlandish origin, it never-
theless represents a general Western
European form of stool in common
use throughout the years of the fif-
teenth and early sixteenth centuries.

From the Baron Cassel van Doorn
Collection

Purchased from Blumka Gallery,
New York, 1967 KCK

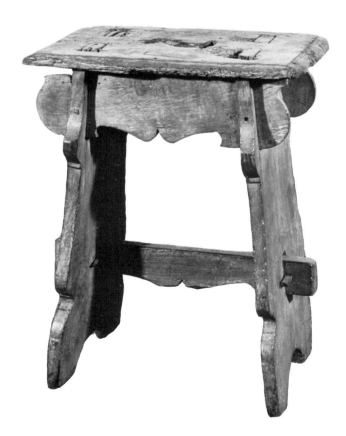

446 Chair

Oak (?) with carved mouldings, arcades at the sides, and shallow relief carving along the sides.
129 × 69.6 cm; length of side panels 53.5 cm; platform base:
9.5 × 79.5 × 67.2 cm
Scandinavian, date uncertain, possibly early 19th century M82.298

Some of the wooden parts are badly wormed. The back of the chair is formed of two boards, the top board with a moulding along its lower edge, the lower board with a moulding along both top and bottom edges.

The box seat has a panelled front, and is set in from the front of the side panels. The seat is roughly cut.

The right side panel of the chair is decorated with an arcade and chip-carved rondels with a low relief figure of an animal. The left side panel, however, is plain on its outside surface and shows no decoration other than the arcading cut into its side and a grooved moulding down the front.

The thickness of the arms is about 3.7 cm at the most, while the back is about 2.5 cm at is maximum thickness. Heavy wrought-iron nails are to be seen at both the back and

front of the chair. The box seat is supported at the back by a modern wooden support.

Chairs of similar box-like construction with slab-like sides were produced in Europe during the Middle Ages. Some examples were made of wood, but others, such as an Italo-Byzantine example of the tenth-eleventh century were of stone (cf Schmitz [cat. 434], pl. 25). Examples of the fifteenth and early sixteenth centuries north of the Alps were frequently ornamented with panels and carved decoration in Gothic style, with combinations of tracery and linenfold panelling (cf Frank Davis, *A Picture History of Furniture*, London 1958, fig. 17, and Eames [cat. 434], pl. 69). On some examples, linenfold panels only occur. On Gothic examples the backs were often of exaggerated height. While of imposing, throne-like appearance, these box-like chairs were of relatively simple construction and provided a basic model for emulation over a long period of time, eventually passing into a distinctively folk-art idiom. While the decoration of the Malcove chair may distantly recall certain Romanesque motives, it is certainly of more recent origin and has its closest parallels in the decoration of furniture of distinctly folk or ethnographic type, of which the most characteristic examples are to be found in Scandinavia as recently as the eighteenth and nineteenth centuries. The spiral decoration in the rondels over the columns of the arcade on the right side panel of the Malcove chair is similar to that found on some Scandinavian furniture, including Danish examples, dated as late as the 1770s (cf Axel Steensberg, *Danske Bondemøbler*, Copenhagen 1949, figs. 107 and 108). The six pointed motives in rondels seen at the top of the panel of the Malcove chair and below the arcade also have specific parallels in Scandinavian folk furniture of comparatively recent origin, including, as above, Danish examples from the late eighteenth and early nineteenth centuries (ibid., fig. 139).

KCK

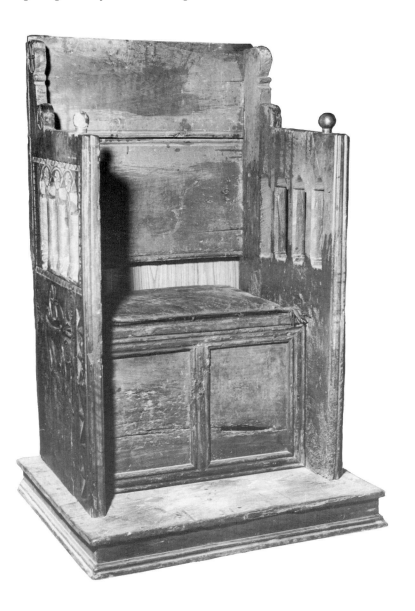

447 Tilt-top pedestal table

Mahogany.
Height: top flat 69.7–70.3 cm; top up
119.8 cm, top 89.5–80.7 × 67 cm
English or Scottish, circa 1800

M82.485

This tilt-top pedestal table is mahogany. The three sabre legs are cut down the outside with four reeds terminating in crescents at the top. The tips are mounted with brass sabots and casters. The heavy urn pedestal sitting on a cylindrical base consists of a low ovoid body with three reeds around the top and long neck. The square block at the top is surmounted by larger rectangles, the lower one pine and the top, mahogany. The rectangular top is cut at the corners and edged with a moulding of three reeds. A rectangular arrangement of mahogany stretchers is glued and screwed under the top. The top hinges on pins put in at the side stretchers of this arrangement. The top itself is made up of two pieces of mahogany. To hold it in position when horizontal, a cast brass draw-latch with T-form mount is screwed to the underside.

The finish shows overall scratching and staining. The top is somewhat faded, with several cracks and the finish 'alligatored.'

This table is a well-made standard piece produced in England or Scotland about 1800. Most of the antique furniture in the Malcove Collection is the type that could have been made by similarly trained craftsmen using standard pattern books anywhere in the British Isles. The dating for this and the other pieces is based on style, construction, form, materials, and evidence of wear. This table was likely originally used for tea and possibly breakfast. For a similar model, only of much finer quality, see Thomas Sheraton, *The Cabinet-Maker and Upholsterer's Drawing-Book* (London 1792–5, repr. New York 1970), fig. 38, pl. 25, opposite p.315.

PK

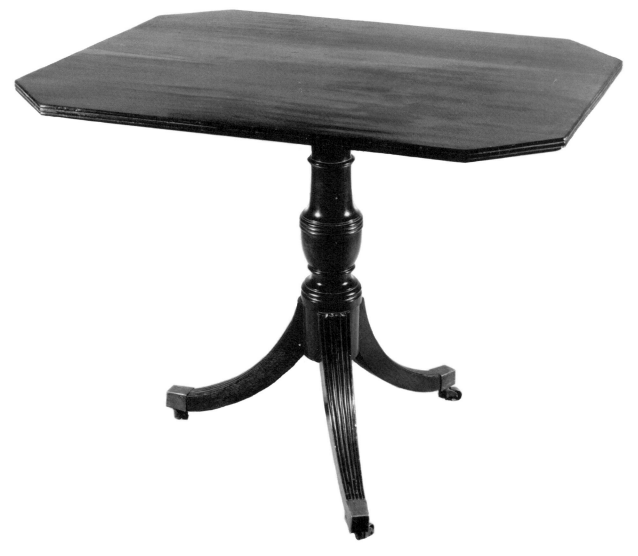

448 Card table

Mahogany, pine, possibly beech.
78–78.6 × 91.5–91.7 × 45 cm
English or Scottish, circa 1800–15

M82.510

This card table has been altered into a console or side table. The woods include veneers of mahogany with solid mahogany, pine, and possibly beech. The oblong top with front rounded corners follows a shape sometimes referred to as 'D-ended.' The fancy figured mahogany veneer panel in the centre of the top is surrounded by a rosewood border with inner stringing of bright yellow boxwood. Originally the edge of the top may have been veneered or 'ebonized' (painted black). The carcass wood is now exposed. The back apron is of plain mahogany. The front and sides are veneered with a central tablet to the front of fancy mahogany veneer outlined in a striped veneer border of exotic wood edged on both sides with satinwood stringing. This front tablet is flanked on either side by figured mahogany veneer with three horizontal strips of boxwood stringing with discs at the ends, the central strip being longer and the other two of equal length. Similar figured veneer and stringing is found on the ends. Small panels of fancy mahogany veneer surrounded by stringing cover the apron section of the tapering square mahogany legs with therme feet.

Remains of a covering of green baize show up under the top and the central crosspiece. Surface remains of glue and wood indicate that a till compartment was located to one side of the top. Hardwood corner blocks have been cut to fit the legs in recent years and have been secured with screws. This piece was originally a card table with two hinged top leaves and an inner lining of green baize. Two pull supports appear to have slid out from under the top. Probably because of damage, it was altered to its present form. The legs have been refinished. Cracking appears along the grain of the carcass wood on the top and there are losses to the veneers, especially at the borders. The finish shows the usual signs of wear and discolouration. This piece was originally made as a fine quality card table in England or Scotland about 1800–15.

For a full discussion of the designs of such card tables and their use see Benjamin A. Hewitt, Patricia E. Kane, and Gerald W.R. Ward, *The Work of Many Hands: Card Tables in Federal America 1790–1820* (New Haven 1982). PK

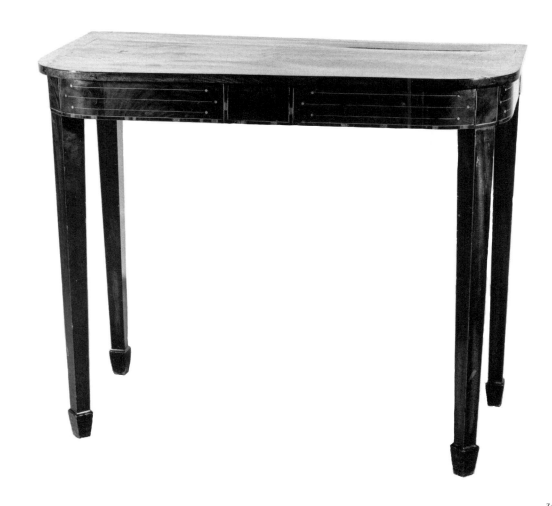

449 Drop leaf pedestal table

Mahogany, beech, maple.
74 × 121 × 62 cm, leaves 17.2 cm
English or Scottish, circa 1820

M82.477

This drop-leaf pedestal table is constructed of mahogany, with beech and / or maple as secondary woods. The rectangular top has two convex reeds at the edge. The two narrow drop leaves extend along the length. The four upcurving sabre legs terminate in brass sabots and casters and have a wide convex central reed and two narrower ones cut into their top surfaces. The step and console curves at the top of the legs meet at a thick rectangular plinth with champfered corners. The plinth is beech or maple with a mahogany veneer. From the plinth rises a rectangular central column, likely of similar construction, with flat cushion moulding and quarter reel moulding around the base. The top is mounted on this column by a glued and screwed shallow box of beech.

Surrounding this box is a larger arrangement of square mahogany moulding screwed and glued under the top and fitted with pivotted supports for leaves fitted into the sides. Wrought-iron braces and screws strengthen the legs.

The legs are faded, scratched, and discoloured. The top is also faded but in better condition and appears to have been refinished. The leaves seem unusually narrow and may have been reduced in width. Worm holes appear on the inner beech mounts around the column and in the plinth block.

The overall heaviness and the reel mouldings suggest a date about 1820 for this English or Scottish table. PK

450 Oval occasional table

Mahogany and maple.
71 cm; top 47 × 38 cm
British or American, circa 1880–1915
M82.481

The oval occasional table is constructed of mahogany and probably maple with other woods and veneers. The heavy top is veneered with darkly grained mahogany edged with purplewood with an inner string of boxwood. Its side is thickly veneered in a light coloured wood. The hinged top opens to reveal a shallow compartment. The top of the apron and the side are veneered in mahogany with a dark coloured band of ebony with equal bands of boxwood to either side around the base. The long tapering square legs have boxwood stringing down the corners. A simulated keyhole with oval boxwood escutcheon ornaments the front of the apron. The bottom of the compartment, which was possibly replaced, appears to be cigar-box mahogany or possibly plywood with pine blocks glued around the edge.

Some buckling and repairs are evident in the veneer. At least four cracks run lengthwise across the top with smaller cracks depthwise near the ends. This table appears to have been refinished. The top is too heavy and imbalances the support structure when opened.

Although this table shows some influence of Thomas Sheraton's designs, it is likely to be circa 1880–1915 given the dark colour and plain, heavy grain of the mahogany. Similar pieces were made at that time in Britain and America. On the bottom, 'No. 4640' is printed in red crayon. A similar number is found on the bottom of the night table in catalogue 460. These inventory numbers suggest that both pieces may have come from a similar source. PK

451 Coffee table

Mahogany, boxwood, oak.
51 cm; top 71 × 48.2 cm
English or American, circa 1920–50
M82.509

The oval coffee table is manufactured of mahogany and other woods. The tray top has a mahogany rim rising to scroll-form handles at the ends. Its center is veneered with a large oval patera (segmented medallion) of boxwood segments, mahogany border, and a surround of boxwood stringing. This pattern is set against a ground composed of mahogany veneer arranged in four quadrants to create a mirror-image grain. This oval is bordered with satinwood or figured birch with inner string bands of ebony and boxwood. A convex moulding extends around the edge of the top. The oak apron is built up of eight arc segments lapped together and veneered with mahogany, with a narrow band of tulip, and tulip and box stringing to the top and the base, respectively. The bottom of the apron is painted black. The four, square mahogany legs are constricted at the top with pronounced convex moulding below and a tapering lower section. The underside of the top is of unfinished maple or birch, possibly the top layer of plywood. Eight countersunk screws secure the apron and legs to the top. The veneer exhibits minor blistering and discolouring, with some wear to the finish.

This table is an American or English form of the twentieth century, circa 1920–50. The model number 2470 inscribed in black china pencil appears on the bottom. It is a typical piece of 'period-style' decorator furniture. Coffee tables to set in front of sofas did not exist before the twentieth century. The top loosely follows a traditional English tray form of the late eighteenth century. PK

452 Upholstered stool

Mahogany and beechwood.
47 cm; top 47.5 × 54 cm
English, Adam / Sheraton,
circa 1780–90 M82.480

This rectangular stool has light-col-
oured mahogany legs and beechwood
sides. The sides are slightly bowed
out at the top and stand on four ta-
pering square legs. On the square
top section of the legs are inlays of
pendant half-oval paterae made up of
four sections of boxwood shaded
with hot sand against a green stained
wood half-oval simulating harewood
with narrow boxwood stringing be-
low. The legs curve in and then out
to a square moulding with concave
edges. The tapering lower section has
recessed panels to the outer sides. A
similar raised square moulding proj-
ects just above the pain foot. This
stool has recently been reupholstered
in a pale café-au-lait silk woven
with round black medallions in two
sizes with three designs. This
matches the set of four chairs and
the sofa in catalogue 454. The bottom

is covered with a fabric woven in a
brown and cream Art Deco diamond
pattern. Removal of this covering
and an earlier layer of black hessian
cloth revealed that the legs originally
had cross-braces across the corners,
as did the set of four chairs. In recent
years these braces had been replaced
with rounded v-form hardwood
brackets cut to fit the corners. Under
an earlier layer of rose upholstery
woven with nubby stripes there were
numerous nail holes suggesting that
it was the second or third upholstery
to have been used. Worm holes were
found in the beech. The feet and
edges of the legs are worn and there
seems to be evidence of refinishing.

While such Adam and Sheraton-
style designs have frequently been re-
produced, especially in the late nine-
teenth and early twentieth centuries,
the wear and cross-braces support a
date of circa 1780–90 for this fine
stool. PK

453 Chest of drawers

Mahogany with oak and pine.
76.8 × 79.5 × 45 cm
British, 1755–1800 M82.478

This small chest of drawers is constructed of mahogany with oak and pine as secondary woods. The plain rectangular form has a projecting base with bracket feet and convex moulding around the top. There is a deep bottom drawer with two shallower drawers above and a pair of shallow drawers at the top. All have a cockbead to the edge and veneered fronts. The drawer sides and bottoms are made of mill-sawn oak. Pine dustboards are set between the drawers. The oak slide under the top is fronted with mahogany. The veneered mahogany top has rounded corners and convex moulding along the top edge of the sides and front. The brass drawer pulls have elongated v-shaped bale handles with swelled centres and round plates with incised borders to the ends. Thick brass surrounds are found at the keyhole of every drawer. Small horseshoe shaped bale handles are mounted on the slide. All the brass shows traces of lacquer and gilding. The plain sides and back of the case are painted black.

The veneered top is soiled and damaged, especially along the left edge. Its left front corner and right back corner have been repaired and reveneered. A more minor repair has been made to the right front corner. It has possibly been refinished at some time. Several large tape marks appear on the finish. The drawer pulls may be period or are at least good appropriate replacements. There is no evidence of replacement inside. The pulls on the slide are more likely to be replacements since old holes have been veneered over. The black paint may be a later addition.

This is a good plain standard British piece, circa 1755–1800. For a similar basic chest of drawers but without the slide see George Hepplewhite, *The Cabinet Maker and Upholster's Guide*, 3rd. ed. (London 1794; Dover reprint 1969), pl. 52, top version.

Hepplewhite states, p. 10, ' ... general dimensions 3 feet 6 inches long by 20 inches deep.' See also *The London Cabinet Maker's Union Book of Prices* by a Committee of Masters and Journeymen (London 1824), pp. 1–18, 'A Dressing or Lobby Chest.' The basic chest, 'All Solid. Three Feet long, two feet eight inches high, the ends one foot seven inches wide, plain back, four long drawers in ditto, cock or flush beaded ... ' cost 18 s. (p. 1); 'A Slider Square clamp'd, lined up in front, and faced with mahogany; solid, or lipp'd for cloth; cock beaded, and c. as in start,' cost an extra 2 s. The Malcove chest of drawers would have required additional charges for the arrangement of drawers, veneering, hardware, and locks which would have resulted in a total cost of £3–4 when new. Note that the above publication, although dated 1824, continues the traditional specifications from editions of the 1790s. PK

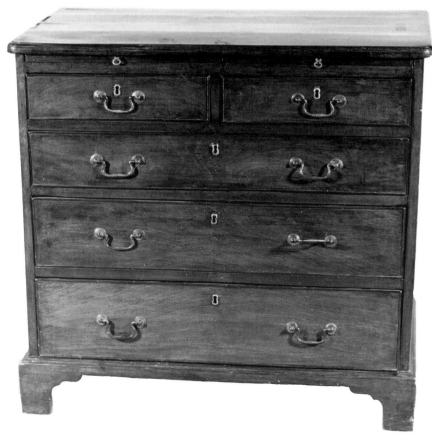

454 Sofa

Maple / Beech. 91.5 × 195.6 × 82 cm
Provenance and date unknown

<div align="right">M82.482</div>

The grain of the show wood of this sofa suggests that it is maple or beech. The camel style back has a large central hump curving down to smaller side humps and continuing down the arms, which curve in below the ends and then bow out to square, slightly splayed feet with rounded outer corners. The seat front is bowed out or in the 'commode' form with two, evenly spaced legs similar to the others. The four corresponding rear legs are splayed back. The café-au-lait silk upholstery matches the set of four chairs and the stool described in catalogue 452 and 456–9. It is edged with a matching double band of piping. A matching single loose cushion fits into the seat and a matching small square throw cushion is available. Steel buttons have been nailed into the tips of the feet.

The finish is worn and exhibits dark spots. The front of the right corner leg, as seen in a front-on view, has been repaired with nails. The front legs have been reinforced with wooden brackets at the tops.

It is difficult to decide on a date for this sofa. Although there is some evidence of wear and repair, it may well be an early twentieth century period-style piece with its second upholstery. The upholstery bears the label of Zeman Co, New York.

The outline of the back and the distribution of the legs bears a general resemblance to pl. 24 in Hepplewhite [cat. 453]. See also ibid., pp. 4–5, where the suggested sofa dimensions correspond approximately to this example.

<div align="right">PK</div>

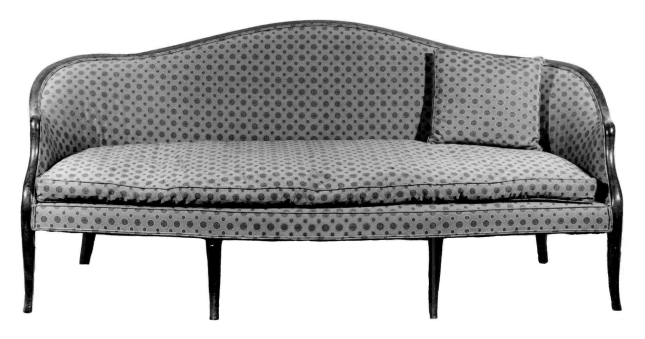

455 Tub chair

Mahogany, leather.
80 × 64 × 70 cm
English, late 18th century (?)

M82.487

This tub chair is constructed of mahogany with unidentified secondary woods. The barrel form has a rounded back curving down to arms which curve in and then swell out above the front legs. Of the four tapering legs, the front pair are slightly cabriole and the rear ones, splayed back. Conical brass caps are attached to the feet with larger brass casters. The upholstery is mottled brown leather with a continuous band of brass tacks along the edges. New, rounded v-form corner blocks are set inside the seat.

One foot has been broken off above the cap and repaired. The leather of the seat area is faded and cracked. The mahogany is faded. Holes from worm activity appear on the frame. The removal of a section of the upholstery uncovered many tack holes which suggests that this chair has been upholstered at least twice previously. This chair seems to be English and, given the form, it could be late eighteenth century. It could also be a well-used late nineteenth / early twentieth century revival piece. PK

456-9 Four side chairs

Mahogany with inlay.
85–6 cm; seat 40.5–41 × 45–6 cm
English or Scottish, circa 1800–20

M82.473.474.475.476

These four side chairs are of mahogany with various wood inlays. The tapering square front legs are joined by an H-stretcher with the crossbar placed toward the front. The rear legs are of square cross section below the seat and curve back. They are joined by a rectangular stretcher set just above the H-stretcher. Above the seat the rear stiles bend slightly

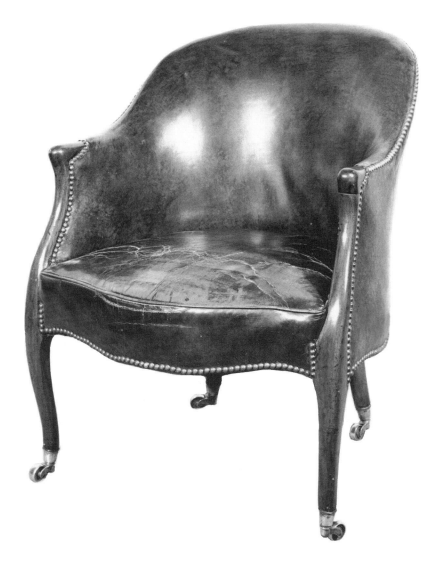

back and have a flat front with rounded back. The central crossbar bows backwards. The wider top crosspiece is also bowed and set into ledges cut out from the front of the stiles. The seat is horse-shoe shaped with a flat front. Boxwood stringing extends down each side of the front of the legs and down the front of the rear stiles above the seat. The central crossbar is outlined with a single band of boxwood stringing, and the upper crosspiece, outlined with a double band with an ebonized (?) strip in between. A horizontally placed oval medallion of satinwood is set in the centre of the top crossbar and edged with boxwood and an inner ebonized band. Small oblong braces are set across the corners inside the seat in the British manner. These chairs have recently been re-upholstered in the same pale café-au-lait upholstery as the stool in catalogue 452 with a double band of matching piping trimming the lower edge.

The mahogany is faded, stained, and scratched, especially at the corners. Some of the faded stringing seems to be black-stained holly or box simulating ebony.

These chairs are English or Scottish circa 1800–20. Such chairs would have been known as 'tablet-top' chairs owing to the central medallion or tablet on the top crosspiece. See *The London Chair-Makers' and Carvers' Book of Prices for Workmanship, as regulated and agreed to by a Committee of Master Chair Manufacturers and Journeymen* (London 1807). Every section of stringing, the stretchers, and other details were charged separately. A full series of prices for each detail is outlined on pp. 10–16. See also pl. 3, figs. 1–4. The central banister variety, which resembles these chairs, is described on page 11 but not illustrated on the plate. PK

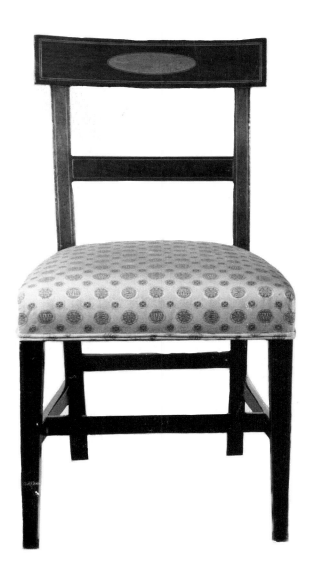

460 Bedside table

Chestnut, cherry, pine, marble.
79.2 × 46 × 34 cm
French, 18th century or later

M82.479.

This bedside table appears to be pri-
marily chestnut with a blonde finish.
The breccia marble top is comprised
of pebbles of brown, cream, yellow,
and rose. The rectangular form has a
scalloped gallery to the sides and
back. The large open central shelf is
likely to be of Continental oak. Kid-
ney-shaped holes are cut through
the sides above this shelf. A drawer is
fitted to the front in the apron below
the shelf. The drawer has a cherry (?)
front and pine bottom with cherry (?)
sides. The whole structure rests on
tapering cabriole legs. The back is
also given a blonde finish.

The wood is full of worm holes
throughout. Strips of wood fill cracks
in the sides. The feet are scratched.

This heavily aged and refinished
piece could be a standard eighteenth-
century example or perhaps a later
fabrication. The variety of woods,
some of them old, makes it difficult
to decide. On the bottom of the
drawer in orange-red crayon appears
'No. 4648.' A similar marking is found
on the occasional table in catalogue
448. Both numbers may possibly refer
to a dealer's inventory.

For a description of the design and
function of such tables see André
Charles Roubo, *L'Art du Menuisier*,
vol. 2, Tome VIII (Paris 1767), p. 740.
Examples are illustrated in ibid.,
vol. 3, pl. 266, figs. 10, 11, and 12. PK

461 Mirror frame

Pine, walnut, mahogany, gesso, gilt.
57.7 × 48.7 cm
Central European (Bohemia)
Biedermeier, circa 1830 M82.483

The looking-glass frame is softwood, probably pine, with figured walnut veneer to the front and mahogany veneer to the outer edge. The inner stepped moulding is gessoed and gilt wood. The fine quality, period mirror with bevelled edge is intaglio-cut verso with a circle surrounded by starbursts top and bottom and an oval arrangement of alternating circles and ovals. In the corners inside the bevel is a palm leaf motif with two small elongated ovals.

The wood is faded and dirty. The gold moulding is dulled by dirty varnish. Minor black smokey streaks appear in the mirror coating in one corner.

This looking-glass is probably central European (Bohemian), Biedermeier, circa 1830. Convex, concave, and other novelty mirrors were a popular early nineteenth-century phenomenon. Similar cutting can be found on Bohemian glass and Venetian looking-glasses. This looking-glass was perhaps an occasional piece for personal consumption rather than part of a larger regular factory production. PK

462 Cellaret

Mahogany, ebony.
63.4 × 49.2 × 31.8 cm
English, 1790–1805 M82.484

This cellaret is fashioned of mahogany with ebony inlay. The deep rectangular box form has a hinged cover. Ebony stringing is applied to the corners and, on the top and four sides, ebony veneer is inlaid in the form of a rectangle with two pairs of indented square loops to the sides. The front keyhole is surrounded by a triangular ebony escutcheon. The edges of the cover and box are ebonized. Old heavy brass bale handles are screwed to the sides. The box rests on a plain mahogany apron with ebony stringing to the top and bottom. The four mahogany legs with square tops are turned with a squashed ball below the three graduated convex bands followed by a long ovoid section and a high, swelled turnip foot. The pine bottom is braced on the underside with prism-shaped pine blocks glued around the edges. Inside, there were originally compartments with high partitions for bottles: three small square ones to the left and two large rectangles to the right. The partitions were constructed of pine with tops faced in mahogany. The large central square compartment was possibly not partitioned.

In recent times, these partitions have been lowered by half and a central flat mahogany board installed at the top level of the altered partitions. The front has been converted to a 'fall front' with a brass brace to the left. At the same time the bottom and the inside of the front were given a heavy, liquid-proof coating of glossy black paint. This produced a new 'liquor cabinet.' The legs show evidence that they were originally fitted with brass caps and casters. At present they are tipped with loosely fitting steel pads. The finish is worn, pieces are missing from the inlays, and two cracks appear on the bottom.

This is an English piece circa 1790–1805, of reasonably good quality. The alterations date about 1920–50.

Such chests held extra wine and liquor bottles or decanters in the dining room. By the 1780s a drawer of the sideboard or one of its pedestals was often devoted to this function. See Ralph Edwards, ed., *The Shorter Dictionary of English Furniture from the Middle Ages to the Late Georgian Period* (London 1964), pp. 113–14, with entry on cellarets by H. Clifford Smith. Fig. 5 shows a very fine cellaret that belonged to Lord Nelson (d. 1805) which is inlaid with similar motifs to our simpler version. Smith notes that Thomas Sheraton in his *Encyclopaedia* (London 1803) had observed that cellarets 'are not so generally used as they were, and amongst the higher classes are wholly laid aside, their place being taken by the sarcophagus form in the figure of ancient stone coffins.'

The Victoria and Albert Museum owns a mahogany sideboard inlaid with similar motifs in ebony (no. w. 47–1937). It is identified as 'English, about 1795.' Since 1962 this piece has been on loan to Kendal (Abbot Hall). PK

463 Library table

Mahogany with beech and pine.
72.5 × 128 × 57.5 cm
British, 1860–90 M82.486

This library table, which we would probably call a desk today, is built of mahogany with beech and pine as secondary woods. The finish appears to be what is known as 'French polish.' The two rectangular pedestals have bowed drawer fronts with a scallop to each side and a recessed centre. A stepped and concave moulding edges the top. Below the top there are three shallow drawers constructed entirely of machine-planed mahogany, one in each bow and the central one in the recess over the knee hole. The pedestals are constructed as two cupboards with bowed fronts simulating three drawers. On the left side a deep bin drawer is located at the bottom with two shallower drawers above. An arc-shaped cut into the top of the drawer fronts allows a hand-hold for pulling them out. The right side contains a double size bottom bin drawer and a smaller one on top. The left drawers have ebonized fronts; the right ones, a dark brown stain which is perhaps the original finish. A high projecting pedestal moulding continues around the base of the desk. The rear of the interior of the knee hole is panelled and the back of the case is fully finished with three panels. The drawers have brass ring pulls with round back plates with a raised and beaded border and rosette boss recessed in the centre. On the top drawers the brass locks are marked 'SECURE LEVER' and 'VR' (Victoria Regina) crowned. The cupboard locks are located at the sides of the knee hole. The finish is worn and scratched.

This is a good quality traditional-style British piece dating circa 1860–90. The free-standing twin pedestal form is similar to an example stamped W. Fry & Co, numbered 1229, and sold by Sotheby-Parke-Bernet Pulborough, England, on 16 November 1982. This walnut example had a wooden gallery and fretwork tracery to the rear. It was illustrated on the cover of *Antiques Trader Gazette*, no. 563, 4 Dec. 1982, and dated to circa 1880. PK

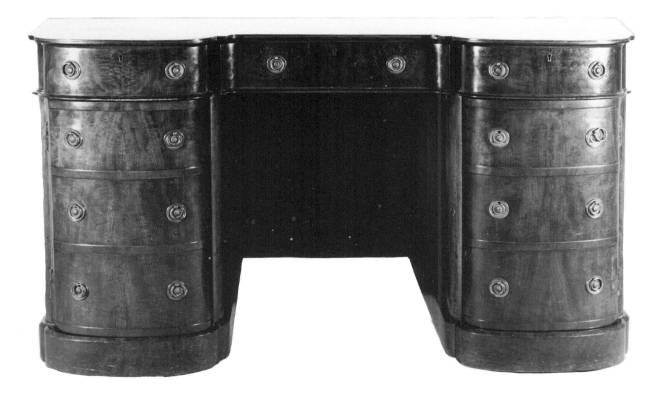

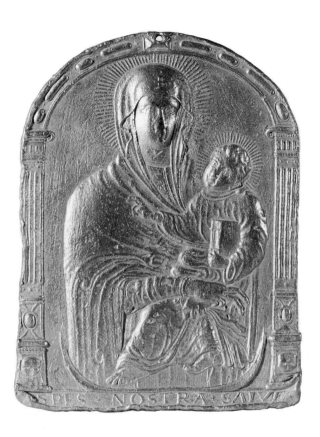 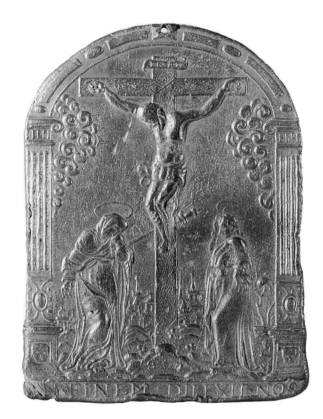

464 Moulded plaque

Lead. 12 × 8.3 cm
Italian, 17th century M82.273

This devotional aid is an arched lead
plaque in moulded relief, pierced
at the top for suspension. On one side
is a Madonna and Child set on a
crescent moon. Christ raises His right
hand in blessing while holding a
book in His left. The figures are set in
an elaborate architectural frame
with Ionic capitals, fluted columns,
decorated bases, and stylobates with
depictions of skulls. Across the bot-
tom is the inscription 'SPES * NOSTRA
* SALVE.'

On the reverse is a crucifixion
with Mary and St John, a Deesis set
against a landscape with steeples and
domes. Across the back of the cross,
just below the area of Christ's knees,
a sword is suspended. Above the
figures of Mary and John are clusters
of curlique 'clouds' with radiate lines.
The scene is set in the same architec-
tural framework as the opposite side.

Below is the inscription 'IN * FINEM
* DILEXIT * NOS.'

From the Ball Collection, Berlin

Purchased from Blumka Gallery, New
York, 22 May 1961 SDC

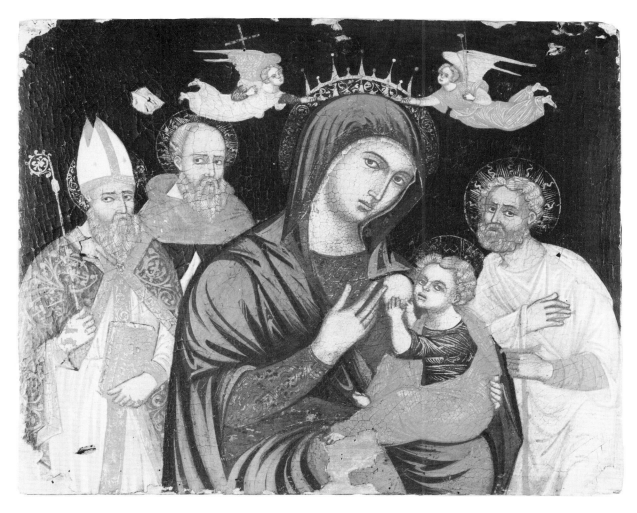

465 Panel of Virgin and Christ Child with saints and angels

Tempera on wood. 410 × 50 cm
Venetian, 15th century (?) M82.95

The panel of the Virgin and Child with saints and angels retains, despite surface damage to the pigment and loss of the gesso and tempera in some areas, much of the delicate gold pattern and highlight of the original composition. Against a black, plain background the seven figures are placed close to the foreground of the panel. The Virgin and Child, the largest figures in terms of scale, occupy the central, front plane of the picture. The three saints flank the Mother and Son. The two small angels place a modest gold filigree crown on the Virgin's head while holding in their other hands a cross (left angel), the symbol of

Christ's Passion, and a lily (right angel), symbol of the chastity of the Virgin. Mary is shown as a *virgo lactans*, nursing her son. (J. Hall, *Dictionary of Subjects and Symbols in Art*, New York / London 1974, pp. 328–9. The type of the *virgo lactans*, one of the oldest forms of the depiction of the Mother and Child, was seen only until the promulgation of the canons after the Council of Trent, 1545–63, which prohibited ' … undue nudity in the portrayal of sacred figures.' This form was particularly favoured in Italy in the fourteenth century.) The figures of the saints, as indicated by their patterned haloes, consist of, left to right, a bishop, possibly Ambrose, a cleric, possibly a Franciscan (the Italian *virgo lactans* was especially popular in Siena and corresponds to the Franciscan idea of the Madonna of Humility as it was defined in the writings of St Bonav-

enture), and St Joseph. The angel bearing the cross is clad in a yellow garment with green undersleeves and has red wings. The one carrying the lily wears a red garment with gold undersleeves and has gold wings. Neither is nimbed and, despite the absence of additional pairs of wings, it is possible that the two angels are meant to represent a seraph (red) and a cherub (blue). The entire composition, with all attendant figures, is rather peculiar, since it combines three separate scenes into one – *virgo lactans*, a *sacra conversatio*, and a Coronation of the Virgin. Even this last scene, the coronation, is out of the ordinary, for Christ as the Risen Lord is the typical figure to place the crown on His mother's head. But from the fifteenth century there are frequent Flemish and German examples which show tiny angels placing quite elaborate crowns

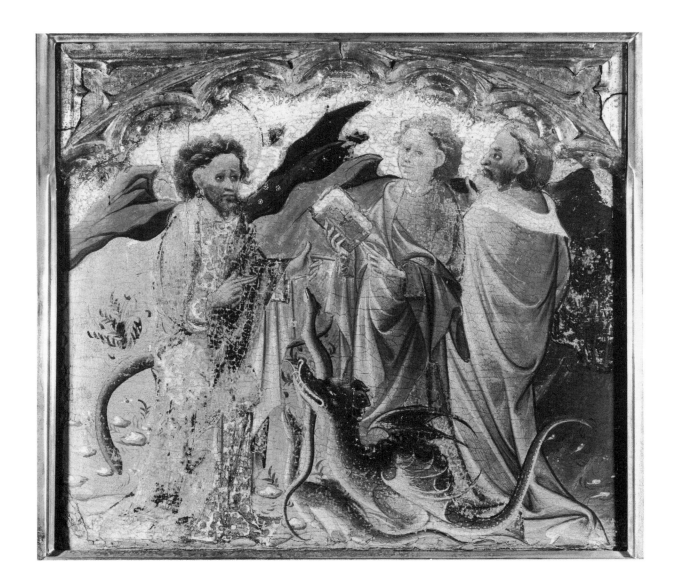

on the head of the Virgin. The handling of the draperies, the emphatic eyes, and the facial features of the figures in the panel bear the mark of the Byzantine world, either directly or indirectly. It is quite possible that the fusion of distinct subjects into one image was done at the specific request of the commissioner of the painting, since it is nearly unique in its presentation. G. Schiller, *Ikonographie der christlichen Kunst* (Kassel 1980), p. 459, no. 817, illustrates the central panel of a mid-sixteenth century Venetian *virgo lactans* as the Queen of Heaven with a mandorla and seraphim and cherubim holding apocalyptical symbols. There are, however, no saints present, nor does the composition otherwise resemble this panel. The style, presentation, and subject manifest a combination of eastern and western features that are perhaps most often found united in Italian Renaissance examples. 'The Coronation of the Virgin, non-existant in Byzantine art, is an essentially Western theme' (S. Symonides, *Fourteenth and Fifteenth Century Paintings in the Academia Gallery Venice*, Florence 1977, p. 18). The *virgo lactans* occurred throughout the Christian world from its early years. MJH

466 St Matthew exorcising the Dragons
GONZALO PEREZ
(Spanish, 1309–1408)

Tempera and oil with gilding on wood. 64.0 × 68.3 × 7.5 cm
Spanish, late 14th–early 15th century
M82.146

The attribution of the panel to Gonzalo Perez, a Valencia painter recorded in the church archives, was made by Chandler R. Post (Thieme-Becker, *Allgemeines Lexikon der bildenden Künstler*, vol. 12, Leipzig 1921, p. 387), who determined its author by means of a stylistic and thematic comparison with works known to be by Perez (C.R. Post, *A History of Spanish Painting*, vol. 12.2, Cambridge, Mass. 1958, fig. 253, p. 597). In his analysis, Post draws his comparisons from the figure types and also from the details of the landscape behind them, particularly the ' ... curious bits of vegetation in the lower right corner, like shells with leaves projecting from them.' Post allows for a possible later attribution of the painting to Pedro Nicolau or another member of the Catalan School of painting, active from about 1390 to 1415. The subject of this painting is St Matthew of Ethiopia who exorcised a pair of dragons brought to him by two enchanters, one young, the other old. In this example a pair of serpents has been added to the dragons. By making the sign of the cross above the dragons, St Matthew subdues the creatures (Réau [cat. 405], vol. 3.2, p. 931. Examples of this subject date from the twelfth century, such as a carved capital in the Church of the Annunciation, Franciscan convent of Nazareth, to the fifteenth century, when the same scene is found in a missal of the Duke of Bedford, Bibliothèque Nationale, Paris). The three figures are placed behind the animals, which occupy the central area. A nimbed St Matthew makes the sign of the cross with his right hand and seems to be gesturing towards the others with his left. The central figure is the younger of the enchanters, who points to the book he holds up in his right hand, likely a compendium of magic. To the right, shown in profile, is the elder enchanter who is wrapped in a heavy cloak. In his upraised right hand we glimpse a small flattish, dark object (perhaps a philosopher's stone or the corner of a book?). In the distant landscape behind the men are fantastic structures of rock. The entire composition is surmounted by a carved, gilded arch. The subject occurs most frequently in Italian and Spanish examples. MJH

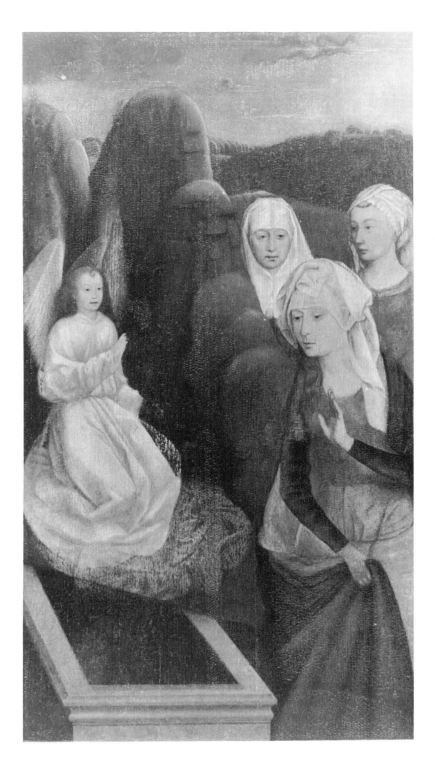

467 *Three Women at the Tomb*

HANS MEMLING
(d. 1494, Bruges),
with shop assistance

Tempera on panel. 49 × 25 cm
Flemish, circa 1485?　　　　M82.511

This painting entered the literature
via a brief entry in M.J. Friedländer's
1928 volume on Memling in the *Alt-
niederlandische Malerei* series (in
1924 he had already written a 'certifi-
cate' for the painting based on a
photograph) as by the master himself
and datable to circa 1485. To a more
conservative eye the damaged condi-
tion permits only an attribution to
his shop, though the design may well
be Memling's. The composition as
well as the subject suggest the wing
(right) of a small altarpiece having as
the central image a Resurrection or
perhaps a Lamentation such as that
in the Galleria Doria in Rome, with
which the Malcove panels bears
certain points of comparison. All
works to which reference is made are
illustrated in Friedlander and Corti /
Faggin, see below, Publication. There
has not been extensive interest in
Memling in recent years and there is
no mention of the Malcove panel
in K.B. McFarlane, *Hans Memling*
(Oxford 1971). See McFarlane for
earlier literature.

Though rarely represented on its
own in Flemish art of the fifteenth
century, the event is the most
important of Easter Morning (see for
example 'Frauen am Grab' in the
*Lexikon der christlichen Ikono-
graphie*, Rome 1970, vol. 2, pp. 54–61;
Schiller [cat. 465], pp. 91–5), the
first confirmation of Christ's resurrec-
tion, as adapted here from the ac-
count in Mark 16:1–8. The other
Gospels and later Meditations offer
variation. In Matthew 28 the ac-
count is embellished with guards sta-
tioned at the tomb, and refers to
only two women. This rendering is
the ultimate source for Memling's
representation in the narrative panels
of the *Joys of the Virgin* (Munich)
and the *Passion of Christ* (Turin) as
well as in the *Resurrection* wing of

the Lubeck altarpiece.

The first woman may be identified as the Magdalene, based on a comparison of her dress with gold-fringed sleeves with that of her counterpart in the Galleria Doria *Lamentation*. The second woman is not distinguished but the third, older woman with the headdress of a married woman may be either Mary the mother of James or, much more likely, the Virgin herself. By the fifteenth century her presence here was conventional, though not supported by scripture. The young man dressed in white is here, as traditionally, characterized more explicitly than in the gospel as angelic. The cloth beneath the kneeling figure would be expected to be Christ's discarded shroud. The purple that has come through with (over?) cleaning suggests another identification: the regal mantle which, conventionally in art, though not in scripture, Christ wears as He rises in triumph from His earthly tomb.

Hans Memling was the foremost master in Bruges from his settling there in 1465 until his death in 1491. His graceful restrained style evokes the artistic language of Rogier van der Weyden with whom he had previously trained but from which the arresting pathos, linear elasticity, and real intensity of the earlier artist had been effectively drained. Panofsky's characterization of this 'serene' imagery is apt: 'it occasionally enchants, never offends, and never overwhelms' (E. Panofsky, *Early Netherlandish Painting*, Cambridge, Mass. 1953, p. 347). As there is little change, dating is difficult. In the present painting the carefully outlined features of the women are entirely typical in their mask-like placidity and may be compared to those in the Rome *Lamentation* or the panel with *Donatrix and Saint* in the Pierpont Morgan Library, New York. However, the rocks, even in their design or contouring, appear more simplified than in other works, and it is perhaps no longer possible to determine whether the crudeness is due solely to damage and clumsy restoration or echoes the initial conception. For now it seems imprudent

even provisionally to attribute more to the master himself than the design of the four figures.

While enough of the original composition remains for this qualified attribution, the present condition is extremely poor. Surface glazes have been lost over the entire surface and repainting is extensive. Widespread blistering and lifting of the paint along crackle lines were treated most recently in 1967. Infill extends in some places down to the wood, especially along the edges, and the vertical, central seam where the panel apparently once split has been rejoined. Friedlander described the panel as consisting of two exterior triptych wings later jointed. This seems improbable, but as the panel was already set into wooden framing strips, backed, and cradled at the time of purchase, it is difficult to judge definitively. As the edges can no longer be examined, the original dimensions are as well unverifiable. From the photographs taken at the time of a 1957 restoration it appears that in the zealous removal of repaint and infill, much detail, such as the very characteristic and graceful right hand of the Magdalene which clearly reflected Memling's refined manner, was removed. Again, judging from the restoration photographs and brief report (1957, 1967), it is not at all obvious that the purple cloth beneath the angel was not reconsidered and covered by the artist himself.

EXHIBITIONS
Bruges, Musée Communale, *Memling*, 1939, no. 35. The Malcove painting was listed in the catalogue but not sent for exhibition.
Columbus, Ohio, Columbus Gallery of Fine Arts, *The Gothic North*, 1949, no. 24

PUBLICATIONS
Friedländer, M.J. *Die altniederlandische Malerei* (Berlin 1928), rev. English ed. 1971, VI, no. 28a
Corti, Maria and G.T. Faggin, *L'opera completa di Memling* (Milan 1969), no. 47, where the Malcove painting is listed as a 'recent attribution' with no further comment.

Rothschild family, London; London dealer in 1928; Ascher and Waller, London dealer in 1939; Van Diemen-Lillienfeld Galleries, New York, in 1949; purchased from them in 1951

JAS

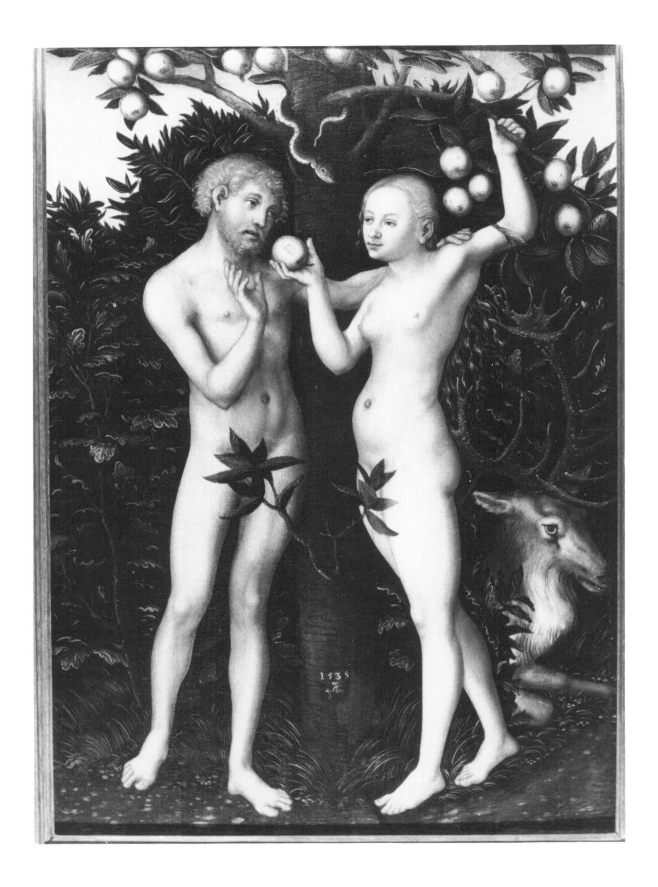

468 *Adam and Eve*

LUCAS CRANACH THE
ELDER (1472–1553)

Oil on panel; 6.35 mm strip of wood
added to the right side; vertical
cracks along the lower edge have
been subject to minor repairs; small
amount of inpainting. 40.5 × 59 cm
Signed and dated 1538 M82.147

The Fall of Man was a well-
established subject in northern art of
the fifteenth and early sixteenth
centuries, becoming especially popu-
lar after Albrecht Dürer's influential
engraving of *Adam and Eve* of 1508.
It was particularly favoured by Lucas
Cranach the Elder and his patrons
if we are to judge from the more than
thirty known surviving versions of
this theme executed by Cranach and
his workshop between the years 1510
and 1546. Signed with the Cranach
monogram of a dragon with folded
wings and dated 1538 on the base of
the tree, the Malcove panel is a work
from the mature phase of the artist's
production when Cranach was mas-
ter of a large workshop and patron-
ized by John Frederick the
Magnanimous. Delicately painted
and in good condition, although the
paint is now thin in some areas,
this is a fine example of the older
Cranach's art, both stylistically and
thematically congruent with the
best of the master's independent ar-
tistic production of the period. Typi-
cal of the fully developed style is
the simplified background showing
sharply contoured foliage and land-
scape elements. Atmospheric effects
are disregarded in favour of brilliant
contrasts of light and dark and a
subtle use of local colour. Pentimenti
visible in the contour of Eve's right
shoulder and Adam's right arm reveal
a characteristic concern for a neat
and elegant silhouette which empha-
sizes relief order rather than a dra-
matic interlocking of forms in space.
Eve's reaching arm permits us to
see the entire sensuous outline of her
body, the instability of her posture
adding to her allurement. The more
Italianate, idealized nudes of Cran-
ach's early period have here evolved
into sophisticated and sensate crea-

tures in which a studied realism is
played off against a tendency towards
the decorative.

Adam moves to accept the apple
in response to the urging of Eve and
the serpent, his action thus antici-
pating the spiritual death of mankind
and the subjection of Adam and his
descendants to mortality. To the
right of Eve a crouching stag symbol-
ically alludes to the succumbing of
Adam to temptation, here
interpreted as the temptation of the
flesh (and thus the Fall as a conse-
quence of evil libidinousness). The
carnal nature of the couple's rapport
is further suggested by the bitten
apple that Eve provocatively offers
Adam. The motif of the bitten apple
occurs frequently in Cranach's
oeuvre, but it is only after about 1525
that it is brought together with the
theme of the Taking of the Apple
by an actively tempted Adam to
make explicit its evil implications.

Iconographically, the figure of Eve
is a variant of the female type cre-
ated by Cranach to convey the popu-
lar contemporary theme of the power
(and danger) of women. The theme
of the power of women in Cranach's
work is discussed by Koepplin and
Falk [see Publications, below] in the
chapter entitled 'Weibermacht, alt-
testamentliche und profane Darstel-
lungen,' vol. II, pp. 562–85. Further
discussion of this theme in the con-
text of the contemporary artist Hans
Baldung Grien is offered by Charles
W. Talbot, 'Baldung and the Female
Nude,' in *Hans Baldung Grien: Prints
and Drawings* (Washington 1981);
A. Kent Hieatt, 'Hans Baldung
Grien's Ottawa "Eve" and its Con-
text,' *Art Bulletin*, LXV, 1983, 290–
304. For a general discussion see Carl
Van de Velde, 'Het Aardts Paradijs
in de beelende kunsten,' essay intro-
ducing the catalogue of the exhibi-
tion *Het Aardts Paradijs*, Zoo
Antwerpen, 1982. Altered slightly in
pose and attribute Eve is readily
interchangeable with the Venuses,
the Three Graces, Judiths, Lucretias,
and jewelled courtesans that were
a speciality of the Cranach work-
shop.

An earlier depiction of Adam and
Eve conforming in many details

(such as the conception of Eve) to
the Malcove panel is located in the
Lee Collection of the Courtauld In-
stitute Galleries (1526; Friedländer
and Rosenberg [FR, see Publications
below], no. 191). A drawing in the
Dresden Kupferstichkabinett is
clearly related to the London panel
(Jakob Rosenberg, *Die Zeichnungen
Lukas Cranach des Älteren*, Berlin
1960, no. 39, p. 22). Roughly contem-
porary variants of the present *Adam
and Eve* are to be found in other
North American collections: Detroit
Institute of Art (FR, no. 192); Norton
Simon Foundation, Los Angeles (FR,
no. 195); and the Art Institute of
Chicago (FR, no. 197).

EXHIBITION
Busch-Reisinger Museum,
Cambridge, Mass. 1967

PUBLICATIONS
Friedländer, Max J. and Jakob
Rosenberg, *Die Gemälde von Lukas
Cranach* (Berlin 1932), no. 287
Koepplin, Dieter and Tilman Falk,
*Lukas Cranach: Gemälde, Zeich-
nungen, Druckgraphik*, 2 vols. (Basel
1976), pp. 656–66
Friedländer, Max J. and Jakob Rosen-
berg, *The Paintings of Lucas Cran-
ach* (Amsterdam 1978), no. 356

Private collection, Silesia; Otto
Mayer Collection, Berlin KAT / JAS

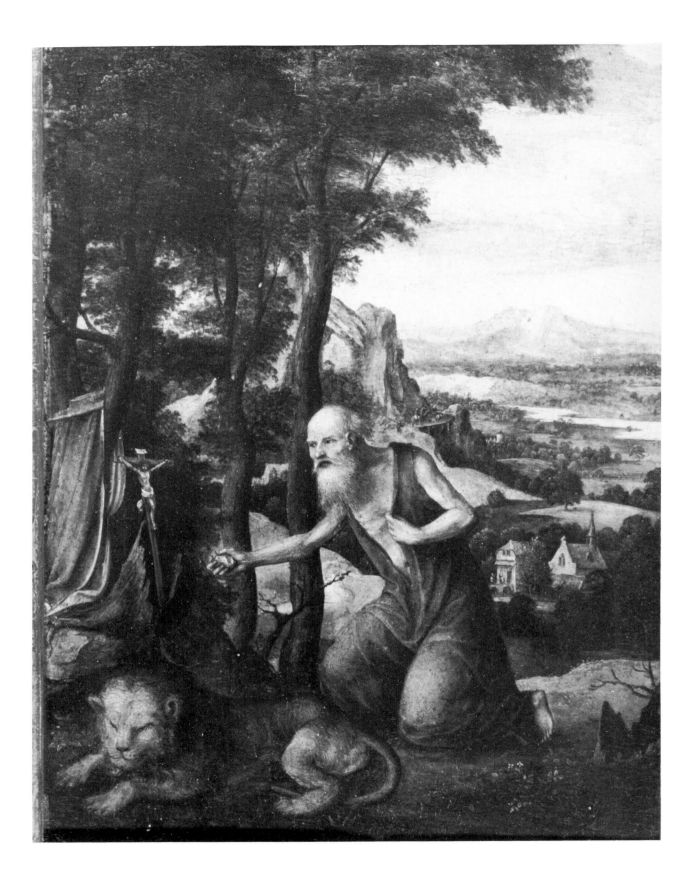

469 *Penitent St Jerome*

JOACHIM PATENIER
(Dinant, 1485–Antwerp,
1524), follower of

Oil on oak panel.
22.5 × 16.5 cm
Flemish, 16th century M82.18

In the school of Antwerp during the first decades of the sixteenth century the hermit saint, usually seen in an act of worship or penance, continued to be a popular subject of small traditional panels intended as a stimulus or accompaniment to private devotion. At the same time, the growing preoccupation with the depiction of landscape, especially in its more amazing forms and produced for domestic adornment with an instructive subtext, added to the appeal of these saints, particularly of Jerome.

St Jerome is shown here mortifying his flesh by beating himself with a rock before a crucifix propped up in a rotted hollow tree stump. He is accompanied in his wilderness refuge by the lion which legend has he befriended. A cardinal's hat and cape is hanging on a tree branch. St Jerome (340 / 50–420), known as one of the Fathers of the Church, was a popular image for the devout in the fifteenth and sixteenth centuries, both the image of him working in his study, exemplifying scholarly dedication to understanding God's word (focusing on his translation of the Vulgate), and of him struggling with the desires of the body during his seclusion in the desert. (For St Jerome himself and his depiction in art see J.N.D. Kelly, *Jerome: His Life, Writings, and Controversies*, London 1975; R. Jungblut, 'Hieronymus: Darstellung und Verehrund eines Kirchenvaters,' Tübingen, Eberhard-Karls-Universität, dissertation, 1967; S. Kuretsky, 'Rembrandt's Tree Stump: An Iconographic Attribute of St. Jerome,' *Art Bulletin*, LVI, 1974, 571–80; M. Meiss, 'Scholarship and Penitence in the Early Renaissance: The Image of St. Jerome,' *The Painter's Choice*, New York 1976, pp. 189–202; P.H. Jolly, 'Antonello da Messina's Saint Jerome in his Study: An Iconographical Analysis,' *Art Bulletin*, LXV, 1983, 238–52.) According to his letters, around 376 / 7 he sought a life of self denial in the Syrian desert, 'parched by the sun' as he says (a description generally ignored in northern art). The tale of his befriending a lion is supposed to have occurred years later when he was living in a monastery near Bethlehem. The references are commonly conflated, apparently for greater impact. In addition, St Jerome was never a cardinal, though he was assigned that honour by later biographers. For example, in the *Legenda Aurea* the reader is instructed that Jerome was ordained a cardinal at age thirty-nine, and then went into the desert. He is normally shown as a much older man subduing his flesh (still 'longing for the pleasures of Rome') and keeping his eyes fixed on the crucifix ('throwing himself before Christ' as he says in his famous letter to his disciple Eusctochium) to remind himself of Christ's ultimate physical sacrifice. The motif of the crucifix propped up in the hollow of a dead tree, as opposed to some other less specific support, has been read as a reference to the wood of the cross as the Tree of Life triumphing over the decay of this world and the Tree of Death from which Eve plucked the apple (see Kuretsky).

This beautifully executed little panel, in good condition except for small scattered areas of repaint and damage to the original marbling (over a gesso base) on the back, testifies to the high quality of painting produced in Antwerp in the first half of the sixteenth century. It reflects the influence of more than one major artist practising there, but cannot now be ascribed with confidence to any one hand. In a letter in 1952 M.J. Friedländer accepted it as a work by the originator of the Antwerp school of landscape painting, Joachim Patenier (1485–1524), but a comparison with that master's generally acknowledged work both in terms of the characterization of the figure and landscape shows that an attribution to Patenier himself is untenable. (On Patenier see R. Koch, *Joachim Patenier*, Princeton 1968; H.G. Franz, *Niederlandische Landschaftsmalerei im Zeitalter des Manierismus*, Graz 1969; D. Zinke, *Patniers 'Weltlandschaft': Studien und Materielen zur Landschaftsmalerei im 16 Jahrhundert*, Frankfurt am Main 1977.)

The lush green landscape in the Malcove *St Jerome* falls from a high foreground plateau with trees to wooded rolling hills in the middle ground with a chapel and other buildings (possibly representing the monastery near Bethlehem or more plausibly the society he has rejected), and then, via a fantastic 'natural' arch of slipping boulders skirted by a trestle with camel caravan, steps down again to a broad river valley. A mountain range on the horizon completes the spatial recession. The listing of motifs suggests Patenier and his formulation of the wilderness landscape as in his various versions of *Landscape with St Jerome*, for instance that in the Prado; (the version in the form of a triptych in the Metropolitan Museum, New York, is accepted by Koch, no. 14, without discussion, but the extremely dry execution suggests the hand of an imitator). Nevertheless, the handling here differs from the crisp linear style accepted as Patenier's. The shifting of the startling, by now *de rigeur* rock formation to a position behind the screen of trees, the screen of trees themselves (reminding one of the presence of Gerard David, famous for his woodlands, in Antwerp at least by 1515), and the softness of the modelling and emphasis on atmospheric values, especially in the dissolving mass of the distant blue-grey mountains, point to the following generation of landscapists in Antwerp such as Herri met de Bles, but even more, Cornelius Massys (circa 1511–after 1562), and thus to the 1540s (for Met de Bles and C. Massys see Franz, above). There is, however, no specific comparison to provoke an attribution.

The diminutive figures of St Jerome animating various of Patenier's *Weltlandschaften* are quite dissimilar to this dominant, intense hermit. Though Patenier established the practice of collaboration with major

figure painters such as Quentin Massys or Joos van Cleve, the overall consistency of the handling of the paint precludes that here. It is also possible that the landscapist adapted a figure design by another hand. In his diary kept during his trip to the Netherlands in 1521, Albrecht Dürer recorded that while in Antwerp, Patenier, there identified for the first time as a 'landscapist,' asked him for drawings of St Christopher (Koch, p. 4). In fact, the distinctive cut of St Jerome's violet-grey tunic, not found earlier in Netherlandish art, parallels closely that found in the work of the German master, most specifically the *Penitent St Jerome* in the Fitzwilliam Museum, Cambridge (F. Anzelewsky, *Albrecht Dürer, Das Malerische Werk*, Berlin 1971, no. 14): sleeveless, rims turned up around the armhole, and with a front opening slit exceptionally deep to expose the navel (perhaps to emphasize the vulnerability of the body). This cut returns in other versions of the subject done in Antwerp. In addition, the adaptation of the lion from Dürer's famous engraving *St Jerome in his Study*, dated 1514, provides a reliable *terminus a quo* for the execution of the Malcove panel, though again one is reminded that Dürer noted that he had copies of the print with him for presentation or sale when he was in Antwerp in 1521. The adaptable lion appears in at least two later *Penitent St Jeromes* from the Antwerp school: one in the manner of Joos van Cleve that was with the dealer Bohler in Lucerne in 1939 and another from the circle of the Brunswick Monogrammist in Viesbaden (Franz, fig. 128).

Dürer's saint is calm compared to the agitation so apparent here. The tension of the body is visibly concentrated in the movement of the head thrusting forward in a way strikingly similar to that curious but pervasive characteristic of many male figures in the paintings of Antwerp's leading master, Quentin Massys, 1465–1530, for instance in the *Altarpiece of the Holy Kindred* finished in 1509 (Brussels). (For Massys see A. Bosque, *Quentin Massys*, Brussels 1975.) Also noticeable here is Massys's characteristic facial construction – sharply cut eye sockets and a long thin nose, prominently rounded and highlighted at the tip. This is not enough for an attribution, however, and one is left with the necessity of an essentially generic ascription.

Baron Van der Feltz, The Hague; G. Seligmann (dealer), New York; purchased 1953 JAS

470 *Time Crowned*
ANONYMOUS CENTRAL
EUROPEAN ARTIST

Black ink over sketches in pencil.
17 × 12 cm
Provenance unknown, date possibly
circa 1600 M82.29

The date 1594 is inscribed at the
bottom centre in black ink, and the
words 'Spranger del' are annotated
on the verso in pencil by a later hand.

 These six figures appear to have
been copied from an unidentified
composition requiring a view from
below which included the crowning
of Father Time (identifiable by his
scythe, wings, evident age, and urn)
by two female personifications, the
one to our right being Justice bearing
a set of scales in one hand (see for
example E. Panofsky, 'Father Time,'
Essays in Iconology, New York 1962,
pp. 69–94). The lower three figures
have been identified as Venus, Amor,
and Psyche (per the 'Certificate of

Authenticity,' Malcove files, pro-
vided by the dealer M. Komor, from
Dr E. Waldmann, director of the
Kunsthalle, Bremen, in 1944, which
concluded that this is a 'Pictorially
well-rounded work, done entirely by
Bartholomaeus Spranger (1546–1625
[sic]) one of the principal masters
of the School of Haarlem [sic]'). They
are not compositionally linked to
the upper figures, nor really very
clearly with each other. On the verso
are found further groups of three
figures: the three nude male figures
standing below are probably Apollo
(lyre), Jupiter (?) (horn of plenty),
Neptune (spiked crown); those above
are a cupid and two reclining draped
women, one holding a flaming heart
(?). A woman's head is sketched in
pencil alone.

 The date 1594 may be either the
date of the drawing or that of the
original composition. The style has
not been identified more closely than
Central European, though it is not
that of the Fleming Bartholomaus
Spranger (1546–1611) as proposed by

a later annotator (see K. Oberhuber,
'Die stilistische Entwicklung im Werk
Bartholomaus Sprangers,' University
of Vienna, dissertation, 1958, and
T. Kaufmann, *Drawings from the
Holy Roman Empire 1540–1680,*
Princeton 1982, especially no. 49, *Mars
and Venus*, dated 1597, in the Smith
College Museum of Art. Both these
authors concur that this drawing
is not by Spranger. No alternative
name has been proposed). The prolif-
eration of indescriptive lines and
the lack of a contour line of one
woman's leg (where a cloud would
be) suggest the type of difficulties
that normally indicate a copy. The
condition is generally good, although
there is some discoloration.

Armand Gobiet, Salzburg, as of 1944.
Purchased from Mathias Komor,
New York JAS

471 *St George and the Dragon*

PETER PAUL RUBENS
(Siegen, 1577–Antwerp, 1640),
workshop

Oil on panel. 30 × 28 cm
Antwerp, mid-17th century (?)

M82.142

This small oil sketch depicts the legendary battle of St George, a second-century Roman tribune, with the dragon that terrorized the countryside of Lydia with its requirement of human sacrifice. In the account popularized by Jacopo de Voraigne's *Legenda Aurea*, while travelling through this area St George happened on the weeping daughter of the king, the dragon's next victim. St George slew the dragon and, in gratitude, the king and his subjects converted to Christianity en masse. Traditionally a symbol of the just overcoming wickedness and oppression, the theme possibly had a special significance in Antwerp as an allegory of the triumph of the Catholic church over heresy, as Zweite has speculated in his discussion of Martin de Vos's *St George* of 1590, Koninklijk Museum voor Schone Kunste, Antwerp (A. Zweite, *Martin de Vos als Maler*, Berlin 1980, no. 776, p. 205).

St George, dressed in full armour and mounted on a rearing white horse, is depicted about to deliver the final blow to the dragon beneath him, its throat already pierced by his lance. In the distance to the right the figure of the princess is faintly and awkwardly sketched in. Pentimenti are visible in the area of the horse's hindquarters where the position of the rump, tail, and legs has been slightly altered. An isolated serpentine coil in the lower right foreground must indicate a discarded position of the dragon's tail.

The panel is in extremely poor condition, hampering an objective evaluation of its original design and execution. Extensive repair and overpainting was undertaken during restoration work done in 1957, and possibly again in 1963 when the panel was attached to a wooden support. A vertical crack at the lower edge has been filled and paint losses in this area restored in water colour; in addition there is considerable inpainting over the entire surface.

The painting was first published by Goris and Held in 1947 as an original work by Rubens. At that time the later addition of a circa 5 centimetre strip of unarticulated sky at the top of the panel was detected and the panel reproduced in a cropped format. In his 1980 monograph on Rubens's oil sketches, Held [see Publications, below] revised his earlier position and withdrew the picture from the Rubens corpus as being unworthy on stylistic grounds of the master's hand. (In a written communication of 20 June 1983 Held reiterated his position; a similar opinion has been kindly offered in written communications from A.M. Logan, and from E. Haverkamp-Begemann, the latter emphasizing the quality of the underlying design.)

The ultimate prototype for the compositional format and subject of the Malcove sketch is the *St George* of circa 1606 by Rubens in the Prado, of which one painted copy, two copy drawings, and an etching after the composition are known. (H. Vlieghe, *Saints*, Corpus Rubenianum L. Burchard, vol. 8, London 1973, II, no. 105, pp. 35–9. The composition represented by the Madrid painting was previously treated by J. Juller Hofstede, 'Rubens' St. Georg und seine frühen Reiterbildnisse,' *Zeitschrift für Kunstgeschichte*, XXVIII, 1968.) Our composition differs from the Prado panel in the positioning and poses of the figures and, perhaps most importantly for a tentative dating of the sketch, in the treatment of the horse. The head of the horse has been imbued with almost human expression through the furrowing of the eyebrow and the intense gaze of the eyes, especially characteristic of Rubens's horses of the 1630s, such as those depicted in the oil sketches of the *Wrath of Neptune* (Fogg Art Museum, Cambridge, Mass.) and *Bellerophon Slaying the Chimera* (Musée Bonnat, Bayonne). We might also draw attention to Rubens's oil sketch of the *Conquest of Tunis by Charles V* (Staatliche Museen, West Berlin) dated by Held to the last phase of the artist's activity: centre right in the middleground, an armed horseman straddles a mount almost identical to the horse in the Malcove *St George* (Held, I, no. 288, p. 387).

Typical of Rubens's workshop practice is the thin layer of light brown priming roughly applied to the gesso base so that the striated trace of the brush remains visible. The composition is sketched in brown monochrome on top of this priming, and then colour is thinly applied to build up the initial design. Compared to Rubens normal brushstroke, however, the work here is timid and insecure. A strong dependency on contour for the articulation of form, a generalized rather than analytic treatment of line, and a facile exploitation of white highlights for modelling all suggest the work of a lesser hand attempting a design of Rubensian conception. Although the twisting figure of St George, dramatically enlivened by the billowing draperies of the cape, is well rendered, elsewhere weaknesses are apparent: for instance, the proportions and internal modelling of the horse, particularly in the area of the chest, and the belaboured, inexpressive brushwork that fails to render the volumes of the dragon.

The relation of the Malcove sketch to a Rubens concept and the workshop practices of his studio seems clear. Our panel, by a contemporary, anonymous hand, was probably done as an exercise in Rubens's style, and may reflect the existence of a lost original by the master. Since Rubens's oil sketches were highly esteemed as works in themselves in the years immediately following his death in 1640 (Held, I, p. 12), the possibility that our panel was executed for the Antwerp art market also merits consideration.

PUBLICATIONS
Goris, J.A. and J.S. Held, *Rubens in
America* (New York 1947), no. 62
Held, J.S., *The Oil Sketches of Peter
Paul Rubens* (Princeton 1980), I,
no. A37

English private collection. Purchased
from a New York dealer in 1946

KAT / JAS

472 Wooded Landscape with Farmhouse
JAN VAN GOYEN
(1596–1656)

Black chalk with light brown wash on paper; inscribed by the artist in black chalk 'inde wilt baen'; annotated number '69' in the upper right hand corner by a later hand; stained on all edges.
Watermark: Arms of Lothringen
15.3 × 9.5 cm
Dutch, 1650–1 M82.13

In this small sketchbook page, Van Goyen captures the rustic charm of the Lower Rhine countryside as it was observed by the artist during a voyage down the Rhine from Arnheim and Cleves in 1650–1. The sketchbook was first published by Dodgson in 1918, the year it came to auction at Christie's, at which time it contained 179 leaves, irregularly numbered in ink in the upper right hand corner by a later hand (Campbell Dodgson, 'A Dutch Sketchbook

of 1650,' *Burlington Magazine*, XXXII, 1918, 234–40). Already at that time a number of leaves had been removed from the book. Disassembled by the collector and art dealer A.M.W. Mensing, the sketchbook was auctioned again in 1937, and was finally split up by Dr Lilienfield of New York who disposed of the sheets individually after 1957. Most of the sketches are today dispersed in different American collections.

Certainly one of the most prolific Dutch artists of the seventeenth century, Van Goyen's well-documented oeuvre comprises some 1500 paintings and more than 1800 drawings. A large number of the drawings were executed in five known surviving sketchbooks (Albertina sketchbook, 1630; London sketchbook, 1627–35; sketchbook in collection of Dr A. Bredius, 1644–9; Dresden sketchbook, 1648; sketchbook of 1650–1, discussed above; see H.U. Beck, *Jan Van Goyen, 1596–1656*, Amsterdam 1972, vol. I, nos. z. 843 / 1–28, z. 844 / 1–109, 1–182, z. 845 / 846 / 1–144, and z. 847 / 1–290, respectively, for the sequence

of sketchbooks). Many of these drawings probably served as studies upon which the artist could draw for later painted compositions. Others seem to have been worked up to a more finished state, possibly intended for sale to private collectors. For a discussion of the possible later uses of the sketchbook drawings see H.U. Beck, 'Jan Van Goyen: The Sketchy Monochrome Studies of 1651,' *Apollo*, LXXII, 1960, 176–8; and his earlier 'Jan Van Goyen's Handzeichnungen en als Vorzeichnungen,' *Oud-Holland*, LXXII, 1957, pp. 241–50.

The inscription 'inde wilt baen' penned in the artist's hand at the top of the Malcove sheet translates literally as 'in the wild track,' which in all likelihood refers to the hunting district near Arnheim and Dieren (written communication from H.U. Beck, 27 November 1954). To arrive at this district from Cleves, Van Goyen would have had to cross the river Ijssel. Indeed, on the sketchbook sheet numbered '68' (today in the Fritz Lugt Collection), the artist wrote 'ijsselse veer.' Beck in his mon-

ograph on Van Goyen notes that the view sketched on the verso of the Lugt sheet (which would have faced our sketch in the original sketchbook) is similar in its topographical description to that of the Malcove drawings (Beck, no. z. 847 / 70, p. 297). He sees this comparison as supporting the general opinion that the sketchbook contained a diaristic account of the artist's journey.

The Malcove drawing belongs to the last and most fertile phase of the artist's activity and is a particularly fine example of Van Goyen's mature work. It is a rapidly executed sketch from nature in which the artist has chosen a view containing some of the motifs most typical of the seventeenth-century Dutch landscape painter – the riverside and woodland scenery of a rural, domesticated world. Whereas many of the sketches in the 1650–1 sketchbook are limited to the study of individual motifs, the composition of the Toronto sheet is quite thoroughly worked out and exhibits the characteristically restless, emphatic style of the artist's late period. After 1640 the stern imposition of the diagonal in Van Goyen's work is relaxed and the composition restructured in terms of a more harmonious and architectonic conception of the landscape. The vertical thrust of the great tree in the foreground is counterbalanced by the broad form and forceful articulation of the dilapidated farmhouse on the river's far bank. The resulting enclosed treatment of space at the composition's centre gives a more intimate scene than that usually observed in Van Goyen's panoramic views of town and harbour. Beck notes that this drawing is compositionally not unlike a small panel in his collection dated 1651 (ibid., no. G.254).

About 1630 Van Goyen all but abandoned pen and ink and turned to black chalk and washes, possibly in order to achieve greater atmospheric effects and a subtler range of accents in his landscapes. In this regard the Malcove sketch is notable for the colouristic effects created by a variety of strokes and varying pressure on the chalk. Wash is skilfully employed to give emphasis to the key structural elements of tree, farmhouse, and river while, at the same time, diffusing individual colour accents to achieve the harmonious tonal effect for which Van Goyen's mature work is prized.

KAT / JAS

473 *Portrait of Duke Wolfgang Wilhelm of Pfalz-Neuberg*

LUCAS VORSTERMAN
THE ELDER
(Bommel, 1595–Antwerp, 1675), attributed to

Oil on panel.
25.8 × 19.3 cm M145

The identity of the noble represented in this small oil study is established by reference to the version engraved in reverse by Lucas Vorsterman belonging to the famous series of engraved portraits commonly known as the *Iconography of Anthony van Dyck*, a series of commemorative portraits such as had become popular from the mid-sixteenth century. (The standard reference is M. Mauquoy-Hendrickx, *L'Iconographie d'Antoine Van Dyck*, Brussels 1956; Duke Wolfgang Wilhelm is no. 118. Other relevant literature on the *Iconography* with reference to the oil studies includes A.M. Hind, 'Van Dyck: His Original Etchings and his Iconography,' *Print Collector's Quarterly*, v, 1915, 1–37, 220–53; M. Délacre, *Recherches sur le rôle du dessin dans l'Iconographie de Van Dyck*, Brussels 1932; H. Vey, *Die Zeichnungen Anton Van Dyck*, Brussels 1962; A. McNairn, 'Van Dyck's Iconography,' *Journal of the National Gallery of Canada*, XXXVIII, Sept. 1980, 1–8; D. de Hoop Scheffer, *Antoon Van Dyck et son Iconographie: eaux-fortes, gravures et dessins de la Fondation Custodia, Collection Frits Lugt*, Paris 1981; C. Brown, *Van Dyck*, Oxford 1982.) It is known in five states, of which the third was included in the 1645 edition of the *Iconography* published by Gilles Hendricx and inscribed below:

'Serenissimus Princeps Wolfangus Wilhelmus, D.G. Comes Palatinus Rheni, / Dux Bavariae, Iuliaci, Cliviae, et Montium: Comes Veldentii, Sponhemii / Marchiae, Ravensburgi et Moersii, Dominus in Ravenstein, Etc. / D.A. van Dÿck Eques Pinxit / Cu. Priuileg: / Vorsterman Sculp.'

The duke is represented in armour of Spanish style from which his *golila* collar escapes at the neck. He wears

the Order of the Golden Fleece. His right hand rests on the top of a commander's baton, and, at his waist, the hilt of his sword is visible. Behind him, billowing drapery provides a suitably dramatic backdrop for this otherwise static image. The Vorsterman engraving shows certain changes from the study, which we assume served nevertheless as the engraver's *modello*, notably in the lower part of the armour where the figure has been cropped at the waist to make room for the legend, thus eliminating the hilt of the sword.

Although in need of cleaning, the painted surface is in excellent condition, with only slight retouchings scattered around its edges and in the areas of the subject's right hand, collar, and forehead. In 1957 the back of the panel was smoothed down, attached to a wooden support, and cradled, and a 1-centimetre strip frame added to all four edges.

Duke Wolfgang Wilhelm of Pfalz-Neuberg (1578–1653) was an important figure in the Julian succession controversy, renewing claims made by his father to the duchies of Berg, Juliers, and Cleves and making successful terms with his rival, the Elector of Brandenberg, in 1628 and again in 1651. Converted to Catholicism in 1614, he played an active role in the politics of the Netherlands, Spain, and France. He was also a collector and patron of Rubens as well as Van Dyck. Thus, the duke's achievements are characteristic of those of the prominent contemporary men and women grouped in the *Iconography* in the three classes of princes and generals, statesmen and men of learning, artists and amateurs.

Although the popularity of the *Iconography* is evidenced by its numerous editions over a period of 200 years, little can be established as to the actual circumstances surrounding its conception or the precise relationship existing between Van Dyck, his engravers, and his printers / publishers. The first reference to the prints as a group is by Huygens in 1632, and a letter of 1636 from Van Dyck, then court painter to Charles I in England (where he resided much of the time between 1632 to 1640),

indicates that the series was in preparation at that time (Vey, I, pp. 46–7). However, with most of the engravers associated with the project located in Antwerp and with none of the engravings in the *Iconography* bearing dates before Van Dyck's death in 1641, it is difficult to ascertain the respective roles of Van Dyck and those with whom he worked in the actual undertaking of the project. For a very useful survey of Rubens's engravers including Vorsterman see vol. II of the catalogue *Peter Paul Rubens, 1577–1640* (Cologne, Wallraf-Richartz Museum, 1977).

Eighty portraits were printed by Martin van den Enden at least in part if not in series by 1641 and in any case by 1645. This group (including twenty-one engraved by Vorsterman) did not include the portrait of Wolfgang Wilhelm. Prior to 1645, and very likely in the years immediately following Van Dyck's death in 1641, the original eighty plates came into the possession of the Antwerp printer Gilles Hendricx. He increased the number of prints to one hundred plus a title page by including fifteen portraits etched by Van Dyck himself, most of them elaborated by various engravers to bring them into line with the rest of the series, and by including a further six portraits from a group of additional engravings derived from Van Dyck's painted portraits. The portrait of Duke Wolfgang Wilhelm belongs to the plates of this latter group, of which Vorsterman engraved three. The title page was dated 1645. While it cannot be excluded that these engravings were planned or even executed while Van den Enden was the printer in charge – just not published and therefore not yet signed – circumstantial evidence suggests that the decision to include the portrait of Wolfgang Wilhelm was taken independently of Van Dyck.

Most of the portraits in the *Iconography* engraved by professional printmakers are here provisionally presumed to derive ultimately from formal portraits previously painted by Van Dyck. The immediate models for the engravers, however, were apparently either Van Dyck's etched

sketches, his chiaroscuro drawings, or oil studies, many of the last by hands other than Van Dyck's. Our portrait belongs to the third category, being entirely executed in brown monochrome, with lead white used for modelling and highlights. A pentimento visible above the figure's right hand reveals that the baton was originally held 2 cm higher. Indeed, the first proof state of Vorsterman's engraving is blank in the area of the hand while the finished states corrrespond here to the position as resolved in the study. As noted by Mauquoy-Hendricx, on an impression of this proof state in the Bibliothèque Nationale, Paris, this passage is sketched in with black chalk. This sequence of corrections to a portrait belonging to an edition post-dating Van Dyck's death in 1641 must be considered a factor in assigning an attribution. The inscription on the engraving, 'D.A. van Dyck Eques Pinxit,' conventionally indicates that the engraver has worked after a painted invention by the artist cited, without precluding the function of intermediary *modelli*. In this case, the archetype is probably a large painted portrait of the duke of which at least sixteen versions are known. The best of these are the full-length portrait in the Alte Pinakothek in Munich (see the recent catalogue *Alte Pinakothek München*, Erläterungen zu den ausgestellten Gemälden, Munich 1983, no. 402), that formerly in the Wilstach Collection in Philadelphia and now in Bremen, and that formerly in the Yerkes Collection in New York. Datable to circa 1628 / 29, these three depict the duke in court dress (not in armour) before an architectural setting and accompanied by a large dog. In the absence of a more exact model, the present study (and the engraving after it) may be considered a free adaptation of this type; the subject's head with swept back hair, short pointed beard, and *golila* collar is borrowed faithfully by the artist responsible for our panel.

The oil studies associated with the *Iconography* have long been a stumbling block for scholars (for a synopsis of the widely divergent

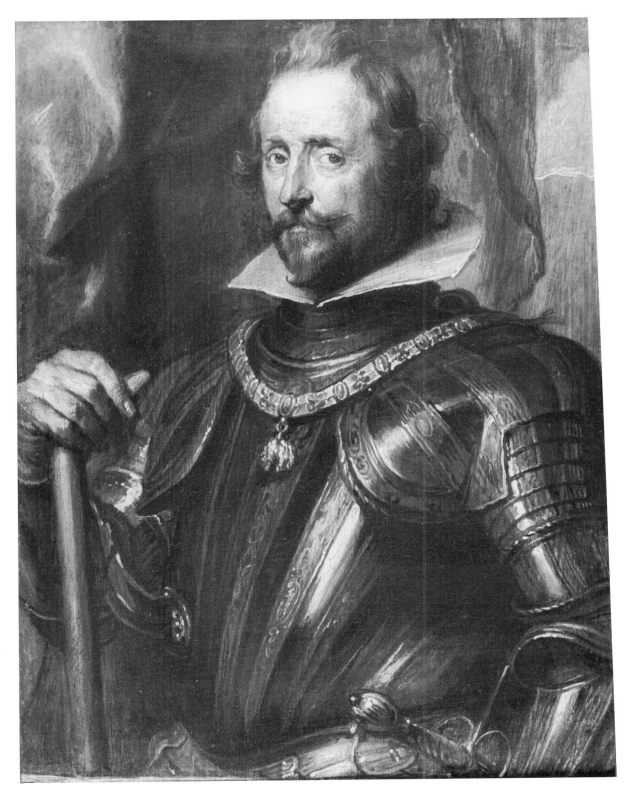

critical history up to 1962 see Vey, I, pp. 48–50). In his pioneering study, Hind (1915) considered them to be engravers' *modelli*, but not necessarily all by Van Dyck. In more recent publications the direct question of authorship, especially of individual panels, has frequently been side-stepped beyond a largely unexplored

generic labelling. They have also been discussed as a kind of shop by-product for commercial purposes, which, in the case of copies (see below), can hardly be excluded. More recently, Vey briefly raises the question of their potential preliminary function – prepared either by Van Dyck's assistants or by the engravers themselves, preferring at last an assignment to Van Dyck's shop. McNairn presents them as part of the preparatory process and as by Van Dyck himself. Brown describes them as in part by Van Dyck, 'others by assistants under his close supervision' and done 'as a guide to the engraver,' but he does not elaborate further. The Toronto study lacks the extremely fluid brushwork associated with Van Dyck and which characterizes many of the oil studies for this series, such as that of Gaspar de Crayer at Boughton House (Brown, fig. 133); while the duke's face is modelled with a rather restrained sensitivity, the remainder is rendered in a relatively mechanical manner.

Portrait drawings by Vorsterman, such as those of Thomas Howard, Earl of Arundel, and especially those related to engravings, reveal Vorsterman to be a talented imitator of Van Dyck's style (studies in Rotterdam and Dublin reproduced respectively as figs. 24 and 27 in E. Göpel, *Ein Bildnisauftrag für Van Dyck: Anthonis Van Dyck, Philippe le Roy und die Kupferstecher*, Frankfurt am Main 1940). On the basis of stylistic affinities between Vorsterman's signed studies – notably the restrained manner of the drawn portrait in Dublin and that of *George Villiers, Duke of Buckingham* in the British Museum (illustrated by A.M. Hind, *Catalogue of Drawings by Dutch and Flemish Artists Preserved in the Department of Prints and Drawings in the British Museum*, London 1915–32, pl. LXXVII) – and the Toronto study, together with the fact that in this Antwerp circle printmakers were known to have made their own *modelli*, and the evidence of the integration of the evolution of this *modello* with the alterations of the plate, the Malcove study can be tentatively attributed to Vorster-

man himself. While other drawn *modelli* are commonly ascribed to him, for example the *Three Marys at the Tomb* (Rotterdam) after Rubens's painting in Pasadena and for his own engraving, there are no other oil studies now so attributed. (All three are illustrated by D. Freedberg, *Rubens, The Life of Christ after the Passion*, Oxford 1983, figs. 8, 10, 11.) The obvious question as to the authorship of other monochrome oil studies engraved by Vorsterman for this series – for instance, that of Francisco de Moncada (sale Hotel Drouet, Paris, 8 March 1982) – is regrettably outside the scope of our present research.

Lucas Vorsterman the Elder has received little scholarly attention except in his capacity as an engraver (see the monographic study by H. Hymans, *Lucas Vorsterman, 1595–1675, et son oeuvre gravé*, Brussels 1893, and the more general discussion in the 1977 Cologne catalogue, *Rubens*, some of which is developed in reference to the discussion in K. Renger, 'Rubens Dedit Dedicavitique, Rubens' Beschäftigung mit der Reproduktionsgraphik,' *Jahrbuch der Berliner Museen*, 1974, 122–75). His activity in that area is well documented, owing chiefly to his association with the Rubens workshop where from about 1618 he was employed for the specific purpose of making engraved reproductions after Rubens's designs. His skill in this medium was remarked by the contemporary artist and critic Sandrart who praised Vorsterman's technique of 'painting with the burin' (*Joachim von Sandrarts "Academie der Bau-, Bild-, und Mahlerey-Kunste" von 1675*, ed. A.R. Peltzer, Munich 1925, p. 243). After Vorsterman's rancorous departure from the Rubens workshop (for the working relationship between the two men see J.S. Held, 'Rubens and Vorsterman,' *Art Quarterly*, XXXII, 1969, 111–29), he was succeeded by a former pupil, Paulus Pontius, who was also later to be closely associated with the *Iconography* project. In 1624 he went to England, returning in 1630. Shortly thereafter he apparently began working with Van Dyck. Until further study is undertaken

on Vorsterman's work as a draughtsman and painter, and until serious critical attention has been directed to the question of the relationship and authorship of the other monochrome oil studies prepared in association with the *Iconography* series, the attribution of the Toronto study will remain tentative, although not inconsistent with the evidence developed thus far. L. Vergera is currently preparing a study on the portrait tradition of the *Iconography*, while Van Dyck's oil sketches as a whole will be the subject of a monograph by J.S. Held. The issues raised by the Malcove panel are being considered at greater length in an article by the present author. At the very minimum the sequence of corrections discernible in the Toronto study and the subsequent engraving demonstrates that at least this one oil study was an integral pat of the preparatory process (that may well have taken place after Van Dyck's death) and therefore is demonstrably not a byproduct or copy.

The largest collection of these oil studies is that of the Duke of Buccleuch at Boughton House which has at its core the '32 ritratti di Chiaro Scuro' first mentioned in the 1655 inventory of the collection of the Earl of Arundel. The list of these panels published by Hind in 1915 included a portrait of Duke Wolfgang Wilhelm, of which no further reference has been made in the literature.

PUBLICATION
Possibly the panel listed in A.M. Hind, 'Van Dyck: His Original Etchings and His Iconography,' *Print Collector's Quarterly*, V, 1915, 30 note 1.

Private collection (said to have been purchased in 1950 at an open-air Hemel Hempstead market); Christie's sale (London, 9 April 1954, lot 129); George Seligman, New York; purchased by Dr Malcove in 1955.

JAS / KAT

474 Head of the Infant St John the Baptist
ANDREA DEL SARTO
(1486–1530)

Black chalk with some white heightening on grey-brown paper.
17.2 × 22 cm
Italian, Florence, circa 1523 M82.9

This drawing is evidently one of four recorded fragments from a cartoon associated with the *Holy Family* painted by Andrea del Sarto for Zanobi Bracci around 1523 and now in the Pitti Palace, Florence. (I am grateful to Nicholas Turner of the Department of Prints and Drawings at the British Museum for drawing my attention to the relationship between the Malcove Collection drawing and the Bracci *Holy Family* by del Sarto. For the most recent discussions of the painting see S.J. Freedberg, *Andrea del Sarto*, Cambridge, Mass. 1963, no. 69, and John Shearman, *Andrea del Sarto*, Oxford 1965, no. 66.) The principal contours around the head have been heavily incised with a stylus indicating that the drawing has been used as a cartoon from which the design was transferred to another surface in the course of preliminary work on a painting. The correspondence between this head and that of St John the Baptist in the Zanobi Bracci *Holy Family*, and the similar relationship between the other three identically executed cartoon fragments and the painting, establishes a strong case for Andrea del Sarto's authorship. Although all the recent authorities who have discussed the painting agree that it contains extensive studio participation and must have been completed by an assistant, the quality of the draughtsmanship suggests the work of del Sarto himself and may be compared with other drawings from his hand. The connection between the four cartoon fragments and the Bracci painting was first noted in 1935 by Fraenckel who did not, however, accept them as del Sarto's own work (I. Fraenckel, *Andrea del Sarto, Gemälde und Zeichnungen*, Strasbourg 1935); the same view is taken by Freedberg, who includes one of the surviving drawings under copies and derivations from the original (Freedberg, p. 159). Shearman firmly assigns the study for the head of the Virgin now in the Rijksprentenkabinet in Amsterdam which bears the same provenance and clearly formed part of the same cartoon to del Sarto himself, however, and comparison of the Malcove drawing with others by the artist would appear to corroborate the attribution (Shearman, p. 386). The other three fragments are studies for the head of the Virgin (Amsterdam, Rijksprentenkabinet, no. 54:41; reproduced by Shearman, pl. 123C), the head of the infant Christ (unlocated), and the head and hand of Joseph (unlocated; reproduced by Shearman, pl. 122C).

Marchese Jacopo Durazzo, Genoa; Durazzo Sale, Gutekunst, Stuttgart, 1872 (no. 3897); Karl Edward Hasse (1810–1902), Hanover (collector's mark lower right, F. Lugt *Les Marques de collections de dessins et d'estampes*, 1921, no. 860); by descent to E. Ehlers, Göttingen; Ehlers Sale, Boerners, Leipzig, 1930; R.E.A. Wilson, London, 1934; Mark Olver MJHL

475 Recto: *Study of a Gryphon*; verso: *A Battle Scene*
ANONYMOUS

Pen and brown ink, over traces of
black chalk, on white laid paper.
Inscribed on reverse, lower right,
'Giulio Romano.' 17.2 × 21.3 cm
French, School of Fontainebleau,
16th century M82.15

For stylistic reasons the old attribu-
tion on the reverse to Giulio Romano
cannot be sustained. Trimming of
the sheet has caused an earlier anno-
tation (verso, lower left) to become
indecipherable. The attenuated and
angular figure style and abrupt cal-
ligraphy employed for the *Battle
Scene* are characteristic of the picto-
rial conventions and drawing style
employed by mannerist artists
around the third quarter of the six-
teenth century, and are particularly
reminiscent of certain tendencies
to be found in some drawings associ-
ated with the School of Fontaine-
bleau. The rather tense and brittle
handling of the pen and deliberately
disconcerting impressions of space
correspond to the frequently
disturbed and capricious mannerisms
of the Fontainebleau School style
of the period which was largely in-
spired by *émigré* Italians whose in-
fluence on contemporary French
artists is often encountered in a
somewhat exaggerated or distorted
version of the mannerist aesthetic
such as is exemplified here.

Distinguishing French from Italian
authorship in the large corpus of
anonymous Fontainebleau style
drawings is a hazardous undertaking,
and the Malcove Collection example
demonstrates very clearly the prob-
lems involved. *The Study of a Gry-
phon* on the recto side appears in
its more controlled handling to sug-
gest an Italian origin, whereas the
Battle Scene on the reverse is more
indicative of a French draughtsman.
The two drawings are, however,
clearly by the same hand to judge
from the manipulation of the pen,
particularly in the way hatching is
used to model forms in an abbrevi-
ated fashion.

Battle scenes of the type portrayed
on the verso of this sheet are a com-
mon subject in the work of School
of Fontainebleau artists and occur in
the decorative arts as well as in
paintings and engravings. The dis-
tinctive style of draughtsmanship,
superimposed planes, and the agita-
ted attitudes of the figures are all
fairly typical of Fontainebleau man-

nerisms in the period between about
1550 and the 1570s. Ultimately the
style is derived from Rosso Fiorentino
(1494–1540), whose work at Fontai-
nebleau for Francis I inaugurated
the school. The study for the Gry-
phon on the recto may have been in-
tended to serve an ornamental
purpose as a supporter or integral
part of a border or some such scheme,

suggesting that the drawing could be the work of an artist involved in designing decorative ornament in the minor arts.

Purchased from M. Glueckselig and Son, New York, 1962 MJHL

476 *Study of Three Nymphs Dancing*
ANONYMOUS

Pen and brown ink with grey wash over pencil. 12.5 × 17.6 cm
French school (?), late 18th century
M82.14

The linear convention employed in the execution of this drawing and somewhat insinuating figure style indicate the work of an artist familiar with the conventions of neoclassical design and late eighteenth-century sensibility. The subject is ultimately derived from the antique Roman reliefs incorporating dancing nymphs or maenads which were prolifically imitated and used for a variety of decorative purposes by neoclassical artists generally throughout Europe. Although the provenance and technique suggest that this may be a French drawing, the style had become so widespread by the latter part of the eighteenth century that it is not always possible to be certain of the school to which an anonymous sketch of this kind belongs. Certain obvious weaknesses in the proportions and placement of the figures, their awkward attitudes, and the quality of the draughtsmanship – superficially fluent but lacking in some passages a convincing comprehension of form – point towards an artist of a rather derivative character and limited facility although, as an example of the more generalizing neoclassical fashion of the period, it is nonetheless a drawing of considerable charm.

Purchased in Paris, date unknown
MJHL

477 *Head of a Bishop*
DOMENICO VENEZIANO
(circa 1410–1461)

Gesso and tempera on wood.
17.7 × 15.6 cm
Italian, 1445–50 M82.144

The panel depicts the head of a bishop, shown in a three-quarter view, with a punched halo pattern framing his head. The paining has been cut from a larger work, thus truncating the crozier the bishop holds in his right hand so that only the terminus remains visible. It is possible that the bishop formed, originally, a part of a *sacra conversatio*, a group of saints or other holy persons engaged in some form of exchange. But it is far more likely that the portrait bust was cut from a panel containing only the single figure. The

bishop may have represented one of the four Latin Church Fathers, Ambrose, Augustine, Gregory, Jerome, and, as such, may have formed a portion of a diptych or polyptych. This would have consisted of a central, large panel with two or several smaller panels placed adjacent to the central panel in a symmetrical composition. Often, all of the panels were united by means of an ornate architectural frame. Or it may simply have been one of four vertical panels commemorating the doctrines and triumphs of the early theologians.

There is considerable surface damage and much of the gold has been lost from the pattern of the clothing, the halo (its faint rinceau pattern is visible only as tracery no longer golden) and the crozier. Despite the wear on the surface of the panel, the face of the bishop is still softly modelled and reflects Domenico's

Venetian experience with the Byzantine style (H. Wohl, *The Paintings of Domenico Veneziano*, New York / London 1980, p. 6). The Northern Italian artists, particularly the Venetians, retained much of the Byzantine style well into the fifteenth century. According to Wohl's grouping of the paintings of Veneziano, on the basis of style and composition, this 'Head of a Bishop' dates from circa 1445–50 (p. 64). MJH

workshop and it was Antonio who achieved a great technical reputation for his marble carvings. Despite the fact that his medium was not stucco, this panel is attributed to Antonio or, more likely, to a member of the workshop, for other marble panels survive by the sculptor which bear a strong resemblance or are identical to the Toronto panel (J. Pope-Hennessy, *The Kress Collection: A Catalogue of Renaissance Bronzes*, London 1965, p. 69: 'His [Antonio's] marble reliefs of the Virgin and Child enjoyed great popularity and were widely reproduced in pigmented terra cotta and stucco replicas.' Certainly this is true of our example). Similar marble pieces may be found in London (J. Pope-Hennessy, *Catalogue of Italian Sculpture in the Victoria and Albert Museum*, vol. 2, London 1964, no. 111, which is identical to the Toronto panel), Leningrad (M. Artamonov, *The Hermitage*, Leningrad 1964, no. 62, which is nearly identical with our panel, with the exception of the two putti and clouds in the background instead of the garland; the poses of the two figures and other details are the same), and Berlin (Berlin, Königliche Museen, *Beschreibung der Bildwerke der christlichen Epochen*, vol. 5, zweite Auflage. *Die Italienischen und Spanischen Bildwerke der Renaissance und des Barocks im Marmor*, Berlin 1913, p. 66, no. 153, which bears a nearly identical pose). Schulz (p. 15) states that during the 1450s and 1460s Antonio's work included, among many other subjects, several relief panels of the Virgin and Christ Child. Therefore, the Toronto panel probably dates from about the same time.

MJH

478 *Seated Virgin and Child*
ANTONIO ROSSELLINO
(or his circle)

Painted and gilt stucco.
Frame: 70.4 × 46.2 × 8.2 cm
panel: 69 × 42 cm
Italian, Florence, circa 1450–67

M82.2

The Virgin and Christ Child are shown seated, in the extreme foreground of the panel, with a garland draped behind them, compressing to a minimum the space available to them. The haloes of the two figures were gilded, as were the cuffs of the Virgin's garment and the star on her cloak. Only traces of the gold remain. Antonio Rossellino was the youngest of five Rossellino brothers who were sculptors in Florence (A.M. Schulz, *The Sculpture of Bernardo Rossellino and his Workshop*, Princeton 1977, p. 3). They shared a

479 *Virgin and Christ Child with Young St John the Baptist*
School of FILIPPINO LIPPI
(1457–1504)

Tempera on wood. 84 × 54 cm
Italian, late 15th, early 16th century
M82.143

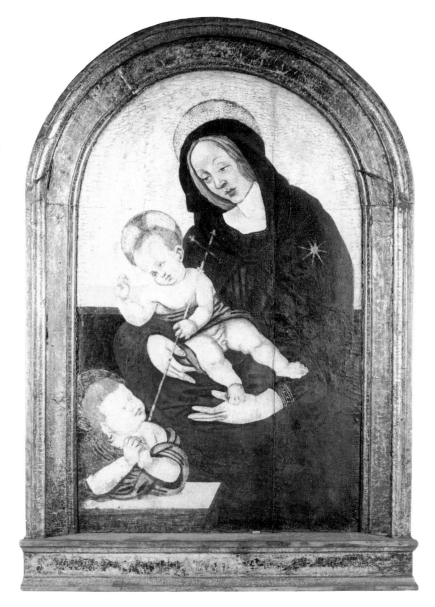

The painting of the Virgin and Christ Child with the young St John the Baptist retains its original frame. It has, however, undergone restoration which has emphasised the flat, linear qualities of the three figures and has, quite likely, considerably altered the appearance of the whole painting. If, indeed, the painting is accurately attributed to the School of Filippino Lippi, his usual delicacy of line has been effaced by the restorer.

The young Baptist, placed in the lower left corner, leans on a table-like structure, possibly an altar, prefiguring the sacrifice of Christ for mankind, and has his hands clasped in an attitude of prayer, while looking up to the Mother and Child. He wears a green garment and a cloak of animal skin, the traditional garb of the saint. This was an aspect of the Baptist particularly favoured by the Renaissance painters. The Christ Child, seated on His Mother's lap and supported by her hands, turns towards the Baptist and blesses him with His right hand, while holding a slender cross-staff in His left. The Virgin regards the two children with an impassive expression. The Child's sole garment is a drape across His chest. The Virgin is clothed in a blue garment, edged with gold at the bodice and on the sleeve and there is a gold star on her left shoulder. This may be a vestige of the three stars traditionally placed on the shoulders and forehead of the Byzantine Virgin, to indicate her virginity before, during, and after the birth of Christ. The three figures have small, gold-tooled nimbi. There is the suggestion of a wall or ledge behind the group, and above that a faint horizon line. Beneath the panel, forming a part of the frame, is the inscription AVE MARIA GRATIA PLENA,

the words spoken to the young Mary by the Archangel Gabriel (Luke 1:28), and therefore often associated with a scene of the Annunciation.

Although the placement of the subjects in the extreme foreground of the painting is typical of Lippi (and many others of his time), the fragility often found in his paintings is not much evident in this example. In L. Berti and U. Baldini, *Filippino Lippi* (Florence 1957), pl. XVIII, 'Madonna and Saints' from S. Spirito, Florence, the figures of the young Baptist, the Virgin and Child bear a resemblance

to our painting, although in the S. Spirito version the lines are much more delicate than in the Toronto painting. However, this may be explained by the over-zealous restoration. It is very likely that our panel should be attributed to the School of Lippi, rather than to Filippino, since the ' ... enthusiasm for the beauties of light and atmosphere ... ' (F. Worth, *History of Italian Renaissance Art*, New York 1971, p. 174) which were standard for Filippino's work are so conspicuously restrained in this painting. MJH

480 *St. Mark (?) Reading*
LUCA CAMBIASO
(Luchetto da Genova)

Pen and iron gall ink with brown
wash over traces of black chalk.
17.7 × 20.8 cm
Northern Italian, circa 1570 (?)

M82.1

Luca Cambiaso (b. Moneglia, near
Genoa, 1527, d.1585, El Escorial,
Spain) was the leading Genoese artist
of the sixteenth century. He studied
with his father Giovanni, a painter of
modest talents, and before the age
of twenty had decorated a number of
palace interiors and facades. His
early 'gigantic' style was much influ-
enced by Michelangelo, whom he
was expected to surpass in brilliance.
In the 1550s and 60s this youthful
exuberance was tempered by the ex-
ample of several Mannerist artists
who had visited Genoa, most notably
Perino del Vaga, Beccafumi, and
Pordenone.

The growing refinement of his
work can best be seen in the series of
Correggio-like nocturnes that date
from the final twenty years of his life.
Serene in mood though monumen-
tally composed, their importance for

the development of the northern
Caravaggisti has yet to be fully ex-
plored.

In 1583 Cambiaso was invited to
Spain by Philip II, but the kindest
accounts of his efforts in the Escorial
describe them as vacuous and banal.
His commissions there were com-
pleted after his death in 1585 by his
assistant Lazzaro Tavarone and his
son Orazio. The most complete mod-
ern biography is Bertina Suida Man-
ning and William Suida, *Luca
Cambiaso, La vita e le opere*, Milan
1958.

Whatever his contemporary repu-
tation as a painter may have been,
Cambiaso's fame today rests largely
on his extraordinary abilities as a
draughtsman. 'Cambiaso drew with
such technical skill and such ease,
that composition after composition
flowed from his pen as easily and
as joyously as Mozart composed his
celestial music' (Robert L. Manning,
Drawings of Luca Cambiaso, New
York 1967–8, Introduction). When
Luca was a child his father hid his
clothes to keep him close to the
drawing board, and he was so prolific
that his wife is said to have used
bundles of his drawings to light the
fire. (Such anecdotes can be found in
Raffaello Soprani, *Le vite de' Pittori*,

Scoltori, ed Architetti Genovesi …
Genoa 1674.) Those that survived
were given to his pupils to be copied
as part of their education, and no
less an authority than Tintoretto
warned against too slavish an imita-
tion of them: 'sono bastanti a rovi-
nare un giovane che non possedi
i buoni fondamenti dell'Arte …
(Carlo Ridolfi, *Delle Maraviglie
dell'Arte*, vol. 2, Venice 1648, p. 68).
No censure is implied here, but rather
a genuine sense of admiration for
such highly personal and imaginative
productions.

Cambiaso's drawings are justifia-
bly popular, their immediate visual
appeal a direct result of their spon-
taneity and dramatic power. The
main problem is one of over-attribu-
tion. He was once seen in the church
of San Matteo painting with a brush
in each hand and doing the work
of ten men (G.B. Armenini, *De' veri
precetti della pittura*, vol. 2, Rav-
enna 1587, pp. 128–9 in the 1823 edi-
tion), and from the number of
drawings that bear his name he must
have been equally adroit with the
pen! Several versions of the same
original design may exist – the result
of his method of teaching – and doz-
ens of imitations still wait to be
removed from the master's œuvre.

The authenticity of the present
drawing is beyond question. Copies
and variants are generally betrayed
by hesitancy and anatomical gaffes,
and there is often a considerable
amount of under-drawing, sometimes
the result of tracing. Here the slight-
est indications of chalk have been
used to block out the main elements
of the composition, and the artist
has then gone to work with his usual
panache. The confident and almost
impetuous quality of the line suggests
that Cambiaso saw speed and facility
of execution as essential ingredients
of his style. Flicks and commas are
used as a kind of graphic shorthand
to suggest interior modelling, and
there too contribute to the overall
impression of virtuosity. The func-
tion of the wash is less to define
specific forms than to complement
them and create a sense of space
in which the figure can comfortably
exist.

Also characteristic of Cambiaso's work is his use of the highly corrosive iron gall ink. In some cases where the ink has been allowed to puddle, it has eaten right through the paper. Here the design is so deeply etched into the paper that it is almost as legible from the back as from the front.

The massive and attenuated saint reclines on a cloud, engrossed in his studies, his left arm resting familiarly on the head of his attribute – a rather disgruntled-looking lion. His precise identity is uncertain. A comparable figure in Princeton is called St Jerome (Felton Gibbons, *Catalogue of Italian Drawings in the Art Museum, Princeton*, Princeton 1977, I, pp. 34–5, no. 87), while another reading saint in the Victoria and Albert Museum appears to be accompanied by an ox and so is identifiable as St Luke (Peter Ward-Jackson, *Italian Drawings, I: 14th–16th Century*, London 1979, pp. 50–1, no. 91). The latter has a halo, the Princeton Jerome does not, so the present drawing may represent the Evangelist rather than the Church Father. Another argument in favour of St Mark might be that the lion here looks slightly more heraldic than real.

The exact purpose of the drawing is equally problematic. The radical foreshortening and 'di sotto in su' illusionism of this sketch and a number of similar images suggest that they may have been preliminary designs for some form of architectural decoration. They are possibly related to a project such as the Prophets and Sibyls that Cambiaso painted in the vaults of the aisles of S. Matteo, Genoa, but these frescoes were completed in 1559, too early for the mature style of the Malcove drawing.

Perhaps these drawings performed a more private function, providing the artist with an opportunity to flex the muscles of his imagination – to express his creativity in a way that was rarely possible in large-scale public commissions. FB

481 *The Holy Family and the Holy Dove appearing to S Francesco di Paola*
GIUSTINO MENESCARDI
(Milan, 1720–?)

Oil on canvas. 79 × 55 cm
Italy, mid-18th century M82.17

The canvas has presumably been relined with a new stretcher, maybe 100 years ago. The general condition is satisfactory; there is some rubbing, particularly at the foot; there is a small hole 8 cm from the top, 15 cm from the left. The painting is placed in a carved wooden eighteenth-century frame, possibly the original.

S. Francesco di Paola is generally shown as an old man in a black monk's habit, with a staff, a book (the Rule of the Minims), a lily, and frequently an angel. He is generally distinguished by the word 'Charitas' in a small glory, which is here replaced by the Holy Dove in a similar small glory. There is a putto at bottom centre with a book bearing the letters CAR (for 'Caritas'). The drapery behind the head of the Virgin bears a blue St George's cross on a mustard ground.

The painting is here attributed to Giustino Menescardi, a Tiepolo follower who is said to have come from Milan (G.A. Moschini, *Guidi di Venezia*, Venice 1815, II, p. 603). The few available facts about Menescardi are set out by Rodolfo Pallucchini, *La Pittura Veneziana del Settecento*, Rome 1960, pp. 108–9. It seems that he may well have been born in Milan, circa 1720, and he may have joined Tiepolo when the latter was in Milan in 1738 or 1740. He seems to have remained in close contact with Tiepolo in the years 1740–2, and then started an independent career (cf George Knox, *Master Drawings*, 1974, XII, 4, p. 381 and note 7; George Knox, *Studies in 18th Century Culture*, 1976, V, p. 30 and note 5; George Knox, *Museum Studies*, Art Institute of Chicago, IX, 1978, pp. 85–7).

His first documented works are the nine-part ceiling and two wall paintings in the Sala del Archivio of the Scuola dei Carmini in Venice, 1748–53, and eight ovals in the ceiling and one wall canvas (?) in the Sala dell'Albergo of the same (cf Don Antonio Niero, *La Scuola Grande dei Carmini*, Venice 1963, pp. 39–45). In 1762 he worked in the Sala dello Scudo of the Ducal Palace (cf Giulio Lorenzetti, *Guida di Venezia*, Rome 1926, p. 251). In 1765 he painted frescoes, long since destroyed, in the Teatro di S. Cassiano in Venice (cf Moschini, p. 603). The major work of his which survives in Venice is the St Augustine altarpiece in the church of S. Stefano (Moschini, p. 576; Lorenzetti, p. 510), which is not dated.

Antonio Morassi (in his monograph *Tiepolo*, London 1962), attributes, I think correctly, a number of canvases to Menescardi, among them, p. 9, Cleveland, *Horatius Defends the Bridge*, *Horatius Swims the Tiber*; p. 12, Florence, Uffizi, *The Erection of a Statue* (a ceiling formerly in a seminary at Udine); p. 37, Ottawa, National Gallery of Canada, 5050, *The Adoration of the Kings* (in recent years on loan to the Winnipeg Art Gallery).

There does not appear to be any reference to the Malcove painting in Morassi's monograph on Tiepolo, given the dimensions. It is evidently by the same hand as Ottawa 5050, and an attribution to Menescardi seems entirely satisfactory. GK

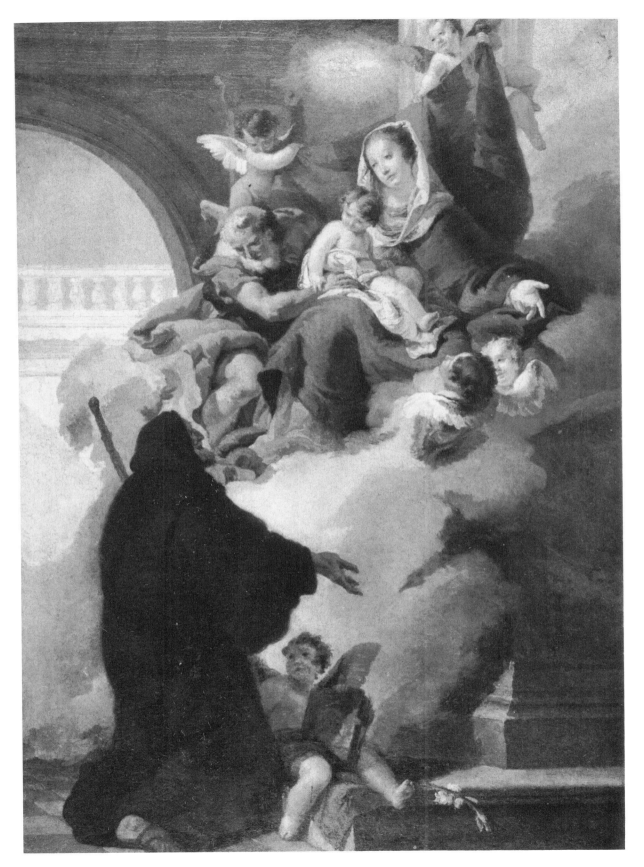

482 *Architectural Capriccio*
GIOVANNI BATTISTA
PIRANESI
(Italian, 1720-1778)

Pen and black ink with gray wash
over sanguine, main structural lines
incised with stylus, on paper laid
down.13.1 × 18 cm
Inscribed in sepia ink on mount,
lower margin left of centre, 'Schizzo
Originale del celebre Piranesi'; par-
tial stamp (possibly a collector's
mark) appears in black or dark blue
ink, very faded, lower right corner
of support, overlapping the mount.

M82.23

Born on the Venetian mainland,
Giovanni Battista Piranesi served
his apprenticeship in Venice (circa
1730–40) studying architecture with
his uncle Matteo Lucchesi, architect
and hydraulics engineer at the Mag-
istrato delle Acque, and with Giov-
anni Scalfarotto. During this period
he also studied perspective under
Carlo Zucchi and gained a knowledge
of stage design through his
association with the Bibiena family
and the Valeriani brothers. In 1740
Piranesi made his first trip to Rome in
the entourage of Marco Foscarini,
Venetian ambassador to Pope Bene-
dict XIV. During this stay in the capi-
tal (1740–3) he learned printmaking
techniques from Giuseppe Vasi, the
leading engraver of Roman views,
and began to associate actively with
members of the artistic and intellec-
tual community, including represen-
tatives from the French Academy
in Rome. After publishing the *Prima
Parte di Architetture e Prospettive*
(1743), an edition of twelve engrav-
ings, Piranesi returned briefly to Ven-
ice (1743 / 4–5). There he encountered
the works of Giovanni Battista
Tiepolo, an experience which pro-
foundly influenced the development
of his mature style.

Settling permanently in Rome
circa 1745, Piranesi concentrated
upon the depiction of archaeological
discoveries and Roman monuments.
He recorded views of ancient and
contemporary Rome in major, en-
graved suites such as the *Antichità*

romane (4 vols., 1756) and the *Ve-
dute di Roma* (135 plates, 1748–78).
Visiting and documenting archaeo-
logical remains, he produced volumes
which included the *Antichità d'Al-
bano e di Castel Gandolfo* (1764) and
the *Antichità di Cora* (1764), with
his treatise on ornament, the *Diverse
maniere d'adornare i cammini*, ap-
pearing in 1769. A strong advocate of
the supremacy of Roman architec-
ture, his theories were summarized in
*Della Magnificenza ed Architetture
de' Romani* (1761). Elected an hon-
orary member of the Society of Anti-
quaries of London (1757) and member
of the Academy of St Luke in Rome
(1761), Piranesi continued to publish
until his death in 1778, his last un-
dertaking being a suite of engravings
based upon the classical antiquities at
Paestum. Within his *oeuvre*, how-
ever, the *Carceri d'invenzione*, a se-
ries of etched views of imaginary
prison interiors (1745, 1760), remain
his most original work.

Piranesi's sensibility to the poetic
quality of ruins, whether real or
imagined, combined with a dramatic
vision influenced by contemporary
Italian stage design, foreshadowed
Romanticism. Writing about the
artistic climate in England during
Piranesi's lifetime, Horace Walpole
offered the following advice (1771):
'This delicate redundance of orna-
ment growing into our architecture
might perhaps be checked, if our
artists would study the sublime
dreams of Piranesi, who seems to
have conceived visions of Rome be-
yond what it boasted even in the
meridian of its splendour. Savage as
Salvator Rosa, fierce as Michaelan-
gelo, and exuberant as Rubens, he
has imagined scenes that would star-
tle geometry, and exhaust the Indies
to realize. He plies palaces on bridges,
and temples on palaces, and scales
heaven with mountains of edifices.
Yet what taste in his boldness! What
grandeur in his wildness! What la-
bour and thought both in his rashness
and details!' (Advertisement to the
Fourth Volume of the *Anecdotes
of Painting*, 4th ed., 1786, in Horace
Walpole, *The Works of Horace Wal-
pole*, London 1798, III pp. 398–9).

In a drawing typical of Piranesi's

early manner, architectural elements
taken mainly from Roman sources
have been massed liberally herein to
construct an intricate, monumental
interior where figures have been
reduced deliberately in scale in order
to enhance the grandeur and enorm-
ity of this invention. The soaring
arches, which lead to heavily cof-
fered chambers, and the dramatic
view taken from an angle reflect the
artist's formative training in Italian
stage design, particularly his studies
with the Bibiena (Andrew Robison,
*Giovanni Battista Piranesi; The Early
Architectural Fantasies: A Guide to
the Exhibition*, Washington 1978,
p. 11).

A dynamic, late Baroque com-
position results from the choice
of perspective, with boldly ruled
orthogonals becoming well-defined
diagonals which move both outward
and upward into the viewer's space.
(The fact that the orthogonals are
incised may indicate preparation for
transfer to a plate, thus suggesting
that the work could be a preliminary
study for a print.) This sense of ex-
tended space is made more immedi-
ate by the way in which the barrel
vaulted chamber has been cut off
intentionally on the right, giving the
impression that the motif continues
beyond the limits of the support.
The strong, curvilinear rhythm es-
tablished by the series of vaulted
chambers, a momentum balanced
visually by the arch and bridge motif
set at right angles to the main ar-
cade, underscores the artist's preoc-
cupation with continual movement
in a composition.

Paradoxically, the linear perspec-
tive system employed to organize
and unify the composition does not
create a rational, coherent space.
Relationships between architectural
members are not clearly defined,
It is not certain, for example,
whether the flight of steps leads to a
higher level upon which figures ap-
pear to be standing. The function
of the colonnades, which seem to be
situated in front of the chambers,
remains problematical. The ambigu-
ity of space and formal relationships,
in keeping with the nature of the
early *capricci*, anticipates the more

expressive juxtapositions found in Piranesi's *Carceri*, first published in 1745.

Freshness and vitality, qualities foremost in the freely rendered sanguine sketch, characterize this drawing. The figures, added after the main structural lines had been laid down in pen and ink, are brushed in summarily with semitransparent wash. Utilizing the white of the paper to indicate highlights, Piranesi has rendered the soft, transparent shadows cast by architectural members through the use of diluted ink, applied with rapid and economical strokes of the brush. Sepia tones, created by experimenting with ink and sanguine chalk in combination, achieve colouristic effects which enrich the work while harmonizing with the overall warmth of its light. Specific details, such as the arch and bridge motif considered previously, have been gone over only to heighten tonal contrasts rather than to rework the existing composition.

Felice Stampfle ('An Unknown Group of Drawings by Giovanni Battista Piranesi,' *Art Bulletin*, xxx, 2, 1948, 122–41) has remarked that the period of the 1740s, when the influences of Bibiena and Tiepolo dominated Piranesi's style, saw the realization of some of the artist's most interesting and beautiful drawings. Although a minor and unsigned study, this *Architectural Capriccio* embodies the lightness and airy execution synonymous with the Venetians. His sensibility perhaps manifests itself most eloquently in the treatment of the pedimented niche which is bathed in light, upper right centre. By means of several broad strokes, Piranesi has made tangible the rays of sunlight which filter obliquely through the interior atmosphere and fall upon the niche, giving it a substance and articulation which reveals his control and personal refinement of the medium.

EXHIBITION
'The Intimate Notation: European Drawings and Watercolours, xvith–xxth Century,' New York, Spencer A. Samuels and Co., October-November 1967, no. 31

Georges Bernier, Paris; Spencer A. Samuels and Co, New York, 1967 AH

483 Sheet of drawings
DELACROIX and his circle

Pen and ink. 19 × 29 cm
French, circa 1852–7 M82.8

The attribution of this sheet of draw-
ings to Delacroix raises questions
about the nature of its connection
with him. There is no mark of Dela-
croix's posthumous sale on the sheet
and it was therefore not one of the
large number in his studio at the
time of his death. If all its drawings
were unquestionably in his style,
or could be related to one or more of
his compositions, the lack of infor-
mation about the early provenance
would be less serious. As it is, we
know nothing about the origin of the
sheet, or about who owned it, before
it came into the collection of Georges
Aubry. This is a significant gap, given
that the predominant style of the
sketches only superficially resembles
Delacroix's.

A number of the forms on the sheet
are anatomically loose and even
odd, in ways that do not reflect his
characteristic liberties. This is true of
the long, boneless fingers at the right,
the fragments of horses and warriors
at the left and the standing woman,
an Amazonian type not found in
Delacroix's known works (see Salo-
mon Reinach, *Répertoire de reliefs
grecs et romains*, Paris 1912, I, p. 222,
and III, p. 165). Whoever drew this
figure strove for liveliness, but in
doing so revealed the limitations of
his grasp of anatomy. They are evi-
dent in the exaggerations of the right
arm, in the uncertainty of the left
leg and in the ambiguity between the
left breast and shoulder.

If there were nothing more to the
sheet its interest for students of Dela-
croix would be slender. This is not
the case because two fragments to
the right of the Amazon, a profile and
a foreshortened head, testify to a
connection with him. It depends on
two things: that the fragments derive
from Rubens and that they evoke
Delacroix's style of emphatic cross-
hatching. Despite abrupt transitions,
the profile and the foreshortened
head are boldly modelled and expres-
sive. In particular, on the upturned

face, we find a pattern of flickering
light and shadow that is one of the
marks of Delacroix's style. And as if
to emphasize the connection, both
fragments can be identified with
details in Rubens's *Life of Achilles*.
In the form of tapestries these eight
scenes are known to have aroused
Delacroix's continuing admiration.
The circumstantial evidence for a
connection with him is therefore
strong. The sheet may be the creation
of someone in his circle, who is fa-
miliar with his style of pen drawing
and who shares his interest in a work
by Rubens which we can identify
with some precision.

The profile is one that Rubens
often uses for such figures of war as
the youthful Achilles and Athena or
Bellona. The type appears regularly
among the secondary characters
of the *Life of Marie de' Medici* and
may be masculine or feminine ac-
cording to the needs of the occasion,
without undergoing much structural
change (Jacques Thuillier and
Jacques Foucart, *Rubens' Life of
Marie de' Medici*, New York 1967).
This ambiguity of gender is appropri-
ate to what appears to be a source
for the two heads under discussion,
the third tapestry and engraving
of Rubens's *Life of Achilles* showing
*Achilles Discovered Among the
Daughters of Lycomedes* (E. Haver-
kamp Begemann, *The Achilles
Series*, London 1975, figs. 19, 20, 27,
28). Here the hero, disguised as a
woman, appears in profile with a
strong nose and full, curving lips,
while beside him one of the
daughters looks up with an engaging
tilt of the head. These are the
elements that have been selected and
put on to the Malcove sheet, Achilles'
plump profile and an upturned head
that borrows the form, if not the
features, of Lycomedes's daughter.

In this second detail there has been
a conflation of types so that the
identification of the head is changed.
The face of Rubens's daughter of
Lycomedes is smoothly, placidly
feminine. By comparison, the
features of the Malcove head are
rugged and convey a deep emotion
not unlike that of the dying Achilles
in the last scene of the Rubens set

(ibid., figs, 72, 73, 83, 84). Both heads
on the Malcove sheet would there-
fore seem to depict Achilles, in a
way that reflects the influence of
Delacroix's approach to copying.
While the heads are close to their
original, they are not literal
imitations. They seem to be an
attempt to understand Rubens's form
and spirit by someone who may
hope to use the Rubensian style for
his own purposes. This would explain
the presence of the Amazon and
the heads of horses and warriors on
the Malcove sheet. Rubens did not
show Achilles' battle with the
Amazons or his slaying of their queen
Penthesileia, but they are among
Achilles' famous exploits and would
have a place in any independent
illustrations of his life.

What we know of Delacroix's own
interest in Rubens's *Life of Achilles*
is based on a combination of
informed speculation and fact. He
may have consulted an engraved set
of the *Life of Achilles* as early as
1838 when he was planning the mu-
rals for the Senate Library of the
Palais Bourbon (1838–47). For one of
the pendentives illustrating Poetry
he chose *Achilles and Chiron*, a
subject found among Rubens's eight
scenes. These had been engraved
by Franz Ertinger in 1679 and by
Bernard Baron in 1724 (ibid., pp.
51–4). Though it is not certain that
Delacroix consulted the engravings
at this time, it is likely that he did,
for his *Achilles and Chiron* is an
elaboration of Rubens's motif that
shows the young Achilles riding on
the back of his centaur tutor.

Delacroix's second period of inter-
est in Achilles is securely
documented by references in his
journal. A set of the tapestries based
on Rubens's designs for the *Life of
Achilles* was owned by the Orleans
family. Delacroix saw these on 26
January 1852 when they were put up
for sale, and his enthusiasm was so
intense that he returned the next
day to make sketches (*Le Journal de
Eugène Delacroix*, ed. André Joubin,
Paris 1950, I, pp. 443–7, 26 January
1852). He describes his impressions at
length in his journal and mentions
Rubens's *Life of Achilles* on five sub-

sequent occasions over a period of eight years (ibid., II, p. 212, 6 July 1854; III, p. 43, 25 January 1857; p. 71, 5 March 1857; p. 92, 18 April 1857; p. 276, 8 March 1860). His stated intention on 5 March 1857 was to acquire a set of the engravings from Deveria so that he could commit them to memory and create a similar series of his own.

We do not know the extent to which Delacroix carried out his plans. That drawings fitting this description are not known suggests that the project did not get far. Even the sketches he speaks of making from the tapestries do not seem to have been identified. Until these are found and published, the two heads on the Malcove sheet may remain the chief visual evidence of enthusiasm for a side of Rubens that Delacroix undoubtedly communicated to his friends.

Several members of his circle were minor and amateur artists, but until their styles are better known there can be no certainty as to the author-

ship of the sheet. By way of conclusion, therefore, we can only mention some of the possibilities. Delacroix's oldest friend, Jean-Baptiste Pierret, cannot be ruled out, although the Malcove sheet was not among his large collection that went to the Louvre. Frederic Villot is another contender. As the Louvre's curator of paintings he was responsible for the controversial restoration of Rubens's *Life of Marie de' Medici*. Villot was a trained engraver whom Delacroix often consulted for information about subjects and technical procedures. In the end their friendship cooled, but Delacroix was still in touch with him in 1858 (ibid., III, p. 192, 10 May 1853, and p. 213, 5 September 1858). In a letter to Villot of 18 October 1834 Delacroix writes, 'Nous pourrons, cet hiver, avoir quelques travaux le soir. La proximité de Pierret nous l'amenera et des batailles sans fin sur Veronese, sur ce polisson de Rubens ... ' (*Correspondence générale d'Eugène Delacroix*, ed. André Joubin, Paris 1935, I, p. 189, October

1834). Here Delacroix describes a combination of lively discussion and drawing which could easily give rise to a sheet of the Malcove type. On the other hand, the drawings may be the work of Raymond Soulier, an old friend and amateur artist to whom Delacroix lent his copy of Rubens's *Conclusion of the Peace* (Lee Johnson, *The Paintings of Eugène Delacroix*, London 1981, I, p. 15, and *Journal*, p. 241, 2 October 1847). Or they may be by one of the Deveria brothers, Achille or Eugène, longtime friends and professional artists, one of whom Delacroix associates directly with the engravings of Rubens's *Life of Achilles* (*Journal*, III, p. 71, 5 March 1857).

EXHIBITION
'Studies and Study Sheets,' in 'Master Drawings from Five Centuries,' Fogg Art Museum, March 1964, no. 16, attributed to Delacroix

From the George Aubry Collection

EK

484 *Paysage à Oisème 1893*
EUGÈNE-LOUIS or
LOUIS-EUGÈNE BOUDIN
(French, 1824–1898)

Oil on canvas.
Signed, dated, and titled in brown,
lower left: 'E. Boudin 93. / Oiseme.'
Numbered and titled in black crayon
(inverted), lower edge of stretcher
verso: '294 (9?) paysage a Oiseme
Environs de Chartres'; inscribed in
black crayon (same hand), on centre
brace verso: 'M. Durand Ruel.'
46.4 × 55.3 cm M82.16

Eugène Boudin, a transitional figure
between the Barbizon School of the
mid-1800s and French Impressionism,
is considered to be one of the *petit-
maîtres* of the nineteenth century.
Co-owner of a stationery store in Le

Havre from 1844 to 1846, he was
encouraged to paint by artists who
displayed their work in his shop win-
dows. In this manner he became
acquainted with such personalities
as Jean François Millet (1814–1875),
Constant Troyon (1810–1865), Eu-
gène Gabriel Isabey (1803–1886), and
Thomas Couture (1815–1879). A
subsequent trip to Paris (1847) and a
journey through northern France
and Belgium introduced Boudin to
such seventeenth-century Flemish
masters as Jacob van Ruisdael, whose
landscapes he often copied. With
the assistance of a three-year grant
from the Town Council of Le Havre
(1851–4), he was able to continue
painting, dividing his time between
the French capital and Honfleur,
his birthplace. As an artist, Boudin
strongly advocated working out-
of-doors, in order to capture the

changing effects of nature directly.
In 1858 he persuaded Claude Monet
(1840–1926), who had moved with
his family to Le Havre in 1845, to
adopt this approach to painting.
From the early 1860s onward, Boudin
also counted among his associates
Gustave Courbet (1819–1877), Jean
Baptiste Camille Corot (1796–1875),
Charles François Daubigny (1817–
1878), and Johan-Barthold Jongkind
(1819–1891), a friend of Claude Mo-
net.

Having successfully entered *Pardon
de Sainte-Anne-la-Palud* in the 1859
Salon des Artistes français, Boudin
decided to establish a studio in Paris.
He never abandoned Normandy and
Brittany, however, consistently re-
turning to execute studies of the sky,
sea, and land which he loved. In
1862, on the advice of Isabey, Boudin
began to frequent the seaside resorts of

Trouville and Deauville, where he executed the fashionable beach-scenes for which he is famous. During the 1870s he also travelled in Holland and Belgium, with trips to Bordeaux.

While Boudin made regular contributions to the Salon, he also took part in the first exhibition of the Impressionists, which was held in Paris (1874). Several years earlier he had shown with Courbet, Manet, Monet, and Daubigny in Le Havre (1868). His success was assured in 1881 when Durand-Ruel began to purchase the majority of his works, the artist's first exhibition with this dealer occurring in 1883. Later, Boudin was awarded the Gold Medal at the World's Fair of 1889, being made a Chevalier of the Legion of Honour in 1892. Although he journeyed to the south of France from 1882, venturing as far afield as Venice in the 1890s, he held a special affection for his native province of Normandy, where he died in 1898.

Boudin favoured the theme of Oisème, near Chartres, during the last ten years of his life. According to Schmit (II, 2258, 2259; III, 2593, 2786–90, 3101–4), twelve paintings exist for the period 1888–93, those dated by month indicating that Bouding journeyed there in mid-May or June. In this series of works the artist has varied his point of view, either depicting the meadows, pathways, gardens, and stream at Oisème, or showing its countryside during harvest.

Paysage à Oisème (1893) exemplifies Boudin's approach to subject matter, composition, colour, and technique. The image of women washing clothes by a river, one of the events from daily life which the artist was fond of representing, occurs throughout his œuvre, as illustrated lower centre. Although Boudin was intent upon capturing the atmospheric effects which he witnessed in nature, his paintings often evoke a timeless quality. In this composition, horizontal and vertical lines, supplemented by regular, triangular shapes, dominate the picture plane, creating a tranquil, stable world into which each of the figures, given anonymity by an intentionally unde-

fined silhouette, is absorbed.

Boudin's technique during this late period was described by Léon Le Clerc, director of the Honfleur Museum, in the local newspaper *L'Echo Honfleurais* (1897), quoted in translation in Lawrence Campbell, 'Boudin: The King of the Skies,' *Art News*, LXV, 7, Nov. 1966, 84–5. According to Le Clerc, the artist first applied a blue-grey ground to the canvas, this colour and tone value being synonymous with those of the sky, his principal motif. He then blocked in the masses, stroke by stroke. It seems that Boudin laid down all the paint for the sky at once, choosing to work it up later. In the second phase, he would take a medium-size brush with pointed tip, meditate upon his subject, then rapidly add the dots and lines of colour from which the various elements in his composition would gradually emerge. From this account, it appears that Boudin used a natural setting as the point of departure for personal contemplation, rather than as an end in itself.

The painter's use of colour helps to create the richness and vibrancy apparent in this late work. The green foliage and green-grey water of the river, for example, are enlivened by strategically placed patches of red which mark a cottage roof. Similarly, the blue ground of the canvas surfaces between strokes to animate the yellow-ochre earth and foreground building on the right. Above is Boudin's luminous, blue sky, filled with white, fleecy clouds, which casts a warm, summer light on the scene; its reflection in the stream below, an ancillary and complementary image, acts as a striking foil to the earthy hues of the river bank to the left.

PUBLICATIONS
Benjamin, Ruth L., *Eugène Boudin* (New York 1937), p. 191
Schmit, Robert, *Eugène Boudin 1824–1898* (Paris 1973), III / 3101, p. 193, being titled 'Oisème. La Rivière,' reproduced

EXHIBITIONS
'Exhibition of Paintings by Eugène Boudin, 1824–1898,' Durand-Ruel Galleries, New York, 30 October–18 November 1933, no. 25, being titled 'Paysage à Oisèmes'
'Exhibition of Paintings: Eugène Boudin,' Durand-Ruel Galleries, New York, 3–21 February 1936, no. 8

Galeries Durand-Ruel, Paris, purchased from artist 1 July 1893; H.M. Johnston, 24 Feb. 1894; Durand-Ruel Galleries, New York; Lillian Malcove, 16 November 1943 AH

485 Untitled sheet of sketches
PABLO PICASSO
(Spanish, 1881–1973)

Ink and pencil on tan paper, torn,
repaired, and signed at top right.
24.0 × 32.3 cm
Summer 1906 M82.28

This drawing shows Picasso in an
informal, unguarded light, for it is
neither a composition in itself nor is
it a series of studies for a specific
purpose. Instead it is simply an as-
semblage of ideas, of notes taken
as the creative urge touched him in
his Rose period. The principal figures
are a woman in left profile and two
standing nudes. Although the draw-
ing is dated in the bibliography be-
low to 1905, the three figures were
probably done in Gosol in the sum-
mer of 1906, since they are related in
spirit to the painting *La Toilette*
(Buffalo, Albright-Knox Museum)

and its accompanying sketches. The
other elements – a hand, a peacock,
an eagle, and three very schematic
elephants – may have been added at
a slightly later date, for there are
similar ideographic sheets dated by
Zervos to 1907 and 1908. If nothing
else, this drawing reveals the aston-
ishing range of the artist's facility,
from art nouveau birds to substan-
tially modelled figures.

PUBLICATIONS
*Studies and Study Sheets: Master
Drawings from Five Centuries*, Fogg
Museum of Art, Harvard University
(Cambridge, 26 March-18 April
1964), no. 29
Zervos, Christian, *Pablo Picasso*,
vol. VI (Paris 1962), no. 633

EXHIBITIONS
Fogg Museum of Art, Harvard Uni-
versity, Cambridge, Mass. 1964
Curt Valentin Gallery, New York,
March 1952. Reviewed in *Art News*,
LI, March 1952, 26

Purchased from Curt Valentin
Gallery, New York, 11 March 1952
RB

486 *Guitar Player*
JACQUES LIPCHITZ
(1891–1973; b. Lithuania, French citizen, 1925)

Gouache on cardboard, signed and dated at lower left. 41.2 × 33.1 cm
French, 1918 M82.22

Although known chiefly for his sculpture, Lipchitz excelled at low relief and small-scale watercolour paintings and drawings. This example, fully in the spirit of the synthetic cubism to which he had been introduced by Juan Gris two or three years earlier, has as its theme a musician, recalling the common analogy of the period between music – the most abstract of the arts, a harmonious relationship of parts – and painting. The guitar is the point of reference, providing not only the theme, but also the eye's point of entry into the somewhat less recognizable pattern of the figure. Speaking of another work of the same year, Lipchitz said that the guitar is 'a stabilizing influence around which the figure is organized and into which it is integrated. The guitar, which is a man-made object [that is, in one sense already abstract], normally remains recognizable, while the figure may be largely disintegrated' (Jacques Lipchitz, with H.H. Arnason, *My Life in Sculpture*, New York 1972, pp. 50–1).

EXHIBITION
Brummer Gallery, New York, 2 December 1935–31 January 1936, no. 10. Reviewed in *American Magazine of Art*, XXIX, Jan. 1936, 38–9; *Art News*, XXIV, 14 Dec. 1935, 20; and *Arts Digest*, X, 15 Dec. 1935, 10. Possibly also exhibited at New Gallery, New York, October 1955, but this cannot be verified. Reviewed in *Art News*, LIV, Oct. 1955, 52, and *Arts*, XXX, Oct. 1955, 48

Purchased from Stephen R. Hahn, New York, 18 October 1955 RB

487 Untitled design for posters and prints

MIKHAIL FEDOROVICH
LARIONOV
(Russian, 1882–1964)

Pencil and gouache on tan paper.
36.4 × 27.2 cm
1922 M82.27

This design was used three times,
twice with relatively minor changes.
Its first application was as a litho-
graph, entitled *A Poet*, bound into
the first edition of Vladimir Maya-
kovsky's *Solntse* (the Sun, Moscow,
1922; discussed and reproduced in
Mary Chamot, 'Russian *Avant-garde*
Graphics,' *Apollo*, XCVIII, no. 142,
Dec. 1973, 494–500, fig. 10). Here the
changes were a matter of colour
and the width of the lower left 'foot'
of the principal form. The design
was then used on a promotional
flyer for the Grand Bal des Artistes,
TRAvesti/ TRAnsmental, 23 February
1923, benefiting the Union des artists
russes (reproduced in Tatiana Lo-
guine, ed., *Gontcharova et Larionov:
Cinquante ans à Saint Germain-des
Près*, Paris 1971, fig. 18). In this ver-
sion the lighter, secondary forms
at the sides of the principal form were
omitted. Lastly it was used to illus-
trate the program of the Grand Bal,
in this case without change (repro-
duced in Waldemar George,
Larionov, Paris 1966, p. 126).

The geometric severity of the de-
sign is somewhat unusual in this
period of Larionov's residence in
Paris, but it does relate to some lino-
leum engravings begun in circa 1920
in the Russian constructivist spirit
(ibid., 106). Nevertheless, it cannot
be said to be fully abstract, for it
represents a poet orating at a lectern,
the sound of whose voice is mani-
fested in the air before him as a
meander pattern.

Purchased at Sotheby-Parke-Bernet,
New York, sale no. 4319, 6–7
December 1979, lot 136, reproduced
in catalogue RB

1920 232 Zweierlei Sterben

488 *Zweierlei sterben*
(two ways of dying)
PAUL KLEE
(Swiss, 1879–1940)

Pen and ink on paper, signed at top
left, dated in pencil. 15.5 × 14.7 cm
1920 M82.7

Zweierlei sterben, like *Fortuna* (cat-
alogue 489), is related to Klee's feel-
ings about the Great War, but it is
also one of many variations he made
on the theme of flight. The configu-
ration on the left is a birdman – bird
head at the bottom, man head at
the top – penetrated by arrows. Klee
saw the arrow as a symbol of man's
capacity, or at least desire, to pene-
trate all realms, earthly and spiritual,
at random. The inquisitive man Klee
saw as an Icarus figure, falling to
his death in an attempt to reach the
sun. Such a man is wounded by
his own tragic curiosity. On the right
is a second way of dying; an old
man, stooped with age, waits pa-
tiently for his end. These figures
might be taken to represent Klee
himself living on after his adventur-
ous friend Franz Marc was killed
in the war. The form in the centre
might be interpreted in either of two
ways; the circle on an elaborate
stem might represent the mystic
centre that lies between all dualities
and towards which all artists should
strive, or the creature might be an
insect, which Klee seems to have felt
to represent the freedom of move-
ment which man did not have.

PUBLICATIONS
*Paul Klee: Sixty-six Unknown Draw-
ings* (Curt Valentin Gallery, New
York, 11–23 April 1955), no. 11, re-
produced
For the theme of flight see Mark
Rosenthal, 'The Myth of Flight in the
Art of Paul Klee,' *Arts*, LV, Sept.
1980, 90–4. For Klee's mysticism see
Robert Knott, 'Paul Klee and the
Mystic Centre,' *Art Journal*, XXXVIII,
2, winter 1978–9, 114–18. For Klee's
relationship with Marc see O.K.
Werckmeister, 'Klee im ersten Welt-
krieg,' in *Paul Klee: Das Frühwerk,
1883–1922*, Städtische Galerie im
Lenbachhaus (Munich 1980), pp.
166–226. For insects see no. 384 of this
last volume.

EXHIBITION
Curt Valentin Gallery, New York,
11–23 April 1955. Reviewed in *Art
News*, LIV, April 1955, 44

Purchased from Curt Valentin
Gallery, New York, 23 April 1955 RB

489 *Fortuna*

PAUL KLEE

(Swiss, 1879–1940)

Pencil on paper, dated in pencil and
signed in ink at top left.
28.6 × 21.6 cm
1922 M82.5

All three of the Klee drawings in the
Malcove Collection can be inter-
preted in the light of recent icono-
graphical studies. *Fortuna* is the
goddess of fate, chance, and
unknown factors. Among her attri-
butes are the wheel upon which
she rides and a number of other
things which Klee chooses to elimi-
nate, such as a ship's rudder and
a cornucopia. Instead, the artist has
confused her identity with that of
Artemis, who as Apollousa was the
goddess of destruction and the light of
the moon. Her attributes are the
crescent headdress, tousled ringlets,
and legs bared to the knees. Klee's
composite goddess seems to relate to
his feelings about the Great War,
for a similar wheel device was used
in such works as *Der Krieg schreitet
über eine Ortschaft* (War strides
over a village) and *Zerstörung und
Hoffnung* (Destruction and Hope).
Fortuna is thus a metaphor of the
uncertainty and absurdity of a mod-
ern world just after it had emerged
from its greatest, most irrational
upheaval. The curious dark bands on
her gown may be a formal exercise
relating to his contemporary teaching
duties at the Bauhaus in Weimar.

PUBLICATION
Grohmann, Will, *Paul Klee: Hand-
zeichnungen, 1921–30* (Potsdam and
Berlin 1934), no. 90 (229) 1922
The two principal studies of Klee and
the war are Michèle Vishny, 'Paul
Klee and the War: A Stance of Aloof-
ness,' *Gazette des Beaux-Arts*, XCII,
1319, Dec. 1978, 233–43, and O.K.
Werckmeister, 'Klee im ersten Welt-
krieg,' in *Paul Klee: Das Frühwerk,
1883–1922*, Städtische Galerie im
Lenbachhaus (Munich 1980), pp.
166–226. The two war pictures cited
in the text above for comparative
purposes are nos. 260 and 241, respec-
tively, in the latter volume.

Purchased from Stephen R. Hahn,
New York, 18 October 1955 RB

490 *Getroffene Luftgeister*
(Wounded air-spirits)
PAUL KLEE
(Swiss, 1879–1940)

Pen and ink on paper, signed at lower
right, dated on support.
21.5 × 29.0 cm
1926 M82.6

From the late 1920s to the early 1930s
Klee did a number of paintings and
drawings involving air-spirits, more
or less human creatures with the
ability to fly. This example shows
two such figures pierced by arrows,
Klee's symbol for man's futile striv-
ing towards the heavens, as in the
story of Icarus. See also *Zweierlei
sterben*, catalogue 488.

PUBLICATION
Grohmann, Will, *Paul Klee: Hand-
zeichnungen, 1921–30* (Potsdam and
Berlin 1934), no. 72 (143 E3) 1926

Purchased from World House, New
York, October 1960, sale no. 4712 RB

491 Untitled design for acrobatic costumes

ALEKSANDRA ALEKSANDROVNA EXTER
(Russian, 1882–1949)

Gouache and pencil on paper, inscribed 'acrobatic costumes' in Russian at lower left. 17.2 × 14.9 cm
1927 (?) M82.26

This design shows two acrobats suspended in a gentle 's' curve from a trapeze. That the artist's concern was more with the formal and spatial possibilities of the design than with the simple creation of a costume or a picturesque scene is evidenced by the female catcher, a feature which is unusual in any period. Exter, well-known as a member of the Russian Avant-garde in the 1910s and early 1920s, emigrated to France in 1924 and concentrated on works for the stage, for fashion, and for interior decoration. This example possibly relates to *Le Cirque*, a ballet of 1927–8 by Elsa Krueger.

See *Artist of the Theatre, Alexandra Exter* (Vincent Astor Gallery, New York Public Library at Lincoln Center, spring-summer 1974), especially no. 48.

Purchased at Sotheby-Parke-Bernet, New York, sale no. 4319, 6–7 December 1979, lot 97, reproduced in catalogue. Acquired from the artist by Simon Lissim and left to his son Michael S. Lissim. RB

Purchased from Spencer A. Samuels and Co, New York, 1969. From the prior collections of Dieter Keller, Stuttgart, and Michael Hertz, Bremen. Maur's volume does not record Malcove as the subsequent owner. RB

493 *Person Holding a Brush*
OSKAR SCHLEMMER
(German, 1888–1943)

Ink and watercolour on yellowed blank postcard, dated 17.3.41 and initialled on back, with message 'Herzlichen Gruss!' addressed to 'Soldat Dieter Keller.' 14.7 × 10.3 cm
1941 M82.20

This work is identified in Malcove's files as 'Painter testing his brush, no. 2' and on the frame as 'Zeichender II, Variante.' Maur's study gives 'Pinselhaltender,' which is translated here.

Schlemmer, head of theatrical design and teacher of stone-carving at the Bauhaus (1920–9), has only recently been given great attention in North America. The two examples in the Malcove Collection (see also catalogue 492) are from late in his career, after his work was reviled in the Nazi exhibition of degenerate art (*Entartete Kunst*, Munich, 1937). From November 1940 to summer 1942 he was reduced to working in the lacquer factory of Dr Kurt Herberts in Wuppertal. While there he sent these works as postcards to a soldier on the east front, Dieter Keller, for whose home in Stuttgart he had executed a mural early in 1940. Both works have themes that Schlemmer returned to on occasion and both reveal some of the artist's central concerns. Schlemmer always believed that the representation of man was the artist's greatest goal, and to that end he sought a decidedly twentieth-century classicism – a vision of calm, generalized figures arranged according to an underlying order that is an odd synthesis of mechanistically determined form and formal uncertainty. In support of this

492 *Head of a Girl Turned to the Left*
OSKAR SCHLEMMER
(German, 1888–1943)

Oil on blank postcard, signed on rear, with message 'Herzliche Grüsse! Ihres.'
14.7 × 10.9 cm
1941 M82.19

This postcard, mailed in an envelope to Dieter Keller, is identified in Malcove's files as 'Inclined head of a girl facing left' and on the frame as 'Geneigter Kopf.' Maur's study gives 'Mädchenkopf nach links gewandt.' For further notes see the discussion of catalogue 493.

PUBLICATION
Maur, Karin v. *Oskar Schlemmer*, II: *Oeuvrekatalog der Gemälde, Aquarelle, Pastelle und Plastiken* (Munich 1979), p. 172, no. G557, reproduced on p. 173. Cf also nos. G563–4. Plans were evidently made to include this illustration in a supplement to Hans Hildebrandt, *Oskar Schlemmer* (Munich 1952), as no. N379 / 2, but the outcome cannot be verified.

EXHIBITION
Spencer A. Samuels, New York, 22 October–26 November 1969. Reviewed in *Artforum*, VIII, Dec. 1969, 66–7; *Art International*, XIV, Jan. 1970, 88; *Arts*, XLIV, Nov. 1969, 35; and *Studio*, CLXXVIII, Dec. 1969

view, he often spoke of a blend of Dionysian perception and Apollonian creation.

PUBLICATIONS
Maur, Karin v. *Oskar Schlemmer, II: Oeuvrekatalog der Gemälde, Aquarelle, Pastelle und Plastiken* (Munich 1979), p. 339, no. A570, reproduced. Cf also nos. G429–31, G595 / 1 and 2, G665, and K132–4. *Oskar Schlemmer* (Spencer A. Samuels, New York, 22 October–26 November 1969), no. 86, reproduced on p. 145. Plans were apparently made to include this work in a supplement to Hans Hildebrandt, *Oskar Schlemmer* (Munich 1952), as no. N787 / 2, but

the outcome cannot be verified. For more correspondence between the artist and Dieter Keller see Tut Schlemmer, ed., *Oskar Schlemmer, Briefe und Tagebücher* (Stuttgart 1977), p. 170.

EXHIBITION
Spencer A. Samuels, New York, 1969. For reviews see catalogue 492.

Purchased from Spencer A. Samuels and Co, New York, 1969. From the collection of Dieter Keller RB

494 *Girl with Flowers*
HENRI ÉMILE BENOÎT
MATISSE
(French, 1869–1954)

Pen and ink on Arches paper, signed
and dated at lower right.
44.0 × 55.5 cm
1941 M82.4

In the introduction to a book on his
Chapelle du Rosaire, Vence, Matisse
wrote that he studied each element
of construction – drawing, colour,
and so on – separately in order to ex-
plore how these elements could be
synthesized without diminishing the
eloquence of any one of them by
the presence of the others. To this
end he adopted a rigorous pattern of
daily habit, painting, sculpting,
drawing, and practising violin only
at certain times of the day. In the

afternoons Matisse drew from the
model, creating stunningly sensuous
drawings like this girl with flowers.
The apparent simplicity of the work
conceals the intense effort which
led up to it, although some prepara-
tory lines are visible upon very
close inspection. The result is a com-
bination of brilliant ease and
improvisation within the strictest
of disciplines, similar, as Matisse
himself recognized, to key compo-
nents in American jazz.

PUBLICATION
Henri Matisse: Dessins et sculptures
(Musée Nationale d'Art Moderne,
Paris 1975). Useful reviews of this
major exhibition are in *Art in Amer-
ica*, LXIII, July-Aug. 1975, 60–1; *Art
International*, XIX, Oct. 1975,
58–60; and *Connaissance des Arts*,
no. 282, Aug. 1975, 58–67.

Purchased from Stephen R. Hahn,
New York, 18 October 1955 RB

495 *Versailles II*
JOHN EGERTON CHRISTMAS PIPER
(British, 1903–)

Gouache, pen and ink on several joined pieces of paper, signed in pencil at lower right. 17.2 × 55.1 cm
1953 M82.21

Although quite famous for his stage design, abstract paintings, and illustrated architectural and topographical books, Piper is best known as a twentieth-century English romanticist specializing in moody views of decaying buildings and inspiring monuments. This particular example depicts part of the palace at Versailles, possibly seen from the west side of the northern gardens, although the specific location is much less important than the general atmosphere evoked. From circa 1948, Piper systematically explored such buildings in England and France. This slightly melancholy vision of a past glory functions as a stepping-stone to Piper's activities of the mid-1950s, extensive studies of French stained glass. While stained glass makes use of lines as defining boundaries over translucent areas of colour, the drawing employs calligraphy over colour masses that reflect, rather than transmit, light. In this, the artist acknowledges a stylistic debt to Raoul Dufy.

PUBLICATIONS
John Piper (Curt Valentin Gallery, New York, 15 February–12 March 1955), no. 21, reproduced
West, Anthony, *John Piper* (London 1979), pp. 91–2, and 128–55

EXHIBITION
Curt Valentin Gallery, New York, 1955. Reviewed in *Art News*, LIII, Feb. 1955, p. 60

Purchased from Curt Valentin Gallery, New York, 1955 RB

However, to assign a specific meaning to the work is less satisfying than to allow its imagery to evoke, rather than denote, the *mysterium tremendum* that the Old Testament represents.

PUBLICATIONS
Eastern European Printmakers (Cincinatti Art Museum, Cincinatti, 10 April– 8 June 1975), no. 21
Ramseger, I, 'Children's Books from Czecho-Slovakia,' *Gebrauchsgraphik*, XLI, April 1970, 29
Stehlíková, Blanka, *Illustrations in Czech and Slovak Books for Children* (Prague 1977), pp. 32–3 and 159

EXHIBITIONS
Cincinatti Art Museum, Cincinatti, 10 April – 8 June 1975, as 'Old Writing'
Willard Gallery, New York, 17 November – 19 December 1970

Purchased from Willard Gallery, New York, 1970 RB

496 *Old Testament*
EVA BEDNÁŘOVÁ
(Czechoslovakian, 1937–)

Drypoint, etching and aquatint, signed, dated and numbered 6 / 6 at lower right. 74.4 × 54.5 cm
1966 M82.25

Bednářová is well known in Eastern Europe as an award-winning illustrator of children's books, but she has sought an outlet for her deep religious convictions in limited edition prints. Bednářová's work most often combines actual or simulated ancient inscriptions with Christian symbols to create an elusive vocabulary of evocative personal imagery. This print shows a simulated ancient script in two columns, treated to look like fading parchment or very low relief. Between the columns are three pairs of joined hands. The gesture of joined hands has meanings ranging from concord, alliance, friendship, and love to mystic marriage and Jungian individuation. The different positions of each pair could be interpreted as different aspects of the Holy Trinity – thumbs commonly representing the Father, supplicating palms the Son, and index fingers the Holy Spirit – between the lines, as it were, of the Old Testament.

497 Recto: *Draped Seated Woman*; verso: *Studies of Standing and Seated Figures*
HENRY MOORE
(British, 1898–1986)

Watercolour. 29 × 24 cm
1948 M82.31

In 1948 Henry Moore executed a number of drawings of single figures and family groups which are among his most monumental studies of the human form. As in his life drawings of the 1920s and in his sculpture throughout his career, *Draped Seated Woman* represents the human figure in repose. Unlike, for example, Degas or Rodin, Moore was not interested in portraying the human body in movement. Both the pose of the fig-

ure and the treatment of the drapery are reminiscent of the 1943–4 stone *Madonna and Child*, in the Church of St Matthew, Northampton. Most of Moore's large drawings of the period were based on sketchbook studies. The present drawing has been squared for enlargement. A related drawing from the same year, entitled *Seated Figure*, is in the National Gallery of Canada, Ottawa.

Another characteristic of Moore's drawings is their extraordinary sculptural three-dimensional quality. Here the traditional light and shade modelling is reinforced in the legs by what the artist refers to as the two-way sectional line method of drawing. Moore has described this linear technique as drawing in two directions 'both down the form as well as around it, without the use of

light and shade modelling.' A num-
ber of life drawings of the late 1920s
show the tentative beginnings of
this technique, which reached its
culmination in a number of sketch-
book studies and larger drawings
of 1948.

In *Studies of Standing and Seated
Figures* (verso) a net of linear sec-
tional lines covers the figure at lower
left. In the other studies on the verso,
the interaction of the figures looks
back to Moore's famous shelter draw-
ings of 1940–1, and to a sculpture of
1945 *Three Standing Figures*, the
sketch model for the large stone carv-
ing of the same title in Battersea
Park, London.

Purchased from Buchholz Gallery,
New York, March 1951 AW

498 Family Group
HENRY MOORE
(British, 1898–)

Bronze. 13 × 9.5 × 6 cm
1945 M82.30

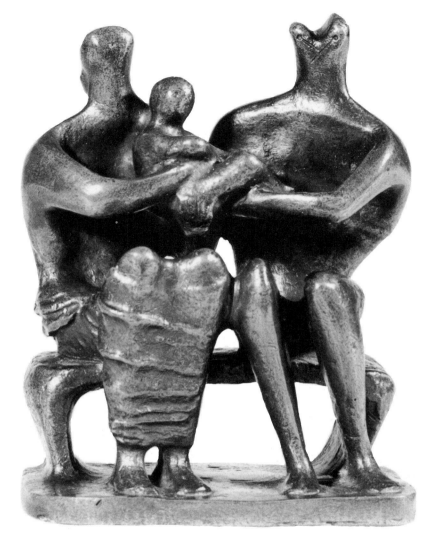

The series of family group maquettes of 1944–5 followed soon after Moore had completed the 1943–4 stone *Madonna and Child*, commissioned for the Church of St Matthew, Northampton. In fact, the initial impetus dates from before the war when the architect Walter Gropius asked Moore if he would consider making a sculpture for a school which he had designed near Cambridge. Moore suggested that a family group would be a suitable subject, but owing to lack of funds the project was never realized. In 1944 Henry Morris, director for education in Cambridgeshire, told the sculptor that he now thought he could raise the necessary money, and Moore began a series of notebook drawings of family groups. In 1944–5, Moore made about a dozen maquettes from these preparatory studies for sculpture. Again Morris found it difficult to raise money for the sculpture, and, moreover, the Education authorities did not like Moore's family group maquettes, which are now among his most highly prized works. Finally, in 1947 Moore was again approached, this time by John Newsam, director of education in Hertfordshire, and asked if he would do a sculpture for a new school at Stevenage. He went to see the school and chose to enlarge from the series of maquettes of 1944–5 the sculpture shown here, 'the one which I thought would be right for Stevenage and also one which I had wanted most to carry out on a life-size scale.' Bronze casts of the large *Family Group* of 1948–9 are at Barclay School, Stevenage, Hertfordshire, the Tate Gallery, London, and the Museum of Modern Art, New York.

In many ways the preparatory drawings and maquettes of 1943 for the large stone *Madonna and Child* of 1943–4 paved the way for the family group sculptures, although in the latter works Moore was not faced with the earlier challenge of depicting a religious subject. From a formal point of view the body of the mother in *Family Group*, and the taut drapery from the waist down, are closely related to similar features in the 1943–4 Madonna. The wide, broad back of the father relates to Moore's 1942 drawings of coal miners. Moore has described the changes which occurred when he enlarged the 1945 maquette: 'The main difference between the two are in the heads, especially in the head of the man. In the small version the split head of the man gives a vitality and interest necessary to the composition, particularly as all three heads have only sight indications for features. When

it came to the life-size version, the figures each became more obviously human and related to each other and the split head of the man became impossible for it was so unlike the woman and child.'

Whereas the mother and child had been one of the most important subjects in Moore's work since the early 1920s, the family group theme was not so much a departure as a continuation of his earlier obsession. The addition of the father creates the family group unit. We focus on the child, firmly perched in the complex knotted arms of the parents. When Moore came to enlarge this maquette in 1948, two years after the birth of his first child, he must have preceved

the family group theme anew, as a
reflection of his own deeply felt joy of
fatherhood.

Purchased from Buchholz Gallery,
New York, 6 January 1951 AW

499 *Upright Solitary Form (Amulet)*

BARBARA HEPWORTH
(British, 1903–75)

Bronze. 8.5 × 6.8 × 2 cm
Date unknown M82.29

In 1931 Barbara Hepworth made a
sculpture in alabaster entitled *Pierced
Form*, the first of many subsequent
works in which the hole is a domi-
nant feature. Of this early, seminal
carving, Hepworth has described
the intense pleasure which she felt in
'piercing the stone in order to make
an abstract form and space; quite
a different sensation from that of
doing it for the purpose of realism.'
Although Archipenko, Lipchitz, and
Gandier-Brzeska were among the
first modern sculptors to pierce, to
open up, the closed volumes of the
figure, we have in fact come to asso-
ciate 'the hole' with the work of
Hepworth and Moore.

 Hepworth's abstract carvings of
the 1930s, strongly influenced by the
sculpture of Brancusi, have a mathe-
matical purity which sets them apart
from the figurative references in
Moore's work of the decade. If in her
early work abstract forms exist in
their own right, without references to
anything else, many of her carvings
and bronzes of the 1940s and 1950s
refer to landscape and to the human
figure.

 Even as small and intimate a work
as this bronze has in its title the
suggestion, on a symbolic level, of
one of the major themes of Hepworth's
work: 'the standing form (which is
the translation of my feeling towards
the human being standing in a land-
scape).' On the one hand the sculp-
ture is reminiscent of the stone
menhirs found in the Cornish land-
scape where Hepworth lived and
worked from 1939 until her death in
1975. On the other hand it is an
amulet, a charm, like one of those
'small things,' as Hepworth wrote in
1934, 'found and kept for their lovely
shape, their weight, their texture
and intense pure colour.'

Purchased from Gimpel Weitzenhof-
fer, New York AW

500 Untitled wall plaque
MARY FRANK
(née Lockspeiser,
British, 1933–)

Unglazed terra cotta.
20.5 × 21.5 × 1.5 cm
1974 M82.3

At the top left is an impression made
by rolling a previously prepared cyl-
inder seal into the soft clay. It depicts
three dancing women and a lone
figure feeding a horse. This pattern is
partly repeated at the top right,
which shows a female orant between
roughly symmetrical ornaments pos-
sibly depicting waves. At the centre is
a hand in an aureole or mandorla of
sorts. At the lower left are three
repetitions of a seal showing a thin
woman standing on a horse. To their
right is a much larger female figure
rising from stylized waves which,
in turn, become great convolutions.
To her right is a partial repetition
of the orant.

After 1975 Mary Frank was chiefly
known for large, freestanding figures,
but her earlier work often consisted
of small reliefs which self-consciously
referred to specific myths. Although
this plaque is equally self-conscious
in its deliberate references to antiq-
uity – the cylinder was an ancient
Mesopotamian device; the orant, an-
cient Greek or early Christian; the
hand, an early Christian symbol of
God the Father – it can also be inter-
preted in a strictly modern way.
For example, the woman emerging
from the waves may represent the
birth of Venus, but it may also be
Woman as a creature of feeling and
intuition, rising above the entrapping
contours of the rational mind. In
this sense, the work is transitional in
the context of the artist's career.

PUBLICATIONS
Herrera, Heyden, 'Myth and Meta-
morphosis: The Work of Mary Frank,'
artscanada, XXXV, no. 220–1, April-
May 1978, 15–26
Munro, Eleanor, *Originals: Ameri-
can Women Artists* (New York 1979),
pp. 289–308
Sawin, Martica, 'The Sculpture of

Mary Frank,' *Arts*, LI, March 1977,
130–2

EXHIBITION
Zabriskie Gallery, New York, Febru-
ary 1975. Reviewed in *Artforum*,
XIII, April 1975, 84, and *Art in Amer-
ica*, LXIII, May-June 1975, 91

Purchased from Zabriskie Gallery,
New York, February 1975 RB

501 Head of Buddha

Grey stone. 16 × 12.1 × 9.7 cm
Thai, 7th–11th century M82.309

The head was probably once in full round, unless something was attached to the upper back of the head, such as a halo. There is a concave break at the rear and a slanting (front to back) break at the neck. Special marks of the Buddha include the (low) *ushnisha* covered with counter-clockwise snail-shell curls. There is no *urna* now visible. The elongated ears are carefully detailed and slotted below. The mask is wide and impressive, with a plastic, bow-like brow-ridge not separated over the nose but continuous. The nose is intact over a wide, full mouth. The edges of the lowered eyes, and to a lesser extent of the lips as well, are emphasized by plastic outlining. The base is drilled for a stake to hold the head to a base for exhibition. The style is difficult to place, as with many such Thai heads. It has elements of Dvaravati style and of the Mon type suggesting an eighth–ninth-century date (cf T. Bowie et al., *Sculpture of Thailand*, New York 1972), p. 44, no. 14) and also of later Lopburi work with a greater degree of conventionalization, such as we see in L. Frederic, *The Art of Southeast Asia* (New York nd), fig. 36 and pp. 40–1. DD

502 Leaf from a manuscript

Palm leaf, inscribed in black ink, with painted inset. 46.3 × 5.0 cm
Nepalese, date unknown

M82.513

The obverse has five lines of text in three sections separated by two perforations for stringing. In the middle of the central section is a painted illustration with a red background, which shows a female divinity in semi *maharajalilasana*. The figure's right hand is before the full chest, while the left hand (the arm is akimbo) is in the lap. The figure wears a red dhoti and a gold crown and earrings. She is seated on a green mat on a golden throne. The body halo is blue, the head halo green, and there is a faint gold aureole outline about the whole suggesting local and general radiance. She is flanked by golden, vase-based, blue columns topped by white profile birds on flower 'capitals.' Above to left and right are two gold disks (sun and moon?) flanking a *kirttimukha*-type frontal device. The reverse has three sections of five-line text only. The work is torn and in worn and soiled condition. DD

503 Man with bowl

Ink drawing on the back of a
manuscript page, brown ink with
whitish wash. 16.2 × 7.4 cm
North Indian, late 18th century (?)
M82.460

A delicate drawing in brownish ink
of a man (facing right) in three-
quarter view holding out a shallow
bowl or dish in his left hand. He
is bearded and barefooted, and wears
a single garment or dress with plain
round neck and long sleeves. Ground
lines sprout linear tufts of grass, while
the sky is indicated at the very top
by wash and curly linear cloud forms.
The reverse shows a page of Persian
poetry in manuscript within yellow
borders. JP

504 Woman with doe

Ink drawing on the back of a
manuscript page. 16.2 × 7.4 cm
North Indian, late 18th century (?)
M82.461

The drawing shows a profile por-
trayal of a turbanned lady with long
hair seated with her right knee up,
left foot on the ground, and a doe
stretching upward from her lap. The
animal's head and neck are being
caressed by her hands. She wears ear-
rings, a necklace, a sari patterned
with bordered squares, and sandals.
Her seat is only vaguely indicated
as a rounded hump or hillock. The
sky is done at the top of the drawing
as a series of horizontal lines with
curly clouds. The drawing is pasted
onto a manuscript page of Persian
poetry, as in catalogue 503. JP

505 The cowherds escape Aghasura

Ink and wash on paper.
19.7 × 28.4 cm
Indian, Chamba, Punjab, date 1753
pencilled on mat M82.11

This drawing depicts one of the epi-
sodes of Krishna's early childhood.
The demon Aghasura, one of the
minions of the evil tyrant Kamsa, is
portrayed as a crocodile-serpent.
Obeying Kamsa's order to destroy the
child Krishna, Aghasura happens
upon a group of children herding
calves and swallows them all. Once
inside the monster, the five-year-
old Krishna so expands his body that
the demon bursts open, freeing the
children as well as the calves.

The drawing telescopes the event
into one frame. The artist represents
the sequence of the action by divid-
ing the scene into three basic parts.
Facing leftwards, the central coiled
figure of the demon is caught in
the act of swallowing two calves and
three childish cowherds. Along the
right side of the central figure, we see
the splitting of his body and the
release of his victims. One calf
emerges at the lower right. Three
children reappear – one atop his head
and the other two from either side.

Along the lower register, the dead
Aghasura is shown. The happy end-
ing is also suggested by the grove
of trees on the right, where Krishna
and his companions will picnic after
their ordeal. EAH

506 Animal studies

Ink drawing. 14.5 × 27.8 cm
Indian, Kotah, Rajasthan, date
unknown M82.32

The main motif is a lion (right)
attacking a boar (left). The boar is
in running position with its head
raised, and the lion's left paw encir-
cles its right shoulder. The lion's
right claws are sunk into the boar's
back and he is biting the boar's neck.
The lion's back paws are braced on
the ground, while its tail is upraised.
Just behind the lion's rump on the
right is a whorl pattern composed of
three circling rabbits, who share
the three ears in the centre of the
pattern. The bodies of these animals
are each depicted in two different
positions – running and leaping. In
the upper left is a faint red sketch
of a flying or running human figure
with its arms outstretched to the left.

JP

507 Krishna admires his stepfather's cattle

Ink and wash on paper.
24.7 × 29.8 cm
India, Guler, Punjab, date unknown
M82.12

The drawing depicts a procession of cows and people moving from left to right through a landscape. At the bottom of the composition a row of rocks suggests the bank of a river. Ten cows lead the procession and are herded along by seven cowherds, one holding a tail, one carrying a goad, and others carrying flowers. All wear turban-like hats. They are followed by a figure dressed in dhoti and crown, holding flowers, gesturing with the left hand towards the cows and turning back to look at a bearded, fully-dressed man behind him. The latter is followed by four women with shawls over their heads. A small figure is half hidden behind the skirt of the woman in front. Two of the women have the fingers of one hand to their lips, as does the man behind them. Last in procession is an old woman leaning on a walking stick. In the upper left are two flowering trees with rocks; upper centre, shrubs and a leafless tree; upper right, two flowering trees with rocks. There is an inscription along the top border. JP

508 Chinese painting of a scholar meditating in his studio. Signature of artist XU BEN 徐賁 (1335–1380)

Ink on paper. 26.6 × 21.7 cm
Chinese, date unknown

M82.10

Collectors' seals: One seal on right margin of mounting: Langya zhaoshi zhenshang 琅邪趙氏珍賞 (intaglio, tall rectangle; owner unidentified)

Seven seals on painting: Shen Zhou 沈周 (1427–1509): Shen Zhou zhenwan 沈周珍玩 (relief, square); Xiang Yuanbian 項元汴 (1525–1590): Zijing 子京 (relief, tall rectangle); Zisun yongbao 子孫永寶 (intaglio, square); Molin miwan 墨林秘玩 (relief, square); Xiang Yuanbian yin 項元汴印 (relief, square); Zijing zhi yin 子京之印 (relief, square); Wu Ting 吳廷 (act. 18th century): Wu Ting (relief, tall rectangle).

The painting depicts a seated scholar meditating in his secluded studio half-hidden in the shade of sumptuous trees that surround his thatched hall. A crane leisurely paces in the open area in front. Its presence reflects the cultivated taste and the eremitic inclination of its master.

This painting may have been part of a much larger composition, because of the crowded composition and insignificant location of the principal subject. The signature of the artist is interpolated. The seals attributed to the highly respected Ming dynasty painter Shen Zhou, as well as the renowned collector Xiang Yuanbian, were also added later to vouch for the authenticity and value of the painting. This work was, however, produced by a later hand.

The artist Xu Ben, to whom this painting is attributed, was a native of Sichuan and lived in Suzhou in Jiangsu province. His literary name was Youwen 幼文 and his sobriquet Beiguosheng 北郭生 . Known as one of the 'Ten Friends of the North City Wall,' he was active in poetic and painting circles.

After native rule was restored with the Ming dynasty (1368–1644), Xu Ben was summoned to serve the emperor Hongwu 洪武 in 1374. Later he rose to the important post of administrative commissioner of Henan province, but was imprisoned for failing to provide adequate supplies for expeditionary armies passing through his province. He eventually died in prison.

In art, Xu Ben followed closely the style of Wang Meng 王蒙 (circa 1309–1385), the youngest among the 'Four Great Yuan Masters,' the other three being Huang Gongwang 黃公望 (1269–1354), Wu Zhen 吳鎮 (1280–1354), and Ni Zan 倪瓚 (1301–1374). Wang Meng's characteristic application of dense and vibrant modelling strokes for the description of the rock surfaces as well as tightly organized composition are some of the prominent stylistic traits inherited by Xu

Ben, as can be seen in this attributed work. The tradition of literati painting, however, came to an impasse, though temporarily, in the last quarter of the fourteenth century, as most of the direct descendants of the Yuan dynasty literati painters, like Xu Ben, invariably suffered fates of imprisonment or execution.

Purchased from Kelekian, Paris KBT

509 China trade painting of a pair of peacock-pheasants with flowering plants

Gouache on pith paper.
21.6 × 29.5 cm
Chinese, mid-19th century M82.453

A pair of peacock-pheasants are depicted strolling in the countryside with lush green grasses, scattered rocks, and flowering plants. The close-up representation and centralized placement of the birds are characteristic artistic devices in this genre to emphasize the significance of the subject. The abundant attention given to the execution of the two peacock-pheasants, as can be seen in the painstaking rendition of the fine hair and feathers decorated with ocelli, reflects the predilection for realism of the artist. His preponderant concern for precision also speaks for his keen observation of nature as well as his technical skill. The overall finer quality of execution sets this painting on a higher level of accomplishment than 'A Pair of Birds on a Lychee Branch' (catalogue 510).

KBT

510 China trade painting of a pair of birds on a lychee branch

Gouache on pith paper.
13.1 × 18.6 cm
Chinese, mid-19th century M82.34

This painting depicts a pair of white-headed bulbuls resting on a branch laden with lychees. It belongs to a type which has been popularly termed as 'China trade painting,' made as early as the mid-eighteenth century but which flourished mainly in the nineteenth century after coastal ports were opened to Western countries. Mass-produced in Canton for export or for foreign visitors to take home as souvenirs, such paintings were executed by Chinese professional artists using Western media and techniques to cater to Western tastes.

In an attempt to satisfy occidental curiosity about this exotic country, the subject matter of these China trade paintings centres around views of coastal ports such as Canton, Hong Kong, Macau, and the Huangbu River, as well as on genre scenes depicting the lives of people from all walks of life. Most commonly depicted are officials and the affluent class in their resplendent attire, the domestic life of the common people, local customs, and street scenes showing skilled labourers such as barbers, pottery repairers, vendors, entertainers, festive processions, and farmers working in the field. Occasionally, representations of grotesque punishment scenes were offered to the Western market. In addition, drawings of birds and flowers were also in popular demand. Such paintings were often made in sets of eight, ten, or twelve leaves, which were bound into albums with figured silk covers. Their decorative qualities were further enhanced by the use of brilliant colours in contrasting combinations, creating a sharp visual impact Westerners of the time found appealing. KBT

511 Roosting birds on a moonlit night
Signature of artist
LIU YUNHENG 劉允衡
(1938–1975).
Seal of the artist Liu (relief, round)

Hanging scroll, ink and colour on Japanese *unryūshi* (cloud-dragon paper). 97.6 × 42.1 cm
Hong Kong, 1972 M82.455

The painting depicts three birds roosting on the branch of a tree by a pond. One bird has quietly dozed off. The other two birds, however, remain alert, surveying from their perch the peaceful surrounding. A soft breeze sends the overhanging branches swaying and gentle ripples spread across the reflection of a full moon.

This painting is an example of the style of the Lingnan School 嶺南畫派. Lingnan (lit. south of the mountain ranges) is another name referring to Guangdong province on the south-

east coast of China. The Lingnan School of painting was formulated in the early part of the twentieth century. Its principal founders were Gao Jianfu 高劍父 (1879–1951), his brother Gao Qifeng 高奇峰 (1889–1933), and Chen Shuren 陳樹人 (1883–1948). All three received traditional training in Chinese painting and then furthered their studies in Japan. Consequently, their works were much influenced by certain Japanese painters, in particular Takeuchi Seihō 竹內栖鳳 (1864–1942), Yokoyama Taikan 橫山大觀 (1868–1958), and Hashimoto Kansetsu 橋本關雪 (1883–1944).

The artistic ideals that these three pioneering masters advocated were to instill Western techniques into Chinese painting in order to create new approaches and fresh ideas. Gao Jianfu stressed that the purpose of painting was to express the thoughts and spirit of a nation. Also, the spirit in art should be in perfect harmony with the spirit of the period. The special geographic location of Guangdong has always allowed its inhabitants to communicate with the outside world. In many respects they tend to take more liberal views than their compatriots living in the capital and cultural centres where the hold of tradition is strong. Enthusiastic response to the paintings of the Lingnan School attracted a large number of followers.

Gao Qifeng established the Lifeng Studio 立峰畫院. Most accomplished among his many students is Zhao Shaoan 趙少昂 (b. 1903), who is able to transmit the art of his teacher and at the same time maintain his individual characteristics. Zhao, in turn, has accepted students to carry on the art of the Lingnan School.

The artist of this painting, Liu Yunheng, was one of the numerous students of Zhao Shaoan. In this work some of the stylistic features of the Lingnan School can be savoured. Most prominent is the predilection for a decorative taste, achieved by emphasizing the atmospheric effect of the scene depicted. In this case a misty moon-lit pond is represented by the bold use of large areas of

washes which vary subtly in tonality to suggest mists and faint light shimmering from the moon as patches of cloud drift over it. The extremely energetic application of the brush to produce a visually rich lineal effect may be observed in the branches. The movement of these branches contrasts with the stillness of the night, enlivening this tranquil scene with a subtle flavour. KBT

512 Woodblock print (*Saitan surimono*)
KATSUKAWA SHUNSHŌ
(1726–1792)

Printed on paper; keyblock in black, five colour blocks (two shades of green, brown, mustard, red).
16 × 21.5 cm
Japanese, late 1780s–early 1790s
M82.33

Surimono were produced during the latter half of Japan's Edo period (1615–1868). Privately published, sometimes for exchange on special occasions somewhat like today's greeting cards, *surimono* often beautifully demonstrate the high technical and aesthetic levels attained in eighteenth- and nineteenth-century Japanese woodblock printing. They were finely printed on high

quality paper and usually included poems printed in cursive calligraphy. Part of the broader category of graphic art known as ukiyo-e, *surimono* could encompass in their designs all ukiyo-e subjects, although portraits of kabuki actors were rare before 1820, and *shunga* (erotica) were much less apparent than in commercially published prints. Birds, flowers, animals, and landscapes depicted on *surimono* encouraged designers to start including such subjects in commercial prints. Educated connoisseurs, usually members of poetry clubs, often conceived the designs for *surimono* and commissioned their production, striving to impress those who would receive the prints with their highly developed aesthetic sensibility and refined taste.

Precursors of *surimono*, *e-goyomi* (picture calendars, or calendar prints) had been part of the œuvres

of well-known ukiyo-e print designers as early as the 1720s. *E-goyomi* were important in the development of colour printing. Book illustrations printed in colour appeared as early as 1730, but calendar prints published in the spring of 1742 probably represent the first use of two-colour printing on single sheets. The Japanese lunar calendar year was divided into twelve months of two lengths – longer months of thirty days and shorter months of twenty-nine days – plus an occasional intercalary month of either type. The number and arrangement of long and short months changed annually. Calendar prints illustrated the order of long and short months for a given year by incorporating it, or sometimes concealing it, in the print design. In 1765 full-colour printing, using more than two or three colour blocks, became feasible partly due to the financial backing of wealthy merchants and members of the samurai class residing in the city of Edo (now Tokyo) who commissioned a large number of *e-goyomi* for that year to present as gifts. Following an inexplicable decline in the number of calendar prints for a few years after 1766, they appeared again occasionally, in a smaller format, until the first decade of the nineteenth century, after which they virtually died out. One probable reason for their demise was the development of *surimono*. Especially towards the end of the eighteenth century there was increased collaboration between the professional print designers and amateur poets. Most of the few *e-goyomi* produced at that time included poems by members of the poetry clubs, as did the contemporary *daishō surimono* which, like *e-goyomi*, incorporated the long months (*dai*) and the short months (*shō*) in their designs. *Saitan surimono* (New Year's *surimono*), as manifested in this example from the Malcove Collection, did not usually indicate long and short months. With the months omitted they could be designed even prior to the official government announcement of the coming year's calendar and be produced in time for New Year's Day presentation.

The three poems on the Malcove *saitan surimono* are haiku or perhaps *senryū*, less serious, sometimes comic poems, although still structurally haiku because of their three lines of five, seven, and seven syllables. Their division under three headings is standard for New Year's *surimono*.

SAITAN	NEW YEAR'S DAY
Kadomatsu ni	Returning to the
Ikuto kaeri zo	[season of]
Hana no haru	New Year's decorations year after year!
	The flowery spring

SHUNKYŌ	EARLY SPRING
Tsumi mandoku	The bad, the good,
Hijiri ya–tsuru	and the saintly
mo hito	[Are found among]
Hito mo tsuru	both cranes and people,
	Both people and cranes.

SEIBO	THE YEAR'S END
Waga mawan	I think I shall dance
Utae niwatori	Sing, barnyard fowl!
Toshi wasure	The end-of-the-year party.

The mention of barnyard fowl, more specifically chickens, possibly dates this *surimono* to 1789, the Year of the Cock.

The printed signature of the poet, Kibun, follows the final poem. In the standard biographical dictionaries of haiku poets Kibun is listed as a *nom de plume* of Sakurai Tadatsugu (1741–1805), a member of the samurai ruling class and lord of Tōtōmi province (the western part of present-day Shizuoka Prefecture). Both he and his father studied haiku while resident in Edo and he is also known by another haiku name he inherited from his father, Ichiōsei. Kibun is recorded as having done illustrations for one of his own books of poems published in 1787. He also contributed to a *saitan-jō*, or illustrated album of linked verse published in observance of the new year. Especially in fashion during the 1750s–80s, these printed albums were collaborative efforts of poetry club members who spontaneously composed, in turn, short stanzas of a long poem, then chose, or designed themselves, illustrations for the poem.

The pictorial section of this *surimono*, parent cranes with three offspring nested in a pine bough, relates to the content of the second poem. However, more generally, the crane as an auspicious symbol of longevity is a felicitous subject for Japanese New Year's.

The printed signature of Shunshō is followed by his cipher, printed in red. Rather different Shunshō ciphers appear, although rarely and printed in black, on other Shunshō prints. Ciphers more similar in form to this one, but brushed – not printed – in red pigment sometimes follow his signature on paintings.

Katsukawa Shunshō was known as a painter of ukiyo-e subjects in particular of beautiful women, before he began designing prints. Primarily a designer of kabuki actor prints, his *surimono* are almost non-existant, judging from published examples. The only Katsukawa Shunshō *surimono* located depicts two deer standing by a stream. It is somewhat atypical, with no poems (Kikuchi, *A Treasury of Japanese Woodblock Prints: Ukiyo-e*, New York 1969, fig. 1420).

Shunshō had many pupils in his Edo atelier including Katsushika Hokusai (1760–1849), the very prolific artist and print designer who is responsible for the approximately fourth largest group of extant *surimono*, surpassed only by his student Hokkei, Shinsai (see catalogue 513), and Hokkei's pupil, Gakutei.

For further reference see Matthi Forrer, *Egoyomi and Surimono: Their Development and History* (Uithoorn 1979); Nihon Ukiyoe Kyōkai, *Genshoku Ukiyoe Daihyakka Jiten*, 11 vols. (Tokyo 1980–2); Roger Keyes, *Surimono: Privately Published Japanese Prints in the Spencer Museum of Art* (Tokyo 1984); Sogo Takagi, *Haikai Jimmei Jiten* (Tokyo 1970); David Waterhouse, 'New Light on the Life of Suzuki Harunobu,' *Ukiyoe Geijutsu*, no. 74, 1982, i-x.

The poems on this print were transcribed with the kind assistance of Ryoko T. Smith. HW

513 Woodblock print
(*Kyōka surimono*)
RYŪRYŪKYO SHINSAI
(1764 ?-mid-1820s)

Printed on paper; keyblock in black, four (?) colour blocks (blue, rose, green, brown), gauffrage and mica Shikishi-ban. 19.5 × 18.1 cm
Japanese, circa 1810–20 M82.35

Ryūryūkyo Shinsai lived in the Kanda district of Edo (now Tokyo). The majority of his surviving artistic output consists of *surimono* accompanied by printed *kyōka* poems, as represented by this example. He also supplied many designs for illustrated books of *kyōka* compilations.

Shinsai was either a direct pupil or a close follower of Hokusai and the style used in his print designs, including those for *surimono*, owes much to his master. Some of Hokusai's landscape prints show experimentation, with varying degrees of success, in using Western perspective. Edo period artists had only limited exposure to European graphic art, as seen in, or in derivations from, copperplate engravings in Dutch books. Two series of Shinsai landscape prints, dating from around the same time or slightly earlier than this *surimono*, show that his understanding of imported perspective probably surpassed Hokusai's.

Few of Shinsai's *surimono* are landscapes. However, this still life is typical of *surimono* subjects conceived by many of the designers, including Shinsai. The final product, as in other ukiyo-e woodblock prints, owed as much to the skills of the block carver and printer as to the design submitted by the artist.

In this *surimono* Shinsai has grouped a variety of objects, at least two of them relating to the New Year's season or to Ebisu festivals. Ebisu, one of the seven popular gods of good fortune, protects fishermen and merchants. He is usually depicted with a *tai* fish (seabream). The *tai* is a ubiquitous Japanese New Year's symbol and staple owing to its phonemic analogy to the word *mede-tai*, propitiousness. Here the

seabream rests on a Nabeshima blue and white porcelain footed dish and is garnished with green and white leaves of *kumazasa*, a kind of low growing ornamental bamboo. The last line of the third and final poem refers to the Young Ebisu Festival, held on the tenth day of the New Year, when women of pleasure and merchants prayed for financial success throughout the year.

The black and (formerly) red lacquered low table or brazier supports a lacquered shallow cup of the type used to drink *toso*, a spiced *sake* imbibed to celebrate the New Year. The written character partially visible in the bottom of the cup is 'longevity,' often used as an auspicious decorative motif. It is unclear how the recessed silver-coloured brazier (?) part of the table functions or supports the *toso* cup.

The elaborate frame with its beaded and tasselled hanging-cord extending down behind it holds a painting of *shakuyaku*, a variety of peony. This flowering plant, although blossoming in late spring or early summer, is probably appropriate to the *surimono* because of its colloquial names – Ebisu grass and, because of its therapeutic properties, Ebisu medicine.

The significance of the spoon which rests against the painting and of the pitcher-like vessel below it are not immediately obvious. The pitcher, however, is decorated with plum blossoms, harbingers of spring. The lunar calendar New Year marked the beginning of spring.

The printed signature, Shinsai, appears in the lower right corner. In the upper right corner, barely visible, although originally printed in red, is a small barrel-shaped drum. (This *surimono* has faded to the extent that the more fugitive colours have disappeared completely.) The drum was the logo of the Taiko-gawa, the circle of *kyōka* poets who named their group Taiko, or 'drum.' The three poets whose names appear before their poems here – Shikishima Michikusa, Fugentei Tōri, and Dondontei [Wataru] (died 1822) – were all probably members of the Taiko *kyōka* society, Dondontei being the

group's leader.

Kyōka imitated classical thirty-one syllable *waka* poems, with a determined number of syllables per line (5-7-5-7-7). As in *waka*, classical literary themes, the seasons, and heart-felt nostalgic emotions were alluded to, but the generally humourous, or even satirical, content of *kyōka* (literally, 'mad poems') differentiate them from *waka*.

Kyōka surimono were circulated among members of the poetry societies to demonstrate the writers' compositional ability in an attractive format. The verses, often in accord with the illustration, could also commemorate special events or holidays.

See Jack Hillier, 'Still-Life in Surimono,' *A Sheaf of Japanese Papers* (The Hague 1979), pp. 75–84; Roger S. Keyes, 'Copies of Square Surimono,' *Ukiyo-e Studies and Pleasures* (The Hague 1978), pp. 57–67; Isaburō Oka, ed., *Fūkei Hanga, Nihon no Bijitsu*, no. 68 (Tokyo 1972); Charlotte van Rappard-Boon, Roger S. Keyes, and Keiko Keyes-Mizushima, *Hokusai and his School* (Amsterdam 1982); and Jūzō Suzuki, *Ehon to Ukiyoe* (Tokyo 1979), pp. 529–71, translated in *Proceedings of the First International Symposium on Surimono* (Tokyo 1979), pp. 39–63. See also catalogue 512. HW

Contributors

PHOTOGRAPHS John Glover, Faculty of Arts and Science, University of Toronto, Toronto, Ontario.

AH Alexandra Haldane, University of Toronto, Toronto, Ontario

AHE Alison H. Easson, Greek and Roman Department, Royal Ontario Museum, Toronto, Ontario

AI Ariane Iseler, Stratford, Quebec

AK Antje Krug, Deutsches Archäologisches Institut, Berlin

AL Anu Liivandi, Department of Textiles, Montreal Museum of Fine Arts, Montreal, Quebec

AW Alan Wilkinson, Art Gallery of Ontario, Toronto, Ontario

CPJ Christopher P. Jones, Department of Classics, University of Toronto, Toronto, Ontario

CW Caroline Williams, Department of Classics, McMaster University, Hamilton, Ontario

DD Doris Dohrenwend, Far Eastern Department, Royal Ontario Museum, Toronto, Ontario

DT David Townsend, Department of Classical and Oriental Languages, San Diego State University, San Diego, California

EAH Elizabeth A. Hayes, Far Eastern Department, Royal Ontario Museum, Toronto, Ontario

EAR Elisabeth Alföldi-Rosenbaum, Princeton, New Jersey

EHW E. Hector Williams, Department of Classics, University of British Columbia, Vancouver, British Columbia

EK Eve Kliman, Department of Art History, Waterloo University, Waterloo, Ontario

EL Elizabeth Leesti, Department of Fine Art, University of Toronto, Toronto, Ontario

EPM Elizabeth Parker McLachlan, Department of Art History, Rutgers University, New Brunswick, New Jersey

FB Francis Broun, Art Gallery of Ontario, Toronto, Ontario

GK George Knox, Department of Fine Art, University of British Columbia, Vancouver, British Columbia

HW Hugh Wylie, Far Eastern Department, Royal Ontario Museum, Toronto, Ontario

IKM Ioli Kalavrezou-Maxeiner, Institut für Byzantinistik, Neugriechische Philologie und Byzantinische Kunstgeschichte der Universität München, Munich, Germany

JH John Hayes, Greek and Roman Department, Royal Ontario Museum, Toronto, Ontario

JO John Osborne, Department of History in Art, University of Victoria, British Columbia

JP Jeannie Parker, Far Eastern Department, Royal Ontario Museum, Toronto, Ontario

JS Joaneath Spicer, Department of Fine Art, University of Toronto, Toronto, Ontario

JSP Jacke Phillips, Near Eastern Studies, University of Toronto, Toronto, Ontario

KAT Kim A. Turner, Department of Fine Art, University of Toronto, Toronto, Ontario

KBT Ka Bo Tsang, Far Eastern Department, Royal Ontario Museum, Toronto, Ontario

KCK K. Corey Keeble, European Department, Royal Ontario Museum, Toronto, Ontario

KO Kathleen Openshaw, Centre for Medieval Studies, University of Toronto, Toronto, Ontario

LC Louise Cormier, Department of Fine Art, University of Toronto, Toronto, Ontario

MD Martin Dimnik, Pontifical Institute of Mediaeval Studies, Toronto, Ontario

MJH Marian J. Hollinger, Centre for Medieval Studies, University of Toronto, Toronto, Ontario

MJHL Michael J.H. Liversidge, History of Art Department, University of Bristol, Bristol, England

MM Marylin McKay, Department of Fine Art, University of Toronto, Toronto, Ontario

MW Marc Waelkens, National Fund for Scientific Research, Gent, Belgium

NM Nancy McElwee, Pontifical Institute of Mediaeval Studies, Toronto, Ontario

NO Nicholas Oikonomedes, Département d'Histoire, Université de Montréal, Montreal, Quebec

NS Noha Sadek, Middle East and Islamic Department, University of Toronto, Toronto, Ontario

PD Paul Denis, Greek and Roman Department, Royal Ontario Museum, Toronto, Ontario

PK Peter Kaellgren, European Department, Royal Ontario Museum, Toronto, Ontario

RB Robert Belton, Fine Art Department, University of Toronto, Toronto, Ontario

RM Roger McCleary, Fine Art Department, University of Toronto, Toronto, Ontario

SDC Sheila D. Campbell, Pontifical Institute of Mediaeval Studies, Toronto, Ontario

TT Teresa Tomory, Markham, Ontario